Jan van Noordt

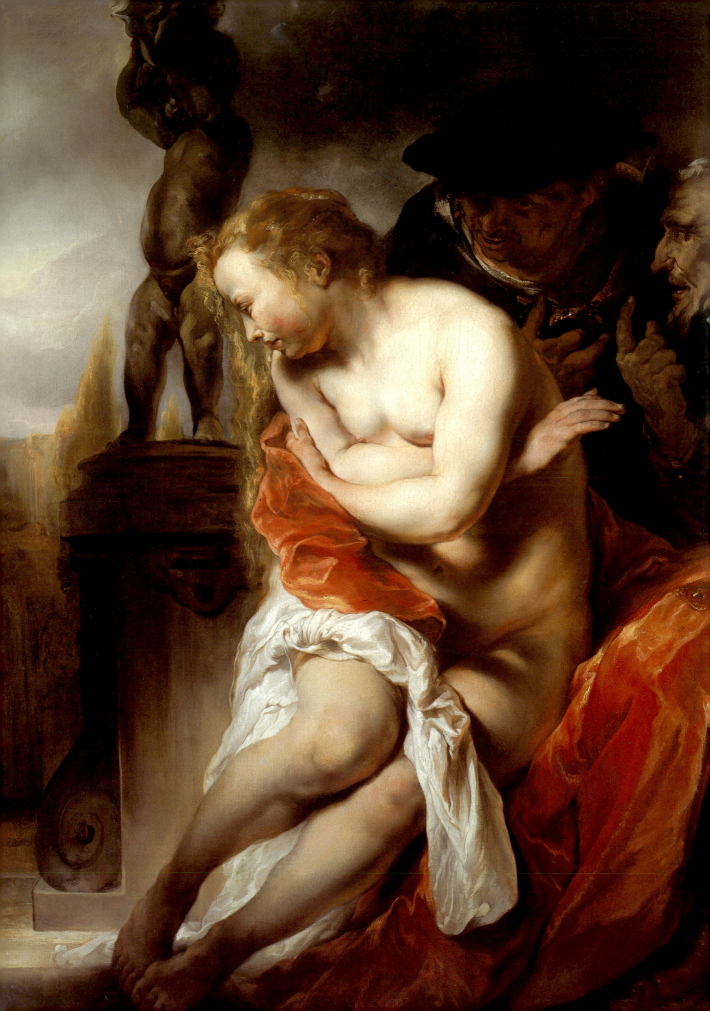

Jan van Noordt

Painter of History and Portraits in Amsterdam

David A. de Witt

McGILL-QUEEN'S UNIVERSITY PRESS Montreal & Kingston • London • Ithaca

©McGill-Queen's University Press 2007

ISBN 978-0-7735-3275-5

Legal deposit fourth quarter 2007
Bibliothèque nationale du Québec

Printed in Canada on acid-free paper.

Publication of this book was made possible in
part by the generous financial support of
Alfred and Isabel Bader.

McGill-Queen's University Press acknowl-
edges the support of the Canada Council for
the Arts for our publishing program. We also
acknowledge the financial support of the
Government of Canada through the Book
Publishing Industry Development Program
(BPIDP) for our publishing activities.

**Library and Archives Canada Cataloguing
in Publication**

De Witt, David A.
Jan van Noordt : painter of history and
portraits in Amsterdam / by David A. de Witt.

Includes bibliographical references and index.
ISBN 978-0-7735-3275-5

1. Noordt, Jan van, 1624?–1676. 2. Noordt,
Jan van, 1624?–1676?— Catalogs. 3.
Painting—Netherlands—Amsterdam. 4.
Painting, Dutch— 17th century. 5. Painters—
Netherlands—Amsterdam—Biography. 6.
Painters—Netherlands—Biography. I. Title.

ND653.N67W58 2007
759.92
C2007-901856-4

This book was designed and typeset by studio
oneonone in Janson 10/13

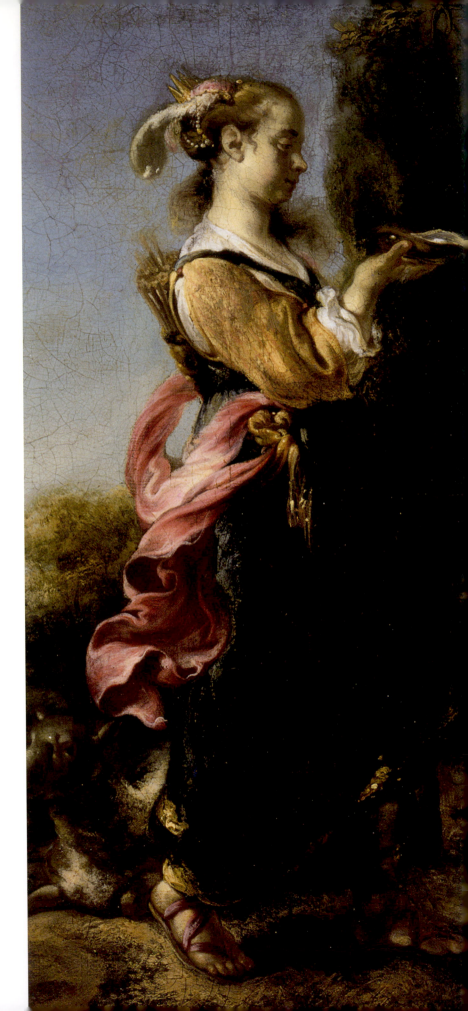

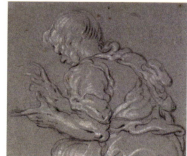

Contents

To Franziska

Acknowledgments

The path of this monograph started at the Department of Art of Queen's University in Kingston, Canada, moved through various institutions in the United States, the Netherlands, and elsewhere in Europe, and then returned to Kingston. Along the way, a number of people lent their assistance, both improving this study and hastening its progress. First and foremost is Professor Volker Manuth of Nijmegen University. His guidance and experience extended over several years as dissertation adviser at Queen's University, and the time before and after as well. His engagement and generosity will always remain for me a model for the scholarly life.

A number of other scholars in the field of Dutch art graciously shared their specialized knowledge and material. I am grateful to Willem van de Watering, Albert Blankert, and Robert Schillemans for discussing with me the problems associated with the study of Van Noordt and for providing numerous important leads to relevant information. A special thanks is owed to the musicologist Jaap den Hertog, who is presently completing a dissertation on Anthoni van Noordt, and who directed me to pertinent archival material on Anthoni's brother Jan. For their help in searching for and interpreting archival documents I would also like to thank S.A.C. Dudok van Heel, Jaap van der Veen, and Marten Jan Bok. At the Amsterdam archive, Johan Giskes shared his views on the interpretation of specific documents related to his own research on Jacobus van Noordt.

In its earlier state as a dissertation, this study benefited from the input of Jane Russell-Corbett, Professor Emeritus J. Douglas Stewart, Professor David McTavish, and William Robinson, who contributed as readers or defence committee members. I also thank Philip Knijff, Odilia Bonebakker, Jonathan Bikker, and Alfred Bader for their informal support by way of discussions of Jan van Noordt's life and work.

No serious study of this type can materialize without the resources of the Rijks-bureau voor Kunsthistorische Documentatie (the Netherlands Institute for Art History) in The Hague. I am grateful to its staff for their ready help with the many and varied types of material collected there.

This study involved a great deal of travel and research, which would not have been possible without the generous financial assistance provided through a Bader Fellowship from the Art Department of Queen's University. My praise goes to Drs Alfred and Isabel Bader for their support of students undertaking dissertation research at Queen's. I am also thankful for the support I received through the Queen's Graduate Fellowship. Equally substantial is the support for the publication of this monograph, both moral and financial, from Alfred and Isabel Bader. They have done much over the years to open the eyes of scholars and laypeople alike to the riches of Dutch Baroque Art, of which the paintings of Jan van Noordt are a vital part.

Jan van Noordt

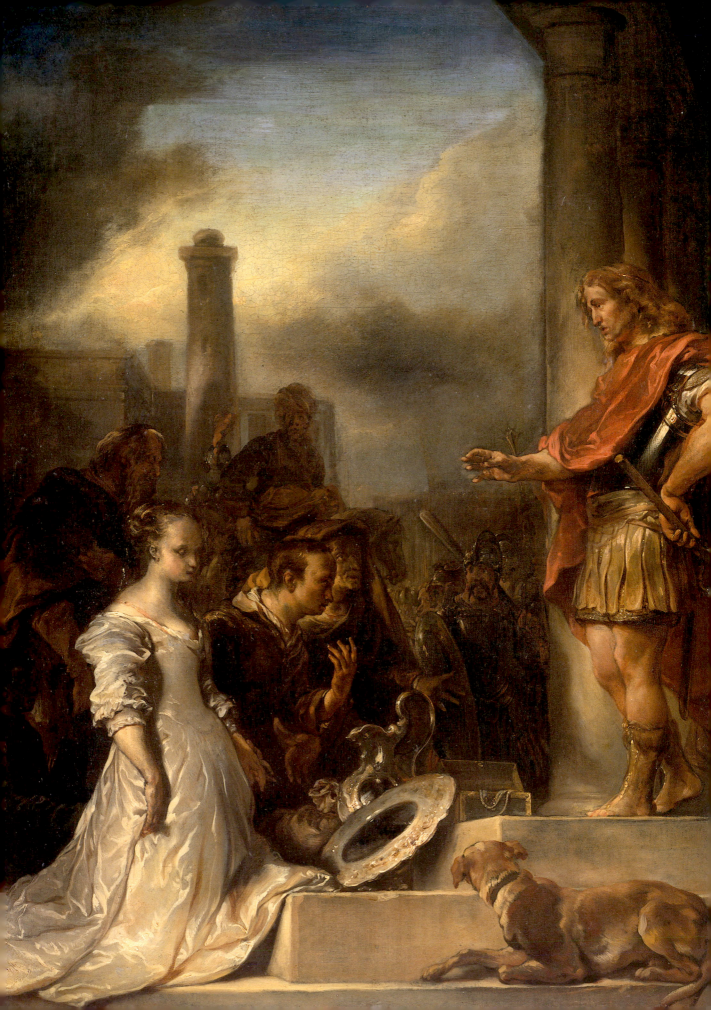

Jan van Noordt

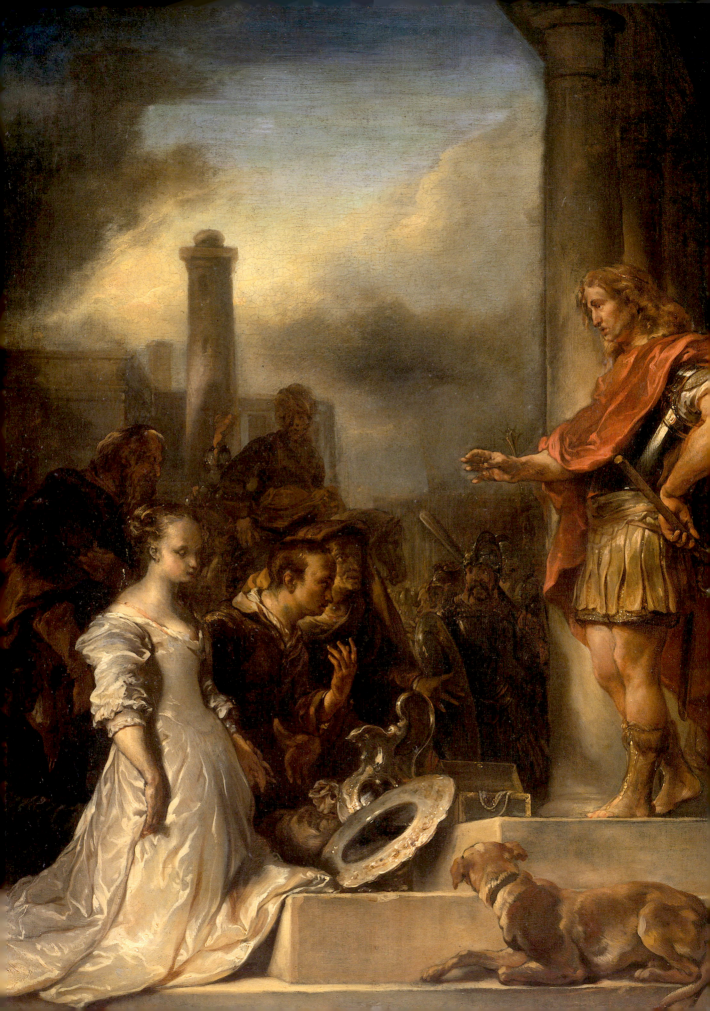

Introduction

There are three paintings by the seventeenth-century painter Jan van Noordt in the Rijksmuseum in Amsterdam, in the most representative collection of the paintings of the Dutch Golden Age. These paintings are *Continence of Scipio* and two versions of the *Portrait of Dionys Wynands* (cat. 27, 51, and 52); in all three Van Noordt conjured moments of beauty, conveyed a sense of gravity, and pursued a vigorous and grand overall effect. He was not content only to match the smooth and pleasing work of some of his more successful contemporaries: the *Scipio* shows a hard edge that borders on the grotesque but contributes significantly to the scene's sober tone.

Such complex qualities have perhaps kept Jan van Noordt's work from becoming better known and the scholarly literature to date provides an incoherent picture of this artist. Until recently, the most substantial study was a 1986 article by the German art historian Werner Sumowski, the doyen of Rembrandt-school studies. However, Sumowski, instead of reaching conclusions, calls for a much more intensive study of the artist and his oeuvre as "one of the most urgent desiderata of art scholarship."[1] The following pages bear out this view, unravelling a number of persistent, significant problems, most of them linked to misattributions. This study presents a picture of an artistic figure whose work has an important place within the art and culture of his age.

The early literature on Van Noordt is contradictory, providing both evidence that he had a strong reputation as well as indications that he remained obscure. In the first great compendium of biographies of the artists of the Dutch Golden Age, Arnold Houbraken's *The Great Theatre* of 1717–21, Jan van Noordt is mentioned only once, in passing, as the teacher of Johannes Voorhout.[2] However, he is called "the famous Joan van Noort, history and portrait painter in Amsterdam." Despite Houbraken's lack of further information on him, a number of lavish and fashionable

portraits by the artist testify that he did, for a period, enjoy high-level patronage, evidence of a considerable reputation.

For many years awareness of Van Noordt was upheld by his paintings. In the late eighteenth and nineteenth centuries, several of his signed and dated works entered prominent public collections. The first art historian to draw significant attention to them and to their creator was Cornelius Hofstede de Groot (1863–1930) who, in a groundbreaking 1892 article, brought together twenty-four Van Noordt paintings, including the three in the Rijksmuseum.[3]

Hofstede de Groot amassed all the documentary evidence on Van Noordt that he could find, following the scientific principles of art historical research propounded around the 1850s by researchers such as Pieter Scheltema (1812–1885).[4] His seeming objectivity was, however, affected by the intensely nationalist agendas of the period.[5] In an effort to distinguish Van Noordt from Rembrandt, who had become the national archetype, Hofstede de Groot alluded to, but could not document, of a trip Van Noordt might have made to Antwerp, thus suggesting that Van Noordt had left his native soil and in this way absorbed the Flemish influences perceptible in his paintings.[6] This interpretation both suppressed the international character of Dutch culture in the seventeenth century and de-emphasized van Noordt's connection to domestic practice. Alfred von Wurzbach's erroneous statement in his lexicon entry on Jan van Noordt of 1910, that Van Noordt studied with Rembrandt, was probably just a hasty misreading of Hofstede de Groot's assertion of the opposite.[7]

Hofstede de Groot's collection of material on Dutch art is now deposited in the Institute for Art History in The Hague, as are further notations concerning documents in Amsterdam and other cities made by Abraham Bredius (1855–1946). Much of this material on Van Noordt is being analyzed and published for the first time here. Since Bredius, scholars have sought to expand our understanding of Jan van Noordt primarily by coming forward with attributions of paintings and drawings to him. Although many of these are correct, others, often made on weak evidence, are not, and the sum total has been confusion. J.O. Kronig's 1911 article[8] and Jean Decoen's of 1931[9] both focus on works that must be rejected as by Van Noordt. Still tenable is the analysis offered by Kurt Bauch in 1926 that Van Noordt likely studied with the Amsterdam painter Jacob Adriaensz. Backer, whose work synthesized the Rembrandtesque and the Rubenesque of the 1630s.[10] This localization of Van Noordt's artistic milieu was developed further by Joachim von Moltke in 1965 with respect to the Rembrandt pupil Govert Flinck, who was very close to Backer.[11] Von Moltke's reattributions of paintings and drawings from Flinck to Van Noordt were often wrong, however. The link was more decisively drawn in a superb 1979 article on Jan van Noordt's drawings by the Rijksmuseum scholar Peter Schatborn, in which he emphasized the shared technique of two chalks on blue-tinted paper.[12] A connection with the talented Rembrandt pupil Gerbrand van den Eeckhout, posited by Saskia Nystad in 1981, was based on indirect documentary references and a critical misattribution, and is not borne out by the present study.[13]

With his demonstrated connections to these artists, Van Noordt belongs to the so-called "Rembrandt school." He found a place in Werner Sumowski's grand series on this group of artists, which began to appear in 1983.[14] In his chapter on Backer in the first volume, Sumowski included a lengthy digression on Van Noordt. Sumowski's priority was formal stylistic analysis, and he drew a brief sketch of the artistic development of Van Noordt. He presented many new attributions to Van Noordt, and more followed in subsequent volumes.[15] In 1986 Sumowski also published a separate monographic article on Van Noordt's paintings, which introduced the artist to English readers.[16]

The broad scope of Sumowski's project precluded the direct study of every painting he attributed to Jan van Noordt. Surprisingly, he did not treat very seriously the careful speculations of Hofstede de Groot and Alfred von Wurzbach that there might be another artist with a similar name.[17] In this study I distinguish five paintings by Jan van Noort that have traditionally been attributed to Jan van Noordt. As well, dozens of other works are removed from the oeuvre, an adjustment that changes and refines our picture of the artist significantly, and several works that have hitherto not been studied with respect to Van Noordt are added. Most important among these is the signed *Cimon and Iphigenia* (cat. 28) that appeared at a recent sale in New York, because it confirms the direct role of Backer in Van Noordt's training. This painting thus curbs speculation about an "early style" and gives a basis for questioning a number of attributions to the early Jan van Noordt.

None of the studies on Jan van Noordt since 1892 has involved any new archival research or biographical material. Art historians have therefore made little progress in identifying his milieu. It fell to the music historian A.G. Soeting to publish the fact that this painter belonged to the Van Noordt family of organists and composers;[20] the boundaries of specialization kept art and music historians from making this connection, even in speculation, for a century. Recent research on the brothers Anthoni and Jacobus van Noordt has yielded several documents mentioning their brother Jan, which were published in articles by Soeting in 1980, Jaap den Hertog and Simon Groenveld in 1987, and Johan H. Giskes in 1989, and in Rein Verhagen's monograph of the same year on Jacobus's son Sybrandus, an organist and a composer.[19] These documents were first cited in art history literature in 1991,[20] and their implications for Jan van Noordt's life and art are fully analyzed here for the first time.

Van Noordt is also an interesting figure because of his position in his society and culture. Scholarly study of seventeenth-century Dutch art expanded greatly in the 1960s in the areas of iconography and the interpretation of themes within their original context. The study of Jan van Noordt's life and work has been accompanied by an increasingly complex comprehension of Dutch culture of the Golden Age, which embraced its international character and pluralistic religious and philosophical climate. In this society, with its institutions and panoply of ideas, the interpretation of many paintings was bound to texts of sacred scripture, literature, and history. Nonetheless, history painting was largely absent from the important

1966 Pelican survey of Dutch seventeenth-century art by Jacob Rosenberg, Seymour Slive, and E.H. ter Kuile.[21] An important turning point was the 1980–81 exhibition *Gods, Saints, and Heroes*, in which Jan van Noordt's role as an interpreter of such themes was represented, although not strongly.[22] The early, over-cleaned *Susanna and the Elders* (cat. 6), which was included in the exhibition, could only suggest his particular approach, and his far more compelling later work and development went unreferenced.

The research for this monograph goes back to my master's thesis at Queen's University, which was completed in 1993 and which focused on only two paintings by Van Noordt (cat. 14, 23). This study conforms to the monograph format, in which all of the available information, and all attributed works and references to such works are considered. The first chapter examines the data on Van Noordt's life, and the second and fifth chapters address the problems of his oeuvre of paintings and drawings. The third and fourth chapters analyze the paintings with respect to the context of their production: the third chapter identifies the market for which Van Noordt worked and follows the artist as he pursued the open market and private patrons, whereas the fourth chapter ties the cultural context to the artist's choices of subject matter for his history paintings. The patterns that emerge in Van Noordt's iconography suggest that he pursued a high moral function for his paintings, consistent with a wider sentiment related to republican political thought and a broader championing of virtuous conduct related to Neostoicism and religious tensions. Van Noordt's preferences in subject matter and style point to an ambitious, serious, and humane spirit, such as typically would have attracted the biographer Houbraken, himself a history painter. It makes his neglect of Van Noordt all the more puzzling.

"Konstrijk schilder te Amsterdam"
The Life of Jan van Noordt

In his single, brief reference to Jan van Noordt, the biographer-artist Arnold Houbraken calls him "famous,"[1] yet he describes him no further, and thus Van Noordt falls victim to Houbraken's tendency to inconsistency. No paintings or biographical details are described; in fact, Houbraken only mentioned him because he was the teacher of Johannes Voorhout (1647–1723) (fig. 1).[2] Voorhout was one of Houbraken's more important sources of information on artists, but ironically he did not supply the biographer with much information on his own teacher.[3] Today Jan van Noordt's paintings are better known than is his life. Nonetheless, the scattered biographical data unearthed over the last century do yield a few clues to his personality and the people with whom he associated, and how they affected his creativity.

Houbraken's biographies became extremely influential, both in their original form and through their later transformations in the hands of other writers.[4] In the great wave of archival research in the second half of the nineteenth century, scholars such as Abraham Bredius and Cornelius Hofstede de Groot could know of Jan

FIGURE I
Portrait of Johannes Voorhout, in Jean Baptiste Descamps, *La vie des peintres flamands, allemands et hollandois, avec des portraits gravés en taille-douce, une indication de leurs principaux ouvrages & des réflexions sur leurs différentes manières*, Paris (C.A. Jombert), 1753–64, 2:207.

van Noordt through the passage cited above. However, these two scholars found few traces of Van Noordt, and these results suggest that he only occasionally made use of legal processes, for business or personal purposes. He contrasts sharply in this respect with his brother Jacobus, who was legally embattled for decades. Jan is more the counterpart of his brother Anthoni, who similarly left little legal or civic documentation but whose artistic legacy also survives to the present.

Even evidence of Van Noordt's year of birth surfaced only recently. An estimate of 1620 was based on two etchings displaying an inexperienced hand, such as would have appeared toward the beginning of his career. Both are inscribed "Jan van Noordt." One, dated 1644, gives Pieter van Laer (1599–after 1642) as inventor (cat. P1), whereas the other is dated to the following year and gives Pieter Lastman (1583–1633) as inventor (cat. P2). These reproductive prints represent, as do several of the paintings (e.g., cat. 28), Van Noordt's first independent artistic steps. However, he was around twenty years old at the time, not twenty-four, as previously estimated. In 1987, the musicologist Jaap den Hertog reported an entry in the record of the Amsterdam Chamber for Orphans in which Jan van Noordt appears as the son of schoolteacher Sybrand van Noordt and Jannitgen Jacobs and the brother of Jacobus, Anthoni, and Lucas.[5] On 20 June 1641, Sybrand van Noordt registered his three youngest sons, who had not yet reached the age of majority, as orphans of their mother, who had died six months before.[6] Jan appeared as Johannes, with his age given as seventeen, which places his year of birth in 1623 or 1624.

As the son of a schoolteacher, Jan van Noordt was born into a milieu that, although not affluent, was socially mobile. Other documents expand the picture, revealing that his father Sybrand was also a musician in the employ of the city of Amsterdam, maintaining the bells of its towers and playing the *beiaard* (carillon) of the Zuiderkerk tower.[7] Sybrand is recorded as such in 1642, only a year after his earliest appearance in a known archival document in Amsterdam. His birth, marriage, and the births of his children are not recorded in the Amsterdam archive, which suggests that the family had arrived in the city only a few years before. His son Jacobus's claim to having been born in Amsterdam, made at his marriage in 1648, seems doubtful.[8] It is likely that Sybrand had previously performed similar functions in another town or city. With such experience he could quickly establish himself in his new location.

Sybrand van Noordt must have attained a respectable level of musicianship. He presumably had a determining role in the training of his sons Jacobus and Anthoni, and they subsequently moved into what were, for musicians in the city, prominent positions, those of organist in the Nieuwezijds Kapel, the Oude Kerk, and the Nieuwe Kerk. The music historian Johan Giskes speculates that Jacobus may have started at the Nieuwezijds Kapel as early as 1639, at the age of twenty-three. Giskes also described the amicable relationship between Jacobus and the organist who was already established in the city, Willem Jansz Lossy, who may have been responsible for his final training. Jacobus also maintained a collegial link with the family of Jan Pietersz Sweelinck (d. 1621), the legendary organist and composer known as the

"Orpheus of Amsterdam," whose place in the Oude Kerk was taken by his son Dirck. Jacobus replaced Dirck upon his death in 1652, while brother Anthoni took over the post in the Nieuwezijds Kapel.[9] There remains the question whether Jan also trained for a similar career, and only later turned to painting. He made his earliest prints and paintings at the age of twenty, although it was usual to complete an apprenticeship between the ages of fourteen and seventeen. Curiously, a persistent attachment to the Sweelinck legacy seems to surface in Jan's emulation of Pieter Lastman in the abovementioned etching and in a few later paintings, long after the older artist had died (see especially cat. 2 and 14). Lastman's teacher Gerrit Pietersz. was also a member of the Sweelinck family, a brother of the composer, and the memory of this contact with Van Noordt's own family may be reflected in these works by him.

Jacobus and Anthoni van Noordt became the most prominent musicians in the city. In 1659, Anthoni published a volume of improvisations on the Genevan melodies for the Psalms, the *Tabulatuur-boeck van Psalmen en Fantasyen* (fig. 2).[10] His application to the States of Holland for copyright was handled in part by Constantijn Huygens (1596–1687), who judged the work's musical qualities and submitted

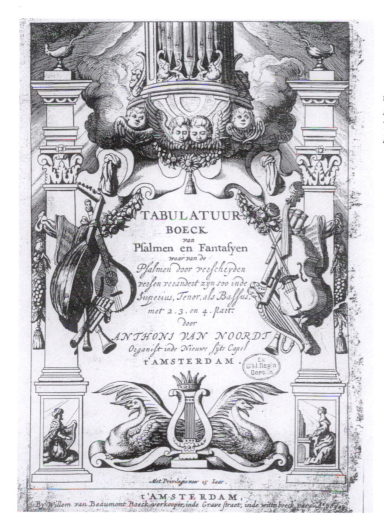

FIGURE 2
Anthoni van Noordt, cover, *Tablatuur-boeck van Psalmen en Fantasyen*, Amsterdam, 1659.

his recommendation for approval. It did not meet a standard of composition comparable to those of Sweelinck, but it did ensure Anthoni a place in the history of Dutch composition.[11] It undoubtedly also helped him gain, in 1664, the more prominent post of organist of the Nieuwe Kerk.[12]

Jacobus also left behind a few compositions, but of lesser artistic value. Nonetheless, his post seems to have garnered him a high social status. In 1663 Jacobus was appointed one of the official municipal wine-testers, a job that supplemented the relatively modest salary he received as organist.[13] He clearly enjoyed the favour of well-placed citizens in Amsterdam. His position was especially confirmed at the baptism of his son Sybrandus in 1659: besides uncle Anthoni van Noordt, the second witness to this event was Anna van Erckel, wife of the wealthy merchant Erasmus Scharlaken.[14] Anna is known to art historians for her second marriage, after the death of Erasmus, to the painter Ferdinand Bol (1616–1680) in 1669.[15] This advantageous alliance allowed Bol to give up his profession at an early age and turn *rentier*. For Jacobus, Anna van Erckel's role at his son's baptism reflected a prestigious social connection.

Jan van Noordt embarked on his artistic career in the mid-1640s. His training was, by the few indications that we have of it, unconventional and diffuse. The important question of the identity of his teacher can only be surmised from diverse observations. The earliest dated works, after Pieter Lastman and Pieter van Laer, were made after these two artists had died.[16] They would exert only a piecemeal influence. Around the same time, 1645, Van Noordt made one of the earliest of the surviving paintings, the *Cimon and Iphigenia* that appeared at a recent New York sale (cat. 28). Like the prints, this painting was also derived from another artist's work: a painting of the same theme by Jacob Adriaensz. Backer (1608–1651) now in Braunschweig of around 1640.[17] Because this version is of better quality than a second depiction now in Cherbourg, and is closer to Backer's conception, it was quite likely produced in Backer's studio, with Backer's painting and the benefit of his guidance at hand. However, Van Noordt was not emulating the current style of Backer, whose *Cimon and Iphigenia* was painted a few years earlier and who had since adopted a lighter palette and a smoother *facture*.[18] He likely encountered Backer's painting near the beginning of his training. It is also possible that he completed his training earlier than thought, around 1640–41.

Archival evidence also links Jan van Noordt to Backer's studio, albeit indirectly. Van Noordt's only documented artistic association in the 1640s was with Abraham van den Tempel (1622/23–1673). In 1648 Van Noordt signed as witness for a testament and codicil related to Van den Tempel's marriage in the same year.[19] Abraham was the son of the Leeuwarden history painter Lambert Jacobsz. (1598/99–1636) and studied under his father's pupil Backer in Amsterdam from 1642 to 1646.[20] It seems that Backer attracted many students, from Houbraken's account of the tutelage of Jan de Baen (1633–1702) in Backer's studio from 1646 to 1651. De Baen apparently had to endure the envy and abuse of a throng.[21] Van Noordt would have preceded that group by about six years. He would have been a fellow pupil of Van

den Tempel, who was closer to his age. The likely period of tutelage would have begun around 1640, when he was sixteen, and seems to have ended around 1644, when he was twenty.[22]

The acquaintance between the two students seems to have lasted. Alongside his career as a painter, Abraham van den Tempel conducted trade in cloth with his brother Jacob. Van Noordt knew Jacob as well. His two signatures on a business agreement of 1646 in Amsterdam indicate that he accompanied Jacob van den Tempel to the notarial office.[23] As will be seen, Van Noordt again signed an agreement with Jacob twenty-six years later, in 1673.

After four years of study with Backer, Abraham van den Tempel moved to Leiden in 1646, and there began to attract distinguished history and portrait commissions, some ten to fifteen years before this would happen to Jan van Noordt. In the interim, Jan van Noordt followed the work of their teacher, Backer, in particular his efforts in the pastoral mode. Two pastoral subjects that recur in Van Noordt's work, *Granida and Daifilo* and *Cimon and Iphigenia*, had also been depicted by Backer.[24] Besides history paintings, the other surviving works from Van Noordt's earlier years are almost all small-scale depictions of shepherds and shepherdesses.

These pieces speak of an artist working for the open market. Ambitious paintings, such as would likely be done only on commission, began to appear around 1659. This is the approximate date of the large and highly finished *Susanna and the Elders* in Leipzig (cat. 7).[25] A few years later Van Noordt counted among his clients the wealthy regents, or *vroedschap*, of Amsterdam's city government. Likely around 1663, he carried out his portraits for Jan Jacobsz. Hinlopen and Leonora Huydecoper, which are mentioned in their testament (cat. L43).[26] This recently discovered document confirms what is clear from the lavish style and opulence of Van Noordt's portraits of the 1660s: they were aimed at the core of Amsterdam's elite. The shift in Van Noordt's market will be examined in greater detail in the third chapter.

The production of Jan van Noordt's workshop leaned toward fashionable portraiture in the prosperous decade of the 1660s. Perhaps as much as any other artist, he satisfied the emerging taste for the Flemish style that had been established by Rubens and Van Dyck and was still being carried forward by Jordaens. In the previous decade artists such as Govert Flinck, Ferdinand Bol, and Nicolaes Maes had rushed to adapt to the trend. Unlike them, Van Noordt did not bear the direct imprint of Rembrandt, and, following Backer's influence, had been incorporating Flemish traits in his work from the beginning. Any ambitions to follow Backer as a history painter in this style were likely constrained at first by the domination of this market by Flinck, who had been the uncontested candidate for the large-scale decorative commissions for the new City Hall. Flinck mastered the new Flemish fashion, but his untimely death in 1660 left a considerable vacuum in this market.

In the following decade, demand for Van Noordt's paintings increased markedly. The history and genre paintings of this period are the finest and most powerful works of his career, and were likely made between portrait commissions. A good

example is the *Susanna and the Elders* in Paris (cat. 8), in which Van Noordt successfully resolved the problems he had encountered in his previous versions. The same is true of a recently rediscovered *Granida and Daifilo* (cat. 34), his second known treatment of this subject.

At this time, Van Noordt had the assistance of at least one pupil, the Johannes Voorhout mentioned by Houbraken. Houbraken cited five years of training at an advanced level with Van Noordt, after which Voorhout "needed nothing other than nature [itself] to work from."[27] Hofstede de Groot calculated that this period began in 1664, when Voorhout was seventeen, and ended in 1669, just before he married and started a workshop of his own.[28] During this extremely productive time for Van Noordt, Voorhout likely carried out some of the work on the paintings, even though no evidence of two hands has yet been detected.

Voorhout's association with Van Noordt may also have involved a mutual interest in music. Although there is only indirect proof of Jan van Noordt's own musicality, his student Voorhout did leave positive traces. In 1674 he travelled to Hamburg; Houbraken reports that he fled the troubles of 1672, the *Rampjaar* ("disaster year"), when the French invaded the northern Netherlands. Voorhout went first to Friedrichstadt on the invitation of Jürgen Ovens (1623–1678), and later proceeded to Hamburg in search of a better market for his art. There he painted a large group portrait, whose four sitters included Hamburg organist Jan Adam Reinken (1623–1722) and Lübeck organist and composer Dietrich Buxtehude (1637–1707) (fig. 3),[29] and who are accompanied by an allegorical figure of Music. Apparently the six formed a circle of music devotees, and it is possible that Voorhout also knew Reinken as a fellow musician, or perhaps through contacts with the Van Noordts in the Netherlands, where Reinken also had his roots. Two years later Voorhout was back in Amsterdam, where a son was born to him and Grietje Pieters Vos in 1677. Johannes Voorhout the Younger became a painter like his father, albeit less accomplished, as well as a music teacher.[30] This possibly reflects the interest of his father and of a circle around the Van Noordt family. In the absence of better evidence of his own participation, Jan van Noordt's connections to the musical world of Amsterdam in the seventeenth century remain circumstantial.

Van Noordt's presence in Amsterdam is confirmed in documents of 1666, 1668, and 1670. In the first two instances, he arranged the purchase of a grave in the Nieuwezijds Kapel for Adriana Kosters of Naarden, who was the daughter of the late Dr Samuel Coster (1579–1655), the doctor and playwright. Coster is best known for having founded the *Schouburgh*, or Theatre, in Amsterdam. Van Noordt's dealing with Adriana is recorded in notarial acts in Amsterdam and Naarden, one of which identifies him as "Johannes van Noordt, artistic painter in Amsterdam."[31] In the third document, of 1670, Jan and his brother Anthoni appealed to the *Schepenbank* of the city of Amsterdam to take action against a certain Arent Brouwer, who was harassing them and their servant Trijntje Bartels, after she rejected Brouwer's proposal for marriage.[32] The text of the request implies that the brothers

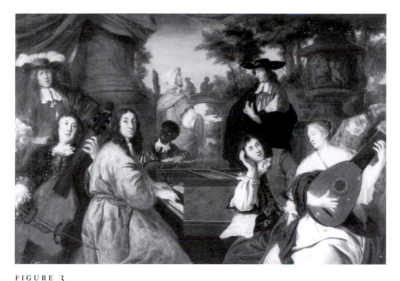

FIGURE 3
Johannes Voorhout, *Allegorical Group Portrait of Johann Adam Reinken and Dietrich Buxtehude*, canvas, 125 × 190 cm, signed and dated 1674, Hamburg, Museum für Hamburgische Geschichte.

were sharing a residence in Amsterdam as well as the services of a maid, which in turn suggests that both were unmarried.

Jan van Noordt then became peripherally involved in the far more serious affair of his brother's bankruptcy, which took place toward the end of 1671. Giskes explains that for some time already, the debts of Jacobus van Noordt and his wife, Elsje Corver, had been mounting for some time.[33] The family spent lavishly and seems to have lost money on bad speculations. Their last hope had been the testament of Elsje's mother, but it turned out to be a liability rather than an asset, and the desperate couple was forced to go to the *Desolate Boedels Kamer* (Chamber of Bankrupt Estates). The ensuing claims and actions produced a great number of surviving documents, and thus ironically Jacobus has become the Van Noordt brother about whom the most is known. Jan appears only once in the paper trail, to claim paintings from the estate: apparently he was a preferred creditor, and the works were by him. They included portraits of his father and grandfather and of two of his brothers, as well as a *Granida and Daifilo*.[34] The latter might be one of the two known versions of the subject now attributed to Van Noordt (cat. 32 and 33), but none of the portraits can be identified. There is no evidence to suggest that Jan was further affected by his brother's downfall.

Jan van Noordt also played a minor role in another, more famous downfall around the same time, that of Gerrit Uylenburgh (1625–1679). The prominent dealer, a son of Rembrandt's former dealer Hendrick Uylenburgh, met with financial disaster after he failed to close the sale of a large lot of Italian paintings to the Elector of Brandenburg, who was the victim of the machinations of his adviser, Hendrick Fromantiou. As Friso Lammertse pointed out only recently, Van Noordt

appears among the many artists, including his friend Abraham van den Tempel, who testified concerning the quality of the paintings in question.[35] Almost all of those artists were established and are still known today. Van Noordt's presence among them lends further support to Houbraken's assertion concerning his reputation.

Uylenburgh could possibly have survived this setback had it not been for the general economic downturn in the United Provinces after 1672, which affected Jan van Noordt as well. The *Rampjaar* was the year of the Triple Alliance against the Netherlands, and the nearly-successful invasion by the armies of Louis XIV. The concentration of power in the Dutch seaborne trade consequently dissipated, and although the very wealthy succeeded in protecting their fortunes, many northern Netherlanders lost their entire capital. As a result, opportunities for entrepreneurs and investment in local industry disappeared. The market for paintings shrank immediately, and only a few paintings from this period from Jan van Noordt's hand have survived. As well, these works are on a more modest scale than before: the *Magnanimity of Scipio* (cat. 27), for example, is his most ambitious and lavish work from 1672 on, but, only about a metre in length, it is a modest easel painting.

It is possible that at this time Van Noordt went in search of a better market for his talent. In 1673, and then again in the next year, he gave power of attorney to another person, to manage his affairs. In the first case it was Pieter van Hartoghvelt, a wine merchant who was related to him by way of his sister-in-law, Elsje Corver.[36] The second person to help Van Noordt was Jacob van den Tempel, for whom he had stood witness to a business agreement nearly thirty years earlier.[37] Jacob had been living in Amsterdam, sharing a house with his brother Abraham and his sister-in-law, until Abraham's death in 1672. Wijnman observes that Jacob's fortunes in the cloth trade had declined over the years (which he does not connect to the general malaise), indicated by the modest circumstances of his marriage in 1676. His address was given as the Bloemgracht, which is where Jan van Noordt was located in 1674.[38] Van Noordt may have gone to seek business elsewhere, after facing difficulties with finding a market in Amsterdam, and for that reason gave two of his friends power of attorney over his affairs. However, the wording in both of these documents is unspecific and follows a general formula. Such legal devices were frequently used, and for a variety of purposes; neither of these two acts indicates why they were created. They are not proof that he left the city: Van Noordt may also have been indisposed by illness, or sought experienced businessmen to handle some of his affairs.

Nonetheless, the impression that Jan van Noordt might have left the city is given again in the next archival document of only a year later. In May 1675 a certain Abraham Blanck called in the notary to draw up an inventory of a house on the Egelantiersgracht that he had been renting to "Mr Johannes van Noordt, painter, and Mr Valentijn, eye-doctor."[39] Most of the items left behind belonged to the artist. They include drawing materials, easels, a piece of red tripe (a velvet fabric), a great many drawings, and a number of paintings: a depiction of Christ, a multi-figured painting, and six portraits, one of these being of a "Do(minee) Dankerts." It is significant that his landlord had an inventory drafted. Such a docu-

ment could be used in making a claim against debts, such as unpaid rent. Jan van Noordt may have been experiencing financial problems, which forced him to move. No later documentation, either in or outside Amsterdam, has come to light. Dudok van Heel has suggested that Van Noordt left Amsterdam for London, accompanying the disgraced Gerrit Uylenburgh.[40] After his downfall, Uylenburgh fled Amsterdam and went to work for the portraitist Sir Peter Lely. Because Van Noordt abandoned a house and its contents around the same time, Dudok van Heel has proposed that he may have been involved in Uylenburgh's dealings and gone with him to London.

Van Noordt was only one of various artists contributing their opinions in the Uylenburgh controversy, however, and his presence among them suggests that he had no special link to the dealer. Furthermore, the predominance of artist's accoutrements in the inventory strongly suggests that he was using the premises on the Egelantiersgracht as an atelier only and was living elsewhere. The inventory does not list many of the trappings of a household, only a few tables, chairs, and a *secreet* (privy). Five years earlier he had been sharing a residence with his brother Anthoni, and in 1674 had given his address as the Bloemgracht. He may have had his residence there, while working in the house on the Egelantiersgracht. These two canals were only separated by one narrow street. They were both in the Jordaan, the neighbourhood established on the city's west flank, outside the grand canals. It was a modest area, populated mostly by the labourers and practitioners of skilled trades who served the city. Many artists also lived there.

Anthoni's death is recorded in February 1675, a little more than a month before Jan abandoned the house on the Egelantiersgracht.[41] This event likely changed Van Noordt's circumstances, perhaps freeing up space elsewhere. In the absence of further evidence concerning the artist's whereabouts after May 1675, we cannot be certain of Jan's reason for moving out of the house on the Egelantiersgracht. The only later trace of Van Noordt is his signature on a 1676 painting, *Mary and the Christ Child* in Gavnø (cat. 13). No evidence of his later activity can be derived from his appearance on a list of members of the St Luke's guild in 1688, since it is almost certainly spurious; this list also includes the names of people known to be deceased.[42] His burial is not recorded in the Amsterdam archive.

The Van Noordt family inhabited a prominent public milieu for the cultivation of a young painter. We have sporadic evidence of contacts with other prominent citizens in the city who had cultural ties, including Sweelinck, Hinlopen, and Coster. It is not overly speculative to suggest that the links of support for a well-known musician could easily translate into ties of patronage for a painter. It took Jan van Noordt ten years before he enjoyed high-level patronage, as the next two chapters will reveal, and he gained it around the time his brothers Jacobus and Anthoni also rose to the top of the city's musical hierarchy. Jan van Noordt's ambition to become a portrait and history painter surely reflects the inspiration of his teacher and supports the notion that this person was Jacob Adriaensz. Backer.

The Development of Jan van Noordt's Style

Around 1640 Jan van Noordt began to study of the art of painting. The thriving port and trading centre of Amsterdam presented the young pupil with probably the largest market for art anywhere at the time. The city boasted several distinct schools of painting, among which that of Rembrandt and his followers had become pre-eminent in the preceding decade. However, only in a general sense did Van Noordt initially follow Rembrandt's model, by focusing on portraiture and history painting and choosing a number of his historical themes from the Old Testament of the Bible. Van Noordt's training took place at one remove from Rembrandt's circle.

His earliest works indicate that he likely studied with Jacob Adriaensz. Backer. A Mennonite from the northern province of Friesland, Backer, with his fellow pupil Govert Flinck, had come to Amsterdam after receiving instruction in Leeuwarden from the painter-dealer and preacher Lambert Jacobsz. Both men would have called first at Lambert's business associate and co-religionist, Hendrick Uylenburgh, who is better known for having brought Rembrandt to Amsterdam from Leiden in 1631. Rembrandt was influenced by the work of the great Flemish painter Peter Paul Rubens during his period in Uylenburgh's workshop, possibly under Uylenburgh's direction, which in turn may have also played a role in steering the stylistic development of Flinck and Backer in the 1640s, when they both added elements of Rubens' aesthetic to their Rembrandtesque styles. This synthesis allowed them to take over Rembrandt's leading position in Amsterdam and also surfaces in the early works of Jan van Noordt.

Our knowledge of Van Noordt's beginnings, and his entire practice, depends heavily on the fruits of connoisseurial study because only a few works bear his signature and a date, and no archival documentation can confirm the authenticity of other works. The signed paintings number only ten, nine of which are also dated.

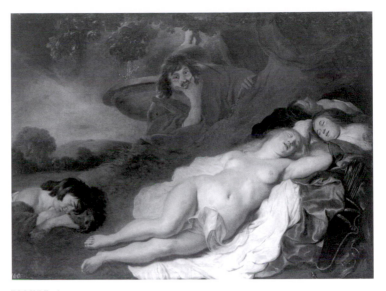

FIGURE 4
Jacob Adriaensz. Backer, *Cimon and Iphigenia*, canvas, 150 × 230 cm,
Braunschweig, Herzog Anton Ulrich-Museums Braunschweig.
Kunstmuseum des Landes Niedersachsen (photo: B.P. Keiser).

An additional four are reliably reported to have been signed and dated. Two prints
bear his name, and no drawings do. This totals around one-tenth of the number of
works that have been attributed to Van Noordt. On this basis, over half of the at-
tributed paintings can be discarded, leaving only sixty-two under his name. The
accretion of misattributed pictures has badly obscured our notion of his style, and
indeed of his oeuvre. This chapter pursues a clear concept of Van Noordt's style
and the way in which it developed over the thirty-five years of his career. The body
of work put forward here as authentic shows a hitherto unrecognized consistency
in the pursuit of effects, iconography, and the elite market for art in Amsterdam.

This ambition first surfaced with the young Jan van Noordt's choice of a
teacher. Kurt Bauch was the first to posit, on stylistic grounds, that he had studied
with Jacob Backer.[1] This notion gained further credence in 1999, when a *Cimon
and Iphigenia* appeared in New York bearing Van Noordt's signature and featuring
a direct borrowing from a painting of the same theme by Backer (cat. 28). The fig-
ure of Iphigenia is taken from Backer's famous *Cimon and Iphigenia* in Braun-
schweig (fig. 4).[2] Significantly, Van Noordt treated this theme in two other known
pictures. In a picture in Cherbourg, the figure of Iphigenia and the basic composi-
tional structure reappear in a rearranged form (cat. 29). However, its execution is
more tentative and laboured, yielding forms and surfaces that lack solidity and
clarity. A third depiction, in Göttingen (cat. 30), is signed and dated 1659 and
clearly adapts the figures in the Cherbourg picture. It moves even further from the
New York painting, which must have preceded the other two works. The New
York painting hails from Van Noordt's beginnings as an artist, likely before 1644,
when he could still draw directly on works seen in the master's studio. Its smooth
handling and direct opaque application of paint are indeed closer to Backer's confi-
dent style than any other painting in his oeuvre. For the face of Cimon, Van Noordt

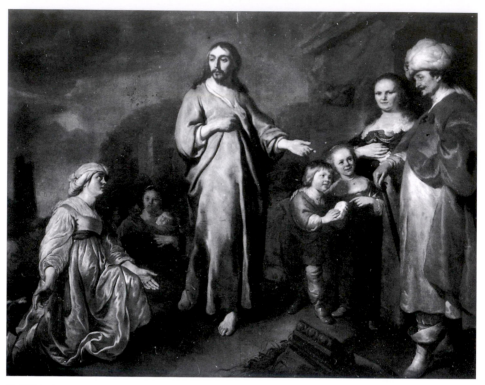

also drew directly on Backer's ripe and heavy-lidded male facial type, as seen in
Backer's figure of Jesus in a painting of 1640, in Middelburg (fig. 5). The weak-
nesses in the modelling of the figures in the Cherbourg picture further support the
notion that it was made after Van Noordt had left his master's workshop and no
longer had free and direct access to his paintings or his guidance.

Van Noordt's career beginnings are marked by two other works in a different
medium. There are two etchings that bear his signature, marking his assumption of
independent status as an artist. One dated 1644, a pastoral scene, is inscribed as
being after Pieter van Laer (cat. p2). The other, dated 1645, *A Landscape with the
Temple at Tivoli*, names Pieter Lastman as its source (cat. p3). These two works are
not independent compositions, but borrow from established artists, and thus paral-
lel the painting that appeared in New York. At the same time, this activity signifies
emerging independence from Backer, who did not produce prints.

Van Noordt chose to study in one of the most successful ateliers in Amsterdam,
with many pupils and assistants. During the 1630s Jacob Backer gained the patron-
age of Amsterdam's wealthiest citizens, and by the 1640s his reputation extended to
the court at The Hague as well. When Van Noordt started his training, around
1640, Backer was already doing very well. Backer's style initially emerged out of
the fusion of Mannerism and Caravaggism of his master Lambert Jacobsz., and

adopted a Rembrandtesque slant in the 1630s. By 1640 he had already moved toward a more elegant style derived from Rubens, taking up Ruben's flowing lines and compositional organization and his fleshy depiction of the figure, which emphasizes the nude. Success greeted this move, quite likely at the expense of Rembrandt, who shunned these particular elements of Flemish fashion. Flinck, who followed Backer in the same development, would become even more successful.

Tantalizingly, one painting has been reported to bear Jan van Noordt's signature and the early date of 1645: *Caritas*, in Milwaukee (cat. 24).[3] The composition, which shows a woman surrounded by children and set in a landscape with trees, was originally more expansive, before the painting was cut down sometime after 1947 and the signature removed. The handling is recognizably derived from Backer, with its smooth forms and surfaces and the emphasis on depiction of flesh, seen in the nude child on the woman's lap. Backer's vocabulary for describing form, complete with reflections and smooth modelling, is nearly completely assumed by his pupil. At the same time the figures show stockier proportions and a smaller scale than is typical of Backer. Van Noordt's application of paint is thinner and more translucent than his master's virtuoso direct touch, speaking of a more hesitant hand at the brush. He speaks with his own, more cautious, painterly voice.

The closest comparison to this composition is a painting of a related theme by Jürgen Ovens, *Allegory of Mother Nature*, in Schloß Gottorf (fig. 6).[4] It dates to 1646, one year after the date on Van Noordt's painting, which suggests that Van Noordt was not borrowing from him but vice versa. *Caritas* is the earliest suggestion of Van Noordt's originality. It also points to further contact with the circle of Backer and Flinck. Ovens was Flinck's pupil and his closest adherent.

Further evidence of Van Noordt's relationship to Backer surfaces in another painting, *Granida and Daifilo* in Sydney, Australia. An unsigned work, it shows the same fluid and dynamic handling of figures and landscape setting seen in *Caritas* in

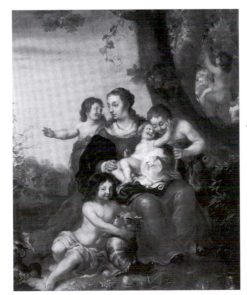

FIGURE 6
Jürgen Ovens, *Allegory of Mother Nature*, panel, 82 × 67.4 cm, signed and dated 1646, Schloss Gottorf, Stiftung Schleswig-Holsteinisches Landesmuseum.

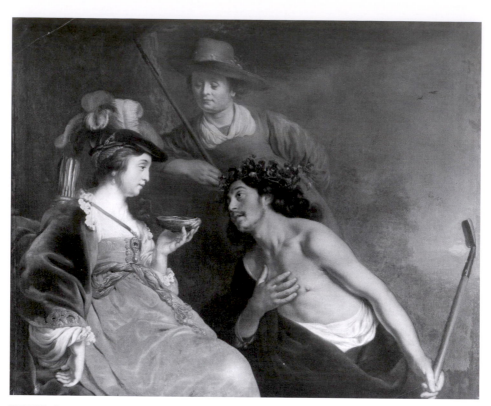

FIGURE 7
Jacob Adriaensz. Backer, *Granida and Daifilo*, canvas, 125 × 161.5 cm, c. 1640,
St Petersburg, Hermitage.

Milwaukee. Backer several times depicted the same scene from the beginning of
the play *Granida* by Pieter Cornelisz. Hooft. Backer's interpretation in the Hermitage
relates most closely to the depiction by his young protégé (fig. 7).[5] Van Noordt
would very likely have seen Backer at work on the Hermitage painting, as a pupil
in his studio, around 1640.[6] He also took over Backer's characteristic division of
the upper register of the background into sky and foliage, forming light and dark
areas. This painting can be placed alongside Van Noordt's second depiction of
Cimon and Iphigenia, in Cherbourg, as an independent adaptation of a work by
Backer that the young artist saw during his period of study.

Van Noordt's choice of smaller figures points to the other dominant artist in
Amsterdam in the 1640s: Rembrandt. From the evidence of several early works,
Van Noordt was drawn toward Rembrandt's compositions that include crowds of
small figures. In a painting in Oldenburg (cat. 10), he adapted the composition of
Rembrandt's grisaille of *John the Baptist Preaching*, in Berlin.[7] Curiously, he fo-
cused on the section of the painting produced in 1634, and his painting is evi-
dence that Rembrandt expanded the composition with additions sometime after
1645, the earliest likely date of Van Noordt's painting. Van Noordt changed the
composition further in a second interpretation of the theme, last in a sale in Lon-
don (cat. 11).

The path from Backer to Rembrandt likely passed through Govert Flinck, Backer's friend and Rembrandt's pupil. Flinck continued to work in Rembrandt's style a little longer than Backer, well into the 1640s. His *Crucifixion* of 1647, in Basel, still shows many Rembrandtesque traits, revisiting the composition of Rembrandt's painting for the Stadholder, which was executed when Flinck was working under Rembrandt. Flinck's painting likely served as a model for a painting of the same theme by Van Noordt, in Avignon (cat. 15).[8] Van Noordt took over the asymmetrical composition and the scattered accents formed by lighted figures. However, instead of the striations and staccato rhythms of fabric folds and the dry, thin technique of Flinck, Van Noordt adhered to the fluid brushwork and smooth modelling learned from Backer. He was clearly synthesizing of new ideas and elements into a style he had already established. In creating a populous crowd, he even went beyond Flinck to draw on the work of Rembrandt, possibly referring to his *John the Baptist Preaching*, a composition he appears to have reworked in a painting in Oldenburg (cat. 10). However, the lively movement, with curved edges creating sinuous lines, strikes a contrast with Rembrandt's emphasis on solid forms of figures and drapery.

Van Noordt's artistic beginnings are marked by dependence and synthesis, as we might expect of a talent not yet matured and without a secure position in the market. He adopted Backer's handling, his themes, and even some of his compositions for his earliest works of around 1643–45. After the end of his training, Van Noordt began to look to the work of other artists as well, including Rembrandt's scenes with small-scale figures.

Connoisseurial Confusion: A Namesake Artist

Scholarly conception of Jan van Noordt's early style has been misled by the inclusion in his oeuvre of an anomalous work, *Disobedient Prophet*, in Gavnø, signed and dated 1653 (cat. R10). Based on a painting by Bartholomeus Breenbergh,[9] the composition features tiny figures that show a curiously finicky, timid handling, with little sense of volume through modelling, and pointed and fluttering contours that relate weakly to form.[10] The same elements characterize a signed and dated *Peasant Interior* of 1660, last with a London dealer (cat. R40). By this date we know Jan van Noordt's style to be otherwise. Three more works in the same hand are similarly signed, but not dated: *Adoration of the Shepherds*, appearing at a sale in Cologne, *Shepherds and Shepherdesses around a Fountain* in Rottenburg, and *Landscape with Shepherd and Shepherdess* in The Hague (cat. R15, R41, R42). These five works were evidently made by another, hitherto unrecognized artist with the same name. His signature differs as well, with block capitals instead of calligraphic script. Furthermore, four out of five times he spells his name without a "d." This small oeuvre of four genre works can be given to Jan van Noort, who was known to have been active from 1653 to 1660, primarily in the peasant genre.

The direction of Van Noordt's development after 1645 must be reconstructed with reference to works that he produced fourteen years later, in 1659. There are no dated paintings from the intervening period. Of the two works dated to 1659, the most important is the *Cimon and Iphigenia* in Göttingen (cat. 30), a reworking of the painting in Cherbourg. Van Noordt retained the general composition, with Iphigenia and her attendants sprawled on the ground to the left, in front of a fountain, and Cimon standing in the upper right quadrant, leaning against his crook. However, he changed the poses of the reclining women, adapting that of the girl to the left in the Cherbourg picture for that of Iphigenia herself, who now embodies a sensual nude display in the centre foreground. She becomes the focus of the group. The artist further enhanced the concentration on her figure by abandoning the lighted background of his earlier conception and casting a strong light on her figure, which isolates her against the surrounding darkness. Gone are the multiple lighted areas, distributed to create a rhythmic effect. This new strategy, which appears to reflect further study of Rembrandt, is revealed clearly in changes in the treatment of the figure of Cimon. In the Cherbourg and New York paintings, Cimon was a second point of emphasis; here, he nearly sinks into the dark trees behind him, yielding prominence to his female object of attention.

The 1659 interpretation of Boccaccio's story also shows a confident fluidity of brushwork not evident in the earlier versions. In the Cherbourg picture, Van Noordt blocked in some areas evenly and with a slow and careful hand, and for the softer consistencies of ground, flesh, and clouds he resorted to a blotchy, unmodulated application. By 1659 he had achieved an independent touch in which a calligraphic curling brush stroke is modulated to describe different surfaces and forms.

The transition to this more decisive approach can be followed in Van Noordt's canvas *Cloelia Crossing the Tiber*, in the Louvre (cat. 25). There, a group of small-scale female figures, most of them nude, are arranged across the horizontal plane. One of the women, crouching in the foreground centre, is isolated in the light against a darker background of shadowy figures silhouetted against the evening glow of the sky. She anchors the composition, this role presaging that of Iphigenia in the Göttingen picture. Its comparatively less resolved use of light places it around 1650–55.

The date of 1659 also appears on another, signed painting by Van Noordt: *Portrait of a Woman*, last in The Hague (cat. 46). Although a portrait, it bears some of the traits just observed in the Göttingen *Cimon and Iphigenia*. The sitter is isolated against the background by a strong light falling on her face. This effect is complemented by the drama of movement in the background, in fluttering drapery and billowing clouds articulated in calligraphic strokes. In the sitter, this energy is carried through only in details such as the curving contours of her folded hands, which creates a disjunction between the grand aspirations of the background and her straight and stiff conservative dress, her puffy features, and her wan smile,

which exude a frail, grandmotherly charm. In his subsequent portraits, Van Noordt resolved such disparities, imbuing his sitters with a suitable vigour. This work was one of his first in this genre. It is a benchmark not only for his developing style, but also for the role of patronage in his career, as will be discussed later.

Mastery and Vigour: 1660–1670

Van Noordt took on greater assurance and ambition in his paintings of the next decade, in his history paintings even more so than in his portraits. He likely painted the large canvas of *Susanna and the Elders*, in Leipzig (cat. 7), soon after the Göttingen *Cimon*. This composition revolves around a large, just-under-life-size figure of Susanna that is engaged in action and emotion. Much like the figure of Iphigenia, she is bathed in light that falls mainly on the foreground, isolating her against a background cast in shadow. This strategy is complemented by the reduced prominence of the elders, compared with an earlier depiction of the theme in Utrecht, which probably dates to the early 1650s. The strong modelling in chiaroscuro of her figure, especially her arms and torso, gives her a massive and sensual presence. At the same time, Van Noordt further refined his handling of light, casting Susanna's face in half-shadow and bringing out its forms and features with reflections. The same attentive virtuosity is evident in the left hand, where her thumb casts a long shadow. Van Noordt placed several still-life objects to the left in bright light, and emphasized their round volumes with modelling and bright, modulated reflections. He would continue to place deftly painted accessories, such as metal vessels and plumply rounded fruit, in his historical scenes through the rest of his career.

The effect of light in some of Van Noordt's paintings of this period is more exaggerated than it was originally. In another painting of around 1660, *Massacre of the Innocents*, in Kingston, light also sets off the foreground (cat. 14). Many figures, punctuated with light and shadow, harken back to Van Noordt's earlier multi-figured compositions. The resulting loss of cohesion may be due to the increased darkness of the areas of semi-transparent paint in the shadow areas. These have almost certainly grown even more transparent against the dark ground, and hence darker, since they were painted, a characteristic of aging oil paintings. Many decisively described figures in the middle ground, soldiers and mothers struggling, are now so dark as to be barely visible, but were surely meant to be seen clearly.

The impression of powerful and vibrant energy in both the Leipzig *Susanna* and the Kingston *Massacre* marks an important aspect of Van Noordt's development in this period. In both works, loose and sinuous strokes of light colour set off bright highlights of drapery folds. This dynamic and elegant approach draws from Flemish art generally, and also the work of Van Noordt's mentor, Jacob Backer.[11]

The Leipzig *Susanna* also shows Van Noordt becoming attuned to the impact of a larger figure scale. Many of his subsequent compositions of the 1660s feature full-length figures that fill the space, yielding greater clarity of action and expres-

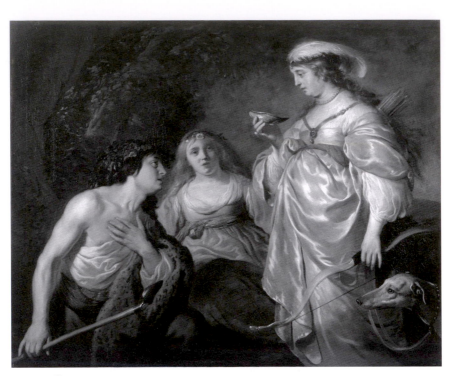

FIGURE 8
Jacob Adriaensz. Backer, *Granida and Daifilo*, canvas, 133 × 162 cm, signed, c. 1645–50, Kingston, Agnes Etherington Art Centre, gift of Drs Alfred and Isabel Bader.

sion. His *Granida and Daifilo* of 1663 (cat. 34), for example, completely transforms the composition of his earlier interpretation of the theme, in Sydney (cat. 33). Instead of small figures inside a deep landscape setting, Van Noordt placed large figures in a shallow space, with Granida stretching nearly the full height of the canvas, occupying the foreground and set against trees and sky. Van Noordt appears to be looking back to Backer, who painted this theme several times, but he stops short of adopting the three-quarter format that Backer used in all three known versions by him, including the one in Kingston (fig. 8). Backer often applied this Caravaggesque format, which was inherited indirectly from his teacher's teacher, Abraham Bloemaert; Van Noordt took it over in only one historical scene, adapted from Goltzius (cat. 22). Van Noordt's exploitation of the monumental presence of the full figure in his picture of 1663 must be explained not in terms of the Rembrandt idiom but within the framework of his deepening interest in Flemish artistic fashion.

It is characteristic of the ambition of Jan van Noordt that he ignored much of what was developing in painting around him in Amsterdam and other Dutch centres in the 1650s and 1660s, including the rise of the smooth and fine handling of the fine painters, or *fijnschilders*. Like the highly successful Rembrandt pupil Nicolaes Maes, he focused on Peter Paul Rubens, arguably the most famous and admired artist in both the northern and southern Netherlands, and on Jacob Jordaens' interpretation of the Rubensian mode. This preoccupation reveals itself in the 1660s not

24

just in Van Noordt's fleshy and elegant figures, but also in his organization of entire compositions into sweeping movement and sinuous lines. It is evident in the 1663 *Granida and Daifilo* (cat. 34), in the alignment of the main lines running through the figures of the two protagonists, in places completed by the span of tension between their connected gazes. No longer do figures serve as masses and accents in space. Now their gestures, poses, draperies, and even their expressions are engaged in a dynamic whole encompassing the entire picture plane. This development is taken even further in a small, free depiction, *Venus and the Three Graces* in the Dutch State Collection (cat. 20) that can be dated to later in the decade. There, fluttering drapery and arching bodies adhere somewhat artificially to an overall circular framework. In two large canvases of *Pretioze and Don Jan* (cat. 31, 32) that just predate the groundbreaking picture of 1663, the main figures are still presented as more isolated entities, although they incorporate elegant poses and are connected by the tension of the glance across space.

Flemish art inspired Jan van Noordt to even greater ambitions, including the challenge of a monumental scale. Only the examples of Rubens and Jordaens could have drawn him to take on a work such as *Juno*, in Braunschweig (cat. 18). This complex, tumultuous composition is anchored by the imposing figure of the goddess in the centre, while other figures conform to sweeping arcs that reflect her pose and the position of her limbs and torso. With such interrelationships, Van Noordt was working toward a greater overall effect, such as he could observe in the grand achievements of the Flemish Baroque. However, the Braunschweig *Juno* is much larger than anything Van Noordt did otherwise, and the chaotic result suggests he overreached his abilities.

He achieved far greater success on a smaller scale, generating great concentration and energy in a work like the *Susanna and the Elders* presently in Paris (cat. 8). There, the body of Susanna arches elegantly to the left, and this curving shape, lit brightly against a dark background of architecture and sky, dominates the entire picture. The genesis of this total engagement of Susanna's figure can be traced back, past the Leipzig painting, to Van Noordt's first known depiction of the theme, a painting in Utrecht that is unfortunately badly overcleaned (cat. 6). There, Susanna sits upright and leans a little away from the elders, who form a separate cluster of activity to the right. In the Leipzig picture, she is much more prominent, and her body is engaged in movement, but she competes for attention with still-life details, background elements, and the two elders. In the final version, Susanna's body fills the canvas, and the presence of the elders is limited to a shadowy pair of heads to the upper right. Instead of competing, the background statue of Cupid continues the sinuous line of Susanna's form. The sweep of her twisted legs is echoed in the red drapery at the bottom right, while the curve of her torso is repeated in the white sash draped over her knees. These adjustments and refinements all underscore Susanna's turn away from the elders, amplifying it into a grand gesture of moral revulsion at their entreaty and threats. In organizing movement throughout the picture plane, Van Noordt took his cue from Rubens and Jordaens.

Van Noordt had learned to organize his composition to concentrate on its most significant expressive figure. He carried forward the development observed in the works of 1659, where he began to use light to isolate the main figure against a darker background. At the same time he also abandoned the details and still-life elements that he had been including in his history scenes from the beginning. This general tendency can be traced back to the work of Pieter Lastman and the Early Amsterdam School, the so-called "Pre-Rembrandtists," and linked to a theoretical demand for richness and variety posited by Karel van Mander in his *Schilder-Boeck* (*Book on Painting*) in the term *verscheydenheit*.[12] In Van Noordt's work it is most evident in his laden composition from around 1660, *Massacre of the Innocents*, which drew from a painting by Lastman now in Braunschweig (fig. 9) and in which Van Noordt even incorporated a Lastmanesque figural pyramid, topped by the mounted rider to the left. Such artificial compositional devices reflect the Mannerist roots of Van Mander's concept of art in their virtuosity and complexity.[13] In moving away from this model toward greater compositional concentration and impact, such as that seen in the later *Susanna*, Van Noordt followed a direction already taken by Rembrandt and his pupils in the 1650s, but he took an entirely Flemish turn with it.

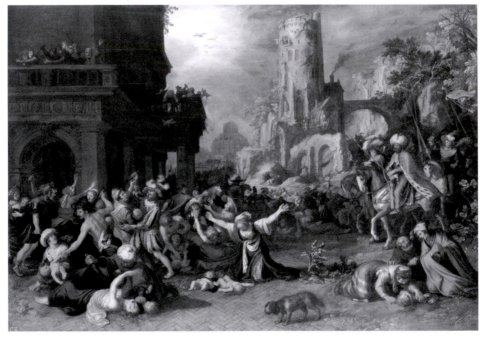

FIGURE 9
Pieter Lastman, *The Massacre of the Innocents*, panel, 85 × 122 cm, c. 1607–08, Braunschweig, Herzog Anton Ulrich-Museum Braunschweig (photo: B.P. Keiser).

The Parallel in Portraiture: 1660–1670

This trend also reveals itself in Van Noordt's portraits, starting with the 1659 *Portrait of an Elderly Woman*. Five years later Van Noordt painted the portrait of the Amsterdam cloth manufacturer Dionijs Wijnands in three-quarter length (cat. 52). It was evidently a major commission for the artist, since he produced a bust sketch of the sitter on copper in preparation and recorded the finished composition in a concise drawing (cat. 51, D12). Here again Van Noordt applies a strong light effect, but he exploits it further in the robust modelling of the sitter's face and hands. The rounded forms play off the undulating edges of drapery, flesh, and hair, in a close parallel to the *Granida and Daifilo* of the previous year. This device is already evident in a portrait of 1661 that we know only from a print, *Petrus Proëlius* (cat. no. Copy 2). In composition and colour use, Van Noordt seems to have depended on the example of his own teacher, taking over the scheme with the open window and outstretched hand, and even the restrained reddish colour note, from Backer's *Portrait of a Man*, in Kassel (fig. 10).[14] Van Noordt's portrait also exploited Backer's characteristic disarming effect of the sitter's display of warmth created by a breaking smile.

It appears that Van Noordt then progressed to the grander format of the full-length portrait in 1665 with *A Portrait of a Young Man with His Dog*, in Lyon (cat. 54). It is one of his most lavish images, with great swaths of drapery and an outlandish costume set off against a pretentious architectural backdrop. The artist pushed his effect of brilliant light even further, with the figure and costume bathed in strong light, casting inky-black shadows, and creamy highlights emphasized by thick opaque paint layers. A column cast in shadow and draped in red sets off the figure forcefully. The composition is more complex than that of the Wijnands portrait, but the many elements are organized tightly into lines of sweeping movement. The dramatic emphasis of folds and edges along the fabric of the arms is echoed and continued in the drapery behind the figure. The pose is dynamic and asymmetrical, with the hat held off to one side and the hand on the hip at the other side and accented by a raking leading foot.

This daring approach attracted mainly commissions for portraits of women and children; it was likely too informal and unrestrained for male portraits. In two paintings titled *A Boy with a Falcon*, in the Wallace Collection, the artist pursued his energetic presentation of the figure (cat. 55, 56). Both figures lean to one side, counterbalancing the weight of the bird of prey they bear on their opposite hands, and restrained smiles exude a calm, confident strength. Sinuous lines in the drapery continue the motion, an effect that is extended in the striking *Portrait of a Brother and Two Sisters*, Zeist (cat. 59). In this composition, the two younger siblings are actively engaged, the girl embracing a viola and the boy reaching out with a falcon in his hand. Open brushwork underscores the energy of the composition with directional strokes of paint, consistent with the development of Van Noordt's style in

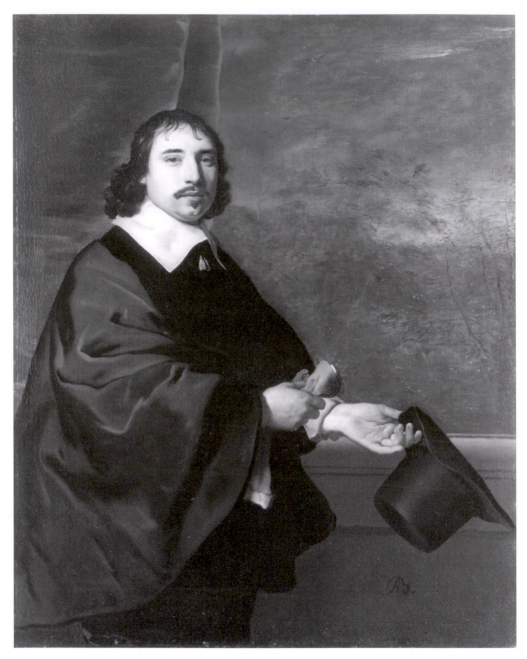

FIGURE 10
Jacob Adriaensz. Backer, *Portrait of a Man*, canvas, 127 × 100 cm, Kassel, Staatliche Museen Kassel, Gemäldegalerie Schloß Wilhelmshöhe.

the late 1660s. A few years later he painted his spectacular multi-figured full-length *Family Portrait*, in Dunkerque (cat. 62), in which the ripe forms, hard light, and containment of movement generate a weighty seriousness that also character-izes his late histories.

Amsterdam Taste following Antwerp Style

The dynamism and elegance that Van Noordt developed in the 1660s conformed to a wider trend in taste among leading patrons of art in Amsterdam. In 1659, the year that Van Noordt first clearly moved in this direction, the dominant painter to the city's elite was Govert Flinck, who was working on paintings for the Amsterdam City Hall, the most prestigious commission of the Dutch Golden Age. Flinck had long adopted a style with smooth modelling, light tonalities, idealized abstracted forms, sinuous lines of drapery folds and edges, clear organization into overall lines, and arrangement of forms through the vertical axis. Houbraken observed that Flinck chose a "lighter" style and abandoned the dark style he had learned from his teacher Rembrandt.[15] Yet Flinck's choice was more adaptive than generative. He simply looked to the compelling synthesis of Rubens' and Rembrandt's style that had already been developed by his friend Jacob Backer.

Backer introduced to Amsterdam a new, dynamic style of figure painting over the course of the 1640s, the final decade of his career. It can be detected in a work as early as his painting *Bacchus and Ariadne*, last in London, of 1643 (fig. 11).[16] Although the figures take calm poses, the composition is engaged by strong diagonals and enlivened by the sinuous lines of bright reflections in the folds of satiny drapery. A few years later, in *Venus, Adonis, and Cupid*, the figures take on active poses (fig. 12).[17] Large in scale, they engage the whole of the picture surface in motion. This picture, datable to just before Backer's early death, was the product of a gradual assimilation of the dynamic style of the great Flemish masters, especially Rubens, into an existing aesthetic base of Backer's teacher Lambert Jacobsz. and Rembrandt.

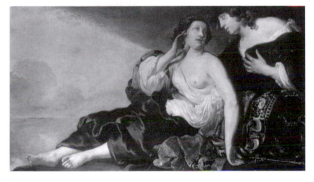

FIGURE 11
Jacob Adriaensz. Backer, *Bacchus and Ariadne*, canvas, 85.1 × 153.7 cm, signed and dated 1643, present location unknown.

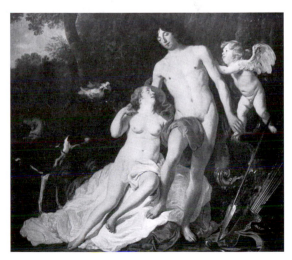

FIGURE 12
Jacob Adriaensz. Backer, *Venus, Adonis, and Cupid*, canvas, 200 × 237 cm, c. 1650, Schloss Fasanerie bei Fulda, Kurhessische Hausstiftung.

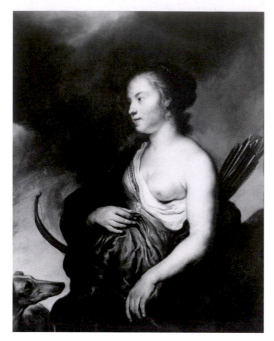

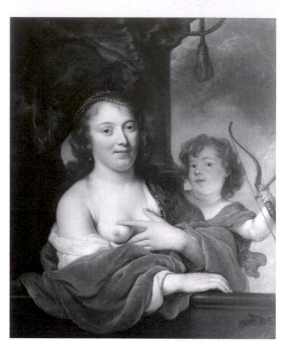

FIGURE 13
Govert Flinck, *Diana*, canvas, 100 × 65 cm, signed and dated 1647, Kimberley, South Africa, William Humphreys Art Gallery.

FIGURE 14
Govert Flinck, *Venus and Cupid*, canvas, 87 × 71.2 cm, signed and dated 1648, Jerusalem, The Israel Museum, gift of the Friends of the Art Museums of Israel (photo ©The Israel Museum, Jerusalem).

Backer and Flinck were former fellow-pupils who evidently maintained a link. Flinck started to adapt his own strongly Rembrandtesque style to the Rubenesque model of Backer in the mid-1640s, as seen in *Diana* of 1647, in Kimberley (fig. 13),[18] *Venus and Cupid*, in Jerusalem (fig. 14), dated 1645, and his pendant portrait of a couple, in Raleigh, of 1646 (fig. 15).[19] In the wake of Backer's death in 1651, Flinck carried on in a similar style, and was able to gain the commission for the decorative cycle of paintings for the Amsterdam City Hall. His grand depiction *Solomon Asks God for Wisdom* of 1658 (fig. 16), painted for the Council Chamber, incorporates a dramatic fall of light, forceful poses, and clusters of figures arranged in sweeping arcs, which enhance the energy of his composition.[20] By this time, Flinck appears to have been looking beyond Rubens to a younger generation of Flemish artists whose work incorporated the smooth abstraction and relative calm of classicism. The House of Orange had already bestowed several commissions on Thomas Willeboirts Bosschaert (1613–1654), an artist from the southern city of Den Bosch who worked for patrons in both the southern and northern Netherlands and whose style exemplifies the new trend. In the 1650s this taste was also firmly established among Amsterdam's patriciate, chiefly because of its aristocratic grandeur. When Ferdinand Bol was engaged to paint scenes for the City Hall in 1660, he was pressured to abandon his Rembrandtesque style in favour of the new aesthetic.[21] This was the year in which Flinck suffered an untimely death, at work

Amsterdam Taste following Antwerp Style

The dynamism and elegance that Van Noordt developed in the 1660s conformed to a wider trend in taste among leading patrons of art in Amsterdam. In 1659, the year that Van Noordt first clearly moved in this direction, the dominant painter to the city's elite was Govert Flinck, who was working on paintings for the Amsterdam City Hall, the most prestigious commission of the Dutch Golden Age. Flinck had long adopted a style with smooth modelling, light tonalities, idealized abstracted forms, sinuous lines of drapery folds and edges, clear organization into overall lines, and arrangement of forms through the vertical axis. Houbraken observed that Flinck chose a "lighter" style and abandoned the dark style he had learned from his teacher Rembrandt.[15] Yet Flinck's choice was more adaptive than generative. He simply looked to the compelling synthesis of Rubens' and Rembrandt's style that had already been developed by his friend Jacob Backer.

Backer introduced to Amsterdam a new, dynamic style of figure painting over the course of the 1640s, the final decade of his career. It can be detected in a work as early as his painting *Bacchus and Ariadne*, last in London, of 1643 (fig. 11).[16] Although the figures take calm poses, the composition is engaged by strong diagonals and enlivened by the sinuous lines of bright reflections in the folds of satiny drapery. A few years later, in *Venus, Adonis, and Cupid*, the figures take on active poses (fig. 12).[17] Large in scale, they engage the whole of the picture surface in motion. This picture, datable to just before Backer's early death, was the product of a gradual assimilation of the dynamic style of the great Flemish masters, especially Rubens, into an existing aesthetic base of Backer's teacher Lambert Jacobsz. and Rembrandt.

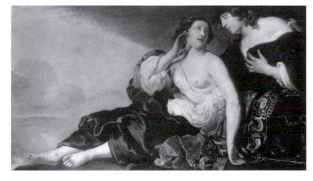

FIGURE 11
Jacob Adriaensz. Backer, *Bacchus and Ariadne*, canvas, 85.1 × 153.7 cm, signed and dated 1643, present location unknown.

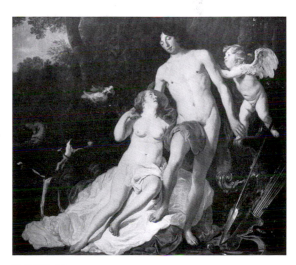

FIGURE 12
Jacob Adriaensz. Backer, *Venus, Adonis, and Cupid*, canvas, 200 × 237 cm, c. 1650, Schloss Fasanerie bei Fulda, Kurhessische Hausstiftung.

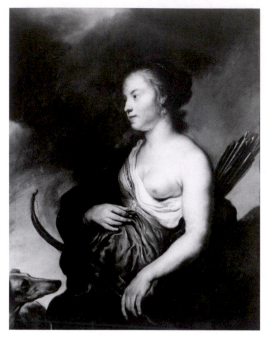

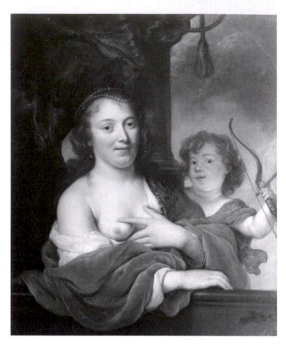

FIGURE 13
Govert Flinck, *Diana*, canvas, 100 × 65 cm, signed
and dated 1647, Kimberley, South Africa, William
Humphreys Art Gallery.

FIGURE 14
Govert Flinck, *Venus and Cupid*, canvas, 87 × 71.2 cm,
signed and dated 1648, Jerusalem, The Israel Museum,
gift of the Friends of the Art Museums of Israel
(photo ©The Israel Museum, Jerusalem).

Backer and Flinck were former fellow-pupils who evidently maintained a link.
Flinck started to adapt his own strongly Rembrandtesque style to the Rubenesque
model of Backer in the mid-1640s, as seen in *Diana* of 1647, in Kimberley (fig.
13),[18] *Venus and Cupid*, in Jerusalem (fig. 14), dated 1645, and his pendant portrait
of a couple, in Raleigh, of 1646 (fig. 15).[19] In the wake of Backer's death in 1651,
Flinck carried on in a similar style, and was able to gain the commission for the
decorative cycle of paintings for the Amsterdam City Hall. His grand depiction
Solomon Asks God for Wisdom of 1658 (fig. 16), painted for the Council Chamber,
incorporates a dramatic fall of light, forceful poses, and clusters of figures arranged
in sweeping arcs, which enhance the energy of his composition.[20] By this time,
Flinck appears to have been looking beyond Rubens to a younger generation of
Flemish artists whose work incorporated the smooth abstraction and relative calm
of classicism. The House of Orange had already bestowed several commissions on
Thomas Willeboirts Bosschaert (1613–1654), an artist from the southern city of
Den Bosch who worked for patrons in both the southern and northern Nether-
lands and whose style exemplifies the new trend. In the 1650s this taste was also
firmly established among Amsterdam's patriciate, chiefly because of its aristocratic
grandeur. When Ferdinand Bol was engaged to paint scenes for the City Hall in
1660, he was pressured to abandon his Rembrandtesque style in favour of the new
aesthetic.[21] This was the year in which Flinck suffered an untimely death, at work

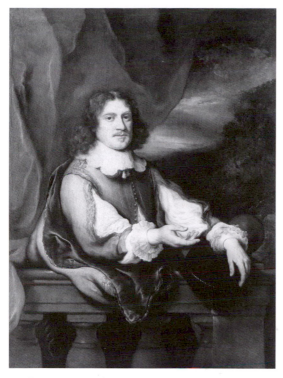

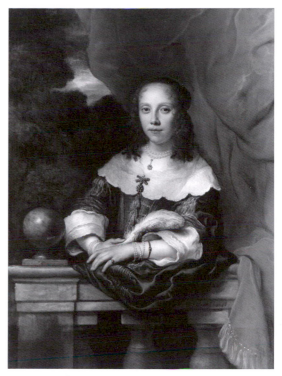

FIGURE 15a
Govert Flinck, *Portrait of a Man*, canvas, 124.5 × 94 cm, signed and dated 1646, Raleigh, North Carolina Museum of Art, purchased with funds from the State of North Carolina.

FIGURE 15b
Govert Flinck, *Portrait of a Woman*, canvas, 124.5 × 94 cm, Raleigh, North Carolina Museum of Art, purchased with funds from the State of North Carolina.

FIGURE 16
Govert Flinck, *Solomon Asks God for Wisdom*, canvas, 465 × 450 cm, signed and dated 1658, Amsterdam, Royal Palace on the Dam.

on the great City Hall cycle, leaving a considerable vacuum in a Dutch market attuned to the Flemish style.

It is not clear whether Jan Lievens also played a leading role in the introduction of Flemish style in the northern Netherlands. He returned to Amsterdam from Antwerp in 1644, having gathered years of exposure to the paintings of Rubens, Van Dyck, and Jordaens. Widely admired, he was in a strong position to influence a generation of Dutch artists. However, he carried out only a canvas of the *Five Muses* in 1650, one of the less important scenes in the *Oranjezaal*, a decorative project that was the most important artistic commission from the House of Orange during the Golden Age.[22] His gentle, lively depiction is lost among the smooth, abstract classicizing scenes by Dutch artists such as Gerrit van Honthorst and the De Brays, and the bombastic keynote allegory by Jacob Jordaens. His later commission for the Amsterdam City Hall was more imposing, but his cool shrill colour and curious penchant for a base tone of forbidding sooty black won him no identifiable followers and no great success in Amsterdam's competitive market.

Portrait style was subject to the personal taste or preference of the sitter, and the flamboyant Flemish style became an important option for patrons in Amsterdam. It realized its most productive interpreter in the Rembrandt pupil Nicolaes Maes. Maes' earliest paintings are strongly Rembrandtesque history pieces, but he quickly abandoned this specialty for portraiture, and at the same time gave up the solid forms and painterly technique that he acquired from his teacher in the early 1650s. Houbraken sketches the change as a result of a trip to Antwerp and a visit to the studio of Jordaens, which may have taken place around 1660.[23] The earliest revelation of his conversion is *Portrait of Two Boys as Hunters* of 1661, which depicts two striding boys in fanciful hunting costume *à l'antique* followed by frisky dogs.[24] Fluttering drapery and energetic poses enliven the picture surface with sweeping curves and flowing, undulating lines. The effect becomes more comprehensive in *Portrait of a Boy as a Hunter* of 1664 and remains in evidence for the rest of his long career (fig. 17).[25]

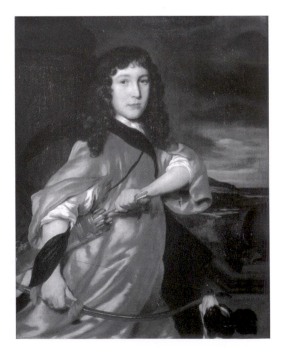

FIGURE 17
Nicolaes Maes, *Portrait of a Boy as a Hunter*, canvas, 79 × 90 cm, signed and dated 1664, present location unknown.

Jan van Noordt followed, not Maes or his other Dutch contemporaries, but his own independent observation of Flemish art, in particular that of Jordaens. His bulging, ripe, flesh and blood figures have nothing to do with the restrained and elegant handling of, for example, Abraham van den Tempel, or Jacob van Loo, whose alabaster nude figures exude a halting sterility, their poses and expressions indebted to polite genre painting and its attention to manners. Van Noordt's preference, awakened by Backer, led him to bypass the classicizing tendency of Flemings such as Bosschaert and focus specifically on expressive and dynamic models such as presented in the work of Rembrandt and Jordaens.

The Pinnacle of Expression: 1670–1676

Having emulated the energy and refinement of the foremost Flemish models in history painting, Van Noordt proceeded in the 1670s to develop a more powerfully dynamic style that eventually achieved an extreme with no parallel in the Dutch or Flemish Baroque. He eschewed the high level of finish that had risen to favour in Dutch painting and developed the rough and painterly element already present in his work as a pointed expressive device, as seen in aspects of his signed and dated *Magnanimity of Scipio* of 1672, in the Rijksmuseum (cat. 27). There, the background architecture is only sketched in, and the figure of Allucius's father, cast in shadow, is sparsely indicated in dark contours and a few light and dark strokes. Even more loosely handled is the figure of a mounted rider emerging above Allucius, portrayed in quick, sweeping strokes of colour. However, the principal figures are painted in a smoother and more refined manner, with lavish description of the bride's dress and virtuoso rendering of the reflective metallic objects at Scipio's feet. The rough and sketchy handling of the secondary figures and background conjures a frenetic atmosphere of tension for the moment in which Scipio makes his dramatic gesture of generosity.

The expressive potential of loose handling must have impressed Van Noordt, because he expanded its application in a painting dated to the following year. *The Levite and His Concubine in Gibeah*, known only through a poor reproduction, was reported signed and dated 1673 when it last appeared at auction (cat. 3). For the principal figure of the field labourer, Van Noordt reserved a loose and direct handling, delineating the highlighted folds of the white shirt in open, quick strokes of light colour. Similarly loose dabs of thinner and more fluid paint create the texture of the foreground earth and the lighted clouds above. The rhythmic pattern of the brush strokes heightens the energy of the scene, already established with compositional lines that sweep through figures and drapery and traverse the space between the two main figure groups. The stability still evident in the *Scipio* of the previous year gives way to an unsettled turbulence that underscores the emotion of the Levite, whose anxiety can be seen in his pleading expression and gesture.

Emotional tone generated through sweeping lines of movement and a rough handling of paint, in addition to facial expression and gesture, is the hallmark of

Van Noordt's last period of activity as a painter. This approach is encapsulated in *Hagar and Ishmael in the Desert*, Kingston (cat. 1). Hagar's anxiety about her son is relayed in her troubled features (likely those of a sitter for a *portrait historié*), and is further played up in the agitated fluttering of her drapery around her and the dramatically sweeping wings of the angel, who suddenly looms above her to announce her rescue. Hagar's figure has great presence, its forms emphasized by loosely applied reflections and smooth, creamy highlights in her face and arms, giving a powerful impression of physical bulk. Tension is further heightened by the strong contrast of technique between the light, thickly applied colours of the centre and left side and the dark right side. There, where the dying Ishmael lies on the ground, Van Noordt used loose, sketchy strokes of brown and black thinly covering the ground layer. The raw technique and dark tones create a sinister tone, conveying the threat the young Ishmael faces.

Desperation is similarly expressed in *Joseph Selling Grain in Egypt*, in the Bader Collection in Milwaukee, in several dramas spread across the width of the composition (cat. 2). Off to the right side sits Joseph, while three groups of supplicants approach him from the left. Loose brushwork abounds, most evidently in the figures to the far left. They are in the worst state, having nothing to offer for food except their freedom. They are painted in directly brushed lines of underdrawing and broadly applied highlights. The loose handling throughout lends an atmosphere of wildness to the scene that is heightened by the patchy effect of broad, direct strokes of impasto colour in the group of Joseph, the woman to his left, and the man and boy to his right. The composition is distantly derived from depictions of the theme by Pieter Lastman and Nicolaes Moyaert (fig. 18),[26] but Van Noordt has bound the groups of figures with interlacing compositional lines and applied a rough technique to evoke the emotional turbulence embodied in a scene of helplessness and rescue. It is tempting to connect his predilection for themes of despair with the sudden threat faced by his country after its attack by the Triple Alliance in 1672.

Both the *Hagar* in Kingston and the *Joseph* in Milwaukee can be dated to around 1675 on the basis of a comparison with a signed and dated painting of that year. *Boy with a Dog and a Falcon* depicts a completely different theme, showing likely an anonymous genre figure with hunting attributes (cat. 45). Again the artist created a rhythmic pattern of patches of thick strokes of opaque colour. In the boy himself, this effect can be seen in the hair and in the hand grasping a spear. These unmodulated areas give the impression of direct treatment, deliberately creating a rough effect. The losses to overcleaning distort the original intention, but what remains strongly suggests a dramatic effect. This approach had been developed by the artist as an expressive device for grand and dramatic historical scenes, but here it misses the mark. The easel-sized canvas is a riot of colour and energetic movement, which only yields a macabre overtone. The subject matter of boy hunters instead typically called for gentle charm and elegance.

Van Noordt's last dated painting marks a return to the restraint of the previous decade. *Madonna and Child* of 1676, in Gavnø, which likely represents the biblical

FIGURE 18
Claes Cornelisz. Moyaert, *Joseph Selling Grain in Egypt*, canvas, 136 × 179 cm, c. 1650, Kingston, Agnes Etherington Art Centre, gift of Drs Alfred and Isabel Bader.

story of the rest on the flight into Egypt, presents a calmer, happier theme than those preceding it (cat. 13). The handling is limited to a smooth, creamy build-up of impasto colours, with lighter tones. The effect of light is emphatic, yielding the same ripe rounded forms of flesh and drapery as seen in earlier works, for example the *Hagar*. Rough handling has disappeared, and even the tree is painted carefully in detail. Undulating lines of figures and drapery link this composition clearly with the Flemish tradition, with Jordaens in particular, but here contribute to a lavish, rather than unnerving effect. This work underscores Van Noordt's rough handling in other works as a stylistic option, which he applied as an expressive element with themes of strong emotion.

Rembrandt as Model for an Ultima Maniera

For a brief period toward the end of his career, Jan van Noordt experimented with a rough style. Although highly unusual among Dutch artists of his period, his choice followed a significant precedent. In Amsterdam some ten to fifteen years earlier, in the last decade of his life, Rembrandt also used an extremely rough, unfinished approach. In his two paintings of 1659 in Berlin, *Moses with the Tablets of the Law* (Br. 527) and *Jacob Wrestling with the Angel* (Br. 528), the scenes are laid in with dark lines of underdrawing on the ground tone, and the figure painted in directly

FIGURE 19
Rembrandt, *Moses with the Tablets of the Law*,
canvas, 168.5 × 136.5 cm, signed and dated 1659,
Berlin, Gemäldegalerie, Staatliche Museen
zu Berlin (photo: Bildarchiv Preussischer
Kulturbesitz / Art Resource NY; Jörg P. Anders).

FIGURE 20
Jacob Wrestling with the Angel, canvas, 137 × 116 cm,
signed, Gemäldegalerie, Staatliche Museen zu
Berlin (photo: Bildarchiv Preussischer Kulturbesitz
/ Art Resource NY; Jörg P. Anders).

brushed areas of lighter, covering colour (figs. 19, 20).[27] Yet these works were not
left unfinished; the artist signed both canvases. It furthermore seems to have been
understood by observers that he deliberately incorporated an unfinished aesthetic
into such works. He came under criticism for this choice from Houbraken, who re-
ported with some sarcasm Rembrandt's statement "a work is finished when the
artist has completed his intention in it…"[28] Because Houbraken is not consistently
reliable, we cannot be sure of what Rembrandt actually said, but clearly he was well
known for the unfinished quality of his late work. Jan van Noordt in 1675 was even
closer to the fact than Houbraken, who wrote in 1717. He was evidently also much
more sympathetic toward the rough style, even though it ran against the fashion of
his day as well.

In his pursuit of a rough style in his mature work Rembrandt in turn emulated
another artist: Titian.[29] The great Venetian master of the sixteenth century was
avidly collected at the highest levels in Amsterdam, just as he had been favoured by
the courts of Europe. A number of Dutch artists and collectors were aware that Tit-
ian, late in his long career, adopted loose and open brushwork for drawing and
modelling his figures, and for completing entire compositions (fig. 21).[30] This de-
velopment in Titian's style was described by Giorgio Vasari in his second, 1568 edi-
tion of *Lives of the Artists*.[31] The biographies of Vasari's most renowned artists were
translated into Dutch and published by Karel van Mander as one section of his
Schilder-boeck.[32] Significantly, Van Mander revisits the question of a loose or rough
style in a didactic poem addressed to young students of art that prefaces the three
volumes.[33] Following Vasari, he recommends that his readers begin in a careful and
fine style, because a rough style was much more difficult than it looked and reflected

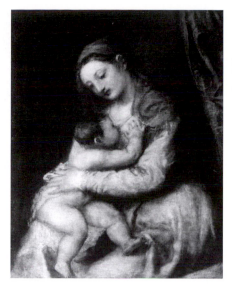

FIGURE 21
Titian, *Madonna and Child*, canvas, 75.5 × 61.3 cm, around 1570, London, National Gallery.

mastery and experience.[34] Van Mander's respect for a rough style also finds expression in his own painting, which was a loose reiteration of the highly refined Mannerist style current in Haarlem when he wrote at the beginning of the seventeenth century, as seen in the work of Cornelis Cornelisz. Van Haarlem and Hendrick Goltzius. This analysis of a rough style with respect to artistic maturity very likely later exerted an influence on Rembrandt, since Van Mander's text was widely known, even among laypeople.[35]

By placing himself in this grand tradition, Van Noordt clearly pursued high artistic ambitions. He alone among his fellow Dutch artists observed this aspect of Rembrandt's career. Even pupils like Aert de Gelder preferred to emphasize the rich textural effects of translucent and impasto paint they had appropriated from Rembrandt and did not experiment with an unfinished technique engaging the ground layer and underdrawing. Van Noordt furthermore took up this handling while maintaining a predominantly Flemish aesthetic based on the work of Jordaens, with swirling energy and massive bulging forms. Needless to say, this combination is unique, and Van Noordt's late style is easily distinguished.

Throughout his career, Jan van Noordt partook of the exchange between the two great Netherlandish centres of painting, Amsterdam and Antwerp. He trained in the manner of his first mentor, Jacob Backer, which itself absorbed aspects of the styles of Rembrandt and Rubens. He quickly revealed a penchant for liveliness in figures and compositions, to the point of stylization. Later he absorbed more elements of the work of Rubens and Jordaens more directly, refining his approach to the figure as well as the overall concentration of his compositions. In his last years he also looked to the unfinished, rough style of the late Rembrandt. None of this was slavish imitation. With the increasing freedom and independence afforded him by his rising position, Van Noordt's choice of the work of Rembrandt and Jordaens as models reveals remarkable ambition and a focused pursuit of extreme emotional effects and physicality. Especially in the works of his final decade, he stood alone among his gentler and more polite contemporaries and contributed a fascinating facet to the Dutch Golden Age of painting.

From Open Market to Private Network
Buyers and Patrons of Jan van Noordt's Paintings

Jan van Noordt's course as an artist followed not only his own creativity and bent, but also the market for paintings in the northern Netherlands. With paintings like *Granida and Daifilo* of 1663 and *Continence of Scipio* of 1672, Van Noordt joined play with those priorities and values of his society that were expressed in art consumption. This society was Amsterdam between around 1645 and 1675. Those Amsterdammers who bought Van Noordt's paintings form the other half of this equation of motivation and significance for the production of his art.

The ownership of Van Noordt paintings by various people in the city is documented in notarial inventories. Of these, the inventories taken before the end of the seventeenth century are the most likely indications of the initial buying public for which the artist produced his work. Unfortunately, except for a few portraits, none of the surviving works can be positively linked to its original owner by way of provenance. However, the inventories give some useful evidence about what kind of people bought what kind of painting by Van Noordt. The paintings themselves are another source of evidence about Van Noordt's clientele. Their stylistic development has been reconstructed in the previous chapter, and quite a few undated paintings can now take a chronological place in Van Noordt's surviving oeuvre. Analysis of the paintings with respect to their dating suggests how Van Noordt's career changed in the late 1650s. Portraits suggest private patronage, which could then have extended to history paintings.

Van Noordt's early years as a pupil of Backer exposed him to that artist's milieu. As we have seen, Backer was one of the most successful painters of the Dutch Golden Age, and he cultivated a clientele that ranged from the court in The Hague to elite collectors and patrons in Amsterdam.[1] Backer's *Cimon and Iphigenia* in Braunschweig was emulated by Jan van Noordt in his two early versions of the

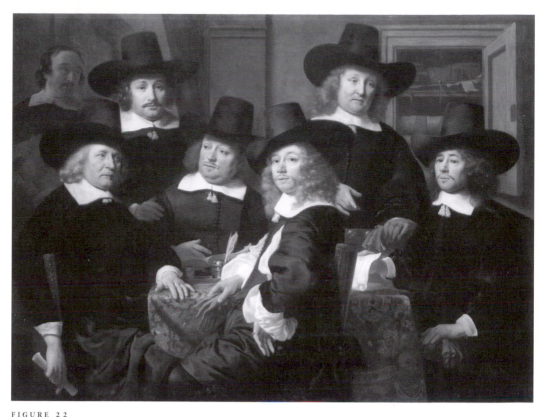

same theme (cat. 28, 29).[2] This painting by Backer, or a version of it, was praised in
a poem by Jan Vos, in which it was reported as being in the collection of Abraham
van Bassen (1613–1680) in Amsterdam.[3] Van Bassen was the scion of a family be-
longing to Amsterdam's regent class, and he served as governor of the Almshouse,
an appointment commemorated in a group portrait of 1657 by Ferdinand Bol (fig.
22).[4] Van Bassen's collection was a likely destination for Backer's painting: an his-
torical theme drawn from literature and involving many figures demanded a high
level of skill of the artist, and implied literary knowledge on the part of both artist
and patron. The investment of education and training was often reflected in the
higher cost of history paintings, and thus in the relative wealth of those who bought
them. This level of patronage was also the aspiration of Van Noordt when he em-
ulated the artistic invention of his master.

At around the same time that Jan van Noordt was following Backer's model,
his fellow-pupil and friend Abraham van den Tempel was starting to enjoy success,
attracting commissions at a level comparable to that of Backer himself. About 1650,
Van den Tempel painted a series of three allegorical paintings celebrating the city
of Leiden and its cloth industry for the Governor's Chamber of the *Lakenhal*, the
Hall of the Weavers' Guild of that city.[5] He was no doubt helped to this assign-
ment by family and Mennonite friends, many of whom were involved in the cloth
trade.[6] Van den Tempel moved to Amsterdam in 1660 and proceeded to forge a

career as an ambitious portraitist, competing with Bartholomeus van der Helst (1613–1670) and Nicolaes Maes (1636–1695) for clients from the city's regent and merchant classes. The same career trajectory was followed by Jan de Baen (1633–1702), another of Backer's pupils, who enjoyed great success in The Hague, being charged with the portrayal of the Grand Pensionary Johan de Witt (1625–1672).[7]

While his fellow-pupils assumed part of Backer's market for portraits, Van Noordt apparently aimed to do the same for history paintings. From the evidence of the surviving works and their dating (albeit in the absence of a dated work), the young artist seems to have concentrated on this type of painting during his early phase up to 1650, before Backer's death in 1651. Furthermore, he favoured Backeresque themes; besides *Cimon and Iphigenia*, he also painted *Granida and Daifilo* (cat. 33) and *Jupiter and Callisto* (cat. 15) in these years.[8] Apparently this strategy did not yield satisfactory results, because Van Noordt abandoned it. In the following decade his history paintings turn away from Backer and take up a variety of other sources. He looked to Cornelis de Vos (1584?–1651) for his *Magnanimity of Scipio* of around 1655–60 (cat. 26), and to the Amsterdam painter Claes Cornelisz. Moyaert (1590/91–1655) for his *Cloelia Crossing the Tiber* of around 1655–58 (cat. 25).[9] This shift suggests that Van Noordt was seeking a broader market in the mid-1650s.

It is quite likely that Van Noordt's early style did not meet the expectations of Backer's patrons. They expected smooth modelling and broad forms yielding a pleasing abstraction, and consistent cohesiveness and concentration in large, multi-figured compositions. As has been argued in the previous chapter, Van Noordt began with rather abrupt effects of modelling and colour and with diffuse arrangements of points of interest. The result was vigorous and lively, but perhaps not pleasing to all. These characteristics would persist in his work, through several phases of change.

Van Noordt seems to have adapted to this situation by turning to the painting of genre subjects. Virtually none of his genre depictions can be dated to the period 1645–50, but quite a few can be placed in the 1650s on the basis of their style. This trend can be observed in relation to the production of paintings in the three categories of history, genre, and portrait over the course of Van Noordt's career:

Period, no. of paintings

Category	1641–50	1651–58	1659–71	1672–76
History	8	9	11	5
Genre	1	9	1	1
Portrait	0	1	16	0

The history of Van Noordt's market can be divided into four phases, roughly one for each decade. The first phase, which focused on history paintings, when Van Noordt began painting genre scenes as well, around 1650. The most important shift takes place around 1659, and in the next, longer period of 1659 to 1671, he

continued to produce history paintings while enjoying very good patronage for his portraits and apparently giving up on the genre subjects of the 1650s. This phase seems to have ended in 1672, the year of economic disaster.

The Market for Genre Scenes

An indication of the way in which Van Noordt's genre pictures found their buyers surfaces in a near-contemporary probate inventory. *Shepherdess* (cat. L31) and *The Five Senses* (cat. L27) by Van Noordt appear in the inventory of Cornelis Doeck (1616–1664) taken after his death.[10] Doeck was an art dealer and erstwhile landscape painter.[11] Although he built up no reputation as an artist, he remains known for having one of the largest Dutch inventories of art in the seventeenth century, counting around 400 paintings. Of his two Van Noordts, only the first could possibly be connected to existing works: *Shepherdess* in Florence and Mänttä, which can be dated to the mid-1650s (cat. 42, 43). If Doeck's painting was not one of these, it was likely another version of the same theme painted around the same time, a period in which Van Noordt seems to have relied to some extent on dealers for the selling of his paintings. This was, according to Houbraken, a less desirable situation for an artist than private patronage.[12] Van Noordt's genre paintings seem generally to be aimed at the dealer trade as they are small in scale, have few figures, and depict themes not directly related to literature. Doeck seems to have traded primarily in such smaller, less expensive works.

Another genre work found its way into the collection of the wealthy fabric dyer Hendrik Oly. When Oly died in 1683,[13] he left behind *A Girl with Fruit* (cat. L33). This painting (again identifiable with the abovementioned works) appears in an inventory of his possessions taken in 1700, after the death of his wife, Neeltje Eland.[14] Four decades before in 1656, Oly had established himself in Amsterdam, when he bought the dye-works in the house named the *Blauwe Snoek* (the Blue Pike), on the Bloemgracht, from Jan Claesz. Ansloo.[15] Around the same time, he married Neeltje Eland, and in the ensuing years had two children, who both died young.[16] The fortune amassed by Hendrik and Neeltje went to other family members. By the evidence of a number of paintings by his own hand appearing in the inventory, Oly was also a dilettante painter.[17] The large number of works he owned, seventy-five, suggests that Oly may have also traded in art. However, they may simply have graced the walls of his various residences; his inventory includes several houses in Amsterdam and Haarlem, and a later document mentions a summer house and garden located between the two cities.[18]

The last person in the seventeenth century known to possess a genre subject by Van Noordt was less wealthy than Oly but much more colourful. An "*harderin van van Oort*" (*Shepherdess* by Van Noordt) (cat. L29) was included in the inventory of Jan Westerhoff (?–1719).[19] When Bredius published this inventory, he also indicated another record, in which Westerhoff was identified as the owner of a hostel

named *De Hoop* (The Hope) on the Kloveniersburgwal in Amsterdam.[20] A curious manuscript in the library of the Amsterdam Zoo, *Natura Artis Magistra*, tells more about Westerhoff. He apparently established a forerunner to the Amsterdam Zoo. Jan Velten, a fellow animal enthusiast, created a small volume of drawings devoted to "Blauw-Jan," as Westerhoff was known in his function as nature-showman.[21] Westerhoff ran a menagerie in the garden behind his hostel on the Kloveniersburgwal. There he put a large collection of birds, a number of exotic animals, and even some unusual human beings on display to the public.[22] He enjoyed renown, and could count in his collection a bird received from Prince William III.[23] In the same room as his *Shepherdess* by Van Noordt hung landscapes and animal still-lifes, suggesting that the pastoral subject was seen as associated with outdoor and nature subjects. The painting of a bucolic girl by Van Noordt in Westerhoff's collection was likely not commissioned from the artist himself. The surviving paintings by him that correspond to the inventory entry for "A Shepherdess" are *A Shepherdess with a Basket of Grapes* and *Shepherdess with a Basket of Fruit*, mentioned above, of around 1655–60 (cat. 42, 43). Westerhoff only arrived in Amsterdam in the early 1660s, well after Van Noordt (as far as we know) abandoned genre subjects of this type. Westerhoff belongs to the later part of the seventeenth century, coming from Oldenburg and gaining his *Poorterschap* (citizenship) in Amsterdam in 1664, where he married Annetje Huggen Schoddenburgh from Heemstede in the same year.[24] After her death in 1696 he remarried in 1698, and he died in his adopted city in 1719.[25] His painting by Van Noordt was not a commission, and was likely purchased through an intermediary, possibly a dealer.

Van Noordt's genre paintings seem to have been made at least in part on speculation, by the evidence of the inventory of Cornelis Doeck. It is not clear whether Hendrik Oly and Jan Westerhoff acquired their paintings through dealers such as Doeck. Oly could possibly have commissioned the artist himself, but Westerhoff almost certainly did not. Generally, genre subjects did not call for personal contact between artist and buyer. Such works tended to be indirect and vague in their references and aimed at a broad and diverse market. This relationship contrasts with the direct access to patrons that was necessary with portraits, which demanded personal contact for the commission, the sitting, and often also for decisions concerning the specific attributes of the portrait.

1659: Van Noordt's Breakthrough in Portrait Patronage

Van Noordt started to attract clients for portraits around 1659, when he produced the signed and dated *Portrait of a Woman*, last in The Hague (cat. 46). He had earlier produced *Portrait of a Boy*, in Johannesburg (cat. 53). This painting is small in scale and strikes an informal tone with the conceit of a play with the frame. In *Portrait of a Woman* the sitter's wan smile and her emphatic gesture of clasped hands resurrect some of the genre-like informality of the earlier child's portrait. At the same time the artist also strove toward a loftier atmosphere, with the

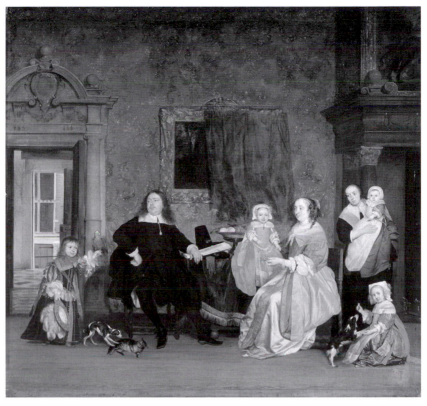

FIGURE 23

Gabriel Metsu, *Portrait of Jan Jacobsz. Hinlopen and Leonora Huydecoper and Their Household*, canvas, 72 × 79 cm, 1657, Berlin, Gemäldegalerie, Staatliche Museen zu Berlin (photo: Bildarchiv Preussischer Kulturbesitz / Art Resource NY; Jörg P. Anders).

columns and drapery in the background. The resulting conflict of tone suggests that this was Van Noordt's first undertaking in the more lucrative area of commissioned portraits.

He quickly gained a substantial reputation. Only a few years later he attracted a portrait commission from the most elite stratum of Amsterdam society, which recently surfaced in a significant documentary find. The testament of Jan Jacobsz. Hinlopen (1626–1666) and Leonora Huydecoper (1631–1663), which they had drawn up in 1663, makes special mention of "*de Conterfeijtsels vande Testateuren, oock t Conterfeijtsel van haer Soon selfs geschildert door J. van Oort*" (the portraits of the testamentees, also the portrait of their son, painted by J. van Noordt himself) (cat. L43 and L44).[26] Unfortunately no surviving pictures by Van Noordt can be connected to this reference. In the text of the document, these paintings precede another one, of the parents with all of their children by Gabriel Metsu, a work that has recently been identified by Judith van Gent as the Metsu family portrait in Berlin (fig. 23).[27]

Jan Hinlopen occupied a powerful position within the regent class of Amsterdam society, a class that controlled all appointments in the city government and the various institutions of public service in Amsterdam. Son of the influential Jacob

Jacobsz. Hinlopen (1582–1629), he occupied the city posts of *Commissaris* (commissioner) and *Schepen* (justice official) as well as serving as ensign and lieutenant on the city militia.[28] Yet his marriage to Leonora in 1657 marked a further step up in his social position, bringing him into perhaps the most prominent family in Amsterdam at the time. Leonora's father, Joan Huydecoper (1599–1661),[29] occupied the post of Burgomaster six times, and many other posts as well; he was also able to secure numerous appointments for family and friends.[30] One of the best known figures of Amsterdam's halcyon days during the stadholderless period of 1650–72, Huydecoper was heavily involved in the city's patronage of art and architecture. An amateur architect, he had a hand in the building project for the City Hall (now the Royal Palace on the Dam). Not coincidentally, the cycle of history paintings and allegories that formed an important part of its interior decoration was commissioned from his favourite artist, Govert Flinck.[31]

Van Noordt stood on the periphery of this world. He was linked to Flinck by way of Jacob Backer, that artist's former fellow-pupil. Moreover, after the death of Backer in 1651, Van Noordt's style followed that of Flinck, incorporating rhythms of highlights and undulating lines, especially in drapery folds, that brought liveliness into the broad, smooth forms and flowing lines inherited from Backer. Indeed, Van Noordt produced a number of lavish portraits in the 1660s that are witness to his further success with this style. By catering to the growing elite taste for energetic effects of movement in paintings, Van Noordt was aiming at the same patronage as Flinck within the Amsterdam patriciate.

The commission from Jan Hinlopen and Leonora Huydecoper marks a noteworthy rise in status, which Van Noordt likely owed in part to his brother Anthoni, the organist and composer. In 1659 Anthoni published his volume of psalms and fantasias for the organ, and subsequently applied for an increase in salary as organist of the Nieuwezijds Kapel.[32] Although this appeal was turned down, Anthoni was placated in 1664 with an appointment to the Nieuwe Kerk, which brought with it the sought-after salary increase. He was also immediately charged with an extensive expansion of the organ in that church. The city-appointed *Kerkmeester* of the Nieuwe Kerk was Hinlopen.[33] It is likely that Hinlopen knew Anthoni before 1664, and in this way came to know his younger brother, from whom he commissioned the portraits of himself, his wfe, and their son sometime before 1663.

However, Van Noordt did not succeed in retaining Hinlopen's favour. Two years after the death of Leonora in 1663, Hinlopen remarried, and in 1666, he turned to the very fashionable Bartholomeus van der Helst for a double portrait of himself with his young new bride, Lucia Wybrands (1638–1719).[34] Hinlopen was returning to the artist from whom he had commissioned a portrait of himself seven years previously, in 1659.[35] There are no firm indications that Van Noordt received similarly prestigious commissions afterward. He evidently could not successfully compete against the portrait specialist Van der Helst for the most elite patronage. However, from the evidence of surviving paintings, Van Noordt did continue to paint portraits for affluent patrons during the decade of the 1660s.

The 1660s: The Decade of Portraiture

Several of Van Noordt's portraits reflect the flamboyant and sumptuous taste and style favoured by Amsterdam's patricians in the 1660s. The most lavish are *Portrait of a Young Man with His Dog*, in Lyon, and *Family Portrait*, in Dunkerque (cat. 54, 62). Unfortunately none of the sitters can be traced with any certainty. Only one of Van Noordt's sitters can be clearly identified today: an inscription on the back of a small portrait on copper in the Rijksmuseum in Amsterdam bears the name of Dionijs Wijnands (1628–1673), an Amsterdam manufacturer of silk (cat. 43).[36] A second version of this portrait, three-quarter-length on canvas, is signed by Van Noordt and dated 1664 (cat. 44). Van Noordt's patron for this commission came from a family of merchants. Dionijs's father, Hendrik Wijnantsz. (1602–1676), had been a *craemer*, or vendor.[37] He is represented with his wife, Aeltje, in pendant portraits in the Rijksmuseum (figs. 24, 25). The social standing of this family was much lower than that of the Hinlopens and Huydecopers; neither Hendrik nor his son was able to gain entry into the regent class by way of a city appointment. However, the daughter of Dionijs Wijnands and Anna Groessens (1631–?), Alida (1655–1724), in 1676 married Hendrik Meulenaer (1651–1704), son of Roelof Meulenaer (1618/19–1691), the city's postmaster for Antwerp.[38]

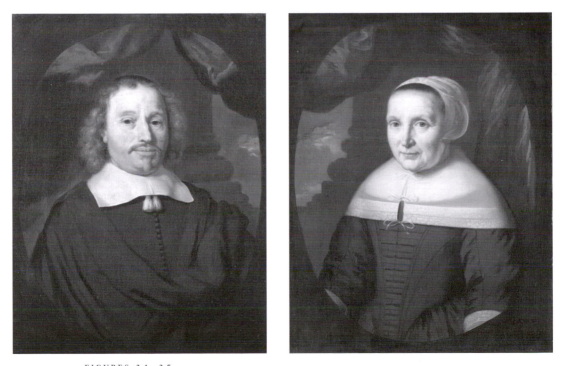

FIGURES 24, 25
Left: Follower of Nicolaes Maes, *Portrait of Hendrick Wijnants*, canvas, 45 × 34 cm, Amsterdam, Rijksmuseum (photo: Rijksmuseum-Stichting Amsterdam).

Right: Follower of Nicolaes Maes, *Portrait of Aeltje Denijs*, canvas, 44.5 × 34 cm, Amsterdam, Rijksmuseum (photo: Rijksmuseum-Stichting Amsterdam).

Nevertheless, Dionijs Wijnands achieved a considerable social position within Amsterdam society and could leave a modest fortune to his heirs.[39] He also participated in the city's literary and theatrical circles. Wijnands was the eleventh member of an exclusive literary society, *Nil Volentibus Arduum*, whose records were preserved in notes made early in the eighteenth century by the poet and playwright Balthasar Huydecoper and published by Bernardus Dongelmans.[40] *Nil Volentibus Arduum* was founded in 1669 by Lodewijk Meijer and Andries Pels with the aim of promoting French Classicist ideals in theatre.[41] At each meeting, which were held every two weeks, one member presented an essay on a set topic. Although the group hoped to see the birth of a classical school of play writing in the Netherlands, it managed no more than the publication of theoretical tracts and the translation of French plays.[42] The painter and art theorist Gerard de Lairesse, although he did not become a member, was a well-known supporter and hosted several meetings at his house.[43] Dionijs Wijnands did not play a major role in the society. He joined only a few years before his early death in 1673 at the age of forty-five. He seems to have participated mainly through attending meetings and making a few presentations. No writings by him are known. He is recorded in Balthasar Huydecoper's notes as having the title of "Doctor," but unfortunately there is no indication of his education or his dissertation topic.[44] Through his membership in this group, Wijnands forms a second, albeit vague link between Van Noordt and the theatre in Amsterdam, the other one already noted, through Samuel Coster, the founder of the *Schouburgh*.[45]

The patrons for Van Noordt's portraiture also included another artist: the marine painter Jan van de Cappelle. Van de Cappelle practised his sublime art while conducting a lucrative family dyeing business (the same trade as that of Hendrik Oly, mentioned earlier), by which he was able to amass a large collection of art, including paintings and many drawings. The contents of his collection are known through an inventory taken after his death in 1679, which lists a portrait of his late wife, Annetje Jans Grotincx (1632–1677), by Jan van Noordt (cat. L47).[46] Another portrait in the inventory is that of Jan van de Cappelle himself, by Gerbrand van den Eeckhout (1621–1674), an artist who is sometimes connected with Jan van Noordt on account of shared themes and stylistic traits.[47] These two entries prompted Saskia Nystad to attempt an identification of two existing pendant portraits, in Amsterdam and in Paris, as Van de Cappelle and Grotincx by Van den Eeckhout and Van Noordt respectively.[48] However, the Paris painting is a misattribution (cat. R45). Nonetheless, Nystad does draw attention to the implication that Van de Cappelle was on friendly terms with Van den Eeckhout and Van Noordt. Curiously, further on in the inventory another portrait of Van de Cappelle is mentioned, a copy made "*van van Noort's tekening*" (after Van Noordt's drawing) (cat. DL4).[49]

Van Noordt seems to have enjoyed a demand for adult male portraits for only a short while. Only one other example can be cited, *Petrus Proëlius*, which has been lost but is known through a reproductive print by Joan de Visscher (cat. Copy 2). The date on the print, 1661, is that of the sitter's death and not of the original por-

trait, which was likely produced shortly before, probably in 1660, judging by the harmony between the elegant pose and the restrained arrangement of background elements, which shows an advance from the 1659 *Portrait of a Woman* discussed above (cat. 46). It can be placed toward the beginning of Van Noordt's activity as a portraitist. His sitter was a *predikant*, or minister in the Reformed Church, as the inscription to the print declares: "*Petrus Proëlius Ecclesiastes Amstelædemensis.*"[50] Van Noordt may have secured this early portrait commission through his younger brother Lucas, who was a *predikant* in nearby Diemen.

Van Noordt attracted only a limited market for his portraiture, possibly through personal or social connections alone. In the 1660s he was competing against artists who focused almost entirely on this specialty: Bartholomeus van der Helst, Nicolaes Maes, and also his own friend Abraham van den Tempel. Nonetheless, a spate of portrait commissions in the decade of the 1660s did permit, or force, Van Noordt to put aside the genre subjects of the 1650s. It is this later time to which Houbraken refers, in *The Great Theatre*, when he identifies Jan van Noordt as a "history- and portrait-painter."[51]

A Private Market for the Later History Paintings

The access that Van Noordt gained to a private market through his portraits would have benefitted his activity as a history painter. However, no concrete evidence, such as a contract, survives of commissions for these works. Only in the in-between category of the *portrait historié* are secure examples found of history paintings done specifically for patrons: in such pictures, patrons had themselves and family and friends portrayed in the roles of the main figures, whose faces thus bear their own features rather than reflecting idealized general types. In Van Noordt's *Hagar and the Angel* (cat. 1), in Kingston, it seems that Hagar is a portrait, and in *Portrait of a Widow and Her Two Sons*, in Bordeaux, a mother plays the role of the widow of Elisha's servant (cat. 60). In *Caritas* of around 1670, a mother appears with her children (cat. 61). All three of these paintings are late works, dating to around 1670–75. They prove that Van Noordt's portrait patrons also had an eye for his talents as a history painter. However, the documentary evidence concerning the early owners of his history paintings shows a diverse market and yields little indication of direct contact with the artist.

Four history paintings by Jan van Noordt appear in the inventories of four early owners who represent a range of social status comparable to that of owners of the portraits. The wealth and power of Jan Jacobsz. Hinlopen was not matched, but it was approached, by Elias Nuyts (1614–1680), whose daughter Catharina (1662–1698) owned one such work, likely a *Granida and Daifilo* (cat. L25).[52] The Nuyts family business was a sugar refinery on the Herengracht known as *De Koning van Polen* (The King of Poland). Run by Elias's father, Cornelis, it was one of the largest sugar refineries in the city, and when it burned down on 3 January 1660, the loss was estimated by the writer Melchior Fokkens at "*drie tonnen goud*," or 300 000

guilders. Nonetheless, the family had sufficient resources to survive the disaster and rebuilt its fortune chiefly through the East Indian trade. A sugar-trading house, this time built in white stone, was established at the same location, and Elias would later return to sugar refining there.[53]

Catharina Nuyts, the daughter of Elias and Catarina Grebert, died young and was survived by her husband, Elias van Valencijn (1652–1738).[54] An inventory of her possessions included a "*Stuk met beelden van van Oort*" (a piece with figures by Van Noordt) (cat. L25).[55] This vague entry takes on more significance when connected to a work in the inventory of Catharina's mother Catarina, taken after her death in December 1714. It includes "*Een Diana met een Jagthooren door Van Oort*" (A Diana with a Hunting Horn by Van Noordt).[56] It was almost certainly the same painting, passed on from Catharina Nuyts to her mother after the daughter's death; it evidently was regarded as belonging to Catharina Nuyts. Since she was born only in 1662, and Van Noordt's latest known works date to 1676 and before, Catharina's painting had likely been bought by her mother, to whom it was later returned. This painting could have been a lost work of a mythological theme, but it may also have been one of Van Noordt's depictions of *Granida and Daifilo*. The idealized figure of Granida, bearing weapons and holding a shell, may have been misinterpreted by the notary in 1715 as the goddess of hunting, Diana. The version of *Granida* that Van Noordt painted in 1663, which appeared recently at a London sale, was in like manner misread when it was catalogued for sales in 1788 and 1905 (cat. 34).[57] The likelihood of a misreading in the 1715 inventory is strengthened by the fact that two paintings of *Granida and Daifilo* survive, whereas there are no known depictions by Van Noordt of "Diana with a Hunting Horn." In the absence of further evidence, however, the identification of Catharina Nuijts's painting remains uncertain. It is also not possible to date the purchase of the work.

Compared with the wealth of Catharina Nuyts, Michiel van Coxie (1649–1688), owner of *Susanna and the Elders* (cat. L4) could only be said to be affluent. An inventory deposited in 1682 with the Admission Registry of the Chamber for Orphans indicates an estate valued at ƒ10 953.[58] Van Coxie's marriage act identified him as a *koopman*, or merchant, from Amsterdam.[59] None of the documents indicates the particular trade he conducted, but it seems to have been a family business: it appears that he stayed in the family residence on the Rosengracht with his parents and his brother Coenraet, who is also identified as a merchant.[60] In 1675, Michiel married Johanna Ida de Vos (1655–1678), with whom he had two children before her death only three years later, in 1678. Three years later, he had an inventory drafted of the possessions he had stored at the house of her father, Pieter de Vos. It was an entire household of goods, among them "*de Sussanna van Jan van Oort*" (the Susanna by Jan van Noordt).[61] If this work had been commissioned by Michiel van Coxie, only one of the three known versions of this theme by Van Noordt is a candidate, the latest one, presently in Paris (cat. 8). It dates to around 1670, when Van Coxie would have been about twenty-one years old. However, he may simply have purchased his *Susanna* by some other means, and it could have been a work from earlier in Van Noordt's career.

Van Coxie was only twenty-seven at the time of the first inventory. Besides the painting by Jan van Noordt, he also owned sculptures, maps, and a clavecembalo, as well as a number of other paintings. One of them is given as "an ox by Rembrandt," and there are also marines by Ludolph Backhuysen and Jan Lingelbach.[62] This list of possessions reflects not a systematic collection of art and objects, but rather a well-appointed, affluent household. This inventory also did not include everything Van Coxie owned, since he made his residence with his own family on the Rosengracht and likely kept many things there as well. The inventory appearance of Van Noordt's painting is not specific enough to indicate whether the young merchant had contact with artists such as Van Noordt or acquired his paintings through less direct channels.

The paintings owned by Catharina Nuyts and Michiel van Coxie cannot be placed decisively in Van Noordt's earlier period or to the later phase, when he enjoyed private patronage. In both cases, the ages of the owners makes a later dating more likely. The themes they chose, *Susanna and the Elders* and quite likely *Granida and Daifilo*, were both very popular, not reflecting a particular viewpoint or taste and suiting both the open market and private commissions.

The specific content of another history painting linked to an early owner is again unknown. In 1670, a *"schilderij van St. Jan, van Jan van Noordt"* (a painting of St John, by Jan van Noordt) (cat. L8) was noted among the possessions of the deceased Jan Wolters (1613–1669).[63] The subject matter corresponds with that of the painting last in The Hague, which dates to about 1655 (cat. 12). However, Wolters' painting may also have been a different interpretation, since lost.

With the *St John*, Jan van Noordt's early work may have already attracted attention from within the highest social class in Amsterdam. Wolters was a German *émigré* from Bremen who established himself as a merchant in Amsterdam, trading mostly in goods from the East Indies. He enjoyed great success, and with his marriage in 1647 to Sara de Geer, the daughter of the wealthy arms manufacturer Louis de Geer, he gained entry into Amsterdam's regent class. Elias points to the records of the Exchange Bank in Amsterdam, where in one year, 1669, Wolters is given as carrying out f384 760 in transactions, a fabulous sum.[64] He evidently sought a suitable expression of his position when he purchased adjoining lots on the Herengracht in 1665, along the stretch that became known as the "Golden Bend" because of the lavish houses standing there.[65] His early death prevented his plans, and the land was eventually sold by his son Raymond to the merchant and real estate broker Laurens Wittebol.[66] In the context of such status, the *St John* today in The Hague is not an ostentatious work, in scale and in style. Its date of around 1655 perhaps corresponds to an earlier, more modest period in Wolters' life.

Adoration of the Shepherds (cat. 9), which recently surfaced and is in Maastricht, could be tied to the *Joseph and Mary* (cat. L7) mentioned in the inventory taken on the death of the painter Melchior d'Hondecoeter (1635–1695), a well-known specialist in game still-lifes.[67] D'Hondecoeter's ownership of a Van Noordt in 1695 does not mark as high a social milieu as that of Wolters. D'Hondecoeter compares

more closely with the painter-dealer Cornelis Doeck, mentioned earlier, who owned two genre paintings by Van Noordt. Like many of his profession, D'Hondecoeter likely sold the works of other artists beside his own.

The traces of Jan van Noordt's history paintings among the possession of Amsterdammers in the seventeenth century delineate a wide range in the market for this part of his output. The scale runs from the wealthy Catarina Grebert and Jan Wolters, through the affluent Michiel van Coxie, to the modest social status of Melchior d'Hondecoeter. To this list of owners can be added several members of Van Noordt's own family, who also held a relatively low social position.[68] This variety contrasts with the limited circle patronizing Joannes Vermeer in Delft, as well as with the strictly elite public for Gerrit Dou's *fijnschilderijen*.[69] It is perhaps a skewed picture. If we remove family and possible artist-dealers, we are largely left with merchants, who represented an important part of Amsterdam's market for art.[70]

The high point of Van Noordt's prominence as a history painter occurred around 1667–1670, when he painted the remarkable *Juno*, in Braunschweig (cat. 18). It must have been done on commission, given its size of nearly three metres across; an artist would generally not undertake such a costly investment of time and materials on speculation. The size also indicates a wealthy patron, because it could only have fit on the walls of a very large house in Amsterdam or a large summer residence outside the city or in another country. In addition, the picture's theme, the goddess of antiquity, called for a patron who was educated and able to appreciate the correct arrangement of attributes and accompanying figures. The daring level of nudity in particular demanded a certain level of enlightenment from the viewer, in the face of traditional religious objections in the Netherlands to sensuality in art. The same conditions applied to works like Backer's *Venus and Adonis*, in Eichenzell, and Cesar van Everdingen's *Jupiter and Callisto*, in Stockholm.[71] These are exceptional paintings in Dutch art, and Van Noordt's *Juno* should likewise be regarded as an anomaly in the artist's career. Such an ambitious commission represents the high point of his status, and within his oeuvre it is an unusual work. The format and subject matter of his other history paintings and his *portraits historiés* reflect largely the status and ideas of the broad bourgeois public in Amsterdam and other cities in the northern Netherlands.

Exempla of Love and Virtue

A Penchant in the Themes of Jan van Noordt's History Paintings

In the early years of the seventeenth century, many new themes appeared in Dutch history painting. It was a time of change; the flourishing trading economy of the northern Netherlands brought great prosperity to the merchants of its cities, especially Amsterdam. Religion and education were high priorities, as reflected in theological debates, book publishing, and in the rapid expansion of history painting production. Many of the themes appearing in these history paintings had been appropriated from the print tradition, especially illustrations made for Bibles and volumes on mythology. By mid-century, when Jan van Noordt began to produce history paintings, the market for such works had become dominated by a great many standard themes. Van Noordt himself largely selected from these themes; only a few of his choices of subject matter appear to be novel.

Instead of iconographic innovation, Van Noordt's output of history paintings raises the broader question of the selection of available themes. He partook of the wider preference for particularly dramatic moments exhibited by Rembrandt and his pupils, especially in the 1630s and 1640s, as Albert Blankert has shown.[1] However, the theoretical underpinning Blankert posits for the choice of these dramatic moments, Joost van den Vondel's interpretation of the classical tragic concept of *peripeteia* as *staetverandering* (change of state),[2] was published only in 1659, well after the fashion took place, and furthermore does not fit most of its scenarios.[3] Michelangelo Merisi da Caravaggio (1571–1610) was more influential in prompting the shift of pictorial taste across Europe, including Amsterdam, toward starkly emotional drama. Furthermore, many themes had long pictorial traditions, which have attracted considerable attention from scholars of Dutch art, among them Christian Tümpel and Volker Manuth in the area of biblical representations[4] and Eric Jan Sluijter in the area of mythological depictions.[5]

There remains the question of whether critical qualities of some themes recommended them to history painters. In his survey of Dutch mythological depictions, Sluijter notes the prevalence of female nudity and the preference for erotically charged stories. He draws a parallel to the popularity of *Susanna and the Elders* among biblical history paintings.[6] Yet such scenes presented powerful stories and dramas, with accompanying moralizing cargo, that held a secure place among other historical themes in painting. Humanist social thought, firmly established in the northern Netherlands, often embraced pleasure and amusement as vehicles for moralizing content. This chapter examines such messages, revisiting Van Noordt's selection of particular moments from the stories and considering a broad sweep of themes to address the function of these paintings within their social-cultural fabric. Jan van Noordt consistently interpreted many of his sources in conformity with two favoured topics: love and virtue. This inclination suggests a public that also consciously interpreted its literary and religious heritage in terms of courting, marriage, and virtuous behaviour in the public sphere, such as could relate to private life. Van Noordt established a market in Amsterdam's social élite, with literary pretensions in some cases, and his choices of subject and interpretation spoke to the interests of this group and thereby revealed a social function for his paintings. Considerable investment was attached to the exemplars of virtue and love presented in these paintings.

Love as a Literary and Pictorial Theme

Romantic love reassumed a place in European literature with the emergence of the courtly tradition of the troubadours. In the early Renaissance in Italy, Dante and especially Petrarch were important in entrenching the expression of love in European literature.[7] Love also surfaces in plays, stories, and novels that were available to Dutch readers in the seventeenth century. While some of this production was native, much of it was foreign, and was made popularly accessible by way of translation. Reflecting its courtly origins, this literature typically emphasized the realization of ideal love in a Neoplatonic sense. Although Giovanni Boccaccio's *Decameron* represented an important and influential alteration by introducing into the courtly discourse a lighter, more carnal element, his story of *Cimon and Iphigenia* propagated the tradition of ideal love by conjuring an unlikely meeting between two lovers and by having the young male protagonist endure considerable struggle to win, or keep, the hand of his beloved. Traces of the chivalric tradition and the epic framework persist.

In the context of the northern Netherlands, this decidedly literate discourse on love should be distinguished from the many moralizing emblems, literary and visual, and paintings that presented wisdom and guidelines about love, marriage, and other amorous pursuits.[8] This other, parallel phenomenon was directed at a popular audience, which included the less learned. Championed by the Dordrecht poet

Jacob Cats (1577–1660), it reflects the practical manifestation of humanism, oriented toward everyday life and operating largely within the constraints of religion.

An important platform for the expression of love in literature and art in the Netherlands was the pastoral setting. In the late sixteenth century, a fashion emerged for themes involving shepherds, shepherdesses, and the countryside, a revival of the grand tradition of classical antiquity represented by Virgil's *Georgics* but more directly sparked by the publication of Battista Guarini's *Il Pastor Fido* (The Faithful Shepherd) in 1589.[9] In the northern Netherlands this mode took hold in 1605 with the play *Granida* by Pieter Cornelisz. Hooft. Not much later it surfaced in the visual arts, with the earliest depiction of a *Shepherd and a Shepherdess*, by Pieter Lastman, of around 1610.[10] The unmistakably amorous slant of Lastman's scene corresponds to the emphasis in Hooft's play on the bond of love that links the protagonists, the princess Granida and the shepherd Daifilo.

The presentation of shepherds and shepherdesses as amorous figures was modelled on the shepherds of Arcadia in the pastoral tradition of the *Georgics*. A reminiscence of a lost golden age, their youth, beauty, and natural instinct became important elements in later discourses of love in the Baroque era. The spectre of distastefully crude country manners, such as seen in contemporary genre paintings, did not harmonize with this perfect world, however, and in some stories the protagonist turns out to be the well-bred child of nobility, who through some twist ended up in the countryside. The tone of the pastoral is thus in the end elevated, and given the setting, the language is often conspicuously refined as well. As a type the Baroque pastoral managed, often playfully and in an unlikely manner, to resolve the tension between low nature and high culture.

Hooft's *Granida* promoted a formula that developed into a more diffuse phenomenon. In the work of Jan van Noordt, some pastoral scenes came from literary sources that were not themselves part of the pastoral fashion but from other contexts, including the fourteenth-century novellas of Boccaccio. In addition, a number of his pastoral scenes, such as shepherdesses or young rustics with nests and floral wreaths, were not taken from a literary source (cat. 35, 39–44). As Peter van den Brink demonstrated in an exhibition catalogue of 1993, such representations should not be categorized separately but are an important demonstration of the wider impact of the pastoral.[11] This discussion will, however, focus on the depictions of literary themes, and on the artist's interpretation of these sources.

Painting the Moment of True Love: Granida and Daifilo

Jan van Noordt took the subject of two of his surviving paintings from Hooft's play entitled *Granida* (cat. 33, 34). This Dutch text enjoyed considerable popularity among artists, and a number of paintings with this theme were recognized and brought together by Sturla Gudlaugsson in a 1949 article.[12] Two of the earliest known are by Utrecht followers of Caravaggio: Dirck van Baburen depicted the

meeting of Granida and Daifilo in a large canvas of 1623, and two years later Gerrit van Honthorst completed a commission for the House of Orange for a scene of the two lovers being pursued by the soldiers of King Artabanus. Honthorst's unusual choice follows the penchant of his patron for themes not previously depicted by artists,[13] and its example was not followed, and did not affect the subsequent pictorial tradition for *Granida and Daifilo*. With a few exceptions, Dutch artists – like Baburen and later Van Noordt – all took up the same particular scene, which falls at the very beginning of the play, and the rest of the story was largely neglected by Netherlandish artists of the seventeenth century.

The conspicuous preference of artists for the scene of Granida and Daifilo's first meeting was noted by Marleen te Poel.[14] Like Blankert, Te Poel linked its popularity to the theoretical concept of *peripeteia* as presented by Vondel. However, Vondel's theory also came too late for the tradition for *Granida and Daifilo*, which was already well established long before 1659.[15]

Van Noordt's prompt to paint this scene came from Jacob Backer, who depicted it at least four times, in paintings in Harlingen, St Petersburg (fig. 6), and Kingston (fig. 7), and at a recent sale.[16] Backer consistently shows the figures in half-length, reflecting the model of his teacher Lambert Jacobsz., who appears to have adopted it from the Utrecht Caravaggisti. These paintings are of a piece with Backer's interest in pastoral themes, which also followed Caravaggisti such as Honthorst. Backer painted a number of pictures of shepherds and shepherdesses, including a bucolic figure that may be a self-portrait (fig. 26), whose amorous bent puts them in the same category as depictions of the opening scene of *Granida*.[17]

Van Noordt followed Backer's example in choosing to depict the moment in which Daifilo falls in love with Granida. Both of his paintings show the moment in the first scene of the play when the Persian princess Granida, having strayed from her hunting party, encounters the shepherd Daifilo and his companion, Dorilea, in the woods. Granida complains of the heat, and Daifilo immediately offers her water from a shell. Daifilo forsakes his shepherdess companion, who is apparently the object of his merely casual affection. Not coincidentally, Dorilea had just completed a monologue on the fickleness of male desire, and her concern becomes real now that she is forsaken for Granida. Both of Van Noordt's depictions show Daifilo kneeling and holding the shell up to Granida, with Dorilea taking a subordinate place, further behind in one painting and off to the side in the other. Granida represents true love for Daifilo, and this scene exemplified the same notion for the contemporary viewer.

The role of the shepherd Daifilo should be interpreted in this context. A platonic interpretation of this change sees Daifilo abandoning earthly love, the shepherdess Dorilea, for an ideal love, the princess Granida. However, this rigid framework of opposition does not seem to characterize the play, which does not condescend toward shepherdesses and the Arcadian life. It should be kept in mind that shepherds were themselves idealized in pastoral literature.[18] The life of the shepherd brings positive qualities to Daifilo. Contact with nature bestows on him an understanding of the spontaneous, unthinking passion of romantic love, which

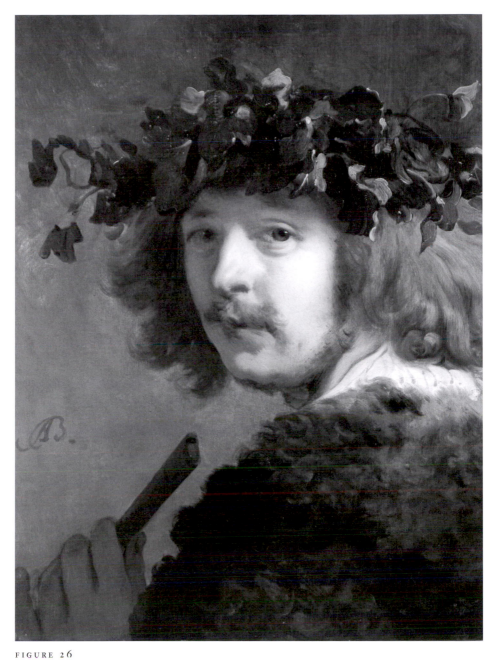

Jacob Adriaensz. Backer, *Half Figure of a Shepherd with a Flute (Self Portrait?)*, canvas, 50.8 × 39.4 cm, monogrammed, The Hague, Royal Cabinet of Paintings Mauritshuis.

is embodied in his immediate response to Granida's thirst. As a result, he is able to leave behind insincere affection for true love.

One of the authenticating characteristics of the relationship represented in Van Noordt's painting is the compatibility between the two new lovers. At first it seems that this criterion is being transgressed when the lowly shepherd falls in love with a princess. However, Daifilo, as it turns out, displays a noble character and refined manners. Hooft has Daifilo go on to face many obstacles, including imprisonment by a foreign rival for Granida's hand. He survives and triumphs, and realizes his love by marrying Granida at the end of the play. He thus proves both true love and a noble character, as he perseveres through difficulties and challenges. These developments expand upon the initial moment of meeting by confirming the truth of Daifilo's feeling for Granida, the intensity of which was expressed by his spontaneous gesture of offering her water in a shell, the only vessel to hand (the shell was also an attribute of Venus). His decided preference for Granida over Dorilea is thus inevitable; the latter was an inappropriate candidate from the beginning. Van Noordt suggests her lower character somewhat by characterizing her as naive and unwitting. By including her so prominently, Van Noordt, and Backer as well, foregrounds the two sorts of love from which Daifilo chooses, correctly.

A Related Theme from Boccaccio

Most of the aspects of true love associated with the story of Granida and Daifilo are also present in a second theme that Van Noordt favoured even more. His three surviving paintings of *Cimon and Iphigenia* (cat. 28, 29, 30) depict an episode in Boccaccio's *Decameron*. Dating to 1315, this collection of comic stories was one of the most celebrated products of the early Italian Renaissance. Boccaccio's text would come to enjoy a great deal of exposure in the sixteenth century in the Netherlands, where Dirck Volckertsz. Coornhert (1522–1590) published in 1564 a well-known translation of a selection of fifty stories from the book. The translation of the remaining stories, by Gerrit Hendriksz. van Breughel, enjoyed similar popularity, undergoing several reprints.[19] The stories of the *Decameron* are presented as being told by various members of a group to each other over a period of ten days. The only part of the *Decameron* that was to enjoy much attention from painters was the passage relating the first meeting of Cimon and Iphigenia, which belongs to the first story of the fifth day.[20] Coornhert included it in his selection of translations, and it also appears in three paintings by Van Noordt.

Like Daifilo, Cimon is presented experiencing true love for the first time. He is introduced in the story as a Galeso, the good-for-nothing son of the Cypriot nobleman Arristype. His father has given up on him and granted his wish to leave the court for the countryside to live the carefree life of a shepherd; the locals give him the derogatory name "Cimon." One day, while walking in the woods, Cimon encounters Iphigenia, a nobleman's daughter, reposing about a fountain with her attendants. The sight of the beautiful young woman, partly disrobed, inculcates in

Cimon not only courtly love but also a befitting demeanour. He returns to his father's court a civilized man who intends to pursue Iphigenia's hand, whereupon follows a complicated storyline of misadventures and challenges and an eventual happy resolution, in which Cimon and Iphigenia are married.

Boccaccio's story was influential, and is recognizably a forerunner to Hooft's *Granida*. It spelled out the requirement that the shepherd-protagonist put his love to the test with a range of trials, echoing faintly the labours of Hercules. These adventures are not only dramatic and entertaining, but they also prove to the reader that Cimon's character has transmuted into something truly noble, and in this way underline a doctrine of class and blood as it applies to breeding and marriage.

Contemporary Interpretations of Cimon and Iphigenia

Cimon's transformation from shepherd to nobleman was also recognized by later Netherlandish interpreters as the most important aspect of Boccaccio's story. When he rewrote the tale into a piece for the stage of the Amsterdam *Schouburgh* in 1639, the playwright Jan van Arp subtitled the frontispiece "Op den reeghel: *Door liefde verstandigh*" (Concerning the rule: *Through love* [made] *wise*).[21] The accompanying print shows the same scene of the first meeting preferred by painters (fig. 27).

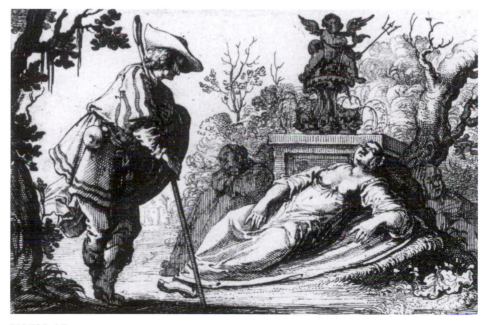

FIGURE 27
Unknown artist, *Cimon and Iphigenia*, frontispiece to Jan Van Arp, *Cimon*, 1639, Amsterdam, Universiteitsbibliotheek Amsterdam.

Of the many Dutch depictions of this scene, the best known is the painting by Backer in Braunschweig (fig. 4). There Cimon is shown, to the right and further back, peering over a bank of earth at Iphigenia and her friends, who lie on drapery spread over the ground, in the centre and to the left. It was not previously known that Backer derived this figural arrangement from an earlier Dutch source, a painting of the same theme from the late 1620s by Abraham Bloemaert that recently resurfaced on the market.[22] Curiously, his scene of male intrusion harks back more to Rubens' *Satyr and Nymph* depictions than to his paintings of *Cimon and Iphigenia*.[23] Whereas Bloemaert's elegant and idealized depiction emphasizes Cimon's transformation into a gentle being, Backer revisits the humour of Boccaccio's scenario by giving Cimon a bewildered, wide-eyed expression, characterizing him as slow-witted, not knowing what he is seeing or how to react. Van Noordt's own depiction shows the prominent figure of Iphigenia in the foreground of Backer's painting, with a few changes (cat. 28). However, he depicts Cimon differently, posing him in the foreground, standing still and leaning on his shepherd's crook. Boccaccio's story emphasizes that after seeing Iphigenia, Cimon takes this position and remains there for awhile, before she awakens. Van Noordt's choice of this particular moment, slightly later than what Backer showed, was likely influenced by the frontispiece to Van Arp's play. The pose gave the same comic suggestion of Cimon's character while making less demand on the young artist's as-yet undeveloped ability to evoke facial expressions.

The same humorous effect was likely also part of the intention behind the open, lightly shocking display of flesh in the figures of Iphigenia and her attendants in the paintings of both Backer and Van Noordt. It is strong medicine indeed that so quickly cures Cimon of his "problem." A less sophisticated contemporary such as Jan Vos fixated on the voluptuousness of Backer's image and drew a moralizing conclusion on the arousing effect of seeing such a beautiful naked woman. Vos's career as a poet and literary scholar is not rated highly, and here it seems that he did not know the story behind the image (he calls Iphigenia a field-nymph, for instance), which links such an erotic encounter with a positive outcome, namely Cimon's finding of true love and the ennoblement of his character. Vos's poem is cited by Eric Jan Sluijter and Nicôle Spaans in a further exploration of the moralizing interpretation of Cimon's viewing of a nude figure.[24] Sluijter and Spaans point to the significance of existing traditions for scenes of male figures admiring beautiful nude female figures, including satyrs spying on nymphs, Jupiter and Antiope, Venus and various admirers, and Diana and Actaeon, and the prevalent message warning against the dangers of lust. Backer's painting of *Cimon and Iphigenia* also appears to allude to this message by including weapons of hunting such as the quiver and arrows in the foreground right, adducing Actaeon and his punishment for viewing the disrobed Diana. In Backer's case, the laden quiver also appears to complete a subtle and witty allusion to another hunter, Cupid, established in the fragment of the fountain sculpture just visible at the top of the picture, where a pair of juvenile feet and ankles, caught in stride, is cut off by the edge. Consistent

with his humour, Backer has inverted the simple moralizing message against lust, setting it against Boccaccio's more positive theme of the positive effects of arousal coupled with true love. Van Noordt also took up this message and its comic vehicle in his renderings of the two protagonists, but found it necessary to recast Backer's suggested presence of Cupid into a clear and obvious figure in action, his arrow mid-flight.

A Third Scenario, from Cervantes' La Gitanilla

While the stories of Granida and Daifilo and of Cimon and Iphigenia were widely disseminated in seventeenth-century Dutch history painting, a third historical theme involving love was more the special domain of Jan van Noordt. Two large, nearly identical paintings by his hand survive (cat. 31, 32) that depict a scene from *De Spaensche Heidin* (The Spanish Gypsy), of 1643, by Mattheus Gansneb Tengnagel (1613–1652?).[25] This play was one of several adaptations that appeared in the northern Netherlands of a novella by Miguel de Cervantes (1547–1616), *La Gitanilla di Madril*, which was published in Madrid in 1613 and translated into French in 1614 and Dutch in 1643.[26] The relevant scene takes place early in Cervantes' story, when Don Jan (*Don Juan* translated into Dutch) first meets Pretioze. He has been out in the woods hunting, and he and his party have lost their way. Don Jan sees the beautiful young woman, dressed in satin, among a band of Gypsies. He is overwhelmed and confused, and for a moment thinks it is Diana, the goddess of the hunt, and that devils have taken her prisoner. He watches for a while and realizes that she is a young woman, one of a band of Gypsies, and he falls in love with her. She sees him and calls him over. Immediately Majombe, her guardian, intervenes to negotiate their interaction.

Van Noordt's two surviving versions depict the moment when Pretioze and Majombe both react to the attention of Don Jan. The two paintings are nearly identical, a unique instance in Van Noordt's known oeuvre. Don Jan stands to the right side, leaning his elbow on a rock. He turns his head to the left, to look over to Pretioze, who sits on a mound of earth. Behind Pretioze stands the old Gypsy woman Majombe, who moves forward to interject between her charge and the surprise intruder. The composition is enriched in the distance with other Gypsies mixing with Don Jan's hunting party, which includes a young black slave holding a falcon.

Cervantes' story provided Van Noordt with yet another exemplar of true love. As with the texts by Boccaccio and Hooft, in *La Gitanilla di Madril* the male protagonist must survive several tests and challenges, which make for a lively and dramatic story, before he can win the hand of his beloved. Don Jan, at the insistence of Majombe, joins the band for two years. A crisis comes when Don Jan is accused of theft by a Spanish woman whose love he has spurned out of devotion to Pretioze; at his arrest he is insulted by a man, whom he kills. As a result he is condemned to death

by the local magistrate. He then reveals his noble status, which afforded him the right to defend his honour. The dénouement of the story features a surprising twist, when Pretioze is revealed to be the daughter of the magistrate and his wife, stolen as an infant by the Gypsy Majombe. A birthmark on her breast is the evidence. The love for which Don Jan has sacrificed so much turns out to have been for a woman of his own high social standing. The authenticity of his feelings is verified by this compatibility of their blood lines, of which he was unaware.

Sturla Gudlaugsson was the first, in 1945, to recognize the subject of Van Noordt's painting and others depicting the same story. He knew only the version that surfaced recently in New York, which was then in London (cat. 31). It had previously been identified as a genre-like "Cavalier et une jeune Femme," or the classical story of Vertumnus and Pomona.[27] Gudlaugsson pointed out the connection to Jacob Cats' *Het Spaense Heydinnetje* (The Spanish Gypsy Girl) of 1637, a Dutch adaptation in verse poetry of Cervantes' story. Gudlaugsson placed Van Noordt's painting within the context of comic themes in genre paintings, linking it to Jan Steen's many "Doctor's Visits," with their mocking scenarios of naïveté and anxiety surrounding unexpected pregnancies. More recently, Peter van den Brink corrected Gudlaugsson by connecting Van Noordt's paintings more specifically to Tengnagel's version of Cervantes' story, and by placing it in the context of pastoral depictions.[28] The story of *De Spaensche Heidin* preserves the element of humour observed by Gudlaugsson in the version by Cats, in Don Jan's extravagant reaction to the sight of Pretioze. Van Noordt played up this conceit by contriving a languid, limp-wristed, drooped-chin pose for Don Jan, which he studied thoroughly in an elaborate preparatory drawing (cat. D9). In his hands Don Jan is a mild caricature of Spanish nobility, aimed at the bourgeois self-image of an Amsterdam audience. The black page also belongs to the Dutch view of Spanish high society as slave-owning, a notion that persists today in Dutch *Sinterklaas* customs, which portray Black Peter accompanying the Saint on his arrival in the Netherlands, having come from Spain.

Nonetheless, the meaning and intention of this play are serious, not comic. The character of Van Noordt's humour is not sarcastic and raucous, but light and tender, so that it does not negate Don Jan's sincerity. Van Noordt thus responded to the explanation given in the play, that at the initial meeting Don Jan was already distraught at the recent death of his mother. The comic element is also subservient to the larger story of the realization of the young nobleman's love for Pretioze. A similarly tender sensibility governed the many current amorous pictorial themes that were placed in a pastoral setting, among which the most influential example was Hooft's *Granida and Daifilo*.[29] There, as with the tradition for *Cimon and Iphigenia*, Van Noordt chose the scene in which the fire of love is sparked, and again it takes place in an outdoor, pastoral setting.

The conspicuous preference among painters for the moment of love has also been noted by Ivan Gaskell.[30] With both literary and pictorial interpretations of Cervantes' novella in the northern Netherlands, Gaskell perceived this choice as a

deliberate avoidance of those aspects of the original Spanish story that were morally dubious in the restrictive culture of bourgeois Holland. One of the most potentially morally offensive elements of the story of *La Gitanilla di Madril* was Pretioze's practice of chiromancy.[31] Tengnagel, for example, went so far as to address this and other problems in a moralizing summary of the story in a separate prologue to his play. Van Noordt apparently knew this parallel account because he incorporated parts of the descriptions that appear in the prologue but not in the play itself.[32] However, there were also positive moral goals motivating the poets and painters interpreting Cervantes that overshadowed their objections to the story. There was, after all, surprisingly high tolerance in the northern Netherlands for theatrical presentations of morally dubious scenarios, as the heritage of the *klucht*, or farce, would indicate.[33] Rather, it is significant that an entirely different literary category was chosen by Tengnagel and his precursors Cats and Dusart. They sought to create a simple and didactic moral drama, and for this reason felt compelled to tame Cervantes' picaresque plot.

Similarly, Van Noordt created a straightforward and practical ideal to recommend to his viewers. He isolated the narrative of an exemplary love affair in Tengnagel's adaptation of Cervantes' novella, when he focused on the decisive moment in the development of Don Jan's love for Pretioze. In doing so, he continued on in the painterly tradition established in depictions of *Granida and Daifilo* and *Cimon and Iphigenia*, of presenting a moment of true love. The decision was likely as much a social as an artistic one. As Donald Haks points out in his survey of marriage and family life in the seventeenth-century northern Netherlands, the choice of a suitably compatible marriage partner ranked high among Dutch social concerns in the early modern era.[34] These paintings presented Dutch viewers, especially young male ones, with exemplars of true love in a framework that addressed the requirements of steadfastness, personal inclination, and class compatibility.

The Context: Exemplars of Virtue in History Paintings

The presentation of morally exemplary behaviour is one of the possible functions of history painting. The depiction of *istoria*, or "history," was already conceived as a means to inspire virtuous action in its viewers when it was first theorized as a separate category of art. The stage was set by the fifteenth-century Florentine artist and humanist Leon Battista Alberti (1404–1472), who alluded to the power of the *istoria* to present moral dramas in his *Della Pittura* of 1435. Alberti's view of history painting was linked by Anthony Blunt to his quasi-republican political orientation, which itself called for serious involvement and contribution on the part of citizens, and which prized *virtù*, or virtuous action.[35] Blunt drew a contrast with the contemplative and metaphysical view that Neoplatonism took on art, a view that would gain prominence later in the fifteenth century, especially in the work and thought of Michelangelo (1475–1564).

In the Dutch Republic in the seventeenth century, there was little talk of Neoplatonism, but both the newly republican state and its newly dominant Calvinist religion brought a great deal of emphasis to bear on the role and responsibility of the individual in politics and in personal conduct. Furthermore, *virtú* formed an important part of Neostoicism, the Christian adaptation of Stoic thought, incorporating its practical aspects into a sincere Christian engagement.[36] The new synthesis found many adherents among the educated elite in the northern Netherlands. They accompanied their peers in Flanders, in part reflecting the influence in both countries of the humanist scholar Justus Lipsius (1547–1606).[37] Stoic principles, especially that of *apatheia* (indifference), offered a rationalist basis amidst the turmoil and tragedy of the religious wars that accompanied the Reformation in the Low Countries.[38] Among Flemish artists, Rubens and Van Dyck showed a keen interest in Neostoicism.[39]

With the exception of Gerrit van Honthorst, none of the artists in the northern Netherlands, as far as is known, followed this revival of the ancient philosophy closely.[40] Instead, it seems to have drawn the interest chiefly of Dutch poets and playwrights, many of whom had come under the influence of Justus Joseph Scaliger (1540–1609), a professor in Leiden. His students included Samuel Coster, who pursued moral edification in his plays, and with whom Jan van Noordt had an indirect personal link.[41] By the second half of the seventeenth century, when Van Noordt was active, Neostoicism had a more diffuse presence in his culture, stimulating interest in the painterly depiction of exemplary actions from history.

The traditional source for themes of this kind was the history of republican Rome, which provided the subject matter for a number of the paintings decorating the Amsterdam Town Hall, for example.[42] At the same time, however, a great many other, often new themes in Dutch history painting were drawn from the Old Testament; Van Noordt himself participated in this fashion. These themes also presented exemplars of virtue, an emphasis that was disengaged from the larger redemptive-historical interpretations that these stories have in the Biblical text. Exemplars of virtue dominate Van Noordt's selection of themes from the Old Testament, consistent with his less frequent depictions of Roman history.

Roman Republican Exemplars in Van Noordt's paintings: Scipio and Cloelia

Roman republican history was one of the prime sources of moral exemplars for the intellectual culture of Europe in the seventeenth century. Indeed, early Rome's history was characterized by the virtuous deeds of its heroes, thanks in great part to Livy, the Latin historian of early Rome. Livy saw one of the most important functions of his own writing of history as being the presentation of exemplars of good and bad conduct.[43] Such exempla also inspired Jan van Noordt, and events from this period of Roman history appear in three of his surviving paintings. Two of these, both *The Magnanimity of Scipio*, take up that famous story (cat. 26, 27), and the third painting depicts the flight of Cloelia across the Tiber and back to Rome

(cat. 25). Both themes feature remarkable action taken to further the cause of the Roman republic in a time of conflict.

Early Rome provided northern Netherlanders of the sixteenth and seventeenth centuries with obvious parallels to the history of their own land, in particular its struggle against the Spanish crown that led to independence. The depictions of the stories of Scipio and Cloelia were based on the accounts of the historians Livy and Plutarch. Plutarch was translated into Dutch in 1601.[44] More widely available in the Netherlands in the seventeenth century was Livy's history of early Rome, having been published in a number of Latin editions and several Dutch translations.[45] His account emphasized the deeds of military commander Scipio as virtuous and in the service of Rome.

For his story of the *Magnanimity of Scipio*, Livy drew on the earlier account by the Greek historian of Rome, Polybius. The key figure, Publius Cornelius Scipio (235/36–183 BC), was perhaps the most important military commander of early Rome, leading the successful campaigns against the Carthaginians in northern Italy and Spain and the eventual conquest of Carthage itself.[46] The event in Van Noordt's painting took place in 210 BC; Livy tells how, after taking one of the towns in Spain, Scipio's soldiers encounter an unusually beautiful young woman and bring her to him as conqueror's booty, for his pleasure. Scipio speaks to her and discovers that she is betrothed to the young nobleman Allucius. The commander summons Allucius and his parents and hands her over to them, untouched. The young woman's parents, upon hearing this news, offer Scipio a lavish gift of gold, explaining that they had originally assembled it as the ransom for their captive daughter. Scipio accepts the treasure only to present it to the young couple as his wedding gift to them. The local people, the Celtiberians, are so impressed by their conqueror's moderation and liberality that they side with Rome, providing Scipio with a critical strategic aid in his eventual victory against Carthage.

Interpretations of Scipio

Livy's account of the story was much more sympathetic than that of his precursor Polybius, which sketched Scipio as an opportunist who cultivated a supernatural persona. This negative characterization even prompted the Protestant Reformer John Calvin, centuries later, to cast aspersions on Scipio's ambition.[47] In contrast, Livy presented him as the supreme moral exemplar. In doing so Livy embellished some details, such as giving the young woman a nobleman fiancé named Allucius. Livy also put into Scipio's mouth a speech to Allucius, in which the commander defines his action as done in duty to Rome and emphasizes his sexual continence.[48] In his *Foundation of the Art of Painting*, Van Mander presented Scipio to students of painting as an exemplum of sexual self-restraint, along with Alexander the Great.[49] The painter-theorist Gerard de Lairesse, writing early in the next century but reflecting the painterly practice of the previous age, singled out this virtue as well, calling up the pictorial theme of Scipio's continence as an example of a

moreel tafereel or morality tableau.[50] Along the same line, the learned poet Ludolph Smids (1649–1720) summoned Scipio as an example of chastity.[51]

Curiously, in those rare depictions of *The Magnanimity of Scipio* painted as *portraits historiés*, the emphasis shifts from Scipio's chastity to that of the unnamed bride. Commissions for such works were typically linked to the occasion of betrothal or marriage, with the young couple depicted along with one set of parents, as in the painting by Gerbrand van den Eeckhout in Toledo, where the couple occupies the foreground centre.[52] In the *portrait historié* in Budapest by Artus Wolffort, formerly attributed to Van Noordt (cat. R28), the focus again is less on Scipio than on the bride, whose sexual innocence and purity is reflected in her conspicuously modest attitude.

This historical event is complex, however, and presents other virtues as well, chiefly generosity and justice. The question of justice in leadership weighed heavily in the eyes of those Dutch who remembered the atrocities meted out by Spanish armies during the first bloody decades of the Eighty Years War. Thus the story of the magnanimity of Scipio was also selected for paintings decorating town halls, the local seats of justice, in the northern Netherlands.[53] At the same time, the particular moment chosen by artists, when Scipio turns the parent's ransom over to the couple as a wedding gift, drew attention to Scipio's generosity and echoes the praise of Allucius (in Livy's account), who "filled his countrymen with the well-earned praises of Scipio, saying that there had come a most godlike youth, conquering everything by arms and especially by generosity and favours."[54] Indeed, Van Noordt's two depictions of this event are most precisely entitled "The Magnanimity of Scipio." This virtue in a ruler was particularly recommended by the sixteenth-century humanist Dirck Volckertsz. Coornhert, himself a champion of tolerance.[55]

Scipio's second gesture, of returning the gift, could also be seen as the application of justice, in refusing a tribute that was not rightfully his. The composition with the presentation of treasures is loosely parallel to depictions of *Manius Curius Dentatus Refusing the Gifts of the Samnites*, in which a Roman emissary maintains the interests of the state by refusing a gift, a theme that was most strategically selected for the Burgomaster's Chamber in the Amsterdam Town Hall.[56] Jan van Noordt realized multiple moral facets in his painterly presentation of Scipio as *exemplum virtutis*. His earlier depiction is less subtle, and more dependent on the model of Cornelis de Vos. The tender, focused expression on Scipio's face in the second, more accomplished version in Amsterdam implies empathy, continence, and magnanimity, all indispensable virtues.

Cloelia as Exemplar of Fortitude

Van Noordt's second Roman republican theme parallels the edifying function of *The Magnanimity of Scipio* (cat. 26, 27). *Cloelia Fleeing across the Tiber*, in the Louvre (cat. 25), presents another moral exemplar, albeit one more singular and less com-

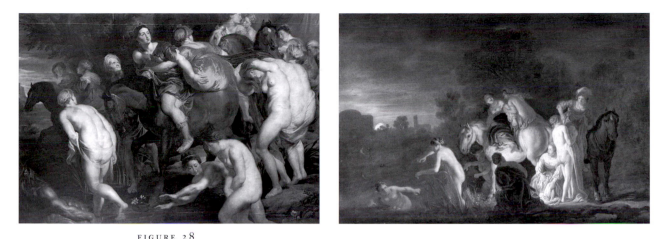

FIGURE 28
Left: Peter Paul Rubens, *Cloelia Crossing the Tiber*, canvas, 236 × 343 cm, formerly Potsdam, Schloss Sanssouci (war loss).

FIGURE 29
Right: Claes Cornelisz. Moyaert, *Cloelia Crossing the Tiber*, panel, 41 × 60.5 cm, signed and dated 1642, Oslo, National Gallery.

plex than Scipio. The artist took up the story of the Roman patrician daughter Cloelia as told by the Greek historian Plutarch in his *Life of Publicola*. Plutarch recounted the siege of Rome by the Etruscan king Lars Porsena, an event that took place in 508 BC. Porsena had allied himself with Tarquinius Superbus, the deposed king of Rome, who sought to regain his throne. After suffering several setbacks, Porsena negotiated a truce with the Roman consul Valerius Publicola, and both sides exchanged hostages as a guarantee. Cloelia was among the ten young women and ten young men from the Roman nobility handed over to Porsena. One day when the women were at the river bathing and found themselves unattended, Cloelia seized the opportunity and led the group across the Tiber back to Rome. Porsena demanded and secured their return, but had undergone a change of mind. He summoned Cloelia, praised her for her bravery, and relinquished his siege.

This episode also appears in Livy's history of early Rome. However, Van Noordt attended to Plutarch's account, rather than that of the better-known Livy, and in so doing followed the pictorial tradition for this story.[57] Plutarch noted the legend that Cloelia made the crossing on horseback, and the depictions by Rubens (fig. 28) and Moyaert (fig. 29) show the group preparing itself at the river's edge with a horse waiting.[58] Similarly, in Van Noordt's painting in Paris, Cloelia stands in front of a mount, amidst her fellow captives who undress for the swim.[59] Livy's account omitted the colourful equestrian element, which nonetheless proved irresistible to artists.

This distinction between the two texts seems to have been somewhat softened for the seventeenth-century Dutch reader. The translator of the widely dispersed 1541 Dutch edition of Livy felt compelled to cite the legend from Plutarch, albeit

with scepticism. Nonetheless, the 1614 reprint of the Livy translation included a printed illustration to this story, showing not only Cloelia on horseback, but her companions as well! The equestrian crossing actually amplified the audacity of Cloelia's action, as it was thought that women in antiquity never rode.[60]

Contemporary Interpretations of a Painting of Cloelia

The main emphasis in this story fell on the courage of Cloelia's deed, so that she exemplified the virtue of fortitude.[61] As such, Plutarch included her story in his *Moralia* among his examples of the bravery of women.[62] In the seventeenth century, the poets Vondel and Vos both wrote epitaphs on a painting by Nicolaes van Helt Stokade (1614–1669), which was in the collection of a Mr Hoogenhuis in the late seventeenth century but has since been lost.[63] Their comments suggest that Van Helt Stokade drew on Livy's version of the story and showed Cloelia swimming the Tiber. Both commentators focus on Cloelia's daring in challenging her captors and risking death.[64] In his earlier poem on a version by Rubens in the Stadholder's collection, Pieter Cornelisz. Hooft goes further, drawing a link between daring and virtue: "For virtue, no path goes untravelled: so the maidens / teach us, who risked their bodies in the current, for freedom."[65]

Van Noordt places special emphasis on the display of courage, and on Cloelia as moral exemplar, by projecting a severe sobriety in his figures. Cloelia, her eyes cast downward, seems to contemplate the risk she is about to take. The sombre mood contrasts with that of Rubens' painting, which was in the collection of Amalia van Solms in The Hague at the time.[66] Rubens followed the printed illustration in the 1614 edition of Livy in showing everyone mounting or already on horseback, and created a scene of great liveliness and drama. Van Noordt's approach owes much more to the dark cast and stable composition of the Moyaert painting in Oslo. At this early phase in his career, he seems to be careful to avoid masking the serious moral message with a flamboyant style. He started to alloy these two elements only much later, and the result is evident in the second depiction of Scipio of 1672 (cat. 27).

Biblical History as a Source of Moral Exemplars

Van Noordt's two moral exemplars taken from Roman history reflect the Renaissance humanist interest in classical antiquity and the resulting rise of Neostoicism. The integration of classical thought with Christianity occupied not only Justus Lipsius but also a number of liberal Christian humanists in the northern Netherlands in the sixteenth and seventeenth centuries. The views of the Dutch humanist Coornhert were strongly influenced by Neostoicism, as reflected in his moral treatise *Zedekunst dat is Wellevenkunst*.[67] Coornhert is best known for advocating tolerance of difference in doctrine, a principle that grew out of his vision of a

Christianity based on individual morality.[68] Comparable principles re-emerged in the northern Netherlands in the seventeenth century in the teachings of the Remonstrants and in the religious practice of the Collegiants.[69] Given this context, it is not surprising to see biblical themes pressed into service by Dutch artists to present exemplars of virtue along humanist-Neostoic lines. Such an interpretation applies to a number of biblical themes in Van Noordt's oeuvre that are consistent with his depictions of Roman history.

The Most Popular Biblical Exemplar: Susanna

The single most important theme for Van Noordt was *Susanna and the Elders*. He took it up at least three times, in paintings in Utrecht (cat. 6), Leipzig (cat. 7), and Paris (cat. 8) that belong to separate points in his career. Two preparatory drawings by him also survive, one for each of the latter two paintings (cat. D2, D3). These images relate to the scene of Susanna's confrontation with the Elders, as told in the apocryphal section of the book of Daniel (13:15–25). Susanna was the beautiful wife of the wealthy Joachim, who owned a house with a courtyard, where the two elders of the town were used to holding court during the day, settling disputes. One evening they conspire and stay behind in the court, hiding. When Susanna goes to take her evening bath there, they approach her and demand sex, threatening to accuse her of adultery if she refuses, which she does. They follow through with their threat, and the assembly condemns her to death. However, the young Daniel, divinely inspired, challenges them, insisting that they testify separately. Their stories conflict, and the assembly in turn condemns them to death for their false accusation. Susanna's innocence and her virtue are proven. The story highlights the special prophetic insight of the youthful Daniel as much as the faithfulness and chastity of Susanna.

Susanna was the most popular biblical theme among Dutch painters of the seventeenth century.[70] For an explanation Eric Jan Sluijter pointed to the story's potential for the erotic display of female flesh, parallel to the conspicuous choice of themes such as *The Judgment of Paris* and *Diana and Callisto* out of classical mythology.[71] Indeed, the artistic tradition for Susanna consistently favoured the scene of her in the bath, partly or fully disrobed. The later, much more modest scene of Susanna's exoneration by Daniel at the trial was painted only seldomly.[72] Van Noordt conformed to the more popular tradition; in all three pictures Susanna is confronted by the elders while she bathes.

The theme of Susanna did not only present eroticism, but allied it with a clear, and high, moral exemplum. The special success of the story arose perhaps out of the highly charged combination of *lering en vermaak*, or edification and delight, the same pair of qualities that, on a lighter level, characterized so many genre themes in Dutch painting of the seventeenth century.[73] In the case of Susanna, there were several moral messages. The most important was the value of chastity, exemplified by Susanna's preservation of her sexual purity, even in the face of the threat of

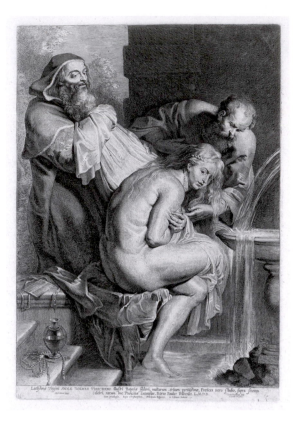

FIGURE 30
Lucas Vorsterman, after Peter Paul
Rubens, *Susanna and the Elders*,
engraving, 38.7 × 28 cm; inscribed:
*P.P. Rubens pinxit. Lucas Vorsterman
sculp. et excud. An°. 1620*, Amsterdam,
Rijksmuseum (photo: Rijksmuseum-
Stichting Amsterdam).

death.[74] Rubens singled out this virtue in the inscription he composed for a print
after his design of *Susanna and the Elders* (fig. 30). He dedicated his representation
of Susanna to the celebrated Dutch poet and scholar Anna Roemers Visscher
(1583–1651), who had preserved her virginity by not marrying:

> To the very chosen virgin ANNA ROEMERS VISSCHER,
> for the brilliant eyes of this illustrious Batavian,
> fluent in many of the arts, in Poetry truly erudite,
> celebrated for much more than her feminine beauty,
> here this rare example of chastity.[75]

When Visscher in turn addressed a poem to Rubens on an unspecified painting the
following year, she did not mention the association with the voluptuous image of
Susanna, and she did not seem to object.[76]

Nonetheless, to many observers at the time, the sensuality of the many depic-
tions of Susanna and the Elders was problematic. In a poem on a painting of Su-
sanna, Vondel praised the protagonist's beauty and chastity, but closed by reflecting
upon the sexually arousing potential of the work; he even referred to the Apostle
Paul's complaints about his "physical weakness" and the "thorn in his flesh."[77] The
pictorial tradition of Susanna gave the erstwhile Reformed minister Jan Evertsz.

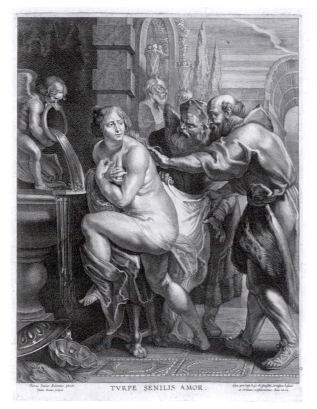

FIGURE 31
Paulus Pontius, after Peter Paul
Rubens, *Susanna and the Elders*,
engraving, 36.9 × 28.6 cm, inscribed
bottom centre: *Turpe senilis amor*,
photo: Amsterdam, Rijksmuseum
(photo: Rijksmuseum-Stichting
Amsterdam).

Geesteranus (1586–1622) grounds for his well-known attack on all paintings in the Latin poem *Idolelenchus*. It was widely disseminated through its inclusion, translated into Dutch, in the editions of Dirck Raphaelsz. Camphuysen's *Stichtelyke Rymen* (Edifying Verses). This was the most popular Protestant songbook of the Dutch Golden Age, undergoing numerous editions, and Camphuysen first included the poem in his 1639 edition. In his poem, Geesteranus protested the moral contradiction of artists' depictions of Susanna: "They place a naked woman bathing between admirers / As a cancer for good morals and evil for the seeing eye / And it would have to be Susanna, a chaste woman."[78]

In spite of its sardonic edge, Geesteranus's statement reflects the fact that Susanna's role as moral exemplar was an integral part of the many depictions of her confrontation with the elders.

A second moral message of this theme was the criticism of lust in old men. The print of Susanna after Rubens' design served as a commentary on this phenomenon when it was shown hanging on the wall in a genre painting, *An Old Man in a Brothel*, in St Petersburg, which is attributed to Jan Steen.[79] This other interpretation was also taken up by Rubens himself, in another print of Susanna after his design, this time by Paulus Pontius (fig. 31), to which Rubens added the inscription "*Turpe senilis amor*" (How disgraceful is the old man in love).[80] Some of the paintings of the subject produced in the northern Netherlands also drew

attention to the morally reprehensible behaviour of the elders. They are given a prominent place and characterized as quite old and driven by desperate lust in the famous 1647 depiction by Rembrandt (Br. 516), for instance (fig. 32).[81] Only two years later Rembrandt's follower Salomon Koninck (1609–1656) also incorporated the double moral message by emphasizing the depravity of the elders, using expression and gesture underscored by the strong light isolating them against the dark background.[82]

Refining the Message of Susanna as Exemplar of Chastity

Within this context, Van Noordt's paintings emphasized on the positive moral example of Susanna. Among his three depictions of the theme, the one in Utrecht (cat. 6) gives perhaps the most attention to the elders, but even there they are decidedly secondary in prominence, confined to the upper right corner. In the second known depiction, in Leipzig (cat. 7), Susanna takes greater prominence, with her large figure scale and her energetic pose, which also yield a fleshly display, albeit not idealized. The emphasis on Susanna applies again to the last of the three paintings by Van Noordt, last in Paris (cat. 8). There, however, her figure is sharply isolated against the background by the strong light effect, which is consistent with Van Noordt's style after 1660. The dark visages of the two elders, to the upper right, are an obscure presence. Also, Van Noordt adopts a less ambiguous pose for Susanna, compared with the Leipzig picture, where she seems to be reacting with surprise to the elders' sudden presence, or perhaps turning awkwardly away from them after they have made their proposal a moment later. In the painting in Paris, Susanna curls up and turns her back to the two elders in a clearer, more expressive pose of rejection. These changes underscore her safeguarding of her chastity, and her rejection of the elders' immoral advances. The three known versions thus show Van Noordt steadily refining the representation of Susanna as an exemplar of virtue.

A Field Labourer as Exemplar of Generosity

Van Noordt's single depiction of *The Levite and His Concubine in Gibeah* (cat. 3) forms a parallel to the theme of *Susanna and the Elders*. This now-lost picture also isolates an example of morally commendable behaviour in a larger and more complex story that has broader historical and theological aspects. Its unusual subject was almost exclusively painted by Dutch artists of the seventeenth century, most of them members of the circle around Rembrandt. To the modern viewer it is at first puzzling why they selected this grisly story to paint. The book of Judges (19:16–21) tells of a Levite, a man from the priestly tribe of Israel, who is travelling with his concubine. They stop in a Gibean town, thinking it is safe. Unable to find lodgings for the night, they go to the town square. There, a field labourer sees them and, out of concern for their well-being, invites them to his house. It is to no avail, for

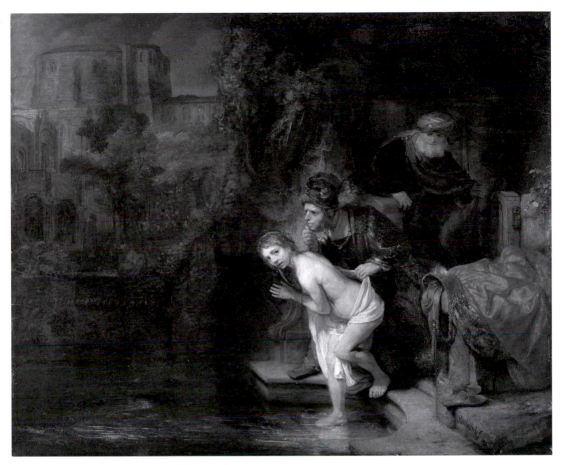

the house is besieged by men of the town, who demand the Levite for sex. When the concubine is offered instead, the men abuse her so badly she dies. In outrage, the Levite dismembers her body and sends out the parts to the different tribes of Israel in an appeal for justice. The townsfolk are then slaughtered for their senseless crime.

Out of this tale of rape and violence, artists almost always chose to depict the labourer offering the couple hospitality, as did Jan van Noordt. Hospitality was one of the Seven Acts of Mercy.[83] Furthermore, the field labourer's actions also exemplify the virtue of generosity, much as the more popular scene of the Magnanimity of Scipio. Van Noordt's painting was even interpreted simply as *Generosity*, in the late nineteenth century, before it was reconnected to the story of the Levite.[84] The other moral messages of the story, such as its warnings against homosexuality, violence, and lasciviousness, are passed over in favour of the more positive recommendation of this virtue.

Van Noordt's Joseph in Egypt

A better-known and more popularly accessible biblical exemplar of virtue is embodied in the figure of Joseph. In his painting *Joseph Selling Grain in Egypt*, in Milwaukee, Jan van Noordt took up the story in Genesis of the son of the patriarch Jacob (cat. 2). Sold into slavery as a boy, Joseph rose to a position of great influence in Egypt when he interpreted a dream of the Pharaoh and prophesied seven years of famine that would follow seven years of plenty, which came to pass. Joseph was placed in charge of storing up grain during the abundant years and selling it during the famine. Alfred Bader was the first to recognize that Van Noordt's painting shows the situation during the final year of famine, when the population was driven to the point of selling themselves and their children to the Pharaoh for food.[85] Van Noordt focuses on the emotion of this final drama. In the middle ground, to the right, sits Joseph, accompanied by administrators, including a busy accountant peering over his book to the right. Joseph looks over to the woman in the centre, who offers her two infant children to him. To the left stand a number of men and boys who, from their tattered clothes and anguished expressions, appear impoverished and desperate. In the background left, a man emerges from the building carrying on his back a sack of grain.

Van Noordt here selected a theme that was even rarer than the story of the Levite and his concubine in Dutch Baroque painting. Sumowski counts only seven examples by artists linked to Rembrandt.[86] Early Amsterdam painters such as Lastman and Moyaert introduced the theme into painting in the 1620s, and Moyaert returned to it as late as around 1650 (fig. 18).[87] The most famous depiction was the painting produced by Nicolaes van Helt Stokade, which he completed in 1656 as part of the decoration for the Chamber of the Treasurer of the City Hall in Amsterdam.[88] The poem on this painting written by Vondel reveals how Joseph served as moral exemplar for the occupants of the office of Treasurer:

> All Egypt brings the governor treasures and possessions.
> And has lived seven years off the distributed grain.
> The free population driven by need becomes the King's slave.
> One man's foresight can sustain thousands.[89]

Vondel's sentiment was characteristically aped by Jan Vos, who also penned a poem on the same painting.[90] Both poems emphasized that the city's treasurers were to avoid depleting its resources, in case those resources should be truly needed later. They could look to Joseph as an example of *Prudentia*, or foresight. Joseph had been interpreted as an exemplar of this classical virtue already in the fourth century, by Ambrosius of Milan.[91] In the seventeenth century, the translators of the States Bible made specific mention of Joseph's foresight in their margin notes.[92] John Calvin made a more general reference to Joseph's virtue in his commentary on the story in Genesis.[93] He went on to point out the role of Joseph's actions in

securing the future of the nation of Israel, an historical implication that does not appear to play a role in Van Noordt's depiction of the story. The artist and his forebears selected specifically the moment in which Joseph saves the Egyptians from starvation as tangible proof of the value of his foresight.

It is well known that the history of the Old Testament nation of Israel had a special significance for the young nation of the United Provinces.[94] Yet contemporary Dutch commentators on depictions of Old Testament themes did not tend to interpret them as reflections of their national identity. Likewise, individual morality emerges as a leading value in a number of the historical themes selected by Van Noordt. As an artist, Van Noordt chose not to grapple, as Rembrandt often did, with the variety of themes and concomitant challenges of narration, expression, and effect handed down by the artistic tradition, especially in the work of its great geniuses. Van Noordt refined his chosen themes along a more social utilitarian model. As demonstrated above, the selections by Jan van Noordt of particular moments in the stories of Susanna, the Levite and his concubine, and Joseph show a consistent interest in the example of virtue presented by the chief protagonist in these scenes.[95] The promotion of virtue out of concern for individual conduct that was central to Neostoicism was disseminated in the Netherlands by figures such as Lipsius, Coornhert, and Scaliger. On a different level, the same concern for individual conduct was popularized by moralists such as Jacob Cats. Interest in Amsterdam theatre, and possibly a friendship with the playwright Samuel Coster, prompted the Amsterdam history painter Jan van Noordt to favour the exemplary function of history paintings. With his scenes from Roman republican history it was a predictable emphasis, with Old Testament subjects less so. The pattern is mirrored in the artist's selection from literature. He chose scenes of the first meeting of lovers in stories such as Cimon and Iphigenia, which presented moral exemplars of true love. This motivation is most clearly profiled in the one theme that Jan Van Noordt appears to have introduced into Dutch history painting, the meeting of Don Jan and Pretioze, from a play adaptation of Cervantes' *La Gitanilla*.

A number of history paintings by Van Noordt do not relate to the exemplary function outlined in this chapter. *Crucifixion*, in Avignon (cat. 15), and *The Massacre of the Innocents*, in Kingston (cat. 14), adhere to traditional religious iconography. Besides these works, several others remain on the margin of the exemplary function. The *Triumph of David* of around 1660 celebrates a moral exemplar, but not the exemplary action (cat. 4). Last, the painting of *Hagar and Ishmael in the Desert* in Kingston presents a dramatic change (cat. 1). However, because Hagar has given up hope and abandoned her child, her situation does not present a particularly strong moral example.

The interpretation of many of Van Noordt's themes in terms of moral example does not exclude the possibility of a Dutch Baroque taste for scenes of sudden change of emotions in the same paintings. All three of Van Noordt's literary exemplars of love, for example, show a sudden turnaround. The depictions of Susanna, Scipio, and Cloelia likewise have a dramatic context. However, we never encounter

the tragic persona who must endure a change for the worse, the *eventus*, and arrive at the recognition: *anagnorisis*.[96] The changes are mainly for the better, affirming the positive example of the protagonist. Indeed, Van Noordt's choices, even for moral exemplars, do not conform to any established, overarching theory. Greek tragedy, and indeed art theory in general, did not dictate Dutch taste in history painting in the seventeenth century. With his sustained interest in moral exemplars, Van Noordt cultivated his society's embrace of practical and accessible models for conduct and gave these figures humanity and grandeur in his paintings.

Jan van Noordt's Drawings
Pictorial Technique and Function

For most seventeenth-century Dutch painters, the making of drawings was a vital part of their practice. It typically served as the preliminary stage of producing finished works in print or paint. This was true for Jan van Noordt, as scholarship has increasingly showed in recent decades. Initially, scholarly understanding of his drawings was frustrated by the lack of signed examples that could serve as a touchstone for identifying his drawing style. For many years, art historians hesitated to attribute drawings to him, sometimes even when there was a direct connection to a painting known to be by him. Thus the drawing *Seated Female Nude*, in Hannover (cat. D2), was recognized as a study for Van Noordt's *Susanna and the Elders* in Leipzig (cat. 7) in the 1960 catalogue of the Hannover collection. Nonetheless, the author maintained the existing attribution of the sheet to Jacob Backer.[1] In 1965, Wolfgang von Moltke suggested it was by Van Noordt, but only in 1979 did Peter Schatborn conclude decisively in favour of the younger artist.[2] With this and several related drawings, Schatborn formed the stylistic basis for attributing other drawings to Van Noordt, including some that had been given to Backer (cat. D2, D11, D16). He assembled an oeuvre of thirteen drawings, consisting entirely of figure and portrait studies. With my additions and subtractions here, the total rises to seventeen.

Unlike his known oeuvre of paintings, this group of Van Noordt's drawings is too small to be representative, however. He presumably produced many more. The 1675 inventory of his studio lists twenty-three "bundles" of drawings.[3] Even if many of those abandoned drawings were by pupils or other artists, at least some of the bundles would have consisted of his own work, totalling hundreds of sheets. The relatively few that have survived allow only very limited conclusions about Van Noordt's practice as a draughtsman. They do yield a significant pattern. Many connect directly to known paintings by the artist, indicating that drawing was an important preparation for painting.

A drawing formerly attributed to Gabriel Metsu has proven to be a key work for the identification of Van Noordt's drawing style.[4] *A Standing Man Wearing a Hat*, in the British Museum (cat. D9), shows an elegant overall effect, resulting from long, sinuous lines and clear contours, with efficient, emphatic modelling using both light and dark chalks. The boldness of the execution is quite foreign to Metsu and points to Backer. At the same time, the agitated effect of loose zigzag hatching and selective use of fine lines are unlike the broad style of Backer. This sheet was first recognized by J.H.J. Mellaart in 1926 as corresponding directly to the figure of Don Jan in Van Noordt's *Pretioze and Don Jan* that was then in the London art trade (cat. 31).[5] With this technique using two chalks, Van Noordt joins other artists working in Backer's orbit. Govert Flinck, who knew Backer from their days of instruction in the studio of Lambert Jacobsz. in Leeuwarden, converted to this style of drawing in the second half of the 1640s, when he also began to follow Backer's style in painting. The use of two chalks and grey paper began to dominate Flinck's drawn output in the late 1640s, as seen in his *Portrait of a Man Standing Next to a Table* of around 1646 (fig. 33).[6] This evolution occurred around the same time that Van Noordt was embarking on his own independent career.

This connection with Flinck through his drawings must be qualified. We lack sufficient evidence to concretely identify Van Noordt's early drawing style of the 1640s. The London drawing dates to around 1660 on the basis of its connection to the two paintings *Pretioze and Don Jan*, and marks only the middle point of Van Noordt's career as an artist. None of the artist's other drawings can be placed much earlier. Two model studies relate to figures in his painting *Venus and the Three Graces*, in The Hague (cat. 20), and on this basis can be dated to as early as 1655 (cat. D6, D7). Although the artist certainly made many earlier drawings, and very likely in a similar style, none from the period between 1645 and 1655, immediately after Van Noordt started on his own, are known to have survived.

The way in which Van Noordt's drawing style developed after 1655 is evident in the drawing *Seated Female Nude* (cat. D3). It served as a study for the figure of Susanna in the painting of *Susanna and the Elders* now in Paris, which allows for the dating of both of around 1670 (cat. 8). The Amsterdam drawing can be compared to the above-mentioned drawing in Hannover (cat. D2), which likewise served as a study for the figure of Susanna in the painting in Leipzig (cat. 7), placing both works around 1659. The two drawings, of the same subject, done at different times, demonstrate the changes in the artist's approach during the intervening period. The Hannover study is more finished and static than its Amsterdam counterpart, with a variation of contours giving a very subtle impression of form. In the later drawing Van Noordt employed stronger contrasts of line as well as dark shadows to give a more bulging and vigorous sense of the volume and weight of flesh. Also, the lines are more loosely drawn and the hatching more open, without any smudging to produce a smoother effect. These qualities give the impression that the mature Van Noordt worked quickly, also in applying the highlights, which are

laid down in thick, direct strokes of white chalk that produce a specular effect. In the figure's head, many details have been treated in a cursory way, in contrast with the earlier drawing in Hannover, where Susanna's frightened expression can be read clearly in the drawing, almost more so than in the painting.

The same, broader treatment of the late Amsterdam drawing appears again in Van Noordt's *Study for the Labourer in Gibeah*, in Amsterdam (cat. D1). The directly applied highlights have become very linear and sinuous, and parallel the overall effect of movement in the painting for which this drawing was made, the lost *Levite and His Concubine* formerly in the Ofenheim collection in Vienna (cat. 3),

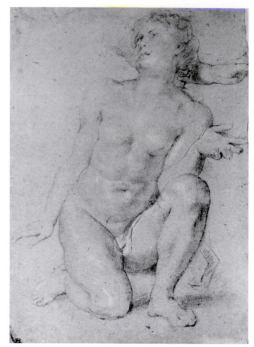

FIGURE 34
Jacob Adriaensz. Backer, *A Seated Female Nude*, black and
white chalk on blue paper, 28.8 × 22.8 cm, Fogg Art Museum,
Harvard University Art Museums, loan of George and
Maida Abrams (photo: Alan Macintyre; courtesy of the Fogg
Art Museum).

FIGURE 35
Peter Paul Rubens, *Male Nude Kneeling*, black and
brown chalk heightened with white on brown paper,
49.4 × 35.1 cm, Berlin, Kupferstichkabinett
Staatliche Museen Berlin

which can be dated to 1673. The distinct use of highlights and contour also ap-
pears in two male figure studies, in Amsterdam and Rotterdam (cat. D10, D11).
They can also be placed in this last identifiable phase of the artist's development
as a draughtsman.

Van Noordt produced almost all of his drawings using the technique of two
tones of chalk on greyish paper. As mentioned above, he learned this technical fea-
ture of his drawings from Backer, his teacher. Whereas a number of Dutch artists
applied this technique occasionally, Backer used it almost exclusively (fig. 34).[7] He
apparently learned it from Lambert Jacobsz. William Robinson suggests, quite
plausibly, that Rubens' use of this technique for many of his studies (fig. 35) pro-
vided Lambert Jacobsz. with a model for his own drawings.[8] Unfortunately there
are no surviving drawings to demonstrate Lambert Jacobsz.'s style. Sumowski has
suggested that Flinck also acquired the technique of light and dark chalks while
studying under Lambert Jacobsz. However, since it appears in Flinck's drawings
only after 1640, it seems plausible that the younger artist was simply influenced by
his older fellow-pupil Backer. Until then his repertoire had consisted largely of
techniques learned from Rembrandt, who favoured the traditional combinations of
black chalk or ink on white ground, using ink washes to suggest tonalities. For
Flinck, and Van Noordt, the use of light and dark chalks on grey paper provided a
painterly range of tones. This technique more closely approximated the modelling
of figures in the final painting.

Jan van Noordt's Drawings in Relation to His Paintings

Drawing was apparently not an independent means of expression for Van Noordt. His painting activity set the criteria for his drawings, and the development of his drawing style followed that of his paintings. An overview of the evidence of the few surviving drawings indicates how closely they were tied to the production of paintings. Sixty per cent of them, nine sheets, can be identified as preparatory drawings for specific paintings. In a number of these cases, Van Noordt took the painted figure directly from the drawing, such as with the British Museum drawing *A Standing Man Wearing a Hat* (cat. D9). In other cases he modified the pose in the final painting, as with the two female nude studies used for the depictions of Susanna (cat. D2, D3). This pattern of connection permits one to conclude that one of the remaining drawings, *Seated Young Man* (cat. D5), also functioned as a figure study for a now-lost painting, probably *The Prodigal Son*.

At the same time, Van Noordt seems to have made many of his paintings without the help of preparatory drawn studies. The Kingston painting *The Massacre of the Innocents* is particularly unresolved in the organization of the figures in the background, which is confusing in places and sometimes illogical (cat. 14). An infrared reflectogram study of this painting has revealed that the artist planned his picture quite spontaneously, with the underdrawing consisting of short hatches rather than long flowing contours, and many changes and additions, with further changes to the composition made at the painting stage (fig. 36). Most of Van Noordt's other paintings were likely designed on the canvas. As we have seen, his drawings focus on figures and do not feature larger compositional aspects.

A demonstration of this particular use for drawing is Van Noordt's *Pretioze and Don Jan*, represented in two nearly identical versions (cat. 31, 32). The study drawing for the figure of Don Jan to the right attests to the artist's care of preparation (cat. D9). The background is, however, filled with a more loosely arranged and drawn crowd of Gypsies, attendants, and hunting hounds. They were apparently drawn directly on the canvas, without the aid of preparatory studies.

FIGURE 36
Infrared reflectogram of cat. no. 14: *The Massacre of the Innocents*, Kingston, Agnes Etherington Art Centre.

The function of three other drawings with respect to Van Noordt's paintings is less obvious. Sheets in Amsterdam (cat. D15) and Mänttä (cat. D16), and one last in Paris (cat. D17) seem to portray family groups. These drawings were quite likely made in preparation for family portraits that have since disappeared. Several other family portraits by him survive, in Bordeaux (cat. 60), Dunkerque (cat. 62), and one that was last at a sale in Paris (cat. 61). Within this group, the closest connection is between the dynamic family group in Dunkerque and the lively drawing in Amsterdam.

Van Noordt's Drawings in the Academic Context

Van Noordt's drawings show a devotion to studying the figure, which was one of the chief aims of the academies of art championed by the Italian theorist and biographer Giorgio Vasari. The northern Netherlands saw no sustained effort to establish a consistent and sustained academy for artists, only isolated efforts in this direction such as those of Karel van Mander and Abraham Bloemaert.[9] Jacob Backer produced a number of drawings that functioned purely as figure studies, and he was joined in this semi-academic approach to drawing from the live model by several other artists in Amsterdam, among them Govert Flinck. There are nude studies by both artists that show the same model and pose from slightly different angles, which attests to their simultaneous production.[10] These sheets date to the second half of the 1640s, a time during which Flinck is documented to have been drawing from the model.[11] Another document attests to Flinck's continuation of this academic practice, after Backer's death in 1651.[12] Among the examples of such studies by Backer, only one can be connected to a painting. They were mainly drawings of women, in languid poses that generate light erotic overtones, not wholly consistently with academic aims.

This example evidently influenced Van Noordt. His surviving drawings are primarily figure studies, rather than compositional studies. Indeed, during the latter half of the 1660s, his own studio may have been the site for a kind of Academy for drawing from the nude. This can be deduced from the evidence of Houbraken's biographies of Johannes Voorhout, Van Noordt's pupil, and of the Enkhuizen-born painter Dirck Ferreris (1639–1693). Ferreris apparently joined Voorhout in attending this "drawing school" shortly after he returned from Rome, around 1667,[13] during the period of Voorhout's tutelage under Van Noordt, which took place approximately from 1664 to 1669.[14] The "drawing school" was quite likely Van Noordt's studio. According to Houbraken, Van Noordt taught Voorhout to work from nature, or life, as his model. Houbraken's scattered references thus point to an academic approach to artistic training in Van Noordt's workshop, one that he would have taken from Backer.

Only two of the surviving drawings seem to have functioned purely for study in the academic sense (cat. D10, D11). They are both drawings of male nudes, without emotional expression, and convincingly observed. They seem to have been

taken from the same model, and so possibly reflect one session only. They do not correspond to any of Van Noordt's paintings, and do not evoke a figure in any historical theme. Van Noordt seems to have adapted the academic practice in a very practical way, with a painting in mind. Most of his figure studies suggest some abstraction and idealization. Van Noordt was evidently conscious of this demand placed on the history painter by the academic tradition.

Conclusion: Painterly Versus Academic Criteria

Viewed as a whole, his oeuvre of drawings indicates that Van Noordt himself relented in the academic practice of drawing from the model, which was aimed at refining the artist's understanding of anatomy and cultivating a repertoire of poses. He apparently did not make many drawings that functioned purely as independent studies, but instead produced most of his drawings with a painting in mind. Some of the drawings, like the *Susanna* study in Hannover (cat. D2), seem to have been done without the aid of a live model, judging by the errors in anatomy. The focus on the figure in Van Noordt's drawings owed to the influence of Backer and to the prominent place that he began to give the figure in his later paintings. Yet even in these paintings, Van Noordt's interest was not absorbed by the virtuoso presentation of the figure alone. A creature of his age, his study of the figure was balanced with the painterly goal of overall emotional expression and the iconographic project of morally exemplary themes.

Conclusion

Unconstrained by a normalizing academic system or by Church patronage, the Dutch Golden Age produced many highly creative and individual painters. This achievement was in turn fostered by the many Netherlanders who directed their interest and financial support to artists and their work, and in the 1660s Jan van Noordt was one of the painters who benefited from this climate. In this, his third decade of activity, he generated a distinct and original style. He synthesized the fashionable Flemish model with his own aesthetic, which had been based largely on the work of Jacob Backer, his teacher, and Rembrandt of the 1630s and 1640s. Van Noordt's portraits and history paintings of the 1660s combine robust forms modelled with strong light effects, powerful sweeping lines and rhythms, and a deft range of *facture* from smooth to painterly. In the next decade another dazzling turn occurred, when he unleashed a positively rough technique for impressive and expressive emotional effect. Occasionally his works suffer from a visual surfeit; however, his most serious weakness is a casual approach to human anatomy, a critical aspect of these two specializations. He joins a select group of Dutch artists, including Leonard Bramer, Rombout van Troyen, and Aert de Gelder, who are known and celebrated primarily for their daring and distinctive painterly styles.

Jan van Noordt was not bashful about his place as an artist. By choosing models as celebrated as Rembrandt and Jordaens, he was clearly striving for greatness. His startlingly grand artistic aspirations declare themselves in paintings like his large and complex multi-figured depiction of *Juno in the Clouds*, in Braunschweig (cat. 18). The seeds of this vision were likely planted during his time in Backer's large and successful studio. Van Noordt clearly pursued a path to a similarly elite patronage, not only with his style, but also with a focus on historical compositions and lavishly stylish portraiture, which the *Juno* combines in a *portrait historié*.

Van Noordt also had models for achievement with in his family. He was born into a musical family of considerable status. In a climate of limited support for their art, Jan van Noordt's two elder brothers, Jacobus and Anthoni, took over the tradition of organ playing and composition established by Jan Pietersz. Sweelinck, the greatest Dutch composer of the age and an influence on Bach. They gained prominent social connections through their posts as organists in the major churches in the city. Sweelinck's family was in turn linked to the painter Pieter Lastman, Rembrandt's influential teacher and Amsterdam's foremost history painter. This illustrious family history would have been very much alive during Van Noordt's formative years in the city of Amsterdam.

Recently it has become clear that he did indeed achieve, albeit on a small scale and for a brief time, elite patronage. He attempted to gain it at the very beginning of his career by painting a number of large history paintings, but in the absence of patronage for them he was forced to resort to genre themes. He was able to devote himself more fully to history painting once again around 1659, when he began to gain private patronage, as indicated by the emergence of his earliest portraits around this time. His halcyon period is marked by portraits for Jan Jacobsz. Hinlopen, indicated by documents, but unfortunately lost (cat. L43). Less securely, the *Juno* also points to the highest social levels, perhaps even nobility or aristocracy in this case.

The artist only gradually developed the style that would gain him this success. Many misattributions have, until now, clouded scholarly conception of his work. Now that strong evidence supports Backer as Van Noordt's teacher and the dominant influence on his early work, it has become possible to remove many works from consideration. The sixty-two remaining paintings show a gradual development of dramatic light effects, compositional concentration, and overall organization into lines of sweeping movement. Van Noordt started, after his training with Backer, by experimenting with small-figured historical compositions, which reveal the influence of Rembrandt. He then developed a flowing style with movement, looking to Flemish art. His late work shows the direct impact of Jacob Jordaens in the bold presentation of robust, fleshy figures. At the same time, Van Noordt embarked on an astonishing synthesis of the work of Rembrandt, but instead of the master's earlier period (which he had already absorbed) he drew from the rough handling of the late paintings, which contributed powerful emotional expression to themes such as *Joseph Selling Grain in Egypt*, *The Levite and His Concubine in Gibeah*, and *Hagar and Ishmael in the Wilderness* (cat. 2, 3, 1). Here Van Noordt stands alone, with an original and daring contribution to the panorama of Dutch painting in the seventeenth century. It is at the same time a sympathetic and moving reading of the expressive function of Rembrandt's late manner of painting, in which rough brushwork accentuates a high emotional tone. In Van Noordt's hand this effect typically underscores a figure's state of desperation.

Jan van Noordt's work and life resurfaced in the scholarly literature in the framework of Werner Sumowski's series on the Rembrandt School. Van Noordt was admittedly not included as a pupil of Rembrandt, and he was discussed only as

a protégé of Backer, who was also not a pupil. Sumowski's case for Backer as a follower was clear, however, as Backer had worked in a strongly Rembrandtesque style in the 1630s. Backer was also closely tied with Govert Flinck, one of Rembrandt's most prominent pupils. This study establishes Van Noordt's place as one of the very few creative talents who synthesized elements of Rembrandt's late paintings, those works that perplexed Houbraken. Perhaps it was this aspect, rather than his smoother style of the 1660s, that propelled Jan van Noordt to the fame attributed to him by Houbraken.

Catalogue

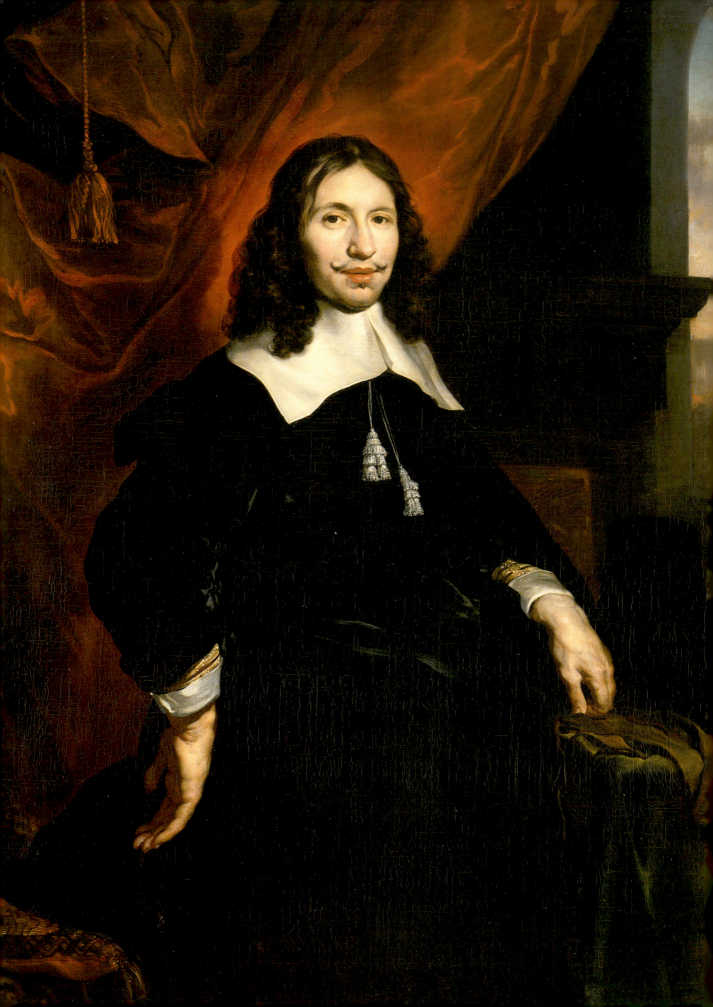

Paintings

ABBREVIATIONS

Br. / number assigned to a painting in Bredius and Gerson 1969

D.B.K. / *Desolate Boedels Kamer* (Chamber of Bankrupt Estates)

D.T.B. / *Doop Ondertrouw Begravenis* (Baptism, Marriage, Burial)

G.A.A. / *Gemeentelijk Archiefdienst Amsterdam* (Amsterdam Municipal Archive)

L.C.I. / *Lexikon der Christlichen Ikonographie*. 1970. 4 vols. Ed. E. Kirschbaum. Rome, Freiburg, Basel, and Vienna: Herder.

N.A.A. / G.A.A. 5072, *Notariëel Archief Amsterdam* (Amsterdam Notarial Archive)

(p) / work known only through photographic reproductions

RKD / *Rijksbureau voor Kunsthistorische Documentatie* (Netherlands Institute for Art History), The Hague

Thieme-Becker / Thieme, Ulrich, Felix Becker, et al. 1907–50. *Allegemeines Künstler-Lexikon*. 37 vols. Leipzig: W. Engelman.

W.K. / *Weeskamer* (Chamber for Orphans)

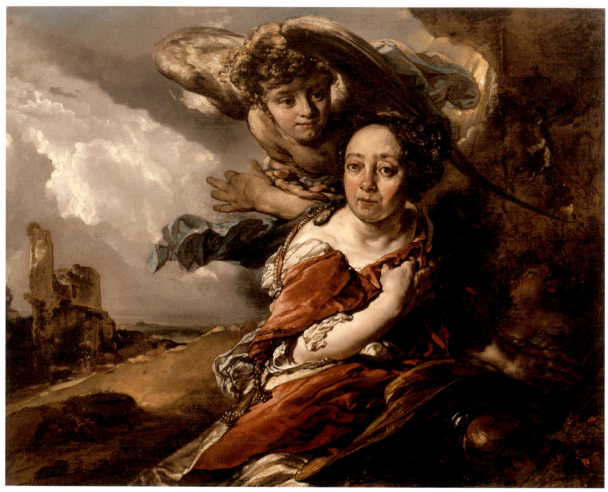

CATALOGUE 1

Hagar and Ishmael in the Desert, canvas, 90.8 × 113 cm, Kingston, Canada, Agnes Etherington Art Centre, gift of Drs Alfred and Isabel Bader, 1997.

Paintings

ABBREVIATIONS

Br. / number assigned to a painting in Bredius and Gerson 1969

D.B.K. / *Desolate Boedels Kamer* (Chamber of Bankrupt Estates)

D.T.B. / *Doop Ondertrouw Begravenis* (Baptism, Marriage, Burial)

G.A.A. / *Gemeentelijk Archiefdienst Amsterdam* (Amsterdam Municipal Archive)

L.C.I. / *Lexikon der Christlichen Ikonographie*. 1970. 4 vols. Ed. E. Kirschbaum.
Rome, Freiburg, Basel, and Vienna: Herder.

N.A.A. / G.A.A. 5072, *Notariëel Archief Amsterdam* (Amsterdam Notarial Archive)

(p) / work known only through photographic reproductions

RKD / *Rijksbureau voor Kunsthistorische Documentatie* (Netherlands Institute for Art
History), The Hague

Thieme-Becker / Thieme, Ulrich, Felix Becker, et al. 1907–50. *Allegemeines
Künstler-Lexikon*. 37 vols. Leipzig: W. Engelman.

W.K. / *Weeskamer* (Chamber for Orphans)

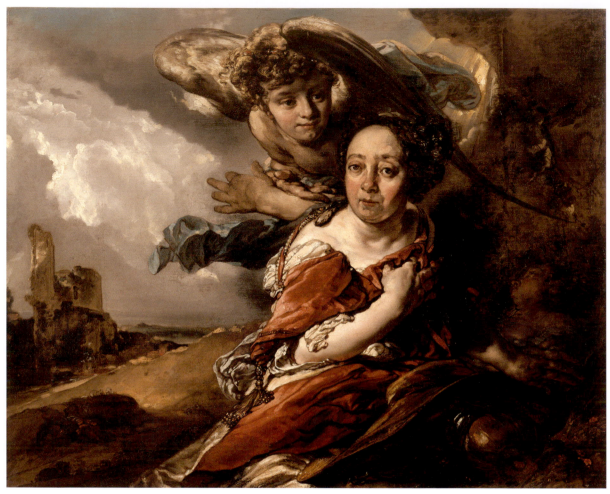

Hagar and Ishmael in the Desert, canvas, 90.8 × 113 cm, Kingston, Canada, Agnes Etherington Art Centre, gift of Drs Alfred and Isabel Bader, 1997.

History Paintings

CATALOGUE 1
Hagar and Ishmael in the Desert
(Genesis 21:9–21), canvas, 90.8 x 113 cm,
Kingston, Canada, Agnes Etherington
Art Centre (acc. no. 40–010), gift of
Drs Alfred and Isabel Bader, 1997

PROVENANCE
Purchased by Robert Hannington in Eng-
land in 1848; Baltimore, collection of Dr
George Reuling; Dr George Reuling et al.
sale, London (Anderson Galleries), 4–5
November 1925, lot 156; W.W. Price (a
niece of Dr George Reuling); New York,
with Dr Frederick Mont; Raleigh, North
Carolina, Chrysler Museum; sale Walter
Chrysler Jr., New York (Sotheby's), 1 June
1989, lot 49 (illus.); Milwaukee, collection
of Drs Alfred and Isabel Bader

LITERATURE
Schneider 1931, 511; Sumowski 1983–94,
1:142n49; 5:3061, 3064n53a, 3075 (illus.);
6:3737, with no. 2408; Friedrich Polleross,
"Between Typology and Psychology: The
Role of the Identification Portrait in Up-
dating Old Testament Representations,"
Artibus et Historiae 12, no. 24, 1991, 102–3
(illus. fig. 23); Van de Kamp 1991–92, 31,
49n46; Von Moltke 1994, 170, no. R8
(as not by De Gelder)

EXHIBITIONS
Birmingham et al. 1957–58 (not numbered
or paginated)

Jan van Noordt shows Hagar in the
desert with her son Ishmael, as told in
Genesis 21. It was her second banishment
from the household of Abraham, where she
had been servant and concubine. When
Ishmael began to waste away in the heat,
Hagar cast him under a bush, not wanting
to see him die. He lies on the ground
under a shrub, to the right side. However,
Hagar's lament catches the ear of God.
Van Noordt depicts the moment in which
an angel appears to her with a divine
message of rescue and hope.

The artist opted for the traditional
depiction of Ishmael as a vulnerable infant,
showing him sturdily wrapped. Though
incorrect, it worked to draw the viewer's
sympathy. The States Bible left the age of
Ishmael in confusion, explaining that the
"child" (*kint*) was actually a boy of seven-
teen.[1] He would have had to be at least a

young boy, to have been able to taunt Isaac and provoke Sarah. The figure of Hagar also does not accord with the story, which identifies her as a young woman; here she appears middle-aged. More significantly, she does not have the idealizing, general features typical of history paintings. They are the specific features of a patron, who commissioned this painting as a *portrait historié*. The sitter may have sought to connect herself with Hagar's specific plight, of having a child in danger, or more generally with the exemplary humility that the once-proud Hagar shows in her desperate situation.

The special significance of the story of Hagar and Ishmael to northern Netherlanders in the seventeenth century remains unclear. Perhaps they were attracted to its elements of crisis and compassion. The moment of angelic intervention also provided a female parallel to the scene of Abraham's sacrifice of Isaac. As with that story, the banishments of Hagar occur many times in the work of Rembrandt and his followers.[2]

The scene conceived by Jan van Noordt is remarkable in Dutch art for its dramatic force. The main figures crowd out the immediate foreground. The angel, especially, projects into the viewer's space through the strong foreshortening of his figure.

Furthermore, the artist conceived the scene as turbulent and dynamic. Hagar twists to the right, away from Ishmael, while the angel sweeps down from heaven with wings spread, toward the viewer. Some of these elements came from other artists' depictions of the same subject. Most significant was a drawing by Rembrandt, showing a similar composition in the centre section, which Van Noordt may have had as his source (fig. 37).[3] Van Noordt enlarged the scale of the figure of Hagar, drawing attention to her expression of anxiety and desperation.

The emotional pitch is heightened by the raw and unfinished quality of the area to the right, around Ishmael, especially in contrast with the finished handling of the main figures. Van Noordt left the broad contours and bold strokes of the underpainting uncovered, in apparent emulation of the technique of some of Rembrandt's history paintings from around 1660.[4] The sweeping movement and the loose and direct handling of this picture relate most closely to the genre painting *A Boy with a Dog and a Falcon* (cat. 45), indicating a date of around 1675.

1 See States Bible 1637, Genesis 21:15, note 21.
2 For a survey of the iconography of this and related subjects taken from the story, see Hamann 1936 and Van de Waal 1947.
3 Rembrandt, *Hagar and the Angel*, reed pen and bistre, with corrections in white body-colour, 18.2 x 25.2 cm, Hamburg, Kunsthalle (inv. no. 22411); see Benesch 1973, 5:253, no. 904 (illus. plate 1179).
4 See 35–6.

FIGURE 37
Rembrandt, *Hagar and the Angel*, reed pen and bistre, with corrections in white body-colour, 18.2 × 25.2 cm, Hamburg, Hamburger Kunsthalle (photo: Bildarchiv Preussischer Kulturbesitz / Art Resource, NY).

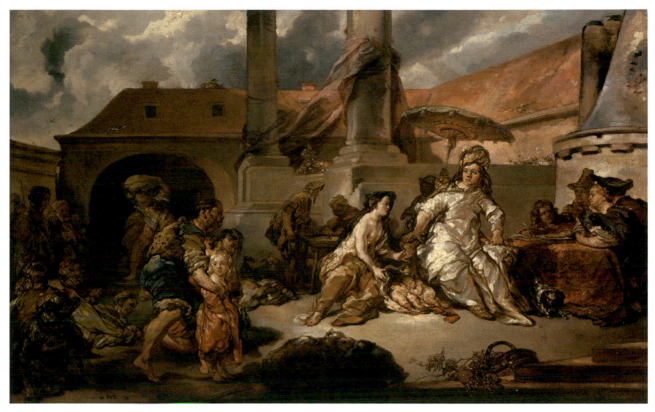

CATALOGUE 2
Joseph Selling Grain in Egypt, canvas, 75 × 118 cm, Milwaukee, Collection of Drs Alfred and Isabel Bader.

CATALOGUE 2
Joseph Selling Grain in Egypt
(Genesis 47:1–26), canvas, 75 x 118 cm,
formerly monogrammed: *GR*; Milwaukee,
Collection of Drs Alfred and Isabel Bader

PROVENANCE
Heidelberg, collection of Bankier Fries;
Basel, with W. Räber Gallery, c. 1930 (as
B. Fabritius); Aarau, collection of Emil
Rothpletz, in 1938 (as Aert de Gelder); sale
Robert Biedermann-Mantel et al., Lucerne
(Fischer), 16–20 June 1964, lot 1594 (as at-
tributed to Aert de Gelder)

LITERATURE
Sumowski 1983–94, 1:140, 142n60, 167
(illus.); 5:3111, with no. 2138; 6:3588 (as
dated 1675), 3737, with no. 2408;
Sumowski 1986, 28, 37n41; collection cat-
alogue Bordeaux 1990, 226, 227n8; exhibi-
tion catalogue Utrecht and Frankfurt 1993,

241n8; Von Moltke 1994, 170, no. R8; Van
de Kamp 1991–92, 47, 53n159

EXHIBITIONS
Kalamazoo 1967, 13 (illus., as Jan van
Noordt, *Elisha and the Widow of Obadiah*);
Milwaukee 1974, no. 19 (illus., as *Joseph
Selling Grain in Egypt*); Milwaukee 1976,
60, no. 25, 61 (illus.); Yokohama et al.
1986–87, 91 (illus., as c. 1650), 159, no. 35;
Kingston 1984, 74–5, no. 35 (illus.)

Alfred Bader was the first to connect
this scene to *Joseph Selling Grain in
Egypt* by Claes Cornelisz. Moyaert (fig.
18).[1] The theme's moralizing significance
for the artist is discussed at length in the
fourth chapter. After years of famine the
people of Egypt are facing starvation, and
they appeal to Joseph, who oversees the
stores of grain that had been stockpiled

during seven preceding years of plenty. Genesis 47:1–26 tells how the people of Egypt subject themselves and their land to state ownership for food. Joseph, as the highest government official, oversees this business. His own brothers will also come to him out of Palestine to buy grain, and so he will be reunited with his family.

The story promoted the virtue of foresight as a God-given talent required of a ruler.[2] This dry political message is not emphasized by Jan van Noordt, who instead creates a human drama. Compared with the depictions by Moyaert,[3] Van Noordt imparted even greater pathos to the participants. He emphasized the confusion of the children, the desperation of their parents, and the sympathy of Joseph, which were expressed largely through facial expressions and bodily poses (for example, the low bow of the father meekly approaching Joseph), but also underscored by the turbulent energy of his late style. The bustling figures form several groups that are organized in a pulsating rhythm across the horizontal format. Van Noordt's approach of engaging the entire picture surface for an overwhelming effect derives from Rubens and Jordaens, but is elaborated with a strong focus on a few figures, in whom the moment is encapsulated: the anxious father and his distracted son in the foreground, and Joseph, seated and pondering, in lavish garments and a turban. This painting shares a deeply emotional tone with other late paintings by the artist, such the *Hagar* in Kingston (cat. 1) and the former *portrait historié* in Bordeaux (cat. 60).[4]

Van Noordt's specific interpretation becomes clear when compared with the works that influenced it. Paintings by Moyaert and Pieter Lastman[5] depicting the same episode incorporate more static figures and restrained gestures. The results are orderly scenes that emphasize Joseph's rationality, rather than the crisis faced by the people around him. Van Noordt also

FIGURE 38
Pieter Lastman, *David and Uriah*, panel, 41.5 × 62.5 cm, signed and dated 1619, The Hague, Royal Cabinet Mauritshuis, on loan from the Instituut Collectie Nederland.

derived his figure of Joseph from Lastman's figure of David in *David and Uriah* in The Hague (fig. 38).[6]

1 Bader 1974, no. 19.

2 One of the earliest known moral interpretations of Joseph as an exemplar of prudence was by Ambrosius. See Ursula Nilgen in L.C.I., vol. 2, col. 423 (*s.v. Joseph von Ägypten*). See also States Bible, 1637, Genesis 41:16, note 23, which emphasizes that Joseph's interpretation of Pharaoh's dream was divinely inspired. Verse 38, note 49 further characterizes Joseph as a leader in Egypt: "*Verstaet wijsheyt en voorsichticheyt/ die Godt sijne geest desen man op eene bysondere wijse gegeven heeft.*" (Meaning wisdom and foresight, which God gave this man through his spirit in a special way).

3 Astrid Tümpel lists three versions of the theme by Moyaert: panel, 69 x 103 cm, monogrammed and dated 1633, Budapest, Szépmüvészeti Múzeum (inv. no. 5259) see: Tümpel 1974, 94 (illus. no. 126), 252–3, no. 48; canvas, 122 x 168 cm, monogrammed and dated 1644, Stockholm, with B. Rapp, in 1956: Tümpel 1974, 114 (illus. no. 154), 253, no. 49; canvas, 136 x 179 cm, c. 1650, Kingston, Agnes Etherington Art Centre (acc. no. 23–038), see Tümpel 1974, 122 (illus. no. 167), 253, no. 50.

4 Olivier LeBihan noted the connection with the painting in Bordeaux: collection catalogue Bordeaux 1990, 226–7.

5 Pieter Lastman, *Joseph Selling Grain in Egypt*, panel, 58.4 x 87.6 cm, signed and dated 1612, Dublin, National Gallery of Ireland (inv. no. 890). See Kurt Freise, "Rembrandt und Lastman," *Cicerone* 5, 1913, 610–11 (illus.), and Hermina Tunsina van Guldener, *Het Jozefverhaal in de Nederlandse Kunst van de zeventiende eeuw*, dissertation, Utrecht, 1947, 78–80. See also exhibition catalogue Amsterdam 1991, 75, illus. 22, 23.

6 Pieter Lastman, *David and Uriah*, panel, 41.5 x 62.5 cm, signed and dated 1619, The Hague, Mauritshuis, on loan from the Instituut Collectie Nederland (inv. no. NK 2834); see exhibition catalogue Amsterdam 1991, 108–9, no. 12 (illus.).

CATALOGUE 3

(p) *The Levite and His Concubine in Gibeah* (Judges 19:16–21), canvas, 48 x 60 cm, formerly signed and dated 1673, present location unknown

PROVENANCE
Paul Mantz sale, Paris, 10 May 1895 (Lugt 53522), lot 72 (as *Generosity*, by Jan van Noordt, 48 x 60 cm, signature partially effaced: "*Un homme richement costumé à l'orientale est assis à droite. Une jeune femme s'appuit sur ses genoux. Derrière ce groupe, un mulet chargé de bagages. A gauche, un vieillard debout semble inviter les voyageurs à pénétrer dans sa maison. La femme placée au premier plan est celle que figure dans la Continence de Scipion de musée d'Amsterdam.*" [A richly dressed man in oriental dress is seated to the right. A young woman bows on her knees. Behind the group a mule loaded with baggage. At the left, an old man standing seems to invite the travellers into his house. The woman in the foreground is the same as the one who appears the Continence of Scipio in the museum in Amsterdam]); Vienna, collection of Wilhelm Ofenheim, in 1930

LITERATURE
Hofstede de Groot 1892, 213, no. 17, 217, no. 18 (as an historical subject with three figures in a landscape, signed "J. ...rt" and dated 1673); Wurzbach 1906–10, 2:243; Kronig 1911, 156; Poglayen-Neuwall 1930, 130 (illus. fig. 6, as a *Biblical Scene* by Barent Fabritius); collection catalogue Louvre 1929–33, 3:42, with no. 1233 (as the Levite in Gibeah, by Van Noordt); Sumowski 1983–94, 1:142n49; Manuth 1987b, 114n387

Judges 19 tells of a Levite travelling with his concubine through the area of Gibeah and stopping in a town square to rest for the night. A passing field labourer offers them accommodation, in part out of concern for their safety. Nonetheless, they

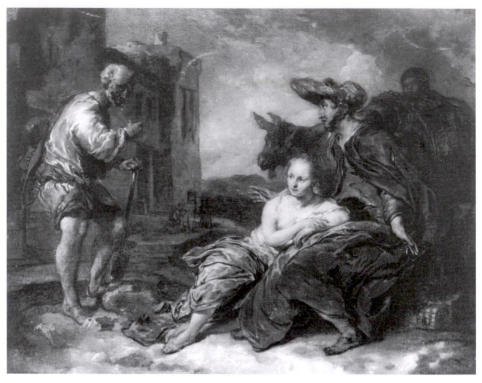

The Levite and His Concubine in Gibeah, canvas, 48 × 60 cm, formerly signed and dated 1673, present location unknown.

are besieged that night by men of the town, who demand the Levite for sex. They are offered the concubine, whom they then abuse to death. Vengeance comes after the Levite dismembers her body and sends out the parts throughout the tribes of Israel, appealing to them for justice; they come and kill the town's inhabitants. This gruesome story delivers multiple moral messages: warnings against homosexuality and infidelity, but also a recommendation of hospitality. It was taken up as a pictorial theme almost exclusively by Rembrandt and his school. Its meaning in this context is addressed in an important article by Volker Manuth,[1] who points out that, although the States Bible translation over-interprets the cruel fate of the concubine as divine punishment for her unfaithfulness to her partner, the depictions by seventeenth-century Dutch

artists instead mainly take up the story's positive message.[2] They focus on the generous offer of the field labourer, and thus foreground the importance of showing hospitality to one's neighbour and to travellers from elsewhere. They can be grouped with the allegorical scenes of hospitality that were traditionally included in printed and painted series of the Seven Acts of Mercy.[3]

Known only through a poor black-and-white photograph at the Witt Library, Van Noordt's depiction of the theme of the Levite and his concubine bears the stamp of his late style. The main figures are large in scale, and they occupy the immediate foreground. Drapery and figures are arranged in broad, sweeping movements. These aspects also appear in another of Van Noordt's late history pieces, *Hagar and Ishmael in the Desert* (cat. 1). Here they

likewise generate a powerful energy that enlarges the emotions of the figures: the desperation of the two travellers and the warm sympathy of the field labourer. As in that work, areas of the present painting are left rather unfinished, with dark painted lines of the underdrawing showing through. The stark rawness of this device underscores the tense predicament of the vulnerable pair of travellers, as does the tumbling energy of the forms and lines.

A drawn study of a man in poor clothing in the Rijksprentenkabinet in Amsterdam corresponds almost exactly to the Gibean field labourer (cat. D1). The figure faces left, and points away from us. The figure and drapery show the same vigorous rhythms of bulging forms. The style of this drawing reflects the handling in Van Noordt's paintings after 1670, such as *A Boy with a Dog and a Falcon*, a dated genre painting of 1675, where the energy plays into a lighter tone (cat. 45). The date of 1673 reported by Hofstede de Groot in 1892 is entirely plausible for the present painting, as well as the related drawing.[4]

1 Manuth 1987a.
2 States Bible, 1637, Judges 19:1 note 1; Judges 19:2, especially note 5. See Manuth 1987a, 20–1.
3 Manuth 1987a, 21–2.
4 See Literature.

CATALOGUE 4
The Triumph of David
(I Samuel 18:6–7), canvas, 135 x 176 cm, indistinctly signed and dated bottom left: *JvanNoo…* (in ligature) */166–*, present location unknown

PROVENANCE
London, Shaper collection; Ludwig-Peter von Pölnitz et al. sale (anonymous section), London (Sotheby's), 12 December 1973, lot 55 (as indistinctly signed); sale, Amsterdam (Mak van Waay), 12 May 1975, lot 206 (illus., as signed and dated 1659); sale, London (Christie's), 8 July 1977, lot 83 (illus.); sale, London (Christie's), 15 February 1980, lot 103 (illus.); London, with Trafalgar Galleries (as signed and dated bottom left); sale, New York (Sotheby's), 6 October 1995, lot 231 (illus.); New York, private collection; sale, New York (Christie's), 6 April 2006, lot 228 (illus.)

LITERATURE
Bénézit 1976, 7:750; Sumowski 1983–94, 1:140, 142n64, 170 (illus.); 6:3588; exhibition catalogue Paris 1987, 87 (illus.)

Van Noordt conceived a theatrical and festive welcome for David on his return from his famous victory over the Philistine giant Goliath. The young shepherd-warrior bears the head and sword of his victim and leads a procession of soldiers and prisoners. They approach from the left, and are greeted by a group of women and girls at the right side, who sing and present flowers to David.

This scene is described in some detail in I Samuel 18:6–7, which mentions the gathering of the women from all the Israelite tribes, the playing of music, and the singing of a two-part response song that praised David over King Saul.[1] This comparison sorely provoked the jealousy of Saul, sending him into depression and giving grounds for his war against David, by which David eventually gained the throne.

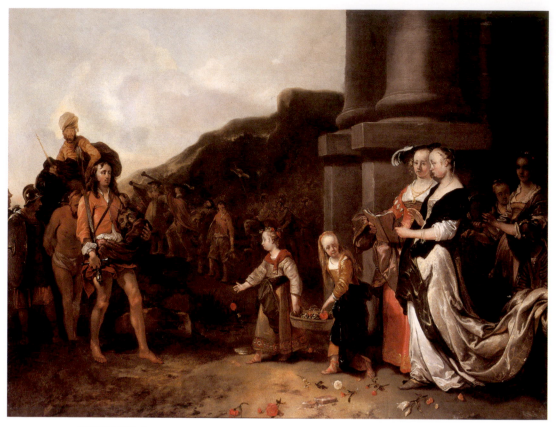

CATALOGUE 4
The Triumph of David, canvas, 135 × 176 cm, indistinctly signed and dated bottom left: *JvanNoo…* (in ligature) */166–*, present location unknown.

The head of Goliath and his sword, being carried by David, do not actually belong to this event, but are a conflation with the presentation by David of these items to Saul, which had already taken place (I Samuel 17:57).

Van Noordt thus created a scene of foreboding. Indeed, the face of David conveys a sober calm rather than joy, reminding the viewer of the coming troubles and his eventual rise to power. There is further allusion; the Triumph of David is traditionally regarded as a prefiguration of Jesus' entry into Jerusalem.[2] This was one basis for its depiction by Netherlandish artists. Van Noordt's direct precedent was likely a painting of the same subject by the pre-Rembrandtist Jan Tengnagel (fig. 39), which shows the same stage-like arrangement in the direct foreground, with the two main groups across from each other.[3]

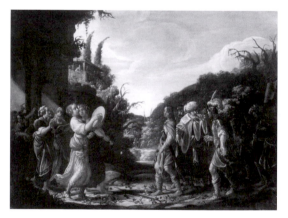

FIGURE 39
Jan Tengnagel, *The Triumph of David*, panel, 55 × 73 cm, present location unknown.

CATALOGUE 5
David, canvas, 64 × 53 cm,
present location unknown.

1 The musical instruments shown do not corre-
spond with the States Bible, I Samuel 19:6,
note 11, which refers to a specific musical
instrument, not known to the translators,
who could only give "musical instruments."
They speculate that it was a three-stringed
instrument.

2 The typological connection to Christ's entry
into Jerusalem was already drawn in the *Biblia
Pauperum* and the *Speculum humanae salvationis*,
the most important medieval collections of
typological interpretations; see R.L. Wyss
in L.C.I., vol. 1, col. 486, *s.v. David*.

3 Jan Tengnagel, *The Triumph of David*, panel,
55 × 73 cm; Viscount Colham sale (section vari-
ous properties), 11 July 1973, lot 109 (illus., as
Pieter Lastman, *The Triumph of David*). Astrid
Tümpel correctly reattributes it to Tengnagel,
but mistakenly interprets the theme as *The
Return of Jephtha*: exhibition catalogue Amster-
dam 1991, 43–5 (illus. no. 33).

CATALOGUE 5
(p) *David*
Canvas, 64 x 53 cm, present location
unknown

PROVENANCE
Sale, Vienna (Dorotheum), 5 November
1963, lot 4 (illus., as J.A. Backer)

The subject at first seems to be simply
a young cavalier. The costume *à
l'antique*, the youthful visage and the
prominent display of the huge sword point
to the identification as the young David.
He carries Goliath's sword, taken at his
battlefield victory over the Philistine
champion. This "heroic portrait" adapts
the type of depiction of saints, and Van
Noordt may have been looking at a paint-
ing such as the one in the Getty Museum
attributed to Salomon de Bray (fig. 40).[1]

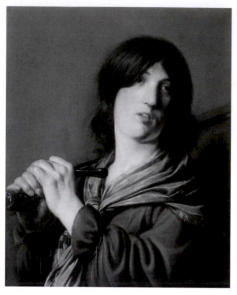

Like *St John the Evangelist* (cat. 12), this work shows flamboyant agitation in clothing and accessories. The focus on curling edges and the reflections in the hilt of the sword are comparable to that in *St John* and point to a date of around 1650–55.

1 Salomon de Bray, *David*, canvas, 62 x 51 cm, Los Angeles, The Getty Museum, inv. no. 69.PA.22; see collection catalogue Getty 1997, 16 (illus.).

CATALOGUE 6
Susanna and the Elders
(Daniel 13), canvas, 113 x 93.5 cm, Utrecht, Museum Catharijneconvent (inv. no. RMCC s75), on loan from the Instituut Collectie Nederland (inv. no. NK 1700)

PROVENANCE
Amsterdam, collection of F. Schmidt-Degener; Amsterdam, with Fa. Fetter, c. 1940; sale, Amsterdam (Fa. Fetter), 1941, lot 17 (illus.); M.C.Ph. De Vassy et al. sale (anonymous section), Amsterdam (Frederik Muller), 20–23 October 1942, lot 69; Amsterdam, with W. Paech; Amsterdam, Eduard Plietzsch (in service to the German occupying force); The Hague, Stichting Nederlands Kunstbezit, in 1945; lent to Utrecht Kunsthistorisch Instituut; returned to The Hague, Dienst voor 's-Rijks verspreide Kunstvoorwerpen (now the Instituut Collectie Nederland) in 1965

LITERATURE
Sumowski 1983–94, 1:143n70, 6:3736, no. 2403, 4020 (illus.); exhibition catalogue The Hague 1992, 260 (illus. fig. 35b)

EXHIBITIONS
Amsterdam 1939, no. 69a (illus. no. 16); Washington, Detroit, and Amsterdam 1980–81, 212, no. 55, and 213 (illus., as c. 1660); Utrecht 1989, 92–5, no. 20 (illus.); Amsterdam and Jerusalem 1991–92, 253, no. 33 (illus.)

COLLECTION CATALOGUES
The Hague 1992, 227 (illus.): Utrecht 2002, 241 (illus.)

The Apocryphal book of Daniel tells how Susanna, the beautiful wife of the wealthy Joachim, is confronted by two elders who are used to holding court at her husband's house. They demand sex, threatening to accuse her of adultery if she refuses, which she does. They accuse and condemn her, but she is vindicated by the

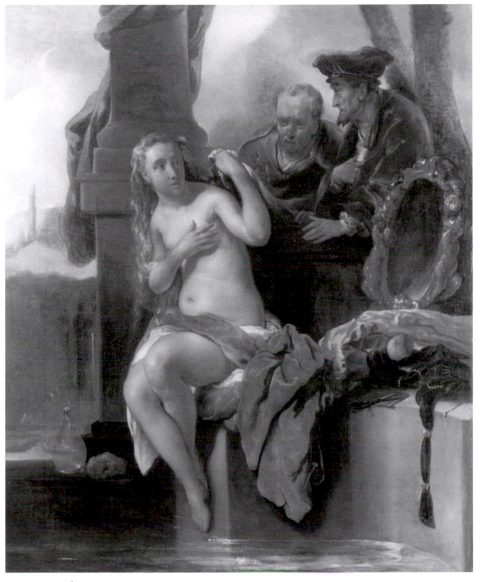

CATALOGUE 6
Susanna and the Elders, canvas, 113 × 93.5 cm, Utrecht, Museum Catharijneconvent, on loan from the Instituut Collectie Nederland.

youthful prophet Daniel, who shows their testimony to be false. The story valorizes Susanna's steadfastness and Daniel's perceptiveness and cleverness, and condemns the adulterous lust and perjury of the elders.[1] The immense popularity among artists of Susanna's infamous bath owed mainly to the uneasy combination of moralization and sensual display.

Van Noordt's three known Susannas each treat the episode differently. The Leipzig picture indulges most in fleshly display, while the Paris painting, in contrast, focuses intensely on Susanna's rejection of the unwelcome proposition (cat. 7, 8). The present work, Van Noordt's earliest interpretation of the theme, emphasizes Susanna's experience of moral dilemma, an aspect he perhaps derived from Rembrandt's depiction, now in Berlin (Br. 340) (fig. 32).[2] Like Rembrandt, Van Noordt presented Susanna in a stilled pose; later

he would invest her figure with the movement typical of his later work, reflecting the influence of Rubens and Van Dyck.[3] Here he also maintains the restraint in facial expression typical of his history paintings before 1660, which reflects the introspection of Rembrandt's approach. This picture likely dates to a few years before the more assured *Cimon and Iphigenia* of 1659 in Göttingen (cat. 30).

1 Rembrandt, *Susanna and the Elders*, canvas, 76.6 x 92.7 cm, signed and dated 1647, Berlin, Gemäldegalerie Staatliche Museen Preussischer Kulturbesitz (inv. no. 828E).

2 For further discussion of the interpretation of Susanna as a moral exemplar, see 67–70.

3 Peter Paul Rubens, *Susanna and the Elders*, panel, 198 x 218 cm, c. 1610, Madrid, Real Academia de Bellas Artes de San Fernando; Anthony Van Dyck, *Susanna and the Elders*, canvas, 194 x 144 cm, Munich, Bayerische Staatsgemäldesammlungen (inv. no. 595).

Susanna and the Elders
(Daniel 13), canvas, 168 x 146 cm, Leipzig, Museum der Bildende Künste (inv. no. 1636)

PROVENANCE
Leipzig, collection of Johann Thomas Richter (1728–1773); by descent to his son Johan Friedrich Richter; Richter sale, Leipzig (Rost and Wiegel), 15 January 1787 (Lugt 4122); Leipzig, Fischer collection; Fischer sale, Leipzig, 8 May 1820 (Lugt 9791), lot 68 (to Lehmann, as 72 *zoll* x 62.5 *zoll* [169.8 x 147.4 cm]); Leipzig, Lehmann collection; Lützschena, collection of the Baron Max Speck von Sternburg; by descent to his son the Baron Alexander Speck von Sternburg; acquired by the Museum der Bildende Künste in 1945; returned to the Speck von Sternburg family, and subsequently donated to the museum in 1997

LITERATURE
Richter 1775, 314 (as Flinck); Parthey 1863–64, 441; Hofstede de Groot 1892, 216–17, no. 17 (as Jan van Noordt); Becker 1904, no. 30 (illus.); Wurzbach 1906–10, 2:243; Kronig 1911, 156; Plietzsch 1915, 51; Decoen 1931, 18; "Deutscher Privatbesitz stellt aus," *Weltkunst* 11, no. 22/23, 6 June 1937, 2; collection catalogue Hannover 1960, 25, no. 3; Von Moltke 1965a, 229 (illus.); Sumowski 1983–94, 1:143n70; 6:3736, with no. 2403; Prêtre 1990, 88–9 (illus. fig. 112); Heiland 1989, 156n50; Sumowski 1998, 78, 79n22

SELECTED COLLECTION CATALOGUES
Speck von Sternburg 1827, no. 3 (as Govert Flinck); Speck von Sternburg 1889, 17, no. 141; Leipzig 1942, 61–100; Leipzig 1967, 144, no. 1636; Leipzig 1979, 172, no. 1636; Leipzig 1995, 138, no. 1636, 336 (illus. no. 484)

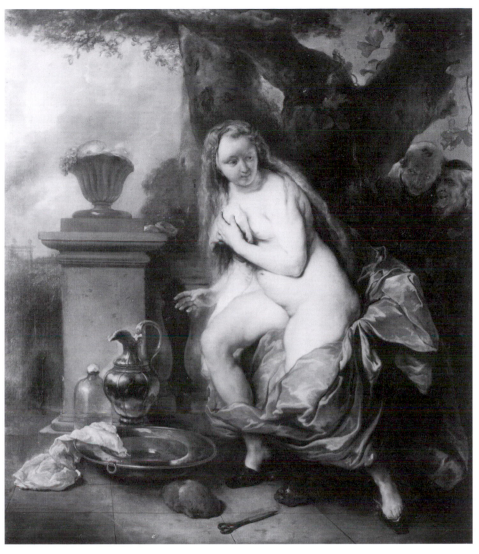

CATALOGUE 7
Susanna and the Elders, canvas, 168 × 146 cm, Leipzig, Museum der Bildende Künste.

EXHIBITIONS
Leipzig 1914, no. 218; Leipzig 1937, no. 54; Leipzig 1998, 157–9, no. 1/84 (illus.)

The theme is discussed in the previous entry for the Utrecht version. In the present painting, Susanna is shown facing the viewer and striking an awkward pose, as if in the middle of moving away from the elders. They are taking Susanna by surprise as she bathes, and she is in the process of recognizing the sudden turn of events. The painting emphasizes the clash between her state of innocence and the sinister intentions of the elders. The comparison with the other two paintings indicates that they represent different moments, slightly later, focusing on the subsequent dilemma of the extortion.

Van Noordt made a significant shift in his handling of the figure in this picture, endowing Susanna with an imposing presence and fleshy physique. For a long time,

this picture was thought to be by Govert Flinck, likely because of the style of the nude figure. It prompted an eighteenth-century observer to contrast it with a *Danae* by Titian in the same collection, as an opposition of prosaic reality versus ideal beauty.[1] Such a characterization of the Rembrandtesque style, here connected with Flinck, was by then a commonplace. Also drawn from Rembrandt and Flinck is the use of chiaroscuro to generate a strong focus on the main figure, which was a major development in Van Noordt's style around 1660.

Susanna's figure at the same time shows the impact of the Flemish Baroque on Van Noordt, especially in its large scale and movement, and its conspicuous emphasis on the nude. However, the influence of Rubens and Jordaens seems to have been indirect, absorbed through the work of Van Noordt's teacher Backer, and more importantly that of Govert Flinck, whose greatest success occured in the previous decade. The connection to both of these artists in Van Noordt's work is further borne out by the use of black and white chalk on blue paper in his figure drawings. One such drawing, now in Hannover, was made by Van Noordt in preparation for the figure of Susanna in this painting (cat. D2).

1 Richter 1775, 314.

CATALOGUE 8
Susanna and the Elders
(Daniel 13), canvas, 124 x 86 cm, Paris, with Bob Habolt

PROVENANCE
M. Baron de Bankheim sale, Paris, 12 April 1747 (Lugt 662), ("*grandeur naturelle, tableau rempli de passions, par Jean van Noort, de l'ecole de Rembrandt, h. de 3p 11po l. de 3p 3po* [127.1 x 105.5 cm]"); Freifrau von und zu Brenken sale, Cologne (Heberle), 1 April 1886 (Lugt 45591), lot 90 (as Gottfried Schalcken, signed "G. Scalken" and dated 1673; to Baitzke); Munich, with A. Rupprecht, in 1889; H.Th. Höch sale, Munich (Joseph Albert), 19–20 September 1892 (Lugt 51022), lot. 192 (illus., as 126 x 102 cm, signed and dated G. Schalcken 1673); Paris, with Demotte, 1925–28; Berlin, Meier collection; Winterthur (Switzerland), with Gino Comuzzi, Galerie zur Kröne, 1988–98; Buenos Aires and Sao Paolo, collection of John Brossen

LITERATURE
Hofstede de Groot 1907–28, 5:327, no. 5 (as Schalken); Schneider 1931 (as Jan van Noordt), 511; Thieme-Becker, 29:570 *s.v. Gottfried Schalcken*; Bernt 1980, 2:925 (illus.); Sumowski 1983–94, 1:140, 142n50, 143n70, 176 (illus.); 6:3589, 3736, with no. 2403; Sumowksi 1986, 28, 37n41; exhibition catalogue Paris 1987, 85

EXHIBITIONS
Munich 1889, 26, no. 152 (as Godfried Schalcken, canvas, 126 x 102 cm)

With the third known depiction of the confrontation between Susanna and the elders, Jan van Noordt arrived at yet another interpretation. He isolated the figure of Susanna by placing it in strong light and having it fill the foreground space of his composition. The recent, unfortunate, trimming of the sides has only served to heighten this effect. Susanna's dynamic

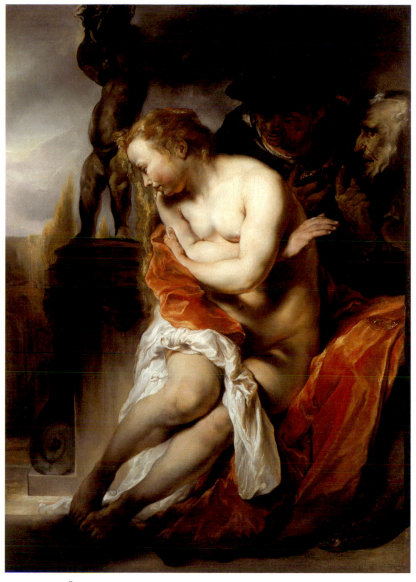

CATALOGUE 8
Susanna and the Elders, canvas, 124 × 86 cm, private collection.

pose expresses powerfully her rejection of
the elders' advances, and of their proposi-
tion. Van Noordt originally developed the
pose of this figure in a drawing now with
the De Boer Foundation in Amsterdam
(cat. D3).[1] The idea to emphasize the long
sweeping arch of her back likely came from
Lucas Vorstermans' print after a composi-
tion by Rubens (fig. 30).[2] It is also a further
development of his own conception in the
painting in Utrecht, where the energy of

her movement is still restrained. He aban-
doned the rather awkward and titillating
display of the interim version, the painting
now in Leipzig.

This painting can be identified with an
entry in the catalogue of a sale in Paris in
1747, which described the work as "life
size, a picture filled with emotion, by Jan
van Noordt, of the school of Rembrandt."
Indeed, this painting shows the artist
reaching height of his power to imbue his

figures and compositions with emotional expression. By the late 1660s, Van Noordt started to reduce the detail by which he sought to enrich his earlier works, in, for example, the Leipzig *Susanna*. The rendering of form, especially in the body of Susanna, achieves the powerful bulging roundness typical of works after 1665. The artist began to exploit sweeping movement in figures and fabric, a characteristic element of works done from around 1670 onward. The organization of Susanna's pose especially shows Van Noordt's exploitation of this expressive element. On the basis of style this work can be dated to around 1670.

1 Schatborn 1978, 120.
2 See 364n75.

CATALOGUE 9
(p) *The Adoration of the Shepherds* (Luke 2:16–17), canvas, 65.6 x 58 cm, inscribed on the reverse of the stretcher: *Bernart Cuyp*, private collection

PROVENANCE
Possibly identical with Amsterdam, collection of Jan van de Cappelle, in 1680 (cat. L5); sale, London (Sotheby's), 12 December 2002, lot 178 (illus., for £11 352, to Noortman); Maastricht, with Noortman Master Paintings

LITERATURE
Possibly identical with Bredius 1892, 34; Hofstede de Groot 1892, 215, no. 2.

Following the biblical text and the pictorial tradition, Jan van Noordt set his *Adoration of the Shepherds* at night. He placed the Holy Family by a shed, off to the left side. The Virgin holds up a candle to light the baby Jesus. The walls and roof of the run-down shed are punctured by gaping holes, and a bundle of straw lies in foreground to the left, prominently catching the light. The shepherds form a group in the centre, dominated by one of their number in the foreground, seen from the side, kneeling to the left toward the baby Jesus on Mary's lap.

The figure of the kneeling shepherd, studied in a drawing (cat. D4), ties this picture closely to several of Van Noordt's works of around 1660. A similar pose is struck by another shepherd, Daifilo, in both of Van Noordt's *Granida and Daifilos* (cat. 33, 34). The figure of the Virgin is in turn related to the desperate mother to the far left in *The Massacre of the Innocents* (cat. 14), a painting that can be dated to around 1660. The present work shows a further development in the articulation of drapery, with fine hatching across the surface, which enhances the suggestion of form and pointing to a possible date of around 1661–62. The composition shows Van

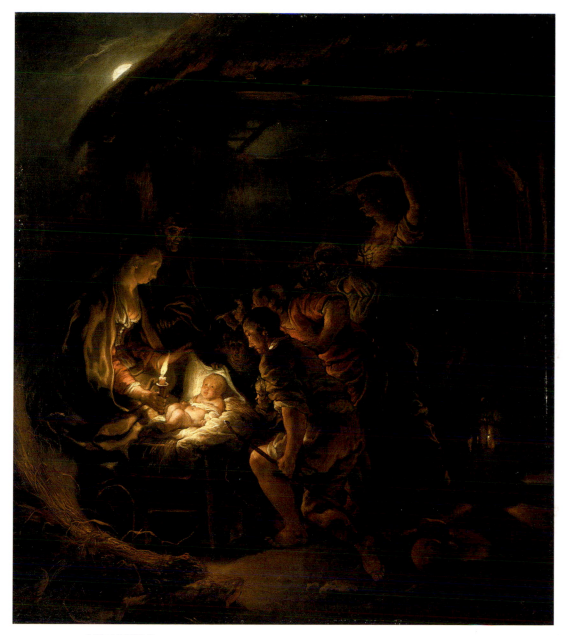

CATALOGUE 9
The Adoration of the Shepherds, canvas, 65.6 × 58 cm, private collection.

Noordt's emerging tendency to dynamic action, employing strong diagonal axes and undulating lines. The execution also conveys energy in the loose handling of secondary figures, such as the two shepherds further back in the group, whose faces are roughly sketched with open strokes of opaque colour. The paint layers enjoy a remarkably good state of preservation. The areas of sky, for example, retains subtle modulations of dark tones. They suggest the atmospheric reflection of moonlight, slightly surreal, lending the scene an evocative sense of mystery.

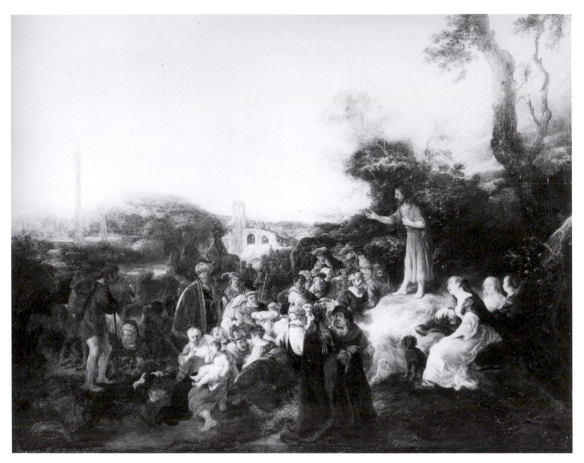

CATALOGUE 10
St John the Baptist Preaching
(Matthew 3:1–12; Mark 1:4–8; Luke 3:1–20), panel, 49.5 x 65 cm, Oldenburg, Landesmuseum für Kunst und Kulturgeschichte (inv. no. 15.649, as Jacob Adriaensz. Backer)

LITERATURE
Bauch 1926, 31, no. 9 (illus. plate, as Backer); Schatborn 1979, 125 (illus. fig. 10); Bruyn et al. 1982, 3:82 (illus. fig. 11, as Jan van Noordt); Sumowski 1983–94, 1:140, 142n53, 163 (illus.), 4:3588

COLLECTION CATALOGUES
Oldenburg 1845, 61, no. 116 (as Rembrandt school); Oldenburg 1881, 72–3, no. 174 (as Rembrandt school: Wulfhagen or De Wit); Oldenburg 1966, 87 (illus., as Backer)

The Gospels of Matthew, Mark, and Luke relate the story of John the Baptist, the Hebrew prophet who devoted himself to the impending ministry of Jesus. The life of John forms a New Testament type for the life of Jesus, complete with miraculous birth and innocent, violent death. A number of Netherlandish artists depicted John's mission, preaching a message of repentance and reform in open areas outside of cities and cultivating a

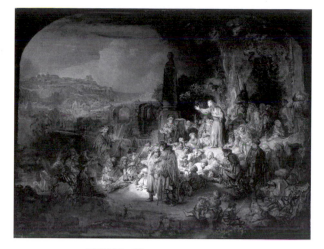

FIGURE 41
Rembrandt, *John the Baptist Preaching*, canvas,
62.7 × 81.1 cm, Berlin, Gemäldegalerie,
Staatliche Museen zu Berlin (photo: Bildarchiv
Preussischer Kulturbesitz / Art Resource NY;
Jörg P. Anders).

following prepared to hear the message of
Jesus. This theme may have been of special
significance to the Protestants of the
northern Netherlands because it echoed
aspects of the history of the Reformation
in these lands, most poignantly the open-
air ("Hedge") sermons of the 1560s.

One of the first notable depictions was
by Pieter Bruegel the Elder, whose pen-
chant for scenes of crowds it well suited.[1]
In the seventeenth century, Rembrandt
created an important interpretation of this
theme (Br. 555) (fig. 41), which became
the basis for the present composition.[2]
Van Noordt took over the pose of John
the Baptist and his placement on a hillside
to the right, the group of Pharisees in the
foreground, and the river and waterfall in
the background. Most telling is the appro-
priation of the expressive, cursory handling
of John the Baptist, evoking his simple
desert existence and his raw emotion in
admonishing his audience. Rembrandt
began his painting around 1634, and fin-
ished it sometime later. The Rembrandt
Research Project has speculated that this
painting perhaps reflects the original com-
position of Rembrandt's grisaille before

he enlarged it.[3] Not taken into considera-
tion was the implication that this painting
must have been made before the enlarge-
ment. They give no date for the second
phase of Rembrandt's work. If it was im-
mediately carried out in 1634, when Van
Noordt was only ten years old, then he
can be excluded as the artist of the present
work as being then incapable of painting it.

The connection to Van Noordt cannot
be dismissed, however. There is hardly
a direct relationship between the two
paintings. Many features of Rembrandt's
composition are much altered in the
Oldenburg canvas. The broken aqueduct
crossing a river in the centre background is
smaller, and sprouts a curious tower on its
left side. The pillar is moved to the left
side, and carries no Emperor's bust. The
foreground pair of Jewish scholars is recast
with an orientation to the right side. To
their left, a young mother receives greater
prominence, and bears a much larger child
on her lap. Camels become horses to the
far left of the composition. More generally,
the grisaille colour scheme is translated
into a painterly colour range. The pinkish
glow at the horizon in particular connects
this work to Van Noordt's early style. It
also displays his roundish volumes of fig-
ures, modelled softly. Some of the figure
types, such as the scrambling child to the
left of centre, are recognizable from Van
Noordt's early genre scenes with children
(e.g., cat. 44), and the undulating forms
of landscape are similar to those in Van
Noordt's earliest pastoral depiction, last
with Leger in London (cat. 35). The very
inconsistency of the treatment of the fig-
ures and the lack of sureness in touch
speak strongly against the museum's attri-
bution to Backer, already an accomplished
artist by 1634, and in favour of the hand of
the young Van Noordt, perhaps as early as
around 1640. He was likely working from
a drawing, or a hazy memory, of Rem-
brandt's famous composition before it
was changed.

1 Pieter Breughel the Elder, *John the Baptist Preaching*, panel, 95 x 160.5 cm, signed and dated 1566, Budapest, Szépmüvészeti Muzeum (inv. no. 51.2829); see collection catalogue Budapest 1968, 1:101–2, 2:illus. pl. 95.

2 Canvas, 62.7 x 81.1 cm (enlarged from 39.8 x 49.5 cm), Berlin, Gemäldegalerie Staatliche Museen Preussischer Kulturbesitz; see Bruyn et al. 1982, 1:70–88, no. A 106 (illus.). The fame of this work in its own age is indicated by its mention in near-contemporary texts; see Hoogstraten 1969, 183, and Houbraken 1976, 1:261. Kurt Bauch cites several variations on this theme in the work of Rembrandt and his followers. (1957, 205).

3 Bruyn et al. 1982, 1:82.

CATALOGUE 11
(p) *St John the Baptist Preaching*
(Matthew 3:1–12; Mark 1:4–8; Luke 3:1–20), panel, 86 x 116 cm, present location unknown

PROVENANCE
Augsburg, with Galerie Gebrüder Veith, in 1786; Munich, collection of the Freiherr von Aretin; Wurzburg, collection of Dr F. von Rinecker (as Rembrandt); F. Von Rinecker sale, Cologne, 30 October 1888, lot 27 (illus., as Rembrandt van Rijn); Munich, with Abt, in 1924; Stuttgart, with L. Schaller, in 1941; Stuttgart, Nagel Collection, (as Rembrandt-school); Francis Phillimore et al. sale (anonymous section), London (Christie's), 24 July 1987, lot 61 (illus., as Jan van Noordt); sale, London (Phillips), 6 July 1993, lot 256 (illus.); North Germany, private collection

LITERATURE
Bauch 1926, 31, 76, no. 8 (illus. plate 23, as Backer); Sumowski 1983–94, 1:140, 142n54, 162 (illus., as Jan van Noordt); 6:3588

This conception of the Sermon of John the Baptist is Van Noordt's second derivation of the famous depiction by Rembrandt of the same theme. Van Noordt seems to have known that work before Rembrandt enlarged it (fig. 41).[1] Van Noordt also followed Rembrandt's method of separating the crowd into smaller groupings, in which people are distracted by each other, such that many do not attend to the important message being delivered. He also used the placement of John the Baptist to the right, the sloping hillside, and the receding landscape view. He shifted the view of John the Baptist from profile to three-quarter, and strongly emphasized his dress, a poor garment of hair, as specified in the Gospels (Matthew 3:4, Mark 1:6).

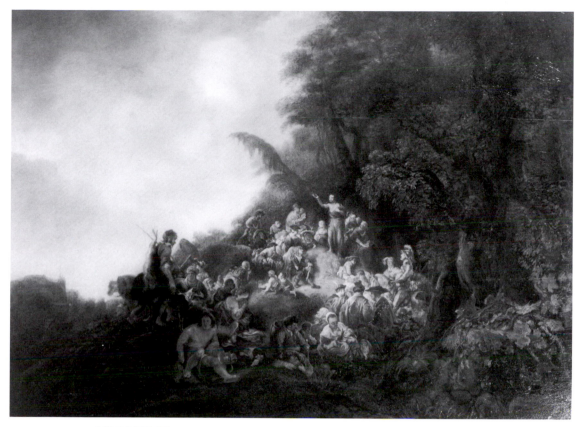

CATALOGUE II
St John the Baptist Preaching, panel, 86 × 116 cm, present location unknown.

Van Noordt's style here compares closely to that of *The Crucifixion*, in Avignon (cat. 15). Typical of his early work is the emphasis on a landscape setting; here the city of Jerusalem appears in the distance to the left. The mounds and hollows of the hillside also separate the different clusters of listeners. Attribution of this scene to Van Noordt, however, is based on the style of the figures, which corresponds in particular to that seen in another early history painting, formerly signed and dated 1645: *Caritas*, in Milwaukee (cat. 24).[2] The faces show the same rounded modelling in translucent paint, with an emphasis on strong light and reflections. In this way Van Noordt dramatised the otherwise static event.

1 See previous entry.
2 Sumowski 1983–94, 1:142n54.

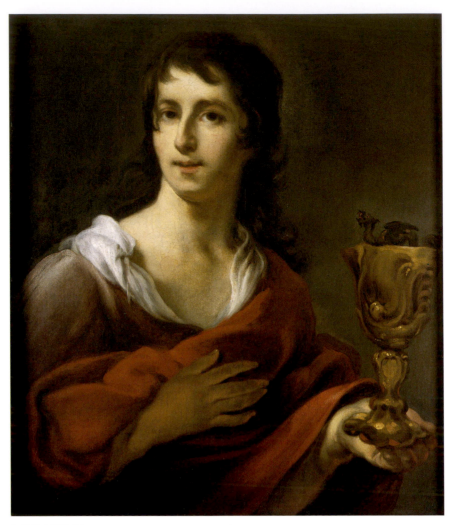

CATALOGUE 12
St John the Evangelist
Canvas, 63.2 x 55 cm, present location
unknown

PROVENANCE
The Hague, private collection; sale,
London (Sotheby's), 10 July 2003, lot
134 (illus.)

LITERATURE
Sumowski 1986, 25 (illus. fig. 5), 26,
36n30; Sumowski 1983–94, 5:3064n38

Van Noordt painted John the Evange-
list as a half-length figure, emphasiz-
ing his youthful visage and two important
attributes, the chalice and the dragon.
These refer to a story about an attempt on
John's life by Aristodemos, after the evan-
gelist interfered with the worship of Diana
at Ephesus. John was given a chalice to
drink from, but he saw a snake or dragon
emerge from it, and thus recognized that it
was poisoned.[1] Van Noordt presented the
dragon as a tiny creature on top of an
enormous gold cup.

The gold cup itself is a free evocation of the famous gilt silver cup created by the Utrecht silversmith Adam van Vianen for the Silversmith's Guild of Amsterdam in 1614 (fig. 42).[2] Van Noordt changed the features, abstracted the figures, and left out the lid.

St John the Evangelist shares with Van Noordt's early *Satyr and the Peasant Family* a strong chiaroscuro with deep shadows and a smooth and flowing handling (cat. 23). Much of the paint appears translucent, except for the bright red that Van Noordt distributed in various areas, such as the lips, the reflections in the golden Nautilus cup, and in the wrist and knuckles of the nearer hand that holds the cloak at the chest. The sash at the neck is also painted thickly in opaque white. The overall predominance of dark and restrained colours, especially in the clothing, places this work with history paintings between 1650 and 1655.

A painting with the same composition appears hanging on the wall in a depiction of a Cabinet of Paintings by Hieronymus Janssens.[3] It may have been a Flemish work that Van Noordt also knew, or the present painting, as part of a Flemish collection. The representation there, among works with varying subject matter, suggests that this painting was not made as part of a series, a typical arrangement with paintings of the evangelists. Like the *David*, of a different size and in a later style, it is an independent presentation, done for the open market, like the *tronies* of Rembrandt and his students.

FIGURE 42
Adam van Vianen, *Silver Cup*, silver, gilt, height 25.5 cm, width 13.2 cm, depth 10.9 cm, signed and dated 1614, Amsterdam, Rijksmuseum (photo: Rijksmuseum-Stichting Amsterdam).

1984, 2:no. 409; and exhibition catalogue Amsterdam 1993, 452–3, no. 112 (illus.).

3 Hieronymus Janssens, *View of a Gallery of Paintings*, canvas, 60 x 77 cm, Madrid, private collection. See exhibition catalogue Madrid 1992, 234–7, no. 33 (illus.). My thanks to Albert Blankert for this information.

1 L.C.I. vol. 7, col. 119. A concise summary of the story appears in Hall 1974, 115.

2 Adam van Vianen, *Silver Cup*, silver, gilt, height 25.5 cm, width 13.2 cm, depth 10.9 cm, signed and dated 1614, Amsterdam, Rijksmuseum. Van Vianen's celebrated creation made its way into numerous Dutch seventeenth-century paintings. See Duyvené de Wit-Klinkhamer 1966, 79–103. See also exhibition catalogue Utrecht 1984, 75, no. 61 (illus.); Ter Molen

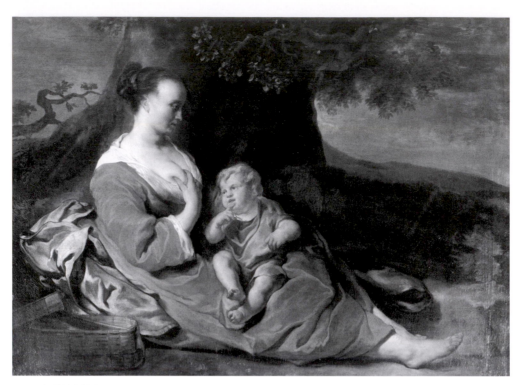

Madonna and Child (Rest on the Flight into Egypt?), canvas, 88 × 124 cm, signed and dated lower left:
Jv Noordt A⁰ 1676, Gavnø, Gavnø Castle Foundation.

CATALOGUE 13
Madonna and Child (Rest on the Flight into Egypt?)
Canvas, 88 x 124 cm, signed and dated lower left: *Jv Noordt A⁰ 1676*, Gavnø, Gavnø Castle Foundation (inv. no. 5413–1)

PROVENANCE
Gavnø, collection of the Baron Reedtz-Thott, from 1785; transferred to the Foundation

LITERATURE
Hofstede de Groot 1892, 214, no. 21, 218, no. 24; Wurzbach 1906–10, 2:243; Decoen 1931, 18; Christine S. Schloss in collection catalogue Hartford 1978, 168n4; Sumowski 1983–94, 1:140, 143n74, 180 (illus.); 5:3111, with no. 2136, 3112, with no. 2141

COLLECTION CATALOGUES
Gavnø 1785, no. 112; Gavnø 1876, 40, no. 112; Gavnø 1914, 35, no. 120

A mother rests on the ground, seated against a massive tree trunk, with her child on her lap. Given the wilderness setting and the basket, it is almost certain that Van Noordt here took up the pictorial tradition of the Rest on the Flight into Egypt. Consistent with tradition, Van Noordt emphasized Mary and the infant Jesus, but, unusually, he left out entirely the figure of Joseph and the donkey. In doing so he transformed the traditional iconography of "The Rest on the Flight into Egypt," which usually included all three people. By depicting only these two in the story, the artist brought the viewer's attention to bear on their experience and their thought processes, and thus defined the event anew, in purely human terms. This approach of *herauslösung* appears more frequently in the work of Rembrandt, with the figures usually caught in a still moment and freed from the narrative context.[1]

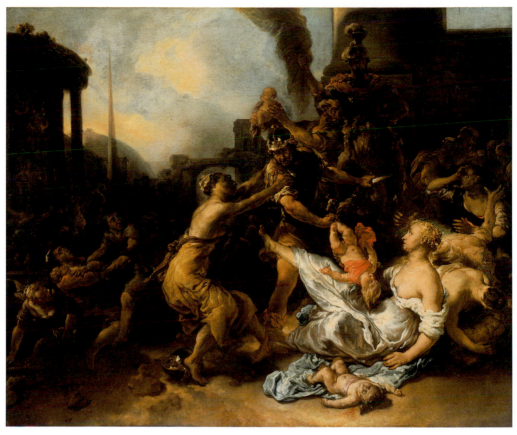

CATALOGUE 14
The Massacre of the Innocents, canvas, 91 × 110 cm, formerly signed and dated: *J. van Noordt 166–*,
Kingston, Agnes Etherington Art Centre, gift of Drs Alfred and Isabel Bader.

The restful composition and handling here show Van Noordt adapting his style to his theme, rather than exhibiting the dynamic energy typical of works from his late period. Here he is much more restrained, achieving an atmosphere of restful tenderness. The mother reclines against a tree, her slack features attesting to fatigue, while the baby smiles and playfully eyes her breast, underscoring the maternal relation. Their stillness is further underlined by the horizontal format, counter to the altarpiece tradition for depictions of the Madonna and Child.

1 My thanks to Albert Blankert for pointing out the connection to this approach in Rembrandt's work, which has been discussed by Christian Tümpel (Tümpel 1968, 161–87).

CATALOGUE 14
The Massacre of the Innocents
(Matthew 2:16–8), canvas, 91 x 110 cm, formerly signed and dated: *J. van Noordt 166–*, Kingston, Agnes Etherington Art Centre (acc. no. 23–040), gift of Alfred and Isabel Bader, 1980

PROVENANCE
C. Sherston sale (anonymous section), London (Christie's), 29 October 1948, lot 150 (as signed and dated: *J. van Noordt 166–*); London, collection of Efim Schapiro, in 1953; acquired from the Estate of Efim Schapiro for the Agnes Etherington Art Centre in 1979 by Dr Alfred Bader

LITERATURE
Sumowski 1983–94, 1:140, 143n61, 169 (illus.), 6:3588; De Witt 1993.

The Gospel of Matthew tells of the mass infanticide in Bethlehem ordered by Herod, which threatened the life of the baby Jesus. As the first martyrdom this theme had a Roman Catholic bias, which may be why it was seldom depicted in the northern Netherlands. The most direct precedent for Jan van Noordt's depiction of this theme is a work by Pieter Lastman, a Catholic, in Braunschweig (fig. 9), from which Jan van Noordt took over the distinctive motif of soldiers throwing babies from a building.[1] Van Noordt also included a prominent obelisk, which could be a proleptic reference to the Flight into Egypt, by which the young Jesus escaped this violence.[2]

The pitched emotions and movement point to the influence of Flemish art on Van Noordt's style. Rapid sinuous lines of reflections in drapery are only the accent to a surface mobilized with overall sweeping movement, powerful gestures of struggle, and expressions of panic, anguish, and brutality. He may have known a depiction by Rubens in Munich, by way of the print by Paulus Pontius, to judge by his heroic depiction of the mothers.[3] A few other paintings by the artist also generate a turbulent atmosphere through similar effects; a good example is *Nymphs and a Satyr* (cat. 21). The present work can likewise be dated to around 1660, consistent with the traces of a date reported in the sale entry of 1948.[4]

The central figure of the mounted soldier reappears in modified form in *Crowning with Thorns* by Van Noordt's pupil Johannes Voorhout (fig. 43), who likely saw this work in the studio during his apprenticeship between 1664 and 1669.[5]

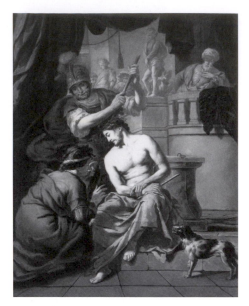

FIGURE 43
Johannes Voorhout, *The Crowning with Thorns*, canvas, 77.5 × 63.5 cm, present location unknown.

1 Pieter Lastman, *The Massacre of the Innocents*, panel, 85 x 122 cm, c. 1607–08, Braunschweig, Herzog Anton Ulrich-Museum (inv. no. 209).

2 My thanks to J. Douglas Stewart for suggesting this interpretation.

3 Peter Paul Rubens, *The Massacre of the Innocents*, canvas, 199 x 302 cm, c. 1636–38, Munich, Alte Pinakothek (inv. no. 752); see exhibition catalogue Kingston 1988, 108; collection catalogue Munich 1998, 314–17 (illus.); Paulus Pontius, after Rubens, *The Massacre of the Innocents*, etching, in two sheets, 62.2 x 44.7 and 47.2 cm.: Hollstein 1949–, vol. 17, 149, no. 5; Voorhelm Schneevoogt 1873, 24, 25, no. 107. I am grateful to J. Douglas Stewart for signalling the importance of Pontius's etching.

4 See Provenance.

5 Johannes Voorhout, *The Crowning with Thorns*, canvas, 77.5 x 63.5 cm, sale, New York (Christie's), 21 May 1992, lot 119 (illus., as signed J. Voorhout); formerly Bob Jones University, Greenville, South Carolina. My thanks to Robert Schillemans for directing me to this picture.

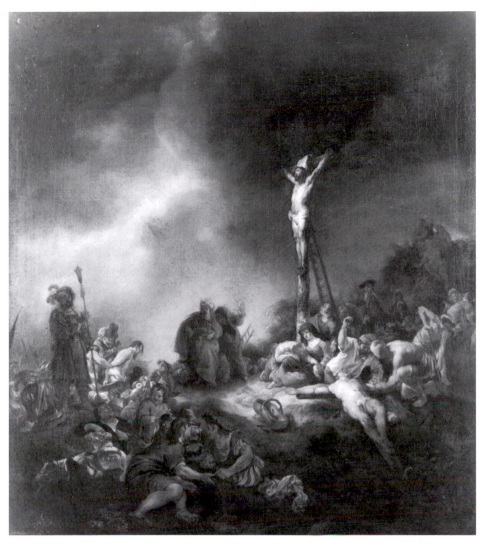

The Crucifixion, canvas, 105 × 94 cm, Avignon, Musée Calvet.

CATALOGUE 15
The Crucifixion
Canvas, 105 x 94 cm, inscribed in a later hand: *G.v.EeckHoudt*, Avignon, Musée Calvet, acquired in 1833 (inv. no. 513)

PROVENANCE
Possibly: C. A. de Court (widow of J. Meerman) sale, Leiden (P. van der Eyk), 25 October 1754 (Lugt 846), lot 31 (as Gerbrand van den Eekhout, for *f*61.–); possibly: Diderick Smith sale, Amsterdam, 13 July 1761 (Lugt 1165), lot 15 (*f*150.– to Lafrens); Dr Johan Pieter Wierman sale, Amsterdam (Van der Land), 18 August 1762 (Lugt 1237), lot 2 (*f*530.– to Hogenberg); sale, Amsterdam, 30 November 1772 (Lugt 2082), lot 1; Jan Tak sale, Soeterwoude, 5 September 1781 (Lugt 3295), lot 5 (*f*499.– to Delfos); M. van Leyden sale, Paris, 10 September 1804 (sale postponed to 15 November), lot 30 (as 40 x 35 *pouces* [108 x 94.5 cm], 400f to Mr La Roche)[1]

LITERATURE
Terwesten 1770, 3:252 (as Gerbrand van den Eeckhout); Roy 1972, 165–6, 220, no. 61 (as G. van den Eeckhout, c. 1655); Sumowski 1983–94, 1:140, 142n55, 149,

165 (illus., as Jan van Noordt), 6:3588, 3735, with no. 2396a; Bruyn 1984, 149 (as Gerbrand van den Eeckhout); exhibition catalogue Paris 1987, 86 (as Jan van Noordt); exhibition catalogue Basel 1987, 114 (illus. 31a, as Jan van Noordt)

In his interpretation of this standard theme, Van Noordt placed the cross bearing Jesus in the foreground, with Mary at its foot. In front, one of the two thieves is being bound to a cross lying on the ground, and to the left the other thief is being led to his cross. The soldier to the left carrying the long staff anticipates the moment when Jesus, just before his death, is offered a sponge with vinegar for his thirst. Van Noordt's depiction bears many similarities to Govert Flinck's *Crucifixion* of 1647, now in Basel (fig. 44). Both images show Christ's cross caught in light, standing to the right of centre, with clustered groups of figures below.[2] The attribution of this work to Gerbrand van den Eeckhout was accepted by Bruyn on the basis of the signature; however, the form and, as Roy has pointed out, the many-figured composition are atypical for him.[3] It bears greater similarity to Van Noordt's depictions of *John the Baptist Preaching* (cat. 10, 11), and is properly placed instead in his oeuvre. In both, groups of small figures engaged in various actions generate an overall turbulent energy, accentuated by curved edges and forms. There are many correspondences between these figures, and with those in his other early paintings, especially *Caritas* (cat. 24). These paintings share a soft and glowing light, illuminating several areas against the surrounding darkness, as well as a correspondingly rounded modelling of form. The patchy chiaroscuro modelling in translucent paint and the diffusion of focus indicate an early date of around 1648.

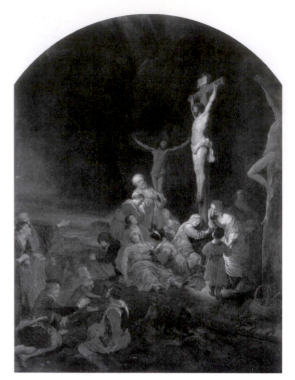

FIGURE 44
Govert Flinck, *The Crucifixion*, panel, 119.2 × 89.2 cm, signed and dated 1647, Basel, Kunstmuseum, permanent loan of the Gottfried Keller Foundation 1904 (photo: Kunstmuseum Basel, Martin Bühler).

1 My thanks to Volker Manuth, who is preparing a monograph on Van den Eeckhout, for indicating these references.

2 Govert Flinck, *The Crucifixion*, panel, 119.2 x 89.2 cm, signed and dated 1647, Basel, Kunstmuseum (inv. no. 212); see Sumowski 1983–94, 2:1024, no. 630, 1062 (illus.).

3 For Bruyn's comment, see Bruyn et al. 1982, 1:70–88, no. A 106. Roy maintained the attribution to Van den Eeckhout; see Roy 1972, 165–6, 220, no. 61.

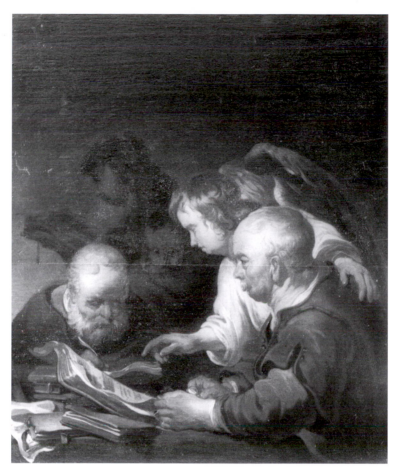

CATALOGUE 16
The Four Evangelists, panel, 40 × 33 cm, Poole, Dorset, collection of C.H. Brown.

CATALOGUE 16
(p) *The Four Evangelists*
Panel, 40 x 33 cm, Poole, Dorset,
collection of C.H. Brown

Four men are shown engrossed in books in the company of an angel. With this painting Van Noordt seems to have created an original representation of the four evangelists. They are accompanied only by an angel, the traditional attribute of Matthew; other attributes of the evangelists are not present. It is unclear whether the artist intended Matthew to be the man to the left, busy writing under the angel's direction, or the man to the right, on whose shoulder the angel rests his hand. The angel may have been intended not as an attribute, but

as a symbol of the divine inspiration of all of the evangelists. If they are to be identified, then it seems likely that Matthew and Luke, who are normally depicted as the most senior and scholarly evangelists, share the foreground, with Matthew to the right, closest to the angel. The man in the background left is likely John, who is typically shown as youthful, leaving Mark as the middle-aged man below him. When the evangelists are shown in a group such as this one, the artist usually gives roughly equal priority to each figure. The unusual prominence given to the one evangelist to the right raises the question of his special significance for the artist or recipient.

This intriguing panel surfaced only recently, and was first given to Van Noordt by Werner Sumowski. The rounded shapes

of drapery, hair, and books point to Van Noordt, as does the characteristic facial type of the angel, with long nose and weak chin, seen in *The Triumph of David* and *The Massacre of the Innocents* (cat. 4, 14). Moreover, the head of the evangelist in the foreground relates directly to the head of one of the two elders (an ignominious comparison) in the artist's earliest depiction of *Susanna and the Elders*, in Utrecht (cat. 6). The head of the other foreground evangelist is drawn from head studies by Jacob Adriaensz. Backer, and used by other artists as well (fig. 45).[1] More astonishingly, the figure of Mark is adapted from *Scholar by Candlelight*, in Milwaukee (Br. 425), of around 1627/28, which can be attributed to Rembrandt.[2] Van Noordt likely painted this panel around 1659, when he started to experiment with strong light effects, generating multiple accents in his compositions. The haphazard placement of the two figures in depth is furthermore characteristic of his ambitious, but not entirely resolved, compositions of the late 1650s and early 1660s, such as those mentioned above.

Van Noordt created this modest image on a small panel, which had likely previously been used for another painting. The boards run in the wrong direction, horizontally in a vertical composition. The split is below the centre, suggesting that the panel had been cut down on one side, and it runs through several prominent heads, a problem artists typically took pains to avoid. These atypical aspects suggest that this painting was not an important commission, and was generated spontaneously, painted on an immediately available and not entirely appropriate support. This raises the hypothesis that the artist may have painted it as a gift for a family member. His younger brother Lucas had completed his theological studies in 1652, and in 1654 became a *predikant* in Diemen, an appropriate context for these Gospel writers.[3] In this case, the foreground figure should be identified

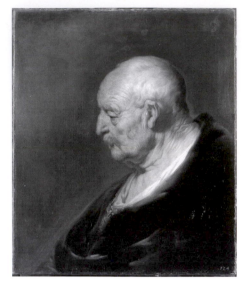

FIGURE 45
Jacob Adriaensz. Backer, *Profile Head of a Old Man Facing Left*, oil on canvas, 63.5 × 53 cm, Dresden, Staatliche Kunstsammlungen Dresden, Gemäldegalerie Alte Meister (photo: Estel/Klut ©SKD).

with Luke, and Matthew would be the other foreground figure, receiving advice from the angel. The artist may have been more inclined to paint such a personal, non-remunerative work while he was working for the open market, and not devoting his energy to commissions from waiting patrons.

1 Jacob Adriaensz. Backer, *Profile Head of a Old Man Facing Left*, canvas, 63.5 x 53 cm, Dresden, Gemäldegalerie Staatliche Kunstsammlungen, inv. no. 1585; see Sumowski 1983–94, 1:195, no. 18, 221 (illus.).
2 Attributed to Rembrandt, *A Scholar by Candlelight*, oil on copper, 13.8 x 13.8 cm (originally 15.5 x 13.8 cm), Milwaukee, collection of Drs Alfred and Isabel Bader. For a discussion of the attribution, see David de Witt, "*The Scholar by Candlelight* and Rembrandt's early transition," in *Collected Opinions: Essays in Netherlandish Art in Honour of Alfred Bader*, London, 2004, 262–77.
3 On Lucas's career, see Giskes 1989, 112–13.

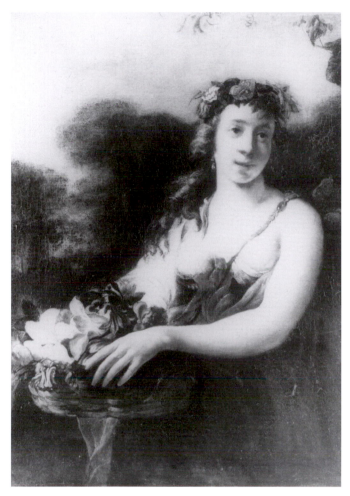

Flora, canvas, 89 × 70 cm, present location unknown.

CATALOGUE 17
(p) *Flora*
(Ovid, *Fasti* V, 183–7), canvas, 89 x 70 cm,
present location unknown

PROVENANCE
Sale Hulin de Loo, Brussels (Palais des
Beaux-Arts), 29 October 1947, lot 98 (illus.
pl. 13, as Govert Flinck, *Pomona*); sale, Am-
sterdam (Sotheby- Mak van Waay), 15–17
June 1982, lot 19 (illus., as Govert Flinck)

LITERATURE
Von Moltke 1965a, 233, no. R43 (as proba-
bly by Jan van Noordt or Jacob van Loo)

A wanly smiling young woman holds a
basket full of flowers in her arms. She
wears a floral wreath on her head and a
simple dress with a low decolleté, held up
by a jewelled leather strap. The garment
relates to the costumes in Van Noordt's
depictions of allegorical figures or god-
desses of antiquity, such as Caritas (cat.
24), Venus (cat. 20, 22), and Juno (cat. 18).
The attributes and dress in this picture

point to an identification as Flora, the goddess of flowers and gardens, who was associated with the blooming of plants in springtime. She had been Chloris, nymph of the fields, but was transformed after her rape by Zephyr, god of the west wind. The most elaborate reference to Flora in classical literature is a passage in Ovid's *Fasti*, in which the poet relates a sudden encounter with the goddess, in which she describes herself to him.[1]

At the beginning of the seventeenth century, Van Mander provided artists with a brief description of Flora in his *Grondt der Edel vrij Schilder-const*, the didactic poem at the beginning of his *Schilder-boeck*.[2] With her many flowers, she served as an example to illustrate the compositional principle of *copia*, or richness. Van Noordt would also have had access to the description of Flora provided in the 1644 translation of Ripa's *Iconologia*, which drew more directly from the passage in Ovid:

> Off to the side stands a young virgin,
> Who often dances, or plays, or hunts,
> This is the season, clad in green,
> Decked with red, white, yellow flowers.
> Her cheeks blush with Milk and Roses,
> Her teeth are white as pearls.
> Coral sways about her lips:
> She is decorated with a floral wreath.
> And devotes herself to playfulness,
> In which lustful Passion avoids her.[3]

Van Noordt may have been influenced by Rembrandt's painting of the same subject in St Petersburg (Br. 102).[4] The pose of the goddess, turned toward the left and holding up flowers in the nearer arm, is similar to the Rembrandt.

The modelling of form, smooth yet with strong transitions, relates to the earliest works by Jan van Noordt, especially, *Caritas*, in Milwaukee (cat. 24), and the two earliest depictions of *Cimon and Iphigenia* (cat. 28, 29). Several details, such as the elongated, squared-off fingers, and the soft, spongy handling of background fo-

liage, confirm the connection to these pictures and point to a date between 1645 and 1650. Unfortunately, this painting is known only through photographs.

1 See Ovid, *Fasti*, in *Ovid*, vol. 5, trans. Sir James George Frazer, 2nd. ed., rev. G.P. Gould, Loeb Classical Library 253, Cambridge, Massachusetts, 1989, 273–87. For a discussion of the theme in the work of Titian and other artists, see Held 1961.

2 Flora is mentioned briefly as an example of a "rich" painting, in Van Mander, *Grondt der Schilder-const*, in Van Mander 1969c, fol. 17v, 32:
"*Oock als* Zephirus Flora *comt ontmoeten/ Daer sy hen voortijts meerder ondercusten/ En ghevlerckte Sanghers* Aurora *groeten/ Jae daer de nieu Blomkens de Lucht versoeten/ De heunich soeckers/ die nae soetheyt lusten/ Connen niet altijt op* Adonis *rusten/* Corcus *en* Smilax *sillen sy niet missen/* Ajaxen, Hiacinten, *noch* Narcissen."
(Also when *Zephirus* comes to meet *Flora* Where she repeatedly kissed him And Singers wearing flowers greet *Aurora* Yea where the new flowers sweeten the air The seekers of honey, who yearn for sweetness Cannot always stay with *Adonis* *Crocus* and *Smilax* they will not pass by *Ajax, Hyacinths,* nor *Narcissi*).

3 Flora appears in Ripa's *Iconologia*, under the heading of the season of Spring; see Ripa 1644, 506, (s.v. *De Lente. Saysoen des Jaers*): "*Oock wort de* Lente *by* Flora, *die met bloemen rontom besteecken is, afgebeeld, hebbende oock de handen vol. Waer van* Ovidius *in't 2 boeck* Metamorph. *gewagh maeckt, 't welck van* Anguillare *aldus is uytgebreyt* (Spring is also represented as *Flora*, who is stuck all around with flowers, and has her hands full as well. To which *Ovid* in the second book of his *Metamorphoses* also aspires, which is thus elaborated by *Anguillare*):
"*Ter sijden staet een jonge Maeghd, Die dickwijls danst, of speelt, of jaeght. Dees is 't Saysoen, in 't groen gekleet, Met root, wit geel gebloemt bespreet. Van Melck en Roosen bloost haer wangh, Haer tanden zijn als peerlen blanck.*

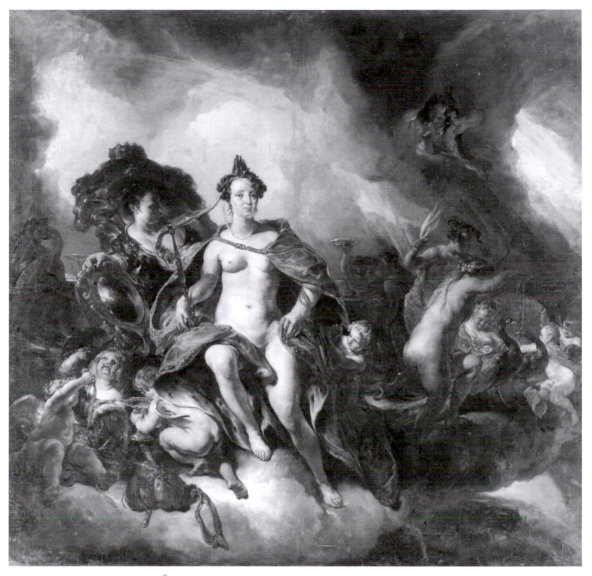

CATALOGUE 18

Juno in the Clouds, canvas, 275 × 287 cm, Braunschweig, Herzog Anton Ulrich-Museums
Braunschweig. Kunstmuseum des Landes Niedersachsen (photo: B.P. Keiser).

't Korael rontom haer lippen swiert:
S' is met een bloeme-krans geciert.
En boert self om de dartelheyt,
Waer geyle Min haer in vermeyt."

4 Rembrandt, *Flora*, canvas, 124.7 x 100.4 cm,
St Petersburg, Hermitage (inv. no. 732); see
Bruyn et al. 1982, 2:495–503, no. A 93 (illus.).

CATALOGUE 18
Juno in the Clouds
Canvas, 275 x 287 cm, Braunschweig, Her-
zog Anton Ulrich-Museum (inv. no. 1373)

PROVENANCE
Impounded by the state in 1740
("*kaufgericht*"); transferred to Schloß
Braunschweig, Ducal collection, in 1820;
transferred to the Herzog Anton Ulrich-
Museum in 1945

LITERATURE
Sumowski 1983–94, 5:3112, no. 2140,
3287 (illus.); exhibition catalogue Utrecht
and Luxembourg 1993–94, 241n8

COLLECTION CATALOGUES
Braunschweig 1983, 156, no. 1373 (illus.);
Braunschweig 1990, 54–5, no. 26 (illus.)

This formidable depiction of the god-dess of classical antiquity corresponds
in many points to the prescription in Karel
van Mander's *Schilder-boeck* of 1604.[1] She
appears here with her crown and sceptre,
purple cloth and robe, a chariot and
horses, many jewelled trappings, and her
peacocks. Off to the left, Juno's husband
Jupiter can be identified by the eagle with
bolts of lightning in his beak, and by his
crown. He is seated and looks on, holding
his head in wonder. Another powerless
spectator is the old woman appearing
above to the right, with sagging breasts
and snakes for hair; she represents *Invidia*,
or envy. Juno is joined by six *putti*, who
play with her jewels and treasures.

The other accompanying figures are
less conventional for representations of
Juno. Immediately to the left of the god-dess, a female figure holds a mirror before
her, an attribute that identifies her as
Prudentia.[2] Foresight, or intelligence, is
one of Juno's qualities. The goddess also
presides over fertility in Nature, which is
referred to by the two figures in the dis-tance to the right of the goddess. There,
Bacchus, god of wine, raises his cup, and
Ceres, goddess of grain, holds ears of
corn.[3] Van Noordt depicted this pair in
similar poses, but from different angles,
in his painting *Sine Cerere et Libero friget
Venus* of around 1660 (cat. 22).

The three female figures to the right,
who drape Juno's peacocks with pearls,
are the *Horae* (the Hours), who attend to
Juno.[4] Children of Zeus and Themis, they
are goddesses of the seasons, and were
traditionally linked to blooming (*Thallo*,

Spring), growing (*Auxo*, Summer), and
ripening (*Carpo*, Autumn) in Nature. Their
connection to fertility links them in turn
to Juno.[5] One of them holds an ear of corn,
which may refer to Summer. They also
had ethical names, given to them already
by Hesiod (*Theogony* 901–7): Spring was
known as Eunomia (law and order), Au-tumn as Diké (justice), and Summer as
Eirene (peace). Another role of the *Horae*,
which seems to be represented here, was as
wardens of the sky; they rolled the clouds
back from the gates of Olympus whenever
the gods went forth in their chariots. The
Horae were only rarely depicted in art,
and there is no precedent for Van Noordt's
representation of them as attendants to
Juno. Van Noordt seems to have been
lead directly by the antique reference in
Homer's *Iliad* (VIII, 479). His humanist
aspiration reminds us that his father was
a schoolteacher as well as a musician,
and may have sparked his son's interest
in learned subjects.[6]

Juno's features do not accord with Van
Noordt's typical idealizations, and may be
those of a sitter, which makes this painting
a *portrait historié*. Sumowski has suggested
that she is a member of the House of
Orange, because the colour takes special
prominence.[7] However, we have no evi-dence to support this link. At the time
there was no stadholder, nor was there
anyone at the court in The Hague who
could have sat for such a portrait. The
risqué pose is highly unusual and does
not speak specifically in favour of a patron
from this court. A drawing of this compo-sition, perhaps a *ricordo*, is in Bremen
(cat. D8).

1 Van Mander, 1969c, fol. 126v (*s.v. Juno*).
2 One of Ripa's personifications of prudence is a
 woman holding a mirror, by which she can rec-ognize her own faults and shortcomings. See
 Ripa 1644, 622–3 (*s.v. Prudenza, of Wijsheid*).
3 For the iconography of Bacchus and Ceres,
 see cat. 22.
4 For a discussion of the roles of the *Horae* and

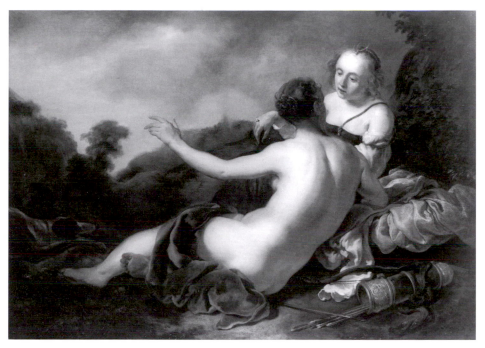

CATALOGUE 19
Jupiter and Callisto, panel, 77 × 107 cm, present location unknown.

their connection to Juno, or Hera, see *Der Kleine Pauly* 1979, 2: cols. 1216–17 (*s.v. Horai*).

5 Thomas Döring first proposed the identification of these three figures as the *Horae,* linking them to Juno by way of their associations with justice and with fertility in Nature. See collection catalogue Braunschweig 1990, 54.

6 On Van Noordt's family, see page 8.

7 See Sumowski 1983–94, 5:3112.

CATALOGUE 19
(p) *Jupiter and Callisto*
(Ovid, *Metamorphoses* II, 401–40), panel
77 x 107 cm, present location unknown

PROVENANCE
Amsterdam, with Enneking Gallery, in 1965; sale, Cologne (Lempertz), 11 December 1989, lot 409 (illus., as Jan van Noordt); sale, Paris (Drouot: Étude Tajan), 9 April 1990, lot 90 (illus., as Jan van Noordt)

LITERATURE
Von Moltke, 1965a, 275, addendum (illus., as not by Govert Flinck); exhibition catalogue Delft, 1965 (not paginated, with illustration, as Flinck); Sumowski 1979–, 5:1958; Sumowski 1983–94, 1:140, 143n69, 174 (illus., as Jan van Noordt); Sluijter 1986, 128, 129, 462n128–6.

Jupiter changes into the shape of Callisto's mistress, Diana, to approach her after she has returned from hunting. This moment is set in Van Noordt's painting by the quiver and arrows lying on the ground in the foreground and the two greyhounds to the left. The artist showed the moment right before Jupiter's advance. Callisto is seen from the back, her hand raised in a gesture that emphasizes how she is innocently engrossed in relating the action of the hunt. We see the face of Jupiter in Diana's guise, crowned with a half-moon, smiling with pleasure at Callisto's beauty.

The tradition for this theme in Dutch art originated with the illustration by Bernard Salomon to an important Ovid edition of 1557.[1] The most important model for seventeenth-century artists was the depiction by Rubens, now in Vienna, which emphasized the sensual figure of Callisto, reclining nude across the foreground, and the affectionate gesture of Jupiter, in Diana's guise.[2] Rubens' painting likely provided the source for a painting by Jacob Backer of the same theme, which survives only as a fragment (fig. 46).[3] In turn, Van Noordt seems to have drawn directly from the painting by Backer, his teacher. The upper half of Callisto seen from the back and the figure and face of Jupiter approximate the fragment by Backer. Van Noordt was similarly influenced by his teacher's work in his early depictions of Cimon and Iphigenia.

The attribution of this easel-sized panel to Van Noordt was first made by Willem van de Watering. The back view of the figure of Callisto, with its broad and rounded shoulder, is typical of Van Noordt's depictions of female figures out of classical mythology. The swelling form of the hand raised in the air further shows Van Noordt's characteristic approach to anatomical form, especially in the use of the underdrawn contour line to strengthen the effect of roundness. The strong dark-light contrast departs from the paler palettes Backer and Flinck typically applied to such sub-

FIGURE 46
Jacob Adriaensz Backer, *Jupiter and Callisto*, canvas, 68.3 × 57.5 cm, present location unknown.

jects. A patchy quality, resulting from distributed highlights and flat areas of lighter tones, with abrupt transitions from light to dark, places this painting around the same time as the Cherbourg *Cimon and Iphigenia*, around 1650 (cat. 29). Von Moltke has identified a drawn study for the figure of Callisto in the Amsterdam Rijksprentenkabinet.[4] The poses do not correspond closely, however, and the painting was likely made independently.

1 See Borluit 1557. For the evolution of the iconography see Sluijter 1986, 128–32.
2 Peter Paul Rubens, *Jupiter and Callisto*, panel, 126 x 184 cm, signed and dated 1613, Kassel, Gemäldegalerie Staatliche Museen (inv. no. GK 86).
3 Jacob Adriaensz. Backer, *Jupiter and Callisto*, canvas, 68.3 x 57.5 cm, sale, London, Christie's, 29 October 1993, lot 57 (illus., as Gerrit van Honthorst).
4 Attributed to Govert Flinck, *Reclining Female Nude*, black and white chalk, and brown ink wash, on blue-grey paper, 24 x 39 cm, signed and dated 1643, Amsterdam, Rijksprentenkabinet, inv. no. 1982–76. See Von Moltke 1965a,

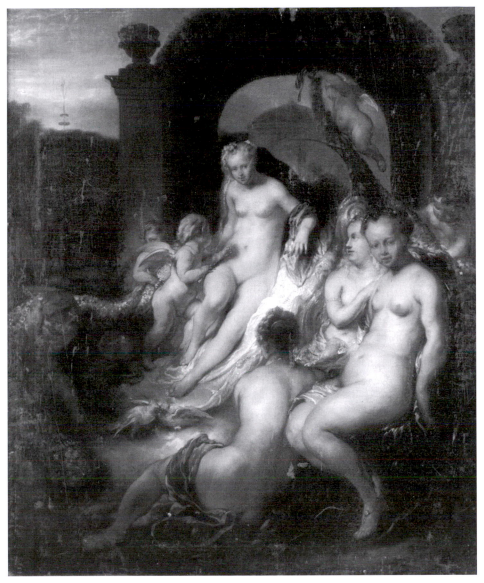

CATALOGUE 20

Venus and the Three Graces, canvas, 79 × 65.5 cm, The Hague, Instituut Collectie Nederland.

219, no. D220; and Sumowski 1979–, 5:1958–9, no. 898 (illus.). The drawing differs from the present painting in the form of the back and shoulder and in the isolation of the figure against a broad and open background.

CATALOGUE 20
Venus and the Three Graces
Canvas, 79 x 65.5 cm, The Hague, Instituut Collectie Nederland (inv. no. NK 1697)

PROVENANCE
Amsterdam, collection of F. Rothman, in 1927; The Hague, collection of A.C. Baron van Heerdt, in 1936; Amsterdam, with

De Boer, in 1940; Berlin, with W.A. Hofer; Berlin, collection of Hermann Göring; acquired by the Dienst voor 's-Rijks verspreide Kunstvoorwerpen in 1946

LITERATURE
Bloch 1927, 605 (illus.); Schneider 1931, 511; Staring 1946, 47 (illus., pl. 16); Von Moltke 1965a, 272; Sumowski 1983–94, 1:143n68; 5:3112, with nos. 2140, 2141; exhibition catalogue Utrecht and Luxembourg 1993–94, 241n8; exhibition catalogue Dijon 2003–04, 151

EXHIBITIONS
The Hague 1936–37, 39, no. 150

COLLECTION CATALOGUES
The Hague 1992, 226 (illus.)

Conjuring the spirit of pagan mythology with a vibrant energy, this picture can be grouped with *Nymphs and a Satyr*, also in The Hague (cat. 21). The goddess of love is seated further back, joined at her right side by Cupid, who leans against her, holding an arrow in his fingers. Following a tradition relating to the Feast of Love, Venus is joined by the three Graces, Agleia, Euphrosyne, and Thaleia, who are seated and reclining in the foreground. The group of figures forms an arc around the centre, a motion echoed in the arch behind them, a piece of garden architecture consisting of trimmed shrubbery flanked by square pillars that are topped with vases. The motion is repeated again in the silhouette of a dome, further back. Four *putti* cavort about with a long festoon, and swathes of drapery continue the motion with sweeping and rippling folds. Van Noordt achieved a similar turbulent energy in *The Massacre of the Innocents* (cat. 14). The present work, with its less-resolved composition, likely dates a little earlier, to around 1655.

Van Noordt's robust early type of female nude followed that of his teacher, Jacob Backer, and ultimately reflected Rubens' absorption of Michelangelo. The broad and round-shouldered figure in the centre foreground also appears, in a different pose, in *Nymphs and a Satyr*. For the figure of one of the Graces to the right, the artist seems to have adapted a pose he studied in a drawing in Rennes, of the head and shoulders of a female model (cat. D7). The figure of Venus is more compact and smooth, and bears many similarities to the *Susanna* in Utrecht and to the drawn figure study in Munich (cat. 6, D2).

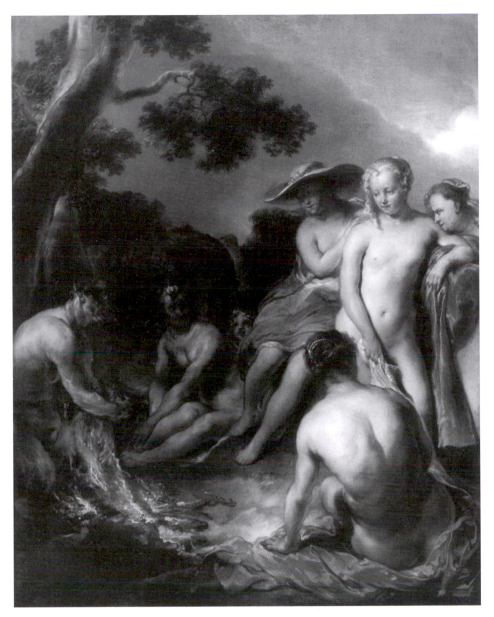

CATALOGUE 21
Nymphs and a Satyr, canvas, 83 × 67 cm, The Hague, Instituut Collectie Nederland.

CATALOGUE 21
Nymphs and a Satyr
Canvas, 83 x 67 cm, The Hague, Instituut
Collectie Nederland (inv. no. 3260)

PROVENANCE
Amsterdam, with Rosenbaum; Amsterdam,
with Jacques Goudstikker (as Jordaens);

Amsterdam, with Goudstikker/Miedl;
acquired by the Dienst voor 's-Rijks
verspreide Kunstvoorwerpen in 1946

LITERATURE
Pieter den Hollander, *De zaak Goudstikker*,
Amsterdam, 1998, 250

EXHIBITIONS
The Hague 1946, 20, no. 41; Utrecht
1946, 32, no. 75

COLLECTION CATALOGUES
The Hague 1992, 227 (illus.)

Van Noordt's theme in this painting
has not yet been identified. The vari-
ous female figures to the right side are
likely nymphs. Although she wears no
crescent moon, the figure in the centre is
likely Diana, who was traditionally accom-
panied by dryads, or wood-nymphs. The
presence of satyrs to the left side reinforces
the identification, as they traditionally ac-
companied the wood-nymphs.[1] One seems
to hold his hands to the fire, perhaps allud-
ing to his state of sexual arousal. One of
the nymphs at the far right menaces him
with a snarl, clenching her fist beside her
head. These narrative elements strongly
suggest a specific story, yet it is possible
that Van Noordt simply made use of classi-
cal personages in a genre-like fashion.[2]

This painting can be grouped with sev-
eral others by Van Noordt, including *Venus
and the Three Graces*, also in The Hague,
which feature many-figured compositions
and a swirling overall movement (cat. 20).
The effect is similar to *The Massacre of the
Innocents* (cat. 14), indicating a date of
around 1660. The isolation of figures in
focused light also emerged in Van Noordt's
paintings of around this time.

1 On nymphs and satyrs see Roscher 1884–1937,
 3: part 1, cols. 520–2.
2 Eric Jan Sluijter has suggested that similar
 scenes by Cornelis van Poelenburg were free
 inventions, developed from the theme of
 Diana and Actaeon (1986, 76)

CATALOGUE 22
(p) *Sine Cerere et Libero friget Venus*
(Terence, *Eunuchus* 4, 5, 732), present
location unknown (photo formerly in the
file of the Statens Fotografisamling pan
Charlottenborg, Copenhagen), canvas,
dimensions unknown

LITERATURE
Decoen 1931, 18

The grouping of Venus, Bacchus, and
Ceres represents a classical saying
best known from a line in a play by Ter-
ence. This remarkable picture, which is
perhaps only a fragment, is known only
through a copy photo in The Hague,
showing Bacchus raising a bowl of wine,
with Ceres to the right, and behind them
Venus, accompanied by Cupid. Venus un-
derscores the connection between love and
food by pinching her nipple with one hand
and raising an orange in the other. Van
Noordt was likely inspired by one of
several well-known prints by Hendrick
Goltzius.[1] In his Baroque reinterpretation,
Van Noordt applied freer and more
spontaneous poses and a more haphazard
arrangement, in which Ceres partly blocks
our view of Venus. The pose of Bacchus,
raising a wine bowl up high, relates direct-
ly to another print by Goltzius depicting
only this deity (fig. 47), which was itself
derived from Michelangelo's famous sculp-
ture of *Bacchus* in the Bargello.[2] By looking
to Goltzius, Van Noordt revisited the
climate of humanism in Haarlem around
1600. Goltzius's friend and fellow human-
ist, the poet, painter, and biographer Karel
van Mander, also included a reference to
Terence in his *Schilder-boeck*.[3]

This work can be grouped with and
Venus and the Three Graces and *Nymphs and
a Satyr*, both in The Hague (cat. 20, 21).
Like them, it combines several classical
figures in a spirited composition. With its
broadly brushed, agitated forms of drapery
in the foreground, and its more fully

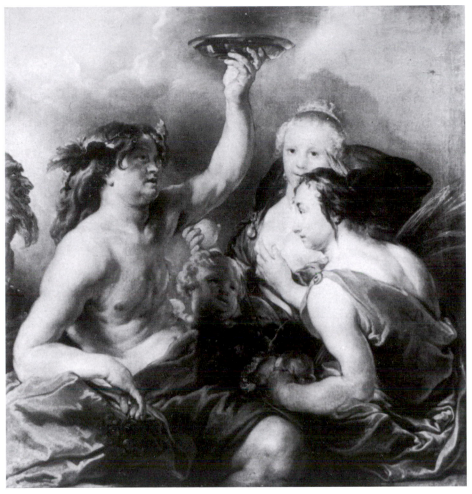

CATALOGUE 22
Sine Cerere et Libero friget Venus, present location unknown, canvas dimensions unknown.

FIGURE 47
Hendrick Goltzius, *Bacchus*, from the series *Bacchus, Venus and Ceres*, engraving, 24.8 × 18.3 cm, Amsterdam, Rijksmuseum (photo: Rijksmuseum-Stichting Amsterdam).

formed volumes built up in opaque lighted areas and strong reflections in the shadows, it likely dates a little later, to around the middle of the 1660s.

1 Hendrick Goltzius, engraving, round, Ø9.6 cm, 1590 (Hollstein 1949–, 305); engraving, round, Ø16.5 cm, 1595 (Bartsch 1803–21, 155; Hollstein 1949–, 133); see Strauss 1977, 2:502–3, no. 284 (illus.); 594–5, no. 325 (illus.). Jan Saenredam after Hendrick Goltzius, engraving, 41.8 x 31.6 cm, 1600 (Bartsch 1803–21, 69); see Huigen Leeflang in exhibition catalogue Amsterdam, New York, and Toledo 2003–04, 219 (illus. fig. 78a); 219–20, no. 78.2 (illus.); 230–3, no. 83.3 (illus.)
2 Hendrick Goltzius, *Bacchus*, from the series *Bacchus, Venus, and Ceres*, engraving, 24.8 x 18.3 cm (Hollstein 1949–, 134); see Strauss 1977, 2:618, no. 336 (illus.). Michelangelo, *Bacchus*, marble, height 183.8 cm without base, c. 1496–97, Florence, Museo Nationale (Bargello); see Hartt 1969, 7077, no. 5 (illus.).
3 Van Mander referred to the proverb in Terence, in his discussion of Venus in Ovid's *Metamorphoses*. See Van Mander, 1969b, fol. 29v. For further discussion of the popularity of this theme among the Haarlem Mannerists, see Dirk Kocks, "Sine Cerere et Libero Friget Venus: Zu einem manieristischen Bildthema, seiner erfolgreichsten kompositionellen Fassungen und deren Rezeption bis in das 18. Jahrhundert," *Jahrbuch der Hamburger Kunstsammlungen* 24, 1979, 117–42.

CATALOGUE 23
The Satyr and the Peasant Family
Canvas, 80 x 96.5 cm, Kingston, Canada, Agnes Etherington Art Centre (acc. no. 27–016), gift of Alfred and Isabel Bader, 1984

PROVENANCE
C.E. Vertue et al. sale, London, 18 July 1910 (Lugt 68919), lot 59 (as Barent Fabritius, 31 x 37.5 in. [78.7 x 94.3 cm] for £31.10 to Grant); collection of Sir Charles Newton Robinson; sale J.C. Robinson et al., Berlin (Lepke), 31 March 1914 (Lugt 74079), lot 48 (illus., as B. Fabritius); Melche collection; Lady Gwen Melchet sale, London (Sotheby's), 23–24 May 1951, lot 11 (illus., as B. Fabritius); sale, London (Christie's), 18 December 1953, lot 93 (B. Fabritius, 31 x 38 in. [78.7 x 96.5 cm]); Dr Max Welti et al. sale, Lucerne (Fischer), 22 June 1954, lot 2309; Milwaukee, collection of Alfred and Isabel Bader; donated to the Agnes Etherington Art Centre in 1983

LITERATURE
Van Braam 1951, 208, no. 1339 (illus., 29, as Barent Fabritius); Pont 1958, 131, cat. B, no. 15 (as Joan van Noordt?); Sumowski 1983–94, 1:142n64; 5:3062n2, 3112, with no. 2142; 6:3588; Sumowski 1986, 27, 28 (illus. fig. 8), 36n34, De Witt 1993.

Aesop's satyr hastily abandons the hospitality of the peasant who rescued him from cold and starvation. Wary of someone who blows "hot and cold," warming his hands but cooling his soup with the same breath, the satyr underscores the moral lesson that one should never trust those who voice contradictory views. A staple of basic wisdom, the Fables had enjoyed a continued use in the instruction of children from antiquity onwards.

The tradition for depicting this particular fable was still young when Van Noordt painted it. The seminal image seems to have been the illustration print in the

CATALOGUE 23

The Satyr and the Peasant Family, canvas, 80 × 96.5 cm, Kingston, Canada, Agnes Etherington Art Centre, gift of Alfred and Isabel Bader, 1991.

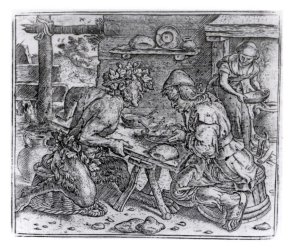

FIGURE 48
Marcus Gheeraerts, *The Satyr and the Peasant*, in Joost van den Vondel, *Vorstelijke Warande der Dieren*, Amsterdam (Dirck Pietersz), 1617, no. 67.

edition of the Fables published in Bruges by Pieter de Clerck in 1567. In the northern Netherlands, the same plate was re-used for the translation of Aesop by Dirck Pers, which was published by Joost van den Vondel in 1617 as the *Royal Garden of Animals* (*Vorstelijke Warande der Dieren*).[1] The engraver Marcus Gheeraerts depicted the startled satyr rising up from the table, looking up at the peasant sitting across from him, who is blowing into his soup (fig. 48). The best-known artist to have taken up the theme in paintings was the Fleming Jacob Jordaens, and he did so several times.[2] In the depiction in Brussels, the satyr actually strikes an admonitory pose, turning toward the viewer and raising his finger. Jordaens' painting, and the print by Vorstermans after it, were well known, and were singled out for mention by Arnold Houbraken when he wrote Jordaens' biography in 1717.[3] Later in the seventeenth century, the Rembrandt pupil Barent Fabritius returned to this theme repeatedly, and fellow-pupil Gerbrand van den Eeckhout also painted it.[4]

The interpretation by Jan van Noordt as well as those by Van den Eeckhout and

Fabritius function much more as narratives than didactic moralizations, drawing attention to the event and its actions and emotions. Van Noordt emphasized the surprised reaction of the satyr, placing his dark figure, posed in an awkward back-step, against the light background sky. The peasant and his wife look over in astonishment, while their daughter sits under the table, oblivious to the drama above. The expressions are not clearly articulated, an aspect that is consistent with the artist's early work, for example the *Cimon and Iphigenia* in Cherbourg (cat. 29), in which the figure of Cimon is silhouetted. Looser in handling and technique, the present work was likely done around 1650.[5] Increasing paint transparency has rendered partly visible a figure in the centre that had been painted over.

1 See Vondel 1617, no. 67. For the identification of Pers as the author, see G.A. Nauta, "De onderschriften der platen van de Warande der Dieren," *Vondelkroniek* 4, 1934, 18–30.

2 Jacob Jordaens, *The Satyr and the Peasant Family*, canvas, 185 x 168 cm, Brussels, Museum van Oude Kunst, inv. no. 6179; see d'Hulst 1982, 97, no. 62, 98 (illus.).

3 Houbraken 1976, 1:157. Houbraken even included a note explaining the fable. Vorstermans' print reproduced the version in Munich (see n1): Lucas Vorsterman Jr., after Jordaens, *The Satyr and the Peasant Family*, engraving, 40.8 x 39.9 cm: Hollstein 1949–, 43:92, no. 97, 93 (illus.); see exhibition catalogue Ottawa 1968, 242, no. 293, 404 (illus.). The version in the Kunstmuseum in Göteborg is a close variation on this composition; see n2.

4 The versions are Barent Fabritius, *The Satyr and the Peasant Family*, canvas, 50.8 x 63.5 cm, Hartford, Wadsworth Athenaeum, Ella Gallup Sumner and Mary Catlin Sumner Collection; see Pont 1958, 32–3, 113, no. 26. Pont dates this picture to 1653–34. See also Sumowski 1983–94, 2:910, 915, no. 549, 929 (illus.). Canvas, 194 x 95 cm, signed and dated 1662, Bergamo, Accademia Carrara; see Pont 1958, 49, 113, 114, no. 27, and Sumowski 1983–94,

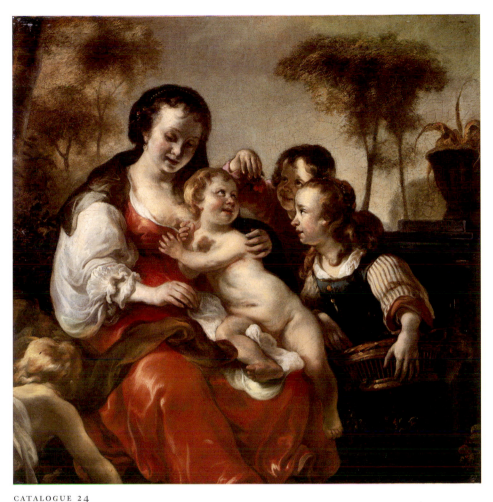

CATALOGUE 24

Caritas, canvas, 62.2 × 61.5 cm (cut down from 120.6 × 104.1 cm), formerly signed and dated 1645, Milwaukee, collection of Mr and Mrs William C. Treul.

2:910, 912, 920, no. 568, 946 (illus.). Gerbrand van den Eeckhout, *The Satyr and the Peasant Family*, canvas, 57 x 76 cm, signed, Stockholm, Nationalmuseum (inv. no. 418); see Sumowski 1983–94, 2:721, 731, no. 421, 784 (illus.). Another version was on the art market in 1950: canvas, 56 x 65 cm, signed and dated 1653; see Sumowski 1983–94, 2:721, 730, no. 416, 779 (illus.).

5 Sumowski viewed it as a late picture, and compared it with the Mänttä *Shepherdess* (cat. no. 43); see Sumowski 1986, 27.

CATALOGUE 24

Caritas

Canvas, 62.2 x 61.5 cm (cut down from 120.6 x 104.1 cm), formerly signed and dated lower right: *JAN V. NOORDT 1645*, Milwaukee, collection of Mr and Mrs William C. Treul

PROVENANCE

Possibly: sale, Amsterdam, 16 September 1739 (Lugt 507; Hoet I, 599), lot 131 (as Van Noort, *Een Vrouw met Kindertjes, Verbeeldende de Liefde, heel konstig* (A Woman with Children, representing Love, very

artistic) for ƒ10);[1] John R. Clayton et al. sale, London (Christie's), 30 January 1914 (Lugt 73722), lot 98 (as *The Madonna and Child, with the Infant Saint John, and 2 Children in a Landscape*, by J. van Noordt, signed and dated 1695, 47½ x 41 in. [120.6 x 104.1 cm], to Leger); London, with Leger Gallery; New York, with Ehrich Galleries; their sale, New York (Anderson Galleries), 12 November 1924, lot 23 (as 49 x 42 in. [124.5 x 106.7 cm], signed and dated 1645); Robert Cluett, Jr. et al. sale, New York (Parke-Bernet) 24 November 1939, lot 72 (illus., signed and dated lower right: JAN V. NOORDT 1645, 48.5 x 42 in. [123.2 x 106.7 cm]); Henry Rogers Benjamin et al. sale, New York (Parke-Bernet), 15–17 May 1947, lot 235 (illus., signed and dated 1645, 48.5 x 41.5 in. [123.2 x 105.4 cm])

LITERATURE
Willem L. van de Watering, in exhibition catalogue Washington, Detroit, and Amsterdam 1980–81, 212; Sumowski 1983–94, 5:3112, no. 2141, 3288 (illus., as Caritas); 6:3737, with no. 2403a; Sumowski 1986, 21, 34n4

COPIES
Panel, 90 x 71 cm, sale, Lucerne (Fischer), 29 May–1 June 1990, lot 2025 (illus., as a copy after Jan van Noordt)

Although previously interpreted as *Madonna and Child with St John the Baptist*, the presence of a whole group of children identifies this scene as *Caritas*, as Sumowski recently observed. As early as in 1739, a sale catalogue listed a painting of "*A Woman with Children, Representing Love*, by Van Noordt," which may well be the present picture.

Van Noordt produced a pastoral rendition of the allegorical theme. He employed the shepherd and shepherdess types he was accustomed to painting at this early stage in his career, such as in *Shepherd Boy with a*

Bird's Nest, recently with Sotheby's in Amsterdam, and *Shepherdess and a Goatsherd*, with Leger in 1960 (cat. 39, 35). The stylistic similarity is significant as well; as in those pictures, the present painting has a very strong light from the right, and translucent glazing that builds up a smooth and rounded modelling of flesh, especially in the nude child. Reflections complete the impression of volume. Undulating contours carry a rhythmic motion through the foreground, complemented by the arrangement of rounded forms of figures and faces. The date of 1645 reported in the sale catalogues of 1939 and 1947 is quite plausible. Unfortunately, date and signature were removed when the picture was later cut down. This date places it contemporary to several of the depictions of Caritas and similar themes by Jürgen Ovens, suggesting contact and mutual influence between these two artists.[2]

1 Cat. no. L20. See Hoet 1752, 1:606.
2 The earliest painting by Ovens with a similar theme is *Allegory of Mother Nature*, panel, 82 x 67.4 cm, signed and dated 1646, Schloß Gottorf, Schleswig-Holsteinisches Landesmuseum; Sumowski 1983–96, 3:2218, 2222n9, 2224 (illus.). Four depictions of *Caritas* by him are known: Canvas, 118 x 102 cm, Amsterdam, Rijksmuseum (inv. no. A 1257); see Sumowski 1983–96, 3:2227, no. 1498, 2253 (illus.); Canvas, 130 x 115 cm, Schloß Dyck, collection of Cecilie Fürstin zu Salm-Reifferscheidt; see Sumowski 1983–96, 3:2227, no. 1493, 2248 (illus.); Canvas, 89 x 74 cm, signed and dated 1657, Budapest, Szépmüvészeti Múzeum (inv. no. 191); see Sumowski 1983–96, 3:2226, no. 1490, 2245 (illus.); Canvas, 83 x 106 cm, New York, collection of Dr D.B. Biegun, in 1957; see *Die Weltkunst*, 1 December 1957, 7.

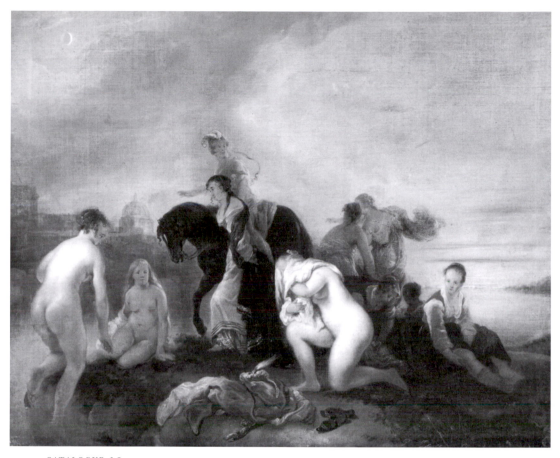

CATALOGUE 25
Cloelia Crossing the Tiber
(Livy, *The Early History of Rome*, II, 13;
Plutarch, *Life of Publicola* XIX, 2–5),
canvas, 86 x 107 cm, Paris, Louvre
(inv. no. R.F. 1985–25)

PROVENANCE
Sale, Paris (Hôtel Drouot: Étude Laurin-
Guilloux Buffertaud-Tailleur), 29 May
1985, lot 56 (as Jacob van Loo); Paris,
with Galerie Chéreau

LITERATURE
Sumowski 1983–94, 6:3736, no. 2401,
4018 (illus.); Louvre 1986, 140 (as Jan
van Noordt)

EXHIBITIONS
Paris 1987, 85–7, no. 56 (illus.)

Van Noordt depicted the Roman girl
Cloelia on the bank of the Tiber,
about to lead her fellow-hostages across
the river in an escape from the Etruscan
king Lars Porsena.[1] Cloelia's bravery
prompted her captor to break off his seige
of Rome. The legend about her crossing
on horseback came from Plutarch, and was
dismissed in the prominent Dutch transla-
tion of Livy of 1541.[2] However, a 1614
edition included a woodcut showing the
horseback crossing, and ironically was like-
ly the source for the subsequent tradition
in painting (fig. 49).[3]

The inspiration for Van Noordt was
likely a painting of the theme by Claes
Moyaert, which shows a similarly static
and pyramidal composition, squat figure
proportions, and small overall figure scale
(fig. 29).[4] Van Noordt further followed

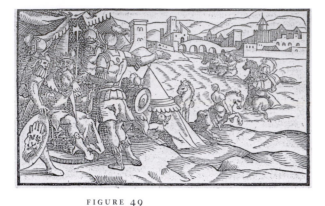

FIGURE 49
Cloelia, woodcut, in Titus Livius, *De Romeynsche historien ende geschiedenissen. Met fig. verciert ende met niewe byvoeghingen verm.*, Amsterdam (Dirck Pietersz), 1614 (photo: Amsterdam, Universiteitsbibliotheek Amsterdam).

Moyaert in showing only Cloelia on horseback.

A date of around 1655 is supported by the style of Van Noordt's painting. It shares with other early paintings, the Cherbourg *Cimon and Iphigenia* (cat. 29), for example, the use of translucent glazes for the darker areas. Van Noordt also built up opaque colours sparingly in his description of figures and faces in this period. The foreground figures, cast in light, show a strong modelling of their round and fleshy bodies, but the figures farther back are thinly painted and shadowy. The depiction of expressions is also quite restrained, and the features of Cloelia underscore a grim sobriety on her part, as she embarks on her risky undertaking.

1 For further discussion of the theme and its interpretation, see xx.

2 See Plutarch, *The Life of Publicola*, in *Plutarch's Lives*, vol. 1, trans. Bernadotte Perrin, Loeb Classical Library 46, Cambridge, Massachusetts, 551–3; and Livy, *Livy*, vol. 1, trans. B.O. Foster, Loeb Classical Library 114, Cambridge, Massachusetts, 1919, 261–3. For a further discussion of these sources, see Silvain Lavessière in exhibition catalogue Dublin 1985, 71.

3 See xxn45; in the edition of 1541, the story appears on fols. 27r-28v. Titus Livius, *De Romeynsche historien ende geschiedenissen. Met fig. verciert ende met niewe byvoeghingen verm.*, Amsterdam (Dirck Pietersz), 1614, fols. 17v–18r. Jacques Foucart has pointed out the publication of a lengthy conversation novel, based on the story of Cloelia, by Madeleine de Scudéry in Paris in 1654–61: see Jacques Foucart in exhibition catalogue Paris 1987, 85–7. This work attested to the popularity of the theme, but it had little impact on Dutch depictions since it appeared too late for most of them. Furthermore, its endless text functioned primarily as a platform for refined conversation. *Clelie, histoire romaine*, 10 vols., Paris (Courbe), 1654–61. A translation into Dutch followed shortly: Madeleine de Scudéry (given incorrectly as "Mr. de Scudery"), *Clelie, Roomsch historie*, 10 vols., Dordrecht (vol. 1: Jasper and Ioannes Goris, 1664; vols. 2–10: the widow of Jasper and Dirk Goris), 1664–76.

4 Claes Cornelisz. Moyaert, *Cloelia Crossing the Tiber*, panel, 41 x 60.5 cm, signed and dated 1642, Oslo, Nationalmuseum (inv. no. 185); see A. Tümpel 1974, 111, 112 (illus.), 267, no. 185.

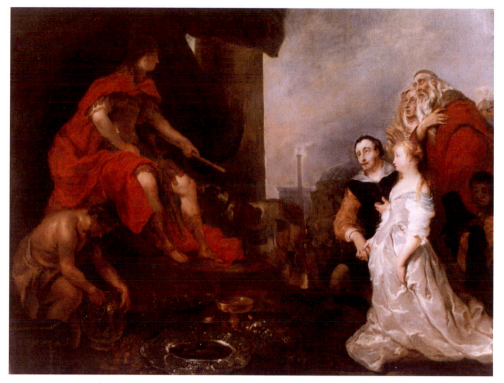

The Magnanimity of Scipio, canvas, 130 × 167 cm, present location unknown.

CATALOGUE 26
(p) *The Magnanimity of Scipio*
(Livy, *Historiarum ad urbe condita*, XXVI, 50; Polybius, *The Histories* X, 19, 3–7), canvas, 130 x 167 cm, present location unknown

PROVENANCE
The Harewood Charitable Trust et al. sale (anonymous section), London (Christie's), 12 July 1985, lot 217 (illus.); collection of Yves Stey; Lyon, Jean-Claude Anaf, in 1988; Dr Jean-Claude Anaf sale, Paris (Hôtel Sofitel), 31 May–1 June 1988; Cusset, with Tempera Achat-Vente, in 1992; sale, Brussels (Paleis voor Schone Kunsten), 14–17 February 1995, lot 1179 (illus., 120)

LITERATURE
La Gazette de l'Hôtel Drouot 97, no. 21, 1988, 99 (advertisement with illustration); exhibition catalogue Perth, Adelaide, and Brisbane 1997, 110n2

The story of the restraint shown by the Roman commander Scipio Africanus is best known through the accounts of the Roman historian Livy and his Greek predecessor Polybius.[1] Scipio, upon receiving a beautiful young girl who had been captured by his soldiers as a gift for his pleasure, had returned her untouched to her betrothed. Her parents then offered him the ransom they had already gathered for her as a token of their gratitude. Scipio presented the treasures to the couple as a wedding gift. By these deeds Scipio exemplified the virtues of sexual continence, generosity, and prudence. The second of these two qualities is emphasized in Van Noordt's painting, which shows Scipio giving away the ransom.

The Roman commander sits to the left side on a throne on a raised platform under a canopy. He holds out a commander's baton in his left hand, gesturing to give away the ransom of silver and gold vessels in the foreground left. To the right of

FIGURE 50
Cornelis de Vos, *The Continence of Scipio*, canvas,
174 × 242 cm, Nancy, Musée des Beaux-Arts
(photo: G. Mangin).

FIGURE 51
Philippe Lambert Joseph Spruyt, after Cornelis
de Vos, *The Continence of Scipio*, etching,
29.7 × 32.4 cm, Amsterdam, Rijksmuseum
(photo: Rijksmuseum-Stichting Amsterdam).

centre, Allucius and his betrothed approach him, meekly kneeling. Rising up behind them are the figures of her parents, whose gestures express astonishment and humble gratitude. Van Noordt adopted the composition from the even larger painting of the same theme by the Fleming Cornelis de Vos (1584–1681; fig. 50).[2] Like De Vos, Van Noordt arranged the action across the foreground. He took over the figure of the kneeling servant to the left, handling a gold vase, but he replaced the boy to the right with a Moorish page, who holds Allucius's hat and cloak. There is an oil sketch for this composition, and it is reproduced in a print (fig. 51) by Philippe Lambert Joseph Spruyt (1727–1801), which mistakenly attributes the invention to Rubens.[3] Perhaps Van Noordt also thought that he was following the famous Flemish master with this picture.

Van Noordt's painting reflects his style of around 1660. He still followed his early penchant for semi-transparent layers of paint, leaving some forms vague and insubstantial; this effect can especially be seen in darker areas, for example the left-hand side, where Scipio sits in the shade of a canopy. The figures show him gradually developing the description of emotions, seen in the desperate parents and the

grateful couple. Furthermore, the stiff opaque forms of the early 1650s have given way to a looser elegance, with flowing brush strokes that reach refinement in the satin gown of Allucius's bride. This work dates to around 1660, the same time as *The Massacre of the Innocents* (cat. 14), which also borrows directly from works by other artists.

1 See Livy, *Livy*, vol. 7, trans. Frank Gardner Moore, The Loeb Classical Library 367, Cambridge, Massachusetts, 1943, 191–5; and Polybius, *The Histories*, vol. 4, trans. W.R. Paton, Loeb Classical Library 64, Cambridge, Massachusetts, 1925, 149. For further discussion of the theme and its interpretation, see 62–4, and also Manuth 1998b, 145–6; Sutton 1982, 14n12; and Lepper-Mainzer 1982.

2 Cornelis de Vos, *The Magnanimity of Scipio*, canvas, 174 x 242 cm, Nancy, Musée des Beaux-Arts. See Czobor 1967, illus. fig. 29.

3 Etching, 29.7 x 32.4 cm. One copy of this rare print is in the collection of the Rijksprentenkabinet, Amsterdam (inv. no. OB 59 800). See Voorhelm Schneevoogt 1873, 140, no. 37. It does not include the figure with the vase, and so more closely follows De Vos's oil sketch of the composition: panel, 47.2 x 53 cm, Budapest, Szépművészeti Múzeum (inv. no. 1489); see Czobor 1967.

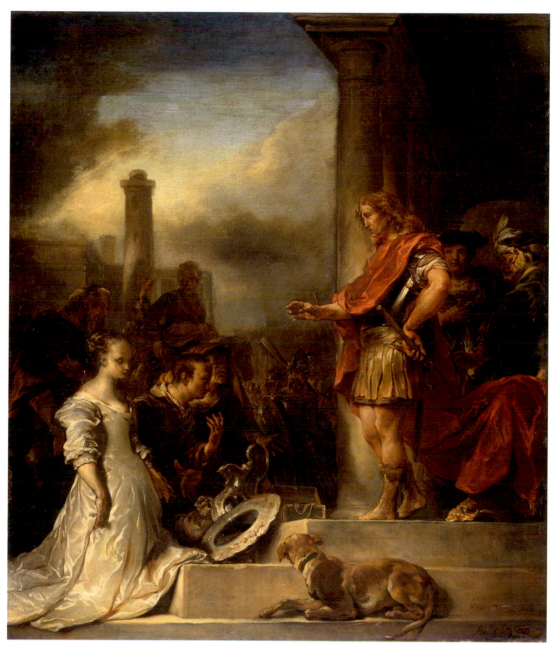

The Magnanimity of Scipio, canvas, 103 × 88 cm, signed and dated 1672, Amsterdam, Rijksmuseum (photo: Rijksmuseum-Stichting Amsterdam).

CATALOGUE 27
The Magnanimity of Scipio
(Livy, *Historiarum ad urbe condita*, XXVI, 50), canvas, 103 x 88 cm, signed and dated, bottom right: *Joan v. Noordt Anᵒ 1672*, Amsterdam, Rijksmuseum (inv. no. 1762)

PROVENANCE
Hendrick Muilman Banderheer van Naamstede sale, Amsterdam (Van der Schley and De Vries), 12–13 April 1812 (Lugt 8345), lot 112; acquired by Mogge Muilman; Amsterdam, collection of H. van der Poll; given to the Rijksmuseum in 1880

LITERATURE

Hofstede de Groot 1892, 213, no. 16, 216, no. 13; Wurzbach 1906–10, 2:243; Kronig 1911, 157; Bauch 1926, 68n92; Decoen 1931, 17 (illus.), no. 11; Pigler 1968, 184 (illus. no. 12); Pigler 1956, 409; Czobor 1967, 351n5; collection catalogue Budapest 1968, 493; Bénézit 1976, 7:750; Christine S. Schloss in collection catalogue Hartford 1978, 168; Schatborn 1979, 123, 126 (detail illustration, illus. 16); Bernt 1980, 926 (illus.); Sumowski 1983–94, 1:140, 143n72, 178 (illus.); 5:3112, with no. 2141; 6:3736, with no. 2403; Haak 1984, 489 (illus. no. 1085); collection catalogue Bordeaux 1990, 226n2, 227n12; exhibition catalogue Utrecht and Frankfurt 1993, 241n8; Golan 1994, 204

SELECTED COLLECTION
CATALOGUES

Amsterdam 1885, 38, no. 256a; Amsterdam 1976, 419, no. A708 (illus.)

EXHIBITIONS

Amsterdam 1950, 73, no. 216; Perth, Adelaide, and Brisbane 1997, 110–11, no. 42 (illus.)

Van Noordt's second depiction of this theme from Livy takes on dynamic energy and grandeur. The artist has placed Scipio on the right side, standing on a dais, under a vaulted portico, with his commanders behind him. On the steps at the bottom left kneel Allucius and his bride, and behind them stand her parents. Scipio stands and raises his right hand to address his audience. Important changes from the previous version (cat. 26), include placing Scipio on the opposite side and elevating him above his audience. His composition follows the classical tradition of the *adlocutio*, which in antiquity was used for scenes of emperors addressing their soldiers.[1]

This second version is more finished than the first, and achieves a more powerful expression and mood. Van Noordt presents the various intense emotions, and the thought of Scipio arriving at his decision. He conveys to a far greater extent the expressions of the abject couple and pleading parents, the calmness and compassion of Scipio, and the admiration of his commanders. Van Noordt reused the most prominent and expressive figure in the previous version, namely Allucius's bride. The bride's mother is also borrowed from an earlier composition, *Pretioze and Don Jan*, where she takes the role of Majombe (in two variants: cat. 31, 32).

1 Van Noordt may have been familiar with the scene of *adlocutio* in the painting by Pieter Lastman of *Coriolanus and the Roman Women*, now in Dublin, which was based in part on a famous Italian renaissance evocation of the classical tradition: the fresco of *The Vision of Constantine* by Giulio Romano and Rafaellino, in the Sala di Constantino in the Vatican; see Broos 1975–76, 200.

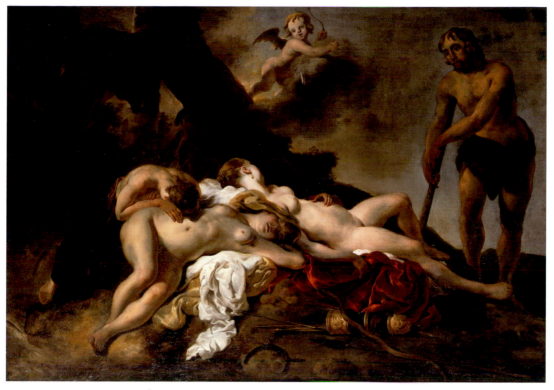

CATALOGUE 28
(p) *Cimon and Iphigenia*
(Boccaccio, *Decameron*, fifth day, first story), canvas, 104.8 x 149.2 cm, signed bottom centre: *Joan V. Noordt*, present location unknown

PROVENANCE
Possibly: D. Ietswaart sale, Amsterdam, 22 April 1749 (Lugt 704),[1] lot 227 (*ƒ*31–0 to G. Morel: "*Een stuk daar Hymen de drie Naakte Nimfen leggende vind, door Jan van Noord* [A piece in which Hymen finds the three reclining nymphs, by Jan van Noord]"); sale, New York (Sotheby's), 28 January 1999, lot 229 (illus.)

With this early painting Jan van Noordt partook of the contemporary fashion for the pastoral. The scene is taken from the fourteenth-century, erotically tinged Italian comedy of Boccaccio's story of *Cimon and Iphigenia*, from the *Decameron*.[2] This theme and its interpretation are discussed in detail in chapter 4.[3] Van Noordt's painting depicts the moment when the shepherd Cimon first encounters Iphigenia, resting with her companions near a fountain in the woods, and falls in love with her. Love sparks a complete transformation in his manner, from that of a boorish simpleton to that of a refined and gracious courtier. This scene is part of a larger fashion for scenes of first meetings of lovers, to which Van Noordt returned in a number of his favoured themes.

This painting is the earliest of three known versions by Van Noordt, and was directly influenced by the depiction of the same theme by his teacher, Backer, now in Braunschweig (fig. 4).[4] The figure of the

woman in the foreground left is a mirror image of Backer's figure of Iphigenia, with only the position of the legs changed. The smooth modelling of all of the figures also closely emulates Backer's style. These similarities give a strong indication that Van Noordt was working in Backer's studio when he made this picture. The second depiction of the same theme, the painting in Cherbourg (cat. 29), shows more variation of light and introduces further changes to the poses of the figures, giving the impression that it was made after Van Noordt left Backer's studio and no longer had access to the master's example.

The figure of Cimon is Van Noordt's own invention. Cimon stands in the foreground, motionless, leaning on his shepherd's crook. Boccaccio's story emphasizes that Cimon took this position and remained there for a while, before Iphigenia awoke and tried to send him away. In Backer's interpretation, he enters as an intruder from the background. Van Noordt's choice lay closer to Rubens' interpretation of *Cimon and Iphigenia*, known in two versions.[5] A more accessible model, and a more likely prompt for Van Noordt's revision of Backer's composition, was the frontispiece to Jan van Arp's adaptation for the stage, *Chimon*, which was published in Amsterdam and presented in the *Schouburgh*, in 1639, ten years before the present painting (fig. 27).[6] The print shows the same scene of Cimon's realization of love, as he dreamily leans on his staff.

collection of the Earl of Wemyss (inv. no. 145, as by or after Rubens); see Held 1980, 1:320–2; 2: illus. plate 247. Rubens' composition was reproduced in an engraving by J.A. Prenner: see Voorhelm Schneevoogt 1873, 131, no. 107 (as "*Nymphs Surprised by a Shepherd*"). The standing pose also appears in a drawing attributed to Govert Flinck, which dates to about 1655, thus after Van Noordt's earliest painted versions, which may have influenced Flinck: *Cimon and Iphigenia*, black chalk, pen, washed with bistre, with small corrections in white, 46.4 x 40.5 cm, Paris, Louvre, Cabinet des Dessins (inv. no. [21.295] 272); see Moltke 1965a, 176, no. D28 (illus.).

6 Van Arp 1639, frontispiece. See exhibition catalogue Utrecht and Frankfurt 1993, 212.

1 Hoet 1752, 2:253.

2 Boccaccio 1972, 406–17.

3 See 56–9.

4 Jacob Adriaensz. Backer, *Cimon and Iphigenia*, canvas, 150 x 230 cm, Braunschweig, Herzog Anton Ulrich-Museum (inv. no. 670). See Sumowski 1983–94, 1:194, no. 7, 210 (illus., as datable to the end of the 1630s).

5 Canvas, 208 x 282 cm, Vienna, Kunsthistorisches Museum (inv. no. 1166); panel, 29 x 44 cm, Gosford House (Scotland),

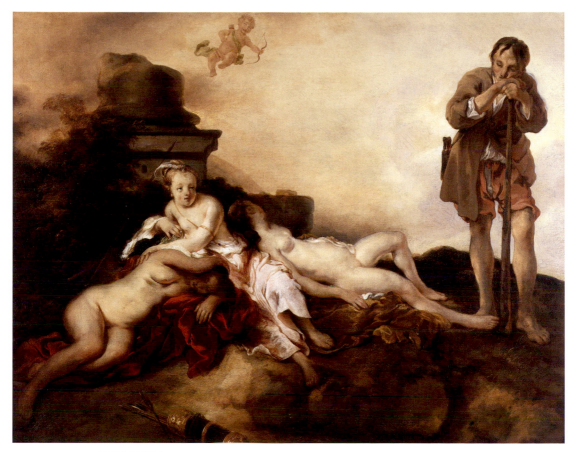

Cimon and Iphigenia, canvas, 94 × 122 cm, Cherbourg-Octeville, Musée d'art Thomas-Henry.

CATALOGUE 29
Cimon and Iphigenia
(Boccaccio, *Decameron*, fifth day, first story), canvas, 94 x 122 cm, inscribed on the stretcher: "*Adam van Noort/ maître de Rubens*," Cherbourg, Musée d'art Thomas-Henry, inv. no. 986.1

PROVENANCE
Possibly: D. Ietswaart sale, Amsterdam, 22 April 1749 (Lugt 704),[1] lot 227 (*f*31–0 to G. Morel: "*Een stuk daar Hymen de drie Naakte Nimfen leggende vind, door Jan van Noord* [A piece in which Hymen finds the three reclining nymphs, by Jan van Noord]"); Budapest, collection of Friedrich Glück, 1914; Gyöngyös, Hungary, collection of Joseph Pásztor; Count

Peter Vay de Vaja et al. sale, Budapest (Steiner), 15 April 1918, lot 122 (illus., vol. 2, cover and pl. III; as Gerbrand van den Eeckhout); sale, Cologne (Lempertz), 27 June 1974, lot 65 (illus., as by G.v. Eeckhout); The Earl of Haddington et al. sale, London (Christie's), 30 November 1979, lot 62 (illus.); Broadhead et al. sale, London (Christie's), 31 October 1980, lot 149 (illus.; as Gerbrand van den Eeckhout, or possibly by Johannes van Noordt); sale, Amsterdam (Christie's), 29 May 1986, lot 150 (illus., as Jan van Noordt); Amsterdam, with John H. Schlichte Bergen; acquired by the Musée d'art Thomas-Henry, Cherbourg, in 1986

LITERATURE

Von Térey 1919, 248, illus. fig. 4, 246 (as G. van den Eeckhout); Roy 1972, 224, no. 93, (as G. van den Eeckhout); Sumowski 1983–94, 1:140, 143n67, 172 (illus., as Jan van Noordt); 5:3057 (as signed and dated 1649), 3062n11; 6:3589, 3736, with no. 2401; Sumowski 1986, 36n16; Blankert 1989, 15 (illus.)

EXHIBITIONS

Paris 1987, 85, 86 (illus.); Kobe and Tokyo 1993, 220, 221 (illus.)

COLLECTION CATOLOGUES

(untitled), Cherbourg, Musée Thomas Henry, 1993 (not paginated)

For at least eighty years, a layer of over-paint covered much of this painting. A recent cleaning uncovered Cupid and an open background of sky, a conception that is very close to the signed painting of the same theme that surfaced more recently at a sale in New York (cat. 28). In both, Cimon stands to the right, a dark figure against a light, open sky. Below to the left, Iphigenia and her attendants lie on the ground. There are many significant differences of detail, however, especially in the prominent nude figure in the foreground left. In the New York painting, this figure corresponds very closely to the depiction of the same theme by Backer, in Braun-schweig (fig. 5). The present painting moves further away from this original model, and must therefore have been done later than the New York painting. Van Noordt moved this figure's arm, draping it over her head. Her left arm is not stretched out, but instead folded under her head, with only the hand emerging. The composition also does not include the male attendant present in the New York version, who does appear in the Backer painting. Also, Cupid and the hunting paraphernalia in the foreground are reduced in promi-

nence. Van Noordt produced a less complex image with more concentration on the main figures. He also chose a slightly later moment, showing Iphigenia after she has awakened, whereas in the New York paint-ing, he showed Iphigenia and her company still asleep, following Backer. Here she leans up and turns toward Cimon, to address him.

One of the additions made by the unknown retoucher, which was later removed, was a false Gerbrand van den Eeckhout signature. Nonetheless, even be-fore the cleaning, the painting was already long recognized to be by Van Noordt.[2] The fluid, semi-transparent application of paint and the spare, restrained handling of faces and expressions connect to a number of early paintings by him, such as *Caritas* (cat. 24). The abrupt transitions from light to dark, evident in the earliest paintings of around 1645, are present here as well. However, the laborious building-up of the surface has diminished. Areas have been brushed in rather broadly, resulting in a patchy quality also seen in Van Noordt's *Callisto* (cat. 19). There is evidence that the present painting was at one time signed by him, in the form of an erroneous inscrip-tion on the stretcher.[3]

1 Hoet 1752, 2:253.
2 Sturla J. Gudlaugsson recorded his attribution in a note with the photograph preserved at the RKD.
3 The inscription on the stretcher attributes the painting to Adam van Noort, the teacher of Rubens. The writer of this inscription probably based it on a now-vanished signature, but con-nected the name to that of the better-known Flemish master. See Jacques Foucart in exhibi-tion catalogue Paris 1987, 85.

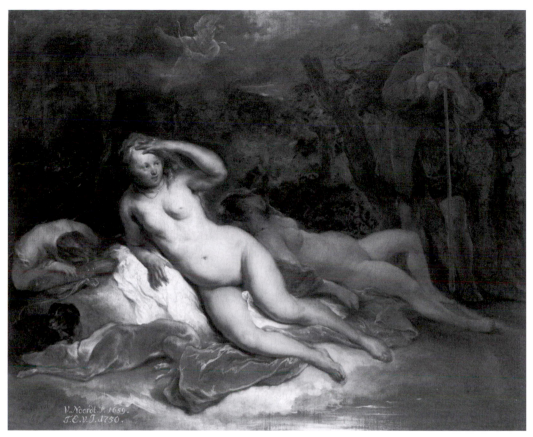

Cimon and Iphigenia, canvas, 77.5 × 96.5 cm, signed and dated 1659, Göttingen, Art Collection of Göttingen University.

CATALOGUE 30
Cimon and Iphigenia
(Boccaccio, *Decameron*, fifth day, first story), canvas, 77.5 x 96.5 cm, signed and dated, lower left: *JvNoordt f1659*, and inscribed in a later hand: *VNoordt.P.1659 T.E.V.J. 1750* (this inscription appears on several other paintings in the collection). Göttingen, Art Collection of Göttingen University (inv. no. 130)

PROVENANCE
Possibly: sale D. Ietswaart, Amsterdam, 22 April 1749 (Lugt 704),[1] lot 227 ("*Een stuk daar Hymen de drie Naakte Nimfen leggende vind, door Jan van Noord* [A piece in which Hymen finds the three nymphs reclining,

by Jan van Noord]," for *f*31–0 to G. Morel); Celle, collection of Johann Wilhelm Zschorn; bequeathed to the University in 1796

LITERATURE
Fiorillo 1815–20, 3:233; Parthey 1863–64, 2:195, no. 1; Hofstede de Groot 1892, 212, no. 9, 216, no. 16; Wurzbach 1906–10, 2:243; Bauch 1926, 68n12; Pigler 1955, 184; Pigler 1968, 343; Bénézit 1976, 7:750; Christine S. Schloss in collection catalogue Hartford 1978, 168n4; Sumowski 1983–94, 1:143n67; exhibition catalogue Utrecht and Luxembourg 1993–94, 239, 241n4

EXHIBITIONS
Braunschweig 1983, 86, no. 33, 87 (illus.);
Dortmund 1984, 12

COLLECTION CATALOGUES
Celle 1789ff., no. 60; Göttingen 1806, 7,
no. 5; Göttingen 1905, 32, no. 74; Göttin-
gen 1926, no. 130; Göttingen 1987, 106–7,
no. 62 (illus.)

This painting is the latest of three known depictions by Van Noordt of the meeting of Cimon and Iphigenia from the story in Boccaccio's *Decameron*. The theme is discussed in the entry to the earliest version (cat. 28), and in chapter 4.[2] The nobleman-turned-shepherd Cimon appears to the right of the picture, standing, leaning over his shepherd's crook. The young daughter of nobility, Iphigenia, who has been resting with her companions, is shown in the foreground left, lying on the ground, nude. Cupid appears in the sky above, having loosed an arrow on Cimon.

This painting clearly followed upon the composition in Cherbourg (cat. 29). The central figure of Iphigenia is derived from the corresponding figure in that painting, a figure that is not present in the version in New York. This painting also continues the move toward simplification and concentration that is already perceptible, to a lesser degree, in the Cherbourg painting. Van Noordt introduced a focused light effect, illuminating the figure of Iphigenia against a darker surrounding area. She is further emphasized through a larger figure scale, with her figure brought forward into the immediate foreground. These effects of light and composition were part of the sharp transition of Van Noordt's style in the late 1650s.

1 Hoet 1752, 2:253.
2 See 56–9.

CATALOGUE 31
Pretioze and Don Jan (*De Spaensche Heidin*)
Canvas, 132 x 170 cm, present location unknown

PROVENANCE
Collection of T. Ockley; C. Fairfax Murray et al. sale, London (Christie's), 20 January 1920, lot 353 (as Gerbrand van den Eeckhout, *Vertumnus and Pomona*, canvas 52 x 67½ inches [132 x 171.3 cm]; to Tooth); London, with A. Tooth & Sons (advertised in *Burlington Magazine* 66, October 1924, 31, November 1924, 32, December 1926, January 1927); sale, London (Christie's), 15 February 1929, lot 81 (as J. van Noordt, *Cavalier and a Young Lady, with sporting figures and gypsies*, canvas, 52 x 67 in. [132 x 170 cm], for £136.10s); London, with J. Leger & Son, advertised in *Burlington Magazine* 73, 11 April 1931; United States, private collection; sale, Genoa (Boetto), 23–24 February 1998 (as French School, 17th century, "*scène allégorique*"); New York, Adam Williams Fine Art, in 1999

LITERATURE
Staring 1946, 74; Cats 1966, 24 (illus.); Gudlaugsson 1975, 29 (illus. no. 25), 33; Bénézit 1976, 7:750; Sumowski 1983–94, 1:142n64; 6:3534n88, 3576; Schatborn 1979, 119–20 (illus. no. 3); Gaskell 1982, 263, 267, (illus. 46a); exhibition catalogue Utrecht and Luxembourg 1993–94, 22, 235, and 238n1 (conflates the present picture and the second copy given below); Sumowski 1998, 79n15

COPIES
(1) Canvas, 117 x 188 cm, sale S. Eckman Jr. et al. (anonymous section), London (Sotheby's), 18 October 1967, lot 11 (as *A Hunting Party Resting*, by J. van Noort: "with a woman in elegant dress, an attendant and a negro holding a hawk and dogs in middle distance, four figures conversing in the background; in a rocky setting with trees")

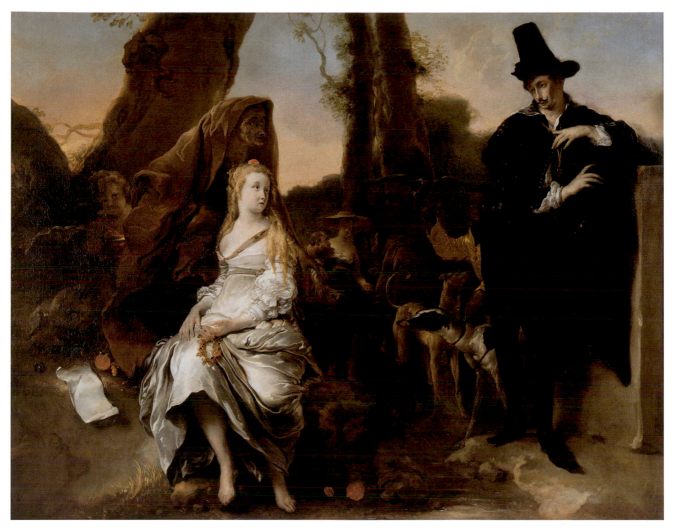

CATALOGUE 31
Pretioze and Don Jan (De Spaensche Heidin), canvas, 132 × 170 cm, present location unknown.

(2) Canvas, 128 x 179 cm, sale, London (Sotheby's), 15 December 1976, no. 17 (as *Vertumnus and Pomona*, by Jan van Noordt: "Pomona, in blue seated in the left fore-ground, Vertumnus disguised as an old woman covered by a brown shawl behind, a young man in black with a black hat to the right, dogs and a servant with a falcon behind.")

A man leaning against a large rock to the right. He turns to the left, and looks across to a young woman in a satin gown seated on a mound near the centre, who returns his gaze. Behind her is an old hag, draped in a rough cloak with a hood. Further back are more figures, including a young black man holding a falcon. Previously, the theme had been identified as a genre-like "Cavalier et une jeune femme," or the classical story of Vertumnus and

Pomona. Gudlaugsson first pointed out the connection to Jacob Cats' *Het Spaense Heydinnetje* (*The Spanish Gypsy Girl*) of 1637, a Dutch adaptation in verse poetry of Cervantes' *La Gitanilla di Madril*, first published in 1610.[1] More recently it has become clear that Van Noordt's painting follows an adaptation of this story for the stage, published in 1643 by Mattheus Gansneb Tengnagel.[2] In particular the roses in Pretioze's hair and hands, and her luxurious white gown, are explicitly mentioned by Tengnagel in Don Jan's monologue as he spies on the gypsy band, with Pretioze in their midst.[3]

But heavens, what do I see! This is beyond
 my understanding!
It is a gypsy band of men and of women!
People strew flowers about! They must be
 holding a wedding!
Or it is a preliminary for a similar feast.
And if someone was married, then it was
 the one,
In white clothing who sits in the middle
 preening.
I wish that she would just turn around!
 There she turns to look! what sparkle
 [...]

Because she is splendidly dressed, Don Jan at first mistakes her for the goddess Diana. It is an aspect not reflected in Cats' earlier version of the story. Cats' poem was published with print illustrations by Adriaen van de Venne, including one of the scene of the first meeting (fig. 52). There, the figure of Pretioze wears plain clothing.[4]

 The somewhat affected pose of Don Jan is explained by reference to the play, which indicates that he is already saddened by the recent loss of his mother, and that he has taken great fright at the voices of the Gypsy band deep in the forest. He is a little crazed, and first thinks that he sees the goddess Diana, taken prisoner by a band of devils. It is in this rather helpless state that he is then smitten with love for her. Van Noordt paid special attention to

FIGURE 52
Adriaen Pietersz. van de Venne, *Pretioze and Don Jan*, etching, in Jacob Cats, *Het Spaans Heydinnetje*, in *'s Werelts begin, midden, eynde, besloten in den trov-ringh, met den proef-steen van den selven*, Dordrecht (Matthias Havius), 1637.

the figure of Don Jan, devising a limp-wristed gesture to project his emotional state. The artist arrived at this invention in a lavish and careful preparatory study drawing (cat. D9).

 Van Noordt painted this picture around 1660. Its composition does not relate to previous depictions by other artists, but rather to his *The Triumph of David*, which was likely done around the same time (cat. 4). It shows the same approach of placing important figures at some distance from each other in the foreground. This is perhaps a theatrical device, to create tension between the figures.

1 Cats 1637; see Gudlaugsson 1975.
2 The frontispiece to Tengnagel's text mentions the play's performance at the *Schouburgh* in that year. See Tengnagel 1643, frontispiece.
3 Tengnagel 1643, 76. Tengnagel's text has two parts, the first a heavily moralizing prose recounting of the story of Don Jan and Konstance/Pretioze, and the second a play version of the same story. The prose section contains greater description, going so far as to specify that Pretioze's white dress shows blue reflections, and that her white skin is blue-veined. On the other hand, the play mentions the

148

CATALOGUE 32
Pretioze and Don Jan (*De Spaensche Heidin*), canvas, 130 × 167.5 cm, Linschoten, Huis Linschoten, Ribbius Pelletier Foundation.

wreathes of flowers being woven by Pretioze, which also appear in the painting but are not cited in the prose text.

4 Gaskell observed that the luxurious costume of Pretioze in Van Noordt's painting but discounted the connection drawn by Gudlaugsson to Van de Venne's print. Gaskell, who only knew the London sale picture, thought that Pretioze wore a diadem in her hair, referring to Don Jan's mistaking her for Diana; it is, however, a rose, as Van den Brink has pointed out. See Gaskell 1982, 263; Gudlaugsson 1975, 33; Peter van den Brink in exhibition catalogue Utrecht and Frankfurt 1993, 236, 238n5.

CATALOGUE 32
Pretioze and Don Jan (*De Spaensche Heidin*)
Canvas, 130 x 167.5 cm, Linschoten, Huis Linschoten, Ribbius Pelletier Foundation

PROVENANCE
Cuyk, Collection of the Jonkheer Adriaan Cornelis Snoek; Rottevalle, Collection of Davina A.J.A. Snoek (1836–1892) and Ds. Henderykus Wijbelingh (?–1881), by inheritance; Utrecht, Adriana Louisa Wijbelingh (1863–1939) and Gerlacus Ribbius Pelletier (1856–1930), by inheritance; Linschoten, Gerlacus Ribbius Pelletier Jr (1887–1969); after his death the painting was transferred to the ownership of the foundation

LITERATURE
Sumowski 1983–94, 6:3534n88

EXHIBITIONS
Utrecht and Luxembourg 1993–94, 22,
235–8, no. 45 (illus. 237)

The two versions of *Pretioze and Don Jan* present the only known example of exact repetition in the oeuvre of Jan van Noordt.[1] It seems that they were painted at around the same time, as they show no significant differences, except slightly with respect to their measurements and the positions of the borders. The present work, which is in poor condition, has been cut down at the top and bottom edges. A discussion of the theme and its sources is found in the previous catalogue entry and chapter 4.

CATALOGUE 33

(p) *Granida and Daifilo*
Canvas, 94.6 x 85.7 cm, Sydney, Art Gallery of New South Wales (inv. no. 1.1973)

PROVENANCE
Collection of Mrs Vera Gascoigne Murray; bequeathed to the Gallery in 1973

LITERATURE
Gazette des Beaux-Arts, series 6, vol. 83 (supplement), 1974, 75, (illus. no. 241); Sumowski 1983–94, 1:140, 142n57, 166 (illus.); 5:3111, with no. 2137; 6:3735, with no. 2397, 3736, with no. 2402; Sumowski 1986, 27, 28, 31 (illus. fig. 10), 37n36; collection catalogue Bordeaux 1990, 226n7; exhibition catalogue Utrecht and Luxembourg 1993–94, 241n9; exhibition catalogue Perth, Adelaide, and Brisbane, 110 (illus.)

In an article of 1949, Sturla Gudlaugsson identified the story of Granida and Daifilo as a literary source for a number of Dutch paintings.[1] It is discussed in greater detail with respect to its interpretation in chapter 4.[2] With a few exceptions, artists consistently took up the moment in the first scene of the play, when the Persian princess Granida, having strayed from her hunting party, encounters the shepherd Daifilo and his companion, Dorilea, in the woods. Granida complains of the heat, and Daifilo immediately offers water from a shell. He has fallen in love with her. His shepherdess companion is at once forsaken for Granida, who represents true love for Daifilo. In the ensuing story Daifilo must overcome obstacles and competition at the Persian court to realize his love. The consistent choice for the "falling in love" moment for a painting was less an aesthetic than a philosophical–moral preference, for promoting the pursuit of true love rather than sensuality.

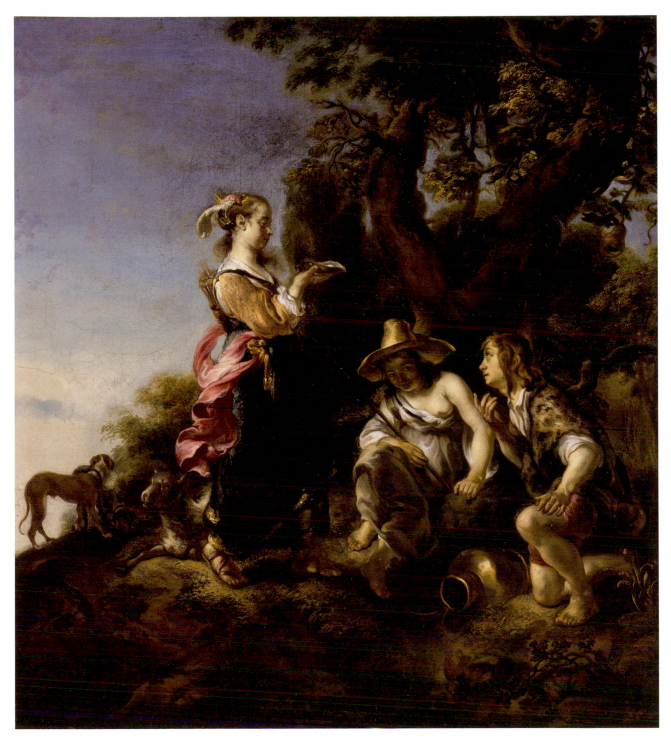

CATALOGUE 33
Granida and Daifilo, canvas, 94.6 × 85.7 cm, Sydney, Art Gallery of New South Wales, bequest of Mrs Vera Gascoigne Murray (photo: Ray Woodbury for AGNSW).

Van Noordt was undoubtedly lead to this theme by the work of his teacher, Jacob Backer, who treated it frequently. Backer's depiction in the Hermitage, his earliest, seems to have most influenced his pupil (fig. 7).[3] Its smaller figure scale and stronger chiaroscuro modelling more closely approach Van Noordt's painting. Sumowski dates the Hermitage painting to around 1635, but it can be placed later, to around 1640, on the basis of a comparison with Backer's *Jesus and the Canaanite Woman*, now in Middelburg and dated to that year (fig. 5).[4] Both paintings set figures against open areas of background, an approach Backer then abandoned in favour of larger figures that filled the composition, as seen in his later depictions of Granida.[5]

This is one of Jan van Noordt's earliest paintings. It contains two distinctive motifs also present in the early *Shepherd and Shepherdess with Goats and Sheep* (cat. 35), namely the sheep to the left, lying behind Granida, and the milk can lying in front of Daifilo to the right. As well in both, the rolling landscape is meticulously modelled in the light falling sharply from the left side. Another work of the same period, *Caritas* (cat. 24), shows the same emphasis on volume and chiaroscuro modelling and the stocky proportions of the figures. Compositionally, both works also display Van Noordt's early approach of distributing highlighted areas.

Equally characteristic for Van Noordt's early work is the careful, restrained emotional expression through the figures. Granida, heavily laden in her royal garb, exudes *hauteur*, a characterization enhanced by her strident pose and a facial expression of subtle bemusement. Across from her, Daifilo's long face and wide-eyed stare betray the wave of emotion that has gushed over him. Van Noordt developed this grace and expression further in his second known version, of 1663, around eighteen years later (cat. 34).

1 See Gudlaugsson 1948a, Gudlaugsson 1948b, and Gudlaugsson 1949.

2 See 53–6.

3 Jacob Adriaensz. Backer, *Granida and Daifilo*, canvas, 125 x 161.5 cm, c. 1640, St Petersburg, Hermitage (inv. no. 787); see Sumowski 1983–94, 1:135, 193, no. 6, 209 (illus., as 1635).

4 Jacob Adriaensz. Backer, *Jesus and the Canaanite Woman*, signed and dated 1640, canvas, 210 x 270 cm, Middelburg, Nieuwe Kerk; see Sumowski 1983–94, 1:194, no. 9, 212 (illus., as c. 1635); 6:3589.

5 Jacob Adriaensz. Backer, *Granida and Daifilo*, canvas, 126 x 162 cm, c. 1640–45, Harlingen, Museum het Hannemahuis (inv. no. 1179); see Sumowski 1983–94, 1:137, 194, no. 10, 213 (illus.). *Granida and Daifilo*, canvas, 121.9 x 161.9 cm, Ireland, private collection, see sale, New York (Sotheby's), 24 January 2002, lot 6; *Granida and Daifilo*, canvas, 133 x 162, signed, c. 1645–50, Kingston, Agnes Etherington Art Centre (inv. no. 35–008); see Sumowski 1983–94, 2:991, 1006n4, 1008 (illus.).

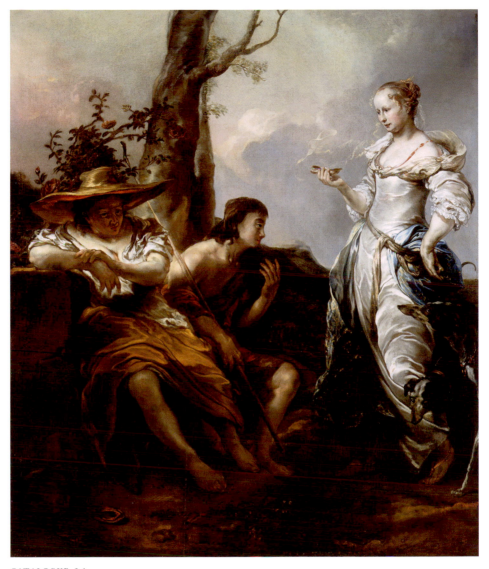

CATALOGUE 34
Granida and Daifilo, canvas laid onto panel, 137 × 117 cm, signed and dated 1663, present location unknown.

CATALOGUE 34
Granida and Daifilo
Canvas laid onto panel, 137 x 117 cm, signed and dated middle left: *Jan v. Noort f 1663*, present location unknown

PROVENANCE
Sale Jonkvrouw M.J. Cosson et al., Leiden, 21 October 1772 (Lugt 2070), lot 1 (as: canvas laid onto panel, signed and dated

1665, 52 x 38 *duim* [133.6 x 97 cm]: *Een kapitaal schilderij, verbeeldende Granida en Daiphilo, en verder bijwerk, alles wonderlyk fix en kragtig geschildert* [an original painting, representing Granida and Daifilo, and other accessories, everything wonderfully solidly and powerfully painted], *f*27 to v. Leyden); *"Deux Amateurs"* sale, Leiden (Delfos), 26 August 1788 (Lugt 4343), lot 107 (as canvas laid onto panel, 52 x 38

duim [133 x 97 cm]), signed and dated 1663: *Drie Beelden waar van twee zitten aan de Voet van een Boom, waar voor een Vrouw staat, pragtig gekleed in 't satyn, en twee jachthonden, zij houd in haar hand een sort van Schulp; het schynt te zijn de Historie van Granida en Daifilo* [Three figures of which two sit at the foot of a tree, in front of which a woman stands, splendidly dressed in satin, and two hunting dogs, she holds in her hand a sort of shell; it seems to be the History of Granida and Daifilo]; *f*7.5 to H. Hoogstraten); Prince Tatarsky (also: Koudacheff) sale, Amsterdam (Frederik Muller), 27 June 1905 (Lugt 63555), lot 22 (illus., as "*Composition Mythologique*"); Berlin, collection of Frau Ida von Schubert, in 1914; sale, London (Phillips), 7 July 1998, lot 78 (illus.); sale, London (Sotheby's), 18 April 2002, lot 34 (illus.)

LITERATURE
Hofstede de Groot 1892, 215, no. 10; collection catalogue Semenov 1906, 254; Wurzbach 1906–10, 2:243; Kronig 1911, 157; Bauch 1926, 68n12; Stechow 1928–29, 185 (as *Granida and Daifilo*, a painting neglected by Budde); Decoen 1931, 18 (as *Diana and a Shepherd*); Gudlaugsson 1949, 38 (illus.), 40; Sumowski 1983–94, 1:140, 143n71, 177 (illus.); 5:3111, with no. 2138, 3112, with no. 2140; Te Poel 1986, 32, 61, no. 28, 94 (illus.); Sumowski 1986, 27, 32 (illus. fig. 11), 37n37; Giskes 1989, 93 (illus.); collection catalogue Bordeaux 1990, 226n1, 227; exhibition catalogue The Hague 1992, 268–9 (illus. fig. 37b); exhibition catalogue Utrecht and Luxembourg 1993–94, 238, 239 note 10, 241n7

EXHIBITION CATALOGUES
Berlin 1914, 32, no. 112

COPIES
Canvas, 65 x 83 cm, Berlin, private collection, in 1961 (photo received by the RKD from W. Paul, conservator at Charlottenburg Palace in Berlin, in 1961) (fig. 53)

FIGURE 53
Anonymous, after Jan van Noordt, *Granida and Daifilo*, canvas, 65 × 83 cm, Berlin, private collection (photo: The Hague, RKD).

This second known version of *Granida and Daifilo* followed the first by about eighteen years (cat. 33). The moment depicted is the same: the initial meeting of the two protagonists in Hooft's play, which takes place in the first scene. Granida, to the right, graciously accepts the shell of water from the kneeling and enamoured Daifilo in the centre. His despondent shepherdess companion, Dorilea, sits off to the left and looks away from the scene. Remarkably, Daifilo makes exactly the same spread-fingered gesture as in the previous depiction; what strikes us as awkward must have seemed at the time an elegant and fitting gesture of amorous devotion.

The composition differs strongly from the earlier picture, however. The scene is reversed from left to right, the figure scale is larger, and the tonality is lighter, linking this depiction to the two interpretations of the same theme by Jacob Backer in Harlingen and Kingston.[1] Van Noordt seems to have followed Backer's development, as these two versions are both later than the one in the Hermitage, which had been Van Noordt's model for the first painting. Another contrast with the first version is the space; there, the action and its setting recede in as one moves to the left, whereas here everything takes place in the foreground plane. Some depth is preserved,

154

with the indistinct open landscape behind the figures. A mound juts out from the sloping hillside between Daifilo and Granida. Its form sweeps toward Granida, forming a rhetorical emphasis on Daifilo's loving gaze.

The overall effect of movement in this composition is typical for the artist's style in the early 1660s. The jocular sprig of roses rising above Dorilea continues the sweeping curve of her body, propped up against a rock. The artist also organized the fall of Granida's satin gown into long curving forms that carry through a motion into the form of her arm, extended in the action of accepting Daifilo's gift of water. The goal was to build up drama, which is also evident in the use of strong colour, in the pinks and blues in the elegant figure of Granida and warm oranges and yellows in Dorilea. A dashing spray of direct brush strokes comprises Dorilea's rough costume, and her face, cast in dark shadow and lit only by reflected light, is coloured a bright orange. The orchestration of such effects generates an exciting brilliance, contained within a masterfully balanced arrangement of elegance and repose. Backer's synthesis of Flemish movement and Rembrandt's stability and force was here given flamboyant charm. While drawn contour lines attest to a careful preparation, translucent paint layers also point to later additions, for example the dogs at the bottom right, and also the outer fold of Granida's mantle.

The resurfacing of this important work, although exciting, brought with it some disappointment. It has been overcleaned, something that had been barely discernible in the old reproduction in the 1905 Tatarsky collection catalogue. Granida's translucent veil fluttering in the breeze, reduced to wispy traces, was even mistaken for smoke from the shell by Hofstede de Groot, who did not recognize the subject matter. Nevertheless, the balance of motion and the elegant grace of the figure of Granida remain in evidence. Another strength is the overall focus on Granida's face. There, Van Noordt subtly captured a calm and composed expression of noble gratitude.

1 See cat. no. 33n2.
2 See 53–6.

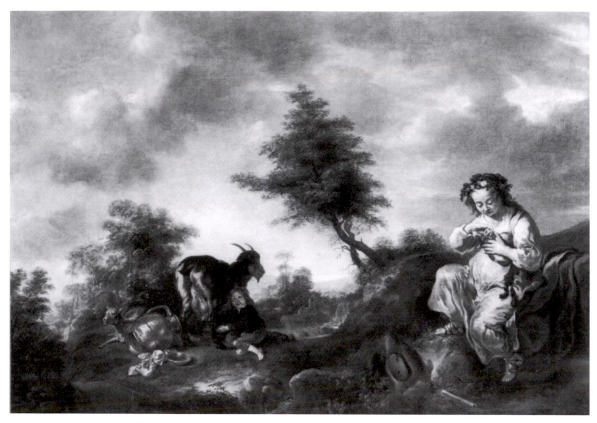

CATALOGUE 35
A Shepherdess and a Goatsherd in a Landscape with Animals, canvas, 83 × 115 cm,
present location unknown.

Genre Paintings

CATALOGUE 35
(p) *A Shepherdess and a Goatsherd in a Landscape with Animals*
Canvas, 83 x 115 cm, present location unknown

PROVENANCE
London, with Leger Gallery, in 1960

LITERATURE
Schneider 1931, 511

This painting, published here for the first time, was first attributed to Jan van Noordt by Sturla Gudlaugsson.[1] It relates in composition and subject matter to the signed and dated print by Van Noordt after a now-lost composition by Pieter van Laer (cat. P1), and likely dates shortly after 1644, the date on the print. This painting belongs to Van Noordt's earliest period, when he still depended heavily on models supplied by other artists. Van Laer (1592/95–1642) was an Italianate genre painter who spent much of his career in Italy and played a leading role among the *Bamboccianti*, a group of painters in Rome who specialized in low-life genre with urban and rural settings. Another Italianate painter, Jan Baptist Weenix (1621–1663), also produced a painting similar to the present one in content and composition, *Milkmaid with Farm Animals*, in Lund, Sweden (fig. 54).[2] Within Van Noordt's oeuvre, however, this small-figured genre scene set in a landscape is unusual. Van Noordt went on to paint larger-scale genre figures, and reserved landscape settings for history paintings. The pastoral element would remain significant for him. Most of his genre scenes would isolate one or more pastoral figures, and a number of his history paintings incorporated pastoral elements in the narrative or setting.

The artist here loosely composed some figures and animals in a rural landscape. A young shepherdess is seated on a mound to the right, with her hat and a flute lying on the ground before her. Further back and to the left side, a goatsherd crouches beside a goat, milking it with one hand into a bowl held in the other. A sheep lies on the ground to the left of them, partly hidden behind a large copper milk jug. The space between the two figures gives a view into the distance, featuring a waterfall and a building with a tower. Framing this open-

FIGURE 54
Jan Baptist Weenix, *Milkmaid with Farm Animals*, canvas, 66 × 79 cm, Lund, Lund University Art Collection.

girl who blithely concentrates on installing a flower in her cleavage. The ribald tone is sustained by the erotic allusions of objects such as the milk can and the flute.

1 Annotation with the photograph at the RKD.
2 Jan Baptist Weenix, *Milkmaid with Farm Animals*, canvas, 66 x 79 cm, Lund, Hugo Engelson Collection at Lund University; formerly St Petersburg, Hermitage; see collection catalogue St Petersburg 1895, 407, no. 1707.

ing to the right is an embankment, with two trees jutting into the sky, dividing the composition at its centre axis. The landscape is wild and rolling, and there are more trees to the left side, in the distance. The eye is drawn from the foreground to the right, into the distance at the left.

This suggestion of space is just one way in which Van Noordt transformed the scene in his print after Van Laer. He also distributed areas of light over the dark area of landscape in the bottom half, and inserted two prominent figures, taking the place of the vague background figure of the milkmaid in the composition by Van Laer. The modelling in both figures, but especially the nearer girl, is soft and fully rounded, a quality the artist pursued from the beginning of his career. The dramatic movement in curving folds of fabric, which marked this artist's work throughout his career, is evident in the girl's dress. The lively movement is carried through in other passages of this work, such as the forms of landscape, and even the puffy clouds above. Thus Van Noordt struck a light tone to match his low subject matter, as underlined by the smiling boy awkwardly milking a patient goat, and the grinning

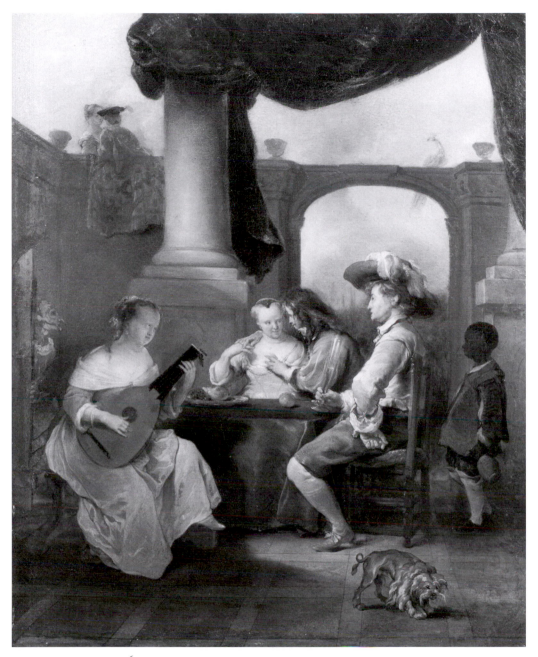

CATALOGUE 36
Musical Company on a Terrace, canvas, 75 × 61 cm, Berlin, Jagdschloß Grunewald (photo: Stiftung
Preußischer Schlösser und Gärten Berlin-Brandenburg/Jörg P. Anders)

CATALOGUE 36
Musical Company on a Terrace
Canvas, 75 x 61 cm, Berlin, Jagdschloß
Grunewald (inv. no. GK I 2238)

PROVENANCE
Paris, Solly Collection; Berlin, Collection
of Kaiser Friedrich Wilhelm III
(1770–1840), in 1821; Berlin, Berliner
Schloß; Potsdam, Bildergalerie Sanssouci;
Berlin, Jagdschloß Grunewald, since 1932

LITERATURE
Hofstede de Groot 1892, 217, no. 20;
Wurzbach 1906–10, 2:243

EXHIBITIONS
Berlin 1890, 69, no. 320 (as Jan Baptist
Weenix)

COLLECTION CATALOGUES
Grunewald 1933, 17; Grunewald 1964,
109, no. 144 (illus., as Jan van Noordt)

A group of flamboyantly dressed young people engage in merry-making and amorous play in the open space of a terrace. This scene belongs to the pictorial tradition of the "Merry Company," which was established around 1610 by Haarlem artists such as Esaias van de Velde, Dirck Hals, and Willem Buytewech. They had transformed the image of the "Courtly Garden of Love," which had lived a long life in late medieval manuscript illumination, paintings, and later on in printed illustrations.[1] Two other sources for the "Merry Company" were the related traditions of the "Garden of Fools" and the biblical parable of the prodigal son, both of which moralized against lasciviousness and drink.[2]

FIGURE 55
Gerbrand van den Eeckhout, *Merry Company on a Terrace*, 53.5 × 66.1 cm, signed and dated 1652, Worcester, Massachusetts, Worcester Art Museum.

In the second half of the seventeenth century, in Amsterdam, Rembrandt's pupil Gerbrand van den Eeckhout painted a considerable number of elegant companies at leisure, as well as similar scenes of soldiers in inns, often playing cards. Among these works in particular, *Merry Company on a Terrace* of 1652, in Worcester, Massachusetts, seems to have provided the inspiration for the present picture (fig. 55).[3] Van Noordt's painting dates a little later, toward the end of the same decade. It approaches his *Cimon and Iphigenia* of 1659 in its emphatic and resolved modelling (cat. 30).

Other close comparisons for dating include Van Noordt's undated *Shepherdess with a Basket of Fruit*, in Mänttä, and *Cloelia Crossing the Tiber*, in Paris (cat. 43, 25), whose figures also have slender hands and fingers, comparable female facial types with large foreheads and small eyes, and, more generally, rounded forms. This painting is more lavish, with a flamboyant treatment of drapery and costume appropriate to the image of affluent society associated with the "Merry Company." Exotic trappings abound, including a peacock above the arch, a masked entertainer entering from the left, a young black page to the right, and a small dog sporting a dashing coiffure in the foreground. It casts a knowing glance at the viewer, underlining the traditional moral message of this type of scene.

1 For the Dutch pictorial tradition of the "Merry Company," see Würtenburger 1937, Renger 1970, and, most recently, Elmer Kolfin, *The Young Gentry at Play. Northern Netherlandish Scenes of Merry Companies 1610–1645*, Leiden: Primavera Pers, 2005. The theme of the Garden of Love has been examined by Roberta Smith Favis: *The Garden of Love in Fifteenth-Century Netherlandish and German Engraving*, dissertation, University of Pennsylvania, 1974, and more recently in Vignau Wilberg-Schuurman 1983. A significant seventeenth-century example of the genre is *Cupido's Lusthof ende der amoureusen boogaert* (Cupid's Garden Retreat and the orchard of love), Amsterdam (Jan

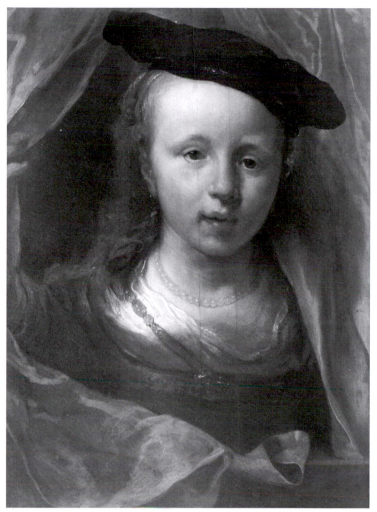

Evertsz Cloppenburch), 1613. This tradition
occasionally surfaced in seventeenth-century
paintings, for example in the background of
Frans Hals' *Portrait of Isaac Massa and Beatrix
van der Laen*: canvas, 140 x 166.5 cm, Amster-
dam, Rijksmuseum (inv. no. A 133); see exhibi-
tion catalogue Haarlem 1986, 128, no. 20. On
the history of the Italian Courtly Garden of
Love, see Watson 1979.

2 See Keyes 1984, 78.

3 Gerbrand van den Eeckhout, *Merry Company on
a Terrace*, 53.5 x 66.1 cm, signed and dated
1652, Worcester, Massachusetts, Worcester Art
Museum, inv. no. 1922.208. See Sumowski
1983–94, 2:747, no. 501, 864 (illus.).

CATALOGUE 37
(p) *A Young Girl Wearing a Beret*
Panel, 55.5 x 41.7 cm, Chatsworth,
Trustees of the Chatsworth Settlement
(inv. no. 466)

LITERATURE
Von Moltke 1965a, 250, no. A117 (as
perhaps by Jan van Noordt?); Sumowski
1983–94, 1:140, 143n84, 188 (illus., as
Jan van Noordt); 5:3112, with no. 2144

This fanciful image lends itself to com-
parison with Van Noordt's *Portrait of a
Boy* in Johannesburg (cat. 53). Both feature
young sitters and a framing device within

the rectangular format of the painting. Here the artist has gone a step further, displaying virtuosity in describing curtains of satiny cloth that hang behind the sitter, fall over her shoulder, and wrap over a balustrade in front of her. Caught in a strong light from the upper left, she casts a shadow on the fabric to the right, enhancing the illusion of space. The light and fluid brushwork suggests a later date than the Johannesburg portrait, as does the smoothly glazed modelling of the sitter's features. There is carefully painted detail as well, especially in the jewellery at her neck and shoulder. The combination of loose and detailed handling also appears in works such as the Leipzig *Susanna and the Elders*, pointing more specifically to a date of around 1660 (cat. 7). The painting in Leipzig, like this one, had formerly been attributed to Govert Flinck.

The sitter wears a beret, which was not a common item of headwear in the seventeenth century. It did enjoy some continuing popularity among artists, however, which suggests that this painting might not be a portrait, but simply a *tronie*, or character head. This type of painting was popular among Rembrandt and his pupils, and especially Ferdinand Bol liked to portray such general types wearing berets. The light atmosphere is also indicated by the pose of the sitter, who sticks her head through the opening between two curtains, drawing the left one aside with a casual gesture of her hand. This portion of the painting had been covered up, likely to make the painting more formal in tone. It was revealed in a cleaning in 1932.

CATALOGUE 38
(p) *A Girl with a Fan*
Canvas, 58.5 x 49.4 cm, present location unknown

PROVENANCE
Private collection

LITERATURE
Sumowski 1983–94, 5:3112, no. 2144, 3291 (illus.)

A young woman clasps her hands and holds a fan between her fingers. She poses in an antique costume featuring a white shirt with ample sleeves and modest *décolleté*, adorned with a rich string of pearls and precious stones that are accented by a large teardrop-shaped pearl. The fanciful dress and generalized features place this picture in the tradition of the *tronie*, or anonymous character-head, established by Jan Lievens and Rembrandt in the 1620s. Van Noordt seems to taken as his model not a sitter, but an existing painting by his teacher, Jacob Backer, *Head of a Young Woman*, with which it compares closely in the features of the girl and in the

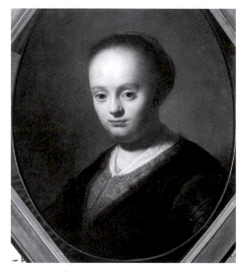

FIGURE 56
Jacob Adriaensz. Backer, *Head of a Young Woman*, panel, 59 × 44 cm, Stockholm, Nationalmuseum.

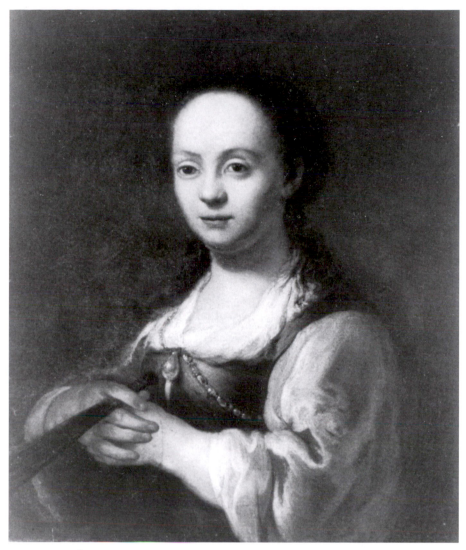

CATALOGUE 38
A Girl with a Fan, canvas, 58.5 × 49.4 cm, present location unknown.

strong chiaroscuro modelling (fig. 56).[1] Backer may have looked in turn to Rembrandt for his painting.[2] Van Noordt likely produced the present painting shortly after his contact with Backer, as the style belongs to his early period. The strong light effect, and the dramatic curves and curls in the fabric, link this work with the Sydney *Granida and Daifilo* and *Caritas* (cat. 33, 24), indicating a date of around 1650.

1 Jacob Adriaensz. Backer, *Head of a Young Woman*, panel, oval, 59 x 44 cm, Stockholm, Nationalmuseum, inv. no. NM 591; see collec-

tion catalogue Stockholm 1990, 291; and Sumowski 1983–94, 1:200, no. 53, 256 (illus.). Another version, attributed by Bredius to Rembrandt but since rejected as such, is in Leipzig: panel, 56 x 42 cm, Leipzig, Museum der Bildende Künste, inv. no. 1054 (as after Rembrandt); see collection catalogue Leipzig 1995, 153, no. 1054.

2 Compare Rembrandt, *A Girl Wearing a Gold-Trimmed Cloak*, oil on panel, oval, 59 x 44 cm, signed and dated 1632 (Br. 89), sale, London (Sotheby's), 10 December 1986, lot 44 (illus.); see Bruyn et al. 1982, 2:166–71, no. A50.

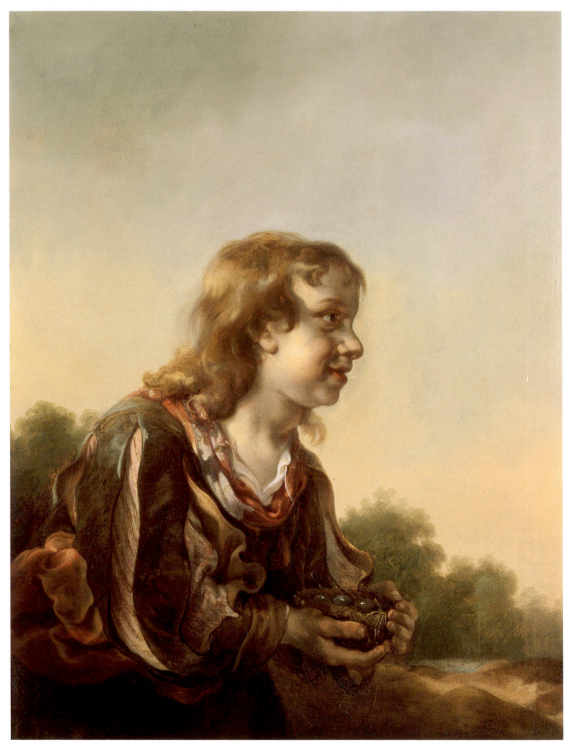

CATALOGUE 39
A Shepherd Boy with a Bird's Nest, panel, 73 × 56.5 cm, Amsterdam, Museum het Rembrandthuis.

CATALOGUE 39
(p) *A Boy with a Bird's Nest*
Panel, 73 x 56.5 cm, Amsterdam, Museum
het Rembrandthuis

PROVENANCE
Mrs Ruddle Brown and others sale (anony-
mous section), London (Christie's), 25 July
1952, lot 113 (as De Noordt, 29 x 24 in.
[73.6 x 61 cm], for ƒ5.5, to Dent); sale,
London (Christie's), 8 January 1971, lot
122 (as Van Noordt, *Portrait of a Boy Hold-
ing a Bird's Nest*, 76.3 x 59.6 cm, for ƒ140,
to Drumond); sale, Amsterdam (Sotheby's),
7 May 1993, lot 34 (illus., as signed
Flinck); Amsterdam, private collection;
given to the Museum het Rembrandthuis
in 2005

LITERATURE
Sumowski 1983–94, 6:3737, no. 2403a,
4021 (illus.)

A young boy, grinning, carries a bird's
nest in his hands. His forward lean
suggests that he is running, and that he has
stolen the nest and is making off with his
egg-filled prize. This picture has its prece-
dent in a Flemish print tradition of nest-
thieves. Such images usually show a group
of young men taking a nest out of a tree, as
in a drawing by David Vinckboons, which
was in turn inspired by the painting by
Pieter Bruegel the Elder in Vienna.[1] Van
Noordt seems to have adapted this type
for his painting, possibly influenced by a
painting attributed to Backer.[2]

This odd theme involving a bird's nest
is possibly a reference to fertility, much
like the painting *A Shepherd and a Shep-
herdess with a Bird's Nest* (cat. 40). It also
refers to love. The moral attached to
Bruegel's painting stated that obtaining
a bird's nest was not just a matter of know-
ing where it was, but also of fetching it.[3]
While such wisdom can be broadly ap-
plied, a later version of the emblem makes
a specific reference to amorous pursuits,

stating that success in love demands action,
and not just an object of affection. This
message was likely implied in the original.
Here, the boy plays the same Cupid-like
role taken up by his counterpart in the
painting last in Vienna, who holds a floral
wreath (cat. 44). He has taken action, and
thus he also spurs the viewer on in the
pursuit of love.

1 Hessel Gerritsz (after a drawing by David
 Vinckboons), *The Nest Thief: Autumnus, with a
 view of Maersen Castle*, etching, 26.3 x 34.9 cm;
 see Bartsch 1978, 53:399, no. 3 (illus.); Holl-
 stein 1949–, 7:107, no. 19 (after David Vinck-
 boons); exhibition catalogue Amsterdam 1997,
 108–10, no. 16. Pieter Bruegel the Elder, *The
 Nest Thief*, panel, 59 x 68 cm, signed and dated
 1568, Vienna, Kunsthistorisches Museum.
2 Attributed to Jacob Adriaensz. Backer, *A Boy
 with a Bird's Nest*, canvas, 76 x 63 cm, sale,
 Amsterdam (Paul Brandt), 2–8 November
 1965, lot 3 (illus., pl. 7).
3 Exhibition catalogue Amsterdam 1997, 110.
 The author concedes that amorous themes, no
 matter how disguised as other, more mundane
 themes, almost inevitably showed some firm
 indication of the underlying erotic message.
 The emblem cited here, however, is explicit.

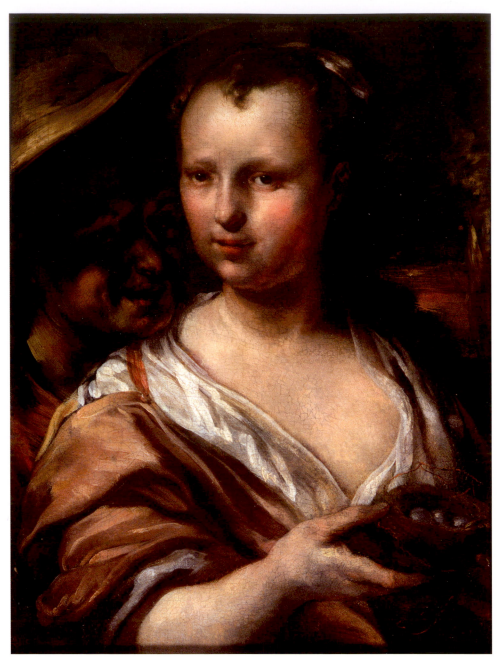

CATALOGUE 40

A Shepherd and a Shepherdess with a Bird's Nest (Allegory of Fertility), canvas, 50 × 39 cm, present location unknown.

(p) *A Shepherd and a Shepherdess with a Bird's Nest (Allegory of Fertility)*
Canvas, 50 x 39 cm, present location unknown

PROVENANCE
Sale, Paris (Drouot-Richelieu), 28 June 1996, lot 50 (illus., as *Vertumnus and Pomona*, and as probably having once been larger); sale, Amsterdam (Sotheby's), 6 May 1997, lot 3 (illus.).

LITERATURE
Sumowski 1983–94, 6:3737, no. 2403a, 4021 (illus.).

This is the earlier of two amorous pastoral pairs that survive from the hand of Van Noordt, the second being *Shepherd and Shepherdess with a Basket of Fruit* (cat. 41). In both, a young shepherdess is approached from behind by a young shepherd, and the two are shown in waist-length, filling the frame. The subject matter differs slightly between the two pictures, with the present painting featuring a bird's nest containing some eggs in the shepherdess's hands, instead of a basket of fruit. Also, the shepherd pushes further into the foreground, adding emphasis to his grinning expression of glee.

The nest and eggs form an obvious reference to the couple's love and anticipated fertility. Themes such as this one comprised a rare platform for explicit expression of eroticism in seventeenth-century Dutch painting.[1] The motif relates in turn to images of nest thieves, such as Van Noordt's own painting of roughly ten years earlier (cat. 39). These images reminded the viewer of the importance of taking action, and not just cultivating desire. Here, the man seems to take the allusion to its completion, approaching the shepherdess and accompanied by the bird's nest that symbolizes her.

The earlier dating of this pastoral pair is based largely on the handling of the figures. The shepherd's ruddy and expressive face is treated rather sparsely, which is more consistent with earlier works. It contrasts with the very soft, almost pudgy features of the woman. A similar treatment of a woman's head appears in the latest known version of *Cimon and Iphigenia* by Van Noordt (cat. 30), a connection that speaks for a dating close to 1659.

1 For a discussion of erotic aviary references in seventeenth-century Dutch genre representations, see De Jongh 1968/69.

CATALOGUE 41

(p) *Shepherd and Shepherdess with a Basket of Fruit (Allegory of Fertility)*[1]
Support not known, dimensions not known

This painting presents an amorous exchange between a shepherd and a shepherdess. He stands behind her to the left side, grasping her shoulder with one hand, and peers across to the basket of ripe fruit she cradles in the left arm. She turns to look at him, smiling, and with her other hand reaches for an apple. The visual joke of the comparison between round fruit and her exposed breast sets a playful tone. A more innocent variation on the theme, showing a much younger pair, was painted by Jürgen Ovens, likely a few years earlier (fig. 57).[2]

Van Noordt painted a number of related pictures treating amorous and pastoral themes. A similar work in composition and content is his *Shepherdess and Shepherd with a Bird's Nest* (cat. 40), except that the basket of fruit is replaced by a bird's nest with eggs. Van Noordt's treatment of this kind of theme was reported in the inventory of the Amsterdam dealer-painter Cornelis Doeck in 1664, which includes "A Shepherd and a Shepherdess by Van Noordt" (cat. L31). Neither of these two paintings is a more likely candidate for Doeck's, because both can be dated to before 1664 on the basis of style. In the present work, the smoothly modelled flesh and drapery, and the elegant features of the shepherdess, bear close comparison to the signed and dated *Granida and Daifilo* of 1663 (cat 34).

1 Reported by Hofstede de Groot at a sale in Germany, in a note with the photograph at the RKD.
2 Canvas, 76.7 x 65 cm, Weimar, Schloßmuseum, inv. no. G2391; see collection catalogue Weimar 1994, 62–3, no. 30 (illus.); and Sumowski 1983–94, 3:2227, no. 1499, 2254 (illus., as late 1650s).

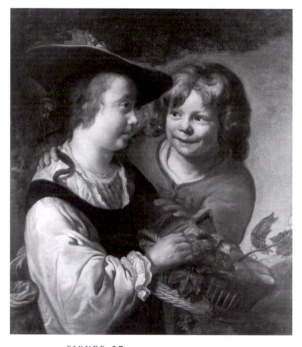

FIGURE 57
Jürgen Ovens, *Shepherd and Shepherdess with a Basket of Fruit (Allegory of Fertility)*, canvas, 76.7 × 65 cm, Weimar, Schlossmuseum, Stiftung Weimarer Klassik und Kunstsammlungen (photo: Klaus G. Beyer, Weimar, 2005).

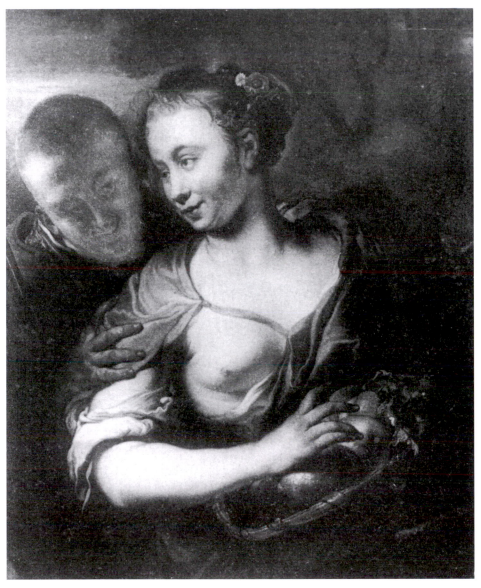

CATALOGUE 41
Shepherd and Shepherdess with a Basket of Fruit (Allegory of Fertility), support not known, dimensions not known.

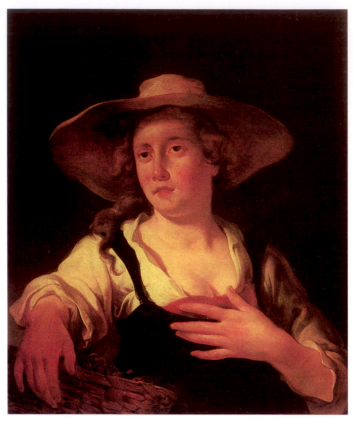

CATALOGUE 42
Shepherdess with a Basket of Grapes, panel, 71 × 59 cm, Florence, Uffizi.

CATALOGUE 42
(p) *Shepherdess with a Basket of Grapes*
Panel, 71 x 59 cm, Florence, Uffizi (inv.
no. p108)

COLLECTION CATALOGUES
Florence 1980,108, 139 (illus.); Florence
1989, 31–2, no. 3.16 (illus., as attributed to
Jacob Adriaensz. Backer)

This painting adopts a simple composi-
tion. A young shepherdess, wearing a
large hat and carrying a basket of fruit in
front of her, faces the viewer. Except that
her head is turned more to the left, she
corresponds closely from the waist up to
the figure in the following catalogue entry,
a three-quarter-length shepherdess in
Mänttä. The Florentine museum tentative-
ly attributes this picture to Jacob Backer.[1]
It does reflect his heavy-lidded facial types
and his penchant for flowing undulating
lines, but does not display Backer's fluid,
assured touch. It is likely by Van Noordt
after his period of study with Backer,
around 1645. The strong reflections, in
particular at the right elbow, the forehead,
and the underside of the large brim of the
hat, produce the same rounded modelling
as seen in *Caritas*, and reappears in both of
the early depictions of *Cimon and Iphigenia*
(cat. 24, 28, 29). The distinctive tapered
shape of the shepherdess's fingers is also
comparable. The deftly painted basket,
with its accentuated woven reeds, shows
the artist's considerable skill at still-life.

1 See collection catalogues, 1989.

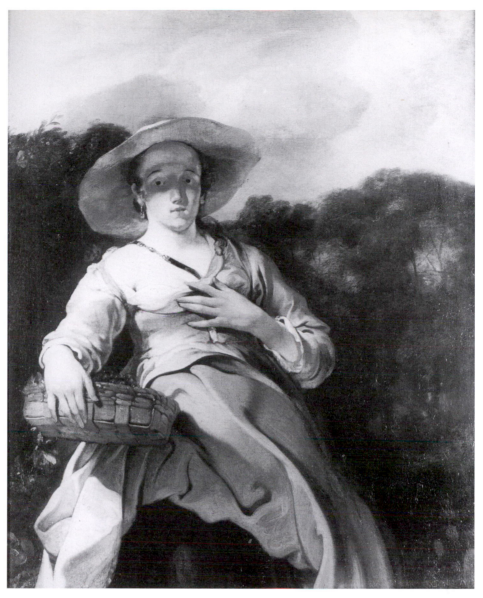

CATALOGUE 43
A Shepherdess with a Basket of Fruit, canvas, 75 × 63 cm, Mänttä, Finland, Gösta Serlachius Museum of Fine Arts.

CATALOGUE 43
(p) *A Shepherdess with a Basket of Fruit*
Canvas, 75 x 63 cm, Mänttä, Finland,
Gösta Serlachius Museum of Fine Arts
(inv. no. 321)

LITERATURE
Sumowski 1983–94, 5:3112, no. 2142,
3289 (illus.); Sumowski 1986, 26, 27 (illus.
fig. 7), 36n32 (as an *Allegory of the Seasons*,
after 1660)

EXHIBITIONS
Mänttä 1980, 61, no. 282

COLLECTION CATALOGUES
Mänttä 1965, no. 279 (illus.); Mänttä 1978,
76, no. 315 (illus.)

COPIES
Canvas, 89.5 x 60 cm (with rounded cor-
ners), sale, Vienna (Dorotheum), 15 March
1990, lot 18 (illus.); sale, Amsterdam
(Christie's), 29 May 1986, lot 90 (illus.)

Van Noordt here reprised his earlier figure of a shepherdess in the painting now in the Uffizi (cat. 42), but painted her in a smaller scale and set her against a landscape background. He seems to have intended a more complex, multi-figured scene, with other figures at her side; there exists a copy of this work in which a satyr appears with a tambourine to the left, and two cows and two sheep in the background right. This was likely the original composition of the present painting. In the copy, the shepherdess's pose, leaning back and to the left, is balanced by the figure of the satyr. Here, the same pose seems inexplicable and off balance. However, no technical research has been done to confirm whether these extra figures were indeed once present.

Van Noordt copied his earlier figure nearly exactly, right down to the drapery folds. However, his handling of the face departs from the heavy impasto of the Uffizi painting, and shows some of the light, thin handling and translucency of his later work. Sumowski makes an appropriate comparison to the Kingston *Satyr and the Peasant Family* (cat. 19), but incorrectly places both of these works late in the artist's career, whereas they characterize Van Noordt's style around 1655. Some of the drapery passages are weak, particularly in the skirt, where stylized folds unconvincingly suggest the heavy weight of coarse fabric. This same stiff impasto treatment characterizes some of Van Noordt's early history paintings, for example his earliest depiction of *Cimon and Iphigenia* (cat. 28).

CATALOGUE 44
(p) *A Shepherd Girl with a Wreath of Flowers*
Panel, 64 x 55 cm, present location unknown

PROVENANCE
Stockholm, with E. Burg-Berger Gallery, in 1937; Stockholm, Nasiell collection, 1937; sale, Stockholm (H. Bukowski), 11–14 November 1959, lot 173 (illus. pl. 20, as Albert Cuyp); sale, Stockholm (H. Bukowski), 6–9 November 1963, lot 152 (illus. pl. 21, as Benjamin Gerritz. Cuyp); Lund, Sweden, collection of Hugo Engelson, in 1964; sale, Stockholm (Bukowski), 28–31 May 2002, lot 410 (illus., as Jan van Noordt); sale, Vienna (Dorotheum), 27 March 2003, lot 207 (illus.); sale, Vienna (Dorotheum), 1 October 2003, lot 353 (illus.) sale, Munich (Hampel), 5–6 December 2003, lot 869 (illus.); sale, London (Christie's), 23 April 2004, lot 66 (illus.); sale, Vienna (Dorotheum), 29 September 2004, lot 178 (illus.); sale, Vienna (Dorotheum), 5 October 2005, lot 88 (illus.)

COPIES
(1) Panel, 56.5 x 48 cm, sale, London (Christie's), 14 March 1903 (Lugt 60937), lot 7 (as *Portrait of a young girl, in green dress, with a wreath of flowers*).
(2) Panel, 57.5 x 49 cm, Leipzig, Kunstsalon Franke, in 1933; collection of Mrs J. Vuyk, in 1941; see Hofstede de Groot 1907–28: 2:52, no. 155a (as Albert Cuyp).

This young shepherdess is one of Jan van Noordt's earliest treatments of an amorous pastoral theme. The persona of Cupid from classical mythology has been transplanted, as it were, to that fantasy realm of shepherds and shepherdesses that was evoked by numerous literary works and paintings in the Netherlands during the seventeenth century. This child is typically identified as a girl, with long hair and wearing a a large-brimmed hat and a sim-

A Shepherdess with a Wreath of Flowers, panel, 64 × 55 cm, present location unknown.

ple, loose rustic dress bound with a sash, accompanied by a sheep whose head pops up at the bottom left. Besides her beckoning, somewhat melodramatic gaze, the wreath of flowers she holds in one hand and the single rose in the other make explicit her role as an inspirer to love. Such wreaths appear in numerous amorous mythological paintings, especially of Amarillis and Mirtillo, produced in the same context; pinks and roses were included in many portraits to indicate engagement or marriage.[1] This painting, with its modest scale and unspecific subject matter was likely not produced for such a specific occasion, but rather for the open market.

This painting dates to around the same time as the Sydney *Granida and Daifilo*, and a little later than the genre scene of a *Shepherdess and Goatsherd* last with Leger (cat. 33, 35). These works share a translucent modelling that yields a soft suggestion of flesh. These passages are set against heavier, stiffer forms of fabric, where the paint is thicker, more opaque, and more directly modelled. The patchy effect in some passages is reminiscent of the Cherbourg *Cimon and Iphigenia* of around 1650 (cat. 29). The curving forms of the drapery folds are also characteristic of Van Noordt's style around this time. With respect to the composition, the distributed highlights are typical of the early works, and create an overall liveliness. Here, the atmosphere especially complements the amorous subject matter and the affable, charming visage of the figure.

1 For carnations as symbols of engagement, see Smith 1982, 62–3. For roses as symbols of marriage, see De Jongh 1967, 25–34. Sluijter has also observed the erotic connotation of floral wreaths in mythological scenes; see Sluijter 1993–94, 50. It is most explicit in a painting of a pastoral couple by Govert Flinck; see Kettering 1977, 41–2 (illus. fig. 24). The English traveller Fynes Moryson, in the early seventeenth century, noted the marital symbolism of wreaths of roses in Holland at the time: "On Friday in the beginning of the Month of July, at five a clock in the evening, I tooke ship, upon the mast whereof was a garland of Roses, because the master of this ship then wooed his wife, which ceremony the Hollanders used." see Moryson 1907–08, 1:114.

CATALOGUE 45
A Boy with a Dog and a Falcon
Canvas, 81.3 x 65.4 cm, signed and dated bottom left: *J. van Noordt 1675*, present location unknown

PROVENANCE
L. Stockbroo van Hoogwoud en Aartswoud sale, Amsterdam, 13–14 November 1855 (Lugt 22627), lot 28 (as 84 x 66 *duim* [85 x 66 cm]; ƒ15, to Manvis, dealer); L. Stockbroo van Hoogwoud en Aartswoud sale, Hoorn, 3 September 1867 (Lugt 29948), lot 577 (as: *Een meisje met een hond, gemerkt Jan van Noordt* [A girl with a dog, signed Jan van Noordt], for ƒ80, to Bourgeois); New York, collection of Dr John E. Stillwell; his sale, New York (Anderson Galleries), 1 December 1927, lot 238 (illus., as dated 1645); New York, Bucher Galleries, in 1931; Dr Leon Lilienfeld and others sale, New York (Sotheby Parke-Bernet), 17–18 May 1972, lot 113 (illus.); collection of Albert Parreno; New York, with Bob Haboldt & Co.; sale, London (Sotheby's), 8 July 1998, lot 189 (illus.); Maastricht, with Robert Noortman Gallery; Amsterdam, private collection; sale, Amsterdam (Christie's), 14 May 2003, lot 191 (illus.)

LITERATURE
Hofstede de Groot 1892, 210; Schneider 1931, 511; advertisement in *Art News*, 5 December 1931; Sumowski 1983–94, 1:142n50; 6:3588, 3737, no. 2408, 4026 (illus.); Sumowski 1986, 21, 34n5; collection catalogue Lyon 1993, 110n2 (as 1645)

EXHIBITIONS
Paris Habolt 1991, 52, no. 21, 53 (illus.)

A young boy poses as a hunter, accompanied by his dog. He is equipped with a spear and a hooded falcon, and wears an imaginary hunting costume *à l'antique*, such as is seen more often in Dutch paintings of the period. His com-

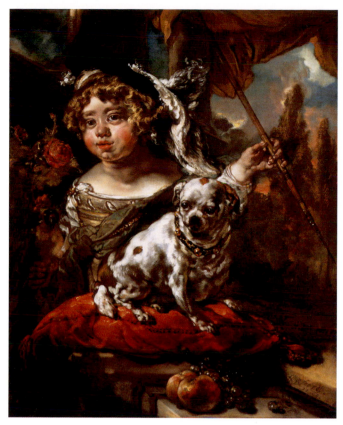

CATALOGUE 45
A Boy with a Dog and a Falcon,
canvas, 81.3 × 65.4 cm,
signed and dated 1675,
present location unknown.

panion is a pug, also known as a Dutch mastiff, an exclusive breed of hunting dog imported from the East.[1] The luxury and leisure aspects of the sport are here emphasized, especially in the pretentious setting of a monumental courtyard with a classical column swathed in drapery in the background, behind which appear open sky and a wood. The boy and his dog sit on stone steps, one of which bears the artist's calligraphic signature and the date of 1675. There are flowers behind them and fruit in the foreground. The stylish display is completed by the bright red cushion under the dog.

The festive mood and the many attributes suggest that this is a genre depiction rather than a portrait. The boy competes with the other elements for attention, very unlike a portrait. Furthermore, he strikes a rather informal pose, and his smiling expression lacks the usual restraint found in portraits. His puffy cherub-like features do not seem to be those of a particular person. Most importantly, however, the open

and loose style applied by the artist seems inconceivable as applied to a portrait produced in Amsterdam in 1675. In the years leading up to this picture, Van Noordt had been applying this style mostly to scenes of history with a heavy emotional overtone. Here he attempted to conjure a jovial atmosphere with the same means. Directly applied patches of light colour create a strong rhythm. This energy is carried through in the cutting diagonals of the spear, the dog, and the feathers of the boy's hat. The harsh contrasts and colours make an uncomfortable match with the light subject matter. In comparison, Van Noordt treated his young hunters of the mid-1660s with greater smoothness and gentleness (e.g., cat. 55, 56). Here, without a binding action or focus by which the viewer can interpret the dramatic effects, as there had been in the earlier history paintings, the result is somewhat chaotic.

1 See Secord 1992, 78–81.

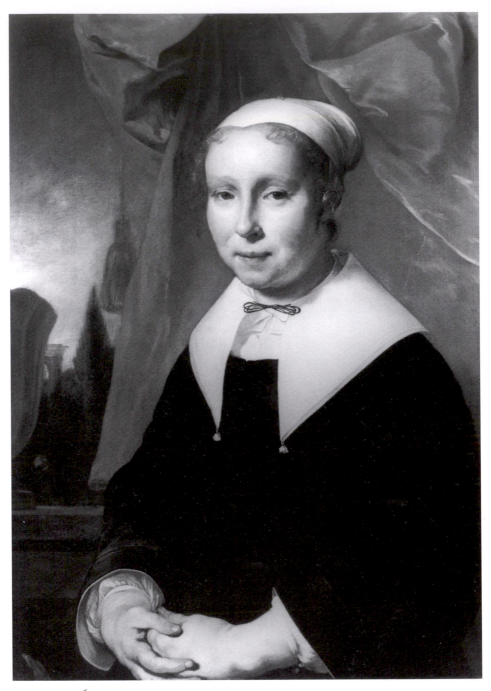

CATALOGUE 46
Portrait of a Woman Wearing a Plain Kerchief and a Coif, canvas, 73.7 × 54.5 cm,
signed and dated 1659, present location unknown.

Portraits: Women

CATALOGUE 46
(p) *Portrait of a Woman Wearing a Plain Kerchief and a Coif*
Canvas, 73.7 x 54.5 cm, signed and dated bottom left, under the vase: *JvNoordt ft 1659*, present location unknown

PROVENANCE
Collection of R.A. Bethell; David Balfour and others sale (R.A. Bethell section), London (Christie's), 21 December 1951, lot 51 (illus., for £42, to W. Sabin); The Hague, with Nystad Gallery, in 1952

LITERATURE
Nystad 1981, 711 (illus.)

This signed and dated work of 1659 represents Van Noordt's beginnings as a portraitist. His work up to this point included mainly genre and history paintings, and some portrait-like *tronies*. This depiction of a sitter shares their smooth and strongly rounded modelling and restrained emotional expression. It also shows his typically lively energy, which is achieved in swelling forms and curving edges. This movement carries through in the background, where draperies hang from classical columns, a pretentious setting adapted from the grand portrait fashion entrenched by Anthony van Dyck. It is somewhat incongruous with the more modest presentation of the sitter. Her sober dress, which does not feature any lace or cuffs, suggests that she may have been a Mennonite. The artist achieved a convincing characterization of her as unassuming, warm, and graceful. The slight smile lends a light touch consistent with the artist's early genre depictions. The mismatch with her surroundings lends credence to the notion that Van Noordt was at the time only starting to develop as a portraitist.

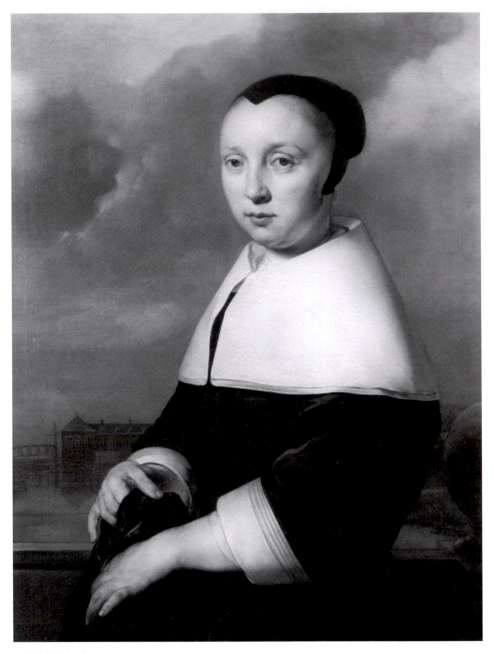

CATALOGUE 47
Portrait of a Woman, canvas, 81.2 × 64.5 cm, Angmering, West Sussex,
collection of Peter and Susan Holland

Portrait of a Woman
Canvas, 81.2 x 64.5 cm, Angmering,
West Sussex, collection of Peter and
Susan Holland

PROVENANCE
Munich, with Drey, in 1914;[1] England,
collection of H. de Vere-Clifton; London,
with Charles Duits, in 1965; sale, London
(Christie's), 30 July 1976, lot 90 (illus.);
The Hague, with Sam Nystad; Voor-
schoten, collection of J.A. van Rossem;
sale, London (Phillips), 5 December 1989,
lot 24 (illus.)

LITERATURE
Nystad 1981, 711 (illus. no. 4, as attributed
to Jan van Noordt); Sumowski 1983–94,
1:140, 143n79, 184 (illus., as Jan van
Noordt); 6:3589; Bruyn 1984, 150, 187
(as not by Jan van Noordt, but reminiscent
of G. van den Eeckhout)

A mature woman directs a calm, strong
gaze at the viewer. Her hands are fold-
ed, and her lightly smiling lips and slightly
lowered eyelids further project self-control
and self-assuredness. Jan van Noordt flat-
tered his sitter by smoothly abstracting her
likeness. The artist poured lavish care into
this picture, to the point of including the
detailed architecture of a country house
and moat in the background left. These
possessions affirm her privileged social po-
sition. Her sober dress suggests she is the
matron of a patrician family. The rather
formal pose and simple composition were
perhaps also demanded by the commission;
they are enlivened by the movement im-
bued throughout, in the swelling forms
of the fingers and the undulating bottom
edge of her collar. The characteristically
vigorous approach of Van Noordt after
1665, which is evident in these passages, is
extended to the background sky, with its
billowing clouds dramatically lit at the
horizon by a strong orange evening glow,
a colour also reflected in the shadow side
of the sitter's neck and face.

1 Reported by Cornelius Hofstede de Groot,
in a fiche kept at the RKD in The Hague.

CATALOGUE 48
Portrait of a Woman, canvas,
78 × 64 cm, London, with Hall
and Knight Gallery.

CATALOGUE 48
Portrait of a Woman
Canvas, 78 x 64 cm, present location
unknown

PROVENANCE
Mme. G. and others sale (anonymous
section), Paris (Drouot: Maurice Rheims),
12–13 November 1952, lot 73 (illus. pl. 5,
as C. Netscher); Paris, private collection,
in 1962; Bergamo, with Steffanoni, in 1973
(as Janssen); sale, London (Sotheby's), 8
June 1998, lot 30 (illus., as Jan van Noordt);
London, with Hall and Knight Gallery

LITERATURE
Sumowski 1983–94, 6:3737, no. 2406,
4024 (illus.)

Jan van Noordt was at the height of his
late-starting career as a portraitist when
he painted the present work, around 1670.
Over the course of the 1660s he moved
toward a smooth and broad treatment of
flesh and drapery. It seems that he came
under the influence of Abraham van den
Tempel, one of the few artists whose con-
tact with him is documented. Van Noordt
even adopted Van den Tempel's abstrac-
tion, and in this way could even further
flatter his young sitter, who is dressed in
costly satin fabric and pearl jewellery. Van
Noordt's own hand remains very much in
evidence, as Jacques Foucart was the first
to recognize.[1] This painting especially dis-
plays the artist's approach to drapery, in
which modelling with chiaroscuro and
reflections achieve strong and distinct vol-
umes, and also emphasize his characteristi-
cally waving lines of edges and folds. The
pursuit of such a vigorous drama reflects
the artist's parallel activity as a history
painter. A technical aspect further links
this work to the late history paintings. The
area beside the figure in the bottom right
corner, which shows a stone vase resting
on a balustrade, has been left unfinished
to the degree that it shows the lines of the
underdrawing, thus contrasting with the
lavish painting in other areas, especially
in the figure.

1 Note with the photograph at the Centre de
Documentation of the Louvre, Paris.

CATALOGUE 49

(p) *Portrait of a Woman on the Steps of a Terrace*
Canvas, 113.5 x 91 cm, falsely signed, bottom left: *F. Bol*, present location unknown

PROVENANCE
Sale, Amsterdam (Mak van Waay), 10–12 February 1942, lot 4 (illus., as 116 x 92 cm, Ferdinand Bol, signed bottom left: *F. Bol*); The Hague, with Vermeulen, 1943–45; sale, Lucerne (Galerie Fischer), 3–7 December 1963, lot 1639 (illus. fig. 55, as Jan van Noordt)

LITERATURE
Collection catalogue Hartford 1978, 168, no. 104n5; Blankert 1982, 186, no. R220 (as Jan van Noordt)

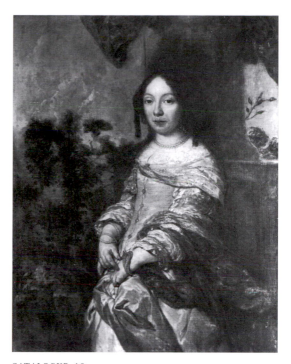

CATALOGUE 49
Portrait of a Woman on the Steps of a Terrace, canvas, 113.5 × 91 cm, present location unknown.

A young girl poses in a glittering satin dress, and is adorned with strings of pearls around her neck and wrists. Her hair is arranged in long falling *pijp-crullen* (pipe-curls). The lavish display is completed behind her with a classical column and drapery suspended above, framing the view to a garden. This portrait had previously been given to Ferdinand Bol; however, the liveliness of the piled folds of her clothing indicates the late style of Jan van Noordt, as do the swelling forms of her hands. Staccato rhythms in the fabric, and an overall organization into a longer, sweeping line through the figure, connect this work more specifically to the portraits and history paintings of around 1670. These elements create a bustling energy typical of Van Noordt's depictions of children. The naive, wide-eyed expression, at the same time serious, further characterizes the sitter as youthful.

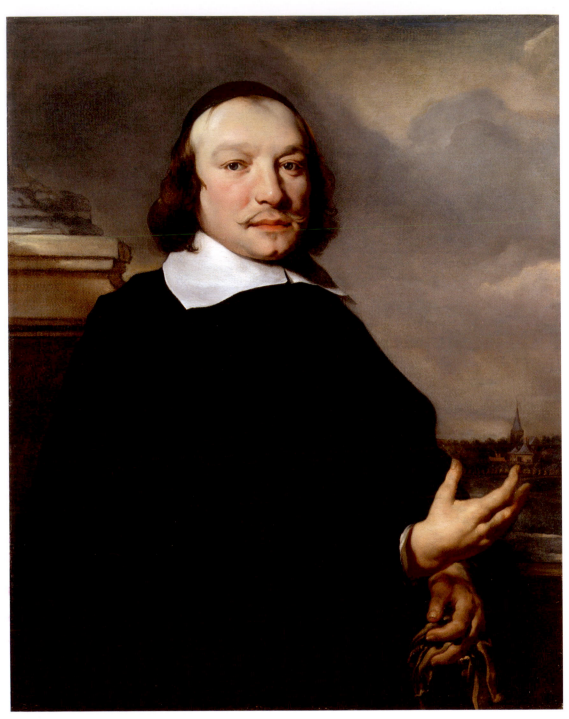

Portrait of a Man Holding a Glove, canvas, 83.2 × 67 cm, London, with Clovis Whitfield Fine Art.

Portraits: Men

CATALOGUE 50
Portrait of a Man Holding a Glove
Canvas, 83.2 x 67 cm, London, with
Clovis Whitfield Fine Art

PROVENANCE
Spain, private collection; sale, London
(Sotheby's), 18 April 2000, lot 21 (illus.);
sale, London (Sotheby's), 2 November
2000, lot 326 (illus., as Jan van Noordt)

This portrait, which recently surfaced,
shows a middle-aged man in half-
length, facing the viewer, raising his proper
right hand. He makes an elegant gesture
to the right, where the pendant portrait
of his wife would have been hanging. That
picture is almost certainly the one in the
Holland collection (cat. 50). The dimen-
sions correspond closely, as does the sup-
port, a herringbone weave canvas likely
of Venetian origin. Both works show a
careful, crisp presentation of the figure,
strong chiaroscuro, roundly modelled
forms, and strongly defined edges set
against the background. These features
place both works around 1665.

Van Noordt gave prominence to the
backgrounds in these portraits, which sug-
gests that these are significant sites for
the sitters. Here it is a village near a large
river, and a church with a tall narrow spire.
This building bears some resemblance
to the church that stood in Diemen, the
village on the Amstel River just to the
south of Amsterdam. It was demolished
in the nineteenth century, but its form was
recorded by various artists, including Rem-
brandt. There is no further evidence to se-
cure identification of the sitters, however.
One candidate, the artist's brother Lucas,
a *predikant* in Diemen, has to be excluded,
since he never married.

CATALOGUE 51
Portrait of Dionijs Wijnands (1628–1673)
Oil on copper, 20.5 x 16 cm, inscribed
on the reverse: *Dionijs Wijnands 1664*,
Amsterdam, Rijksmuseum (inv. no. A710)

PROVENANCE
Amsterdam, Jhr. J.S.H. van de Poll;
bequeathed to the Rijksmuseum in 1880

LITERATURE
Hofstede de Groot 1892, 216, no. 14 (as
not likely by Van Noordt); Moes 1897,
2:655, no. 9335; Wurzbach 1906–10,
2:243; Decoen 1931, 17; Staring 1946, 75;
Kolleman 1971, 120; Bénézit 1976, 7:750;
Schatborn 1979, 118; Bernt 1980, 2:924
(illus.); Sumowski 1983–94, 1:140, 143n77,
182 (illus.); 5:3112, with no. 2145

SELECTED COLLECTION
CATALOGUES
Amsterdam 1885, 38, no. 256c; Amsterdam
1976, 419, no. A710 (illus., as Jan van
Noordt)

The inscription, in a seventeenth-
century hand on the back surface of
this painting's copper support, identifies
the sitter as "Dionijs Wijnands." The same
person appears in a large, three-quarter-
length portrait, and also in a drawing, all
taking the same pose (cat. 52, D14). In his
1946 article, Staring expressed some doubt
about Van Noordt's authorship of the small
copper panel, but did not put forward any
relevant observations. On the contrary,
the close match of colour, and the lively
bulging forms, especially in the hand, are
strong stylistic links to the large painted
version on canvas, which is signed and
dated. The painting on copper was likely
made in preparation for it. This delightful
small image, with its vivacious effect of
loose and quick brush strokes, gives the
impression of having been taken from life.
Its composition includes only the head and

torso, which suggests that the artist used
this sitting to capture a likeness. He later
translated it into the form of a large three-
quarter portrait including a background
of architecture, drapery, and a vista.

This cluster of works suggests that the
artist took his portrait commission serious-
ly, and it appears to have been an impor-
tant step toward elite patronage. Although
it was known for some time, G. Kolleman
was the first to publish further information
on the identity of the sitter, in 1971.[1]
Wijnands was born in 1628, the son of
the *kraemer* (vendor) Hendrick Wijnantsz
and Aeltje Denijs (figs. 24, 25), who are
depicted in portraits in the Rijksmuseum
collection.[2] Dionijs's marriage to Anna
Groessens is recorded on 27 February
1654.[3] The couple built up a small fortune
through the manufacture of silk fabrics in
Amsterdam. In 1663 Dionijs was listed as
one of the members of the city's new com-
mittee of silk manufacturers.[4] On his early
death in 1673, he was given as living on the
Bloemgracht, where his wife had been liv-
ing before their marriage, and also where
Jan van Noordt was recorded as living in
1674.[5] The couple likely spent their nine-
teen years together at this address. Their
social success is indicated by their daugh-
ter's marriage to Hendrik Meulenaer,
the son of the prominent Amsterdam mer-
chant and regent Roelof Meulenaer and his
wife, Maria Rey, who are known through
their portraits by Ferdinand Bol, of 1650,
hanging in the Rijksmuseum.[6]

In addition to his social standing, Wij-
nands also enjoyed literary status. In 1671
he became one of eleven members of the
group *Nil Volentibus Arduum*, led by An-
dries Pels, which advocated a classicizing
approach to theatre based on French mod-
els.[7] Neither the two painted portraits or
the drawing, from seven years earlier in
1664, include any references to this aspect
of Wijnands's life, however. There is a pos-
sibility that Van Noordt's special attention
to this portrait may have stemmed from

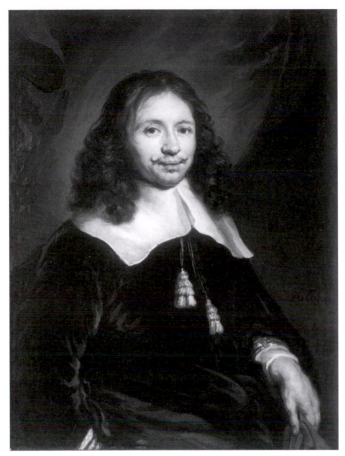

his apparent connection to the theatre. This interest is reflected in his depiction of themes appearing on stage in Amsterdam, and may have grown out of social connections, such as to Dr Samuel Coster (1579–1665), the founder of the Amsterdam *Schouburgh*, or city theatre.[8]

1 Kollemans 1971, 118.

2 G.A.A. D.T.B. 40 (Baptism) 440 (Nieuwe Kerk), 5 March 1628.

3 G.A.A. D.T.B. 473 (Marriage) 210 (Church) 27 February 1654. Attributed to Nicolaes Maes, *Portrait of Hendrick Wijnantsz*, canvas, 45 x 34 cm, Amsterdam, Rijksmuseum (inv. no. A703); *Portrait of Aeltje Denijs*, canvas, 44.5 x 34 cm, Amsterdam, Rijksmuseum (inv. no. A702); see collection catalogue Amsterdam 1976, 359, *s.v.* copy after Nicolaes Maes.

4 G.A.A. 5020 (*Privilegiën en Keurboeken*) no. 16, *Keurboek* "O," fol. 34v, dated 17–24 April 1663.

See Leonie van Nierop, "De zijdenijverheid historisch geschetst," *Tijdschrift voor geschiedenis* 46, 1931, 43.

5 His death was reported in the annals of *Nil Volentibus Arduum*; see Dongelmans 1982, 209 (document no. 801), where he was given as having died 11 September 1673. G.A.A. D.T.B. 1056 (Burial) 87 (Nieuwe Kerk), 15 September 1673. On Jan van Noordt's location in 1674, see 350n32.

6 Alida Wijnands was baptized on 12 February 1655 as the child of Dionijs Wijnands and Anna Groessens: G.A.A. D.T.B. 105 (Baptism) 28 (Westerkerk). For her marriage, see 45 and 356n38.

7 Dongelmans 1982. He first appeared as a group member on 27 January 1671 (310, no. 859).

8 See 12 and 350n31 concerning Adriana Kosters, daughter of Samuel Coster and granddaughter of Adriaen Lenaertsz.

CATALOGUE 52
Portrait of Dionijs Wijnands (1628–1673)
Canvas, 124 x 103.5 cm, signed and dated
middle right: *Joan van Noordt f Aᵒ 1664*,
Amsterdam, Rijksmuseum (inv. no. A709)

PROVENANCE
Amsterdam, Collection of Jhr. J.S.H. van
de Poll; given to the Rijksmuseum in 1880

LITERATURE
Hofstede de Groot 1892, 212 nos. 12, 14,
16; Moes 1897–1907, 2:655, no. 9335;
Wurzbach 1906–10, 2:243; Decoen 1931,
17; Staring 1946, 74–5 (illus. no. 2); Kolle-
man 1971, 120; Bénézit 1976, 7:750;
Schatborn 1979, 119 (illus. no. 2); Bernt
1980, 2:924 (illus.); Sumowski 1983–94,
1:140, 143n78

SELECTED COLLECTION
CATALOGUES
Amsterdam 1885, 38, no. 256b; Amster-
dam 1976, 419, no. A709 (illus.)

The sitter is discussed in the previous
catalogue entry. This three-quarter-
length portrait closely follows the small
study on copper in the pose, and also in the
red drapery swathed above and the stylized
bulging form of the sitter's hand below to
the right. In this large version Van Noordt
added a tall hat on a table, and a view out a
window onto buildings and a dramatic
cloudy sky, lit red by a sunset. Wijnands's
pose with one arm akimbo relates to the
work of Bol, as mentioned in the previous
entry. The full-length depiction of the sit-
ter, holding a letter in his right hand,
comes remarkably close to an unidentified
portrait in Vaduz that can be attributed to
Abraham van den Tempel, which may have
been done later (fig. 58).[1] The ripe, heavy
forms, and the predominance of black and
red, lend a serious air to the warm smiling
expression and lively movement of this de-
piction. This colour scheme and the dis-

play of emotion relate to the portraits of
Jacob Backer; it compares closely to his
Portrait of a Man, in Kassel (fig.10).[2]

1 Abraham van den Tempel, *Portrait of a Man
 with a Letter*, canvas, 119 x 94 cm, Vaduz,
 Sammlungen des regierenden Fürsten von
 Liechtenstein (as Thomas de Keyser).
2 Jacob Adriaensz. Backer, *Portrait of a Man*,
 canvas, 127 x 100 cm, Kassel, Staatliche Kunst-
 sammlungen, Gemäldegalerie Schloß Wil-
 helmshöhe (inv. no. M 1984/5); see Sumowski
 1983–94, 1:138, 203, no. 71, 274 (illus.).

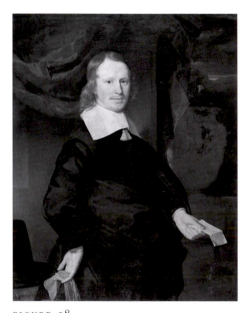

FIGURE 58
Abraham van den Tempel, *Portrait of a Man
with a Letter*, canvas, 119 × 94 cm, Vienna,
Sammlungen des Fürsten von und zu
Liechtenstein (as Thomas de Keyser).

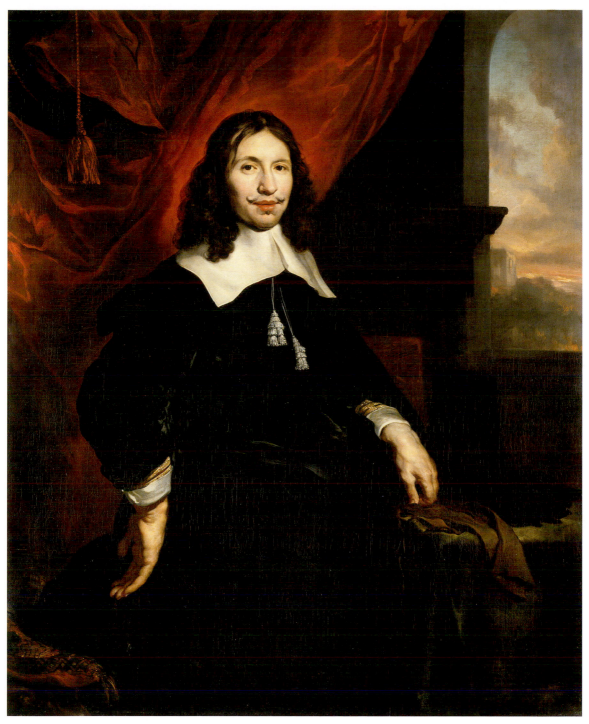

CATALOGUE 52
Portrait of Dionijs Wijnands, canvas, 124 × 103.5 cm, signed and dated 1664, Amsterdam, Rijksmuseum (photo: Rijksmuseum-Stichting Amsterdam).

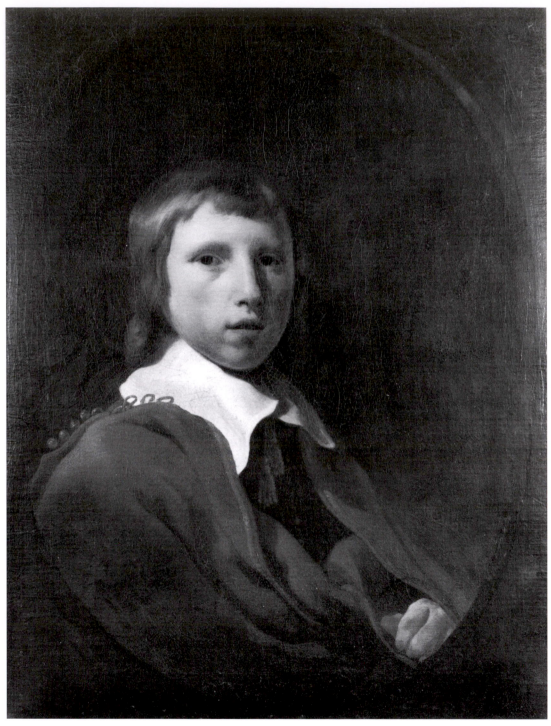

CATALOGUE 53
Portrait of a Boy, canvas, 63.5 × 48.5 cm, Johannesburg, Johannesburg Art Gallery.

Portraits: Children

CATALOGUE 53
(p) *Portrait of a Boy*
Canvas, 63.5 x 48.5 cm, falsely mono-
grammed lower right: *AB*, Johannesburg,
Johannesburg Art Gallery (inv. no. 9)

PROVENANCE
Amsterdam, collection of Bernard
Houthakker, in 1929 (as signed by Flinck);
Johannesburg, collection of Eduard
Houthakker; donated to the Johannesburg
Art Gallery in 1949

LITERATURE
Bax 1952, 23, 134 (as Jacob Adriaensz.
Backer); Von Moltke 1965a, 253, no. R136
(illus., as Jacob Adriaensz. Backer); exhibi-
tion catalogue Chicago 1969, 47; Marais
1971, 6–7; Sumowski 1983–94, 1:140,
143n83, 186 (illus., as Jan van Noordt);
4:3737, with no. 2407; Sumowski 1986,
26 (illus. fig. 6), 36n31; Carman 1994, 53
(illus.)

EXHIBITIONS
Amsterdam 1929, 14, no. 48 (as G. Flinck);
Delft 1950 (as Jacob Adriaensz. Backer)

COLLECTION CATALOGUES
Johannesburg 1988, 20 (illus. fig. 11),
92–4, no. 31

This portrait of a boy wearing a mantle and a broad collar was attributed to both Flinck and Backer before Kurt Bauch suggested Jan van Noordt.[1] It relates close-ly to Backer's *Portrait of a Boy* of 1634, showing a similarly strong side lighting that falls evenly on broad areas of the head and the heavy fabric (fig. 59).[2] The bold shape of the white collar especially points to Backer's influence, as do the reduced form and folds of the mantle. The attribu-tion to Van Noordt rests partly on the em-phatic modelling, achieved through the strong reflections in the head and hands. This mild exaggeration also occurs in the hair, where reflections suggest a shine. An-other characteristic touch is the treatment of the eyes, where the artist highlighted the eyelids, producing a hard effect. It is a modification of Backer's own distinct, but softer, handling of this feature. Van Noordt evidently sought a strong and dramatic effect in this early portrait. He

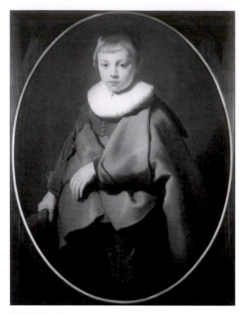

introduced a lively energy through the un-
dulating lines of edges and folds in the fig-
ure, and even more so in the fabric. These
aspects tie this work to paintings such as
the Cherbourg *Cimon and Iphigenia* and
The Satyr and the Peasant Family (cat. 29,
23). It can be dated to around the same
time, between 1650 and 1655. It is the
artist's earliest surviving portrait, but he
would have to wait until the end of the
decade to receive steady patronage for his
skill in this specialization.

1 Note on the back of the photo at the Rem-
 brandthuis Study Centre in Amsterdam.
2 Jacob Adriaensz. Backer, *Portrait of a Boy in
 Grey*, canvas, oval, 94 x 71 cm, signed and dated
 1634, The Hague, Mauritshuis (inv. no. 747);
 Sumowski 1983–94, 1:200, no. 52, 255 (illus.).

CATALOGUE 54
Portrait of a Young Man with his Dog
Canvas, 154 x 121 cm, signed and dated, at
the base of the column: *Joan v. Noordt f./A⁰
1665*, Lyon, Musée des Beaux-Arts (inv.
no. B577)

PROVENANCE
Paris, with F. Kleinberger, in 1894; Paris,
with A. Fréret; acquired by the Lyon
Museum in 1897

LITERATURE
Gonse 1900, 168; *L'art et les artistes* 19,
1914, 263 (illus.); Decoen 1931, 17 (illus.
fig. 12, 15); Schneider 1931, 511; Staring
1946, 75 (illus. pl. 4, 76); Boucher 1965,
259 (illus.); Foucart and Lacambre 1968,
193; collection catalogue Wallace Collec-
tion 1968, 224; exhibition catalogue Paris
and Amsterdam 1970, 274; exhibition
catalogue Lille, Arras, and Dunkerque
1972, 83; Bénézit 1976, 7:750; exhibition
catalogue Dunkerque 1983, with no. 30;
Sumowski 1983–94, 1:143n76; 6:3737,
no. 2404 (and with no. 2405), 4022 (illus.);
exhibition catalogue Paris 1987, 86; collec-
tion catalogue Bordeaux 1990, 227n11;
exhibition catalogue Lyon, Bourg en
Bresse, and Roanne 1992, no. 95; Sutton
1992, 735; exhibition catalogue Dijon
2003–04, 151

EXHIBITIONS
Lyon and Paris 1991, 109–11, no. 35
(illus.); Haarlem and Antwerp 2000, 262,
266–8, no. 74 (illus.)

COLLECTION CATALOGUES
Lyon 1912, 44 (illus. plate 73); Lyon 1993,
154, 155 (illus.)

Jan van Noordt summoned his full pow-
ers for this portrait of a young man and
his little companion. The artist could apply
his facility for very smooth modelling of
flesh cast in a strong light, which he devel-
oped under the influence of Backer, to

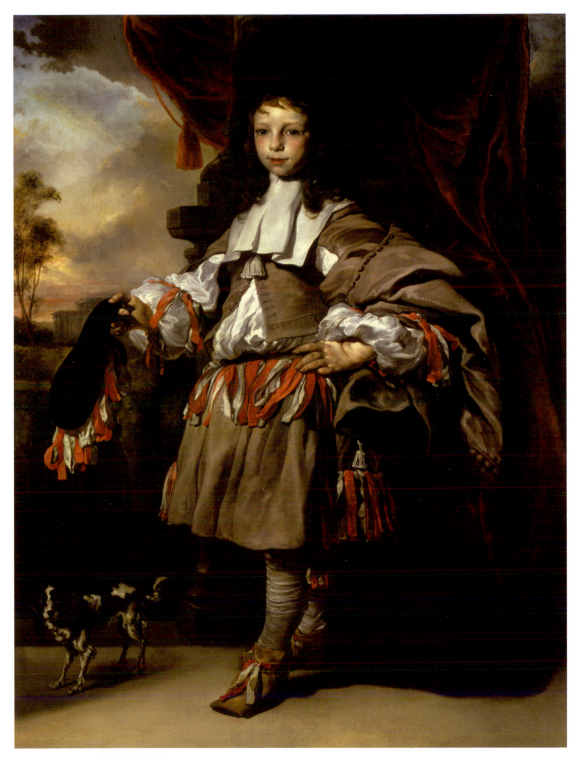

CATALOGUE 54
Portrait of a Young Man with His Dog, canvas, 154 × 121 cm, signed and dated 1665,
Lyon, Musée des Beaux-Arts.

great advantage. Van Noordt had not followed the tonal shift in Backer's style around 1645, but kept his backgrounds dark, for a heightened overall impact, as is evident here. A number of like depictions survive, done in the artist's style of the mid-1660s. A similarly sumptuous full-length in Brussels portrays a young boy in the guise of a drummer; two half-length pictures in the Wallace collection feature idealized types, holding hunting falcons (cat. 57, 55, 56). The number of pictures of children in Van Noordt's oeuvre suggests that his fetching style was recognized in its own day as especially applicable to younger sitters.

The sitter wears an elaborate hunting costume. The leather jacket and boots are appropriate for retreat to country estates. Country houses even appear in the backgrounds of two portraits by Van Noordt (cat. 47, 59). The large scale and lavish description of setting and costume prove not only the mastery of the artist but also his success in attracting affluent patronage.

CATALOGUE 55
Portrait of a Boy with a Falcon
Canvas, 82 x 66 cm, London, Wallace Collection (inv. no. P20)

PROVENANCE
London, collection of Sir Richard Wallace, inv. 48 l. 5, N

LITERATURE
Staring 1946, 75–7 (illus. no. 5); Bénézit 1976, 7:750; Christine S. Schloss in collection catalogue Hartford 1978, 168; Sumowski 1983–94, 1:140, 143n76, 183 (illus.); collection catalogue Bordeaux 1990, 227n9

SELECTED COLLECTION CATALOGUES
Wallace Collection 1901, 61, no. 20 (as Nicolas Maes); Wallace Collection 1968, 224, no. P20 (illus.); Wallace Collection 1979, 174, no. P20 (illus.); Wallace Collection 1992, 247–9 (illus. P20)

EXHIBITIONS
Bethnal Green 1872–75, 6, no. 82; or 13, no. 181, 72

COPIES
Canvas, 72.5 x 61 cm, collection of G.R.F. Tompkins, in 1970 (provenance: Collection of Lady Nancy Vivian, in 1968; sale The Duke of Beaufort and others, 25 November 1970, London (Sotheby's), lot 120 (illus.); see collection catalogue Wallace Collection 1968, 224; Bénézit 1975, 7:750

A young boy poses as a hunter, holding up a falcon in the left hand while in the right grasping the leash of a animal outside of the picture. The setting is the open countryside, and in the background to the right walks a traveller, a tiny figure appearing just below the boy's hand. The sitter wears a lavish costume that reflects his high social status. It accords with the association, for Netherlanders of the

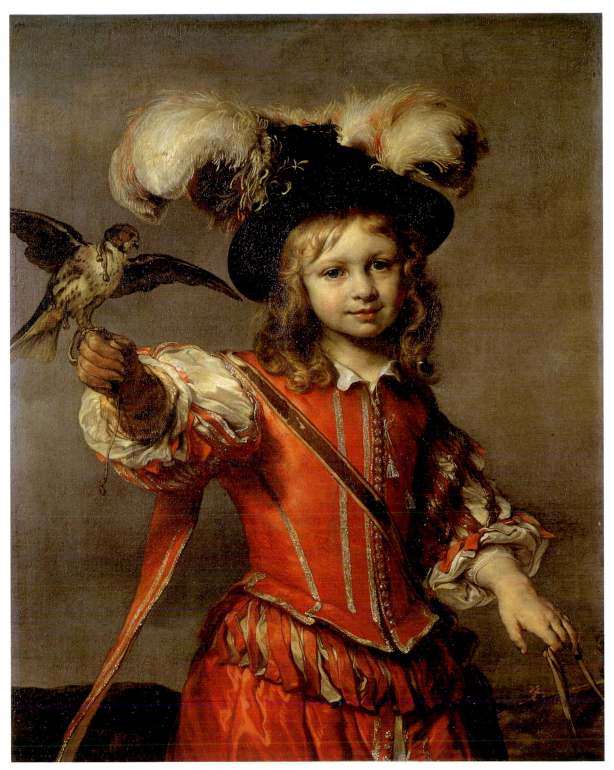

seventeenth century, of the sport of hunting with wealth and the ownership of land. The doublet with slashed sleeves is fitted with gold and red straps at the bottom. A flamboyant hat, decked with ostrich feathers, completes the display. The long red strap swaying behind the boy is an ornamental version of a leading string, a feature of the costume of younger children, by which they were supported while learning to walk.[1]

This painting relates closely to Van Noordt's *Portrait of a Young Man and his Dog* in Lyon (cat. 54). The modelling is similarly smooth and sensual, without the movement and brushwork seen in later works, such as the second painting with the same name (cat. 56). The present work shows more detail, especially in the metallic reflections of the stripes on the red doublet. Van Noordt's accomplished modelling of flesh is demonstrated in the plump round features of the young face. The wan smile of the boy underscores this image's incomparable charm, while the dark background and the strong chiaroscuro lighting lend it an air of gravity.

A copy of this painting shows squatter dimensions. The figure is cut off a little higher, but more of the right hand is showing. The right hand especially suggests that the original picture has been trimmed at the right edge. The copy does not show any of the landscape background that Van Noordt characteristically included.

1 My thanks to Marieke de Winkel for pointing out this feature and its special function.

CATALOGUE 56
Portrait of a Boy with a Falcon
Canvas, 62 x 53 cm, London, Wallace Collection (inv. no. P96)

PROVENANCE
Neufchatel, collection of George, 10th Earl Marischal (1694–1778); Count Perregaux sale, Paris (George Ridel & Seigneur), 8–9 December 1841 (Lugt 16388), lot 17 (as Maes, for Fr. 4001, to Duchatel; otherwise as to Lord Yarmouth); collection of the Baron Delessert, in 1842; London, collection of Sir Richard Wallace, (inv. 20, l. 40, as Maes)

LITERATURE
Smith 1842, supplement, 579; Decoen 1931, 18; Staring 1946, 75; Bénézit 1976, 7:750; Sumowski 1983–94, 1:143n76; exhibition catalogue Lyon and Paris 1991, 110n4

SELECTED COLLECTION CATALOGUES
Wallace Collection 1901, 69, no. 96 (as Nicolas Maes); Wallace Collection 1968, 224–5, no. P96 (illus., as Jan van Noordt); Wallace Collection 1979, 174, no. P96 (illus.); Wallace Collection 1992, 249–50 (illus. P96)

This depiction of a young man with a hunting falcon joins three others in the oeuvre of Jan van Noordt (cat. 45, 55, 62).[1] The formula is the same as that of the other painting in the Wallace Collection: a youthful figure in a bright red costume holds up a bird of prey, which dramatically spreads its wings (cat. 55). Other artists who portrayed sitters in a similar way include Van Noordt's friend Abraham van den Tempel (fig. 60).[2] The liveliness of Van Noordt's interpretation conveys the spontaneity of the sitter's youthful age. Compared with the other young falconer by Van Noordt in the same collection,

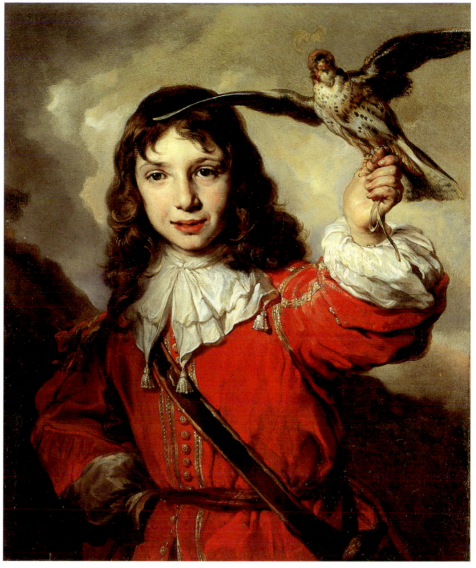

CATALOGUE 56
Portrait of a Boy with a Falcon, canvas, 62 × 53 cm, London, Wallace Collection. Reproduced by kind permission of the Trustees of the Wallace Collection, London.

some details differ: there is no leash, and the falcon is held up in the sitter's proper left hand. The forms are treated softly and smoothly, but there is some loose, fluid brushwork in the figure, and especially in the vague background landscape and sky. The costume seems a little less lavish, with no plumed hat to cover the sitter's long falling locks. The sitter also takes a more active pose, leaning to the left. The com-

position as a whole is organized along this diagonal, with the falcon, the band across the front of the boy's costume, and the slope of the background landscape following it. This overall movement places this picture among Van Noordt's later works, toward 1670. It compares with the *portrait historié* in Bordeaux (cat. 60), and can be dated to around the same year.

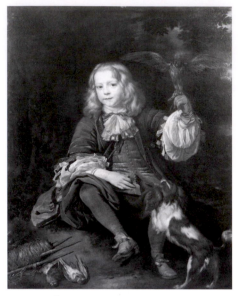

Abraham van den Tempel, *Portrait of Cornelis van Groenendyck*, canvas, 125.5 × 100.5 cm, signed and dated 1668, Paris, Fondation Custodia, on loan from the Haags Historisch Museum, The Hague.

1 Hans Buijs connects the pose to that of the boy in the *Portrait of a Brother and two Sisters* in Zeist (cat. no. 59). See exhibition catalogue Lyon and Paris 1991, 110n4.

2 Abraham van den Tempel, *Portrait of Cornelis van Groenendyck*, canvas, 125.5 x 100.5 cm, signed and dated 1668, Paris, Fondation Custodia, on loan from the Haags Historisch Museum, The Hague (inv. no. 41–1870); see Wijnman 1959, 72b (illus.), 75, no. 12.

CATALOGUE 57
Portrait of a Boy with a Drum
Canvas, 120 x 103 cm, Brussels, Museum van Oude Kunst (inv. no. 699)

PROVENANCE
Sale Princess Mathilde, Paris, 17 May 1904 (Lugt 62314), lot 25 (as Nicolas Maes, for Fr. 5000); acquired by the Brussels Museum

LITERATURE
Wurzbach 1974, 2:243; Kronig 1911, 156; P. Colin, *Vues de Villes, Châteaux, Monastères et Monuments publiques dans la collection des Musées royaux de Peinture et de Sculpture*, Brussels, 1916, 2, no. 11; *Bulletin des Musées Royaux des Beaux-Arts de Belgique* 2, 1929, 20;[1] Decoen 1931, 17; Staring 1946, 48; Bénézit 1976, 7:750; Blankert 1982, 143; Sumowski 1983–94, 1:143n76; 6:3737, no. 2405, 4023 (illus.); exhibition catalogue Lyon and Paris 1991, 110n4; collection catalogue Lyon 1993, 110 (illus. 35a)

EXHIBITIONS
Bordeaux 1990, 227n10; Brussels 1995

SELECTED COLLECTION CATALOGUES
Brussels 1906, 134, no. 699; Brussels 1913, 65, no. 699 (illus. pl. 119); Brussels 1927, 172, no. 699; Brussels 1984, 212, no. 699 (illus.)

This portrait of a richly dressed boy incorporates both military and civic references. Posing beside a drum and in front of an ensign's banner, and armed with a dagger, the sitter plays the role of the young drummer of an armed company, much like the young Oscar van der Waeyen in the well-known portrait by Bol (fig. 61).[2] The scene is itself set in the city of Amsterdam: to the left, a window gives a view of rooftops and of two identifiable features of the Amsterdam cityscape: the cupola and dome of the Stadhuis (now the Royal

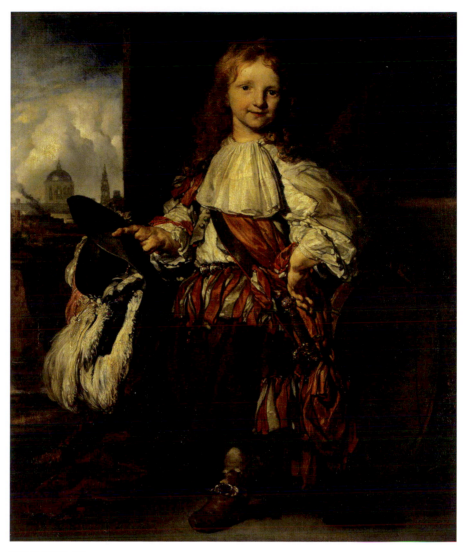

CATALOGUE 57
Portrait of a Boy with a Drum, canvas, 120 × 103 cm, Brussels, Museum van Oude Kunst.

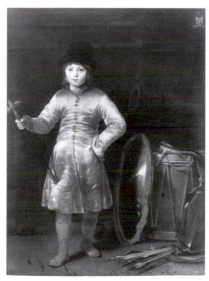

FIGURE 61
Ferdinand Bol, *Portrait of Oscar van der Waeyen*, canvas, 158 × 120 cm, signed and dated 1656, Rotterdam, Museum Boijmans Van Beuningen.

Palace on the Dam), and the Herring-Packer's Tower.[3] These references suggest that the sitter is in the city's civic guard and not in a standing army, which the Polish costume in Bol's portrait implies.[4] Van Noordt portrays his sitter in luxurious clothes, including a leather jacket flamboyantly trimmed with ribbons, an item worn by boys in a number of portraits of affluent Netherlanders in the 1660s, including ones by Van Noordt in Lyon and in the Wallace Collection in London (cat. 54, 55, 56).

This complex display of luxury and social status is enlivened by the artist's handling of the brush. Van Noordt departed from the smooth modelling of surfaces in works of the mid-1660s by leaving visible brush strokes. They are loose and fluid in the front and sleeves of the boy's jacket, and especially in the wall and the background vista. Broad, direct touches can be seen in the part of the standard in shadow in the bottom left. Soft daubs of light colour indicate highlights in the hands and costume and yield a rhythmic effect. Such painterly flair connects this work to the Amsterdam *Magnanimity of Scipio* of 1672 (cat. 27), and indicates a date of about 1670–72. This portrait is thus one of the latest of Van Noordt's to survive.

1 The catalogue entry mentions the cleaning of this picture, carried out by M.M. Vergote and De Heuvel.

2 Ferdinand Bol, *Portrait of Oscar van der Waeyen*, canvas, 158 x 120 cm, signed and dated 1656, Rotterdam, Museum Boijmans Van Beuningen, inv. no. 1701: Sumowski 1983–94, 1:307, no. 146, 385 (illus.); Blankert 1982, 59, 66b (illus. pl. 150), 142, no. 139.

3 The Herring-Packer's Tower stood at the opening of the Singel on the Ij. It was taken down in 1829. See collection catalogue Van Eeghen 1988, 146–7, no. 100, 213, no. 213.

4 Blankert draws a connection between Oscar van der Waeyen's military costume and the Polish wars against the Turks that were taking place around the same time. See n2.

CATALOGUE 58
(p) *Portrait of an Infant Girl with Symbols of Love*
Dimensions and support unknown, present location unknown

PROVENANCE
London, collection of R. Holland-Martin; London, collection of Lady Jamieson

LITERATURE
Wishnevsky 1967, 85, 176, no. 33, 312 (illus. fig. 19); exhibition catalogue Lyon and Paris 1991, 110n2

An infant girl poses with various symbolic attributes of love. Cupid's bow and quiver of arrows lie in front of her, the doves of Venus play beside her, and one hand is placed on an apple, the prize offered to Venus by Paris for her offer of erotic love. Her costume consists of loose drapery, and she is adorned with a pearl necklace and pearl bracelets, an armband of precious metal, and a small coif set with flowers. Although her features appear to be those of a particular person, the many trappings give her the abstract identity of an allegorical figure, so that this painting functions as an allegorical portrait.

Frits Lugt was the first to recognize Van Noordt's hand in this picture.[1] Indeed, the bulging forms of infant flesh and the energetic flowing lines of drapery folds belong to the late phase of Van Noordt's development, when his work was at its most distinctive. The overall conformity to a diagonal, from lower left to upper right, and the loose, visible brush strokes in the drapery and the clouded sky also help to place this work late in the oeuvre. It compares to *A Boy with a Dog and a Falcon* of 1675 (cat. 45), and can be dated to around the same time.

1 Note with the photograph at the Witt Library, Courtauld Institute, London.

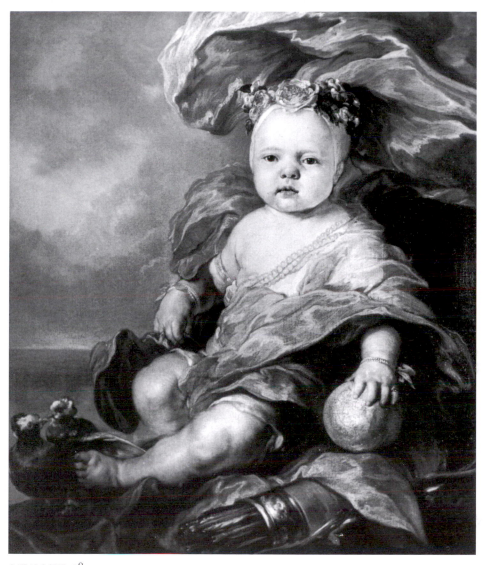

CATALOGUE 58
Portrait of an Infant Girl with Symbols of Love, dimensions unknown, support unknown,
present location unknown.

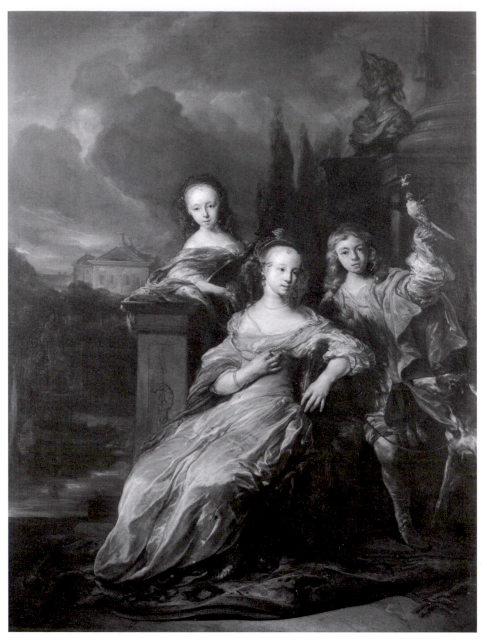

CATALOGUE 59
Portrait of a Brother and Two Sisters, canvas, 160 × 117 cm, Zeist, Slot Zeist,
on loan from A. baron Baud.

Portraits: Groups

CATALOGUE 59
Portrait of a Brother and Two Sisters
Canvas, 160 x 117 cm, Zeist, Slot Zeist,
on loan from A. baron Baud

PROVENANCE
Zeist, Slot Wulperhorst, Collection of Jhr.
H. M. Huydecoper; Soestdijk, Collection
of Mr Jean Chrétien baron Baud (by suc-
cession)

LITERATURE
Hofstede de Groot 1892, 216, no. 15;
Wurzbach 1974, 2:243; Decoen 1931, 18;
Staring 1946, 75, 77 (illus.); Pigler 1955,
165–6 (illus. no. 14); Sumowski 1983–94,
1:142n49; 6:3737, with no. 2405; exhibi-
tion catalogue Lyon and Paris 1991,
110n4; exhibition catalogue Dijon
2003–04, 151

EXHIBITIONS
Amsterdam 1910, 8, no. 28; Amsterdam
1952, 57–8, no. 119

Three children gather in the garden of a country estate. The eldest takes the most prominent place, seated on a chair in the foreground centre. She leans her arm on the backrest and turns to look to the right, where her brother stands behind her. He takes a striding pose and shows himself ready for the hunt, holding up a falcon in the right hand and keeping a hound on a leash with the left. To the left appears the second sister, leaning against a stone pillar and playing a lute. These siblings enjoy the activities and relaxation associated with the summer retreat to country estates of the most affluent *burgers* of cities such as Utrecht, The Hague, and Amsterdam in the seventeenth century. Here, the wealth and the leisure of the sitters is especially declared by their lavish clothing, with its encumbering excess of costly reflective fabric. In the distance stands a large country house, which has unfortunately not yet been identified. The scene is completed by a fountain with a statue of a *Venus Pudica*. A second antique sculpture, the flamboyant bust of an emperor, rests at the base of a large column to the right. These two pieces attest to the rising interest in classical sculpture in the Netherlands in the second half of the seventeenth century.[1]

This is one of the more dramatic and vibrant portraits in Van Noordt's oeuvre.

The overall impact is strengthened by the setting of the lighted foreground group against a dark sky filled with billowing clouds and accented with a red evening glow. A sweeping movement is defined by the diagonal through the figure of the seated girl. Jan van Noordt evidently studied this pose by means of a drawing, now in Rotterdam (cat. D12). It is complemented by the active poses of the two other figures behind. The boy with his falcon seems to be a later development of the smaller of the two young falconers in the Wallace Collection (cat. 55).[2] The loose brushwork in some passages, especially the fabric, suggests a date of around 1670.

1. Henk Th. van Veen, "Uitzonderlijke verzamelingen. Italiaanse kunst en klassieke sculptuur in Nederland," in exhibition catalogue Amsterdam 1992, 108–9. On the role of various members of the Deutz family in importing sculpture from Italy to the Netherlands, see Bikker 1999, 281, 287–90.
2. Hans Buijs was the first to connect the older girl's pose to the Rotterdam drawing, and that of the boy to the Wallace collection painting. See exhibition catalogue Lyon and Paris 1991, 110n4.

CATALOGUE 60
Portrait of a Widow with her Two Sons (formerly *The Widow of Elisha's Servant Implores his Aid*)
Canvas, 118 x 99 cm, Bordeaux, Musée des Beaux-Arts (inv. no. Bx 1988.3.1)

PROVENANCE
London, collection of Miss Emily Leslie; collection of the First Duke of Westminster; Brussels, Myrtil-Schleisinger collection (by succession); sale Smallenburg (Myrtil-Schleisinger section), Amsterdam (Frederik Muller), 6 May 1913, lot 76 (illus., as 115 x 199 cm [*sic*], by J. van Noort); sale, Brussels (Giroux), 15 March 1926 (illus., as N. Maes); Paris, collection of Adolph S. Schloss; seized by the German occupying forces; Munich, Collection Point, in 1947; sale, Paris (Vente des Domaines), 25 May 1950, lot 65; sale, Paris (Palais d'Orsay), 28 March 1979, lot 196 (illus.); sale, Paris (Drouot), 19 June 1981 (as attributed to Nicolaes Maes); The Hague, with Hoogsteder Gallery (as Jan van Noordt), from there acquired by the Bordeaux museum in 1988

LITERATURE
Decoen 1931, 16; Sumowski 1983–94, 1:141, 143n87, 191 (illus.); 6:3589, 3645 (illus.); *Revue du Louvre*, 1988, no. 4 (announcement of the acquisition)

EXHIBITIONS
Brussels 1924, no. 105 (as Nicolas Maes); Bordeaux and Pau 1995, 27, no. 4 (illus.)

COLLECTION CATALOGUES
Bordeaux 1990, 225–7, no. 65 (illus.)

The original subject matter of this painting was only recently made evident. It had been thought to be a portrait of a mother and her two children. However, the orientation of two of the figures strongly suggested that the canvas was once larger and included more figures to

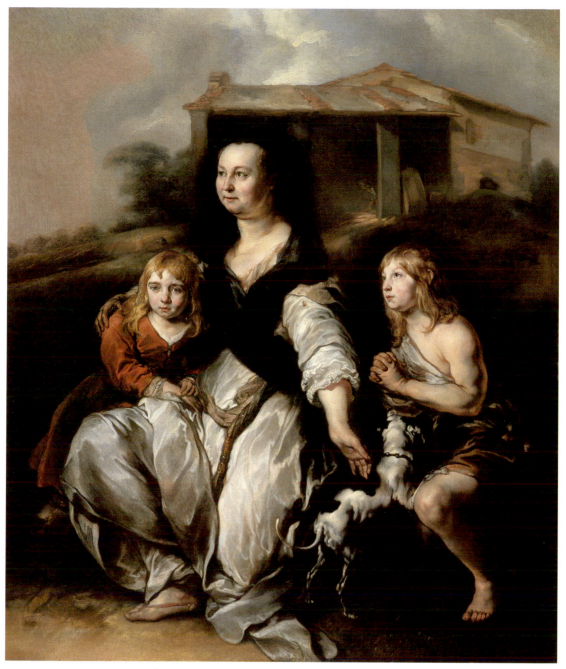

CATALOGUE 60
Portrait of a Widow with Her Two Sons (formerly: *The Widow of Elisha's Servant Implores His Aid*), canvas,
118 × 99 cm, Bordeaux, Musée des Beaux-Arts (©Cliché du M.B.A. de Bordeaux /photographe
Lysiane Gauthier).

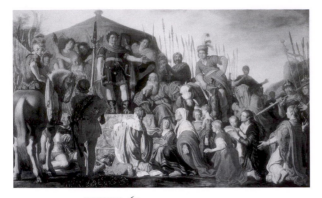

Pieter Lastman, *Coriolanus and the Roman Women*,
panel, 81 × 132 cm, signed and dated 1625,
Dublin, the Provost, Fellows and Scholars of
Trinity College.

the left side. Also, the dramatic poses and
passionate expressions gave grounds to
suspect that a history was being enacted.
These indications were borne out when
the painting underwent restoration, after it
was acquired by the museum in Bordeaux
in 1988. After the removal of overpaint,
part of a standing male figure appeared
at the left edge. He had been cut off and
overpainted before the painting went to
auction in 1913.[1] His appearance and
rough costume marks him as a biblical fig-
ure, whereas the woman's dress and pose
identify her as a widow accompanied by
her two sons.

They enact the Old Testament story
of the widow of Elisha's servant (2 Kings
4:1–7). Facing pressure from creditors
after the death of her husband, she appeals
to the prophet for aid. By miraculously
causing a large quantity of oil to material-
ize, he provides her with the means to pre-
vent her creditors from taking her two
children into slavery. Rembrandt portrayed
this theme in a drawing now in Vienna,
which became the starting point for a
painting by Barent Fabritius.[2] Although
Van Noordt's conception shows some simi-
larities, it rather reflects the influence of
Backer, with its large figure scale and
movement generated by curved and flow-

ing lines. The figures are also oriented
more toward the viewer. The un-idealized
and specific features of the woman lead to
the conclusion that she sat for a *portrait
historié* accompanied by her two sons, one
of whom looks up to the figure of the
prophet, while the other looks out to the
viewer. The scenario possibly refers to the
particular circumstances of the patron for
this work, who must have been a widow
herself. Ironically, it is a lavish work, dating
to the height of Van Noordt's career and
popularity among Amsterdam's elite, and
thus cannot reflect poverty on the sitters'
part. Unfortunately it has not yet been
possible to identify the threesome por-
trayed here.

Van Noordt's picture fits into a broader
pictorial tradition of "pleading women."
The same basic group of figures could
function as a framework for several similar
themes. Van Noordt drew directly from
paintings that participated in this tradition
for his distinctive figure of the widow and
her dramatic pose, kneeling, with arms
down and drawn back with open hands
making a pleading gesture. He was likely
looking at *Jesus and the Canaanite Woman*
by Backer (fig. 5), and took over Backer's
figure of the Canaanite woman to the left.
Backer in turn adopted this figure from
earlier sources. It appears in the centre of
a 1625 painting by Pieter Lastman, *Cori-
olanus and the Roman Women* (fig. 62), for
which Lastman also made a drawing.[4]

The present painting demonstrates the
late phase in Van Noordt's work, when he
conceived of his compositions in terms
of overall movement and organization.
This tendency can be observed here in the
sweeping line running from the dog at the
bottom right through the figures of the
boy and his mother. It originally continued
to the arm of the prophet at the left, re-
vealed during the recent restoration but
covered up again. A date of around 1670
is also indicated by the confident, fluid
brushwork, which looks ahead to the 1672
Magnanimity of Scipio (cat. 27), while still

After removal of varnish and overpaint.

showing the smooth and broad modelling
of the figures seen in works of the mid-
1660s.

1 The catalogue to the 1913 sale (see prove-
 nance) illustrated the picture in its present for-
 mat, but gave a width of 199 cm, which should
 instead read 99 cm.
2 Barent Fabritius, *Elisha and the Widow of his*

Servant, canvas, 104.5 x 97 cm, sale, London
(Phillips) 6 December 1988, lot 42 (illus., as
Elijah and the Widow of Zarephath). The
composition matches the middle section of the
drawing by Rembrandt: *Elisha and the Widow of
his Servant*, pen and black ink, 17.2 x 25.4 cm,
Washington, D.C., collection of Dr Felix
Somary: see Benesch 1973, 1:1024 (illus. no.
1240).

3 See collection catalogue Bordeaux 1990, 226. Jacob Adriaensz. Backer, *Jesus and the Samaritan Woman*, canvas, 210 x 270 cm, signed and dated 1640, Middelburg, Nieuwe Kerk; see Sumowski 1983–94, 1:194, no. 9, 212 (illus.).

4 Pieter Lastman, *Coriolanus and the Roman Women*, panel, 81 x 132 cm, signed and dated 1625, Dublin, the Provost, Fellows and Scholars of Trinity College. See exhibition catalogue Amsterdam 1991, 124–7, no. 20 (illus.). A preparatory drawing also survives: *A Kneeling Woman and a Boy*, red chalk, heightened with white, on orange-tinted prepared paper, 26.5 x 19.6 cm, Hamburg, Kunsthalle (inv. no. 23980); see exhibition catalogue Amsterdam 1991, 158–9, no. 31 (illus.). This same figure was also studied in two drawings in Amsterdam: Pen in brown ink, over a sketch in black chalk, 175 x 165 mm, Amsterdam, Rijksprentenkabinet; see collection catalogue Amsterdam 1998, 1:127, 128, no. 278 (as Jacob Simonsz. Pynas); 2:152 (illus. no. 278); and black chalk, 23.6 x 19 cm; see collection catalogue Amsterdam 1998, 1:197, no. 445 (as anonymous); 2:219 (illus. no. 445r).

CATALOGUE 61
(p) *Portrait of a Mother and Three Children*
Canvas, 106 x 87.5 cm, present location unknown

PROVENANCE
Sale, Genoa (Galeria Vitelli), 7–12 November 1938, lot 46 (illus.); collection of the Furst zu Schwarzenberg; his sale, Lucerne (Galerie Fischer), 20–26 November 1962, lot 2326 (illus. pl. 55, as Jürgen Ovens); Fermor-Hesketh and others sale (anonymous section), London (Christie's), 8 July 1988, lot 37 (illus., as Jan van Noordt): sale, Paris (Hôtel George V: Étude Ader Tajan), 15 December 1993, lot 45 (illus.)

LITERATURE
Exhibition catalogue Lille, Arras, and Dunkerque 1972, 82–3 (illus., as Jan van Noordt); Sumowski 1983–94, 5:3112, with no. 2141

This unusual group portrait alludes to a theme originating in the classical iconographical tradition. A mother, with her three children around her, sits on a fanciful gilded throne carved in *kwabstijl*, or auricular style, which was pioneered at the beginning of the century by the Utrecht silversmith Adam van Vianen. Its flamboyant movement lends the scene an exotic, otherworldly air, which suits the iconography. Furthermore, the sitters are all dressed *à l'antique*, and the mother's costume even incorporates the daring element of an open bosom. It is especially this element that defines her pose as the allegorical figure of Caritas, or the Christian virtue of love.[1] She exemplifies this virtue by devoting herself to nurturing children, in particular by the giving of her mother's milk.[2] Van Noordt's choice of this allegorical framework for a portrait followed upon other paintings, including one painted for the House of Orange by Paulus Moreelse in 1621.[3] The allegory is amplified in the decoration of the throne, which adds an

CATALOGUE 61
Portrait of a Mother and Three Children as Caritas, canvas, 106 × 87.5 cm, present location unknown
(photo ©Christie's Images Limited 2005).

extra, sculpted child. The carved flower in the backrest of the throne could be identified as a sunflower, which was a common symbol of loving devotion.[4] A second Virtue, that of Hope, is represented in the statue in the background left, of a woman holding an anchor.[5] The combination of these two virtues follows a recommendation in the Dutch version of Cesare Ripa's *Iconologia*.[6]

This conceit borders on the category of *portrait historié*, which Van Noordt engaged in a number of pictures. The classical reference here relates most closely to the *Juno* in Braunschweig. In that painting the reference is made even more explicit by the inclusion of numerous attributes, and by an even more *risqué* level of nudity (cat. 18).

Jacques Foucart was the first to recognize the hand of Van Noordt in this painting. The very smooth and broad modelling of flesh places its style among the works of 1665–70. The sweeping movement points to a later date, as does the organization of the children's poses in a diagonal line. Van Noordt probably painted it around 1670, in the same period as the similarly lively family portrait in Dunkerque (cat. 62). The present work is much more closely cropped, suggesting that it might have been trimmed down.

1 The Apostle Paul cites the three virtues of faith, hope, and charity in I Corinthians 13:13.

2 Dirck Pers's influential translation of Cesare Ripa's *Iconologia* gave examples of how to represent Caritas, as a woman clothed in red, a flame rising from her head, holding a child under her right arm and suckling it, with two other children at her feet. See Ripa 1644, 292 *s.v. Carita* (illus.), 293.

3 Paulus Moreelse, *Portrait of Sophia Hedwig, Duchess of Nassau Dietz, as Charity, with her Three Children*, canvas, 140 x 122 cm, signed and dated 1621, Apeldoorn, Rijksmuseum Paleis Het Loo; see exhibition catalogue Haarlem 1986, 312–15, no. 78 (illus.).

4 This carved sunflower echoes the one appearing in the frame to Ferdinand Bol's latest *Self*

Portrait, which Eddy de Jongh has demonstrated to be a symbol of nonsensual love, repeating the meaning of the sleeping Cupid in the painting. It referred to the mature love of the artist's second marriage: canvas, 128 x 104 cm, Amsterdam, Rijksmuseum (inv. no. A42). See Eddy de Jongh, "*Bol vincit amorem*," *Simiolus* 12, 1981–82, 158–61.

5 The catalogue of the 1988 sale (see Provenance) described the statue behind as representing faith. However, the Pers edition of Ripa's *Iconologia* (see n1) prescribed the figure of hope, and not faith, as a maiden holding an anchor. See Ripa 1644, 147, *s.v. Geloof*, 205, *s.v. Hope*.

6 Ripa's second figure of hope takes on some of the attributes for *Caritas*, with the explanation that these two virtues are inseparable from each other. See Ripa 1644, 205, *s.v. Hope*.

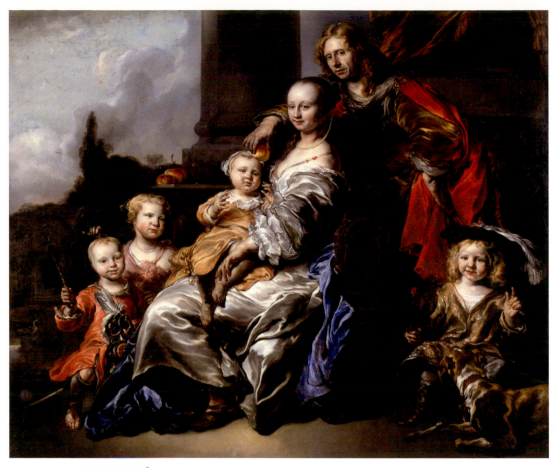

Portrait of a Family, canvas, 160 × 192 cm, Dunkerque, Musée des Beaux-Arts.

CATALOGUE 62
Portrait of a Family
Canvas, 160 x 192 cm, Dunkerque, Musée
des Beaux-Arts (inv. no. 732)

PROVENANCE
Collection of the Duchesse de Roche-
chouart; sale, Paris (Palais Galliera), 7
December 1967, lot 148 (illus., as attrib-
uted to N. Maes); Paris, with J.O. Leegen-
hoek, (as Jan van Noordt); acquired by
the museum in 1967

LITERATURE
Foucart and Lacambre 1968, 193 (illus. fig.
10), 194; exhibition catalogue Paris and
Amsterdam 1970, 274; Sumowski 1983–94,
5:3064n38

EXHIBITIONS
Lille, Arras and Dunkerque 1972, 82

(illus.), 83, no. 45; Dunkerque 1983,
no. 30 (illus.)

COLLECTION CATALOGUES
Dunkerque 1974, no. 50; Dunkerque 1976,
49, no. 363

Van Noordt portrayed a family of six
gathered on a terrace. Trees and fo-
liage in the background place the scene in
a country estate. The setting is somewhat
ostentatious, with massive stone columns
wrapped in drapery and, in the middle dis-
tance, a pool with a swan and a fountain
topped with a classical sculpture. The high
social status of the sitters is also declared
in their lavish dress, which tends toward
an excess of fabric, especially in the silver
satin dress of the mother and the bright
red cape of the father. The loose-fitting

designs are suited for the country recreation that occupies this group. The young son at the bottom right attends to two pets, a green, yellow, and red Amazon parrot in his hand, and a hound in front of him.[1] The young boy to the left holds a riding crop aloft for the decorative hobby horse he rides; he is appropriately shod with small riding-boots. His sister standing behind crowns him with a wreath of flowers. The light and playful mood is emphasized by the father holding an apple in front of his infant daughter, seated on her mother's lap, and by her gesture of reaching out with both hands to grab it. The artist also seems to have positioned this fruit so as to create a visual pun on the breasts of the child's mother, directly adjacent, revealed by the deep *décolleté* of her dress. The casual atmosphere is associated with the country leisure of wealthy urban dwellers, which had become increasingly popular in late seventeenth-century Holland. Some of the group portraits by Jürgen Ovens incorporate spontaneous interactions to convey a similarly relaxed mood, and likely inspired Van Noordt here.[2] A drawn family portrait by Van Noordt shows a similar attitude in the poses of the sitters, and may have been an early form of the composition of the present painting (cat. D15).

Van Noordt painted this large and flamboyant family portrait a few years after the *Portrait of a Young Man and his Dog* of 1665 (cat. 54). It shows the strong, brilliant light and full smooth modelling that the artist developed in this period. The head of the mother is the focal point, modelled with bright, creamy highlights, blackish shadows, and strong glowing reflections. The composition retains the rhythmic liveliness of Van Noordt's earlier works. The placement of five sitters' heads along a weaving diagonal from the bottom left to the top right corners points to the development of the artist's later tendency to organize movement along larger, sweeping lines, an aspect that points to a date of around 1670.

Given the size of this large, multi-figured painting, its condition is remarkably good. Some overcleaning is evident in the area to the bottom right, in the parrot and the hat of the boy holding the bird. Also, the drapery on which the mother sits is finished in a bright blue glaze that seems to have given the artist some difficulty, as it is very uneven and roughly painted, especially in comparison with the confident and fluid handling in the rest of this work. Most of the painting is finished to a high level.

1 I am grateful to Volker Manuth for providing the specific identification of this bird.
2 Compare with Ovens' *Portrait of Colonel Hutchinson and his Family*, canvas, 132 x 170 cm, signed and dated 1659, Munich, with Konrad O. Bernheimer, in 1997; and *Portrait of a Family*, canvas, 150 x 213 cm, signed and dated 1658, Haarlem, Frans Halsmuseum (inv. no. 229); see Schlüter-Göttsche 1978, 12 (illus. fig. 4); exhibition catalogue Haarlem 1986, 244–45, no. 56.

Paintings Known Only through Reproductions

(p) *A Couple Playing Chess*
Panel, 55 x 46 cm, present location
unknown

PROVENANCE
Paris, with Benedict, in 1957 (as Gerbrand
van den Eeckhout)

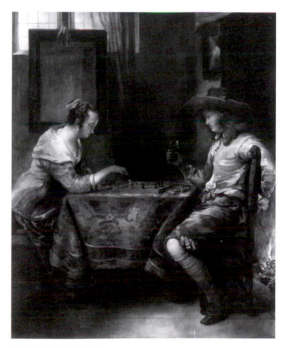

CATALOGUE COPY 1
Anonymous, after Jan van Noordt, *A Couple Playing Chess*, panel, 55 × 46 cm, present location unknown.

A flamboyantly dressed couple is absorbed in a game of chess. This scene of young men and women at leisure belongs to the larger category of the "Merry Company," whose tradition and interpretation is discussed in greater detail with respect to Van Noordt's *Musical Company on a Terrace in Berlin* (cat. 36). Such images were primarily a form of moralization against lasciviousness. This message seems to have been pushed into the background in the picture by Van Noordt.

In his choice of theme, Van Noordt was evidently influenced by the Amsterdam painter Gerbrand van den Eeckhout, who painted a number of scenes of card- and backgammon-playing. The composition of this picture, with the symmetrical arrangement of the two figures sitting across from one another at the table, is particularly close to the painting *Two Officers Playing Cards*, last in Amsterdam, and attributed to Van den Eeckhout (fig. 63).[1]

The stylistic link of this picture to Van Noordt was first recognized by Willem van de Watering.[2] The most comparable

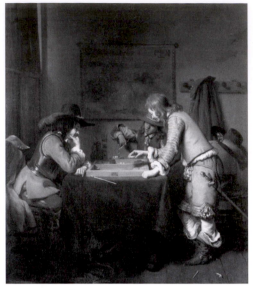

FIGURE 63
Attributed to Gerbrand van den Eeckhout, *Tric-trac Players*, panel, 41 × 33 cm, signed and dated 1673, collection of R. Laubinger (photo: RKD).

example in his oeuvre is the Berlin *Company*. The characteristic traits of Van Noordt's style of around 1655–1660 have here been transmitted, for example the emphatic suggestion of volume in the figures through reflections and soft modelling, and elegantly swelling forms and curving contours. However, these aspects occur here with some exaggeration, combined with weaknesses not typical of the artist. In particular the cursory manner with facial features have been described speak against his authorship. This is evidently not an original work, but a copy of one by Van Noordt that has since been lost.

1 Attributed to Gerbrand van den Eeckhout, *Tric-trac Players*, panel, 41 x 33 cm, signed and dated 1673, collection of R. Laubinger, in 1953; see exhibition catalogue Matthiessen 1953, no. 26; Sumowski 1983–94, 2:748, no. 516 II.
2 Note of 23 July 1969 with the photo of this painting at the RKD. I am grateful to Volker Manuth for referring me to this picture.

CATALOGUE COPY 2
Portrait of Petrus Proëlius (1615–1661)
Known only through the print by Joan de Visscher: engraving, 39 x 28 cm, inscribed below: *Joan de Visscher sculpsit/ obiit 19 Augusti 1661/ Ætatis 45/ Joan van Noort pinxit/ Nicolaus Visscher excudit*; with a poem given in Latin and in Dutch by Jacobus Heyblocq:

Iam fatis in tenebris latuit, cui gratia lumen
Præbuit e gremio commiserante Dei.
Nuper in Amsteliis sonitu penetrante cathedris
Hoc gravitas vultu conspicienda fuit!
Putet humi, patet in superis, etinare, suisque,
Simpliciterque latens, tripliciterque patens.
Hæc tibi picturæque fluunt, o amice! tuæque
Fudimus, hev gemitus et pia justa neci.

't Is lang genoech in't graf, en achter 't kleed
* geschuilt,*
Dat nu al ruim een jaar zijn aangezicht
* bedekte,*
Waarom zoo meenig oog zoo bitter heeft
* gehuilt,*
Hy heeft voor 't sterffelijk het eeuwige geruilt,
De VOORZON die aan 't Y een lichte star
* verstreckte,*
Waar toe hem d'Hemelvoocht zoo gunstelijk
* verwekte.*
Dit pronkbeeld hebt gij by uw Amstelaars
* verdient;*
Dus leeft g'ook na uw doot, mijn trouwe harten
* vriend!*
Jacobus Heiblocq.

(It's long enough in the grave, and hidden behind the cloth,
That has hid his face now for around a year,
Why has so many an eye shed bitter tears,
He has exchanged the mortal for the eternal,
The BREAKING SUN that gave to the Y a bright star,
For which the Guardian of Heaven so favourably created him.
Among your Amsterdammers, you have earned this lavish portrait;

PETRUS PROÏLIUS ECCLESIASTES AMSTELÆDAMENSIS.

CATALOGUE COPY 2

Joan de Visscher, after Jan van Noordt, *Portrait of Petrus Proëlius* (1615–1661), engraving, 1663, 39 × 28 cm.

So you also, my faithful bosom friend, live
 on after dying.)

LITERATURE
Nagler 1832–52, 10:265; Muller 1853, 205,
no. 4298; Wessely 1866, 10, 11, no. 12;
Le Blanc 1970, 4:135, no. 12; Hofstede
de Groot 1892, 212, no. 10, 215, no. 12;
Wurzbach 1974, 2:243; Hollstein 1949–,
41:96–97 (with illus.)

The inscription on this print after a
portrait by Jan van Noordt identifies
the sitter as Petrus Proëlius, minister in
Amsterdam. Proëlius's father Henricus
(1566–1643) was also a Reformed Church
predikant, and his brother Jacobus (1619–
1652) followed the same profession.[1]
Van Lieburg traced the career of Petrus,
through stays in his native town of Pijnacker,
and Gouda, to a final period in Amster-
dam. It was there that he commissioned a
portrait from Van Noordt. The date of
1661 on the print refers not to the original
portrait, but to the year of Proëlius's death.
The print itself dates to a year later, 1662,
according to the poem in the inscription,
which states that the sitter died a year
previous.

Proëlius draws his right hand up to
his heart, a gesture seen in two earlier
portraits of ecclesiastics by Rembrandt, of
Joannes Uyttenbogaert in 1633 (Br. 173)
and Johannes Elison in 1634 (Br. 200).
These sitters all adopt the posture of the
confessor, which descended from the
iconography of St Jerome in the desert.
However, the print reverses the original
painting, as seen in the fall of light from
the right, whereas it was always shown
coming from the left in the original paint-
ing. There, the gesture would have been
shown as made by the left hand. However,
it is quite possible that Jan van Noordt had
a reproductive print in mind when making
the painting, and may have purposely
engaged the wrong hand so that the print
would correctly convey the symbolic
gesture.

The printed reproduction communi-
cates many characteristic elements of Van
Noordt's style. The strong light thrown
against the column behind the sitter helps
to emphasize him; this greater focus on
the sitter began to appear in Van Noordt's
work around 1660. The tendency toward
puffy swelling forms of the hands, how-
ever, only enters the artist's work around
1659, and can be seen in the 1659 *Portrait
of a Woman* (cat. 46). The original portrait
thus likely dates only a few years before
the sitter's death. The sweeping lines of
drapery folds, in the background and in
Proëlius's own clothing, are a more general
aspect of Van Noordt's style.

The inscription attests to Proëlius's
popularity and status in Amsterdam. Jacob
Heyblocq (1623–1690), its writer, was a
teacher of French and Latin in Amster-
dam, and is best known for his famous
album amicorum.[2] The books in the right
background assert the sitter's learning, as
does the skull cap he wears, an item long
favoured by ecclesiastics and academics.[3]

1 Van Lieburg 1996, 197.
2 See Heyblocq 1998.
3 The prominent theologian Joannes Uytten-
 bogaert, for example, wears a skull cap in the
 1633 portrait by Rembrandt in the Amsterdam
 Rijksmuseum. See Volker Manuth in exhibition
 catalogue Kingston 1996, 35, no. 2.

Paintings That Cannot with Any Certainty Be Attributed to Jan van Noordt

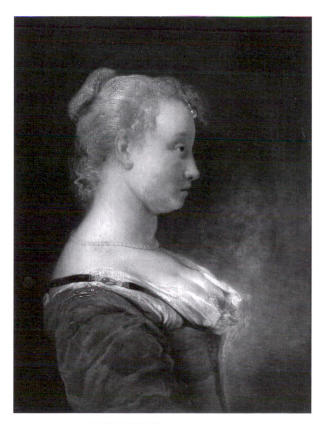

CATALOGUE UI
Profile Bust of a Woman
Panel, oval, set into a larger rectangular panel, 55 x 42 cm, Lier, Museum Wuyts-van Campen (inv. no. 66, as Jan Lievens)

COLLECTION CATALOGUES
Lier, 1946, no. 50 (as Rembrandt)

This forceful profile head of a young woman follows the model established by Rembrandt with his painting in Stockholm of 1632 and adapted by many artists in his circle, including Jan van Noordt's teacher, Jacob Adriaensz. Backer.[1] However, the artist selected a very different physiognomy, closer to some that appear in several history paintings of around 1660 by Jan van Noordt. The tall forehead, curved bridge of the nose, receding chin, and protruding upper lip reappear in the falling woman in the foreground right of *The Massacre of the Innocents* (cat. 14), and also in the closest of the singing women to the right in *The Triumph of David* (cat. 5). Willem van de Watering was the first to draw the connection and to reattribute the present work to Van Noordt instead of

Lievens, the name it currently bears (it was earlier catalogued as a Rembrandt). In addition, the soft modelling of flesh and the loose and wavy fabric of the dress are consistent with Van Noordt's style. However, some uncertainty is raised by other elements, especially the striated description of hair, which is very much unlike Van Noordt's suggestion of larger masses and indeed more characteristic of Lievens. The painting of the features also yields an uncharacteristically soft and flat effect, whereas Van Noordt often defined such forms with crisp edges. Lastly, the strong light effect of chiaroscuro, which builds volume and adds drama in many of Van Noordt's works, including portraits, is not present here. It is possible, then, that this work is by another artist.

1 Rembrandt, *A Young Woman in Profile*, canvas, 72.2 x 54.5 cm, signed and dated 1632, Stockholm, Nationalmuseum; see Bruyn et al. 1982 2:160, no. a49; Jacob Adriaensz. Backer, oil on panel, oval, 60.4 x 49.6 cm, Warsaw, Narodowe Muzeum (inv. no. M. Ob. 35); see exhibition catalogue Braunschweig 1989, 148–9, no. 42 (illus.).

CATALOGUE U2
(p) *Portrait of a Woman with a Fan*
Canvas, 116 x 88 cm, present location unknown

PROVENANCE
M. Mersch sale, Paris (Drouot: Henri Baudoin), 8 May 1908, lot 47 (illus., as Nicolas Maes)

The growing demand in the 1660s for spirited liveliness and lavishness in portraits is reflected in this painting of a richly appointed young woman holding a fan. Her level of flamboyance likely reflects not only her wealth, but also her unmarried state; portraits of married people, produced in the same context, are typically much more sober. Among Van Noordt's own works, the most appropriate comparison is with the *Portrait of a Brother and Two Sisters* now in Zeist (cat. 59), where the girl in the foreground is comparably resplendent and takes a similarly dramatic, engaged pose. Both sitters wear a satin gown, a pearl necklace, a tiara set with pearls, and armbands of precious metal set with stones. In the present work a chain adorns the bodice, rather than another string of pearls. Another small difference are the clasps at the front of the dress. The similarities point to a near-contemporary date, likely around 1665–67.

At the sale appearance of this painting in 1908 it was attributed to Nicolaes Maes, undoubtedly on the basis of the movement in the pose. Aspects that point instead to Van Noordt include the strong light effect, the solid masses of drapery, and the characteristically bulging forms of the nearer hand. The background is severely plain, however, giving only a faint suggestion of a column or drapery. It departs from the richness typical of Van Noordt in the 1660s, which casts a measure of doubt on any reattribution to him.

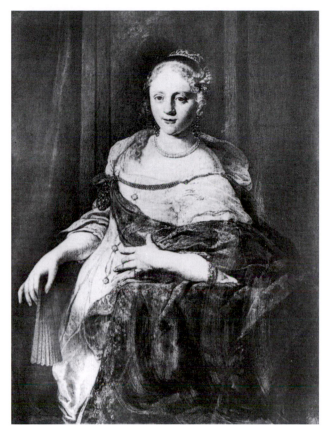

CATALOGUE U2
Portrait of a Woman with a Fan, canvas,
116 × 88 cm, present location unknown.

CATALOGUE U3
(p) *Still Life with Musical Instruments*
Canvas, 87.6 x 81.9 cm, New York,
collection of Richard Kitchin, in 1956

EXHIBITIONS
Raleigh 1956, no. 49 (illus., as Samuel van
Hoogstraten)

A still-life of musical, scholarly, and painterly objects is arranged on a table in the foreground. A songbook, with the distinctive horizontal format peculiar to the type, hangs over the front edge, partly covering a study drawing of a nude female. A little further back, sheets of music and a small sculpture of a child rest atop a heavy volume in a lavish leather binding. To the right lie a watch, and a palette with its thumb-hole crammed with *penceelen*, or artist's brushes. Behind them, a violin is propped up at an angle, against a globe that is cut off by the right edge. This collection is contemplated by a young man, who rests his head on his elbow, at a window in the background left. He wears a beret, which was out of fashion by the middle of the seventeenth century but remained popular among artists.

The three spheres of music, art, and learning are mixed together, and they are linked to the young man. This painting may be a portrait, in which the sitter expresses his interests or his profession. It is not clear from the figure whether his features are individual or not, and this scene could also be interpreted as a genre-like still-life devoted to the three mentioned themes. More significantly, this combination was embodied by Jan van Noordt, who came from a musical family and pursued learned themes in his history paintings. It is remotely possible that he proffered himself here, in the same way as had Samuel van Hoogstraten, with a still-life.[1] Unfortunately the attribution to Van Noordt cannot be judged conclusively owing to the poor reproductions available.

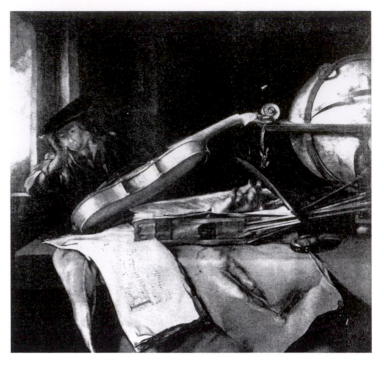

CATALOGUE U3
Still Life with Musical Instruments, canvas, 87.6 × 81.9 cm, New York, collection of Richard Kitchin.

If it is by him, a date of around 1655 is plausible, judging from the broad handling of the figure. Van Noordt would have been around thirty years old, a not unlikely age for the sitter in this painting.

Several decades later, Van Noordt's pupil Johannes Voorhout produced a painting with a foreground still-life incorporating references to art (fig. 64). Although the figure there is a woman, occupied with painting, the scene seems to reflect the influence of the present picture, lending some support to a connection (direct or indirect) to Van Noordt.[2]

1 Samuel van Hoogstraten, *Self-Portrait with Vanitas Still-Life*, Rotterdam, Museum Boijmans Van Beuningen, inv. no. 1386; see Sumowski 1983–94, 2:1296, no. 849, 1332 (illus.).

2 Johannes Voorhout, *Still Life with a Woman at an Easel*, canvas, 48.5 x 40.3 cm, signed lower right: *J. voorh*, Worcester, Massachusetts, Worcester Art Museum (inv. no. 1923.209); see collection catalogue Worcester 1974, 1:148–9, no. 1923.209; 2:566 (illus.); and Kuretsky 1979, 102, no. d-10, 208 (illus., as Johannes Voorhout).

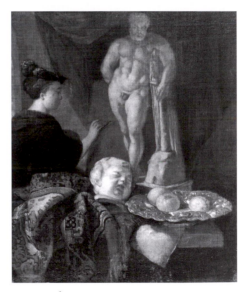

FIGURE 64
Johannes Voorhout, *Still Life with a Woman at an Easel*, canvas, 48.5 × 40.3 cm, signed: *J. voorh*, Worcester, Massachusetts, Worcester Art Museum, museum purchase.

Rejected Paintings

Note: in most cases, the following works are organized according to the existing interpretation of subject matter to facilitate searching. Revisions are brought forward in the discussion.

CATALOGUE R1
(p) *The Flight of Lot and His Daughters* (Genesis 19:30–6), panel, 32 x 57 cm, monogrammed bottom left, present location unknown

PROVENANCE
Sale, Berlin (Lepke), 15 May 1928, lot 72, (as Jan van Noordt, Heroische Landschaft, panel, 32 x 57 cm, signed: *"Hinter ein baumbestandenen Hügel der Brand von Sodom und Gomorrha; vorn Loth mit seinen Töchtern auf der Flucht"* [Heroic Landscape, Behind a woody hill the burning of Sodom and Gomorrah; in the foreground Lot and his daughters in flight], for 140 M); sale, Berlin (Lepke), 5 February 1929, lot 11 (as Jan van Noordt, signed, for 300 M); Professor van Esmard et al. sale, Berlin (Lepke), 10/11 December 1929, lot 43 (as Jan van Noordt, signed); Mme. Berall de Siret et al. sale, Brussels, 15 December 1930, lot 58 (illus., pl. 11, as Jan van Noort, *Paysage avec épisode Biblique repré-sentant la fuite de Loth et ses Filles*, mono-grammed bottom left); Paul Frenkel Charnowitz sale, The Hague (Van Marle & Bignell), 8 December 1931, lot 81 (as Jan van Noort [Antwerp 1587–1626 Madrid], panel, 33 x 56 cm, mono-grammed bottom centre, for / 150); sale, Paris, 21 December 1941, lot 83a (as Jan van Noordt)

The monogram, figure scale, and use of landscape show no links to Van Noordt's painted oeuvre. He is not known to have monogrammed any of his works.

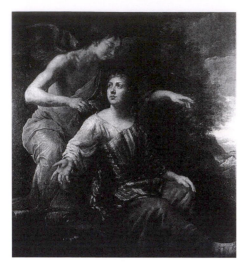

CATALOGUE R2
(p) *Hagar and the Angel*
(Genesis 21:9–21), canvas, 130 x 114 cm,
present location unknown

PROVENANCE
Sale, Paris (Drouot-Richelieu), 27 April
1989, lot 16 (illus., as attributed to Jan
van Noordt)

The very large figure scale and the
flat, broad treatment of form bear
no relation to Van Noordt's style.

CATALOGUE R3
(p) *Joseph in Prison*
(Genesis 40:12–9), canvas, 97.7 x 118.3 cm,
present location unknown

PROVENANCE
Sale, New York (Christie's), 29 July 1965,
lot 316 (as Johannes Victors); New York,
Central Picture Galleries

LITERATURE
Art Journal 25, no. 2, 1965/66 (illus., in
advertisement, as Victors); Sumowski
1983–94, 5:3064n38 (as Jan van Noordt);
Miller 1985, 348 no. R40 (as Gerbrand
van den Eeckhout)

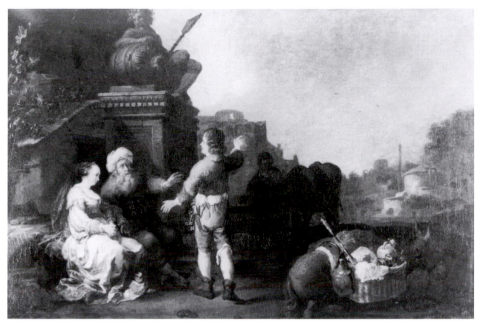

CATALOGUE R4
The Levite and His Concubine in Gibeah, canvas, 69 × 115 cm, Hamburg, private collection.

CATALOGUE R4
(p) *The Levite and his Concubine in Gibeah*
(Judges 19:16–21), canvas, 69 x 115 cm,
Hamburg, private collection

LITERATURE
Sumowski 1983–94, 5:3111, no. 2136,
3283 (illus., as Jan van Noordt)

The attribution of this painting to Van
Noordt was first made by Christian
Tümpel. It is supported by Sumowski, who
draws comparisons with *The Levite and His
Concubine in Gibeah* in Budapest (cat. R7),
and to the *Madonna and Child* in Gavnø
(cat. 13).[1] The small figure scale, the flac-
cid impression of form, and the attention
to minute detail are not closely related to
Van Noordt's style.

1 See Literature.

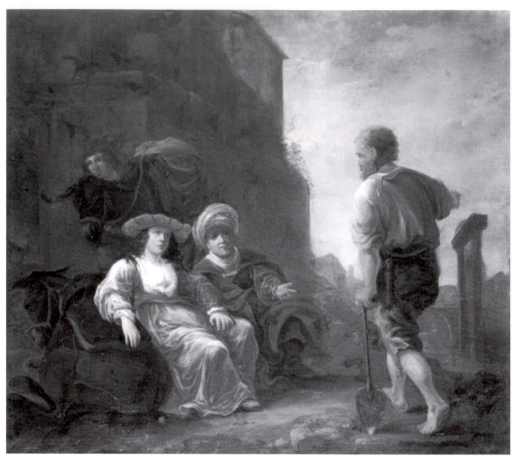

CATALOGUE R5
The Levite and His Concubine in Gibeah, canvas, 81 × 95 cm, present location unknown.

CATALOGUE R5
(p) *The Levite and his Concubine in Gibeah*
(Judges 19:16–21), canvas, 81 x 95 cm,
present location unknown

PROVENANCE
London, Trafalgar Gallery, in 1989; sale,
London (Christie's), 19 March 1991,
lot 92 (illus.); sale, London (Phillips), 10
December 1991, lot 202 (illus., as Jan van
Noordt); sale, Cologne (Lempertz), 6 De-
cember 1997, lot 1201 (illus. pl. 23, with
the report that Sumowski has changed his
mind and now regards the painting as a
later autograph version of the Budapest
painting, rather than as a variation by an
unknown artist)

LITERATURE
Sumowski 1983–94, 6:3753, no. 2510,
4133 (illus., as anonymous variant of
The Levite and His Concubine in Gibeah
in Budapest [cat. no. R7])

The artist has pursued a suggestion of
light through chiaroscuro, without
achieving the strong sense of form typical
of Van Noordt. The building and the
donkey to the left are particularly vague.

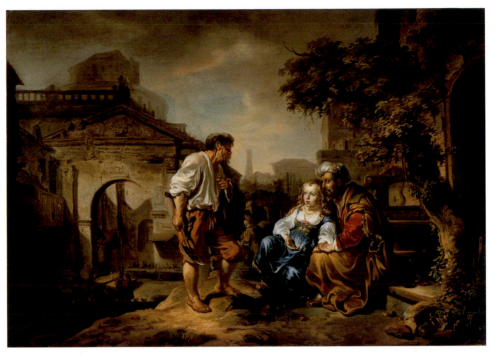

CATALOGUE R6
The Levite and His Concubine in Gibeah, canvas, 64.7 × 90.5 cm, present location unknown.

CATALOGUE R6
The Levite and his Concubine in Gibeah
(Judges 19:16–21), canvas, 64.7 x 90.5 cm,
present location unknown

PROVENANCE
Cambridge, collection of Mrs de Beau-
mont; sale, London (Christie's), 12 March
1926, lot 45 (as *Laban, Rebecca and Jacob*,
by G. Flinck, £60.18, to Asscher); sale,
Cologne (Lempertz), 1 December 1927,
lot 215 (illus., as *Italian Folk Scene*, by
Victors); Belgium, private collection; Sir
Francis Dashwood et al. sale (anonymous
section), London (Christie's), 4 July 1986,
lot 1 (illus.); London, Alan Jacobs Gallery;
New York, Gutekunst & Co., in 1992

LITERATURE
Collection catalogue Louvre 1929–33,
3:42, with no. 1233 (as *The Levite in
Gibeah*, by Flinck); Sumowski 1983–94,
5:3111, no. 2134, 3281 (illus., as Jan van
Noordt); Sumowski 1986, 24 (illus., fig. 3),
25, 36n27; Manuth 1987b, 114n387;
Tableau, November 1986, 71 (illus.); exhi-
bition catalogue Amsterdam and Jerusalem
1991, 138 (illus. fig. 10); Van Gent and
Pastoor 1994, 83, 87n58, 138 (illus. plate 10)

EXHIBITIONS
Fall 1986 Catalogue, London, Alan Jacobs
Gallery, 1986, no. 8 (illus.); *Pictura*, Maas-
tricht, 1987; *The European Fine Art Fair*,
Maastricht, 1993, 88 (illus.)

The generally even thickness and opaci-
ty of the paint speak strongly against
the hand of Van Noordt, who typically
used semi-transparent underlayers that re-
mained as part of the final image. Further-
more, this picture strongly emphasizes the
articulation of deep space; the vista to the
left includes a convincing plunge to the
lower level of the town. This approach

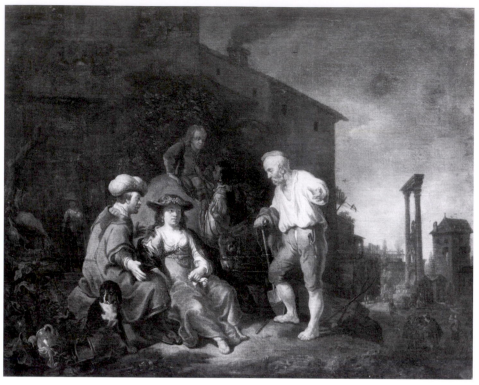

reflects the influence of a composition painted in 1658 by Gerbrandt van den Eeckhout, in Moscow.[1] This secondary focus is not developed in the one known depiction of the same subject by Van Noordt (cat. 3).

1 Gerbrand van den Eeckhout, *The Levite and His Concubine in Gibeah*, canvas, 225 x 232 cm, signed and dated 1658, Moscow, Pushkin Museum (inv. no. 1676). See Sumowski 1983–94, 2:721, 732, no. 426, 789 (illus.).

CATALOGUE R7
(p) *The Levite and His Concubine in Gibeah* (Judges 19:16–21), canvas, 90 x 114 cm Budapest, Szépmüvészeti Múzeum (inv. no. 9822)

LITERATURE
Pigler 1968, I:128 (as attributed to Gerbrand van den Eeckhout); Sumowski 1983–94, 1:140, 142n59, 164 (illus., as Jan van Noordt); 5:3111, Sumowski 1986, 24 (illus.), 25, 36n27; Manuth 1987a, 114,n384; exhibition catalogue Dijon 2004, 151

COLLECTION CATALOGUES
Budapest 2000, 57 (illus.)

This scene's absorption in details of figures and landscape is quite unlike Van Noordt's work. There are several links to

another rejected painting, *The Rest on the Flight into Egypt* in St Petersburg (cat. R17). The donkey standing behind the field labourer is nearly identical to the beast standing behind Joseph in the St Petersburg painting. Further similarities include the broad, heavy handling of drapery, and the suggestion of rounded form through broad highlights and reflections. Also, the seated woman wears a similar flat, low-brimmed hat. The two works are quite likely by the same artist. The present work also incorporates a borrowing from the work of Jacob Adriaensz. Backer. The artist adapted the head of the field labourer from the figure of Hippocrates in Backer's painting *Hippocrates Visiting Democritus in Abdera*.[1]

1 Jacob Adriaensz. Backer, *Hippocrates Visiting Democritus in Abdera*, canvas, 94 x 64 cm, Milwaukee, collection of Drs Alfred and Isabel Bader; see Sumowski 1983–94, 1:193, no. 3, 206 (illus.).

CATALOGUE R8
The Levite and his Concubine in Gibeah
(Judges 19:16–21), panel, 89 x 93 cm
Lille, Palais des Beaux-Arts (inv. no. P1397, as Gijsbert Jansz Sibilla [c. 1598–after 1657])

PROVENANCE
Lille, Collection of Alexandre Leleux; bequeathed to the museum in 1873

LITERATURE
Sumowski 1983–94, 6:3736, no. 2398, 4015 (illus., as Jan van Noordt); Manuth 1987a, 114n385 (as Gijsbert Jansz Sibilla)

COLLECTION CATALOGUES
Lille 1875, 28, no. 75 (as Bramer); Lille 1893, 32, no. 100 (as "Genre de Bramer"); Lille 1984, 28

EXHIBITIONS
Lille 1974, 84, no. 59 (illus., as Gijsbert Jansz Sibilla)

The scene is set on a hilltop, with figures projecting against the sky. The artist has used background architecture to establish a strong diagonal. In these aspects this painting is similar to the *Ruth and Boaz* formerly in the Butôt collection (cat. R11). They are perhaps by the same artist.

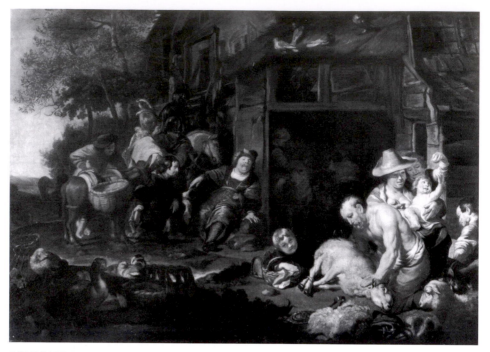

Cat. no. R9. *Nabal Refuses to Give Food to David and His Men*, canvas, 122 × 85 cm, present location unknown.

CATALOGUE R9

(p) Jürgen Ovens, *Nabal Refuses to Give Food to David and His Men*

(I Samuel 25), canvas, 122 x 85 cm, present location unknown

PROVENANCE
Sale, Zürich (G&L Bollag), 21 April 1934, lot 71 (illus. no. 19, as J. Jordaens); sale, Cologne (Lempertz), 15 November 2003, lot 1171 (illus., as Flemish seventeenth century)

LITERATURE
Sumowski 1983–94, 6, 3736, no. 2400 (and with no. 2399, as Jan van Noordt), 4017 (illus.); exhibition catalogue The Hague 1992, 264n6, 265 (illus. fig. 36c)

The 1934 sale catalogue cites an expertise by Cornelius Hofstede de Groot attributing this painting to Jan van Noordt.

His view has more recently been supported by Paul Huys Janssen.[1] However, this unfocused and turbulent composition cannot be placed anywhere in Van Noordt's oeuvre. The depiction of facial expressions is more free and varied than is typical for Van Noordt's early works. It does not show the emphasis on rounded volumes seen in his works of the 1660s and 1670s. Other aspects, such as the angular formation of drapery and edges and emphasis on details, show no connection at all with the style of Van Noordt. Some of the figure types, including the mother and child to the right, relate more closely to the early work of Jürgen Ovens, as does the predilection for pink and greenish tones.

1 See exhibition catalogue The Hague 1992, 264n6.

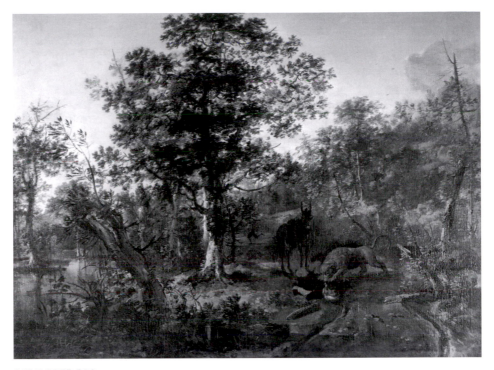

CATALOGUE R10
Jan van Noort, *The Disobedient Prophet*, canvas, 115 × 154 cm, signed and dated: *ian. V. Noort f.1653*, Gavnø, Gavnø-Fonden.

CATALOGUE R10
Jan van Noort, *The Disobedient Prophet* (I Kings 13:24), canvas, 115 x 154 cm, signed and dated bottom centre, on log: *ian. V. Noort f.1653*, Gavnø, Gavnø-Fonden (inv. no. 5413–2)

PROVENANCE
Gavnø, collection of the Baron Reedz-Thott

LITERATURE
Hofstede de Groot 1892, 212, no. 8, 217–18, no. 23 (as possibly by another J. van Noort); Wurzbach 1906–10, 2:243; Bauch 1926, 68n92; Decoen 1931, 18; Sumowski 1983–94, 1:140, 142n63, 168 (illus.); 5:3113, with no. 2147

COLLECTION CATALOGUES
Gavnø 1785, no. 40; Gavnø 1876, 33 no. 85; Gavnø 1914, 33–4 no. 119

The small figure scale and the emphasis on landscape tie this picture stylistically to two other paintings that have been attributed to Jan van Noordt: *Shepherds at a Fountain* (cat. R42) and the *Landscape with Shepherd and Milkmaid* (cat. R41). It also shows the same block-lettered signature, spelled without the "d." These works can be reattributed to a second artist, identifiable as Jan van Noort.[1] In this composition, he adapted the figure group from Bartholomeus Breenbergh's earlier depiction of the same theme.[2]

1 See 21.
2 Canvas, 98 x 165 cm, signed and dated 1630, New York, Newhouse Galleries, in 1958; see Roethlisberger 1981, 55–6, no. 121 (illus. fig. 121).

(p) Hendrick Heerschop, *Ruth and Boaz*
(Ruth 2:10), oil on copper, 32.2. x 38 cm,
present location unknown

PROVENANCE

Sale, Vienna (Dorotheum), 4–7 December
1973, lot 91 (illus., as Claes Cornelisz.
Moeyaert); St Gilgen, collection of F.C.
Butôt; his sale, Amsterdam (Sotheby's),
16 November 1993, lot 91 (illus., as Jan
van Noordt)

LITERATURE

Sumowski 1983–94, 6:3736, no. 2399
(also with no. 2398), 4016 (illus., as Jan van
Noordt)

COLLECTION CATALOGUES

Butôt 1981, 18, 204, no. 83, 205 (illus., as
Jan van Noordt)

The attribution of this painting on cop-
per to Jan van Noordt was first made
by Willem van de Watering (in a note with
the photograph at the RKD). The compo-
sition and the setting are similar to *The
Levite and His Concubine in Gibeah* in Lille
(cat. R8). The stiff, angular folds of drapery
are quite unlike Van Noordt's style. The
figure and facial types, and also the distinc-
tive use of a pinkish-red colour, point in-
stead to the Haarlem painter Hendrick
Heerschop (1620/21–after 1672).[1]

1 This attribution was suggested to the author
 by Albert Blankert in an oral communication
 of 10 November 1998.

Esther at Her Toilette
(Esther 5:1), panel, 105.5 x 78 cm, Europe,
private collection

PROVENANCE

Possibly: Van den Branden sale, Brussels,
13 April 1801 (Lugt 6234), lot 227 (as
Govert Flinck, *Une femme qui se fait coiffer
par sa chambrière*, panel, for Fr 70=0, to
Deroij); London, Hallsborough Gallery;
sale, Milan (Finarte), 24 October 1989,
lot 29 (illus., as circle of G. Flinck); The
Hague, Hoogsteder & Hoogsteder
Gallery, in 1992

LITERATURE

Sumowski 1983–94, 5:3111, no. 2135,
3282 (illus., as Jan van Noordt); Sumowski
1986, 22 (illus. fig. 1), 23, 36n23; Boonen
1994, 118n9

EXHIBITIONS

The Hague 1992, 54, 258–61, no. 35
(illus., as Jan van Noordt)

This strongly lit scene borrows ele-
ments of its composition from Rem-
brandt's painting of the same theme in
Ottawa.[1] The artist adopted the strong
pyramidal grouping of Esther and her ser-
vant, and balanced it with a table to the
left. He further elaborated the scene by
placing the bed behind them, and a lavish
still-life on the table that includes Adam
van Vianen's famous Silver Cup of 1614.[2]
The meaning of this scene was for a time
concealed by a restorer's alterations. The
background with the bed was overpainted,
and Esther's gaze was redirected toward
the mirror. An historical scene was thus
converted into an allegorical genre scene
of *Vanitas*.

 The closest comparison to Van
Noordt's work is with the *Susanna and the
Elders* in Leipzig (cat. 7). However, the
present picture contains none of its long,
sinuous lines of drapery folds, dramatically

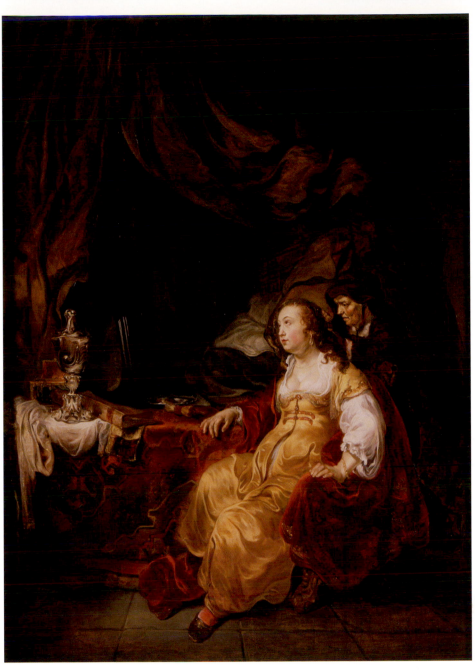

Esther at Her Toilette, panel, 105.5 × 78 cm, Europe, private collection.

accented by strong chiaroscuro. The modelling of the face and figure is also done in a consistent neutral white colour, unlike the contrasts of cool and warm tones typical of Van Noordt. The handling of paint is dry and stiff in areas of shadow, which Van Noordt usually brushed in fluidly, in semi-transparent paint. The present picture cannot be attributed to Van Noordt, but it can be placed in the circle of artists around Flinck and Backer.

1 Rembrandt, *Esther*, canvas, 108.5 x 92.5 cm, signed and unclearly dated 1633, Ottawa, National Gallery of Canada (inv. no. 6089); see Bruyn et al. 1982, 2:266–75, no. A64 (illus.).
2 See cat. no. 12n2.

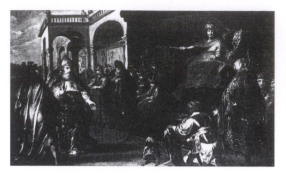

CATALOGUE RI3
A Priest before a King, panel, 86.5 × 142.5 cm,
present location unknown.

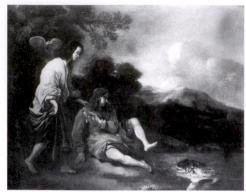

CATALOGUE RI4
Tobias Frightened by the Fish, canvas, 80 × 100 cm,
present location unknown.

CATALOGUE RI3
(p) *A Priest before a King*
Panel, 86.5 x 142.5 cm, present location
unknown

PROVENANCE
Metropolitan Museum of Art et al.
sale (anonymous section), New York
(Christie's), 10 June 1983, lot 113 (illus.,
as Johannes van Noordt)

To judge by the many-figured composi-
tion and the emphasis on classical ar-
chitecture, this painting perhaps belongs to
the first quarter of the seventeenth century.

CATALOGUE RI4
(p) *Tobias Frightened by the Fish*
(Tobit 6:2–3), canvas, 80 x 100 cm, present
location unknown

PROVENANCE
The Hague, Galerie Internationale,
c. 1930 (as Govert Flinck)

LITERATURE
Sumowski 1983–94, 6:3736, no. 2402,
4019 (illus., as Jan van Noordt)

Sumowski based his attribution to Van
Noordt on a comparison with the
Granida and Daifilio in Sydney (cat. 33).
However, it does not display the same
fully-rounded modelling of the figures.
Although it was previously attributed to
Govert Flinck, it perhaps stems from an
artist from the group around Lastman.
The composition of this painting is
indebted to Lastman's depiction of the
same theme, in Leeuwarden.[1]

1 Pieter Lastman, *Tobias Pulling the Fish from the
Water*, panel transferred to canvas, 78 x 101.5
cm, signed and dated 16(?)3, Leeuwarden,
Museum het Pincessehof, Stichting Ottema-
Kingma; see exhibition catalogue Amsterdam
1991, 90–1, no. 3 (illus.).

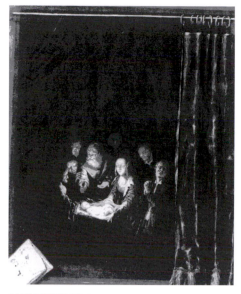

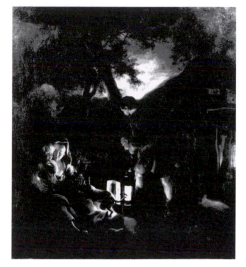

CATALOGUE R16
Emanuel de Witte, *The Departure for the Flight into Egypt*, canvas, 72 × 63 cm, signed, Munich, Bayerische Staatsgemäldesammlungen.

CATALOGUE R15
Jan van Noort, *The Adoration of the Shepherds*, panel, 57.5 × 47 cm, signed and dated: *Jan Nordt fec. 1653*, present location unknown.

CATALOGUE R15
Jan van Noort, *The Adoration of the Shepherds*
(Luke 2:16–17), panel, 57.5 x 47 cm, indistinctly signed and dated bottom left: *Jan Nordt fec. 1653*, present location unknown

PROVENANCE
Drimborn, Aussem collection, in the nineteenth century; sale, Cologne (Kunsthaus am Museum: Carola van Ham), 24–27 June 1992, lot 948A (illus. pl. 63, unsold); sale, Cologne (Kunsthaus am Museum: Carola van Ham), 23–25 June 1993, lot 913 (illus. pl. 69, as Jan van Noordt, for DM 5500)

T he stilted handling and small-scale figures link this to the other paintings here attributed to a second artist, Jan van Noort (cat. nos. R9, R37, R38, R39).[1] Here, he was influenced by a print by Hendrick Goltzius of the same theme.

1 See xx–xx.

CATALOGUE R16
Emanuel de Witte (1617–1692), *The Departure for the Flight into Egypt* (Matthew 2:14), canvas, 72 x 63 cm, Munich, Bayerische Staatsgemäldesammlungen (inv. no. Rembrandt-Schüle no. 197)

PROVENANCE
Düsseldorf, Collection of Johann Wilhelm von Pfalz-Neuburg Elector Palatinate (1658–1716), in 1716 (as J. Jordaens); Munich, in 1822 (as Bartolommeo Schiadone)

LITERATURE
Van Gool 1971, 2:536 (as Jordaens); Decoen 1931, 18; Peltzer 1937–38, 269–70, 275–6, no. 22 (as attributed to Paudiss), 279 (illus. no. 17); Sumowski 1983–94, 5:3111, with nos. 2137 and 2138, 3284 (illus., as Jan van Noordt)

COLLECTION CATALOGUES
Düsseldorf 1716 (not paginated); Düsseldorf 1719, 16, no. 64 (as Jordaens, 2 *Fuß* 6 *Zoll* x 2 *Fuß* 2 *Zoll* [78.5 x 68.3 cm]);

Düsseldorff 1778, 1:348, no. 343; 2 (illus., pl. 15, engraving by Chr. von Mechel, as Jordaens, 2 p 2 po x 1 p 11 *po* [68.3 x 60.2 cm]); Munich 1845, 310, no. 612 (as Bartolomeo Schidone [c. 1570–1615]); Munich 1885, 73, no. 334 (as Rembrandt school)

This scene is mostly painted in dark, translucent colour. The areas of highlights, reflecting the light cast from the lantern in the foreground, and by the hearth in the hut to the right, are painted in a flat, pasty technique, quite atypical for Van Noordt. The red mantle of Mary contrasts with, for example, Van Noordt's fluid modelling with sharp reflections in the red dress of the girl in the Kingston *Satyr and the Peasant Family* (cat. 23). The head of Mary, with its thick and unmodulated application of highlights, gives a flat effect, which is also seen in the head of the child. The limited range of colour, with only some orange, red, and blue distributed sparsely in the figures and the foreground details, is also unlike Van Noordt, who typically capitalized on sharp colour effects. The recent uncovering of the signature of Emanuel de Witte secures the attribution to this artist.

CATALOGUE R 17
(p) *The Rest on the Flight into Egypt*
(Matthew 2:14), canvas, 92 x 68.8 cm
St Petersburg, Hermitage

PROVENANCE
St Petersburg, Semenov collection

LITERATURE
Sumowski 1956/57, 256, 268 (illus. no. 5, as Barent Fabritius); Sumowski 1959, 290 (as not by Barent Fabritius); Blankert 1976, 97, 153, with no. A20 (as Jan van Noordt, attribution by Willem van de Watering); Sumowski 1983–94, 1:140, 142n65, 171 (illus.); Sumowksi 1986, 23 (illus. fig. 2), 36n25

EXHIBITIONS
(*Rembrandt, His Predecessors and Followers*), St Petersburg, Hermitage, 1969, 57, no. 90 (illus., as Gerbrand van den Eeckhout); Dijon 2004, 150–1, no. 28 (illus., as Jan van Noordt)

SELECTED COLLECTION CATALOGUES
Semenov 1906, 92, 67, no. 157 (illus., as Barent Fabritius); St Petersburg 1958, 2:284, no. 3072 (as possibly by Barent Fabritius)

A number of aspects link this painting with the *Levite and His Concubine in Gibeah* in Budapest (cat. R7). The donkey is nearly identical, and the figures of Mary and the concubine bear many resemblances to one another. The two paintings also share stylistic elements, such as a tendency toward rounded contours of figures and forms, giving a soft effect, and a penchant for distracting details of foliage and still-life. These aspects in turn distinguish both of these works from Van Noordt's oeuvre. Sokolova's insistence on the attribution to Van Noordt merits serious consideration, as the handling of the trees and the drapery are reminiscent of Van Noordt's early

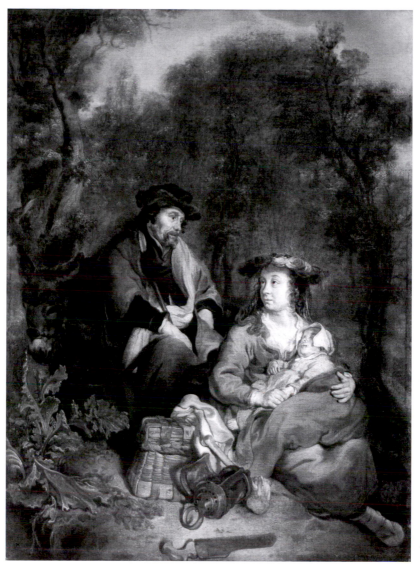

CATALOGUE R17
The Rest on the Flight into Egypt, canvas, 92 × 68.8 cm, St Petersburg, Hermitage.

work. Also, the rendering of the concubine's face closely follows that of some of his early genre figures, such as *Shepherd Girl with a Basket of Flowers* (cat. 44). However, it must be noted that the calm, workmanlike modelling and rendering of the fall of light nowhere display the drama and agitated excitement common to all of Van Noordt's work. The same applies to the brushwork, which is smooth and systematic, but never lively. The folds of fabric in the drapery show none of the accentuation seen in the *Shepherd Girl*, for example. The present picture is likely the work of a follower or pupil, perhaps even working in the artist's workshop. Sumowski draws a comparison with two other works he attributes to Van Noordt, *Esther at Her Toilette* (cat. R12) and *Departure for the Flight into Egypt* in Munich (cat. R16), which are here also rejected.

CATALOGUE R18
Jürgen Ovens, *Mary, Elizabeth, and St John*, canvas, 73.7 × 56.5 cm, present location unknown.

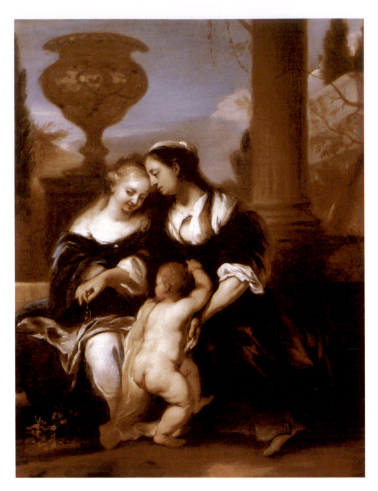

CATALOGUE R18
Jürgen Ovens (1623–1678)
Mary, Elizabeth, and St John
Canvas, 73.7 x 56.5 cm, present location unknown

PROVENANCE
Collection of A.L. Finlayson; Edward Dent et al. sale (anonymous section), London (Christie's), 14 March 1930, lot 21 (as Gerbrand van den Eeckhout); The Earl of Bradford et al. sale (anonymous section), London (Christie's), 18 December 1980, lot 188 (illus., as Jan van Noordt); Angus Acworth et al. sale (anonymous section), London (Christie's), 19 March 1982, lot 22 (illus., as Johannes van Noordt); The Hague, Hoogsteder & Hoogsteder Gallery, in 1992 (as Jürgen Ovens)

LITERATURE
Sumowski 1983–94, 3:2227, no. 1495, 2250 (illus., as Jan van Noordt)

EXHIBITIONS
The Hague 1992, 60, 272–5, no. 38 (illus., as Jürgen Ovens)

The facial types, the abrupt transitions of tone and colour in the modelling, and the distinct use of yellow ochre are more reminiscent of Jürgen Ovens than Van Noordt, and support the recent reattribution to this artist made by Paul Huys Janssen.[1]

1 See exhibition catalogue The Hague 1992, 272–5.

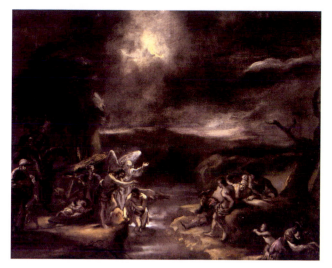

(p) *Jesus and the Samaritan Woman at the Well*
(John 4:7–26), panel, 51 x 64 cm, present location unknown

PROVENANCE
Sale, Lucerne (Fischer), November–December 1967, lot 2299 (illus. pl. 50, as Jan van Noordt); sale, Lucerne (Fischer), 2 June 1981, lot 477 (illus.).

The broad modelling and abstracted forms differ strongly from Van Noordt's figure style.

CATALOGUE R19
The Baptism of Jesus, canvas, 69 × 85.5 cm, present location unknown.

CATALOGUE R19

(p) *The Baptism of Jesus*
(Matthew 3:16; Mark 1:10; Luke 3:21; John 1:32), canvas, 69 x 85.5 cm, present location unknown

PROVENANCE
Sale, Vienna (Dorotheum), 7–8 November 1991, lot 278 (illus.); Milwaukee, Collection of Drs Alfred and Isabel Bader; sale, London (Christie's), 4 July 1997, lot 242 (illus., as Jan van Noordt)

LITERATURE
Sumowski 1983–94, 6:3735, no. 2396a, 4013 (illus., as Jan van Noordt)

The thick, impasto application of paint and flatly modelled areas are unrelated to Van Noordt's work.

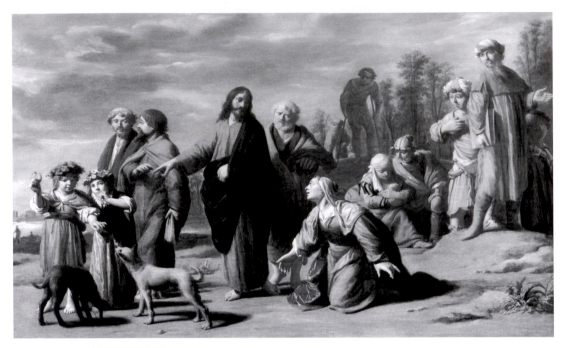

CATALOGUE R2I
Willem van Oordt, *Christ and the Canaanite Woman*, panel, 75.5 × 123.5 cm, signed: *v. Oort*, Utrecht, Museum Catharijneconvent.

CATALOGUE R2I
Willem van Oordt (active 1635–1665)
Jesus and the Canaanite Woman
(Matthew 15:22–8; Mark 7:25–9), panel, 75.5 x 123.5 cm, signed lower right: *v. Oort*, Utrecht, Museum Catharijneconvent (inv. no. SCCs. 12)

PROVENANCE
Greenville, South Carolina, Bob Jones University Collection (as H. ter Brugghen); The Hague, Hoogsteder & Hoogsteder Gallery

LITERATURE
Sumowski 1983–94, 6:3526, 3531n54; Dirkse 1980, 76–8 (with colour illustraton, as Jan van Noordt); Dirkse 1997, 13–16 (illus., as Willem van Oordt)

EXHIBITIONS
Utrecht 1989, 88–91, no. 19 (illus., as Jan van Noordt, c. 1650, an uncharacteristic work)

COLLECTION CATALOGUES
Utrecht 2002, 242 (illus., as Willem van Oordt)

This painting has been reattributed convincingly by Paul Dirkse to the Utrecht painter Willem van Oordt. Dirkse based his reattribution on the remnants of a signature and on a comparison of the figure style with several signed drawings by this artist.[1]

1 See Dirkse 1997.

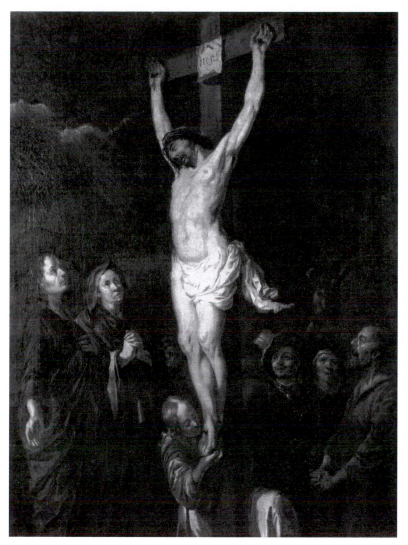

The Crucifixion, canvas, 82 × 70 cm, Amersham, Buckinghamshire, England, collection of Ms H.C.W. Dally.

CATALOGUE R22
(p) *The Crucifixion*
Canvas, 82 x 70 cm, Amersham, Bucking-hamshire, England, collection of Ms H.C.W. Dally

PROVENANCE
The Right Honourable The Countess of Southesk et al. sale, London (Christie's), 19 June 1942, lot 124 (as Carel Fabritius); London, collection of Efim Schapiro, by 1953; sale, London (Christie's), 15 December 1976, lot 34 (illus. pl. 18, as Jan van Noordt, 90.1 x 69.9 cm); sale, London (Christie's), 18 May 1979, lot 212 (as Jan van Noordt, 90.8 x 69.8 cm)

The angular quality of the drapery folds, the facial types, and the broad, flat lighting of the figure of Christ suggest that this painting was not done by Jan van Noordt. At the RKD this work is placed under the name of Egbert van Heemskerck (c. 1634–1704).

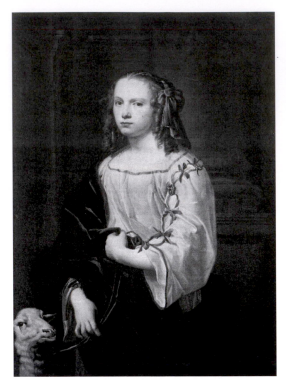

CATALOGUE R23
St Agnes, canvas, 116 × 91 cm, present location unknown.

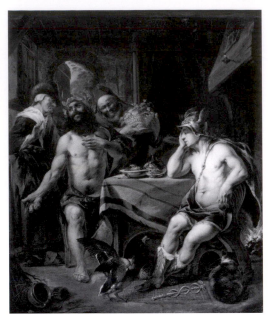

CATALOGUE R24
Jupiter and Mercury in the House of Philemon and Baucis, canvas, 80 × 67 cm, signed: *Jordaens P.*, Helsinki, Sinebrychoff Art Museum and Göhle collection.

CATALOGUE R23
(p) *St Agnes*
Canvas, 116 x 91 cm, present location unknown

PROVENANCE
With an Amsterdam dealer in 1935; Lucerne, in 1945; Zürich, Bruno Meissner Gallery, in 1991

LITERATURE
Staring 1946, 81 (as Jan van Noordt); Wishnevsky 1967, 68, 169, no. 24

The abstracted facial features, the soft effect of light, and the broad model-ling of the figure point to the possibility that this painting was produced by a Haarlem artist, under the influence of clas-sicizing painters such as Pieter Fransz de Grebber (1600–1651/52). At the RKD, this work is placed under the name of the portraitist Isaac Luttichuys (1616–1673).

CATALOGUE R24
(p) *Jupiter and Mercury in the House of Philemon and Baucis*
(Ovid, *Metamorphoses*, 8, 630–724), canvas, 80 x 67 cm, falsely signed, bottom left: *Jordaens*, Helsinki, Sinebrychoff Museum (inv. no. A11377, as Jan van Noordt)

PROVENANCE
Göhle collection

LITERATURE
Sumowski 1983–94, 5:3111, no. 2139, 3286 (illus., as Jan van Noordt); Sumowski 1986, 31, 32, 37n45; exhibition catalogue Bordeaux 1990, 226n4; exhibition cata-logue Utrecht and Frankfurt 1993, 239, 241n5

COLLECTION CATALOGUES
Helsinki 1988, 85 (illus.)

The composition of this painting is adapted freely from the depiction of the same theme by Adam Elsheimer.[1] The

artist apparently knew the reproductive print by Hendrick Goudt, and followed its left-to-right orientation.[2] The false signature indicates that the artist was once thought to be Jacob Jordaens. This painting also cannot be attributed to Jan van Noordt. His output has little in common with the hard, exaggerated musculature and the pursuit of detail in this picture. Another work showing these characteristics, *Juno Asks Jupiter for Io as a Gift*, in Paris (cat. no. R26), can tentatively be given to the same, anonymous, artist.

1 Adam Elsheimer, *Jupiter and Mercury in the House of Philemon and Baucis*, c. 1608/09, oil on copper, 16.9 x 22.4 cm, Dresden, Staatliche Kunstsammlungen; see Andrews 1977, 34–6, 153–4, no. 24 (illus. pl. 87).
2 Hendrick Goudt, after Adam Elsheimer, *Jupiter and Mercury in the House of Philemon and Baucis*, engraving, 16.4 x 22 cm, dated 1610; see Hollstein 1949–, 8:156, no. 6 (illus.).

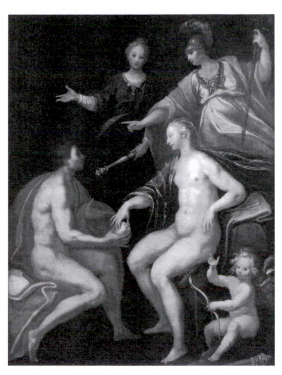

CATALOGUE R25
The Judgment of Paris, canvas, 146.5 × 114 cm, present location unknown.

CATALOGUE R25
(p) *The Judgment of Paris*
(Homer, Iliad, 24, 25–30), canvas, 146.5 x 114 cm, present location unknown

PROVENANCE
Sale, Paris (Hôtel Drouot, Étude Tajan), 23 June 1997, lot 76 (illus., as Jan van Noordt [Amsterdam 1562–1641])

The sale catalogue entry attributes this Italian-looking picture to an artist who lived in Amsterdam from 1562 to 1641, reflecting some confusion about his identity.

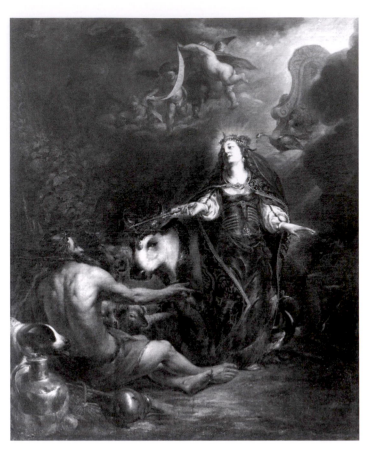

CATALOGUE R26
Juno Asks Jupiter to Give Her Io as a Gift (Ovid, *Metamorphoses*, 1, 616), canvas, 113 x 108 cm, Paris, Louvre (inv. no. RF 1973–3)

PROVENANCE
Paris, with A. Stein; given to the Louvre in 1973

LITERATURE
Sumowski 1983–94, 1:140, 143n73, 179 (illus., as Jan van Noordt); Sluijter 1986, 55, 394–5n10; Sumowski 1986, 31, 37n44; exhibition catalogue Paris 1990, 226n5; exhibition catalogue Utrecht and Frankfurt 1993, 239, 241n6

COLLECTION CATALOGUES
Paris 1979, 98 (illus., as Jan van Noordt)

The composition of this painting is indebted to a depiction by Pieter Lastman of the same theme, in London.[1] The hard muscularity of the figure and the attention to detail distinguish this work from the style of Van Noordt, but link it to the *Jupiter and Mercury in the House of Philemon and Baucis* in Helsinki (cat. R24), which was likely done by the same, anonymous, artist.

1 Pieter Lastman, *Juno Asks Jupiter to Give Her Io as a Gift*, panel, 53 x 76 cm, signed and dated 1618, London, National Gallery (inv. no. 6272); see collection catalogue London 1973, 359, no. 6272 (illus.).

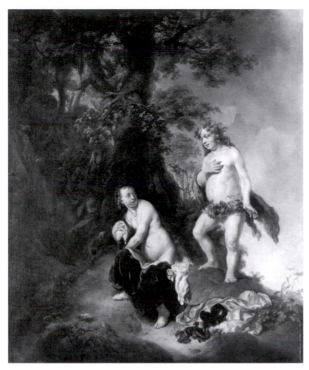

CATALOGUE R27

(p) *Bacchus and Ariadne*
(Philostratus the Elder, *Imagines*, 1, 15),
canvas, 81.5 x 67.5 cm, Warsaw, Museum
Narodowe (inv. no. м.06.564)

PROVENANCE
Amsterdam, collection of "M.D."; sale,
Amsterdam (A. Mak), 23 April 1929, lot 63
(as Jan van Noordt, *Bacchus et Ariane*, can-
vas, 80.5 x 68 cm: "*Dans un site boisé, Ariane
en train de se déshabiller pour prendre un bain,
est surprise par Bacchus. Le jeune dieu entière-
ment nu, les reins couverts de pampres s'adresse
à Ariane qui s'empresse de s'envelopper le corps
d'un manteau en velours pourpre. Par terre, un
manteau vieil or et un châle vert anglais* [In
a wooded area, Ariadne, undressing for a
bath is surprised by Bacchus. The young
god, entirely nude, his private parts cov-
ered by vine branches, addresses Ariadne
who hastens to cover herself with a mantle
of purple velvet. On the ground an old
mantle of gold and a shawl of English
green]," *f*210.– to Van Diemen); Vienna,
Schmit Collection; sale, Vienna
(Dorotheum), 6 October 1942, lot 4 (illus.
no. 17, as Jacob Adriaensz. Backer); ac-
quired by the Warsaw Museum in 1969

LITERATURE
Janina Michalkowa, "Nouvelles Acquisi-
tions du Département de la Peinture Eu-
ropéenne 1963–1969," *Bulletin du Musée
National de Varsovie* 9, 1970, 30, no. 2, 31
(illus., as Backer); Murdzeńska 1970,
97–106; Sumowski 1983–94, 1:140, 142n66,
173 (illus., as Jan van Noordt); 6:3735,
with no. 2397; Sumowski 1986, 23, 36n25

This picture was first attributed to
Jan van Noordt by Kurt Bauch.[1]
The alternative attribution by Cornelius
Hofstede de Groot (in a note with the pho-
tograph at the RKD to Jacob Adriaensz.
Backer, was adopted by Janina Michalkowa.[2]
Backer is a more likely candidate for the
authorship of this painting, given the loose
fluid handling of the fabric on the ground
and draping Ariadne, and the distinctive
heavy eyelids of both figures.

1 Bauch suggested Van Noordt in a note with
 the photograph of this painting at the RKD.
2 See Literature.

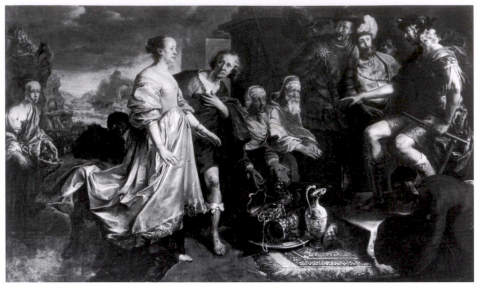

Artus Wolffort, *The Magnanimity of Scipio*, canvas, 198 × 325 cm, monogrammed right: *I.W.*, Budapest, Szépmüvészeti Múzeum.

CATALOGUE R28
(p) Artus Wolffort (1581–1641),
The Magnanimity of Scipio
(Livy, *Historiarum ad urbe condita*, 26, 50),
canvas, 198 x 325 cm, monogrammed
lower right: "I.W." on the bundle carried
by the black servant, Budapest, Szép-
müvészeti Múzeum (inv. no. 96.4)

PROVENANCE
Budapest, collection of Dr Béla Hermann;
Australia, collection of Ervin Katz, in 1996

LITERATURE
Müvezet 4, 1915, 311 (as Victor Wolfoet);
Pigler 1955, 169–86 (illus., as Jan van
Noordt); Pigler 1968, 407 (illus.), 409;
Czobor 1967, 351n5; Wishnevsky 1967,
95, 223, no. 140; Golan 1994, 204–7, 290
(illus. fig. 48, as Jan van Noordt); exhibi-
tion catalogue Perth, Adelaide, and
Brisbane 1997, 110n2

COLLECTION CATALOGUES
Budapest 1968, 493 (as Jan van Noordt),
Budapest 2000, 126 (illus.)

Andor Pigler based his attribution of
this painting to Jan van Noordt on a
reading of the monogram as "I V N."[1] It
should rather be read as "I W." The differ-
ence between its style and that of other
paintings by Jan van Noordt was not lost
on Pigler, who explained it by characteriz-
ing the artist as lacking a strong personali-
ty. However, Pigler's attribution to Van
Noordt must be discarded. The diffuse
composition, the distinctive facial types,
and the awkward poses do not connect to
Van Noordt's style. They do bear some
relation to the work of Antwerp painter
Artus Wolffort (1581–1641). The two fig-
ures in the centre are quite likely portraits,
despite Pigler's surprising assertion that
bourgeois Dutch patrons would not have
deigned to be portrayed as prisoners
of war.

1 See Pigler 1955, 184.

CATALOGUE R29
Hippocrates Visiting Democritus in Abdera,
canvas, 80.5 × 63 cm,
Europe, private
collection.

CATALOGUE R29
Hippocrates Visiting Democritus in Abdera
Canvas, 80.5 x 63 cm, Europe, private
collection

PROVENANCE
With a dealer in Berlin, 1932; Duisburg,
Henle Collection; sale, Lempertz,
(Cologne), 21 June 1990, lot 107 (illus., as
Jan van Noordt); The Hague, Hoogsteder
& Hoogsteder (dealer), in 1992

LITERATURE
Blankert 1967, 41n2 (as Jan Pynas);
Sumowski 1983–94, 6:3735, no. 2397,
3736, with no. 2399, 4014 (illus., as Jan
van Noordt); Sumowski 1992, 54

EXHIBITIONS
Cologne 1964, no. 29 (illus., as Jan Pynas,
c. 1605–10); exhibition catalogue The
Hague 1992, 262–5, no. 36 (illus., as Jan
van Noordt)

The composition of this painting fol-
lows the interpretation of the same
theme by Pieter Lastman.[1] In both paint-
ings the scene is set at the bottom of a hill.
Along its crest in the background, onlook-
ers are gathered at the edge of a town. The
artist of the present work evoked the unsta-
ble leaning pose that Lastman devised for
Hippocrates, about to address his subject.
He modified it slightly, by having the doc-
tor raise his finger in a gesture of address.
The artist took one of his motifs, the pro-
file head of Democritus, from the head of
the aged prophet in Lambert Jacobsz.'s *The
Disobedient Prophet*, now in Amsterdam.[2]
 These influences suggest that this
painting was likely made in the first half of

the seventeenth century, when the subject matter reached its greatest popularity in the circle of Lastman and Moyaeart.[3] This period precedes Van Noordt's activity as an artist. There are also stylistic reasons for dismissing Jan van Noordt as the author of this work. The artist emulated Lastman's light tonality and his use of opaque colours mixed with white throughout his scenes. In contrast, Van Noordt tended to build up his pictures with underlayers in dark, translucent paint, much of which remained in the final image. Here, the lighted forms in the foreground show an especially heavy application of impasto paint, painted directly, without the modulation typical of Van Noordt. In the figure of Democritus, this manner of handling yields a hard, stiff effect. In particular, the face and hands do not show the soft modelling that Van Noordt reserved for flesh, even in his earliest pictures. Another feature distinguishing this work from Van Noordt's oeuvre is the heavy use of yellow ochre, distributed throughout the landscape.

The sheep in the foreground, one of the painting's most salient details, had been covered up by a previous owner or dealer, evidently to help sell the painting to a public with sensitive taste. It was uncovered during a recent restoration.

1 Pieter Lastman, *Hippocrates Visiting Democritus in Abdera*, panel, 111 x 114.5 cm, signed and dated 1622, Lille, Palais des Beaux-Arts de Lille, inv. no. P2055. See exhibition catalogue Amsterdam 1991, 110–11, no. 13 (illus.).
2 Lambert Jacobsz., *The Prophet from Bethel Meets the Man of God*, canvas, 82.5 x 111 cm, signed and dated 1629, Amsterdam, Museum het Rembrandthuis, on loan from the Rijksmuseum (inv. no. 1293a).
3 For paintings of this theme by Lastman and other Amsterdam artists of his generation, and the most incisive discussion of the textual sources, see Broos 1991.

CATALOGUE R30
Nero Fiddling during the Burning of Rome, panel, 90 × 54.5 cm, present location unknown.

CATALOGUE R30
(p) *Nero Fiddling during the Burning of Rome*
Panel, 90 x 54.5 cm, present location unknown

PROVENANCE
Sale, London (Philips), 27 October 1980, lot 17 (as Jan van Noordt)

The exaggeratedly muscular physique of Nero does not accord with Van Noordt's approach to the male figure. The abrupt transitions of tone in the modelling produce a flattening of forms, at variance with the ripe, rounded forms typical of Van Noordt.

CATALOGUE R31
Caritas, canvas, 98 × 76 cm, present location unknown.

CATALOGUE R31
(p) *Caritas*
Canvas, 98 x 76 cm, present location unknown

PROVENANCE
Smith Barry et al. sale (anonymous section), London (Sotheby's), 12 July 1972, lot 83 (as Jan van Noordt, *The Madonna and Child with Children*: "The Madonna in blue, kissing the hand of the Child standing on a cushion before her in a pink tunic, a child on either side of her," for £600)

This painting is a copy of Jürgen Ovens' Caritas of 1657 in Budapest.[1]

1 Jürgen Ovens, *Caritas*, canvas, 89 x 74 cm, signed and dated 1657, Budapest, Szépmüvészeti Múseum (inv. no. 191); see Sumowski 1983–94, 3:2226, no. 1490, 2245 (illus.).

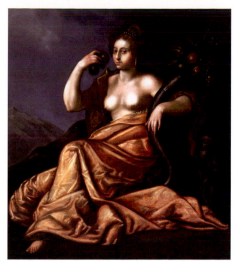

CATALOGUE R32
Allegory of Taste, panel, 98 × 87.5 cm, Zwolle, Stedelijk Museum Zwolle, on loan from the Vereeniging tot Beoefening van Overijsselsch Regt en Geschiedenis, since 1996.

CATALOGUE R32
(p) *Allegory of Taste*
Panel, 98 x 87.5 cm, Zwolle, Stedelijk Museum Zwolle, on loan from the Vereeniging tot Beoefening van Overijsselsch Regt en Geschiedenis, since 1996

PROVENANCE
Zwolle, Provinciaal Overijssels Museum, since 1886 (as Pieter van Noort, 1671)

LITERATURE
Lydie van Dyck, "Een aapje als identificatie van een voorstelling," *Overijsselse Historische Bijdragen* 113, 1998, 144–7 (illus., as Joan van Noordt)

The idealized, slender figure and the softly rounded modelling in strong chiaroscuro is reminiscent of the Mannerist style of Haarlem artists of the last decade of the sixteenth century. In a recent article, Lydie van Dyck identified the theme of this picture as an allegory of taste by drawing attention to the ape to the lower right. She pointed out that these animals were thought to have an especially refined sense of taste.[1]

1 See Literature.

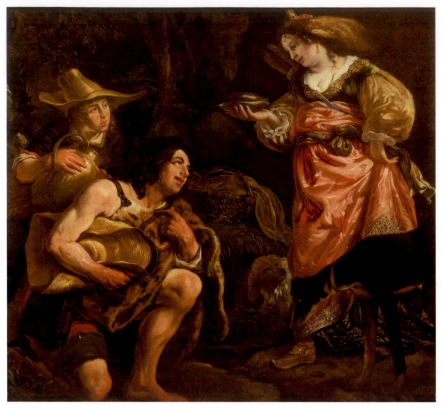

Granida and Daifilo, canvas, 178 × 194 cm, Europe, private collection.

CATALOGUE R33
Granida and Daifilo
Canvas, 178 x 194 cm, Europe, private
collection

PROVENANCE
Sale, London (Sotheby's), 4 April 1984,
lot 52 (illus., as Jan Cossiers); The Hague,
Hoosteder & Hoogsteder Gallery;
Germany, private collection

LITERATURE
Sumowski 1983–94, 5:3111, no. 2138,
3285 (illus., as Jan van Noordt); Te Poel
1986, 32, 62, no. 29, 95 (illus. no. 37);
Sumowski 1986, 27–33 (illus. 29 fig. 9),
36n35

EXHIBITIONS
The Hague 1992, 266–9, no. 37 (illus.);
Utrecht and Luxembourg 1993–94, 236,
239–41, no. 46 (illus.)

Sumowski's 1996 article on Van Noordt's
paintings focused on his reattribution
of this large-scale *Granida and Daifilo* from
the Antwerp painter Jan Cossiers (1600–
1671) to Jan van Noordt. However this
painting does not display Van Noordt's
fluid handling of semi-transparent paint,
nor his rounded modelling of forms. The
two figures to the right especially show a
dry, stiff technique. Other aspects that speak
against the attribution to Van Noordt in-
clude the large figure scale, in which the
figures crowd the frame, as well as the un-
resolved modelling of drapery, in particular
in the costume of Granida. The former
attribution to Cossiers is also not satisfac-
tory, although it is closer to the mark.

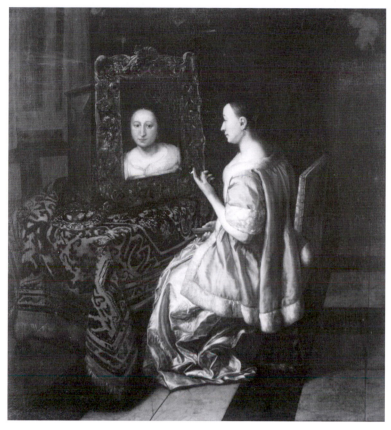

CATALOGUE R34
Joos van Geel, *A Lady at Her
Toilette (Allegory of Vanitas)*,
canvas, 82 × 74.5 cm, present
location unknown.

CATALOGUE R34
(p) Joost van Geel (Rotterdam 1631–1698)
A Lady at Her Toilette (Allegory of Vanitas)
Canvas, 82 x 74.5 cm, present location
unknown

PROVENANCE
St Petersburg, Semenov Collection; Berlin,
collection of the Elector Schaumburg-
Lippe; sale, Berlin (Herman Ball & Paul
Graupe), 10 December 1932, lot 140
(illus. pl. 25, as Jan van Noort); sale, Berlin
(R. Lepke), 15 March 1935, lot 272 (illus.
pl. 9, as J. v. Noort, possibly by S.v.
Hoogstraten); Berlin, A. Freiherr Ritter
von Riedenau, in 1938; sale, Zürich
(Koller), 5–21 November 1974, lot 2801
(illus. pl. 2, as Jan van Noordt); sale, Lon-
don (Phillips), 14 December 1999, lot 185
(illus., as Jan van Noordt); sale, London
(Phillips), 4 July 2000, lot 212 (illus., as

Joos van Geel); sale, Zürich (Koller),
16 March 2005, lot 3065 (illus.)

LITERATURE
Kronig 1911, 157

COLLECTION CATALOGUES
Semenov 1906, 121, no. 298

The dominance of still-life detail, the
angular treatment of drapery, and the
flat modelling of the figure bear no con-
nection to Van Noordt's style. The attri-
bution to him was originally based on a
comparison with *A Lady at Her Toilette* in
Brussels (cat. R35), a painting that is here
also rejected as by Van Noordt.[1]

1 See collection catalogue Semenov 1906, 121,
 no. 298

CATALOGUE R35
A Lady at Her Toilette (Allegory of Vanitas),
canvas, 75.5 × 62.5 cm, monogrammed
and dated: *JN 1670 f.*, Brussels, Museum
van Schone Kunsten.

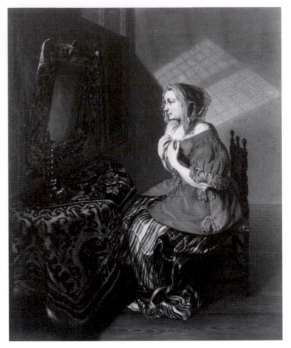

CATALOGUE R35
A Lady at Her Toilette (Allegory of Vanitas)
Canvas, 75.5 x 62.5 cm, monogrammed
and dated (vague): *JN 1670 f.*, Brussels,
Museum van Schone Kunsten (inv. no.
616)

PROVENANCE
Munich, Hanfstaengl Collection; Brussels,
Thys Collection, as Jan Baptiste Weenix
(inv. no. 1327.1A); from there acquired
by the museum, in 1812

LITERATURE
Kronig 1911, 156–8; Decoen 1931, 18;
Schneider 1931, 511; Sumowski 1983–94,
1:142n49; 5:3112, no. 2143, 3290 (illus.)

SELECTED COLLECTION
CATALOGUES
Brussels 1889, no. 495 (as J.B. Weenix);
Brussels 1900, no. 616 (as "unknown
Netherlandish master"); Brussels 1906 (as
Janssens Elinga); Brussels 1927, 172, no.
616; Brussels 1984, 212–13, no. 616 (illus.,
as Jan van Noordt)

The most striking aspect of this picture
that distinguishes it from Van Noordt's
style is colour. The predominance of
pinks and purples is quite unlike Jan van
Noordt's palette. The flat and stiff model-
ling and the emphasis on detail link the
painting to a depiction of the same subject
that last appeared at a sale in London
(cat. R34). This work cannot be linked to
a known artist. The present work takes
over much of the pose of a painting of the
same theme by Gabriel Metsu, formerly
in Wassenaar.[1]

1 Gabriel Metsu, *Young Woman at Her Toilette
(Vanitas)*, panel, 27.3 x 21.5 cm, signed, Wasse-
naar, collection of S.J. van den Bergh, in 1950.
See Robinson 1974, illus. 151.

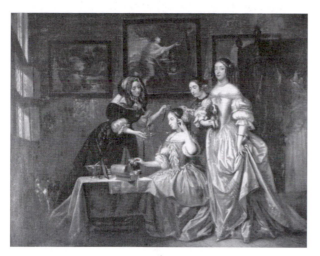

CATALOGUE R36
Women with a Maid at a Toilette, canvas,
57 × 74 cm, Mexico City, Museo Franz Mayer.

CATALOGUE R36
(p) *Women with a Maid at a Toilette*
Canvas, 57 x 74 cm, Mexico City, Museo
Franz Mayer

PROVENANCE
Paris, collection of Baron Kervyn de
Lettenhove; Paris, collection of Charles
L. Cardon; Paris, collection of E. Lorenz;
New York, Kleinburger & Co. (dealer);
sale Mrs Louis Colwell et al., New York,
(Parke-Bernet), 18 November 1957, lot
40 (as Jan van Noort)

EXHIBITIONS
Hartford 1949, 20, no. 32 (as Jan van
Noordt); Mexico City 1964, 16, no. 72
(illus., as Jan van Noordt)

The attribution of this painting to Van
Noordt may have been based on the
Vanitas in Brussels (cat. R35), here rejected.
They were done by different artists; this
image is similarly elegant and restrained
but is richer in detail and composition.
The flat modelling and the calm organiza-
tion of drapery contrast with the move-
ment and liveliness typical of Van Noordt.

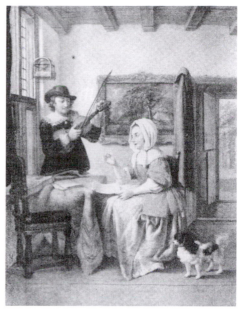

CATALOGUE R37
A Musical Couple, canvas, 46 × 37 cm, present
location unknown.

CATALOGUE R37
(p) *A Musical Couple*
Canvas, 46 x 37 cm, present location
unknown

PROVENANCE
Sale, Vienna (Dorotheum), 15 September
1955, lot 115 (illus., as Jan van Noordt)

The attribution seems to be based on
a connection to the Brussels *Vanitas*,
here rejected (cat. R35). The handling of
space and figure show no similarities to
the work of Jan van Noordt.

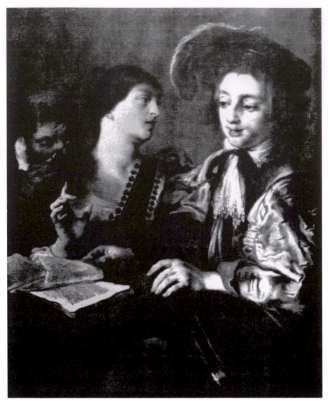

CATALOGUE R38
The Music Lesson, canvas,
100 × 76 cm, monogrammed,
upper centre: *HB*, present
location unknown.

CATALOGUE R38
(p) *The Music Lesson*
Canvas, 100 x 76 cm, monogrammed,
upper centre: *HB* (interlaced), present
location unknown

PROVENANCE
Berlin, De Vries & Co. (as Jan Lijs);[1]
Amsterdam, Gebroeder Douwes Gallery,
in 1930; sale, Amsterdam (Sotheby- Mak
van Waay), 13–15 June 1933, lot 30 (illus.,
as Jan van Noordt, *La leçon de musique*,
105 x 84 cm); E.A. Iordens sale, The
Hague (Van Marle & Bignell), 27–28 Feb-
ruary 1935, lot 937 (illus., as Joh. van No-
ordt, canvas, 85 x 105 cm); sale, Brussels,
25 October 1938 (for Bfr. 3400);[2] Dieren,
D. Katz Gallery, in 1938 (as H. ter Brug-
ghen); Almelo, Hedeman Collection; sale,
Amsterdam (Paul Brandt), 22–25 October
1963, lot 7 (illus., as H. ter Brugghen,
100 x 76 cm)

LITERATURE
Bénézit 1976, 7:750

EXHIBITIONS
The Hague 1936, 105, no. 575 (as Jan van
Noordt, *Musiceerende Family* [A Family
Making Music], canvas, 105.5 x 85 cm)

The attribution to Jan van Noordt was
suggested by Hans Schneider.[3] Rather
crudely painted, this picture shows none
of the organized movement in the drapery
nor the curving lines of drapery folds
typical of Van Noordt.

1 Note with the fiche on the painting, by
 Cornelius Hofstede de Groot, at the RKD.
2 Bénézit 1976, 7:750 (no lot number is given).
3 Note with the photograph at the RKD.

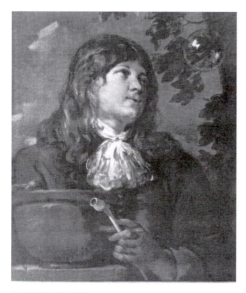

CATALOGUE R39
Head of a Man: Homo Bulla, canvas,
59.5 × 51.5 cm, present location unknown.

CATALOGUE R39
(p) *Head of a Man: Homo Bulla*
Canvas, 59.5 x 51.5 cm, present location
unknown

PROVENANCE
Amsterdam, with J. Goudstikker; sale,
Cologne, 11–12 March 1938, lot 129
(illus., as Nicolaes Maes, *Portrait of a
Princess in a Park, with Her Son*, canvas,
117 x 103 cm); Cologne, with Abels
Gallery, 1938; collection of Major
Höhne (as a *Homo Bulla*)

The present genre scene was cut down
from a portrait of a woman attended
by her servant, a young man. Originally
he stood to the left, and carried an orange
tree in a basket. The reduction took place
after 1938, when the painting was in
Cologne. The tree was then painted over,
and the bubble and pipe were added, as
were details of fabric and foliage. The
original portrait of the woman showed a
dry handling of light impasto that yields a
hard effect, unlike the softer modelling in
translucent glazes typical of Van Noordt.

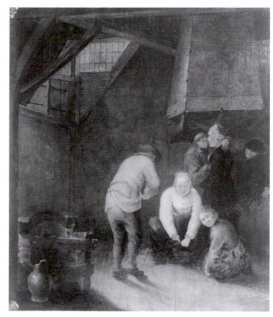

CATALOGUE R40
Jan van Noort, *Peasant Interior*, support not
known, 30.5 × 26.3 cm, signed and dated: *Jan
Noordt f.1660*, Brentwood, England, collection
of E. Stowers Johnson.

CATALOGUE R40
(p) Jan van Noort, *Peasant Interior*
Support not known, 30.5 x 26.3 cm, signed
and dated, on the well: *Jan Noordt f.1660*,
Brentwood, England, collection of
E. Stowers Johnson

PROVENANCE
Possibly Friedrichstadt, inventory of
Jürgen Ovens, 1678[1]

The hesitant, rough execution of this
picture is similar to that of *The Disobe-
dient Prophet*, in Gavnø (cat. R10), *The
Adoration of the Shepherds*, last in Cologne
(cat. R15), and the *Shepherds and Shep-
herdesses near a Fountain* in Rottenburg (cat.
R42), all by the artist identified here as Jan
van Noort.[2] The block-lettered signatures
are similar, although the one here includes
a "d," not present in the other two. Jan van
Noordt consistently applied a calligraphic

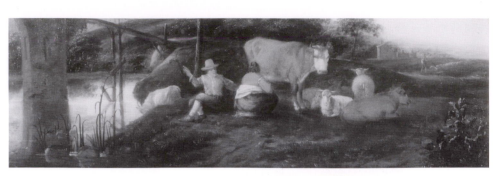

CATALOGUE R41
Jan van Noort, *Landscape with a Shepherd and a Milkmaid*, panel, 23.1 × 74.4 cm, signed bottom right: *J. Noort*, present location unknown.

signature, starting already in his print of 1644 (cat. P2).

1 Harry Schmidt, "Das Nachlass-Inventar des Malers Jürgen Ovens," *Oud Holland* 32, 1914, 39, no. 24: "*Ein Original von Johan von Nordt worauff ein Bawern Heüszgin (An Original by Jan van Nordt of a Peasant Household).*"
2 On Jan van Noort, see 21.

CATALOGUE R41
(p) Jan van Noort, *Landscape with a Shepherd and a Milkmaid*
Panel, 23.1 × 74.4 cm, signed bottom right: *J. Noort*, present location unknown

PROVENANCE
Sale Dr J.J. Merlo, Cologne, 9–10 December 1891 (Lugt 50318), lot 129 (as 54 x 75 cm, signed bottom right: *J. VAN NOORT*, to Neumans, for 100M); Van Oudshoorn et al. sale, Amsterdam (Roos), 24 November 1896 (Lugt 54764), lot 60 (as 25 x 72 cm, for *f*76, to Roos); F. de Wildt, van Alphen-Hovy, Cremers, *et al.* sale, Amsterdam (Frederik Muller), 30 November 1920 (Lugt 81289), lot 1066 (as 23 x 74 cm, signed left: *J. van noort*); The Hague, collection of P.M. Zetz; sale, The Hague (Venduehuis der Notarissen), 8 November 1994, lot 12 (as Jan van Noort, *Herderspaar* [Shepherd Couple], oil on panel, 22.5 x 70 cm, signed)

LITERATURE
Hofstede de Groot 1892, 217, no. 21; Wurzbach 1906–10, 2:243

This work is by the same Jan van Noort who painted four other known pictures (cat. R10, R15, R40, R42).[1] The cow is nearly identical to the one in the Steiner collection painting in Rottenburg (cat. no. R42).

1 See 21.

252

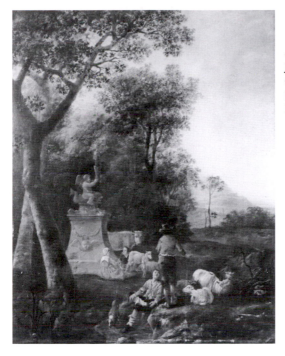

CATALOGUE R42
(p) Jan van Noort, *Shepherds in a Landscape with a Fountain*
Panel, 74 x 61 cm, signed bottom centre, on a stone: *J. Noort*, Rottenburg, collection of Josef Steiner

PROVENANCE
Bregentved, Adam Gottlob Count Moltke (1709–1792); Copenhagen, collection of Count J.G. von Moltke; Von Moltke sale, Copenhagen, 1–2 June 1931, lot 97; sale, Copenhagen (Rasmussen), 5 December 1973, lot 5 (illus., for ,1735); sale, Copenhagen (Rasmussen), 8–9 November 1977, lot 275 (illus.); sale, Zürich (Koller), 15–16 May 1981, lot 5018 (illus.)

LITERATURE
Hofstede de Groot 1892, 217, no. 22 (as Jan van Noordt); Wurzbach 1906–10, 2:243; Sumowski 1983–94, 5:3113, no. 2147, 3294 (illus., as possibly by another J. van Noort)

SELECTED COLLECTION CATALOGUES
Moltke 1756, no. 102; Moltke 1780, no. 144; Moltke 1818, 148, no. 141 (as Jan van Ort); Moltke 1841, 57, no. 99; Moltke 1885, 52, no. 99; Moltke 1900, 51, no. 99

Sumowski connects this picture to the early etching after Van Laer (cat. P1) and to the Italianate landscapes of Jan Both (c. 1615–1652), while at the same time conceding doubt about the connection to Jan van Noordt. It is, however, more closely related to a painting by Willem Schellinks (1627–1678) and a similar one attributed to Jan Baptist Weenix.[1] On account of the signature, the rural subject matter, and the small figure scale, this painting can be attributed to the artist identified as "Jan van Noort," who painted four other known pictures (cat. R10, R15, R40, R41).[2]

1 Willem Schellinks, *Shepherds and Shepherdesses at a Fountain*, panel, 63.5 x 52 cm, Budapest, Szépművészeti Múseum (inv. no. 225); see exhibition catalogue Milan 1995, 168–9 (illus.); attributed to Jan Baptist Weenix, *Shepherds and Shepherdesses at a Fountain*, canvas, 108 x 102 cm, Switzerland, private collection (stolen in 1992, photo in the RKD).
2 See 21.

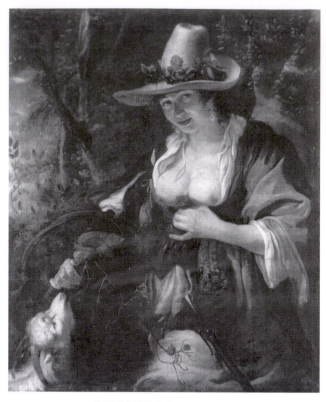

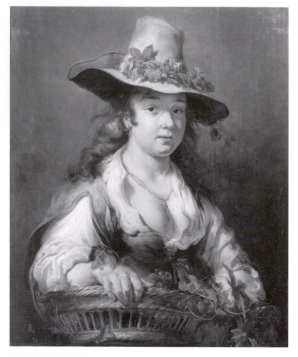

CATALOGUE R44
A Girl with a Basket of Fruit, panel, 75 × 60 cm,
The Hague, Galerij Willem V, on loan from the
Instituut Collectie Nederland.

CATALOGUE R43
A Shepherdess, canvas, 92 × 111 cm, present
location unknown.

CATALOGUE R43
A Shepherdess
Canvas, 92 x 111 cm, present location
unknown

PROVENANCE
Sale, New York (Sotheby's), 15 October
1987, lot 88 (illus., as Circle of Jan van
Noordt); Turin, Caretto Gallerie, in 1988

EXHIBITIONS
*29ᵃ Mostra Maestra fiamminghi ed olandesi
del XVI e XVII secolo*, ed. Luigi Caretto,
Turin (Caretto Gallerie), 1988, 29 (illus.,
as Jan van Noordt, *Portrait of a Woman in
Shepherdess Costume*)

CATALOGUE R44
Jürgen Ovens (1623–1678)
A Girl with a Basket of Fruit
Panel, 75 x 60 cm, The Hague, Galerij
Willem V, on loan from the Instituut
Collectie Nederland (inv. no. NK 1742)

PROVENANCE
Amsterdam, with Joseph M. Morpurgo,
in 1929; Haarlem, collection of M. de Rid-
der; Amsterdam, with Emmeric; Munich,
Collecting Point, in 1945; returned to
The Netherlands

LITERATURE
Von Moltke 1965a, 238, no. 59
(illus., as probably by Jürgen Ovens);
Schlüter-Göttsche 1971, 88 (illus. no. 10);
Schlüter-Göttsche 1978, 33 (illus. no. 41);
Sumowski 1983–94, 1:140, 143n75, 181
(illus., as Jan van Noordt); 5:3112, with no.
2144; 6:3737, with no. 2403a; Sumowski
1986, 27, 36n33

EXHIBITIONS
Amsterdam 1929, no. 1302 (as Jacob
Adriaensz. Backer)

COLLECTION CATALOGUES
The Hague 1992, 227 (illus.)

The subject matter and the light mood
of this painting point to the circle of
Jacob Adriaensz. Backer. Although Van
Noordt's penchant for rounded forms and
curving lines is evident, his fluid handling
and translucent layers are not. Many pas-
sages here, such as the brim of the hat, the
dress, the near hand, and the breasts, dis-
play a dry, careful handling. This aspect
relates to the early style of Jürgen Ovens,
when he was still under the influence of his
teacher, Govert Flinck. Also, the face bears
a resemblance to that of Ovens' wife
Maria, whom he depicted often. However,
the attribution to Ovens must remain ten-
tative in the absence of a more closely
comparable painting from his hand.

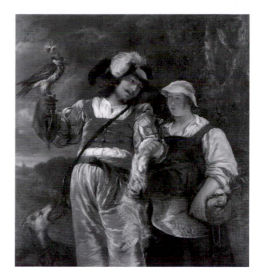

CATALOGUE R45
A Falconer and a Shepherdess, canvas, 154.5 × 143 cm,
present location unknown.

CATALOGUE R45
(p) *A Falconer and a Shepherdess*
Canvas, 154.5 x 143 cm, Chaumont,
Musée d'Art et Histoire

PROVENANCE
London, Lesser Gallery; sale, London
(Christie's), 25 February 1905, lot 76
(as A. Cuyp); sale, London (Christie's),
7 November 2001, lot 48 (illus., as Jan
van Noort); sale, Paris (Christie's),
26 June 2002, lot 14 (illus.)

The smooth handling and large figure
scale, together with the strong colour
and rhythmic lines, place this work in the
circle of Backer and Flinck. The flat treat-
ment of form points away from Van
Noordt to Abraham van den Tempel, but
the detached effect of the nervous strokes
of paint (especially in the man's costume)
suggest the hand of a follower of this artist.

CATALOGUE R46
Jürgen Ovens, *Portrait of Anna Susanna van den Bempden de Neufville*, canvas, 110 × 82 cm, Amsterdam, Six Collection.

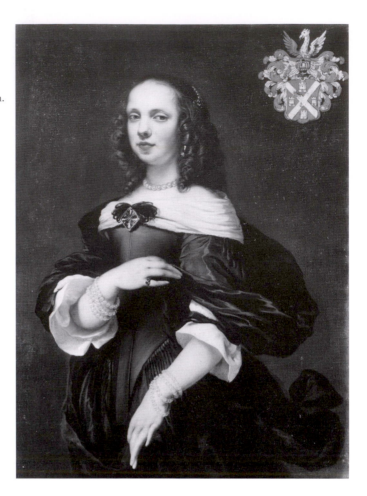

CATALOGUE R46
Jürgen Ovens, *Portrait of Anna Susanna van den Bempden de Neufville*
Canvas, 110 x 82 cm, Amsterdam, Six Collection, inv. no. ss-54

PROVENANCE
Acquired by Jan Six III (1668–1750) through his third marriage, around 1740; thence by descent

LITERATURE
Staring 1946, 79–80 (as Jan van Noordt)

The near-monochromatic colouring of flesh, highlighted with red in the cheeks, relates to the earlier portraiture of Jürgen Ovens, who adapted the style of his mentor, Govert Flinck. He also took up use of the zig-zag highlights in the drapery, a dramatic touch developed by Flinck in the 1650s. The extreme stylization of the hands, however, is uncommon for most formal portraits by Ovens, although it can occasionally be found in his history paintings. The sharp accentuation of the eyes is particularly atypical for Van Noordt, but can be seen in Ovens' *Portrait of a Woman* in a private collection.[1]

1 Jürgen Ovens, *Portrait of a Woman*, canvas, 113 x 87 cm, present location unknown; see Sumowski 1983–94, 6:3738, no. 2412, 4030 (illus.).

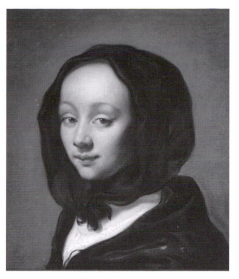

CATALOGUE R48
Jürgen Ovens, *Portrait of a Young Woman Wearing a Black Shawl*, canvas, 41 × 37 cm, Milwaukee, collection of Drs Alfred and Isabel Bader.

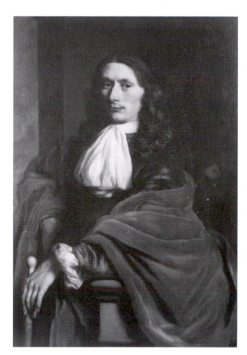

CATALOGUE R47
Portrait of Cornelis de Jonge van Oosterland?, canvas, dimensions not known, signed: *N. Maes fec.*, Lisse, Keukenhoff.

CATALOGUE R47
(p) *Portrait of Cornelis de Jonge van Oosterland?* (1645–1694)
Canvas, dimensions not known, falsely signed: *N. Maes fec.*, Lisse, Keukenhoff

LITERATURE
Staring, 1946, 77–8 (illus., as Jan van Noordt)

This portrait is unusual for showing the light coming from the right side. It may be based on a print. The flat modelling and broad, flat drapery speak against Staring's attribution to Van Noordt, which has not been taken up in subsequent scholarship.

CATALOGUE R48
Jürgen Ovens (1623–1678)
Portrait of a Young Woman Wearing a Black Shawl
Canvas, 41 x 37 cm, Milwaukee, collection of Drs Alfred and Isabel Bader

PROVENANCE
New York, Fearon Gallery, in 1925; Montreal, collection of R.W. Reford; Montreal, Elsie Stephen Reford (widow of the preceding); by descent to L. Eric Reford of Montreal, in 1984; sale, New York (Sotheby's), 19 January 1984, lot 1 (illus., as Haarlem School, seventeenth century)

LITERATURE
Sumowski 1983–94, 5:3112 no. 2145, 3292 (illus., as Jan van Noordt); 6:3737, with no. 2407

EXHIBITIONS
Kingston 1984, 60–1, no. 27 (illus., as Dutch, seventeenth century)

A number of stylistic aspects point to the later style of Jürgen Ovens. Most distinct are the wavy, linear highlights in the black dress, the neutral-black shadow

area on the right side of the face, and the dramatic catch-light in the eyes. The same traits appear in Ovens' signed *Portrait of a Family* in Schloß Gottorf, in the dress and the face of the mother to the right.[1]

1 Jürgen Ovens, *Portrait of a Family*, canvas, 152 x 191 cm, signed; see: Sumowski 1983–94, 3:2237, no. 1548, 2303 (illus.).

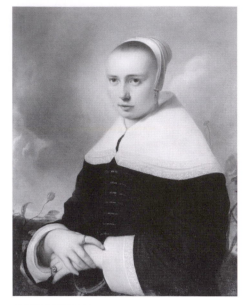

CATALOGUE R49
Portrait of a Woman, canvas, 74.4 × 57.5 cm, Paris, Collection Frits Lugt, Institut Néerlandais.

CATALOGUE R49
Portrait of a Woman
Canvas, 74.4 x 57.5 cm, Paris, Fondation Custodia (inv. no. 8835)

LITERATURE
Nystad 1981, 710–12 (illus. 710, as Van Noordt); Sumowski 1983–94, 1:143n81; Bruyn 1984, 150

COLLECTION CATALOGUES
Paris 1983, 95–7, (illus. pl. 61)

The face of the sitter in this portrait shows a dry, careful handling. The soft modelling and the overall pinkish glaze applied to flesh yield a relatively flat impression of form, quite uncharacteristic of Van Noordt.

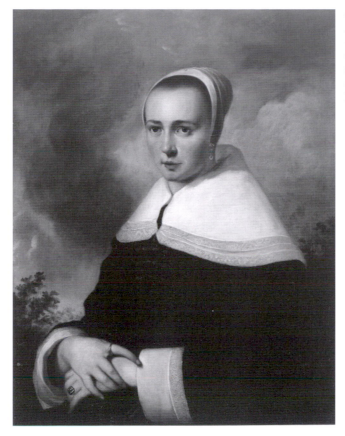

CATALOGUE R50
Portrait of a Woman
Panel, 76.9 x 84.2 cm, Chicago, Art Insti-
tute of Chicago, Lax and Leola Epstein
Collection (inv. no. 1954.284, as attributed
to Jan van Noordt, *Portrait of Annetje Jans
Grotincx*, c. 1655)

LITERATURE
Nystad 1981, 712n1 (as Van Noordt,
Portrait of Annetje Jans Grotincx, c. 1655);
Sumowski 1983–94, 1:140, 143n80, 185
(illus.); Bruyn 1984, 150 (as Jan van
Noordt)

This painting is possibly a copy of the
Portrait of a Woman with the Fonda-
tion Custodia in Paris (cat. R49). Although
the likenesses differ slightly, the paintings
do share details such as the highlights in

the clouds to the left. The careful handling
and flat treatment of form here have little
in common with Van Noordt's work.
This painting has also been attributed to
Jacobus Leveck,[1] whose style of the late
1650s it approaches.

1 Note with the photograph at the RKD.

CATALOGUE R 51
(p) *Portrait of a Lady Holding Roses*
Canvas, 114 x 90 cm, falsely signed at the
lower left: *F. Bol*, Hartford, Wadsworth
Atheneum (inv. no. 1912.1)

PROVENANCE
Sale, Amsterdam (Mak van Waay), 10–12
February 1942, lot 4 (illus., as Ferdinand
Bol); The Hague, Vermeulen (dealer),
1943–45

COLLECTION CATALOGUES
Hartford 1978, 76 (illus. pl. 89), 168, no.
R219

The sitter's hairstyle indicates a date toward the end of the seventeenth century. The flat modelling and the restraint in the drapery and pose do not relate to Van Noordt's oeuvre of portraits.

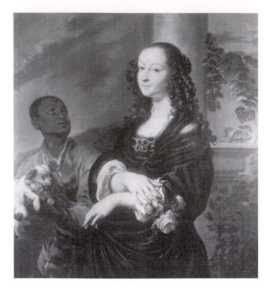

CATALOGUE R52
A Lady Attended by a Moor with a Dog,
canvas, 112 × 98 cm, present location unknown.

CATALOGUE R52
(p) *A Lady Attended by a Moor with a Dog*
Canvas, 112 x 98 cm, present location
unknown

PROVENANCE
Sale, Amsterdam, 31 March 1914, lot 23
(as G. Flinck); sale, The Hague (P.H.
Holman), 6 June 1916, lot 134 (illus., as
Jan van Noordt); Berlin, with C. Benedict,
c. 1928

LITERATURE
Cicerone, 2 September 1931, cover illustration; Staring 1946, 79 (as Jan van Noordt);
Von Moltke 1965a, 255, no. 147 (as not by
Flinck)

COPIES
Canvas, 27 x 22.2 cm, Harriet Gray Blackwell et al. sale (Walters Art Gallery section), New York (Christie's), 26 March
1987, lot 66 (illus., as School of Jan van
Noordt)

The simplified handling of facial features and the flat modelling speak against attributing this weak picture to Van Noordt.

260

(p) Jürgen Ovens (1623–1678)
Portrait of a Woman Holding an Orange
Canvas, 81.5 x 64.5 cm, Budapest,
Szépmüvészeti Múseum (inv. no. 1645)

COLLECTION CATALOGUES
Budapest 1968, 767–8, Budapest 2000,
125 (illus.)

EXHIBITIONS
Milan 1995, 112–13, no. 39 (illus., as
Jan van Noordt)

This work is an interpretive copy of
a painting by Govert Flinck that
appeared at a New York sale.[1] The artist
is quite likely his pupil Jürgen Ovens.

1 Govert Flinck, *Portrait of a Young Woman
Holding an Orange*, canvas, 74.6 x 60.3 cm; sale,
New York (Sotheby's), 14 January 1994, lot 24
(illus.).

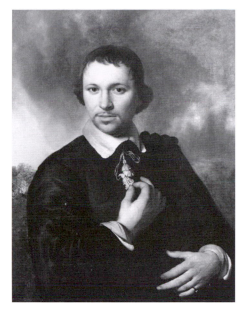

CATALOGUE R54
Gerbrand van den Eeckhout, *Portrait of a Man*,
canvas, 74.6 × 57.5 cm, signed and dated: *G.V
Eeckhout 1653*, Amsterdam, Amsterdams
Historisch Museum.

CATALOGUE R54
Gerbrand van den Eeckhout (1621–1674)
Portrait of a Man
Canvas, 74.6 x 57.5 cm, signed and dated:
G.V Eeckhout 1653, Amsterdam, Amster-
dams Historisch Museum (inv. no. A
40424, as Gerbrand van den Eeckhout)

PROVENANCE
Private collection, Amsterdam; acquired by
the Museum in 1988

LITERATURE
Haak 1969, 183 (illus. no. 295, as Ger-
brand van den Eeckhout, signed and dated
1656); Nystad 1981, 710 (illus. no. 2,
as signed and dated 1653); Sumowski
1983–94, 1:140, 143n82, 187 (illus., as Jan
van Noordt); 6:3899 (as not Van Noordt,
but G. van den Eeckhout); Bruyn 1984,
150 (as Gerbrand van den Eeckhout)

The traditional attribution to Gerbrand
van den Eeckhout, supported by a
signature, is convincing.

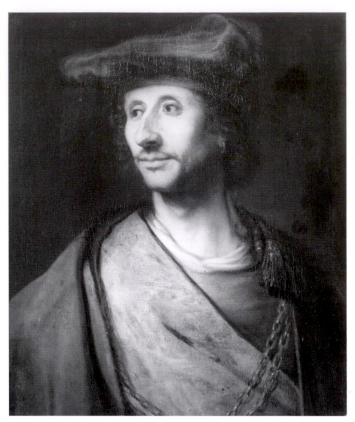

CATALOGUE R55
*Portrait of a Man Wearing a Beret
and a Chain*
Canvas, 61.5 x 51.5 cm, Schwerin,
Staatliches Museum (inv. no. 3089)

LITERATURE
Cornelius Hofstede de Groot, "Kritisch
Bemerkungen zu einigen Niederländern in
der Schweriner Galerie," *Repertorium für
Kunstwissenschaft* 17, 1894, 180, no. 92 (as
an early work by Bol); Sumowski 1983–94,
1:140, 143n86, 190 (illus., as Jan van
Noordt); 6:3589

SELECTED COLLECTION
CATALOGUES
Schwerin 1882, 59–60, no. 93 (as Ferdi-
nand Bol); Schwerin 1891, 12 (as Ferdi-
nand Bol, c. 1647); Schwerin 1951, 59
(as Ferdinand Bol or Carel Fabritius)

COPIES:
Canvas, 61 x 50 cm, private collection

The broad, heavy treatment of the
drapery does not relate to Van
Noordt's approach. This work can be
placed in the circle of Ferdinand Bol on
account of the flat areas of pale, sharp flesh
tones in the face. Although it is attributed
to Bol at the museum, it is likely by a
follower of this artist.

CATALOGUE R56
(p) *Portrait of a Young Man in a Beret*
Canvas, 76 x 73 cm, falsely signed bottom left: *Bol*, Mostyn Hall, collection of Lord Mostyn

LITERATURE
Sumowski 1983–94, 1:140, 143n85, 189 (illus., as Jan van Noordt); 5:3113, with no. 2146; 6:3589; Von Moltke 1994, 190

EXHIBITIONS
London 1952, 54, no. 262 (as Ferdinand Bol)

COPIES:
1. (Without the Beret) canvas, 70 x 61.5 cm, Switzerland, private collection; see Von Moltke 1994, 190, no. R92 (as not by Bol)
2. (Without the Beret) canvas, 76 x 67 cm, The Hague, Instituut Collectie Nederland, see collection catalogue The Hague 1992, 47, no. NK 2542 (illus., as manner of Ferdinand Bol)[1]

The traditional attribution of this painting to Ferdinand Bol rests largely on Bol's known penchant for *tronies* of male character heads sporting berets. The beret was already in the seventeenth century an archaic item of dress, but as such it enjoyed a special status among artists, as it still does today.[2] Bol took it over as an attribute from Rembrandt and included it in a number of paintings, including his self-portrait. Nonetheless, it may be a later addition to this work, since both known copies do not include it. The present work relates to among Bol's tronies, although it is not by his hand.

1 My thanks to J. Douglas Stewart for directing my attention to this second copy.
2 See Marieke de Winkel, "The Interpretation of Dress in Vermeer's Paintings," in *Vermeer Studies*, Studies in the History of Art 55, 1998, 332.

CATALOGUE R57
(p) *Portrait of a Young Man in a Beret*
Canvas, 82 x 65.5 cm, St Petersburg, Hermitage

PROVENANCE
Acquired by Empress Catherine II (reigned from 1762–1796); entered the Hermitage gallery in 1797

LITERATURE
Van Dyke 1923, 55 (illus. pl. 8, as Bol); Van Hall 1963, 30, no. 5 (as Bol, *Self-Portrait*); Linnik 1980, 127 (illus. no. 165, as Samuel van Hoogstraten?, *Portrait of Carel Fabritius*); Blankert 1982, 174, no. R110, (illus. fig. 113, as not by Bol, but reminiscent of Gerbrand van den Eeckhout and Jan Baptist Weenix); Sumowski 1983–94, 5:3113, no. 2146, 3292 (illus., as Jan van Noordt)

ELECTED COLLECTION CATALOGUES
St Petersburg 1828, 138 (as Bol: "Quelques portraits"); St Petersburg 1863, 188, no. 850; St Petersburg 1895, 24, no. 85; St Petersburg 1958, 2:140 (illus. no. 133, as Ferdinand Bol), 142, no. 761

This picture is an adaptation of Carel Fabritius's *Self-Portrait* in Rotterdam.[1] The artist, who unfortunately cannot be identified, has dressed the figure in a much richer costume, producing a *tronie*. The broad handling of forms gives a flattening effect in some areas, which differs from the rounded modelling applied by Van Noordt.

1 Carel Fabritius, *Self-Portrait*, panel, 65 x 49 cm, signed, Rotterdam, Museum Boijmans Van Beuningen (inv. no. 1205); see Sumowski 1983–94, 2:985, no. 603, 990 (illus.).

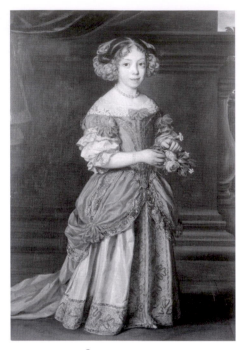

CATALOGUE R58
Portrait of a Young Girl Holding Flowers, canvas, 131.9 × 88.9 cm, present location unknown.

CATALOGUE R58
(p) *Portrait of a Young Girl Holding Flowers*
Canvas, 131.9 x 88.9 cm, present location unknown

PROVENANCE
Sale, London (Christie's), 9 July 1976, lot 49 (illus. pl. 16, as Jan van Noordt)

This delicate portrait shows a smooth, flat modelling of the face and a hard, crisp handling of details such as the eyes, aspects that do not surface in Van Noordt's portraiture.

CATALOGUE R59
(p) Nicolaes Maes (1634–1693)
Portrait of a Girl at a Fountain
Canvas, 87.5 x 70 cm, around 1662, present location unknown

PROVENANCE
Amsterdam, art trade, in 1924;[1] sale, Bern (Galerie Dobiaschofsky), 23 October 1971, lot 341 (with cover illustration in colour, as Nicolaes Maes)

LITERATURE
Valentiner 1924, 59 (illus., as Nicolaes Maes); Decoen 1931, 10 (illus. fig. 3, as Jan van Noordt)

The modelling in strong light yields a flattening and simplification of features that are uncharacteristic of Van Noordt. The composition and format closely approximate a portrait by Nicolaes Maes of 1662, supplying a strong indication of attribution and date.[2]

1 Note with the photograph at the RKD.
2 *Girl with a Shell at a Fountain*, canvas, 90.5 x 72 cm, signed and dated 1662, stolen from a Los Angeles private collection in 1992; see Krempel 2000, 293, no. A56 (illus. fig. 97, as Maes).

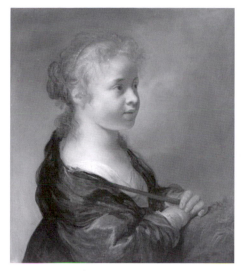

CATALOGUE R60
(p) Govert Flink, *A Young Shepherdess*
Panel, 57 x 50.5 cm, The Netherlands,
private collection

PROVENANCE
Freiherr von Ketteler from Schloß
Schwarzenraben sale, Amsterdam (Sothe-
by's), 21 November 1995, lot 29 (illus., as
Jan van Noordt, *A Portrait of a Girl as a
Shepherdess*); London, Johnny van Haeften
Gallery, in 1995

The facial type with rounded features
and the broad modelling with dry
paint are more reminiscent of Govert
Flinck in the late 1640s than Van Noordt
during any period in his career.

The artist possibly did not paint a sit-
ter's portrait here, but instead conjured a
general figure of a shepherdess.

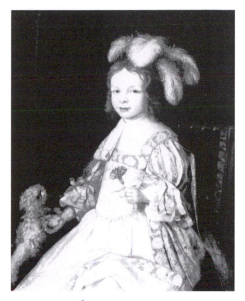

CATALOGUE R61
(p) *Portrait of a Seated Girl with a Carnation
and a Poodle*
Canvas, 77.5 x 61 cm, present location
unknown

PROVENANCE
Dillington House, Illminster, Somerset-
shire, collection of R.H.Y. Vaugh-Lee;
Boston, Vose Gallery, in 1954; Boston,
collection of Caroline G. Doty; sale, New
York (Christie's), 11 January 1989, lot 157
(illus., as attributed to Jan van Noordt)

LITERATURE
Sumowski 1983–94, 6:3529n19 section 12

Sumowski rightly characterized this pic-
ture as "In every respect, exquisite, but
certainly not by Jan van Noordt."[1]

1 See Literature.

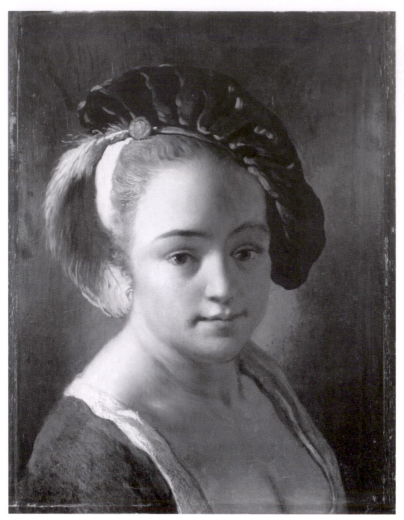

CATALOGUE R62
(p) *Portrait of a Girl with a Feathered Beret*
Panel, 45.7 x 34.8 cm, present location unknown

PROVENANCE
Sale, London (Christie's), 13 July 1928 (as Pieter de Grebber, for 38 gns, to Skilliter); Fa. van Braam sale, Amsterdam, 1 July 1943, lot 9 (illus., as Govert Flinck); The Hague, Van Marle & Bignell Gallery, in 1944; sale, Turin (Caretto), 3–10 December 1995, lot 32 (illus.); sale, Amsterdam (Christie's), 18 November 1993, lot 128 (illus., as Jan van Noordt); sale, Vienna (Dorotheum), 15 October 1996, lot 136 (illus.)

LITERATURE
Exhibition catalogue, The Hague, A.J. Boer Gallery, 1951 (as Jan de Bray); Von Moltke 1965a, 249, no. 112 (illus., as perhaps by Jan van Noordt); Sumowski 1983–94, 6:3526, 3535n89, 3577 (illus., as Jan van Noordt)

The fabric is too stiffly and dryly painted, and the shadow area of the head too flatly modelled, for this painting to be considered a Van Noordt. It is possible that the artist created a general type here, instead of painting the portrait of a sitter.

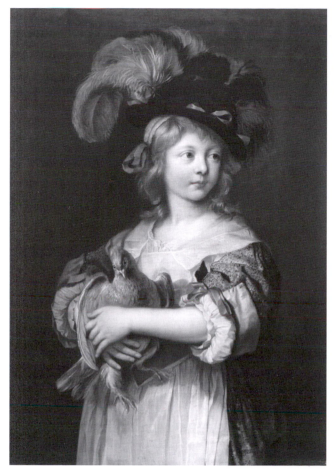

CATALOGUE R63
Portrait of a Girl with a Bird,
canvas, 82 × 61 cm, present
location unknown.

CATALOGUE R63
(p) *Portrait of a Girl with a Bird*
Canvas, 82 x 61 cm, present location
unknown

PROVENANCE
Dr James Hasson et al. sale (anonymous
section), London (Christie's), 15 December
1961, lot 16 (as Van Noordt, *Portrait of a
Girl*, 332 x 252 in. [85 x 64.8 cm]: "..., in a
white and grey dress and feathered hat,
holding a Rooster"); London, collection of
M.W.T. Leatham Esq.; sale, London
(Christie's), 30 March 1979, lot 3 (illus.)

LITERATURE
H.G. van Gelder, review of exhibition
London 1952, in *Burlington Magazine*,
95, 1953, 34 (as not by Jan van Noordt);
Robert Melville, review of exhibition

Liverpool 1956, in *Architectural Review*
120, November 1956, 332–4 (illus., as
Jan van Noordt)

EXHIBITIONS
Amsterdam 1952, 57, no. 118; London
1952, no. 641; Liverpool 1956, 15, no. 31

COPIES
Canvas, 89 x 71 cm; sale, Munich (Wein-
müller), 19–20 June 1974, lot 839 (illus.,
as attributed to Jan van Noordt)

The crisp, detailed treatment of fabric
and of the bird contrasts with Van
Noordt's more fluid handling, and the face
does not show his typical emphasis on
rounded forms.

CATALOGUE R64

(p) *Portrait of a Girl with Fruits before her, and an Angel at her Side*

Canvas, 120.5 x 86.5 cm

PROVENCANCE

Sale, New York (Sotheby's), 13 March 1985, lot 103 (illus., as attributed to Jan van Noordt and Frans van Everbroek)

The entry for this painting in the sale catalogue of 1985 attributed it to two painters, Jan van Noordt and Frans van Everbroek. Presumably the figures were thought to have been painted by Van Noordt. However, the soft modelling, in broad light from head on, is more strongly reminiscent of Haarlem painters such as Pieter de Grebber.

CATALOGUE R65

(p) Nicolaes Maes (1634–1693)

Portrait of a Girl with a Dog

Canvas, 91.2 x 72.9 cm, signed and dated lower right: MAES 1664, inscribed "Æt 4^m 6^v", present location unknown

PROVENANCE

Collection of H. Linde; New York, Leon Hirsch collection (as Nicolas Maes); his sale, New York, 29 January 1914 (Lugt 73715), lot 48 (illus.); New York, with Ehrich Galleries; C. Bayart sale, Brussels (J. & F. Fievez), 10 December 1928, lot 39 (illus. pl. 17); sale, Amsterdam (Christie's), 9 May 2001, lot 133 (illus., as Nicolaes Maes)

LITERATURE

Hofstede de Groot 1907–28, 6:595, no. 548 (as Nicolaes Maes); Valentiner 1924, 58 (illus.); Decoen 1931, 16 (illus. fig. 2 as Jan van Noordt); Krempel 2000, 295, no. A65 (illus. fig. 155, as Nicolaes Maes)

The pale, broad visage as well as the drapery show a crisp, hard treatment of form that is unlike Van Noordt's supple, fleshy approach, and points to the late work of Nicolaes Maes. There is no reason to doubt the signature and date.

CATALOGUE R66
(p) Adriaen Hanneman (around
1604–1671)
Portrait of a Boy
Canvas, 118 x 94 cm, Antwerp, Koninklijk
Museum voor Schone Kunsten (inv. no.
854, as Adriaen Hanneman)

PROVENANCE
Paris, collection of the Marquess Maison,
in 1907

LITERATURE
Decoen 1931, 16 (illus. fig. 5, as Jan van
Noordt)

COLLECTION CATALOGUES
Antwerp 1988, 178, no. 854 (illus.,
as Hanneman)

The soft light yields a flat effect of
modelling, in contrast to the rounded
modelling favoured by Van Noordt. The
costume of the boy also does not reflect
Van Noordt's penchant for curving lines
of drapery folds. There is no reason to
dispute the traditional attribution to
Hanneman.

CATALOGUE R67
Portrait of a Boy with a Pony, support and dimen-
sions unknown, present location unknown.

CATALOGUE R67
(p) *Portrait of a Boy with a Pony*
Support and dimensions unknown, present
location unknown

PROVENANCE
Munich (Galerie Helbig), in 1911 (as a
Dutch master of the seventeenth century)

LITERATURE
Decoen 1931, 17 (illus. fig. 10, as Jan van
Noordt)

This painting shows inconsistencies in
the effect of light and the modelling
of forms, especially in the costume and the
horse. The hands are very indistinct forms.
These weaknesses, and the stiff presenta-
tion, do not relate to Van Noordt's work.

CATALOGUE R68
(p) *Portrait of a Young Man*
Panel, 148.5 x 116.3 cm, inscribed on a
coat of arms to the right: AET.9 A°1654,
Krakow, Wawel Museum (inv. no. 1, as
Jan van Noordt)

PROVENANCE
Collection of the Count Leon Pimiriski;
acquired by the Museum in 1935

LITERATURE
Jerzy Szablowski, *Die Sammlungen des
Königsschlosses auf dem Wawel*, Herrsching
Henschel Verlag: 1975, 92 (illus., as Jan
van Noordt); Sumowski 1983–94, 6:3737,
with no. 2405 (as not by Van Noordt)

COLLECTION CATALOGUES
Krakow 1935, no. 28; Krakow 1994, 20

The abstracted features and the black-
ish background give the impression
that this picture was painted by a southern
European artist.

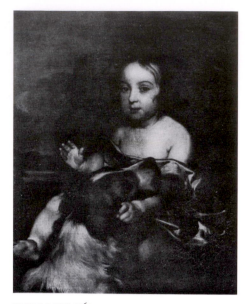

CATALOGUE R69
Portrait of a Seated Boy with His Dog, canvas,
75.5 × 62.5 cm, present location unknown.

CATALOGUE R69
(p) *Portrait of a Seated Boy with His Dog*
Canvas, 75.5 x 62.5 cm, present location
unknown

PROVENANCE
Sale, Brussels (Giroux), 12 March 1927,
lot 75 (illus. pl. 54); sale, Brussels, 17
December 1928, lot 64 (as Jan van Noordt,
L'enfant au chien, canvas, 75 x 63 cm)

LITERATURE
Decoen 1931, 17 (illus. fig. 7, as Jan van
Noordt)

The soft modelling of this evocative
portrait more closely follows Van
Dyck's light touch than Van Noordt's
more forceful modelling.

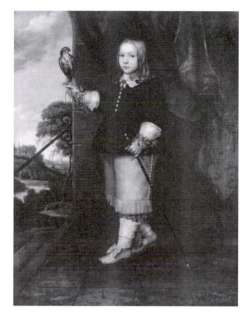

CATALOGUE R70
Portrait of a Boy with a Falcon, canvas,
150 × 112 cm, Mexico City, collection of
C.H.E. Phillips.

CATALOGUE R70
(p) *Portrait of a Boy with a Falcon*
Canvas, 150 x 112 cm, Mexico City,
collection of C.H.E. Phillips

EXHIBITIONS
Mexico City 1964, 16, no. 73 (illus., as
Jan van Noordt)

The broad, flat forms of drapery and
the even, soft modelling of the head
do not reflect Van Noordt's preference for
movement and a strong modelling of form
in light.

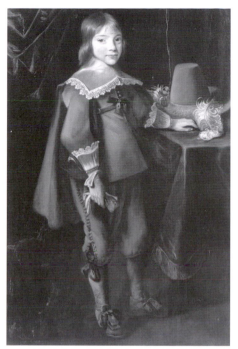

CATALOGUE R71
Portrait of a Six-Year-Old Boy, panel,
109.2 × 72.2 cm, dated 1641, present
location unknown.

CATALOGUE R71
(p) *Portrait of a Six-Year-Old Boy*
Panel, 109.2 x 72.2 cm, inscribed: *Aetatis 6
A⁰ 1641*, present location unknown

PROVENANCE
R.M. Broadhead et al. sale (anonymous
section), London (Christie's), 18 July 1980,
lot 113 (illus., as Jan van Noordt)

The angular, flat forms of drapery in
this weak portrait speak against the
attribution to Van Noordt.

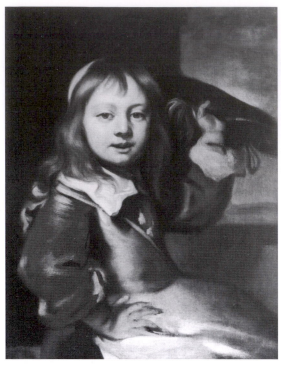

CATALOGUE R72
(p) *Portrait of a Boy Raising his Hat*
Canvas, 71 x 60 cm, present location
unknown

PROVENANCE
London, Leger Gallery, in 1945; Halma
Wellin, Luxembourg, collection of Max F.
Masson, in 1952 (as Barent Fabritius);
Munich, with Galerie Arnoldi-Livie, in
1994 (as Jan van Noordt)

LITERATURE
Advertisement in the *Burlington Magazine*
86, 1945, April, 3 (as B. Fabritius, dated
1665); Sumowski 1983–94, 6:3737, no.
2407, 4025 (illus., as Jan van Noordt,
panel, 66 x 47.5 cm)

EXHIBITIONS
Munich 1995, no. 6 (illus.); Munich 1995,
6–7, no. 2 (illus.)

This picture was not taken up by Daniel
Pont in his monograph on Barent
Fabritius. Aspects that speak against Gud-
laugsson's attribution to Van Noordt in-
clude the flat modelling of the face and the
broad handling of fabric, with the impasto
highlights at the shoulder that show traces
of the brush.[1]

1 The attribution to Jan van Noordt by Sturla
 Gudlaugsson is recorded in a note with the
 photograph of the painting at the RKD.

CATALOGUE R73
(p) Karel van Savoy (1619–1665)
Portrait of a Boy Holding a Feathered Cap
Canvas, 65 x 52 cm, Petworth, Sussex
(National Trust)

LITERATURE
Sumowski 1983–94, 4:2538 no. 1697a,
2547 (illus., as by Karel van Savoy)

COLLECTION CATALOGUES
Petworth 1920, 102, no. 119 (as School
of Rembrandt)

The attribution of this attractive por-
trait to Jan van Noordt was originally
made by Sturla Gudlaugsson.[1] The face
and the drapery show a smooth, soft mod-
elling, at odds with the strong light effects
favoured by Van Noordt. Sumowski's attri-
bution to Karel van Savoy is not entirely
convincing.

1 Note with the photograph of the painting at
the RKD.

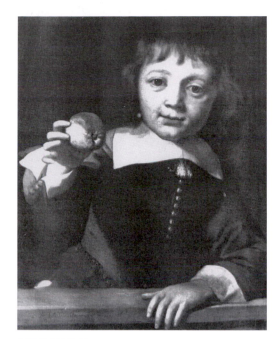

CATALOGUE R74
Portrait of a Six-Year-Old Boy with an Apple,
canvas, 53.5 × 42.5 cm, dated 1656, present
location unknown.

CATALOGUE R74
(p) *Portrait of a Six-Year-Old Boy with
an Apple*
Canvas, 53.5 x 42.5 cm, inscribed: *AETAT:
6 1656*, present location unknown

PROVENANCE
Amsterdam, with Gebroeder Douwes,
in 1976 (as Jan van Noordt)

The flat treatment of drapery does not
accord with Van Noordt's typically
lively handling of such materials. The
modelling of the face, though soft, presents
flat surfaces and angles, in contrast to Van
Noordt's emphasis on rounded volumes.

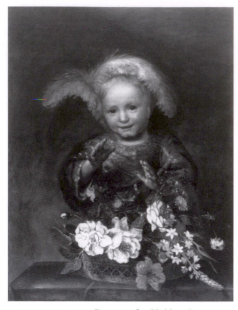

CATALOGUE R75. *Portrait of a Child with a Basket of Flowers*, canvas, 71.8 × 56.5 cm, present location unknown.

CATALOGUE R75
(p) *Portrait of a Child with a Basket of Flowers*
Canvas, 71.8 x 56.5 cm, present location unknown

PROVENANCE
Shrewsbury, England, collection of Colonel Dugdale; New York, with David M. Koetser Gallery, in 1952; New York, with Hirsch & Adler Gallery, until 1957; Columbus, Georgia, Columbus Museum; sale, New York (Sotheby's), 22 May 1997, lot 106 (illus., as attributed to Jan van Noordt); Amsterdam, with Gebroeder Douwes Fine Art, in 1998 (as Jan van Noordt)

LITERATURE
Van Fossen 1969, 270, no. 75 (illus. fig. 78, as Arent de Gelder); Von Moltke 1994, 194, no. R110 (illus. fig. 115, as not by De Gelder)

The dry handling with its visible hatching differs from the style of Van Noordt, but also from that of De Gelder. The flowers are likely by a second artist.

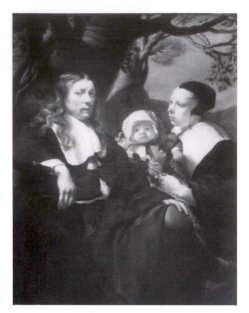

CATALOGUE R76
Portrait of a Family, canvas, 137 × 107 cm, Brussels, Museum van Oude Kunst.

CATALOGUE R76
Portrait of a Family
Canvas, 137 x 107 cm, Brussels, Museum van Oude Kunst (inv. no. 4056)

PROVENANCE
B. de Harde Swart et al. sale, Amsterdam, 16 November 1847, lot 88 (as N. Maas, to Thyssen); Paris, Kleinburger Gallery; acquired by the Museum in 1913

LITERATURE
Hofstede de Groot 1907–28, 6:602, no. 550 (as Maes); Van Dyke 1914, 35, no. 803; Decoen 1931, 16 (as Jan van Noordt); Schneider 1931, 511; Bénézit 1976, 7;750; Sumowski 1983–94, 1:141, 143n87, 191 (illus.); 6:3589; Bruyn 1984, 160n17 (as by an Italianate Landscapist, perhaps Karel Dujardin)

SELECTED COLLECTION CATALOGUES
Brussels 1957, 63, no. 803 (as Nicolas Maes); Brussels 1984, 182, no. 803 (illus., as Nicolaes Maes)

EXHIBITIONS
Brussels 1962–63, no. 121

Strong reflections create a glowing effect of light that, combined with the sharp edges of forms, evokes the figure style of the Italianate landscape painter Karel Dujardin (1622–1678), who also painted a number of portraits and history paintings.[1] However, the abstracted forms and weak background details in turn speak against an attribution to this artist.

1 Bruyn has tentatively suggested Dujardin as the author. See Literature.

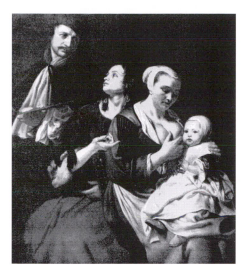

CATALOGUE R77
Portrait of an Artist with his Family, canvas, 121 × 110.5 cm, Gdansk, Museum Pomorskie.

CATALOGUE R77
(p) *Portrait of the Artist with His Family*
Canvas, 121 x 110.5 cm, Gdansk, National Museum in Gdansk (inv. no. ML 443)

PROVENANCE
Collection of H.M. Clark, in 1921; London, Colnaghi Gallery, in 1939; Goudstikker et al. sale, Berlin (Lange), 12 March 1941, lot 71 (illus. pl. 59, as Jan van Noordt)

COLLECTION CATALOGUES
Gdansk 1969, no. 56 (illus.)

EXHIBITIONS
Dieren 1939, no. 65 (illus. pl. 59); Warsaw 1950, 19, no. 172, (illus., as Jan van Noordt)

To judge by the known documents, Jan van Noordt did not marry nor have any children. Therefore it is highly unlikely that this portrait, evidently a self-portrait of an artist with his family, is by him. Furthermore, the simple compositional organization along a diagonal, and the awkward pose of the woman to the left, do not accord with Van Noordt's approach to group portraiture.

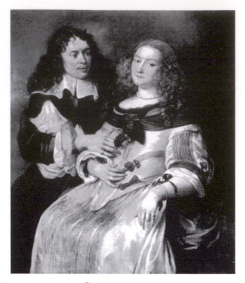

CATALOGUE R78
Marriage Portrait, canvas, 122 × 104 cm, mono-grammed: *JN*, present location unknown.

CATALOGUE R78
(p) *Marriage Portrait*
Canvas, 122 x 104 cm, monogrammed:
JN, present location unknown

PROVENANCE
Berlin, Dr F. Rothman Gallery, in
1925–26; Bézine et al. sale, Brussels, 14
June 1927, lot 213 (with reversed illustra-
tion); sale, Berlin (Lepke), 30 April 1929,
lot 68 (illus., pl. 28); New York, private
collection; sale, London (Parke-Bernet),
29 March 1965, lot 30 (illus.); William C.
Cornell et al. sale (anonymous section),
New York (Sotheby Parke-Bernet), 6 De-
cember 1973, lot 108 (as Jan van Noordt,
122 x 104 cm); sale, Nuremburg (Klinger),
8 March 1975, no. 813 (illus.)

LITERATURE
Pantheon III, 1929, 235 (illus., as signed:
Ioan van Noort), 22; Schneider 1931, 511

In contrast to Van Noordt's emphasis on
rolling drapery folds and emphatic mod-
elling, the costumes and faces here show
flat surfaces and an emphasis on texture.
The report of a signature is likely
spurious.[1] The work is monogrammed,
counter to Van Noordt's known practice.

1 See Literature.

CATALOGUE R79
Still Life with Candlestick
Canvas, 82 x 90 cm, Paris, Louvre, (inv. no.
M.I. 937, as attributed to Nicolas Maes)

PROVENANCE
Paris, collection of Louis La Caze;
bequeathed to the Louvre in 1869

LITERATURE
F. Reiset, *Notice des tableaux légués au Musée
impérial du Louvre par M. Louis La Caze*,
Paris, 1871, 25, no. 76 (as Willem Kalf, 83
x 102 cm); Sumowski 1983–94, 1:654, no.
352 (as Heymen Dullaert), 664 (illus.);
5:3112, with no. 2143 (as Jan van Noordt);
6:3505

COLLECTION CATALOGUES
Paris 1922, 100, no. 2437 (as J. van Streek);
Paris 1979, 84 (illus., as attributed to N.
Maes)

This painting lacks the colour and use
of reflections that are present even in
early Van Noordt paintings. The flat, pow-
erful impasto treatment gives a hard effect,
especially in the white cloth draped over
the front of the table, contrasting with the
free and fluid handling of Van Noordt.
The fabric and the transmitted image of
the lemon through the glass are both mas-
terfully handled in softly applied layers of
paint, but these passages are entirely too
regular and methodical to be by Van
Noordt. Sumowski bases his attribution
largely on the candlestick, which also ap-
pears in the Brussels *Vanitas* (cat. R35), a
painting rejected on the basis of its stiff
and minute style and shrill colour.

Paintings Known Only from Literary Sources

CATALOGUE L1
The Sacrifice of Isaac
Canvas, 132 x 106.5 cm
Reference: J.B. Alston-Roberts-West
et al. sale (anonymous section), London
(Christie's), 8 May 1931, lot 83 (as J. van
Noordt, canvas, 52 x 42 in., for £4.4,
to Turner)

CATALOGUE L2
Judah and Thamar
Reference: Sale, Rotterdam, 6 June 1810
(Lugt 7802), lot 84 (as Jan van Oort, *Juda
en Thamar*, canvas, *"ongemeen krachtig en
stout geschildert"* [Unusually powerfully
and solidly painted], for *f*8.-10.-)

CATALOGUE L3
Samson and Delilah
Canvas, 114 x 161 cm
Reference: Mrs G.F. Blackwell et al. sale
(anonymous section), London (Sotheby's),
10 January 1973, lot 102 (as Van Noort,
*Samson Apprehended by the Philistines,
Delilah Sitting to the Left*)

CATALOGUE L4
Susanna and the Elders
Reference: Inventory of Michiel van
Coxie (1649–1688), G.A.A., N.A.A. 4495b,
Notary Jacob Matham (*Minuutacten*), 1018,
dd 14 April 1681: *"de Susanna van Jan van
Oort"* (the Susanna by Jan van Noordt)

Unfortunately there is no further evidence
to connect this work to any one of the
three known depictions by Jan van Noordt
(cat. 6–8).

CATALOGUE L5
The Nativity
Reference: Inventory of the artist and dyer
Jan van de Cappelle, G.A.A., N.A.A. 2262,
Notary Adriaen Lock, *Minuutacten van
Inventarissen*, dd 4 January 1680, 1190,
no. 97: *"een Kersnacht van Jan van Noort
(A Christmas Eve by Jan van Noort)"*

LITERATURE
Bredius 1892, 34; Hofstede de Groot 1892,
215, no. 2

This painting is possibly the recently redis-
covered *Adoration of the Shepherds* (cat. 9).

CATALOGUE L6
The Holy Family
Canvas, 114 x 82.9 cm
Reference: Herman ten Kate sale, Amsterdam, 10 June 1801 (Lugt 8262), lot 127 (as J. van Noort, canvas, 44 x 32 *duim*; "*Deeze Ordonantie stelt voor een Heilige Familie; men ziet Maria met het Kindje, nevens haar Joseph: alles meesterlyk en fyn van penceels behandeling* [This composition presents the Holy Family, one sees Mary with the little Child, beside her Joseph; everything masterly and fine in the handling of the brush]," for *f*11.– to Reyers)

CATALOGUE L7
Joseph and Mary
Reference: Inventory of Melchior d'Hondecoeter (1636–1695), G.A.A., N.A.A. 6257 "d", Notary Cornelis Costerus (pagination illegible due to fire damage), dd 14 April 1695: "*Joseph en Maria van van Oort* (Joseph and Mary by Van Noordt)"

LITERATURE
Bredius, 1915–22, 1212.

CATALOGUE L8
St John
Reference: Inventory of Jan Wolters, G.A.A., N.A.A. 2853, Notary Dirck Dankerts, 335, *dd* 4 April 1670: "*een dito (schilderij) van St. Jan, van Jan van Noordt* (a ditto [painting] of St John, by Jan van Noordt) F.10.–.–"

This could be the painting now in a private collection in The Hague (cat. 10).

CATALOGUE L9
Jesus and the Samaritan Woman at the Well
Panel, 52.1 x 38.7 cm
Reference: Mrs C.M. Crichton-Maitland et al. sale (anonymous section), London (Sotheby's), 23 February 1966, lot 124 (as Van Noordt, *Christ and the Woman of Samaria at the Well in the Foreground of a Landscape*, panel, 20½ x 15¼ in., for £160, to Mrs Johann)

CATALOGUE L10
The Crucifixion
Reference: Inventory of Jacobus van Noordt, G.A.A. 5072 (D.B.T.) no. 376, fol. 247v, *dd* 19–20 November 1671: "*een kruisiging Christij van Van Noort* (A Crucifixion by Van Noordt)"

LITERATURE
Hofstede de Groot 1892, 215, no. 5; Giskes 1989, 92, 119n36

This may be the painting in the museum in Avignon (cat. 13).

CATALOGUE L10
The Crucifixion
Panel, 75.6 x 106.5 cm
Reference: sale, London (Christie's), 11 May 1979, lot 38 (as Van Noordt, for £600)

CATALOGUE L11
The Resurrection
Reference: Jan Steen sale, Alkmaar, 12 August 1750 (Lugt 733), lot 6 (as: Jan van Noort, *Een verbeelt de verrysing Christi* [One represents the resurrection of Christ])

CATALOGUE L12
Noli me Tangere
Panel, 59.7 x 44.5 cm
Reference: Christopher Lorimer et al. sale (anonymous section), London, (Sotheby's), 4 May 1966, lot 138 (as Van Noort, *Noli me Tangere*, panel, 23½ x 17½ in.: "...with Christ in the right foreground, a town before mountains in the distance.")

CATALOGUE L13
Mary Magdalene
Reference: sale, Amsterdam, 4 May 1706
(Lugt 199), lot 2 (as: J. van Noort, *Maria
Magdalena,* for *f*11.–, to W. Reyers)

LITERATURE
Hoet 1752, 1:78; Hofstede de Groot 1892,
215, no. 9

CATALOGUE L14
Diana and Actaeon
Oil on copper, 75 x 105 cm
Reference: sale, Paris (Martin Laporte),
27 April 1801 (Lugt 6246), lot 50 (as Van
Oort, oil on copper, 30 x 42 *pouces*: "*Paysage
richement composé, ou l'on voit Diane et ses
Nymphes qui s'amusent à danser. A la gauche,
est un jeune homme qui paroit changé en arbre.
Près delà sont des troupeaux, ensuite des chiens
et les attributs de la déesse. Dans le fond, sont
encore des nymphes, dont une lance des flèches*
[Richly composed landscape, in which
Diana and her nymphs amuse themselves
with dancing. To the left is a young man
who seems to be changing into a tree.
Close by are animals, and dogs, and the
attributes of the goddess. In the back-
ground are more nymphs, one of whom
shoots arrows].")

CATALOGUE L15
Diana and Actaeon
Canvas, 155 x 189 cm
Reference: sale, London (Sotheby's), 31
January 1968, lot 49 (as J. van Noordt, *A
Hunting Party with a Young Man as Actaeon*)

CATALOGUE L16
Nymphs Sacrificing before a Statue of Pan
Canvas, 129.5 x 102.8 cm
Reference: Sir Dennis Stucley et al. sale
(anonymous section), London (Sotheby's),
9 October 1968, lot 119 (as Van Noort,
canvas, 51 x 40½ in.)

CATALOGUE L17
Cupid
Canvas, 91.4 x 71.1 cm
Reference: John List Crawford et al. sale,
New York (Parke-Bernet) 20/21 February
1946, lot 174 (as: J. van Noordt, Cupid,
36 x 28 in., "Depicted as a boy in rose
tunic with multicoloured wings, in move-
ment to the left, holding his bow and
drawing an arrow from a quiver at his
side. Sky background.")

CATALOGUE L18
Venus, Diana, and Juno
Canvas, 205.7 x 152.4 cm
Reference: Earl of Albemarle et al. sale
(anonymous section), London (Sotheby's),
7 November 1951, lot 66 (as: J. van
Noordt, *Three Young Girls Posing as Venus,
Diana, and Juno,* canvas, 81 x 60 in.)

CATALOGUE L19
Silenus
Reference: sale Catton, London (Green-
wood), 11 March 1802 (Lugt 6375a),
(first day), lot 78 (as Van Nordt, *Silenus*)

The Rubenesque theme may link this
painting to Van Noordt's Flemish name-
sake Adam van Noort.

CATALOGUE L20
Caritas
Reference: sale, Amsterdam, 16 September
1739, lot 131 (as Van Noort, *Een Vrouw
met Kindertjes, Verbeeldende de Liefde, heel
konstig* [A *Woman with Children, Represent-
ing Charity,* very artistic], for *f*.10)

This reference possibly relates to one of
the two surviving depictions of the theme
by Van Noordt (cat. 24, 61).

CATALOGUE L21
A Horn of Plenty (Allegory of Abundance)
Reference: Inventory of the artist and dyer
Jan van de Cappelle, G.A.A., N.A.A. 2262,
Notary Adriaen Lock, *Minuutacten van
Inventarissen*, *dd* 4 January 1680, 1190,
no. 84: *"een cornicopia van Jan van Noort"*
(a cornucopia by Jan van Noort)

LITERATURE
Bredius 1892, 34; Hofstede de Groot 1892,
21,5 no. 1

CATALOGUE L22
Cleopatra and the Pearl
Canvas, 161 x 118 cm
Reference: Major R.A. Carnegie et al. sale
(anonymous section), London (Sotheby's),
20 October 1971, lot 107 (as Noordt: "An-
thony in a red cloak to her right, and other
figures behind her," to Chitton Gallery,
for £400)

CATALOGUE L23
Cimon and Iphigenia
Panel, 85 x 64 cm, monogrammed bottom
right: *W.H.*
Reference: J. Nanninga Uitterdijk sale,
Kampen, 11/12 September 1917 (Lugt
77093), lot 15 (as: *Bad na de jacht*; *"In een
bergachtig landschap zit eene naakte vrouwen-
figuur op een rood kleed; peilen, blauwe kokers
ende bogen liggen op den grond, daarbij is een
beeld en een bron, terwijl een mannenfiguur
met de eene hand rustende op een lans, met de
andere hand de vrouwenfiguur opricht"* [*Bath
after the Hunt*; In a mountainous landscape,
a nude woman sits on red drapery; arrows,
blue quivers, and bows lie on the ground,
next to them there are also a statue and a
spring, while a male figure with one hand
on a lance, points to the female figure with
the other hand].)

The wooden support, mountainous land-
scape setting, and pointing gesture of
Cimon distinguish this painting from the

known versions by Van Noordt (cat. 28,
29, 30). The description may refer to
another, unknown version.

CATALOGUE L24
Cimon and Iphigenia
Reference: David Ietswaart sale, Amster-
dam, 22 April 1749 (Lugt 704), lot 227 (as
Jan van Noord; *"Een stuk daar Hymen de
drie Naakte Nimfen leggende vind, door Jan
van Noord* [A piece in which Hymen finds
the three reclining nymphs, by Jan van
Noord]," for *f*31–0, to G. Morel)

LITERATURE
Hoet 1752, 2:253; Hofstede de Groot
1892, 215, no. 8

This painting could be one of the three
surviving known versions of the theme by
Van Noordt (cat. 28, 29, 30).

CATALOGUE L25
Granida and Daifilo?
Reference: Inventory of Catarina Grebert
(1634–1714), G.A.A., N.A.A. 5442, Notary
Livinius Meijer, document no. 92, *dd* 2 Oc-
tober 1715: *"Een Diana met een Jagthooren
door Van Oort*: 24:–:–" (A Diana with a
hunting horn by Van Noordt)

PROVENANCE
Amsterdam, collection of Catharina Nuyts
(1662–1698)[1]

Catarina Grebert survived her daughter,
and the painting given in her inventory as
by Van Noordt is quite likely the same as
the one appearing in the estate of her
daughter seventeen years earlier. There it
is described less specifically. The title
"Diana with a Hunting Horn" refers to a
theme that is atypical for Van Noordt. It is
possibly a mistaken reference to the figure
of Granida in a depiction of *Granida and
Daifilo*, in which she would be shown hold-
ing a shell in her hand.

1 N.A.A. 4604a (*Minuutacten*), 288, *dd* 6 August 1698, Notary Johannes Backer: "*Een Stuk met beelden van van Oort*" (A piece with figures by Van Noordt).

CATALOGUE L26
A History
Reference: sale, Rotterdam, 15 September 1834 (Lugt 13762), lot 108 (as Van Noordt, *Een historieel*)

CATALOGUE L27
The Five Senses
Canvas
Reference: Inventory of the painter and dealer Cornelis Doeck (?–1664), G.A.A., N.A.A. 2733, Notary Jan Hendrick Leuven, *Minuutacten*, 13 July 1667, 1623, no. 297: "*De Vijf Sinnen van Van Oort 12 st[uivers] doeck*" [*The Five Senses* by Van Oort 12 stuivers canvas]. The same inventory appears a second time in the archive, in a more legible version: N.A.A. 2741, 673.

LITERATURE
Bredius 1915–22, 109; Dirkse 1997, 16n11

Owing to the spelling of the name, Paul Dirkse has suggested that this painting was by Willem van Oordt. However, the subject matter fits better among the genre depictions by Jan van Noordt than the New Testament biblical scenes by Van Oordt. Furthermore, the following painting in the inventory (cat. L31, missed by Bredius, and unknown to Dirkse) is a pastoral given to the same artist, a work whose theme relates even more specifically to known paintings by Jan van Noordt.

CATALOGUE L28
Musical Company
Reference: sale, Amsterdam 10 June 1705 (Lugt 193), lot 24 (as *Een Muziek in een Kamer*, for *f*42.–)

LITERATURE
Hoet 1752, 1:79

CATALOGUE L29
A Shepherdess
Reference: Inventory of Jan Westerhoff (?–1719), G.A.A., N.A.A. 4448, Notary Michiel Bockx (not paginated), *dd* 16 July 1698: "*Een harderin van van Oort*" (A Shepherdess by Van Noordt)

This could be the painting of the same theme presently in the museum in Mänttä (cat. 43).

CATALOGUE L30
A Shepherd and a Shepherdess Making Music
Reference: sale, Amsterdam (Beukelaer), 15 April 1739 (Lugt 503), lot 159 (as Van Noord, *Een speelende Herder en zingende Herderin*, for *f*.13.10.–)

This painting does not appear in Hoet's transcription of the sale catalogue.

CATALOGUE L31
A Shepherd and a Shepherdess
Reference: Inventory of the painter and dealer Cornelis Doeck (?–1664), G.A.A., N.A.A. 2733, Notary Jan Hendrick Leuven (*Minuutacten*), 13 July 1667, 1623, no. 298: "*een harder en een harderin van van Oort.*" The same inventory appears a second time in the archive, in a more legible version: N.A.A. 2741, 673.

The subject matter of this painting fits well among Van Noordt's pastoral scenes, which emphasized the figure. It is possibly identical with one of the two known depictions of pastoral pairs by him (cat. 40, 41). It is less likely that this inventory entry refers to the artist known as "J. van Noort," since his pastoral depictions invariably emphasize the landscape setting

and include only small-scale figures
(cat. R40–R42).

CATALOGUE L32
A Shepherd Sleeping in a Stall
Reference: Jan Maul et al. sale, Leiden,
28 September 1782 (Lugt 3464), lot 122
(as Van Noorth: "*Een Slapende Herder in
een stal, benevens twee Gijten, en meer bijw-
erk, zeer goed* [A Sleeping Shepherd, in a
Stall, also two goats and other accessories,
very good]," for *f*14.–, to Fouquet)

This work is possibly by the second artist
known as "Jan van Noort," who specialized
in rural genre, in contrast to the pastoral
mode favoured by Jan van Noordt (cat.
R40–R42).

CATALOGUE L33
A Girl with Fruit
Reference: Inventory of the dyer and
painter Hendrik Oly, G.A.A., N.A.A. 5970,
Notary Christoffel Hellerus, *Minuutacten*,
document no. 51, *dd* 30 January 1700, fol.
10r: "*N⁰ 56 Een dito (stuck) sijnde een Meijsje
met vrugten, door Jan van Noort*" (No. 56 A
ditto [piece] being a Girl with fruit, by Jan
van Noordt)

LITERATURE
Bredius, 1915–22, 2036

This is possibly the painting in Mänttä or
the one in Florence (cat. 42, 43).

CATALOGUE L34
Peasant Interior with a Pig on the Ladder
Canvas, 54 x 74 cm
Reference: J.F. Signault Chz. & J.J.v. Lim-
beek sale, Amsterdam, 12 May 1834 (Lugt
13672), lot 466 (as J. van Noort, *Een Bin-
nehuis met een varken op de leer* [An Interior,
with a Pig on the Ladder], for *f*9.–,
to de Pré)

PROVENANCE
Sale, Amsterdam, 1 April 1833 (Lugt
13261), lot 134 (as J. van Noort, "*Een
Binnehuis, met een varken op de ladder* [An
Interior, with a pig on the ladder]," canvas,
5 *poids* 4 *doux* x 7 *poids* 4 *doux*, for *f*18.–,
to Van Delden)

The setting of a peasant interior relates
to the painting by second artist known as
"Jan van Noort" (cat. R40).

CATALOGUE L35
An Inn with Peasants
Reference: sale, London, 27 April 1925
(Lugt 88483), lot 39 (as Van Noort, *An
Interior, with Italian peasants music-making
and conversing*)

The theme of peasant life is reminiscent
of the interior scene by the second artist
known as "Jan van Noordt" (cat. R40).

CATALOGUE L36
A Musical Company in a Landscape
Reference: sale, Amsterdam (Beukelaer),
15 April 1739 (Lugt 503), lot 160 (as Jan
van Noordt, *Een Musicerent Gezelschap
in een Landschap*, for *f*.9–10–)

CATALOGUE L37
A Hawking Party
Canvas, 108 x 99 cm
Reference: H.M. Robinson et al. sale,
London (Christie's), 13 April 1927, lot 137
(as Van Noort, 49½ x 39 in., for £16.16,
to Seger)

CATALOGUE L38
Three Boys Tasting Stew
Canvas, 77.5 x 106 cm
Reference: C.C. Hutchinson et al. sale
(anonymous section), London (Christie's),
3 March 1916 (Lugt 75531), lot 79 (as Van

Noordt, canvas, 30½ x 41¾ in.: *Three Boys, one of whom is tasting food from a stew-pan,* for £6.6, to Weekes)

CATALOGUE L39
Two Boys
Canvas, 49.5 x 59.7 cm
Reference: sale, London (Christie's), 27 January 1950, lot 125 (as Van Noordt, 19½ x 23½ in.)

CATALOGUE L40
A Boy with a Bird's Nest
Reference: sale, London, 27 April 1925 (Lugt 88483), lot 39 (as Van Noort)

This painting could possibly be the same one as cat. 39.

CATALOGUE L41
A Happy Couple
Reference: Masson sale, Paris (D.P. Puillet, Gaudissart), 21–24 December 1818 (Lugt 9487), lot 120 (as J. van Noort, *"Femme qui fait de la dentelle auprès d'une cavalier qui tient sa pipe* [Woman making lace, while next to her a cavalier holds his pipe]," for Fr 46.50)

CATALOGUE L42
An Interior with a Woman and a Child
Canvas, 54 x 62 cm
Reference: Smith sale, Rotterdam, 26 April 1830 (Lugt 12330), lot 122 (as Van Noorth, *"Een Binnenhuis met eene vrouw, kind en verder bijwerk, zeer goed* [An interior with a woman, a child, and other accessories, very good]," for f.41.–, to Hopman)

CATALOGUE L43
Portrait of Jan Jacobsz Hinlopen (1626–66) and Leonora Huydecoper (1631–63)
Reference: Testament of Jan Jacobsz

Hinlopen and Leonora Huydecoper, G.A.A., N.A.A. 1147, Notary Justus van de Ven, folio 58r, *dd* 16 October 1663. The Van der Meulen family archive in Utrecht contains a copy of this testament, dated 29 December 1673: Rijksarchief Utrecht, Archive R57, no. 295: *"…de Conterfeijtsels vande Testateuren,…selfs geschildert door J. van Oort…* (the Portraits of the Testamentees…painted by J. van Noordt himself)"

LITERATURE
Van Gent 1998.

CATALOGUE L44
Portrait of Jacob Hinlopen (1658–63)
Reference: Testament of Jan Jacobsz. Hinlopen and Leonora Huydecoper, G.A.A., N.A.A. 1147, Notary Justus van de Ven, fol. 58r, *dd* 16 October 1663: *"…oock t Conterfeijtsel van haer Soon selfs geschildert door J. van Oort…* (also the portrait of their son, painted by J. van Noordt himself)"

LITERATURE
Van Gent 1998.

A portrait of Jacob Hinlopen, the son of Jan Jacobsz. Hinlopen and Leonora Huydecoper, appears in the testament drawn up for his parents in 1663, cited in the previous catalogue entry.

CATALOGUE L45
Portrait of the Predikant Cornelis Dankerts (1620/24–1693)
Reference: Inventory of Jan van Noordt, G.A.A., N.A.A. 4370, Notary Silas van Jaerlant (*Minuutacten*), fol. 195v, *dd* 2 May 1675

The inventory of the contents of Jan van Noordt's studio mentioned several paintings that were left behind, including the portrait of the Rev. Dankerts. The only

person with whom this reference can be identified is Cornelis Dankerts, who began his ministry in Amsterdam in 1665 (he appears in Van Lieburg 1996, 46).

CATALOGUE L46
Portrait of Caspar Netscher (1635/36–1684)
Panel, 12 x 11 cm
Reference: Sale, Brussels (Palais des Beaux-Arts: Jan de Mul), 21–22 June 1951, lot 280 (as attributed to Jan van Noort, *Portrait présumé de Netscher*)

CATALOGUE L47
Portrait of Annetje Jans Grotincx (1632–1677)
Reference: Inventory of the artist and dyer Jan van de Cappelle, G.A.A., N.A.A. 2262, Notary Adriaen Lock (*Minuutacten van Inventarissen*), 4 January 1680, 1190, no. 103: "*een dito (conterfijtsel) zijnde des overledenis vrouw Zal. van Jan van Noort* (a ditto [portrait] of the deceased's late wife by Jan van Noort)"

LITERATURE
Bredius 1892, 34; Hofstede de Groot 1892, 215, no. 3; Russell 1975, 12; Nystad 1981.

CATALOGUE L48
Portrait of a Lady
Canvas, 120 x 99 cm
Galerie van Diemen & Dr Otto Burchardt sale, Berlijn (Achenbach), 13 October 1937, lot 67 (as Jan van Noordt, *Damenbildnis*: "*Hüftbild. Die vor Draperie stehende Dargestellte trägt ein weißes Gewand und reichen perlschmuck. Am rechten Bildrand Steinvase* [Waist-length portrait. The sitter, standing in front of drapery, wears a white garment and rich pearl jewelry. To the right a stone vase]," for RM 800)

PROVENANCE
Sale A. Taxinge-Nasby et al. (anonymous section) Stockholm (H. Bukowski), 25–27

April 1934, lot 97 (as Joan van Noordt, Damportrëtt, canvas, 120 x 99 cm: "*Stående knästycke, gace något åt h. kroppen åt v. Hon bär vit låghalsad siderdräkt och parlband. I bgr. drapen och t.v. utsikt över en park.*")

CATALOGUE L49
Portrait of a Man
Canvas, 201.8 x 139.6 cm
Reference: R.J.R. Arundell et al. sale (anonymous section), London (Christie's), 9 February 1973, lot 98 (as Jan van Noordt, *Portrait of a Gentleman*, canvas, 201.8 x 139.6 cm: "…full length, wearing a black and white slashed doublet and hose decorated with ribbons standing in an interior with his hat on a table beside him and a hilly landscape in the distance.")

CATALOGUE L50
Portrait of a Young Man with a Hawk
Canvas, 114.3 x 80 cm
Sale, London (Christie's), 22 December 1920 (Lugt 81457), lot 84 (as Van Noordt, *Portrait of a Cavalier*, canvas, 45 x 31½: "…in black dress and white collar, a hawk by his side.", for ƒ14.–)

CATALOGUE L51
Portrait of a Boy
Canvas, 101.6 x 86.4 cm
Reference: Henry Wellcome et al. sale (Mrs E.M. Bourlet section), London (Sotheby's), 23 June 1943, lot 93 (as Jan van Noordt, canvas, 40 x 34 in.: "…half-length, elaborate costume: red shirt, hat in his right hand.")

CATALOGUE L52
Portrait of a Boy Falconer in a Landscape
Canvas, 116.7 x 88.9 cm (cartouche shaped)
Reference: David Astor et al. sale (anonymous section), London (Christie's), 15 October 1971, lot 89

This painting is perhaps a copy after one of the two depictions of the same theme in the Wallace Collection (cat. 55, 56).

CATALOGUE L53
Portrait of a Boy with a Hawk
Canvas, 150 x 111.8 cm
Reference: The Wauchope Settlement Trust sale (anonymous section), London (Christie's), 12 May 1950, lot 77 (as A. van Noordt, *A Boy, in Dark Coat and Buff Breeches, Standing on a Terrace Holding a Hawk on His Right Hand*, canvas, 59 x 44 in., for £36.15, to Adams)

The subject matter relates to several paintings (featuring a falcon instead of a hawk) by Jan van Noordt (cat. 55, 56).

CATALOGUE L54
Portrait of a Boy with a Hawk
Canvas, 109.2 x 83.8 cm
Reference: Sir George Harvey et al. sale (anonymous section), London (Christie's), 28 January 1916 (Lugt 75433), lot 20 (as Jan van Noordt, *A Boy, Standing in a Landscape, Holding a Hawk*, canvas, 43 x 33 in.)

This painting may be related to one of the two paintings of the same theme in the Wallace Collection (cat. 55, 56).

CATALOGUE L55
Portrait of a Boy with a Parakeet
Panel, 59.7 x 49.5 cm
Reference: Lady Somerset et al. sale, London (Christie's), 29 November 1920 (Lugt 81272), lot 70 (as Jan van Noordt, 23½ x 19½ in.)

CATALOGUE L56
Portrait of a Boy with a Gun
Panel, 21.6 x 12.7 cm
Reference: Henry Haes sale, London (Christie's), 16 June 1916 (Lugt 75867), lot 151 (as Van Noort, *A Youth Carrying a Gun*, 8½ x 5 in., for £9.19.6, to Duncan)

CATALOGUE L57
Portrait of a Boy with his Dog
Canvas, 114.7 x 101.6 cm
Reference: Lucy Wothan James et al. sale, New York (Parke-Bernet), 28–30 November 1940, lot 307 (as John van Noordt, *Boy with Dog*, canvas, 49 x 40 in.: "Full-length figure of a child in saffron tunic and scarlet mantle, holding an arrow, a running dog at his side. Landscape background.")

CATALOGUE L58
Portrait of a Boy with a Feathered Hat
Canvas, 56.5 x 44.5 cm
Reference: sale, Amsterdam (Paul Brandt), 18–25 May 1976, lot 121a (as Jan van Noort, *Portrait of a Noble Boy with Feathered Hat*: "He wares [*sic*] a red jacket with golden buttons," for *f*990)

CATALOGUE L59
A Landscape with Figures
Reference: sale, London (Christie's), 27 April 1793 (Lugt 5044, second day), lot 34 (as Van Noordt, *A Landscape and Figures*, for £3.–, to Lansbridge)

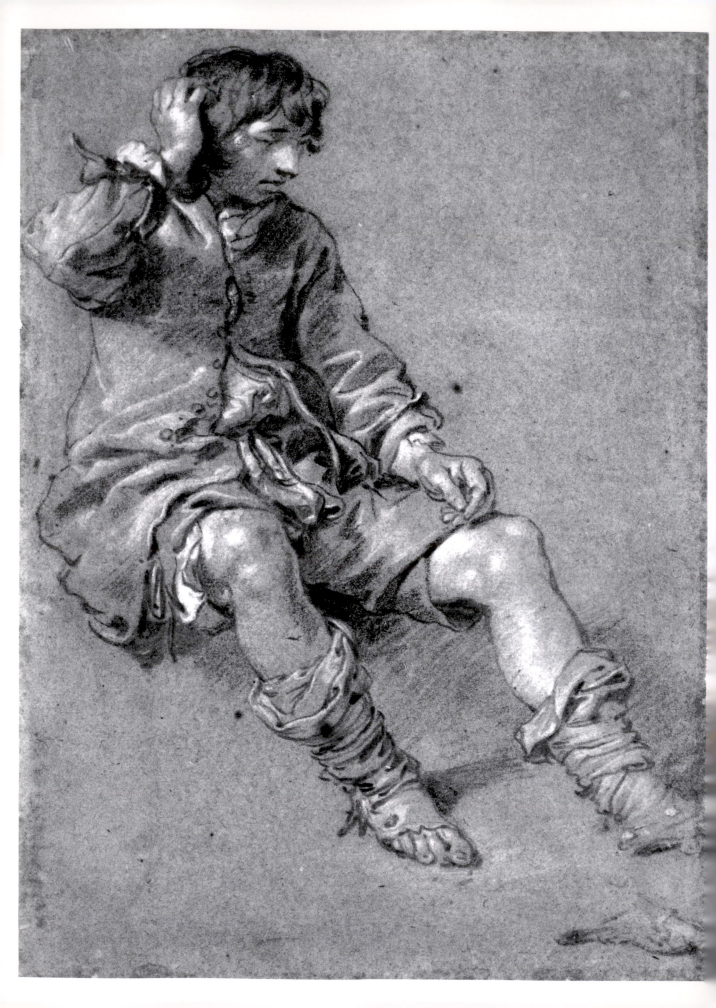

Drawings

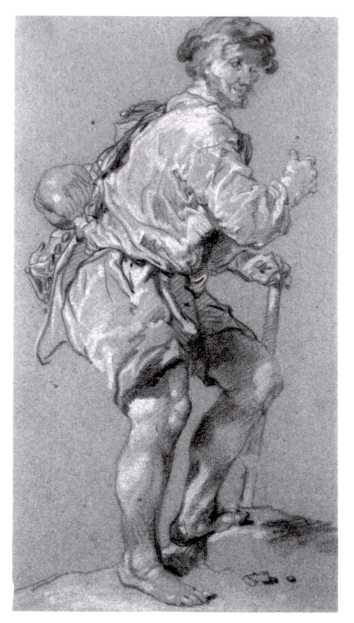

CATALOGUE D I

Study for the Labourer in Gibeah, black and white chalk on grey paper,
29.3 × 15.9 cm, Amsterdam, Rijksprentenkabinet.

Drawings

CATALOGUE D I
Study for the Labourer in Gibeah
Black and white chalk on grey paper
29.3 x 15.9 cm, Amsterdam, Rijksprenten-
kabinet (inv. no. A 676)

LITERATURE
Schatborn 1979, 121, 123, 125 (illus. fig.
10, as *A Pilgrim*), 128n24; Sumowski
1983–94, 1:140, 142n53

A middle-aged man with wild, curly hair
and a beard stands in profile to the
right, his head turned slightly toward the
viewer. He gestures with his right hand,
pointing into the distance. In his other
hand he holds a staff or the handle of a
spade, and on his back he carries a water-
gourd and a large, wide-brimmed hat. This
figure has until now been identified only
as a pilgrim. However, illustrations of the
painting formerly in the Ofenheim collec-
tion allow for a more precise identification
(cat. 3). That work depicts the disturbing
story of the Levite and the concubine in
Gibeah (Judges 19:16–21). The present
drawing corresponds, even in details, to
the figure of the labourer, who welcomes
the Levite and the concubine into his
home out of concern for their safety. The
attention paid to the field labourer in this
drawing reflects the prominent position he
takes in the painting, and underlines Volk-
er Manuth's conclusion that his charity was
one of the possible interests in this other-
wise unlikely theme.[1] The field labourer
presents an exemplar of Hospitality, which
was one of the Seven Acts of Mercy. The
connection with the Ofenheim *Levite* al-
lows for a dating of this drawing to 1673.

1 See 364n83.

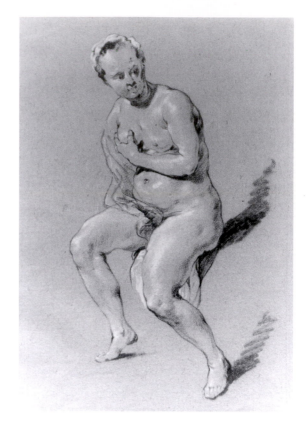

CATALOGUE D2
Seated Female Nude: Study for Susanna and the Elders, black and white chalk on grey-blue paper, 31.9 × 22.2 cm, Hannover, Niedersächsisches Landesmuseum Hannover.

CATALOGUE D2
Seated Female Nude: Study for Susanna and the Elders
Black and white chalk on grey-blue paper 31.9 x 22.2 cm, Hannover, Niedersächsisches Landesmuseum Hannover (collection no. 134, as Jacob Adriaensz. Backer)

PROVENANCE
Nitzscher collection (as Antoine Watteau)

LITERATURE
Von Moltke 1965b, 126, no. 2 (as Jan van Noordt?); Schatborn 1979, 120, 128n18 (as Jan van Noordt); Sumowski 1998, 78, 79n22

COLLECTION CATALOGUES
Hannover 1960, 25, no. 31 (illus. pl. 10, as Jacob Backer)

This forceful figure study relates directly to Jan van Noordt's painting of *Susanna and the Elders* in Leipzig (cat. 7). The seated figure lurches to the left while turning her head to look to the right, a pose that closely matches that of the painted Susanna, with only the missing right hand and minor disparities in the position of her left foot and hand. Other small differences occur in the drapery and hair.

Among Van Noordt's surviving drawings this one shows a high degree of finish, not only in the differentiated contours, but also in the smooth and soft modelling of flesh. It was likely the use of black and white chalk on blue-tinted paper that prompted the attribution of this drawing to Jacob Adriaensz. Backer, which rested until Wolfgang von Moltke in 1965 suggested Van Noordt as the artist. Peter Schatborn confirmed it in 1979. Unlike Backer and Govert Flinck, who created similar figure studies on blue paper for the market, Van Noordt seems to have applied this technique largely to the preparation for his paintings, as is the case with the present drawing. It was likely made at the same time as the painting, around 1659.

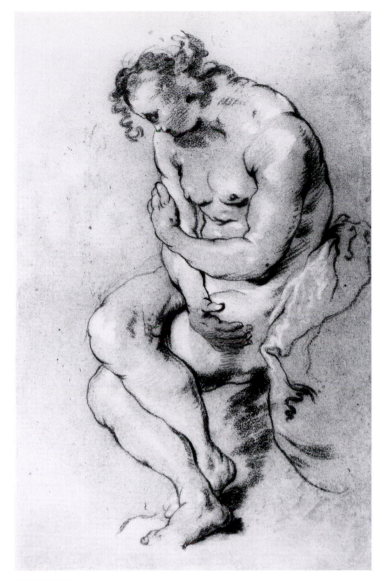

CATALOGUE D3
Seated Female Nude: Study for Susanna and the Elders
Black, white and red chalk on grey paper
34.5 x 21.8 cm, Amsterdam, P. & N. de Boer Foundation

LITERATURE
Von Moltke 1965b, 126 no. 4; Schatborn 1979, 120, 123 (illus.); 128n20; Sumowski 1986, 28, 32 (illus. no. 13); 37n40

EXHIBITIONS
Laren 1966, 28 no. 162 (as formerly attributed to Flinck, now Jan van Noordt)

As with many of Jan van Noordt's surviving drawings, this one relates to one of his known paintings. The pose of the figure corresponds to that of Susanna in the *Susanna and the Elders* now in Paris (cat. 8). Her body is turned to the left and arched inward. In the painting this is her

gesture of rejection against the elders, who approach from the right side. Van Noordt made some changes to the pose in the Paris painting. There, the head is tilted further up, the left arm is curled upward and the legs are beside each other rather than wrapped around one another, and turned more toward the viewer. The hatching underneath her in the drawing suggests the form of rough earth, rather than the stone block on which she sits in the painting. These differences suggest a process of adjustment and refinement in arriving at Susanna's painted pose.

For the pose in this drawing Van Noordt seems to have adapted the figure from a now-lost painting of the same subject by Rubens, known only through an engraving by Lucas Vorsterman (fig. 28).[1] In this print, the pose of the figure of Susanna is similar to that in Van Noordt's drawing, only it is reversed from left to right, as it would have been in the original design by Rubens, which suggests that Van Noordt may have seen the original painting. The position of the legs in his drawing, with one foot tucked in behind the other ankle, is another distinctive borrowing, as is the lock of hair falling over the forehead.

Van Noordt achieved a powerful, bulging suggestion of flesh in his drawn study. The heavy contour is dramatically varied to indicate swelling form, and curved hatching and bright highlights and shadows further emphasize volume. This effect points to the direct influence of Rubens. Elsewhere, Van Noordt knew the Flemish master more by way of the interpretation of Backer, but here the effect is livelier and less smooth than Backer. The technique of this drawing still speaks of Backer's impact on Van Noordt, as Backer lead a small fashion for figure studies in black and white chalk on blue-tinted paper.

Van Noordt made a number of small corrections in his drawing. He began with a light contour line. Just above the legs, the artist left such a contour line and drew another one lower down, which he then

strengthened in the same heavy tone used for the rest of the figure. The lower hand has been changed significantly, with light black lines, indicating straight fingers, erased and replaced by heavier red lines showing curled fingers. This change looks ahead to the final painting, in which the entire arm is curled, conforming to the closed circular sweep of Susanna's body.

1 For Vorsterman's print after Rubens, see 364n72.

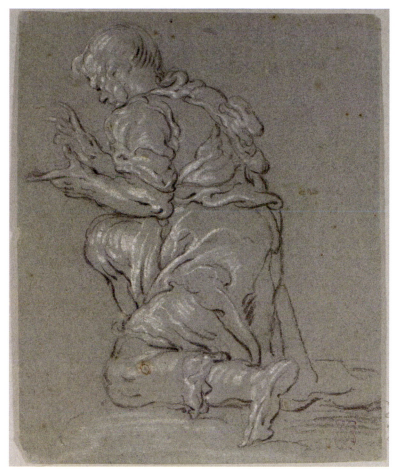

CATALOGUE D4
Study for a Shepherd
Black and white chalk on blue-grey paper
18.1 x 14.6 cm; private collection

PROVENANCE
Private collection (unidentified collector's
mark: HM in a circle); Berne, collection
of Wolf Burgi (his mark, not in Lugt);
London, art trade; sale, London (Christie's
South Kensington), 7 December 2005,
lot 369 (illus., as Dutch School, late
sixteenth century)

This vibrant and solidly executed sheet
circulated until now as a product of
Dutch Mannerism. The free hand and vo-
cabulary of arcing strokes, as well as the
technique of two chalks on coloured paper,
point to Van Noordt. Indeed, it can be
connected to the figure of one of the shep-
herds in his *Adoration of the Shepherds* (cat.
9), a painting that likewise resurfaced only
recently on the art market. Oriented in the
same angle away from the viewer, and like-
wise kneeling and looking downward, the
figure wears the same kind of simple, loose
peasant's costume as his counterpart in
the painting, with cloth bunching at his
elbows and waist. They also share the same
cropped coiffure yielding a rounded form
for the head, although in the painting Van
Noordt smoothed his features considerably
from the rough-hewn visage evident here.
He also adjusted the pose in several ways,
most importantly placing the shepherd on
his right knee instead of his left, and draw-
ing the lower leg back to create a diagonal,
which is in line with the staff he holds in

his lowered left hand. He initially planned to have the shepherd holding his hands in front of him and spreading his fingers, perhaps in a gesture of worship, as seen here. The rhythmic effect of hatching and undulating lines forms a corollary to the vigorous energy of the artist's style in his paintings of around 1660, the approximate date of this drawing and the related painting.

CATALOGUE D5
Seated Young Man: Study for the Prodigal Son?
Black and white chalk, and oiled chalk, on green-grey paper, 32.4 x 23.1 cm, Amsterdam, Rijksprentenkabinet (inv. no. 1977:31)

PROVENANCE
De Girard de Milet van Coehoorn collection; London, collection of Miriam Sacher; London, Kate de Rothschild Gallery, in 1977

LITERATURE
Schatborn 1979, 120, 121, 124 (illus. no. 9), 128n21; collection catalogue Budapest 2005, 184–86 (illus.)

EXHIBITIONS
London 1977, no. 20 (illus. on cover, as attributed to Jan van Noordt)

A young man is shown seated on the ground. He scratches his head in confusion, his closed eyes suggesting that he is exhausted. His clothes are worn out and dishevelled, although they seem to have once been part of an expensive costume, as they include a long doublet, breeches, stockings, and boots. In particular the loose, puffy undershirt, which stylishly billows out of the opening of his jacket and at the ends of its sleeves, suggests that this young man is not a shepherd, as Peter Schatborn has proposed, but rather someone who was once well-to-do but is now in desperate straits.[1] The hands and legs are also soft and fleshy, suggesting a lifestyle free of hard labour or hardship.

Van Noordt seems to have produced this elaborate full-length figure study in preparation for the now-lost painting *The Parable of the Prodigal Son* (Luke 15:11–32), which possibly shows the moment when the profligate's money has run out, and he confronts his downfall.

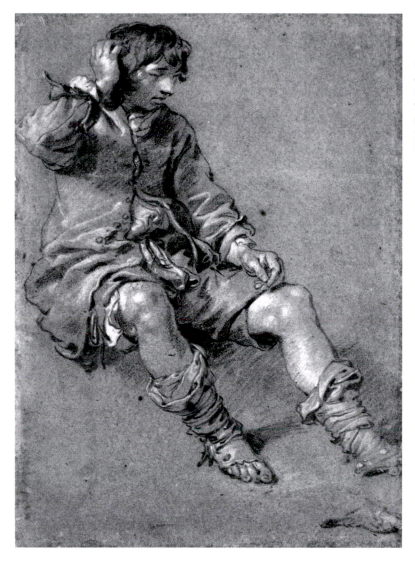

CATALOGUE D5
*Seated Young Man: Study for
the Prodigal Son?*, black and
white chalk, and oiled chalk,
on green-grey paper,
32.4 × 23.1 cm, Amsterdam,
Rijksprentenkabinet.

The function as a study seems to be indicated by the correction in the bottom right corner. There was not enough room for the foot, and so this part was included in a separate passage, a little lower, suggesting that it needed to be studied for inclusion in a painting. The entire figure was studied elaborately, making for one of the artist's most finished drawings. Areas of flesh are drawn in soft, thick strokes, with soft, rounded highlights in white chalk differentiating its consistency from that of the fabric, which is drawn in harder, crisper lines. Heavy lines in a different, oiled black chalk appear in the shadow areas and give emphasis to the effect of light. The facial features are given in very broad, smooth description, except for the thin, sharp line for the closed eyelids. The rich overall effect relates to Van Noordt's paintings of 1665–70.

1 Schatborn 1979, 121, 128n23. Schatborn related this figure to one of the figures in the painting *Shepherds and Shepherdesses at a Fountain* in the Steiner collection (cat. no. R42), which was done not by Jan van Noordt but by the lesser-known "Jan van Noort," the author of four other known paintings as well (cat. nos. R10, R15, R40, R41).

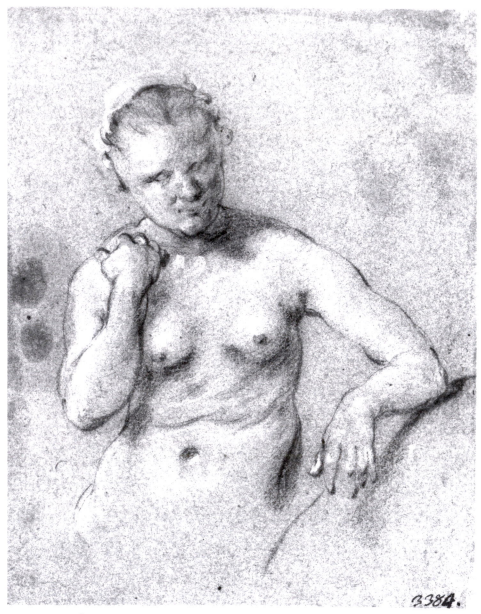

CATALOGUE D6
Seated Female Nude: Study for Venus, black and white chalk on blue-grey paper, 19.2 × 15.2 cm, Munich, Staatliche Graphische Sammlung München.

CATALOGUE D6
Seated Female Nude: Study for Venus
Black and white chalk on blue-grey paper,
19.2 x 15.2 cm, Munich, Staatliche
Graphische Sammlung (inv. no. 13622,
as Jacob Adriaensz. Backer)

LITERATURE
Bauch 1926, 107, no. 53 (as Backer, a copy
of a drawing in Leiden); Sumowski 1998,
78 (illus. fig. 5, mistakenly as in Hannover,
Kestner Museum), 79n21 (incorrectly as
34.8 x 18.5 cm)

COLLECTION CATALOGUES
Munich 1973, 44, no. 219, (illus. pl. 369,
as Jacob Adriaensz. Backer, attribution by
J. Byam Shaw)

Only partly finished, with lacunae in
the contours, this lively drawing gives
the impression of having been taken di-
rectly from the model. The figure is shown
from the waist up, and from the vague in-
dication of her hips is seated and leans over
to the right side. Her elbow is propped
against a large rounded form to the right,
which is only shown vaguely, while the
other hand is drawn up to her shoulder.
The model, with her broad, puffy cheeks
and arched eyebrows, seems to have posed
also for Van Noordt's drawing in Han-
nover (cat. D2).

This drawing was made in preparation
for the artist's depiction of Venus in his
painting of *Venus and the Three Graces* now
in The Hague (cat. 20). Both figures show
the same arch of the torso, tilt of the head,
and positioning of the model's proper left
arm and hand. Especially the drooping
hand corresponds closely to that of Venus
in the painting. She also has the same
smallish breasts and lightly smiling expres-
sion. Van Noordt changed the pose in
some aspects as well, turning the head and
torso slightly to the left, and moving the
proper right arm down, so that it falls at
Venus's side. He likely produced both

around 1655. The pose was adapted from
the figure of Susanna in the painting in
Utrecht (cat. 6).

Van Noordt made this study on thin
and fragile blue-tinted paper, which over
time has suffered several horizontal creases
across the centre. Some large ink blotches
mar the image on both sides of the figure.

CATALOGUE D7
Bust of a Woman with a Feathered Headdress: Study for One of the Three Graces, black, white, red, and yellow chalk on blue paper, oval, 23.4 × 20 cm, Rennes, Musées de Beaux-Arts de Rennes (photo: Louis Deschamps).

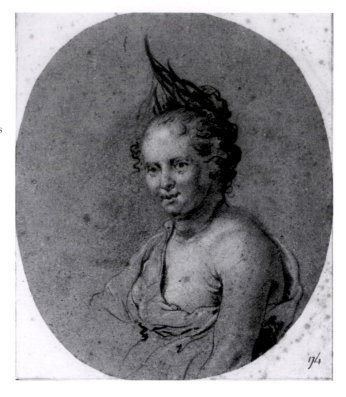

CATALOGUE D7
Bust of a Woman with a Feathered Headdress: Study for One of the Three Graces
Black, white, red and yellow chalk on blue paper, glued down, oval, 23.4 x 20 cm Rennes, Musées de Rennes (inv. no. INV 794.1.3388)

LITERATURE
Schatborn 1979, 123, 124, 127 (illus. no. 17), 128n31

PROVENANCE
Collection of the marquis de Robien; appropriated by the State in the Revolution; deposited with the Museum in 1794

A young woman poses in a feathered headdress and drapery that falls off her shoulder. With these exotic trappings, she could possibly be taking the role of a figure in classical mythology. Indeed, this drawing appears to be a study for one of the three Graces in the painting *Venus and the Three Graces* in The Hague (cat. 20).

The pose, with the head tilting forward and turned more to the viewer than the shoulders, and the unusual headdress correspond to those of the nymph seated in the foreground right; the drawn figure, however, is clothed. Her face shows the same bright and smiling expression as in the painting. Both works show a strong chiaroscuro. Furthermore, the sketchy quality of this drawing, especially in the hair and drapery, provides a lively spontaneity that evokes the charged atmosphere of the painting, with its energetic, free composition.

Of Jan van Noordt's many figure studies for paintings, this drawing is unusual in that it only studies the nymph's head and shoulders. As most lines trail off before the edge, the sheet has evidently not been trimmed down from a larger drawing. The only exception is the bottom right corner, where the lines describing the arm and the back are cut off by rounded edge. The drawing was probably originally rectangular, and later reduced to an oval shape.

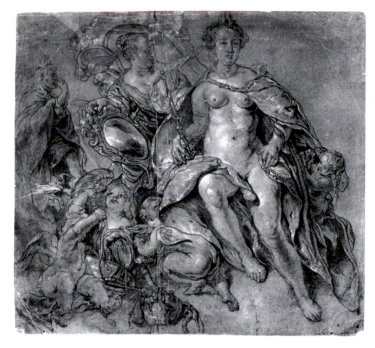

CATALOGUE D8
Juno in the Clouds, black, white and red chalk on green-grey paper, 41 × 44.8 cm, inscribed: *Élève de Rubens*, Bremen, Kunsthalle.

CATALOGUE D8
Juno in the Clouds

Black, white and red chalk on green-grey paper, 41 x 44.8 cm, inscribed, bottom right: *Élève de Rubens*, Bremen, Kunsthalle (inv. no. 1953/4)

Jan van Noordt planned the middle and left section of his imposing painting of *Juno* in Braunschweig (cat. 18) in this detailed study. It shows the goddess accompanied by amoretti to either side. Behind her to the left, a female figure holds a mirror to her; she must represent *Prudentia*, and here she underscores Juno's wisdom.[1] Further back stands Juno's gilt throne, formed in the same flamboyant, auricular style as the frame of the mirror. Off to the left side and further back, Juno's husband, Jove, appears seated in profile, holding his chin in bewilderment as he looks upon the scene of her triumph. Even Jove's eagle seems to be cowed by the spectacle, as he peers out from under the god's ample robe.

Peter van den Brink was the first to connect this drawing to Van Noordt, by way of the Braunschweig painting.[2] It matches the respective part of the painting closely, presenting most of the details of the figures and attributes. The close correspondence raises the question as to whether this drawing is perhaps simply a *ricordo* of the finished painting, done by Van Noordt, or even another artist. Its technique closely follows that of Van Noordt's drawings. Most of them are done in black and white chalk on blue-green paper, and several also include passages in red chalk.[3] Furthermore, the sweeping, emphatic contour lines and softly modulated highlights also strongly correspond with his drawing style. The careful finish here, higher than in most of his other drawings, may be explained by the special character of the painting to which it is related. The Braunschweig *Juno* is Van Noordt's largest, most ambitious work, and he almost certainly engaged assistants, who could have used this drawing as a guide. The artist likely presented the patron with this drawing as a *modello* before embarking on the commission.

1 For the identification of this figure, see cat. no. 18n2.

2 Written communication with the author in an e-mail of 19 March 1993.

3 Red chalk was also used in three other drawings: cat. nos. D3, D7, and D17.

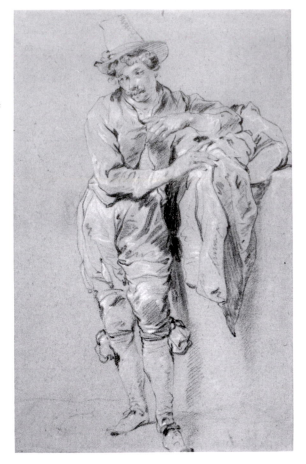

CATALOGUE D9
Study for Don Jan
Black, white, and red chalk on grey paper
36.3 x 22.7 cm, London, British Museum
(inv. no. 1852-5-19-6)

LITERATURE
Mellaart 1926, 28, no. 13 (illus., as Jan van Noordt, formerly attributed to Gabriel Metsu); Schneider 1931, 511; Von Moltke 1965b, 126, no. 1; Schatborn 1979, 119, 120, 127n12 (illus. no. 4); Sumowski 1998, 77, 79n15; collection catalogue Budapest 2005, 186

COLLECTION CATALOGUES
London 1915–32, 4:7–8, no. 1 (illus. pl.5)

An elegantly dressed man takes a languid standing pose, cocking his head to the left side and timidly hooking his finger over the button at his collar. His cloak is draped over a large rock, against which he leans. His fashionable costume features breeches, stockings, and a doublet, and is topped off with a tall pointed hat. This figure was evidently drawn in preparation for Jan van Noordt's painting *Pretioze and Don Jan*, which exists in two versions (cat. 31, 32), and several copies. It thus likely dates to around 1660. The pose and the costume match those of Don Jan to the right side in both paintings, and Van Noordt evidently took great care to refine his image of the dapper, infatuated Spanish nobleman. Already in this drawing he had conceived of Don Jan's affected gesture of hooking his finger over the button of his doublet. The artist created a finished study with sensitively varied contours, but also with loose scrawls that lend it liveliness. The fluid contours are handled with surety, but the overall grace is diminished by the flat, rapid hatching in shadow areas.

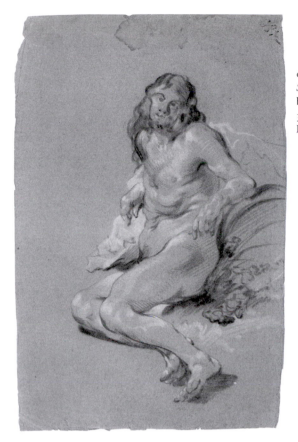

CATALOGUE D10
Study of a Male Nude, Seated on the Ground,
black and white chalk on blue paper,
36 × 24 cm, Amsterdam, collection of
Paul Russell.

CATALOGUE D10
Study of a Male Nude, Seated on the Ground
Black and white chalk on blue paper,
36 x 24 cm, Amsterdam, collection of
Paul Russell

PROVENANCE
Sale, London (Phillips), 2 July 1990, lot 33
(illus.); sale, London (Phillips), 7 July 1993,
lot 74 (illus.)

LITERATURE
Sumowski 1998, 78, 79n20

A nude young man is shown seated on
the ground, leaning back on his el-
bows, which are propped against a mound
of earth behind him. His body is angled
off to the left, but his head is turned to face
the viewer. There is some foliage below
to the right, and behind the figure is some
piled-up drapery. With no clear connec-
tion to a particular personality in a history
painting, this figure may have been drawn
as a nude study in the classical academic
tradition.

Van Noordt used a varied contour line
and modelling in smooth highlights and
hatched shadows to achieve a strong sense
of the volume and consistency of flesh. He
conveyed the tension of the awkward pose,
clearly articulating the rotation at the
waist, even using some fine lines, applied
loosely and spontaneously. Some other
areas are more broadly drawn, with less
clarity, such as the neck and chin and the
left shoulder. The flowing movement and
the patchy effect of the highlights compare
closely with the female nude study in Ams-
terdam (cat. D3), drawn in preparation for
the *Susanna* in Paris (cat. 8). Both sheets
can be dated to the same period, around
1670, late in Van Noordt's career. This
drawing also compares closely with the
figure study of a nude male in Rotterdam
(cat. D11), and the similarities with the
model in both drawings suggest that they
were made in the same session.

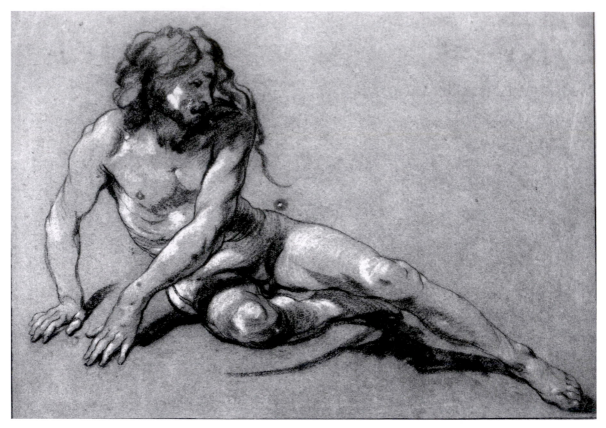

CATALOGUE D11
Study of a Reclining Male Nude, black and white chalk on blue paper, 26.4 × 37.7 cm, Rotterdam,
Museum Boijmans Van Beuningen.

CATALOGUE D11
Study of a Reclining Male Nude
Black and white chalk on blue paper,
26.4 x 37.7 cm, Rotterdam, Museum
Boijmans Van Beuningen (inv. no. MB
1978/T6, as Jacob Adriaensz. Backer)

PROVENANCE
Sale, Amsterdam (Sotheby-Mak van
Waay), 3 April 1978, lot 130 (illus. 118,
as Backer)

LITERATURE
Sumowski 1998, 77 (illus. fig. 4), 78, 79n17

COLLECTION CATALOGUES
Rotterdam 1988, 120, no. 39, 121 (illus.,
as Jacob Adriaensz. Backer, c. 1640–50)

A young reclining nude male raises
himself up on his hands, and turns his
head to face the right. From his long, flow-
ing hair and the evidence of a beard, he is
the same model as appears in the drawing
in Amsterdam (cat. D10). Here as well, his
pose does not seem to be for a particular
figure in a history painting. Both drawings
seem to have been made in the same ses-
sion of drawing from the model, in the ac-
ademic tradition. They share the dramatic
effect of varied contour lines and specular
highlights with the female figure study in
Amsterdam (cat. D3), and likely also date
to around 1670. The present drawing is
more finished, with more regular contour
lines and hatching and completed details
of hands and feet.

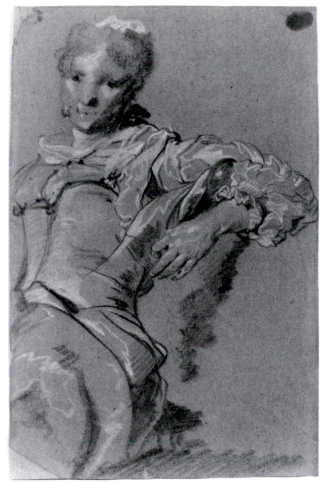

CATALOGUE D12
Portrait Study of a Seated Woman,
black and white chalk on
blue-grey paper, 28.3 × 19 cm,
Rotterdam, Museum Boijmans
Van Beuningen.

CATALOGUE D12
Portrait Study of a Seated Woman
Black and white chalk on blue-grey paper
28.3 x 19 cm, Rotterdam, Museum
Boijmans Van Beuningen (inv. no. J.O.1,
as J. Ochterveld)

LITERATURE
Schatborn 1979, 123, 126 (illus. no. 15),
128n29

A young woman, seated in a chair and resting her arm over its back, turns to face the viewer. She is sumptuously dressed in a satin gown and a full, loose-fitting blouse with sleeves to just below the elbow. Only her head and torso are shown, and the lesser detail at the bottom and left edges suggest that this is the complete drawing and has not been cut off. The formal pose and the costume identify this drawing as a portrait study. The face is surprisingly unfinished, so the artist may have painted it directly from life or from another study. The figure closely approximates the young woman to the right in Van Noordt's *Portrait of a Brother and Two Sisters* now in Zeist (cat. 59), a connection that confirms the attribution of this drawing to Van Noordt, first made by Schatborn.[1] However, the costume differs in several aspects, particularly the *decolleté*, which is much deeper in the painted figure. The drawing's style, with strong, sweeping contour lines and highlights, and vigorous modelling, is closely related to later drawings dating to around 1670, such as the study for *Susanna* in Amsterdam (cat. D3). This is also the approximate date of the painting in Zeist.

1 See Literature.

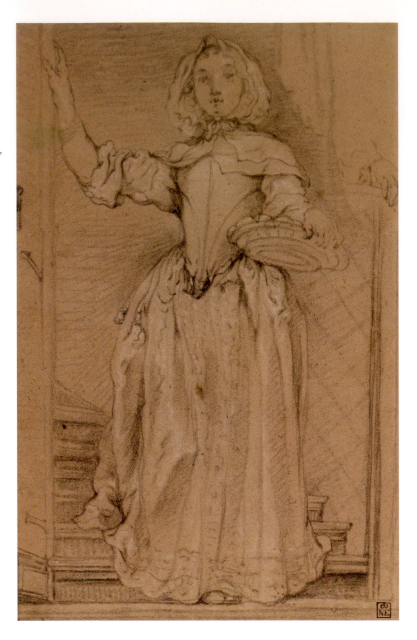

CATALOGUE D 13
Portrait of a Woman with a Basket
Black and white chalk, with framing lines
in black ink, 38.7 x 24 cm, Budapest,
Szépmüvészeti Múseum (inv. no. 3077)

PROVENANCE
Esterházy Collection (inv. no. 20. 33, as
Casper Netscher, Lugt Marks 1965, 1966);
Országos Képtár (Lugt Mark 2000, on
the mat)

LITERATURE
Sturla J. Gudlaugsson, "Kanttekeningen bij
de ontwikkeling van Metsu," *Oud Holland*
83, 1968, 24 n44 (illus. 13)

EXHIBITION CATALOGUES
Simon Meller, *Régi mesterek rajzai
XIV-XVIII század (Drawings by Foreign
Masters XIV-XVIII centuries)*, Budapest,
Szépmüvészeti Múseum, 1911, no. 90
(as Casper Netscher)

COLLECTION CATALOGUES
Budapest 2005, 184–6 no. 175 (illus., as by
Jan van Noordt, or possibly Gabriël Metsu)

Only recently did Teréz Gerszi identify the hand of Van Noordt in this rendering of a young woman standing at the foot of a winding staircase with a basket of fruit under her arm.[1] Although the figure recalls the various depictions of eavesdropping maids by Nicolaes Maes,[2] it appears that Van Noordt used the pose on the stairs as a starting point for a study of the portrait, as indicated by the woman's lavish dress and upright pose. The introduction of genre elements in portraiture also appears in the drawing of a nurse with children in Mänttä (cat. D16). The broad, soft handling of facial features and the undulating quality of contour link both works, and point toward a date late in the 1660s for the present sheet. The deep collar, or *labaar*, was popular from the 1650s through the following decade Van Noordt revisited the pose of the right hand over the basket to the upper right. The architecture was evidently added later, as it circumvents the hand study. Weak and without spatial quality, it may have been completed by another artist or pupil.

1 See Collection catalogues.
2 For example: *The Eavesdropper*, 1657, panel, 92.5 x 122 cm, Dordrecht, Dordrechts Museum, on loan from the Institute Collectie Nederland (inv. no. NK 3045); see Sumowski 1983–94, 3:2023 no. 1370, 2096 (colour illus.)

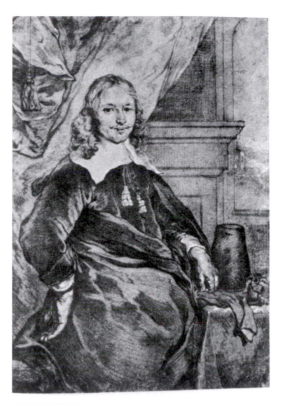

CATALOGUE D14
Portrait of Dionijs Wijnands, black and white chalk on grey paper, 39 × 28.7 cm, present location unknown.

CATALOGUE D14
Portrait of Dionijs Wijnands (1628–1673)
Black and white chalk on grey paper,
39 x 28.7 cm, present location unknown

PROVENANCE
Carl Schöffer sale, Amsterdam, 30 May 1893 (Lugt 51799), lot 289 (as *Portrait d'un jeune homme distingué, aux deux crayons, sur papier gris, Hauteur 39, largeur 28 cent.*); Jhr. Alfred Boreel et al. sale, Amsterdam, 15 June 1908 (Lugt 66680), lot 439 (as J. van Noordt, black and white chalk on grey paper, 40 x 29 cm); F. Adema van Scheltema sale, Amsterdam (Frederik Muller), 11 June 1912 (Lugt 71448), lot 533 (illus. pl. 46; *f*50.– to F.M.); sale, Amsterdam (Mensing), 27–29 April 1937, lot 494 (for *f*110.–, to Colnaghi)

LITERATURE
Valentiner 1941, 291, 293 (illus. fig. 15),

295; Staring 1948, 48n4; Schatborn 1979, 118–19, 127n5 (illus. no. 1)

COPIES
Black and white chalk on blue-grey paper, 24 x 26.6 cm, Paris, École Nationale Supérieure des Beaux-Arts; see collection catalogue Paris 1950, 53, no. 427 (as a copy after Jan van Noordt)

At the sale appearance of this drawing in 1911, it was immediately linked to the larger of two painted portraits of the Amsterdam silk manufacturer Dionys Wijnands (cat. 43, 44) by Jan van Noordt. As in the painting, Wijnands is shown in three-quarter length, standing beside a table bearing his hat and gloves, on which he rests his proper left hand. Behind him a curtain is drawn to the left side to reveal a mantelpiece in the centre, and to the right an open window gives a view to a building in the distance. The painting shows these elements as well, only adding more houses and foliage in the view out the window.

The function of this drawing in relation to the painting is not exactly clear. It is an elaborately finished drawing, right down to the drapery description in the background and ruled lines for the interior architecture. More significantly, the artist pursued painterly effects in the build-up of a rich tonal scale, especially in the shirt and mantle worn by the sitter, where a network of hatching in black chalk defines its dark colour. This technique is not evident in many of Jan van Noordt's other drawings. The difference might lead to the speculation that the drawing was done after the painting, perhaps even by another artist. However, peculiar elements of Jan van Noordt's drawing style, especially his use of flowing contours, do appear here, for example in the drapery to the upper right. Similarly this sheet shows his characteristic softly modulated highlights in white chalk, suggesting round forms, in the hands and in the tablecloth to the right. These elements support the longstanding attribution to Van Noordt. The artist likely produced this finished drawing as a *ricordo*, to document this important portrait commission after it left his studio.[1]

1 On this practice in the De Braij family studio in Haarlem, see Jeroen Giltaij and Friso Lammertse, "Maintaining a Studio Archive: Drawn Copies by the De Braij Family," *Master Drawings* 39, 2001, 367–94.

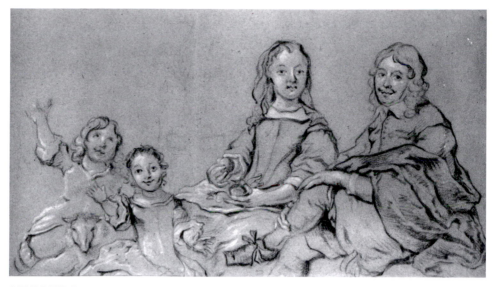

CATALOGUE D15
Pastoral Family Portrait, black and white chalk on blue-grey paper, 20.3 × 36.2 cm, Amsterdam, Rijksprentenkabinet.

CATALOGUE D15
Pastoral Family Portrait
Black and white chalk on blue-grey paper
(on two sheets, with a vertical seam
13.9 cm from the left), 20.3 x 36.2 cm,
Amsterdam, Rijksprentenkabinet (inv. no.
A 675, as Jan van Noordt)

This lively portrait of a young couple and their two children has been remarkably well preserved. The surface and the open background are marred only by a vertical seam to the left of centre. The technique is more sketchy than many of Van Noordt's drawings, which typically functioned as studies for paintings. Nonetheless, the strong contours, reflection in shadows, and the rubbed-in highlights indicate the hand of Van Noordt, as Peter Schatborn was the first to recognize.[1] The loose and direct marks in black and white chalk give the impression of having been taken from life. The poses of the parents are informal and relaxed, the father holding his one leg crossed over the other, the mother with a fruit in each hand, one in her lap and the other held up to the viewer. In contrast, the two children at the left are in full flight, their tilting bodies, broad smiles, and flailing arms giving a dynamic impression of children at play. This pair compares to Van Noordt's own drawn portrait group of three children, last in Paris (cat. D17), but the present drawing shows even greater freedom of action. Van Noordt advantageously applied a sketchy handling in conjuring a recreational atmosphere. More specifically, it is a pastoral setting, partaking of the fashion for idyllic representations of shepherds and the countryside that became so fashionable in seventeenth-century literature and images.[2] This interpretation, suggested by the mother holding fruit, is firmly defined by the sheep poking its head out between the two children. The mood and setting come close to Van Noordt's large family portrait in Dunkerque (cat. 62), and the present drawing may have functioned as a study for a similar portrait.

1 See Literature.
2 On the phenomenon of pastoral imagery in the Netherlands, see Kettering 1983 and exhibition catalogue Utrecht and Luxembourg 1993–94.

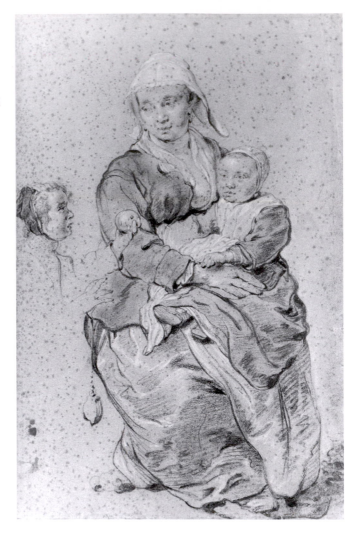

CATALOGUE D16
Portrait of a Seated Woman with Two Children, black and white chalk on grey paper, 41 × 26 cm, Mänttä, Gosta Serlachius Museum of Fine Arts.

CATALOGUE D16
Portrait of a Seated Woman with Two Children
Black and white chalk on grey paper,
41 x 26 cm, Mänttä, Gosta Serlachius
Museum of Fine Arts

PROVENANCE
Sale, Amsterdam (Muller), 11 June 1912 (Lugt 71448), lot 166 (to Hofstede de Groot); The Hague, collection of Cornelis Hofstede de Groot; sale, Leipzig (Boerner), 4 November 1931, lot 10 (as attributed to Jacob Adriaensz. Backer)

LITERATURE
Bauch 1926, 111, no. 10 (as by an unknown follower of Jacob Adriaensz. Backer); Bernt 1957, 1, no. 19 (illus., as Jacob Adriaensz. Backer); Trautscholdt 1958, 364 (as not by Jacob Adriaensz. Backer); Sumowski 1998, 76 (illus. fig. 3, as Jan van Noordt), 77, 79n13

EXHIBITIONS
The Hague 1930, 6, no. 13; Helsinki 1936, 25 (as Johannes van Noordt)

COLLECTION CATALOGUES
Hofstede de Groot 1923, no. 2 (illus., as Jacob Adriaensz. Backer)

COPIES
Black and white chalk, with ink wash, 37.5 x 26.2 cm, sale, Berlin (Henrici), 21 June 1919 (Lugt 79114), lot 164 (as J. Toorenvliet)

Van Noordt made an elaborate study of this intimate domestic scene of a wet nurse accompanied by two children. Her role here is indicated by her costume, especially the hairpiece, and by the blouse, opened to expose her breast to the infant child sitting on her lap. Both of these figures look over to the left, toward a second, older child, who holds up an apple to her younger sibling. Only her head and arms are shown; the artist did not complete her figure. In contrast, the other two figures are described in detail, with emphasis on the flowing folds of their dresses.

The expressions on their faces – the patient attention of the woman, the earnest appeal of the older sister, and especially the wide-eyed wonder of the baby – have been differentiated with subtlety. When this drawing was in the collection of the Dutch art historian Cornelius Hofstede de Groot, the attribution rested under the name of Jacob Adriaensz. Backer. More recently, Werner Sumowski revised this judgment in favour of Jan van Noordt.[1] The technique of black and white chalk on blue-tinted paper is common to both of these artists. However, the busy effect of rhythmically undulating contours in drapery folds points to Van Noordt, as does the vigorous effect of volume achieved through modelling, and the curiously swelling forms of the fingers. The lively interaction between the figures compares closely to several large group portraits by Van Noordt of around 1670, for example the Dunkerque *Portrait of a Family* (cat. 62), which also features a baby who is being offered an orange. The present drawing was perhaps a study for a similar multi-figured portrait of the same period that has since been lost.

1 See Literature.

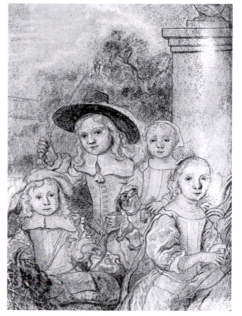

CATALOGUE D 17
Portrait of Four Children on a Goat Cart, black, white and red chalk on blue-grey paper, 31.6 × 23 cm, present location unknown.

CATALOGUE D 17
Portrait of Four Children on a Goat Cart
Black, white, and red chalk on blue-grey paper, 31.6 x 23 cm, present location unknown

PROVENANCE
Paris, with Gallery J. Kraus

LITERATURE
Barbara Ann Scott, "Voltaire, the European Traveller," *Apollo*, July 1978, 68 (illus. no. 4, as Jan van Noordt)

Four children are crowded in and around a small coach. There are two brothers and two sisters, ranging in age from around two to around eight years old. The boys are on the left, the traditional side for males in family portraits. The boy at the back is dressed in a tall, wide-brimmed hat and a doublet with a wide flat collar and a tassel, and loose, billowing

sleeves, features that compare closely with the costume of a young man traditionally identified as Cornelis van Groenendyck in Abraham van den Tempel's portrait of 1668.[1] The younger boy wears a floppy beret sporting large feathers. To the right, both of the girls wear tight bodices and billowing sleeves; the older girl to the front has decorative leading straps, and her younger sister wears a loose cap over her hair. The younger girl keeps a small pug on her lap, who is playfully springing up to her face. She sits in an elaborately carved cart, the sides of which can be seen to the right. It is drawn by the goat that stands at the bottom left; its eyes and horns are barely visible at the left edge. The animal is under the control of the older boy standing farther back, who holds a riding crop aloft.

Van Noordt's drawing compares with a number of paintings of children in and around a cart, usually showing one or more goats in front. One of the earliest examples of this type of portrait is by Ferdinand Bol; other examples include paintings by Jürgen Ovens, Nicolaes Maes, and Gerbrand van den Eeckhout.[2] Like them, Van Noordt has shown the children busily enjoying country recreation. The setting is an estate, with trees in the background and, on the right, a stone pillar topped with a sculpture, of which we can see only the bottom. The lower half of the composition is filled with life, and expresses the artist's vision of youth, much as in the family portrait in Amsterdam (cat. D15).

Compared with the drawing in Amsterdam, the present sheet is much more highly finished, giving many details of costume. The composition goes into depth, and extends to the outside edges. The bottom and sides appear to have been trimmed, as many forms have been cut off. A few elements remain vague, in particular the bottom right corner, which appears to be part of the coach. Also it is not clear whether the girl to the right has something in her hands. The near-completeness of this

drawing suggests that it was intended to be a finished work. It seems to have been made as a drawn portrait drawing, like that of *Dionijs Wijnands* (cat. D12), perhaps in connection with a painting.

1 See cat. no. 62n2.
2 Ferdinand Bol, *Four Children on a Goat Cart*, canvas, 211 x 249 cm, Paris, Louvre (inv. no. 1062); and Gerbrand van den Eeckhout, *Portrait of Willem Woutersz Oorthoorn on a Goat Cart*, canvas, 95 x 120 cm, Germany, private collection. For a discussion of these two paintings, and other examples, see Manuth 1998b, 139–42.

Rejected Drawings

CATALOGUE DR1
(p) *Reclining Female Nude*
Black and white chalk on brown-grey
paper, 31.7 x 22.7 cm, London, Courtauld
Galleries (inv. no. 4002)

LITERATURE
Von Moltke 1965a, 214, cat. no. D202
(illus., as Govert Flinck); Schatborn 1978,
note 20 (as Jan van Noordt)

The regular hatching, the soft model-
ling, the staccato rhythm of drapery
folds, and the facial type with heavy eyelids
are reminiscent of the style of Jacob Adri-
aensz. Backer's later drawings. The drama
of movement in line and the suggestion
of strong light typical of Van Noordt are
not in evidence.

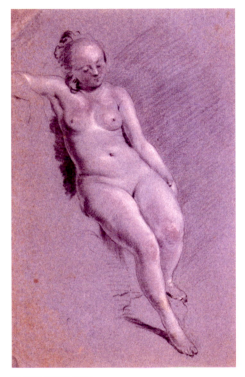

CATALOGUE DR2
Seated Female Nude, black, white, and red chalk
on blue-grey paper, 22.7 × 36 cm, Rotterdam,
Museum Boijmans Van Beuningen.

CATALOGUE DR2
Seated Female Nude
Black, white, and red chalk on blue-grey
paper, 22.7 x 36 cm, Rotterdam, Museum
Boijmans Van Beuningen (inv. no. H58, as
Barent Graat)

LITERATURE
Von Moltke 1965a, 272, with no. 224 (as
Jan van Noordt); Von Moltke 1965b, 126,
no. 3

COLLECTION CATALOGUES
Rotterdam 1969, 65 (illus. pl. 155, as Jan
van Noordt)

This coloured figure study shows none
of Van Noordt's emphatic use of con-
tour lines.

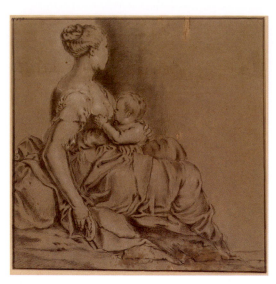

CATALOGUE DR3
Study of a Seated Woman with a Child on Her Lap,
black and white chalk on blue-grey paper,
dimensions not known, Hamburg, Hamburger
Kunsthalle (photo: Bildarchiv Preussischer
Kulturbesitz / Art Resource, NY)

CATALOGUE DR3
(p) *Study of a Seated Woman with a Child
on Her Lap*
Black and white chalk on blue-grey paper,
dimensions not known, Hamburg,
Kunsthalle, inv. no. 1963/184

LITERATURE
Von Moltke 1965b, 126, no. 5 (as Jan van
Noordt)

Neither figure style nor technique
relate to Van Noordt's work.

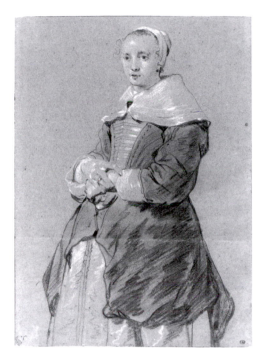

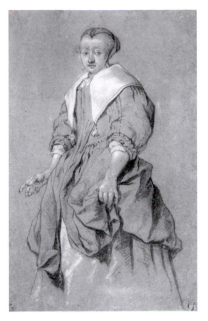

CATALOGUE DR4
Abraham van den Tempel, *Study for a Portrait of a Woman*, black and white chalk on blue-grey paper, 29 × 20.7 cm, Paris, École Nationale Supérieure des Beaux-Arts.

CATALOGUE DR4
(p) Abraham van den Tempel, *Study for a Portrait of a Woman*
Black and white chalk on blue-grey paper, 29 x 20.7 cm, Paris, École Nationale Supérieure des Beaux-Arts

LITERATURE
Schatborn 1979, 122, 126 (illus. no. 13, as Jan van Noordt), 128n27

COLLECTION CATALOGUES
Paris 1950, 46, no. 372 (illus. pl. 94, as Gabriel Metsu?)

The pose duplicates that of the *Portrait of a Woman* in Paris (cat. R44), which has been rejected as by Van Noordt. Like the painting, the drawing's technique shows a stiff carefulness not typical for the artist.

CATALOGUE DR5
Abraham van den Tempel, *Study for a Full-Length Portrait of a Woman*
Black and white chalk on blue-grey paper, 34.7 x 22 cm, London, British Museum (inv. no. 1912-12-14-16)

LITERATURE
Schatborn 1979, 122, 123, 126 (illus. no. 14, as possibly by Abraham van den Tempel), 128, no. 28

COLLECTION CATALOGUES
London 1915–32, 3:11, no. 2 (illus. pl. 4)

The angular shapes, straight lines, and regular hatching do not correspond to the flowing hand seen in Van Noordt's drawings. Schatborn has plausibly suggested Abraham van den Tempel as the author of this sheet. The sitter's dress corresponds exactly to that worn by the sitter in the *Portrait of a Woman* appearing at Sotheby's in 1951, which is signed and dated 1659 (cat. 39), indicating a date for this drawing of around the same time.

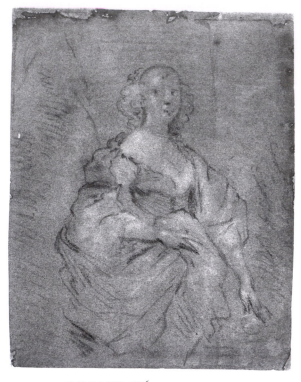

CATALOGUE DR6
Study for a Portrait of a Woman, black and white chalk on blue-grey paper, 27.3 × 21.7 cm, Madrid, Museo Cerralbo.

CATALOGUE DR6
(p) *Study for a Portrait of a Woman*
Black and white chalk on blue-grey paper, 27.3 x 21.7 cm, Madrid, Museo Cerralbo (inv. no. 4759)

COLLECTION CATALOGUES
Madrid 1976, 140, no. 123 (illus., as Johannes van Noordt)

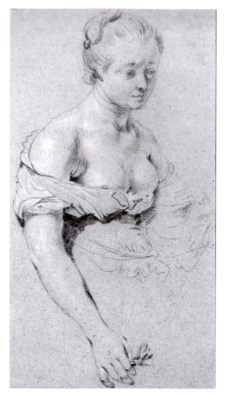

CATALOGUE DR7
A Woman with a Flower, black and white chalk on brown paper, 25.7 × 13.5 cm, Frankfurt am Main, Städelisches Kunstinstitut, Graphische Sammlung.

CATALOGUE DR7
(p) *A Woman with a Flower*
Black and white chalk on brown paper, 25.7 x 13.5 cm, Frankfurt, Städelisches Kunstinstitut (inv. no. 2.3260, as Gabriel Metsu)

LITERATURE
Van Regteren Altena 1963, 16 (illus. pl. 10, as by Jan van Noordt); Schatborn 1979, 128n31

The ubtle effects of very thin contours and hatched lines contrast with the vigour of line and form characteristic of Van Noordt's figure drawings, and place this drawing closer to the style of Gabriel Metsu.

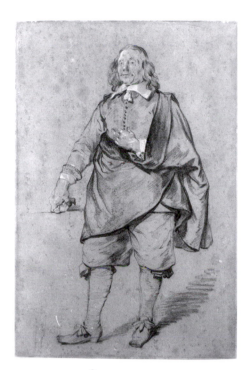

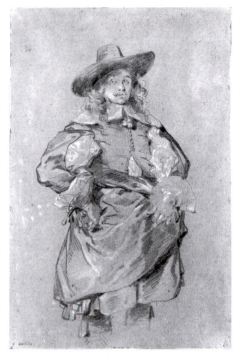

CATALOGUE DR9
Portrait of a Standing Man, black and white chalk on blue paper, 36.2 × 24 cm, Vienna, Albertina.

CATALOGUE DR8
Abraham van den Tempel, *Portrait of a Standing Man*, black and white chalk on grey paper, 34.6 × 23 cm, Rotterdam, Museum Boijmans Van Beuningen.

CATALOGUE DR8
Portrait of a Standing Man
Black and white chalk on grey paper, 34.6 x 23 cm, Rotterdam, Museum Boijmans Van Beuningen (inv. no. R74, as Abraham van den Tempel)

LITERATURE
Exhibition catalogue Rotterdam 1969, 50 (illus. no. 98, as Govert Flinck); Schatborn 1979, 121, 122, 125 (illus. fig. 11, as Jan van Noordt)

CATALOGUE DR9
(p) *Portrait of a Standing Man*
Black and white chalk on blue paper, 36.2 x 24 cm, Vienna, Albertina (inv. no. 17.585, as Metsu)

LITERATURE
Meder and Schönbrunner 1893–1908, 4: not paginated, *s.v.* Metsu, no. 427 (illus. no. 427, as Gabriel Metsu); Van Regteren Altena 1963, 16 (illus. pl. 9b); Schatborn 1979, 121, 122, 125 (illus. no. 12, as Jan van Noordt), 128n26

COLLECTION CATALOGUES
Joseph Meder, *Handzeichnungen vlämischer und holländischer Meister des XV.-XVII. Jahrhunderts*, Albertina- Facsimile, Vienna (Albertina), 1923, 8, 15 (illus. pl. 32)

The use in this drawing of thin lines, occasionally even delicately twisted and wispy, is closer to the style of Metsu than the more vigorous handling of Van Noordt.

CATALOGUE DR 10
A River Landscape with Ships
Brush and ink wash, over an older under-
drawing, 27 x 19.5 cm, monogrammed and
dated 1688, present location unknown

PROVENANCE
Sale, Frankfurt am Main (F.A.C. Prestel),
26–28 May 1930, lot 297 (as Jan van
Noordt, *Flusslandschaft mit hohem Felsen,
im Vordergrund eine Fähre mit mehreren
Rindern* [River landscape with high rocks,
in the foreground a sailing ship with some
cattle], 27 x 19.5 cm)

COLLECTION CATALOGUES
Dealer catalogue, Bern (Gutekunst &
Klipstein), Spring 1924, no. 112 (as Jan van
Noordt, *Flusslandschaft mit hohem Uferfelsen
und einer Schiffsfähre* [River landscape with
high rocky shores and a sailing ship],
27 x 19.5 cm)

The subject matter of this drawing and
its late date speak strongly against the
attribution to Jan van Noordt.

CATALOGUE DR 11
A Landscape
Coloured, Sale Diderik Baron van Leyden,
Amsterdam (Van der Schley et al.), 13 May
1811 (Lugt 7991), 78, folder "W," lot 48
(as Jan van Noort)

Judging by the subject matter and the
spelling of the artist's name, this drawing
is quite likely not by Jan van Noordt but
by another artist identified in this study
as "Jan van Noort."[1]

1 See 21.

Drawings Known Only from Literary Sources

CATALOGUE DL1
The Entombment
Pen and wash, 28.5 x 24.6 cm
Reference: *Exposition de dessins et quelques peintures du XVᵉ siècle au XVIIIᵉ siècle*, exhibition catalogue Paris (Férault), 1930, no. 25 (as Jan van Noordt)

CATALOGUE DL2
Seated Female Nude with Index Finger to her Lips
Black and white chalk on grey paper, 43 x 25.5 cm

Reference: sale, Lucerne (Fischer), 19 October 1946, lot 305 (as Jan van der Noort, *Das Schweigen*: "sitzender Frauenakt mit dem Zeigefinger auf den Mund weisend" [*Silence:* "seated female nude pointing with her index finger to her lips"].)

CATALOGUE DL3
Seated Female Nude
Black and white chalk, 43 x 26 cm
Reference: sale, Atherton Curtis et al., Bern (Klipstein), 28 April 1955, lot 363 (as Jan van Noort, *Sitzender Mädchenakt*)

CATALOGUE DL4
Portrait of Jan van de Cappelle (1626–1679)
Reference: Inventory of the artist and cloth dyer Jan van de Cappelle, G.A.A., N.A.A. 2262, Notary Adriaen Lock (*Minuutacten van Inventarissen*), dd 4 January 1680, 1191, no. 123: " *een Conterfijtsel van de overleden van van oorts tekeningh*" (a portrait of the deceased after Van Noordt's drawing)

LITERATURE
Bredius 1892, 34; Hofstede de Groot 1892, 215, no. 3; Russell 1975, 12; Nystad 1981, 712; exhibition catalogue Amsterdam 1999, 141

Prints

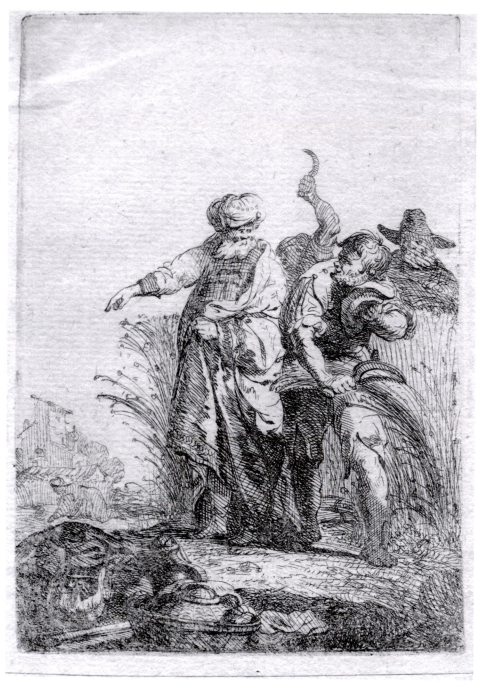

CATALOGUE P1
Boaz and Ruth, etching, 10.6 × 7.3 cm.

Prints

CATALOGUE P1
Boaz and Ruth (Ruth 2:8-13)
Etching, in one state, 10.6 x 7.3 cm

LITERATURE
Bartsch 1797, 2:95, no. 5 (as a follower of Rembrandt, *Boos et Ruth*, 3 *pouces*, 10 *lignes* x 2 *pouces*, 8 *lignes* [10.4 x 7.2 cm]: "*Boos est représenté debout au milieu de l'estampe, parlent à un moissonneur, et faisant signe de la main droite vers Ruth que l'on voit dans le fond à gauche, occupée à glaner*"); Schneider 1931, 511, no. 5; Hollstein 1949–, 14:183, no. 5 (as Jan van Noordt, ascribed by Van der Kellen)

A good impression of this etching recently surfaced at a London sale.[1] The sinuous line, fleshy figures, and distributed highlights carry forward the handling seen in the early print after Pieter van Laer (cat. P2), but also connect this work to Van Noordt's history paintings of the 1650s. For this independent composition, Van Noordt selected a theme from the Book of Ruth, depicted occasionally by followers of Rembrandt, of the meeting of the faithful but poor woman Ruth and her wealthy kinsman Boaz, which led to their marriage. The Christian tradition interprets this meeting as miraculously furthering the genealogy of the Messiah. However, within the oeuvre of Van Noordt, the theme fits among a number of depictions of the first meeting of couples, such as *Cimon and Iphigenia* and *Granida and Daifilo* (cat. 28–34), and, like them, recommends to the viewer the pursuit of true love as a moral goal, as discussed in chapter 4.

1 Sale, London (Bonhams), 30 June 2003, lot 79 (as Johannes van Noordt IV, unsold); Van der Kellen's report of an impression in Dresden could not be substantiated.

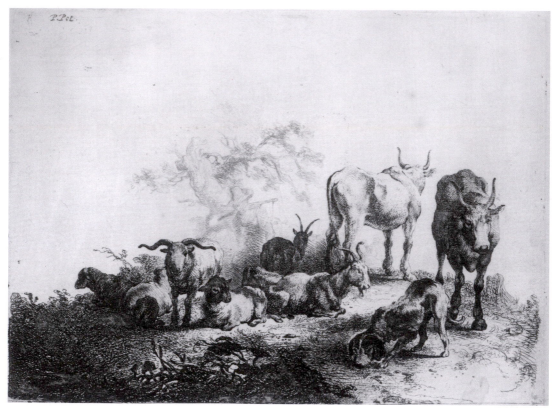

CATALOGUE P2
Landscape with Farm Animals and a Milkmaid, after Pieter van Laer, etching, 15.7 × 21.6 cm, inscribed: *PETRUS VAN LAER inv. J.V.N. fecit 1644.*

CATALOGUE P2
Landscape with Farm Animals and a Milkmaid, after Pieter van Laer, etching, in two states, 15.7 x 21.6 cm, inscribed: *PETRUS VAN LAER inv J.V.N. fecit 1644*

LITERATURE

Bartsch 1803–21, 1:16, 17 (not numbered); Heller 1836, 3:188; Heller 1854, 98; Kramm 1974, 3:1208; Andresen 1870, 2:233, no. 1; Le Blanc 1970, 3:105, no. 1; Nagler 1832–52, 4:610, nos. 2, 3; Dutuit 1970–72, 5:205, no. 2; Hofstede de Groot 1892, 210; Wurzbach 1906–10, 2:243 (*s.v. Radierungen*), no. 1; Schneider 1931, 511, no. 1; Hollstein 1949–, 14:182, no. 1 (illus.)

In this print Jan van Noordt took up the genre of rural animal scenes. In the centre and to the left are four sheep, three lying on the ground and one standing and facing the viewer. Interspersed among them are three goats, one of which is standing. To the right stand two cattle, and in front of them a dog. These animals occupy the top of a mound of earth. Behind them is a milkmaid, wearing a simple dress and a tall, wide-brimmed hat, and carrying pails of milk on a yoke over her shoulders. She walks up the other side of the hill toward the viewer, and is situated further back, so that only the upper part of her body is visible over the crest of the hill. Her figure is also shown more vaguely than the animals, emphasizing the distance from the viewer by suggesting the inter-

vening atmosphere. A strong light falls on the group from the right side, suggesting dawn or dusk.

The scene is characteristic of the work of animal painters in the Netherlands, the most prominent among them being Paulus Potter (1625–1654). The inscription identifies the inventor as the Italianate painter Pieter van Laer (1599–after 1642). Unfortunately, there does not survive any work by Van Laer that matches this scene. However, it does come close to the prints of farm animals that Van Laer produced in a series, in Rome, for Ferdinando Afan de Ribera.[1] The closest similarity is with *The Buck, Two Goats, and Three Sheep near the Woman with the Reel* (fig. 65). It shares with the present print a glowing Italianate light effect, and the grouping of different-coloured animals placed in the foreground. The claim of the inscription here, crediting Van Laer with the composition, is thus quite plausible.

The subject matter of this print is unusual for Van Noordt. It relates to only one other work in his oeuvre, the *Shepherdess and a Goatherd in a Landscape with Animals* formerly in London (cat. 35). This painted composition was likely derived from the present print. Van Noordt quickly abandoned the type, and his later pastoral depictions place much less emphasis on animals and landscape than on the figure, reflecting more the work of his teacher, Jacob Adriaensz. Backer.

The theme of rural animals also surfaces in two of the four known paintings by the other "Jan van Noort" (cat. R41, R42). There does not seem to be any connection to the present print, however. The other artist used a distinctly different signature, in block letters, and spelling the last name without a "d." Here, the initials are written calligraphically, and correspond exactly to the first three letters of the signature on Van Noordt's second print, after Lastman (cat. P2). There, he signed with his full last name, which includes the "d." Furthermore, the signature on that later print is

FIGURE 65
Pieter van Laer, *The Buck, Two Goats, and Three Sheep near the Woman with the Reel*, etching, 12.9 × 17.5 cm, Amsterdam, Rijksmuseum (photo: Rijksmuseum-Stichting Amsterdam).

similar to the one that Jan van Noordt used when he witnessed a business transaction for Jacob van den Tempel, in 1646.[2] In the second state of this print, the inscription was removed and replaced by the name of "H. Pot," which likely referred to Hendrick Pot (c. 1585–1657) as the publisher. The only other aspect distinguishing the later state is the fainter background detail.

1 Etching, 12.9 x 17.5 cm see: Hollstein 1949–, 10:4, no. 5. This print was part of a series of eight; see Hollstein 1949–, 10:10, nos. 1–8.
2 See 349n22.

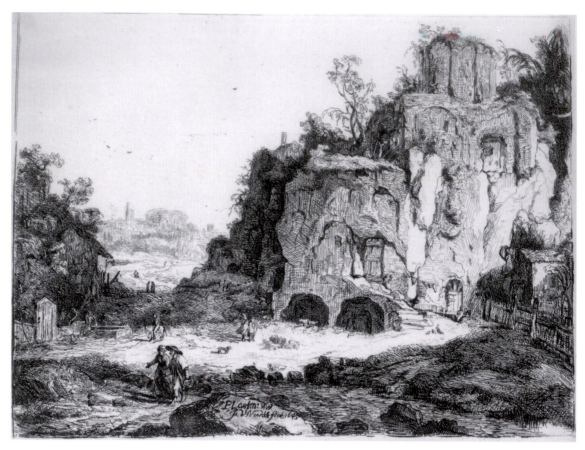

Landscape with the Temple of the Sybil at Tivoli, after Pieter Lastman, etching, 16.5 × 21.7 cm, inscribed bottom centre, on the rock: *P. Lastm: inv JVNoordt fecit 1645.*

CATALOGUE P3
Landscape with the Temple of the Sybil at Tivoli, after Pieter Lastman
Etching, in two states, 16.5 x 21.7 cm,
Inscribed bottom centre, on the rock:
Lastm: inv JVNoordt fecit 1645

LITERATURE

Bartsch 1803–21, 1:16 (not numbered); Heller 1836, 3:188; Mariette 1851–60, 3:66; Heller 1854, 98; Kramm 1974, 3, 1208–9; Andresen 1870, 2:233, no. 2; Carl Vosmaer, *Rembrandt, sa vie et ses oeuvres,* 1877, 478, no. 50; Le Blanc 1970, 3:105, no. 2; Nagler 1832–52, 10:264; Nagler 1832–52, Monogrammisten, 4:610; Hofstede de Groot 1892, 210; Wurzbach 1906–10, 2:17 (*s.v. Pieter Lastman, Radierungen, nach ihm gestochen*), no. 5, 243 (*s.v. Johannes van Noordt IV, Radierungen*), no. 2; 3:106; Freise 1911, 86, no. 124 (illus. fig. 9); Schneider 1931, 511, no. 2; Hollstein 1949–, 10:37, no. 6; 14:182, no. 2 (illus.); Larsen 1957, 111; Broos 1975/76, 205–6 (illus. fig. 6); Dutuit 1970–72, 5:205; *Exhibition of Dutch and Flemish Drawings 16th–19th Century*, exhibition catalogue London (P & D Colnaghi & Co. Ltd.), 1976, unpaginated, with no. 25; Paula Wunderbar, "Miscellanea: 1. Adriaen van der Cabel (1631–1705)," *Delineavit et Sculpsit* 1, 1989, 27; exhibition catalogue Utrecht and Frankfurt 1993, 196, 198n7

This landscape scene is dominated by the form of a large hill to the right side. It occupies the middle distance and fills nearly half the composition. At its top stands the ruin of an ancient circular tem-

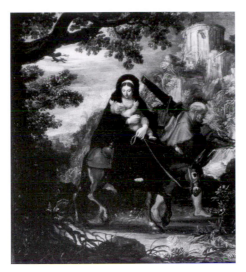

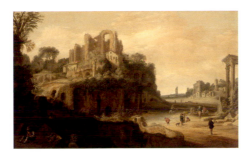

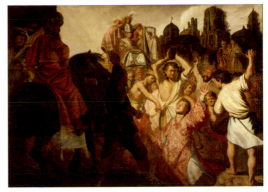

ple, which can be identified as the Temple of the Sybil, part of the Villa complex built by the Roman emperor Hadrian at Tivoli, near Rome. Other parts of this complex can also be seen. At the bottom of the hill are the remains of two vaults that have been built into its side. The setting also includes some later houses, built among the ruins to the right and left sides, and to the left a vista with another hill, which is topped with a round domed temple. The

scene is completed by staffage in the foreground and middle distance.

Besides inscribing his own name as maker of this print, on a rock in the centre foreground, Jan van Noordt also included that of Pieter Lastman as its inventor. His etching transmitted some of the characteristic traits of Lastman's style, evident in his paintings, such as the use of diagonal slopes in the background landscape, and the strong effect of light. Van Noordt evidently followed one of the landscape drawings that Pieter Lastman made during his stay in Rome from 1603 to 1607.[1] Unfortunately only one of these drawings has survived, and the specific drawing used by Van Noordt for his print has been lost.[2] These drawings provided Lastman with motifs for the landscape backgrounds of his history paintings for the rest of his career. The background in his painting *The Flight into Egypt* in Rotterdam, for example, shows a temple and a hill similar to those in the present print (fig. 66).[3] Lastman's original composition seems to have influenced Pieter Groenewegen (active 1623–1657), whose painting of the ruins of the Palatine Hill shows a striking similarity to the present print, only reversed from left to right, as Lastman's drawing would have been (fig. 67).[4] Ben Broos has also pointed out the similarity to the back-

ground of Rembrandt's *Stoning of St Stephen* in Lyon (fig. 68).[5] Lastman's drawing was evidently well known among artists, and so presented itself to the young Van Noordt as a likely model for an etching.

This etching exists in two known states that differ little from one another. The second state contains passages that have been partially burnished out and subsequently reworked. This change is most evident in the foreground rock, where the signature is placed.

1 Kurt Freise cites thirteen literary references to landscape drawings by Pieter Lastman. See Freise 1911, 192–3, nos. 57–68 (including no. 61a).

2 Pieter Lastman, *View of the Palatine Hill in Rome*, pen with brown ink, brown and grey wash over a sketch in black leadpoint, 16.4 x 23 cm, private collection. For a discussion of the place of this sheet in Lastman's stylistic development as a draughtsman, see exhibition catalogue Amsterdam 1991, 146–7, no. 26 (illus.).

3 Pieter Lastman, *The Flight into Egypt*, panel, 29 x 25.5 cm, signed and dated 1608, Rotterdam, Museum Boijmans Van Beuningen (inv. no. 1442); see collection catalogue Rotterdam 1972, 42; Freise 1911, 54–5, no. 58 (illus. fig. 6).

4 Pieter Anthonisz Groenewegen, with figures by Esaias van den Velde, *Landscape with the Ruins of the Palatine and the Forum Romana*, canvas, 56 x 90.5 cm, Amsterdam, Rijksmuseum (inv. no. A3965); see collection catalogue Amsterdam 1976, 249 (illus.). On the authorship of the figures, see Keyes 1984, 179, no. 29 (illus. pl. 375).

5 Rembrandt, *The Stoning of St Stephen*, panel, 89.5 x 123.5 cm, signed and dated 1625, Lyon, Musée des Beaux-Arts (inv. no. A2735); see Bruyn et al. 1982, 1:67–73, no. A1 (illus.). On the connection to Van Noordt's print, see Broos 1975/76, 205–6.

CATAOGUE P4
The Adoration of the Shepherds
Etching, in one state, 10.4 x 7.3 cm

LITERATURE
Bartsch 1797, 2:96, no. 4 (as a follower of Rembrandt, *Nativité de Jésus Christ*, [3 p 9 lignes x 2 pouces 8 lignes]: "*Ce sujet est éclairé par la lumière qui sort du berceau, dans lequel est couché l'enfant Jésus. La Vierge placée vers la droite de l'estampe lève la couverture, pour le montrer aux bergers. Saint Joseph est debout derrière elle. Sur le devant de la gauche on voit un berger et une bergère à genoux. Le fond, au milieu duquel on voit une grande porte ouverte, est fort ombre. Ce morceau est d'un bel effet, et gravé avec assez d'esprit; il est rare* [This scene is illuminated by the light which emanates from the crib, in which the baby Jesus lies. The Virgin placed to the right of the print lifts the cover, to show him to the shepherds. Saint Joseph is seated behind her. In the foreground left one sees a shepherd and a shepherdess on their knees. The background, in the centre of which one sees a large door, is in deep shadow. This piece has a beautiful effect, and is engraved with requisite liveliness, it is rare]"); Rovinski 1894, 2: col. 55 (Atlas no. 342, as Anonymous); Schneider 1931, 511, no. 6 (as Jan van Noordt); Hollstein 1949–, 14:183, no. 6

The rounded forms of heads and features, and the tendency toward curled lines, link this etching to Van Noordt's paintings of the late 1650s. The range of hatching to achieve texture and tone is unresolved, much as in the two signed prints by the artist (cat. P1 and P2). There is a connection to Van Noordt's painting of the same theme from this period, last in Maastricht, in the arrangement of the three main figures of the shepherd, Jesus, and Mary (cat. 9). The left–right reversal suggests that Van Noordt may have made this print after the painting.

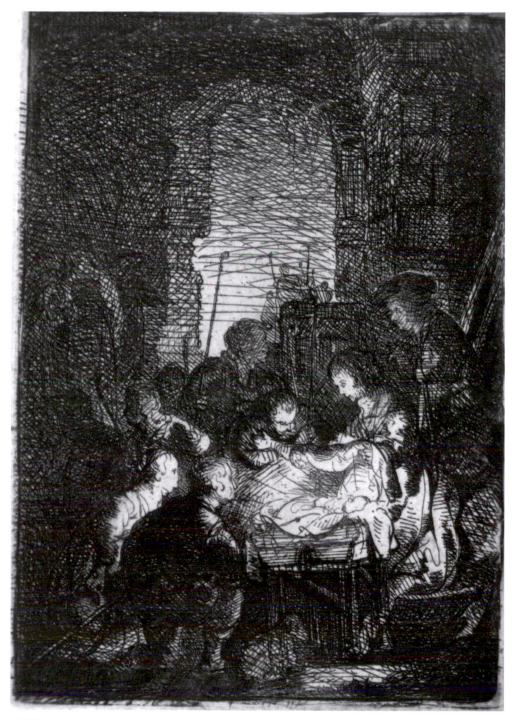

CATALOGUE P4
The Adoration of the Shepherds, etching, 10.4 × 7.3 cm.

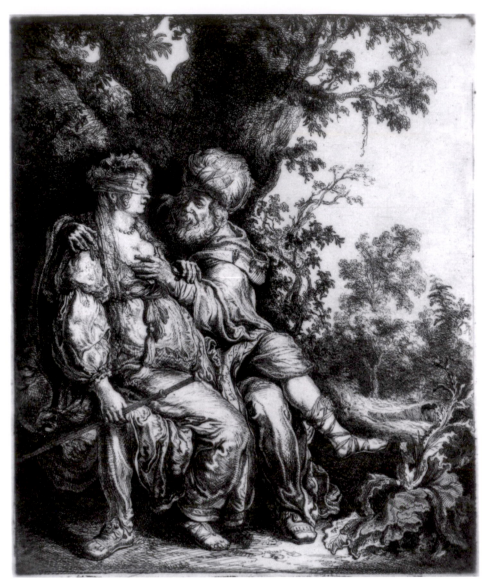

CATALOGUE PRI
Pieter Lastman, *Judah and Tamar*, etching, 21.4 × 17.6 cm, inscribed: *PL*.

Rejected Prints

CATALOGUE PRI
Pieter Lastman, *Judah and Tamar*
(Genesis 38:14-18)
Etching, in one state, 21.4 x 17.6 cm,
inscribed: *PL*

LITERATURE
Kramm 1974, 3:954; Van der Kellen 1866,
2:16 (as Jan van Noordt); Andresen 1870,
2:20; Vosmaer 1877, 480–81, no. 1 (as at-
tributed to Lastman); Rovinski 1894, 2:
col. 73, no. 74 (Atlas no. 432, as Pieter
Lastman); Wurzbach 1906–10, 2:17 (*s.v.
Lastman, Radierungen*), no. 1; 3:106 (*s.v.
Pieter Lastman*, as attributed to Jan van
Noordt); Freise 1911, 213, 218–24 (as Van
Noordt); Hollstein 1949–, 10:35, no. 1
(illus.); 14:169, with no. 3; Cornelius
Müller in Thieme-Becker, 22:413; Larsen
1957, 111, 112 (illus. fig. 1), 113n1; exhibi-
tion catalogue Milwaukee 1976, 50;
Blankert 1982, 31n5; Sluijter 1986, 110,
446n5; Manuth 1987a, 92n307

EXHIBITIONS
Berlin 1989, 751–2, no. 8/18 (illus.)

This print follows closely Lastman's painting of the same theme, last sold from the Arnon collection in New York.[1] There exists a drawing of the same composition, but the present print was clearly not based on it. Instead the print follows the painting in its elaborate detail.[2] The attribution of the print to Jan van Noordt, first made by Johan Philip van der Kellen, has not been adopted by all scholars.[3] Freise drew the link to Van Noordt's Italian landscape print after Lastman (cat. P2). He pointed to the handling of foliage as evidence; however, in the present print these parts achieve far greater volume and suggestion of softness.[4] It is generally much more accomplished than the landscape etching, which shows some rough hatching and a much weaker suggestion of form. The landscape print was likely made after a drawing, not a painting.

There is a strong possibility that this print was made by Lastman himself, as the characteristic monogram suggests. The style is not far removed from Lastman's manner of pen drawings. This print was well known. It became the basis for a painting formerly in the collection of Efim Schapiro, with the same reversed composi-

tion.[5] A second print after Lastman's painting, which greatly expands the background scenery, was made by Pieter Nolpe (1613/14–1652/53).[6]

1 Pieter Lastman, *Judah and Thamar*, panel, 123.2 x 92.7 cm, sale David Arnon et al., London (Christie's), 12 December 1959, lot 83. For a discussion of the painting with respect to the prints after it, see Larsen 1957.

2 Attributed to Pieter Lastman, *Judah and Thamar*, red chalk, 26 x 20 cm, Budapest, Szépmüvészeti Múzeum; as mentioned and illustrated in Meder and Schönbrunner, 3: no. 258; see Freise 1911, 213–14 (as not by Lastman).

3 See Literature.

4 See Freise 1911, 218–19.

5 Unknown artist, panel, 42.4 x 35.6 cm, London, collection of Efim Schapiro; see exhibition catalogue Milwaukee 1976, 50–1, no. 20 (illus.); provenance: sale, Berlin (Lepke), 6 March 1906, lot 244 (as *Judah and Thamar*, after Lastman).

6 Pieter Nolpe, after Pieter Lastman, *Judah and Tamar*, etching, 41.2 x 51 cm; see Hollstein 1949–, 14:169, no. 3. For a discussion of the relation between this print and Lastman's painting, see Freise 1911, 219, 220 (illus. pl. 12, no. 41).

CATALOGUE PR2
The Rest on the Flight into Egypt
Etching, in one state, 9.4 x 6.6 cm, dated lower left, beside the donkey: *1642*

LITERATURE
Bartsch 1797, vol. 2, 97, no. 6 (as follower of Rembrandt, *Un Repos en Egypte*, 3 p, 61 x 2 p, 51 [9.4 x 6.5 cm]: "Pièce de nuit joliment exécutée dans le goût de Rembrandt, quoiqu'elle ne semble pas être de lui. Saint Joseph est placé au milieu de l'estampe, ayant la tête appuyée sur sa main gauche, et tenant un bâton de la droite. La Vierge est à côté de lui, avec l'enfant Jésus sur ses genoux. Ils sont tous deux assis sur une butte au bas de quelques arbres, à une branche desquels est attachée une lanterne qui éclaire tout le sujet. L'âne est couché sur le devant à la gauche de l'estampe. On lit au bas vers le milieu l'année 1642. Ce morceau est rare" [Night scene beautifully executed in the manner of Rembrandt, although it does not seem to be by him. Saint Joseph is placed in the centre of the print, having his head leaning on his left hand, and holding a stick in his right. The Virgin is at his side, with the baby Jesus on her knees. Both of them are seated on a mound below some trees, on one branch of which hangs a lantern which lights the entire scene. One reads below towards the centre the year 1642. This piece is rare].); Rovinski 1894, 2: col. 55, no. 4 (Atlas no. 340, as Anonymous); Schneider 1931, 511, no. 4; Hollstein 1949–, 14:186, no. 6

The regular hatching of this dark scene announces a confident and experienced hand. The date of 1642, already noted by Bartsch, places it before Van Noordt's earliest signed prints, which show much greater hesitation and unevenness.

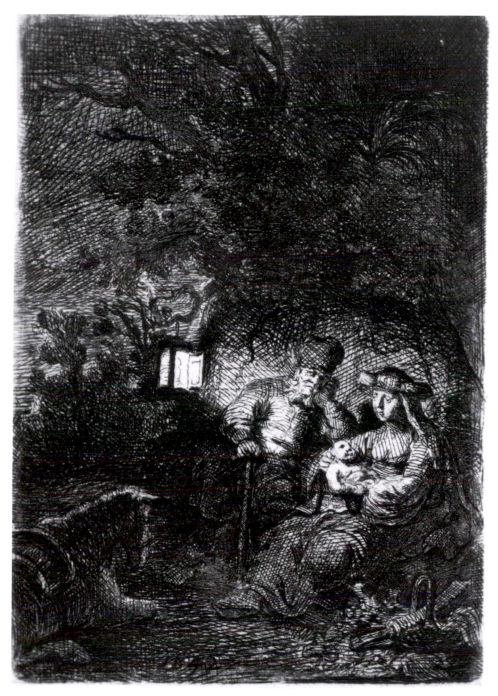

CATALOGUE PR2
The Rest on the Flight into Egypt, etching, 9.4 × 6.6 cm, dated 1642.

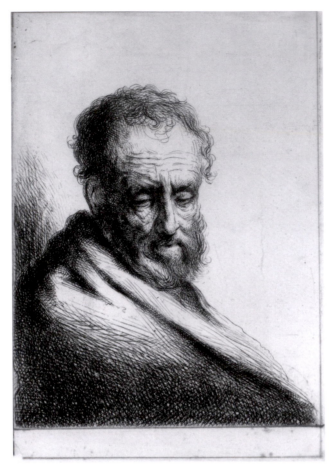

CATALOGUE PR3
Head of an Old Man, after
Rembrandt or follower,
etching, 16.9 × 12.5 cm.

CATALOGUE PR3
Head of an Old Man, after a follower of
Rembrandt, etching, 16.9 x 12.5 cm

LITERATURE
Nagler 1832–52, 4:610, Rovinsky 1984, 2:
col. 67, with no. 66B (as attributed to Ger-
brand van den Eeckhout); Schneider 1931,
511, no. 3 (as Jan van Noordt); Hollstein
1949–, 14:183, no. 9 (illus.); collection cat-
alogue Oxford 1999, 103–4, 202 (illus. fig.
8, as Johannes van Noort)

This print reproduces a painting done
in Rembrandt's style in Oxford.[1]
There is little evidence, beyond the ten-
dency toward curled lines, to connect this
print to Van Noordt. It does not display

the variation of hatching characteristic of
the two signed prints by him, which reap-
pears in the print *Adoration of the Shepherds*
(cat. P3).

1 Panel, 16 x 13 cm, Oxford, Ashmolean Museum
(inv. no. A804); see Literature, 1999.

Prints Known Only from Literary Sources

CATALOGUE PL1
St Christopher (after Adam Elsheimer)
Etching, dimensions not known
Reference: Mariette 1851–60, 2:223
(as Van Noordt)

LITERATURE
Schneider 1931, 511, no. 7 (as Van Noordt)

CATALOGUE PL2
51 etchings
Dimensions not known
Reference: Jan Yver sale, Amsterdam, 25 March 1816 (Lugt 8845) (as "*Het eigen geëtste werkje van J. van Noort, 51 stuks* [The autograph etched work by J. van Noordt, 51 pieces]")

LITERATURE
Kramm 1974, 1209; Hofstede de Groot 1892, 210 (as by an eighteenth-century J. van Noort, active in Leiden); Groeneveld and Den Hertog 1987, 126n44 (as perhaps by Van Noordt)

As Hofstede de Groot suggested, these prints are likely by a later namesake of the artist.

CATALOGUE PL3
A Hunter with his Dogs
Etching, 31.5 x 20.2 cm
Reference: Jan Gijsbert baron Stolk de Soelen sale, Amsterdam (C.F. Roos), 31 March 1851 (Lugt 20277), 23, portfolio 17, lot 314 (as Dirck Stoop, "*Un homme entourée de plusieurs lévriers, pièce inconnue* [A Man Surrounded by Several Greyhounds, unknown piece]," for *f*49.– to Engelbertsz)

LITERATURE
Schneider 1931, 511, no. 8; Hollstein 1949–, 14:183, no. 8

The attribution was made by Van der Kellen in manuscript annotations at the Rijksprentenkabinet in Amsterdam and cannot be verified. The subject matter does not relate closely to Van Noordt's known oeuvre.

Documents Pertaining to the Life of Jan van Noordt

ABBREVIATIONS

D.B.K. / *Desolate Boedels Kamer* (Chamber of Bankrupt Estates)
D.T.B. / *Doop Ondertrouw Begravenis* (Baptism, Marriage, Burial)
G.A.A. / *Gemeentelijk Archiefdienst Amsterdam* (Amsterdam Municipal Archive)
N.A.A. / G.A.A. 5072, *Notariëel Archief Amsterdam* (Amsterdam Notarial Archive)
RKD / *Rijksbureau voor Kunsthistorische Documentatie* (Netherlands Institute for
 Art History), The Hague
W.K. / *Weeskamer* (Chamber for Orphans)

1602, 19 November: G.A.A. D.T.B. 1144 (Burial), 60. Burial of Daniel van den Oort, living "*inde Clauisingel*" (in the clavecembalo) in the Carthusian Cemetery.

1607, 24 July: G.A.A. 5073 (W.K.) no. 546, (*Inbrengregister* [Entrance Register] 14), fol. 315v. Jacques de la Verdure, son of Marijken Cornelisdr van Roosendael and Jacques de la Verdure, receives items out of the estate of his mother from the house of her deceased second husband, Daniel van Oort, who had been a builder of clavecembalos.

1640, 19 December: G.A.A. 5004 (Burial Register of the W.K.), no. 20 (*Zuiderkerk* and *kerkhof*). Burial of Jannitgen Jacobs, wife of Sybrandus van Noordt and mother of Jan van Noordt. "*Jannitgen Jacobs bij Rusland op d'hoeck van Slijckstraet School-meesters vrou*" (Jannitgen Jacobs at Rusland on the corner of the Slijkstraet, School-teacher's wife).

1641, 20 June: G.A.A. 5073 (W.K.) no. 796, (*Inbrengregister* no. 25), folio 44r. Sybrandus van Noordt registers with the Chamber of Orphans the inheritance of his three children who are not of the age of majority from their mother. They are to receive 1200 guilders, or 400 guilders each.
"Den 20 Juny 1641 heeft Sijbrant van Noort schoolmr. bewesen zij drije kindr. als Anthoni out 22 Jaren, Johannes out 17 Jaren ende Lucas out 13 Jaren daer moe-ders aft was Jannitgen Jacobs van haer moeders erf tesamen de somme van Twaelf-hondert gulden ens daer voren hij beloofd borge te stellen. Ende zal zijn voorzg. kindr. houden met belovde goede ende onder verbant ende de zal hij voors blijven Sitten ende te behaechde Jacobus van Noort de mondige broeder van kinde. pre-sent Frederic de Vrij ende Mr. Albert Bas Weesmrs."
(The 20th June 1641 Sijbrant van Noort Schoolteacher presented his three chil-dren, being Anthoni 22 years old[,] Johannes 17 years old and Lucas 13 years old whose deceased mother was Jannitgen Jacobs[,] promises to post a deposit for their inheritance from their mother together a sum of twelve hundred guilders. And shall keep the aforementioned children with the promised goods and within stric-tures and shall furthermore remain where he is and to the approval of Jacobus van Noordt the brother of the children who has reached the age of majority, in the presence of Frederic de Vrij and Mr. Albert Bas Orphan Officials.)

1646, 4 March: N.A.A. 993, Notary Jan Bosch, document no. 19, fol. 9r. Jan van Noordt witnesses to a note drawn up for the Portuguese Jew Jacob Ferro, naming the Leiden merchant Jacob van den Tempel and the dyer Jacob Uytenhove as cred-itors, for goods purchased from Isaac Rocamora of Leiden. The margin notes record the subsequent payment. The first note, dated 4 June 1646, records the col-lection by the sheriff from Ferro, for Rocamora, at the request of Van den Tempel. It also cites an obligatory note to Jacob van den Tempel, drafted in Leiden and dated 30 May 1646, to which Jan van Noordt bears witness, in Amsterdam. The second note, at the bottom, confirms that Ferro has paid Rocamora.

1648, 25 November. Leiden City Archive 506 (Old Notarial Acts) no. 754, Notary Arendt Joachimsz Raven (*Minuutacten*) document nos. 198 and 199. Jan van Noordt signs as witness to a codicil to the testament of the painter and cloth merchant Abraham van den Tempel, in Leiden.

1668, 18 January: Naarden City Archive, Old Notarial Archive no. 3678 3, Notary Jacob Atten. Jan van Noordt acts on behalf of Adriana Kosters, the only child of Dr Samuel Coster. Van Noordt is authorized to transfer to Adriana the ownership of a double grave in the Nieuwe Zijds Capel in Amsterdam. She is entitled to this grave, being the only daughter of the only son of its occupant, Adriaen Lenaartsz.

"Comparerende voor mij Jacob Atten van d'eed. Heere van Holland geadmitteert openbaer Notaris binnen Naerden ende getuigen nagenoemt de Eerb. Joffr. Aertjen Kosters, dochter van de Eerb. Heere Dr Samuel Koster za: inwoon. ende erve deser stede voorn., verklaert geconstitueert ende gemachticht te hebben gelijk sij constitueert ende macht mits dese d'E: Mr Joannes van Noort burger tot Amsterdam, omme in den name ende van wege haer comparant te procureren ende bevorderen dat bij de heeren Kerkmeesteren van de Nieuwe Sydt Capel aldaer seker graf leggende in deselve kerke achter de preekstoel gekomen van Adriaen Lenaerts[1] haer Comparantes voornoemde Vaders Vader za: op de naem van haer Comparantes overgedragen ende gestelt mede alsoo sij verklaert te wesen, een eenigh kint en erfgename van gemelde haer Vader Samuel Koster Za: de welke mede een eenigh kind en erfgenaem van Adriaen Lenaarts geweest is. Belovende voorgoed ende van waerde te houden tgene dese aengaen by den Geconstitueerde gedaenende verricht sal werden. Gepasseert binnen Naerden ten compoire mijns Notarij ter presentie van Eers. Jan Storm ende Jan Atten als getuigen die dese minute neffen mij Notaris get. hier te verricht sijnde getekent hebben op de 18 jan. a° 1668
Welk getuige ik
J. Storm
Jan Atten
J. Atten Nots. 1668 1/18"
(Appearing before me Jacob Atten Public Notary in Naarden admitted by the Honourable Lords of Holland and witnesses, hereafter named the Honourable Miss Aertjen[sic] Kosters, daughter of the late Honourable Dr Samuel Koster, dwelling and property in this city abovenamed, declares to have appointed and empowered, just as she appoints and empowers herein, the Honourable Mr Joannes van Noort burger of Amsterdam, in the name and according to the will of her the party to procure and proceed with the Lord Churchmasters of the Nieuwe Zijds Capel there a certain grave lying in the same church behind the pulpit coming from Adriaen Lenaerts[1] the party aforenamed her late father's father, be transferred to and placed under the name of the party, such as she declares to be, an only child and heir of aforementioned father Samuel Coster, deceased, who was the only child and heir of Adriaen Lenaerts. Promising to hold as true and good, everything that pertains to this according to the party shall be carried out. Passed in Naarden at the office of my Notary in the presence of the honourable Jan Storm and Jan Atten

who have signed along with me the Notary as witnesses to this minute having been drawn up on the 18th of January 1668)

1. In the margin: "*In syn leven stadts timmer man*" (During his life city carpenter).

1668, 25 January: Naarden City Archive, Old Notarial Archive no. 3679 A30, Notary Jacob Atten. Jan van Noordt is authorized by Adriana Kosters to sell the double grave in the Nieuwe Zijds Capel occupied by her deceased grandfather Adriaen Lenaartsz. Van Noordt is specifically mentioned as a "*Konstrijk Schilder*" (artful painter).

"Comparerende voor mij Jacob Atten Bij d'Ed. Hove van Hollt geadmitteerde openbaer Notaris binnen Naerden ende de getuigen nagenoemt e'Eerb. Juffr. Adriana Kosters inwoonder te deser voorn. Stede Verclaert, geconstitueert ende gemagtigt te hebben gelijk sij sulks doet bij dese – d'Ed: Jan van Noort konstrijk Schilder t'Amsterdam, omme in't den name ende van wegh haer constituante te verkopen, voor soodanigh somma van pennighen als hem de constitueerde goe duncken ende geraden achter sal, seeker haer constituantes Grafstede leggende inde Capel genaemde Heijligestede, haer als eenige kint ende erfgenaem van d'Eer: Hr. Samuel Koster za: competerende 'tselve te cederen ende trans: porteren daer ende soo't behoren sal, eigendom ende quitinghe te passeren, voor d'evictie te causeren haer persoon ende goederen daernvoor te verbinden – de kooppenningh t'ontfangen, somma alles ende in alle gevalle dese aengaende te doen ende laten geschieden al gene sij constiuante self somme present sijnde soude de komme doen ende laten geschieden, belovende voor goeddende van waerde te houden ende doen houde hetgene hij Hem Geconstitueerde dese aengaende gedaen ende verrichte sal werden, onder verbant als na rechten, Gedaen binnen Naerden te comptoire mijnes Notarij ter presentie van d'Ed.B. Mr. Jan van Schagen ende Jan Atten als getuigen op den 25 Januarij aᵒ 1668–
Jan van Schaghen
Jan Atten
Welk getuige ik
J. Atten Not:
1668 1/25"

(Appearing before me Jacob Atten public Notary in Naarden admitted to the Honourable Court of Holland and the witnesses named hereafter the honourable Miss Adriana Kosters inhabitant of this aforementioned city declares to have appointed and empowered as she does herein – the honourable Jan van Noordt artful painter in Amsterdam, in her name and according to her wish to sell, for whatever sum of money as he the appointed thinks good and advise, specifically her the appointer's grave lying in the Chapel called the Heilige Stede, she as only child and heir of the Honourable Samuel Koster, deceased, to complete the surrender and transfer there as shall be appropriate, to pass on ownership and receipt, to bring about the removal[,] to bind her goods and person- to collect the sale price, in sum to carry out everything in every case pertaining to this, promising to hold and have others hold

in truth and respect that which he the Appointed shall carry out concerning this, under agreement and according to right, Carried out in Naarden at my office of Notary in the presence of the Honourable Mr Jan van Schagen and Jan Atten as witnesses on the 15th of January in the year 1668.)

1668, 3 July: N.A.A. 3607, Notary Antonij van de Ven (*Minuutacten*) folio 10r,v. The third document related to Adriana Kosters is an Amsterdam record of the sale of the grave, by Jan van Noordt, to a Mr Gerrit Luijks.

"Op Huijden den Derden Julij 1668 Compareerden voor mij Antonij van de Ven bij den H. Nots. ende de nagenoemde getuijgen, Hr. Jan van Noordt konst schilder wonende hier ter stede als procuratie hebbende van Juff. Adriana Kosters in dato den 25 Januarij 1668 voorden Notaris Jacob Atten ende seeker getuijgen- tot Naarden gepaseert, ende verclaerde in dien qualiteijt vercogt, getransporteert, ende (in vollen eijgendom) overgegaen te hebben, geen hij doet bij desen – aen ende te behoeve Hr. Gerrit Luijks – Coopman alhier en dubbelt graftstede liggende achter de predickstoel in de Nieuwe Sijts Cappel N⁰. 35 & 36 – en dat om ende voor Seecker somme van penningh daeroom den verkoper bekent voldan ende betaelt te zijn den eersten penningh, metten laesten, den voorgn. Coper daervan niet alleen quiterende, en vercogt oock dit voor een dubbelt graftestede tallen dage jegens eenen tegelijcken ter vrijen ende vrij te waren, maer oock om te causeren hij Compt. de Heren Kerckmr. van den Nieuwe Sijts Capel voorn. om de gemelte dubbelt graftstede op de boecken van den naer (en op sijne) van de voorgn. Juffw. Costers namens voorall sijne verbint hij Compt. qualitate qua sijn persoon ende goederen roerend en anstaend hebbende ende getuijgend, alle de selve ende den keur van dien submitterende ten Gedwongen van alle Rechten ende Gerechten Ten goed vertrouwen Ende consisterde mij Nots: hier van te horen op dese date Gepasseerd binnen Amsterdam ter presentie van Abram Theunemans ende Abraham van Bergman als getuigen – –"

A. Teunemans Joan: v. Noordt

A. van Ven

Not

(Today the Third of July 1668 before me Antonij van de Ven Notary [in Amsterdam] with the Court and the witnesses named hereafter, appeared Mr Jan van Noordt painter living in this city as having authorization from Miss Adriana Kosters dating to 25 January 1668 passes before the Notary Jacob Atten and certain witnesses in Naarden, and declared in this capacity to have sold, transferred, and (in complete ownership) surrendered, which he does herein, to and to the discretion of Mr. Gerrit Luijks- merchant in this place a double grave lying behind the pulpit in the Nieuwe Zijds Capel No. 35 & 36 and that by and for a certain sum of money which is known to the seller has been completed and paid the first penny together with the last, the aforementioned Buyer not only receiving, and buying also this for a double grave for all time against and opposition, as free and being free, but also that he the party cause the Lord Churchmasters of the Nieuwe Zijds Capel abovementioned to record the double grave of hers of the according to

(and on his) the aforementioned Miss Coster's name. Above all he commits accordingly his person and goods portable and real estate having and witnessing, submitting all the same to the discretion of the Power of all Rights and Judgements in good Faith and I Notary assert to have heard on this day passed in Amsterdam in the presence of Abram Theunemans and Abraham van Bergman as witnesses)

1670 (no date). G.A.A. 5026, *Requesten*, 370a, third folder, fol. 789. Jan van Noordt and his brother Anthoni request that the Justices of Amsterdam take action against a certain Arent Brouwer. Brouwer had courted the maid of the Van Noordt brothers, Trijntje Bartels, and had been rejected. For the previous seven months, he had been harassing the three of them on the street.

"Aen de Ad. Heeren van den Gerechte der stadt Amsterdam.

Geven eerbiedelijck te kennen, mr. Anthoni van Noort, organist van de Niewe Kercke alhier ende Jan van Noort, sijn broeder, hoe dat hun supplianten dinstmaaght Trijntjen Bartels een tijdt langh door eenen Arent Brouwer, sijderedersgesel, gevrijt sijnde, deselve haar dienstmaacht de voors. Arent Brouwer heeft affgeslagen; 't is nu sulx, Edele Achtebare Heeren dat de voors. Arent Brouwer nu al seven maanden herwaartz dagelijcx groote insolentie end moetwillicheit ontrent hun supplianten huys heeft gepleeght ende dat deselve, wanneer hij de voors. Trijntjen Bartels oft hun supplianten op de straat rescontreert, telckenmaalen in presentie van eerlijcke luyden aerant, scheldende de suppliante ende hun voors. dienstmaacht sulx uyt dat sich de luyden met meenichten daarontrent vergaderen, 't welck nu veele maalen is geschiet; dat mede de supplianten hun uur gunt voors. hebben geaderesseert gehadt aen wijlen den Ed. Heer Dr. Cornelis Witzen, in zijn leven hooftofficier deser stede die de voors. Brouwer al heeft gedaen interdiceren, doch evenwel in sijn boosheit voortvarende, sulx dat sij supplianten[1] dagelijcx de straat met vrede niet konnen gebruycken; derhalven keren hun de supplianten tot U. Ed. Achtbaerheiden, eerbidelijck versoeckende dat deselve, regart nemende in desen, gelieven den voors. Arent Brouwer te gelasten dat hij van sijn voos. insolentie ende gewelt sal affstandt doen, oft mijnheer den officer de saack inhanden te stellen ende de voortz daarover te disponeren sulx als U, Ed. Achtbaerheiden naar recht, reden, ende billicheit verstaen sullen te behoren. 't Welck doende etc." (My thanks to S.A.C. Dudok van Heel for his transcription of this document.)

(To the Honourable Lords of Justice of the city of Amsterdam)

Make known with all due respect, Mr. Anthoni van Noordt, organist of the Nieuwe Kerk here and Jan van Noordt, his brother, how the plaintiffs' maidservant having been courted for a time by one Arent Brouwer, silk weaver, their maid rejected the aforementioned Arent Brouwer; 'tis now so, Honourable Esteemed Sirs that the aforementioned Arent Brouwer for seven months already has perpetrated great insult and contempt against the plaintiffs, whenever he encounters the aforementioned Trijnten Bartels or the plaintiffs on the street, repeatedly in the presence of respectable persons in the vicinity, cursing the plaintiffs and their aforementioned maidservant, such that people gather around in a crowd, which has now happened many times; that also the plaintiffs have addressed their concern to the

Honourable deceased Sir Dr Cornelis Witsen, in his life chief officer of this city who already reprimanded the aforementioned Arent Brouwer, nonetheless, continuing on with his abuses, so that every day the plaintiffs[1] were unable to use the streets in peace, therefore the plaintiffs turn to you, Honourable Esteemed Sirs, with all due respect seek that the same, consider this, please order the aforementioned Arent Brouwer that he desist in his aforementioned insults and violence, or place the matter in the hands of my Lord the Officer and proceed with it as your Honourable Esteemed Sirs deem according to justice, reason, and efficiency, which shall be done etc.)

1. In the margin: "noch oock hun gemelte dinstmaaght" (nor their aforementioned maidservant).

1671, 3 December. G.A.A. 5072 (D.B.K.) 738, folio 44. Jan van Noordt is named as a creditor to the estate of his brother Jacobus van Noordt, who has declared bankruptcy.

1671, 18 December. G.A.A. 5072 (D.B.K.) 738, folio 49 (18 December 1671). Jan van Noordt, as creditor, claims items from the house of his brother Jacobus, including portraits of his father and grandfather and of his two brothers, and a *Granida and Daifilo*. Although the paintings are likely by him, he is not mentioned as their author.
"Johannes van Noort eijscher Contra de curateurs van de boedel van Jacob van Noort, Gedagen
Commissarisen admitteren eyscher als sijn eygen saeken te moogenemen de schilderijen hiernaer gespecificeert berustende inde boedel van Jacob van Noort, als naementlyck een schilderij van de eysschers beste vader en van syn vaeder twee van syn broeders, ende een schilderij van Granida en Deyfilo. Bij aldus de eysscher by eede sal willen verclaeren van deselve schilderijen eygen toe behoren welckx eed hij geconsenteert by eed te doen, Actum et presentibus utsupre."
(Johannes van Noordt plaintiff against the trustees of the estate of Jacob van Noordt, summoned.
The commissioners allow the plaintiff to take as his own property the paintings hereafter specified in the estate of Jacob van Noordt, namely a painting of the plaintiff's dear father and of his grandfather[,] two of his brothers, and a painting of Granida and Daifilo. The plaintiff wishes herein to declare under oath that the same paintings belong to him which he consented to do under oath.)

1673 July (no specific date). N.A.A. 3032, Notary Henrik Venkel, (not paginated). Jan van Noordt empowers the wine merchant Pieter van Hartochvelt to collect his debts for him.
"Heeden den [] Julij 1673 compareerde voor mij Henrik Venkel, Nots. Pb. in presentie van naergen. getn. Hr. Johannes van Noort, won. binnen deser stadt, verbleken bij desen verclaerde te constitueren Hr. Pieter van Hartochvelt, wijnkoper

alhier, omme van alle hij gel. sijne debieturen t'eijsschen en ontfangen, sodanige sommen van penn., als Edln der seven bevonden sal werden aen hem const. schuldich te zijn, volgen die reken ende bescheijden daer en zijnde, der geconst. ten hande gestelt, en. ontfn. quitantie te veragteren, ende voor naermaninge (ist noot) te causeren, alle opposanten ende weijgenaers tot betalen bij behooven middelen gerechten te constiugeren ter dien eijnde van dEhr Schepen Extrs, dHrn. Commisse van. desolate Boedels, zee, en kleijne saken, ende voor hoedanige andere heren, hoven gerechten, ende rechteren, Daert. ende eijsschen sal, ende commiseren aldaer op ende jegens eenen tegen t'ageren ende recht te spreken, so wel eijsschen, als verwensn. in omnibus ad lites in communis forma. ende voorts te Beloven, aldus gedaen t'Amst. punt."

(Today the [] July 1673 before me Henrik Venkel, Notary Public in the presence of witnesses mentioned below, appeared Mr Johannes van Noort, living in this city, and herewith declares to appoint Mr Pieter van Harochvelt, wine buyer here, to collect and demand from all the debtors named by him, such sums of money as the Honourable Seven shall deem to be owed to him the party, according to the relevant figures and documents that have been given to the Appointee and to undertake to secure the receipt and to issue a warning (if necessary) to bring to payment all those who resist and refuse using the appropriate legal means to this end with the Honourable Justices Extraordinary, the Committee of Bankrupt Estates, Sea and Small Affairs and before such other Lords, courts of justice, and judges, shall claim against them and submit there to and against to act against and to demand justice, demands, as much as requests, in everything according to the usual way, and furthermore to promise, thus done in Amsterdam etc.)

1674, 16 April. N.A.A. 3731a, Notary Pieter Sas (*Minuutacten*), fol. 115r,v: Jan van Noordt appoints the merchant Jacob van den Tempel (brother of the artist Abraham van den Tempel) to collect debts for him.

"Op Huijden den 16de April aº 1674 compareerde voor mij Pieter Sas Notaris publicq ende in presentie van de naebest. getuijgen Hr. Johannes van Noort woonende op de blomgracht binnen deser stede, ende verclaerde den voorn. comparant geconstitueert ende machtigh gemaeckt te hebben sulcx doende mits desen d'eersame Jacob van den Tempel, mede wonende alhier, om uijt sijn comparants naem ende van sijn nent wegen alle sijnne saeken waer te nemen – alle schulden actien en pretentien die bij sijn voorn:– geconstitueerde alrede opgegeven heeft en noch bekent maken sal te innen vordern ende te ontfangen, van allen ontfangen quitantie te passeren ende voor naermaningh, ist noot, te causeren – alles inde min en vrintschap ist doenelijk, indien met door middelen van Justitie, tot dien eijnde te compareren voor alle heeren gerechten ende rechteren als vereijsschen ende requireren sal ende aldaer op ende tegens reparij gelijcken der Hr: debiteuren, ende alle andere hen parthijie makende te ageren ende recht te spreeken soo int eijsschen als verweren in omnibus ad lites in communi forma: sententien te versoeken, te hooren pronuntieren, die te doen executeren ende de saecken ten uijte eijnde toe te vervolgen, authoriserende hij comparant sijn voorn. geconstitueerde mede: om met een

342

ijgelijk te mogen accorderen, compromisseren ende verdragen, tot dien eijnde in te gaen tijkenen ende passeren soodanige compromissen accorderen ende andere ac- tein met ofte sonder pena onder ofte sonder condemnatie van soodanigen heren hoven ende gerechten als requireren sal, ende voorts noch in desen soo in als buij- ten rechten alles meer te doen ende ten laten sals hij comparant selfs present sijnde soude konnen often mogen doen, alwart ook soo dat de sake nader ofte speciiael- der last vereijsschen dan voorn: staet, Beloovende ende: alles oprecht gedaen t/ Amsterdam ter presentie van Gijsbert ende Johannes Tenchinck als get. ende"

Joan: V. Noordt

gijsbert tenchinck

johannes tenchinck

Quod attestor

Pieter Sas

Nots

(Today the 16th of April 1674 appeared before me Pieter Sas Notary Public and in the presence of witnesses mentioned below Mr Johannes van Noort living on the Bloemgracht in this city, and the abovenamed party declared to have appointed and empowered herewith the honourable Jacob van den Tempel, also living here, to take account of all his affairs in his name and at his behest, to collect all debts such as the abovementioned party has already submitted and will disclose[,] to demand the payment and to collect, to cause receipt of all that is collected, and to issue warning if necessary, everything in love and friendship as is common, if necessary by means of Justice, to this end to appear before all Lords of Justice and judges as will be demanded and required[,] and there to act to and against restitution just as the Lord debtors and all others who take stand[,] to act and demand justice in de- manding as well as in claiming in everything according to the usual way: to seek sentences, to declare, and to see done, and to pursue every case as far as is possible, the party authorizes the aforementioned Appointee also, to make arrangements, settle compromises with everyone, and other acts with or without penalty such as the Lord Justices and Judges shall require, and furthermore in these as well as out of court to do and to have done just as if the party would be able to do if he himself were present, even if the affair requires greater special trouble than aforemen- tioned: Promises and everything done rightfully in Amsterdam in the presence of Gijsbert and Johannes Tenchinck as witnesses etc.)

1675, 2 May. N.A.A. 4370, Notary Silas van Jaerlant (*Minuutacten*), fols. 195r,v. At the behest of a certain Abraham Blanck, an inventory is drawn up of the contents of a house on the Egelantiersgracht. It had been occupied by the painter Jan van Noordt and the "Eye-master" (possibly a spectacle-maker) Mr. Valencijn, who had vacated it recently. Even though the document claims that the two men had been living there, the goods left behind more closely reflect use as an atelier than as a residence.

"Op huijden den 2 Maij 1675 hebbe ick Silas van Jaarland nots. publ. de. mij uijt- ten name en van wegen Abraham Blanck neffens den selven gemelt sijn huyse sta-

ende eijnde Egelantiers gracht alwart voor desen, soo mij geseijt een, Mr. Valen-
teijn oogmeester ende Johannes van Noort schilder gewont hadden ende eergiste-
ren daer uijt vertrocken waren en aldaer de naervolgende goederen, mij in het
voorn. huijs bevonden , geinventariseert ende opgest. door mij, het meeste ende
kleijnde (zoo het niet wegende) goet op het achterkamertje boven de keucken ge-
slag ende versegelt

omtrent 25 stux tijkengoet
drie en twintige boecken ofte
bondels soo klijn als groot tijken
werck gebonden in een bondel
linnen deeckens, en secreet koffertje
ende een kussen
drie houten doosjens en twee boeckjes
een stuck root trijp [crossed out]
een (portret en eenige blommen) [crossed out] *hooft van een man*
eenige bloemen
een portraict van een vrou
twee kleyne hoofjes
een begonne stuck met drie tro.
een portret van do. danckerts
twee paneelen
een stuk root trijp met een
satijne rock
eenige boecken
een lantaren
in de (binnen kamer [crossed out]*) keuken*
twee tafels [crossed out]
een hout tafeltje
twee stoelen
op de solder
9 peeneelen
2 stoelen
2 tafeltjes
2 esels om op te schilderen
in't voorhuijs
een christus
een contrefeijtsel van een out man
een bort met den turckxsen oogmeester

Aldus desen geinventarisert op wesen
dato —- present Daniel Luycken en
Johannes Martini als getuijgen
IJaarland

not publ.

JMartini

D: Luycken

(Today the 2nd of May, I, Silas van Jaarland notary public, in the name of and at the behest of Abraham Blank accompanying the same aforementioned in his house standing at the end of the Egelantiersgracht where previously, so I am told, a Mr Valentijn eye-master and Johannes van Noort painter had lived and vacated the day before yesterday; and the following goods there, found by me in the aforementioned house, inventoried and drawn up by me, the most and the small goods, that were not heavy, stored in the back room and sealed.

-25 pieces of drawing material

-23 books or bundles of large and small drawings, bound in bundles

-linen blankets, a privy-chest,

and a small pillow

-3 wooden boxes and 2 small books

-a head of a man

-some flowers

-a piece of red tripe [crossed out]

-a (portrait and some flowers [crossed out]) head of a man

-a portait of a woman

-2 small heads

-a work just begun, with 3 heads

-a portrait of Do.[minee] Danckerts

-2 panels

-a piece of red imitation velvet, and a satin skirt

-some books

-a lantern

In the (inside room [crossed out]) kitchen,

-2 tables [crossed out]

-a small wooden table

-2 chairs

In the attic,

-9 panels

-2 chairs

-2 small tables

-2 painting easels

In the front room,

-a Christ

-a portrait of an old man

-a panel with a Turkish Eyemaster [?]

In sum these inventoried on the aforementioned date as present Daniel Luycken and Johannes Martini as witnesses)

IJaarland notary public

Notes

ABBREVIATIONS

Br. / number assigned to a painting in Bredius and Gerson 1969

D.B.K. / *Desolate Boedels Kamer* (Chamber of Bankrupt Estates)

D.T.B. / *Doop Ondertrouw Begravenis* (Baptism, Marriage, Burial)

G.A.A. / *Gemeentelijk Archiefdienst Amsterdam* (Amsterdam Municipal Archive)

L.C.I. / *Lexikon der Christlichen Ikonographie*. 1970. 4 vols. Ed. E. Kirschbaum. Rome, Freiburg, Basel, and Vienna: Herder.

N.A.A. / G.A.A. 5072, *Notariëel Archief Amsterdam* (Amsterdam Notarial Archive)

(p) / work known only through photographic reproduction

RKD / *Rijksbureau voor Kunsthistorische Documentatie* (Netherlands Institute for Art History), The Hague

Thieme-Becker / Thieme, Ulrich, Felix Becker, et al. 1907–50. *Allegemeines Künstler-Lexikon*. 37 vols. Leipzig: W. Engelman.

W.K. / *Weeskamer* (Chamber for Orphans)

INTRODUCTION

1 Sumowski 1986, 21.

2 Houbraken 1976, 3: 223–4: "*Deze eerste school ontwassen, klom hij* [Johannes Voorhout] *tot een hooger op, onder het bestier van den beruchten Joan van Noort, Historie- en poutret-schilder t'Amsterdam, onder wien hij vijf jaaren de Konst bleef oeffenen, en daar in zoor veer quam, dat hij voors niet meer als het leven ten voorwerp noodig had.*" (Having grown out of this first school, he climbed up to a higher one, under the direction of the famous Joan van Noort, History- and portrait-painter at Amsterdam, with whom he stayed for five years to practice Art, and advanced so far, that from then on he needed nothing other than nature [itself] to work from.) In seventeenth-century Dutch, the word *berucht* meant "famous." It has since shifted to its opposite, "infamous." See G.J. van Sterkenburg, *Een Glossarium van zeventiende-eeuws Nederlands*, 3rd ed., Groningen: Wolters-Noordhoff, 1977, 27.

3 Hofstede de Groot 1892, 215–18, nos. 1–24.

4 For the development of the writing of artist's biographies in the Netherlands in the nineteenth century, see Scheller 1961.

5 Robert Scheller (1961) has pointed out that this generation of scholars, in their seeming objectivity, also followed preconceptions and ideals in the search for material, especially when researching the case of Rembrandt.

6 Hofstede de Groot 1892, 218: "*Van REMBRANDT en zijn school, is er geen spoor te ontdekken.*" (Of REMBRANDT and his school, not a trace is to be discovered.)

7 See Wurzbach 1906–10, 244.

8 Kronig 1911, 147–9.

9 Decoen 1931, 9–19.

10 Bauch 1926, 56, 68n92.

11 Von Moltke 1965a, 49.

12 Schatborn 1979.

13 Nystad 1981. See cat. no. R49.

14 Sumowski 1983–94, 1:139–41.

15 Sumowski 1983–94, 5:3111–3, nos. 2134–47; 6:3735–7, nos. 2396a–2408.

16 Sumowski 1986.

17 See Hofstede de Groot 1892, 210, and Wurzbach 1906–10, 243.

18 Soeting 1980.

19 Soeting 1980, Groenveld and Den Hertog 1987, Giskes 1989, and Verhagen 1989.

20 See Hans Buijs in exhibition catalogue Lyon and Paris 1991, 109.

21 Jacob Rosenberg, Seymour Slive, and E.H. ter Kuile, *Dutch Art and Architecture: 1600 to 1800*, The Pelican History of Art, Harmondsworth, Baltimore, and Ringwood: Pelican Books, 1966.

22 Exhibition catalogue Washington, Detroit, and Amsterdam 1980–81.

CHAPTER ONE

1 See 347n2.

2 Ibid.

3 In vol. 3, Houbraken cites Voorhout as a source for his information on Theodorus Ferreris ("*Frerés,*" 1643–93): 185; Horatius Paulyn (1644/45–1674): 186; Mathias Scheits (c. 1635/40–c. 1700): 147; Ernst Stuven (c. 1660–1712): 372; and Dirk Dalens (1658/59–88): 386.

4 Houbraken's remarks on Jan van Noordt were often simply plagiarized by later writers. For the references to Van Noordt, see Weyerman 1769, 3:61; Descamps 1972, 3:209; Fiorillo 1815–20, 3:233. For a discussion of the *Nachleben* of Houbraken's text, see Cornelis 1995.

5 See Appendix (1641, 20 July). First cited in Groenveld and Den Hertog 1987, 113, 124n22.

6 See Appendix (1640, 19 December).

7 G.A.A. 5024 (Book of Resolutions of the Ruling and Old-Burgomasters), no. 1, fols. 145v and 150r. See Bijtelaar 1947, 55–6. See also Soeting 1981, 273, 279n3; and Giskes 1989, 85, 117n11.

8 G.A.A., D.T.B. 675 155, *dd* 3 January 1648. See J. A. Alderbringk Thijm, *Bouwsteenen voor Nederlandsche Muziekgeschiedenis* 3, 1881, 15. Bijtelaar does regard the family as born and established in the city (1947, 113). She points out the possible connection to a builder of clavecembalos, Daniel van Noordt, whom she gives as dying in 1607. She does not cite her source. Such a person does appear in the archive of the Chamber of Orphans in 1607; see Appendix (1607, 24 July). This may be the same person as the Daniel van Noort who died in

1602; see Appendix (1602, 19 November). His address is given as "the *Clauisimbel*," which quite likely refers to the product manufactured in that house.

9 Giskes 1989, 94–6. Dirck Sweelinck was the more illustrious connection; the fame of Dirck's father, Jan Pietersz Sweelinck, was international. His influence spread through his compositions and through his students, who exported his improvisational methods to centres such as Hamburg and Lübeck. On Anthoni's appointment, see Groenveld and Den Hertog 1987, 113, 124n22; Seiffert 1897, 88; Van Biema 1906, 189–91. Fischer claims that Anthoni started in 1638 (1960, 41).

10 See Van Noordt 1976.

11 See Groenveld and Den Hertog 1987.

12 This appointment took place on 20 August 1664: G.A.A. 5014, *Stadsrekening*, no. 2, fol. 194r. See Van Biema 1906, 186.

13 Giskes 1989, 102–6, 121n77–81.

14 G.A.A., D.T.B. 9, 244 (Oude Kerk: witnesses Anna van Erkel, Anthonij van Noort).

15 For Bol's biography, see Blankert 1982, 12–22.

16 Lastman died in 1633. Van Laer disappeared after setting out once again from Haarlem for Rome in 1642: Theodorus Schrevelius, *Harlemum, sive urbis Harlementis. Incunabula, incrementa, fortuna varia, in pace, in bello*, Leiden: Matthaeus, 1647, 290, 384. See Janeck 1968, 17–19.

17 See cat. no. 28n3.

18 On the dating of the Backer painting, see Thomas Döring, in collection catalogue Braunschweig 1990, 30, no. 14 (illus.).

19 See Appendix (1648, 25 November). The second of these two documents seems to be the one mentioned by Bredius: (1915–22, 7: [addendum] 225). The first is recorded in Bredius's annotations deposited at the RKD. See also Hofstede de Groot 1892, 211, no. 7, and Wijnman 1959, 58. On Jan van Noordt's contact with Abraham's brother Jacob in 1646, see Appendix, 1646.

20 Wijnman 1959, 67–8. Like Van Noordt, Abraham van den Tempel was also neglected by Houbraken, who only mentioned him with respect to his students. This neglect was redressed by the biographer Johan van Gool. Van Gool has Abraham van den Tempel studying with Joris van Schooten in Leiden and he may have spent some time with Van Schooten after moving to Leiden, and before striking out on his own. See Van Gool 1971, 1:38. However, it is more likely that Van Gool was wrong. Wijnman carefully pieced together the evidence indicating that Abraham was in Amsterdam, where Backer was, before this move. The work of Van den Tempel points strongly to a link with Backer (even more strongly than does the work of Jan van Noordt), who was also a family friend and the student of Abraham's father, Lambert Jacobsz. In contrast, it shows little in common with Van Schooten's work.

21 Houbraken 1976, 2:304–5.

22 Pupils usually started around the age of eleven or twelve and typically spent between three and four years with a master, often moving to a second master for a kind of finishing training for another one or two years. Ronald de Jager arrived at these estimates through the study of apprenticeship contracts (1990, 69–70). Similar figures were proposed by Josua Bruyn, in "Rembrandt's workshop: its function & production," in exhibition catalogue Berlin, Amsterdam, and London 1991–92, 69.

23 See Appendix (1646, 4 March).

24 See cat. nos. 28 and 33.

25 A dating of c. 1659 is based on close stylistic similarities with the signed and dated *Cimon and Iphigenia* in Göttingen (see cat. no. 30).

26 For further discussion of this commission, see chapter 3, 43–4.

27 Houbraken 1976, 3:223.

28 Houbraken 1976, 3:223. Houbraken states that Voorhout first trained for six years with Constantijn Verhout in Gouda, and then for five years with Jan van Noordt. Hofstede de Groot points out that Voorhout married in 1670 at the age of twenty-three, and that his lengthy period of training must have just ended. He estimates that Voorhout started with Verhout at the usual age of eleven or twelve and stayed from 1658 to 1664. His period under Jan van Noordt in Amsterdam would have spanned the years 1664–69. See Hofstede de Groot 1892, 212–13, no. 14. Independently, Schneider estimated the period in Van Noordt's atelier to be around 1670: see Hans Schneider, entry for Johannes Voorhout in Thieme-Becker, 34:543.

29 See Jaacks 1978, 56–9, and Wolff 1983.

30 Han Schneider in Thieme-Becker, 34:543. Voorhout also appeared as the assessor of an estate in Amsterdam in 1682; see Bredius 1915–22, 1:257, 260.

31 See Appendix (1668, 18 January; 1668, 25 January; 1668, 3 July). In the second document, Van Noordt is identified as a *konstrijk schilder* (artistic painter). Adriana Kosters was the only child of Dr Samuel Coster. Besides the *Schouburgh*, Coster also founded the *Neder-duytsch Akademie* (the Dutch Academy) in Amsterdam.

32 See Appendix (1670, undated). See Groenveld and Den Hertog 1987, 113, 124n28. The reference to a person with a similar name appears in the *Kohier* of 1674, a register of the tax levied in 1674 on the net worth of Amsterdam's more affluent citizens: G.A.A 5028, *Thesaurieren Extraordinaris*, inv. no. 622, *Kohier van den 200º penningh, 1674, Wijk* 43, fol. 403r. A "Jan van Oort" is listed with his wife and assessed at sixty-five guilders, which corresponds with a worth of ƒ13,000, a comfortable level of wealth. He is almost certainly the apothecary who acquired a parcel on the Prinsengracht in 1672: G.A.A 5062, *Kwijtscheldingen*, 2R, fol. 49v, *dd* 21 January 1672. He acquired his *Poorterschap*, or citizenship, in Amsterdam in 1665: G.A.A. 5033, no. 5, *Poorterboek*, book 2, 561. Another namesake of the artist married a Josijntje Renaarts in Naarden in 1662. The couple came from Amsterdam: Naarden City Archive, D.T.B. 14, 25, *dd* 25 June 1662. However, the record of this marriage in the Amsterdam Archive identifies the bridegroom as a *Schoenmaeker*, or cobbler, who came from *Culemborgh*: G.A.A., D.T.B. 482, 539, *dd* 18 March 1662.

33 See Giskes 1989, 106–9.

34 See Appendix (1671, 3 December; 1671, 18 December).

35 G.A.A., Notarial Archive 2239, Notary A. Lock, pp. 130–1, *dd* 12 May 1672; see Friso Lammertse in *Uylenburgh & Son. Art and commerce from Rembrandt to De Lairesse 1625–1675*, exhibition catalogue London (Dulwich Picture Gallery) and Amsterdam (Museum het Rembrandthuis), 2006, 84–5; on the controversy in general, see 79–103.

36 See Appendix (1673, July, no specific date). Pieter van Hartochvelt was a brother of Anthonij van Hartochvelt, who had married Elysabeth Corvers. Elysabeth's sister Elsje was married to Jan's brother Jacobus. For an outline of the genealogy of these families, see Giskes 1989, 112–5.

37 See Appendix (1674, 16 April). First cited in A.D. de Vries, "Biografische Aantekeningen," *Oud Holland* 3, 1885, 237.

38 G.A.A., D.T.B. 504, 210, *dd* 28 August 1676. See Wijnman 1959, 93n1. Jacob van den Tempel married Maritge Cornelis Witzen (no relation to the regent family of the same name), who only monogrammed the act (i.e., she presumably had not learned to write). Jacob moved in with Maritge, who lived on the Tuinstraat, a rather modest location in the Jordaan; see Wijnman 1959, 93n2. His profession was given as *factoor* (agent); he was no longer trading independently with his own capital but was in the employ of another. For Jan van Noordt's location in 1674, see Appendix (1674, 16 April).

39 See Appendix (1675, 2 May 1675). First published in Hofstede de Groot 1892, 213–14.

40 See Dudok van Heel 1982, 81–3, 90n54.

41 G.A.A., D.T.B. 1091 138, *dd* 23 February 1675 (Zuider Kerk). The first reference to this document was made by Ch.M. Dozy, "Aantekeningen uit het Archief van Amsterdam," *Tijdschrift der Vereeniging voor Noord-Nederlands Muziekgeschiedenis* 2, 1887, 221.

42 Roeloff Modeus, for example, was buried on 13 September 1664: G.A.A., D.T.B. 1047 115 (Oude Kerk). For discussion of this list see Isabella Henrietta van Eeghen, "De Amsterdamse Sint Lucasgilde in de 17de eeuw," *Jaarboek Amstelodamum* 61, 1969, 68n1, 97, 98 addendum 1, and also Oldewelt 1942. Neither author questions the list's veracity.

CHAPTER TWO

1 See Bauch 1926, 28–35.

2 See cat. no. 28n3.

3 See cat. no. 24, Provenance.

4 See cat. no. 24n2.

5 See cat. no. 33n3.

6 See the discussion of the dating of Backer's painting in cat. no. 33.

7 See cat. no. 10.

8 See cat. no. 15n2.

9 See cat. no. R10n2.

10 Cornelius Hofstede de Groot did speculate that this work was perhaps by another artist (1892, 217–18, no. 23).

11 Indeed, Backer's Flemish transformation had already been followed earlier by Van Noordt's fellow pupil under Backer, Abraham van den Tempel.

12 For a recent discussion of the meaning of the term *verscheydenheit*, see Melion 1991, 28–9, and the comment by Hessel Miedema in Miedema 1993, 153.

13 Van Mander 1973, 1:139; 2:476–80. For Lastman's responsiveness to Van Mander's theory, see Broos 1975/76, 203n9, 10, and exhibition catalogue Amsterdam 1991, 125–7. For Lastman's painting, see cat. no. 14n1.

14 See cat. no. 52n2.

15 Houbraken overlooked the Flemish models Flinck adapted, and pointed only to Italian art as a source for Flinck's lighter style. See Houbraken 1976, 2:21, and Von Moltke 1965a, 27.

16 Canvas, 85.1 x 153.7 cm, signed and dated 1643; sale, London (Christie's), 20 July 1973, lot 237. See Sumowski 1983–94, 1:194 no. 11, 214 (illus.).

17 Canvas, 200 x 237 cm, Schloß Fasanerie, Fulda, Kurhessische Hausstiftung; see Sumowski 1983–94, 1:195 no. 14, 217 (illus.).

18 Canvas, 100 x 65 cm, signed and dated 1647, Kimberley, William Humphreys Art Gallery; see Sumowski 1983–94, 2"1029 no. 647, 1079 (illus.). Von Moltke places the change in Flinck's style around 1642, but points to a still-Rembrandtesque painting of that year, *The Prodigal Son*, in Raleigh, canvas, 130 x 168.5 cm; see Von Moltke 1965a, 27, 76–7 no. 52 (illus. pl. 9).

19 *Venus and Cupid*, canvas, 87 x 71.2 cm, signed and dated 1645, Jerusalem, Israel Museum, inv. no. M2219–7–63; see Von Moltke 1965a, 86 no. 102a, 87 (illus.). *Portrait of a Man, Portrait of a Woman*, pendants, canvas, 124.5 x 94 cm (both), signed and dated 1646, Raleigh, North Carolina Museum of Art, accession nos. 58.4.2 and 58.4.3; see Sumowski 1983–94, 2:1039 nos. 702 and 703, 1134, 1135 (illus.).

20 Canvas, 465 x 450 cm, signed and dated 1658, Amsterdam, Royal Palace on the Dam, Council Chamber; see Sumowski 1983–94, 1027 no. 640, 1072 (illus.).

21 See Blankert 1975, 19–23.

22 Canvas, 319 x 240 cm, signed and dated 1650, The Hague, Huis ten Bosch, *Oranjezaal* (South Wall); see Sumowski 1983–94, 3:1785 no. 1206, 1845 (illus.). On the commission, see Brenninkmeyer-de Rooij 1982, 155 (illus. fig. 28).

23 Houbraken 1976, 2:275–6.

24 Canvas, 79 x 90 cm, signed and dated 1661, present location unknown; see Sumowski 1983–94, 6:3733 no. 2383, 3997 (illus.).

25 Canvas, 88.9 x 69.9 cm, signed and dated 1664, sale, London (Christie's), 12 April 1985, lot 134 (illus.); see Sumowski 1983–94, 3:2029 no. 1399, 2125 (illus.).

26 For the related painting by Lastman, see cat. no. 2n1; for the depiction by Moyaert in Kingston, see cat. no. 2n2.

27 *Moses Showing the Tablets of the Law*, canvas, 168.5 x 136.5 cm, signed and dated 1659, Berlin, Gemäldegalerie Staatliche Museen Preussischer Kulturbesitz, inv. no. 811; see Tümpel 1986, 286 (illus.), 392, no. 27; *Jacob Wrestling with the Angel*, canvas, 137 x 116 cm, signed, same location, inv. no. 828; see Tümpel 1986, 292 (illus.), 392, no. 29.

28 Houbraken 1976, 1:259: "*een stuk voldaen is als de meester zyn voornemen daar in bereikt heeft…*"

29 On Titian as a source for Rembrandt's rough style in his late paintings, see Van de Wetering 1998, 203–11.

30 On the interest in Titian in the northern Netherlands, see Jaap van der Veen, "Liefhebbers, handelaren en kunstenaars. Het verzamelen van schilderijen en papierkunst," in exhibition catalogue Amsterdam 1992, 123–4; Roelof van Gelder, "Noordnederlandse verzamelingen in de zeventiende eeuw," in *Verzamelen van rariteitenkabinet tot kunstmuseum*, eds. Elinoor Bergvelt, Debora J. Meijers, and Mieke Rijnders, Heerlen: Open universiteit, 1993, 127–8; and Logan 1979, 67–75, 150–7 nos. 33–6, 171–4.

31 Vasari 1963, 4:208–9.

32 Van Mander 1969a, fols. 174–7; see Van de Wetering 1991, 21.

33 Van Mander 1973, 260–1, fol. 48v.

34 Seemingly unaware of Van Mander's viewpoint, Herbert von Einem reached the conclusion that the "Late Style" of an artist is typically inimitable: "Zur Deutung des Alterstiles in der Kunstgeschichte," in *Album Amicorum J.G. van Gelder*, The Hague: Martinus Nijhoff, 1973, 90.

35 David Beck, a schoolteacher in The Hague, mentions reading Van Mander's text several times in 1624. See David Beck, *Spieghel van mijn Leven*, Hilversum: Verloren, 1993, 46 *dd* 12 February 1624, 54 *dd* 29 February 1624, 128 *dd* 6 July 1624.

CHAPTER THREE

1 An example of Backer's work for the House of Orange is his painting *Freedom*, canvas, 162.5 x 115.8 cm, Berlin, Jagdschloß Grunewald (inv. no. GK I 3073); see Sumowski 1983–94, 1: 197 no. 29, 232 (illus.). It was commissioned as an overmantel of the *Nieuwe Gallerij* of the Castle at Buren. See C. Willemijn Fock, "The Princes of Orange as Patrons of Art in the Seventeenth Century," *Apollo* 110, December 1979, 474 (illus. fig. 21); and Lunsingh Scheurleer 1987, 44, 45, 46 (illus.), 49. The high regard for Backer among Amsterdam patricians is reflected by the commissioned *Portrait of the Arquebusier's Civic Guard Company of Captain Cornelis de Graeff and Lieutenant Hendrick Lauwrensz*, canvas, 367 x 511 cm, signed and dated 1642, Amsterdam, Rijksmuseum (inv. no. C 1174). See Sumowski 1983–94, 1:203 no. 75, 278 (illus.). On the commission, see Willem Martin, "Backer's Korporaalschap uit den Kloveniersdoelen te Amsterdam," *Oud Holland* 50, 220–4 (illus. fig. 1).

2 See cat. no. 28n3.

3 Vos's poem appeared in the collection published in 1662: Vos 1662, 541. The poem was later quoted by Houbraken, (1976, 1:336–7). For the most recent discussion of it, see Weber 1991, 217. Abraham Ernst van Bassen: G.A.A. D.T.B. 39 (Baptism) no. 335 (Nieuwe Kerk), *dd* 26 November 1613, Abraham, son of Warner Ernst [van Bassen] and Maria Pieters Hollesloot, witness Henrikje Koenen; G.A.A. D.T.B. 1047 (Burial) 273 (Oude Kerk), *dd* 17 January 1680: Abraham Ernst van Bassen, from the Herengracht.

4 Ferdinand Bol, *Six Governors and the Attendant of the Nieuwe-Zijds-Huiszittenhuis, Amsterdam,* canvas, 143 x 192 cm, signed and dated 1657, Amsterdam, Rijksmuseum (inv. no. 540). See Blankert 1982, 156, no. 179 (illus. pl. 191). Abraham is fourth from the left, in the centre foreground. Elias does not include him among the children of Warner Ernst van Bassen (1581–1630) and Maria Pieters Hollesloot. See Elias 1963, 1:303, no. 96. However, he is named among four of their children who were not yet of the age of majority in an entry in the records of the Amsterdam Chamber for Orphans made upon the death of their father: G.A.A. 5073, W.K., no. 792 (*Inbrengregister*) no. 21, fol. 205v, 17 September 1631. Abraham's father, Warner, bequeathed his four youngest children, named in the *Weeskamer* entry, 32 000 guilders, part of a fortune that he had amassed through the manufacture of earthenware goods. In a derisory poem, Vondel dubbed him *Malkus* (i.e., Malchus, the High Priest's servant whose ear St Peter severed), in reference to his one-eared wares. Warner had also gained acceptance into the city's elite regent class and filled several minor posts in the city government. See Elias 1963, 1:303.

5 All three paintings belong to the Stedelijk Museum "De Lakenhal" in Leiden: Abraham van den Tempel, *Maiden Leiden Crowned by Minerva,* canvas, 176 x 221 cm, signed and dated 1650 (inv. no. 425); *Peace Welcomes Science,* canvas, 207 x 266.5 cm, signed and dated 1651 (inv. no. 427); *Prosperity Flees from War,* canvas, 207.5 x 265.5 cm, signed and dated 1651 (inv. no. 426). On the commission, see Wijnman 1959, 64.

6 Upon his marriage, Abraham van den Tempel identified himself as a *laeckendrapier*, or cloth merchant. For Van den Tempel's connections to the cloth trade in Leiden, see Wijnman 1959, 55, 56, 64.

7 These two portraits are presently known through countless copies, of which two are in the collection of the Rijksmuseum in Amsterdam: Jan de Baen, *Portrait of Johan de Witt,* canvas, 125 x 98 cm, inv. no. A13; *Portrait of Cornelis de Witt,* canvas, 124 x 97 cm, inv. no. A14.

8 For the relevant paintings by Backer, see cat. no. 33n2, and cat. no. 15n3.

9 For the relevant paintings by De Vos and Moyaert, see cat. no. 26n2, and cat. no. 25n4.

10 Bredius 1915–22, 109, no. 170, mentions the second painting but not the first one, which he did record in notes left at the RKD. Doeck's death is recorded three years earlier: G.A.A. D.T.B. 1091 (Burial) fol. 85v (Zuider Kerk), *dd* 26 May 1664: "*kerck doodt den 26 ditto (maij) Cornelus Doeck onder galerij 15.-.-*". Doeck's marriage is recorded in Amsterdam: G.A.A. D.T.B. 447 (Marriage), 53 (Church), *dd* 28 November 1637: "*Cornels Willemsz van A out 21 jaar schilder woonen op de N: Z: achterburghwal out 20 jaar ende Cornelia Rochols van A woon inde Langestraat geass. met haar moeder Cornelia Rocholt by geen ouders hebbende*" (Cornelis Willemsz. of Amsterdam painter living on the Nieuwe Zijds Achterburghwal 20 years old and Cornelia Rochols of Amsterdam living in the Langestraat assisted by her mother Cornelia Rocholt he having no parents).

11 Abraham Bredius, "De Kunsthandel te Amsterdam in de XVIIᵉ eeuw," *Amsterdamsch Jaarboekje,* 1891, 56. Bredius claimed that a document of 1639 referred to Doeck as "erstwhile painter" ("*eertijds schilder*"), but gave no reference. Doeck's inventory mentions a number of works by him (see n10). The earliest references to Doeck in the Amsterdam archive are the marriage record cited in n10, which identifies him as a painter, and an appearance as

husband of Cornelia Rocholt (also Rochelt), who claimed her portion of her father's inheritance, presumably shortly after her marriage: G.A.A. 5073 (W.K.) 796 (*Inbrengregister*), no. 21, fol. 112v, *dd* 12 May 1638. In the following years, the baptisms of four of their children are recorded in the archive: G.A.A. D.T.B. 42 (Baptism), 175 (Nieuwe Kerk), *dd* 15 January 1640: Cornelia (witness Trijntje Roochels); G.A.A. D.T.B. 42 (Baptism) 321 (Nieuwe Kerk), *dd* 2 September 1642: Baefje (witness Dirck Bisschop); G.A.A. D.T.B. 8 (Baptism) 33 (Oude Kerk), *dd* 17 November 1644: Willem (witnesses Dirch Bisschop and Cornelia Roochelt); G.A.A. D.T.B. 8 (Baptism) 120 (Oude Kerk), *dd* 10 March 1647: Emmerens (witnesses Elsje Melchiors and Dirck Bisschop).

12 Houbraken frequently speaks disparagingly of dealers with respect to their treatment of artists, as in the life of the dealer-painter Gerrit Uylenburg (1976, 2:294), and in a digression on the status of artists (1976, 2:232). He twice referred to dealers as *keelbeulen*, or "headsmen-executioners," in his lives of Philips Wouwerman (1976, 2:74) and Caspar Netscher (1976, 2:74, 3:94). My thanks to Hendrik J. Horn for these references.

13 G.A.A. D.T.B. 1074 (Burial) 63 (Noorder Kerk), *dd* 7 October 1683: "*Hendrik Olij.*"

14 See Bredius 1915–22, 2036.

15 G.A.A. 5062, *Kwijtscheldingen*, no. 47, fol. 141, *dd* 3 March 1656: Hendrik Oly purchases a house and a dye-works on the Bloemgracht, near the Bullebacx House, named the *Blauwe Snoek*, for *f*4000, from Jan Claesz. Ansloo.

16 It seems that Oly came from elsewhere, and acquired his *Poorterschap* in the city when he married one of its citizens. G.A.A. 5033, *Poorterboek*, *dd* 17 November 1656: "*Henric Olij, Lakenverwer gehuwd met Heijltie Eland dochter van Elbert Claesz Elant Lakenkoper*" (Henric Olij, fabric dyer, married to Heijltie Eland daughter of Elbert Claesz. Elant cloth merchant). Their children are recorded in burial notices that do not give names, indicating that they died shortly after birth: G.A.A. D.T.B. 1055 (Burial) fol. 93v (Nieuwe Kerk), *dd* 6 March 1657: child of Henderick Olij; G.A.A. D.T.B. 1100[b] (Burial) 167 (Westerkerk), *dd* 16 June 1659: child of Henderick Olij.

17 See Bredius 1915–22, 2035. The two paintings in the inventory that are by Oly himself, no. 19, *Landscape with Animals*, and no. 67, *Landscape with Figures*, suggest that Oly specialized in landscapes.

18 N.A.A. 5970, Notary Christoffel Hellerus (*Afschriften van Testamenten*), fols. 351r–352r, *dd* 12 December 1699, mentions a garden and a leisure-house on the garden of Persens Laen (Persens Lane), along the Sloterdijk, on the Haarlemmer Treckweg.

19 The inventory was taken on the occasion of Westerhoff's second marriage, to Bejatris (Beatrice) van Hoften: G.A.A. D.T.B. 529 (Church), 138, *dd* 17 July 1698. Anna van Schoddenburg had died two years earlier: G.A.A. D.T.B. 1057 (Nieuwe Kerk), fol. 58v, *dd* 11 September 1696. Westerhoff, evidently a Catholic, was buried in the Carthusian Cemetery on 11 April 1719: G.A.A. D.T.B. 1173 (Burial) 16.

20 N.A.A. 5790, Notary Cornelis van Buuren (*Minuutacten van Testamenten, etc.*), 1025–6, *dd* 7 September 1701 (accompanied by a sealed, abbreviated version, included in the same notarial volume, but not paginated). This document, the testament of Catharina van Papenbroeck, makes specific mention that it was passed in the house of Jan Westerhoff, "*hospes inde Herberg de Hoop staende op de Kloveniers burgwal*" (Keeper of the hostel De Hoop standing on the Kloveniersburgwal).

21 The name was taken from the name of the house, "Zum blaauwen Jan," which had previously been used as a blue-dye-works. It stood on the east side of the Kloveniersburgwal, across from the Slijkstraat. See Witkamp 1888, 313, and Gustave Loisel, *Histoire des menageries de l'antiquité à nos jours*, Paris: Doin et Fils, 1912, 2:52, section 7.

22 See Witcamp 1888, 312–16.

23 D.C. Meijer, Jr., "Blauw-Jan," *Amsterdamsche Jaarboekje* 1889, 41–8. Westerhoff's portrait also appears in the book by Velten. See exhibition catalogue Amsterdam 1992, 139, no. 285a (illus.).

24 G.A.A. 5033, no. 5, *Poorterboek*, no. 2, 522, *dd* 13 May 1664: "*Jan Barentsz Westerhof Oldenburch*." G.A.A. D.T.B. 485 (Marriage) 309, *dd* 4 April 1664: Jan Barentsz. Westerhof and Annetje Huggen.

25 G.A.A. D.T.B. 1057 (Burial) fol. 58v (Nieuwe Kerk), *dd* 11 September 1696: "*Anna van Schoddenbeurch, vr. v. Jan Westerhof Cloven. burgw.*" (Anna van Schoddenbeurch, wife of Jan Westerhof on the Kloveniersburgwal). G.A.A. D.T.B. 529 (Marriage) 138 (Kerk), *dd* 17 July 1698, Jan Westerhof and "*Bejateris*" (Beatrice) van Hoften. G.A.A. D.T.B. 1173 (Burial) 16 (Karthusiers Kerkhof), *dd* 11 April 1719: "*Jan Westerhof in de Egelantiersstra. bij de baangraft laat 1 kind na*" (Jan Westerhof on the Egelantiersstraat near the [Lijn]baangracht leaving behind one child).

26 Cat. nos. L43 and L44. The testament was first published by Judith van Gent (1998). For further information on Jan Jacobsz. Hinlopen and Leonora Huydecoper, see Elias 1963, 1:309, with no. 98.

27 Canvas, 72 x 97 cm, around 1662, Berlin, Gemäldegalerie Alte Meister, Staatliche Museen Preussischer Kulturbesitz (inv. no. 792); see Van Gent 1998. The portrait was previously thought to depict the family of Gillis Valckenier; see Isabella Henrietta van Eeghen, "De familiestukken van Metsu van 1657 en van De Witte van 1678 met vier levensgeschiedenissen," *Jaarboek Amstelodamum* 68, 1976, 78–82.

28 Elias 1963, 1:309. See also Dudok van Heel 1996.

29 Jan Jacobsz. Hinlopen and Leonora Huydecoper married on 3 April 1657; see Elias 1963, 1:309.

30 Huydecoper occupied this position in 1651, 1654, 1655, 1657, 1659, and 1660; see Elias 1963, 1:384, no. 126. His son Joan would occupy it thirteen times; see Elias 1963, 1:518, no. 191.

31 On Joan Huydecoper as a patron of the arts and architecture, see Gary Schwartz, "Jan van der Heyden and the Huydecopers of Maarseveen," *The J. Paul Getty Museum Journal* 11, 1983, 197–220. For a discussion specifically of his patronage of architecture, see Koen Ottenheym, *Philips Vingboons (1607–1678): Architect*, Zutphen: Walburg Pers, 1989, 37–45.

32 Van Noordt, 1976. For the appointment, see G.A.A. 5039 (*Thesaurieren Ordinaris*) no. 2 (*Resoluties 1657–64*), fol. 194, *dd* 21 August 1664: "*Anthonis van Oort is aengenomen tot organist in de Nieuwe kerck in plaets van Nicolaes Losty*" (Anthonis van Oort is appointed as organist of the Nieuwe Kerk as replacement for Nicolas Lossy): Van Biema 1906, 186. Den Hartog drew the connection between the publication of the *Tablatuur-boeck* and Anthoni's appeal for an increase in salary. Anthoni's designs on the post in the Nieuwe Kerk were perhaps signalled by the frontispiece of the *Tabulatuur-boeck*, which borrows numerous elements of the decoration of the Great Organ there. See Groenveld and Den Hertog 1987, 109–27.

33 See Van Gent 1998, 130, and Elias 1963, 1:309.

34 Bartholomeus van der Helst, *Portrait of Jan Jacobszn Hinlopen and Lucia Wijbrants*, canvas, 134 x 160.8 cm, signed and dated 1666, present location unknown, sale, London (Christie's), 11 November 1996, lot 134 (illus.). The identification was first made in Dudok van Heel 1996.

35 Bartholomeus van der Helst, *Portrait of Jan Jacobsz Hinlopen*, canvas, 116 x 89.5 cm, signed and dated 1659, Twente, Kasteel Twickel. For the identification of the sitter, see Dudok van Heel 1996, *passim*.

36 For the documentary evidence concerning the biography of Dionijs Wijnands, see cat. no. 51n1–7. See also Kolleman 1971, 118.

37 G.A.A. D.T.B. 427 (Marriage), 365 (Church), *dd* 30 December 1622: "*Hendrik Wynantsen craemer out 20 jaer gass. met Beerten Frans sijn vader inde Sint Lucien steech ende Aeltien denijs out 23 jaren geass. met Denis Denijsn haer vaeder woon. inde Calverstraet*" (Hendrik Wynantsz. age 28 years assisted by Beerten Frans his father in the Saint Lucien Alley and Aeltje Denijs age 23 years assisted by Denis Denijsn her father living in the Calverstraet). Attributed to Nicolaes Maes, *Hendrik Wijnands*, canvas, 45 x 34 cm, Amsterdam, Rijksmuseum, inv. no. SK-A-702. This painting is accompanied by its pendant: *Aeltje Denijs*, canvas, 44.5 x 34 cm, Amsterdam, Rijksmuseum, inv. no. SK-A-703. In 1674, Wijnands' worth was assessed at an affluent *f*35 000; his sum for the 200th-penny tax was *f*175: G.A.A. 5028 *Thesaurieren Extraordinaris*, inv. no. 662, *Kohier van de 200⁰ penningh*, *1674*, fol. 243, in *wijk* 26: "*Hendrik Wijnands f*175.-.-.."

38 G.A.A. D.T.B. 502 (Marriage) 378 (Church), *dd* 13 February 1676: "*Hendr. Meulenaar van A. out 25 jaar Coopman woon't op watergraftstrr. met Roelof M. syn wader ende Alida Wijnants van A. out 21 jaar geaß. met Hendrik wynants haar gr. vader*" (Hendrik Meulenaer of Amsterdam, age 25, living on the Watergrachtstraat, with Roelof Meulenaer his father, with Alida Wijnands of Amsterdam, age 21, assisted by Hendrik Wijnantsz, her grandfather). See Kolleman 1971. Life spans for these people are: Alida (1655–1724), Anna Groessens (1631–?), Hendrik Meulenaer (1651–1704), Roelof Meulenaer (1618/19–91).

39 His estate was assessed at *f*25 000 in 1674. G.A.A. 5028 *Thesaurieren Extraordinaris*, inv. no. 662, *Kohier van de 200⁰ penningh*, *1674*, fol. 398, *wijk* 42: "*erven van Denijs Wijnantsz f*125.-.-" (the heirs of Dionijs Wijnands *f*125).

40 Wijnands first appeared on 27 January 1671: Dongelmans 1982, 310, document no. 859. My thanks to Jonathan Bikker for indicating the appearance of Wijnands in the records of *Nil Volentibus Arduum*.

41 See De Vries 1998, 7. See also J.W.H. Konst, *Woedende wraakghierigheidt en vruchtelooze weeklachten. De hartstochten in de Nederlandse tragedie van de zeventiende eeuw*, Assen and Maastricht: Van Gorcum, 1993, 212–19.

42 On the publication activity of *Nil Volentibus Arduum* see Dongelmans 1982, 311–423. A chronological list of publications appears on 315–17.

43 De Vries 1998, 7.

44 Dongelmans 1982, 209, document no. 801.

45 On Van Noordt's dealings with Adriana, the daughter of Samuel Coster, see 12.

46 See Bredius 1892, 34, and Hofstede de Groot 1892, 215. Annetje Jans Grotincx: G.A.A. D.T.B. 471 (Marriage) 36 (Church), *dd* 26 February 1653: "*Compareerden voor den Heer Jacob Hinlopen Comissaris Johannes van der Capelle van A. verwer, out 26 Jaer geassis. met syn vader Franciscus van der Capelle woon. opde Lelygracht ende Annetje Jans Grotincx van A. out 20 Jaer, geaß. met Wopke Jans haer moeder, op de Princegracht*" (Appearing before the Lord Jacob Hinlopen Commissioner Johannes van der Capelle of Amsterdam, dyer, age 26 years assisted by his father Franciscus van der Capelle living on the Lelygracht and Annetje Jans Grotincx of Amsterdam age 20 years, assisted by Wopke Jans her mother, on the Prinsengracht). G.A.A. D.T.B. 1056 (Burial) 37 (Nieuwe Kerk), *dd* 2 September 1677: "*Anna Grotingh en kraemkint*" (Anna Grotingh with newborn child). This record indicates that she died from a late childbirth at the age of 44.

47 N.A.A. 2262, Notary Adriaen Lock (*Minuutacten van inventarissen*), 1190, *dd* 4 January 1680.

48 See Nystad 1981.

49 Wilhelm Valentiner reached the hasty assumption that the drawn portrait referred in Van de Cappelle's inventory was the drawing now identified as being of Dionijs Wijnands (cat. no. D13). See Valentiner 1941, 295.

50 For further discussion of Proëlius, see cat. no. Copy 2.

51 Houbraken would have known about Van Noordt through Johannes Voorhout, who was one of his more important sources, and who was, as Houbraken states, the pupil of Van Noordt. Voorhout entered Van Noordt's studio around 1664, by which time his master had already begun to concentrate on portraits and history paintings. On Voorhout as a source for Houbraken, see 348n3. His period of study with Van Noordt is mentioned by Houbraken in 3:224–5.

52 Elias Nuijts: G.A.A. D.T.B. 39 (Baptism) 369 (Nieuwe Kerk), *dd* 14 December 1614, Elias, son of Cornelius Nuyts and Emmerens de Raet. Catharina Nuijts; G.A.A. D.T.B. 1069 (Burial), 16 (Nieuwe Zijds Kapel), *dd* 1 October 1680. Catharina Nuijts: G.A.A. D.T.B. 106 (Baptism), 38 (Westerkerk), *dd* 10 December 1662; (death indicated in inventory of 1698; see note 50); Catharina Grebert: G.A.A. D.T.B. 7 (Baptism), 8 (Oude Kerk), *dd* 24 September 1634: Catarina, daughter of Jean Grebber and Abigail van Ceulen; G.A.A. D.T.B. 1070 (Burial), fol. 150v (Nieuwe Zijds Kapel), *dd* 24 December 1714: Catharina Clara Nuijts.

53 Fokkens and Veenhuisen 1662, 73. In 1674, Elias was listed as a *suikerbacker*, or sugar refiner: G.A.A. 5028, *Thesaurieren Extraordinaris*, inv. no. 662, *Kohier van de 200° penningh, 1674*, fol. 373. See J.F.L. de Balbian Verster, "De Brand van de Koning van Polen," *Maandblad Amstelodamum* 16, 1929, 53–4.

54 Elias van Valencijn was thirty-four years old when he married in 1686, indicating a birth date of around 1652: G.A.A. D.T.B. 514 (Marriage), 567 (Church); G.A.A. D.T.B. 1104 (Burial), fol. 15v (Westerkerk), *dd* 3 April 1738: "*Elias van Valencijn.*"

55 See cat. no. L25n1.

56 See cat. no. L25.

57 See the Provenance for cat. no. 34.

58 G.A.A. 5073 (W.K.) no. 564, (*Inbrengregister*), no. 35, fols. 225v–226r, *dd* 28 April 1682.

59 G.A.A. D.T.B. 501 (Marriage), 491 (Church), *dd* 9 May 1675. The witnesses were Michiel's brother Coenraet and Johanna's father, Pieter de Vos. Michiel's address was given as "*op de Rosegracht*" (on the Rosengracht).

60 For Michiel's address, see n59. For Coenraet's address: G.A.A. D.T.B. 500 (Marriage), 144 (Church), *dd* 24 March 1674: "…*Coenraet van Coxcij van A. (ouders doot), out 21, woont op de rosegracht…*" (…Coenraet van Coxie from Amsterdam, [parents dead], age 21, lives on the Rosengracht…). It was the same address as that given for the brothers' father, Michiel van Coxie, on his own marriage to Catharina Metsu twenty-five years earlier: G.A.A. D.T.B. 454 (Marriage) 474 (Church), *dd* 25 October 1640. In 1649, the elder Coxie bought another property on the same *gracht*: G.A.A. 5062, *Kwijtscheldingen*, no. 42, fol. 171, *dd* 6 May 1649.

61 See cat. no. L4.

62 N.A.A. 4495b, Notary Jacob Matham, (*Minuutacten*), 1017–8, *dd* 1 January 1680–14 April 1681. Gary Schwartz alludes to this document with respect to two surviving depictions of slaughtered oxen by Rembrandt: panel, 73.3 x 51.8 cm, Glasgow, Art Gallery and Museum (Br. 458); and panel, 94 x 69 cm, Paris, Louvre. Surprisingly, Schwartz identifies Van Coxie as an artist, likely confusing him with the sixteenth-century Flemish history painter Michiel Coxie (1499–1592). See Schwartz 1984, 255.

63 G.A.A. D.T.B. 1101 (Burial), 91 (Westerkerk), dd 28 August 1669: "*Jan Woltarsz.*" N.A.A. 2853, Notary Dirck Dankerts, 335, *dd* 4 April 1670. Jan Wolters was born in Bremen, and his year of birth can be calculated to 1613 on the basis of his marriage record, which gives him as thirty-four years old in 1647: G.A.A. D.T.B. 465 (Marriage), 58 (Church), *dd* 2 August 1647.

64 G.A.A. 5077, *Wisselbank, Grootboeck*, no. 54 (August–February 1669), 206 (ƒ153 458), and

55 (February–August 1669), 240 (f231 302). Elias gave the sum of f669 000 for the year 1666, but the one surviving volume, of two for that year, indicates only f64 654: no. 49, 228. Elias 1963, 1:516.

65 J.F.L. de Balbian Verster, "De Bocht van de Heerengracht," *Jaarboek Amstelodamum* 7, 1930, 218.

66 Hendrik Frederik Wijnman, in *Vier Eeuwen Herengracht*, ed. H. de la Fontaine Verwey, Amsterdam: Stadsdrukkerijvan Amsterdam, 1976, 555.

67 N.A.A. 6257 "d," Notary Cornelis Costerus, *dd* 19 April 1695 (pagination illegible: damaged by fire). See Bredius 1915–22, 1212.

68 One of the paintings, *Crucifixion*, in the estate of Jacobus van Noordt was given specifically as by his brother Jan; see cat. no. L10. Jan van Noordt claimed several of other paintings from the estate of his brother Jacobus, including portraits of their father and grandfather and of two of his brothers, and a *Granida and Daifilo*: G.A.A. 5072 (D.B.K.) 738, folio 44 (*dd* 3 December 1671), and folio 49 (*dd* 18 December 1671). The inventory of Jan's younger brother, Lucas, also included a number of paintings, without any specific mention of the artist: G.A.A. 5073, W.K., no. 981, *Boedelinventarissen*, 1705, Inventory no. 5: drafted in Diemen on 19 January 1693, deposited with the Weeskamer of Amsterdam on 2 October 1705. My thanks to Jaap den Hertog for this reference.

69 For the patronage of Joannes Vermeer, see Montias 1989, 246–62; of Gerrit Dou, see Houbraken 1976, 2:37 and exhibition catalogue Leiden 1988, 24–8.

70 Marten Jan Bok pointed out that most of the collectors cited by Van Mander in 1604 were affluent merchants and traders (1994, 93–4).

71 Jacob Adriaensz. Backer, *Venus and Adonis*, 200 x 237 cm, Eichenzell, Hessische Hausstiftung, Museum Schloß Fasanerie (inv. no. 336); Cesar van Everdingen, *Jupiter and Callisto*, canvas, 165 x 193 cm, Stockholm, Nationalmuseum (inv. no. NM1175). For both paintings, see exhibition catalogue Rotterdam and Frankfurt 1999–2000, 160–3, no. 25 (illus.), and 188–91, no. 188 (illus.).

CHAPTER FOUR

1 Blankert first raised this issue in his essay in the exhibition catalogue Washington, Detroit, and Amsterdam 1981, 26–7.

2 In his monograph on Rembrandt's pupil Ferdinand Bol (1616–1680), Blankert hypothesized that Bol and his fellows attempted a visual parallel to the sudden change of fortune typical of tragic literature (1984, 35–6, *s.v. Peripeteia*). Blankert posited that the poet and playwright Joost van den Vondel (1587–1679) had provided an impulse to these artists in his introduction to his 1659 play, *Jephta*. There Vondel explained his own setting of the biblical story within the framework of classical tragic poetry. He introduced the term *staetverandering* (change of state), his interpretation of the classical Greek term *peripeteia*, a term most broadly disseminated through Aristotle's famous theoretical tract on poetry. See Aristotle, *Poetics*, X and XI, 39–43. The story of *Jephta*, which does fit well, was only rarely depicted, so it forms an exception rather than a rule in Dutch Baroque history painting. One of the few original compositions of this theme is the painting by Pieter Lastman of around 1610: panel, 121 x 200 cm, the Netherlands, private collection; see exhibition catalogue Amsterdam 1991, 86–7, no. 1 (illus.). Esaias van den Velde made a close adaptation in grisaille: panel, 28.5 x 42.5 cm, signed and dated 1625, sale Ingram, London (Sotheby's), 6 May 1964, lot 150 (illus.); see Keyes 1984, 120, no. 5 (illus. pl. 342).

3 Bruyn 1983, 210.

4 See Tümpel 1968; Tümpel 1969; Tümpel 1971, Manuth 1987a, Manuth 1987b.

5 See Sluijter 1986. With respect to scenes from history, only a very limited study of particular subjects has been made to date; see Golan 1994.

6 Sluijter 1986, 268. A similar observation had already been made by Blankert; see exhibition catalogue Washington, Detroit, and Amsterdam 1981, 26.

7 See Leslie J. Topsfield, *Troubadours and Love*, Cambridge and New York: Cambridge University Press, 1975. The literature on the representation of love in Italian poetry in the age of Dante is vast. A detailed discussion can be found in Thomas Hyde, *The Poetic Theology of Love: Cupid in Renaissance Literature*, Newark, London, and Toronto: University of Delaware Press and Associated University Press, 1986, 13–110.

8 See De Jongh 1967.

9 Battista Guarini, *Il pastor fido. Tragicomedia pastorale de Battista Guarini*, Venice: Giovanni Battista Bonfadino, 1589. For a discussion of the significance of this book for Dutch pastoral painting, see Kettering 1983, 21. On its impact on Dutch literature, see E.L. Verkuyl, *Battista Guarini's* Il Pastor Fido *in de Nederlands Dramatische Literatuur*, Assen: Van Gorcum, 1971, 35. Verkuyl points out that the date appearing on the *editio princeps*, 1590, was inaccurate.

10 Pieter Lastman, *Landscape with Shepherd and Shepherdess*, panel, 38.5 x 54 cm, private collection; see exhibition catalogue Amsterdam 1991, 88–9, no. 2 (illus.), and exhibition catalogue Utrecht 1993, 196–7, no. 34 (illus.).

11 See Peter van den Brink, "Het Gedroomde Land," in exhibition catalogue Utrecht 1992, 9–10. Van den Brink sought to widen the scope of the pastoral category beyond depictions of scenes from pastoral literature considered by Alison McNeil Kettering in her groundbreaking study of Dutch pastoral painting; see Kettering 1983.

12 See Gudlaugsson 1949.

13 Dirck van Baburen, *Peter van Hardenbroek and Agnes van Hanxelaer as Granida and Daifilo*, oil on canvas, 165.7 x 211.5 cm, signed and dated 1623, New York, private collection; see exhibition catalogue Utrecht and Luxembourg 1993–94, 87–91, no. 4 (illus.); and Gerrit van Honthorst, *Granida and Daifilo Surprised by the Soldiers of Artabanus*, canvas, 145.2 x 178.5 cm, signed and dated 1625, Utrecht, Centraal Museum (inv. no. 5571); see ibid., 172–6, no. 27 (illus.). On the novel iconography favoured by the House of Orange, as reflected in scenes from Heliodorus by Abraham Bloemaert and Cervantes by Jan Lievens, see exhibition catalogue The Hague 1997–98, 100–7, nos. 2 and 3, and De Witt 1999, 185. These choices likely reflect the role of the learned Constantijn Huygens as arbiter of taste at court.

14 See Te Poel 1986, 11–14.

15 Another early depiction of the meeting scene is by the Amsterdam painter Claes Cornelisz. Moyaert, dating to around 1629. Claes Cornelisz. Moyaert, *Granida and Daifilo*, panel, 36 x 57 cm, monogrammed, c. 1629, Stockholm, collection of Knut Tilbugs; see Tümpel 1974, 292 (illus., fig. 123), 268, no. 189, and Te Poel 1986, 83, no. 24.

16 For the depictions of *Granida and Daifilo* by Backer, see cat. no. 33nn3, 5.

17 Jacob Adriaensz. Backer, *Half Figure of a Shepherd with a Flute (Self-Portrait?)*, canvas, 50.8 x 39.4 cm, The Hague, Mauritshuis (inv. no. 1057); for pastoral figures by Backer, see Sumowski 1983–94, 1:196–9, nos. 26, 33, 35, 36, 44; 5:3078, nos. 1993, 1994; 6:3690, no. 2179.

18 Te Poel 1986, 8. Te Poel sees Hooft as setting up a contrast between the ideal love of Daifilo for Granida and his earthly, sensual life of a shepherd, reflected in his love for Dorilea. Introduction, in Pieter Cornelisz. Hooft, *Granida*, Zutphen, W.J. Thieme & Cie, 1940, p. viii. According to A.A. Verdenius, Hooft was influenced by the Platonic ideals represented in Castiglione's *The Book of the Courtier* and Pietro Bembo's *Asolam*.

19 Dirck Volckertsz. Coornhert was the first to produce a translation of a substantial part of Boccaccio's *Decameron* into Dutch; see Coornhert 1564. It was reprinted several times in the

sixteenth and seventeenth centuries, in 1583, 1597, 1607, 1612, 1632, and 1640. The story of Cimon and Iphigenia appears on fols. 54v-58r. Forty years later, Gerrit Hendriksz. van Breughel published a translation of the second half of the *Decameron*: Van Breughel 1605. It was reprinted in 1605, 1613, and 1644. See exhibition catalogue Leiden 1975, 25–7.

20 See Von Terey 1919, and Nicôle Spaans in exhibition catalogue Utrecht 1993, 211–15. In her thesis on Dutch depictions of *Cimon and Iphigenia*, Nicôle Spaans catalogued 54 depictions of the opening scene: Nicôle Spaans, `*Door de Liefde Verstandig*': *een onderzoek naar de picturale ontwikkeling van het thema* Cimon en Efigenia *en een aanzet tot de interpretatie van voorstellingen met dit onderwerp (1370–1700)*, Master's thesis, Leiden University, 1991.

21 Van Arp 1639, frontispiece. The scene also appears in the background of an emblem published by Jacob Cats in 1635: *Amor docet Musicam* in *Spiegel vanden Ouden en Nieuwen Tijt*, 3rd. ed., Dordrecht: M. Havius, 19, no. 7. Held discussed Cats' emblem as evidence of the continuing popularity of the theme after Rubens had depicted it around twenty years earlier; see Held 1980, 1:320–1. In the context of Amsterdam, the frontispiece to Van Arp's play is likely to have had a more direct impact on artists than Cats' emblem.

22 For Backer's painting, see cat. no. 28n4; Abraham Bloemaert, *Cimon and Iphigenia*, oil on panel, 36.9 x 52.1 cm, signed; sale, London (Christie's), 8 December 2005, Evening Sale, lot 2 (illus.). The catalogue entry notes that Marcel Roethlisberger dates the painting to the late 1620s.

23 Peter Paul Rubens (figures), with Frans Snyders (animals) and Jan Wildens (landscape), *Cimon and Iphigenia*, canvas, 208 x 282 cm, c. 1617, Vienna, Kunsthistorisches Museum (inv. no. 1166); *Cimon and Iphigenia*, panel, 29 x 44 cm, Gosford House (Scotland), collection of the Earl of Wemyss (1948 inv. no. 145, as by or after Rubens). Rubens' composition was reproduced in an engraving by J.A. Prenner: see Voorhelm Schneevoogt 1873, 131, no. 107 (as "Nymphs surprised by a Shepherd"). This print is not mentioned in the subsequent literature.

24 See Sluijter and Spaans 2001. For Vos's poem, see Vos 1662, 541. Vos's poem was cited by Houbraken 1:336–7. The second poem cited by Houbraken in connection with Backer's painting, by Ludolph Smids, took up the familiar trope of praising a painting's deceptiveness, suggesting that Mars would have mistaken Iphigenia for Venus. Smids, who was normally well-informed, apparently also did not know the story well and thought Iphigenia a "shepherdess." See Houbraken 1976, 1:337, and "*De schoon IPHPGENIE van Cyprus*," in Smids 1685, 28, and Smids 1694, 170–1.

25 Tengnagel 1643.

26 Miguel de Cervantes Saavedra, *The Little Spanish Gipsy*, in *Exemplary Stories*, trans. Lesley Lipson, Oxford and New York: Oxford University Press, 1998, 7–70. The French translation of six of the novellas, including *La Gitanilla*, by Francois de Rosset, appeared in Paris in 1618 published by Jean Richer and was the basis for the Dutch translation by Felix van Sambix: *Het Schoone Heydinnetje*, Delft (published by the author), 1643.

27 See cat. no. 31, Provenance.

28 See Peter van den Brink, in exhibition catalogue Utrecht and Luxembourg 1993–94, 235–6.

29 One of Van Noordt's two versions of *De Spaensche Heidin* (cat. no. 32) was included in the exhibition *Het Gedroomde Land*, which was devoted to the broader phenomenon of the pastoral in seventeenth-century Dutch painting. Exhibition catalogue Utrecht and Luxembourg 1993–94, 235–8, no. 45 (illus. 237).

30 Gaskell 1982, 267.

31 See Gaskell 1982.

32 The prologue, but not the play, specifies that Pretioze is weaving flowers when Don Jan first sees her.

33. See Van Stipriaan 1996, 15–18.

34 See Donald Haks, *Huwelijk en gezin in Holland in de 17de en 18de eeuw. Processtukken en moralisten over aspecten van het laat 17de en 18de eeuwse gezinsleven*, Assen: Van Gorcum 1982, 105–8.

35 Leon Battista Alberti wrote the Latin edition of *Della Pittura* in Florence in 1435, and produced an Italian edition in the following year. The *editio princeps* of the Latin text of Alberti's book appeared a century later, published in Basel by Thomas Venator in 1540. The first publication in the northern Netherlands was of the Latin text, by Elsevier in Amsterdam, in 1649. Blunt characterized Alberti's thought as leaning toward republicanism and emphasizing the role of the individual citizen (1966, 4–5, 21). Although Alberti does not single out depictions specifically of moral exempla, he did cite other kinds of scenes of moral drama, such as the *Calumny of Apelles*. See Alberti 1972, 94–7.

36 See Bouwsma 1975, in particular 59–60.

37 Justus Lipsius spent most of his academic career in Leuven, but also taught at the University of Jena from 1572 to 1574 and the University of Leiden from 1579 to 1591. See Jason Lewis Saunders, *Justus Lipsius. The Philosophy of Renaissance Stoicism*, New York: Liberal Arts Press, 1955, 11–14, 18–34. For a discussion of his ideas and their impact, see Oestreich 1975.

38 See Bouwsma 1975, 31n100.

39 For Rubens' friendship with Lipsius and his interest in Neostoicism, see Morford 1991. For a discussion of Neostoicism in the work of Van Dyck, see Stewart 1990–91.

40 On Neostoical references in several works by Honthorst, see Jonathan Bikker in exhibition catalogue Kingston 1996, 7–8, and Morford 1991, 186.

41 For the impact of Lipsius on Pieter Cornelisz. Hooft and Hendrik Laurensz. Spiegel, see Oestreich 1975, 187–8. On the role of Scaliger as disseminator of Neostoic principles at Leiden and his influence on Samuel Coster; see Smits-Veldt 1986, 29, 58–80. Coster identified himself particularly strongly with these ideas, going so far as to adopt a distinctly Neostoic emblem, a turtle, accompanied by the phrase "*Over al thuys*" (At home everywhere), referring to the Neostoic principle of carrying one's "house" (i.e., philosophical grounding) along wherever one goes; see Smits-Veldt 1986, 4–5. On the link between Jan van Noordt and Samuel Coster, see 12 and 350n8.

42 For an analysis of the iconography of the paintings made for the Amsterdam *Stadhuis*, or City Hall, see Blankert 1975.

43 Titus Livius, *Historiarum ad urbe condita*, preface, 9–11. See McGrath 1997, 33–43.

44 Plutarch, *Plutarchus. 'T leven ende vrome daden vande Doorluchtige Griecsche ende Romeynsche mannen/ met haer figueren*, trans. M. Everart, Leiden (Jan Claesz. van Dorp), 1601. The story of Cloelia appears on page 76. Strangely, Everart seized upon the alternative identification, also mentioned by Plutarch, of the heroic maiden as Valeria, the daughter of the consul Publicola, and did not even mention Cloelia. Later interpreters did not follow Everart's idiosyncratic choice.

45 Titus Livius, *Historiarum ad urbe condita*, no. 26, 50. The Latin editions published in the Netherlands were numerous, especially in the sixteenth century. There were two main Dutch translations, the one by Jan Gymnicus, published by Florus in Antwerp in 1541, was reprinted numerous times: in 1585, 1597, 1614 (four times), 1635, 1646, and 1650. In contrast, the translation by J.H. Glazemaker of 1646, published in Amsterdam by Jacob Lescaille, was not reprinted. See Geerebaert 1924, 131–2. The edition of 1614 introduced woodcut illustrations: Titus Livius, *De Romeynsche historien ende geschiedenissen. Met fig. verciert ende met niewe byvoeghingen verm.*, Amsterdam (Dirck Pietersz), 1614. The scene of Scipio and the Spanish bride appears on folio 102r.

46 For Scipio's career, see Scullard 1970.

47 On Polybius's view of Scipio, see Scullard 1970, 23–5. On Calvin's citing Scipio as an example of ambition, see Bouwsma 1975, 44n172.

48 Livy, *Historiarum ad urbe condita*, no. 26, 50, 4–8; "As a young man, I speak to you as a young man – to lessen embarrassment between us in this conversation. It was to me that your betrothed was brought as a captive by our soldiers, and I learned of your love for her – and her beauty made that easy to believe. Therefore, since in my own case, if it were only permitted me to enjoy the pleasures of youth, especially in a proper and legitimate love, and had not the state preoccupied my attention, I should wish to be pardoned for an ardent love of a bride, I favour what is in my power – our love. Your betrothed has been in my camp with the same regard for modesty as in the house of your parents-in-law, her own parents. She has been kept for you, so that she could be given you as a gift, unharmed and worthy of you and of me." See Livy, *Livy*, vol. 7, trans. Frank Gardner Moore, Cambridge, Massachusetts, 1943, 191–5.

49 See Van Mander 1973, 1:273, 2:612. Van Mander's text was widely known and would likely have been a reference for Van Noordt.

50 De Lairesse 1969, 1:117–8: "*De Moraale Tafereelen zyn waare geschiedenissen of voorvallen, alleen tot stichtinge of leerzaame voorbeelden voorgesteld, te kennen geevende braave daaden of mislagen der menschen, welke daar in hunne rol speelen, door eenige bygevoegde zinbeteekenende Beelden uitgedrukt, welke de neigingen, die hen gedreven en vervoerd hebben, uitdrukken: als by voorbeeld, by* Alexander, *de Eerzucht: by* Marcus Aurelius, *de Goedertierenheid: by* Augustus, *de Godvruchtigheid: by* Scipio Africanus, *de Gemaatigdheid; wanneer hy de jonge Ondertrouwde, die hy gevangen had, aan haaren Bruidegom weder overgaf: en meer diergelyke anderen, gelyk* Horatius *in zyne Zinnebeelden zeer konstig en verstandig heeft vertoond.*" (Moral Scenes are true histories or events, presented exclusively as edifications or instructive examples, telling of virtuous deeds or failures in people, who there play their role, explained with a few complementary symbolic Figures, which express the inclinations that motivated and drove them: as in for example, with *Alexander*, pursuit of honour: with *Marcus Aurelius*, compassion: with *Augustus*, piety: with *Scipio Africanus*, continence; when he returned the young Betrothed, whom he had taken prisoner, to her Bridegroom: and others that are similar, as *Horace* presented with great understanding and art in his Emblemata.) For a discussion of De Lairesse's ideas and their application, see Snoep 1970, 159–217.

51 Smids 1694, 301.

52 Gerbrand van den Eeckhout, *Portrait of Wouter Oorthoorn, Christina van Dien, and Jochen van Dien, as Allucius, his bride, and her father, in The Magnanimity of Scipio*, canvas, 138 x 171.4 cm, signed and dated 1658, Toledo, Ohio, Toledo Museum of Art (inv. no. 23.3115). For the identification of the sitters, see Manuth 1998b, 146.

53 See Golan 1994, 182–200. For a German example, see 1998b Karl Simon, *Abendländische Gerechtigkeitsbilder*, Frankfurt am Main: Verlag von Waldemar Kramer, 1948, 18–20; for Dutch examples, see Albert Blankert, in exhibition catalogue Amsterdam 1975, 17–18.

54 Livy, *Historiarum ad urbe condita*, no. 26, 50, 13.

55 See Coornhert 1982, 423–4.

56 Govert Flinck, *Manius Curius Dentatus Refusing the Gifts of the Samnites*, canvas, 485 x 377 cm, signed and dated 1656, Amsterdam, Koninklijk Paleis, Burgomaster's Hall, south chimneypiece. See Sumowski 1983–94, 2:1026, no. 638, 1070 (illus.). For a discussion of the iconography, see exhibition catalogue Amsterdam 1975, 15–18 (illus. no. 7). The story appears in Plutarch's *Life of Marcus Cato*; see *Plutarch's Lives*, trans. Bernadotte Perrin, Loeb Classical Library 46, London and New York: Heinemann and McMillan, 1914, 307–9, 18.2.

57 Plutarch, *The Life of Publicola*, in *Plutarch's Lives*, vol. 1, trans. Bernadotte Perrin, Loeb Classical Library 46, London and New York: Heinemann and McMillan, 1914, 551–3; and Livy, *Livy*, vol. 1, trans. B.O. Foster, Loeb Classical Library 114, Cambridge, Massachusetts, 1919, 261–3. See also Silvain Laveissière in exhibition catalogue Dublin 1985, 71.

58 Peter Paul Rubens, *Cloelia Crossing the Tiber*, canvas, 236 x 343 cm, formerly Berlin, Gemäldegalerie Staatliche Museen Preussischer Kulturbesitz (now lost: formerly inv. no. KFM 946); see exhibition catalogue The Hague 1997, 66 (illus. fig. 5). Claes Cornelisz. Moyaert, *Cloelia Crossing the Tiber*, panel, 41 x 60.5 cm, signed and dated 1642, Oslo, Nationalmuseum (inv. no. 185); see A. Tümpel 1974, 111, 112 (illus.), 267, no. 185.

59 Most artists, including Van Noordt, seem to have been unaware of Cloelia's young age. Only Ludolph Smids, at the end of the seventeenth century, pointed out that Silius had placed her age at twelve (1690, 7–9). See Silius Italicus, *Punica*, trans. J.D. Duff, 2 vols., Loeb Classical Library, Cambridge, Massachusetts, and London: Harvard University Press and Heinemann, 1950, 86–7, Book 10, 488–98.

60 See n44: fols. 27r-28v. The story of Cloelia, illustrated with a woodcut, appears on fols. 17v-18r.

61 Coornhert devoted a chapter of his moral treatise on conduct to expounding the virtue of inner strength. See Coornhert 1982, 316–29.

62 See Plutarch, *Moralia*, trans. Frank Cole Babbitt, Loeb Classical Library, Cambridge, Massachusetts, 1931, 3:513–7, 250, a-f.

63 Both poems are reproduced in Smids 1690, 7–9.

64 "*De roomsche Klelia ontswom, met deed'le maagden, / De gijzeling, en 't oog der schildwacht, en de dood…*" (The Roman Cloelia swam away, with the noble maidens, from / captivity, and the eye of the guard, and death…); Joost van den Vondel, cited in Smids 1690, 9, and Houbraken 1976 1:367. Jan Vos presented several points of praise in his verse: "*Schildery van de Roomsche Klelia, door Nikolaas Heldt Stokade geschildert. / Hier ziet men Klelia de gyzeling ontzwemmen. / Zo wordt een vrouwelist vereent met mannemoedt. / Haar zucht tot vryheidt laat zich niet van boei-ens klemmen. / Men streeft, om vry te zijn, door wall', door zwaardt en vloedt.*" ("Painting of the Roman Cloelia, painted by Nicolaas van Helt Stokade. / Here one sees Cloelia swimming away from captivity. / So a female cunning is united with manly courage. / Her desire for freedom will not be bound with shackles. / One strives to be free, over shore, through sword and flood."); Vos 1662, 522.

65 "*Geen wegh is ongebaent voor vroomheidt: zo de maeghden / Ons leeren, die op stroom haar liif, om vryheidt, waeghden.*" Hooft 1636, 337. Cited, with updated spelling, in Smids 1690, 9.

66 This painting is often identified with the work formerly in Berlin (see n58); see Carola van Meeren, "*For the Preservation of her Legacy*' The Vicissitudes of Frederick Henry and Amalia of Solms' Collection of Paintings," in exhibition catalogue The Hague 1998, 66 (illus. no. 5), 67, 255n46. Hessel Miedema suggests that it might have been a smaller painting now in the Louvre; see "De Tiber en de Zwemmende Maagden: een afknapper," *Nederlands Kunsthistorisch Jaarboek* 19, 1968, 137–8. This work is there given to Abraham van Diepenbeeck, after Rubens: canvas, 115 x 145 cm, Paris, Louvre (inv. no. 1210). See collection catalogue Paris 1979, 47 (illus.).

67 Coornhert 1982.

68 For a discussion of Coornhert's religious views, including his particular amalgamation of Stoic and Christian principles, see Christiane Berkvens-Stevelinck, "Coornhert, een eigenzinnig theoloog," in *Dirck Volckertsz. Coornhert. Dwars maar recht*, Zutphen: De Walburg, 1989, 18–31.

69 On the Remonstrant controversy and the rise of the Collegiants, see Israel 1995, 393–5, 460–5. For the history of the Collegiants, especially in the second half of the seventeenth century, see Andrew C. Fix, *Prophecy and Reason. The Dutch Collegiants in the Early Enlightenment*, Princeton: Princeton University Press, 1991.

70 Sluijter 1986, 280, 517n280–1.

71 Sluijter 1986, 290, 526–7n290–2. A similar view was put forward by Blankert in exhibition catalogue Washington, Detroit, and Amsterdam 1981, 26.

72 One rare example is Gerbrand van den Eeckhout, *Daniel proving the Innocence of Susanna*, canvas, 57.8 x 65.4 cm, Hartford, Connecticut, Wadsworth Atheneum (acc. no. 1959.255); see Sumowski 1983–1994, 2:739, no. 462, 825 (illus.).

73 See exhibition catalogue Amsterdam 1976.

74 Ripa devoted several headings in the *Iconologia* to the virtue of chastity; see Ripa 1644, 262–6 *s.v. Pudicitia* (three headings), *Castita* (two headings), and *Castita Matrimoniale*.

75 Lucas Vorstermans, after Peter Paul Rubens, *Susanna and the Elders*, engraving, 38.7 x 28.0 cm; inscribed below left: P. Rubens pinxit. Lucas Vorsterman sculp. et excud. Anº. 1620. The inscription across the bottom reads: "*Lectissimae Vergini ANNAE ROEMER VISSCHERS, illustri Bataviæ sijderi, niltarum Artium peritissimae, Poetices vero studio, supra sexum celebri, rarum, hoc Pudicitae exemplar, Petrus Paulus Rubenus. L.M.D.D.*". Voorhelm Schneevoogt 1873, 10, no. 84; Hollstein 1949–, 43:12, no. 4. My thanks to Axel Rüger for his assistance with the translation of the inscription from the Latin. For discussion of this inscription, see McGrath 1984, 81–90; the inscription is mentioned on 81–4, (illus. 82), 89n69. See also Op de Beeck 1973, 207–21.

76 Anna Roemers, *Alle de gedichten*, ed. Nicolas Beets, Amsterdam: J.L. Beijers, 1881, 81–7. See Op de Beeck 1973, 217–18.

77 Joost van den Vondel, *Op een Italiaensche Schildery van Susanne*, c. 1650, in Vondel 1927–40, 2:489–94.

78 "*Men doet een naeckte vrouw sich tusschen minnaers baden / Tot kancker van goe seen 'en schoubaer oogh fenijn / En dat sal toch Susann'/ een kuyssche vrouwe sijn*," Johannes Evertsz. Geesteranus, *Tegen 't geestig-dom der schilder-konst, straf-rymen ofte anders Idolelenchus*, trans. Dirck Raphaelsz. Camphuysen, in Dirck Raphaelsz. Camphuysen, *Stichtelyke Rymen*, Amsterdam, 1647, 218. For more information on the history and reception of the *Idolelenchus*, see Manuth 1993, 246nn50, 51.

79 Attributed to Jan Steen, *An Old Man in a Brothel*, panel, 49 x 37 cm, signed, Moscow, Pushkin Museum (as *The Old Sick Man*). See Braun 1980, cat. no. 127; collection catalogue Moscow 1975, 120, no. 25 (illus.); and Della Pergola 1967, 17, fig. 6.

80 Paulus Pontius, after Peter Paul Rubens, *Susanna and the Elders*, engraving, 36.9 x 28.6 cm, inscribed bottom centre: "*Turpe senilis amore*" (How disgraceful is the old man in love); see Hollstein 1949–, 17:148, no. 1. The phrase, provided by Rubens, was taken from Ovid (*Amores*, Book 1, 9, 4). See Volker Manuth in exhibition catalogue Braunschweig 1994, 232, and McGrath 1984, 83–5 (illus.).

81 Rembrandt, *Susanna and the Elders*, canvas, 76.6 x 92.7 cm, signed and dated 1647, Berlin, Gemäldegalerie Staatlicher Museen Preussischer Kulturbesitz (inv. no. 828E). See Bredius and Gerson 1969, 428 (illus.), 600, no. 516.

82 Salomon Koninck, *Susanna and the Elders*, panel, 45 x 38.5 cm, signed and dated 1649, private collection; see exhibition catalogue Braunschweig 1994, 232–3, no. 75 (illus.).

83 Manuth 1987b.

84 See cat. no. 3, Provenance.

85 Bader 1974, no. 19.

86 Sumowski 1983–94, 5:3403.

87 Pieter Lastman, *Joseph Selling Grain in Egypt*, panel, 58.4 x 87.6 cm, signed and dated 1618, Dublin, National Gallery of Ireland. See exhibition catalogue Amsterdam 1991, 75 (illus. figs. 22 and 23). Astrid Tümpel identifies three versions of the theme by Claes Cornelisz. Moyaert: canvas, 136 x 179 cm, c. 1650, Kingston, Agnes Etherington Art Centre (acc. no. 23–038), see Tümpel 1974, 122 (illus. no. 167), 253, no. 50; panel, 69 x 103 cm, monogrammed and dated 1633, Budapest, Szépmüvészeti Múzeum (inv. no. 5259), see Tümpel

1974, 94 (illus. no. 126), 252–3, no. 48; and (support not known), 122 x 168, monogrammed and dated 1644, Stockholm, B. Rapp (dealer), in 1956: Tümpel 1974, 114 (illus. no. 154), 253, no. 49.

88 Nicolas van Helt Stokade, *Joseph Selling Grain in Egypt*, canvas, 165 x 190 cm, signed and dated 1656, Amsterdam, Royal Palace on the Dam; see exhibition catalogue Amsterdam 1987, 36 (illus.), 38, no. 16; and also Blankert 1982, 95, with no. 12 (illus. fig. 72). Christian Tümpel has interpreted a painting commissioned from Ferdinand Bol for the council chamber of the Zuiderkerk, as representing the same theme. Bol's painting does not conform to the iconography established by Lastman and Moyaert and followed by Van Helt Stokade, however; the people bring gifts, instead of offering themselves and their children. Furthermore, it is not clear that some of the figures are carrying sacks of grain out of the building at the right. The traditional reading (supported by Blankert) that Bol depicted *Solomon Collecting Gifts for the Building of the Temple* remains the more convincing one. See Christian Tümpel in exhibition catalogue Hamburg 1983–84, 318; Netty van de Kamp in exhibition catalogue Amsterdam and Jerusalem 1991–92, 228–9, no. 16 (illus.); and Albert Blankert in exhibition catalogue Amsterdam 1975, 47–9, no. 13 (illus. fig. 39).

89 "*Geheel Egypte brengt den Ryksvoogt schat en have / En leeft nu zeven jaar by't uitgereikte graan. / Het vrye volk door noot word 's Konings eigen slave. / Een mans voorzigtigheid kan duizenden verzaân.*" Joost van den Vondel, in Houbraken 1976, 1:367. Vondel also wrote a trilogy on Joseph's story: *Joseph in Dothan. Joseph in Aegypten. Joseph in 't hof*, Amsterdam (Dominicus van der Stichel), 1640. He was likely inspired by the play written by his relative, and Mennonite friend of the period, Jan Tonnis: *Josephs droef en bly-eynd'-spel…*, 3 vols., Groningen (Augustyn Eissens), 1639; see H.F. Wijnman, "De Emder lakenhandelaar Jan Tonnis, schrijver van "Josephs droef en bly-eind spel," een relatie van Vondel," in Wijnman 1959, 137–48.

90 *De honger dryft het volk naar Josephs schuur om graan. / De Voorzorg is een burg voor land en onderdaan; / Men zorgt aan 't Y, in weeld, tot steun van andre tyen. / De Schatbewaarders zyn tot heil der Burgeryen.* (Hunger drives the people to Joseph's barn for grain. / Foresight is a fortress for a state and its subjects; / One builds up on the Ij, in prosperity, reserves for other times. / The Treasurers are a blessing to the citizenry.) Jan Vos, in Houbraken 1976, 1:367.

91 Ursula Nilgen, in *L.C.I.*, vol. 2, col. 423, *s.v. Joseph von Ägypten*.

92 See States Bible, 1637, Genesis 41:16, note 23, which emphasizes that Joseph's interpretation of Pharaoh's dream, forecasting years of plenty and famine in Egypt, was divinely inspired. Note 49 to verse 38 further characterizes Joseph as a leader in Egypt: *Verstaet wijsheyt en voorsichtigheyt/ die Godt sijne geest desen man op eene bysondere wijse gegeven heeft* (That is to say wisdom and foresight, which the Spirit of God gave to this man in an extraordinary way).

93 John Calvin, *Commentaries on the Book of Genesis*, vol. 2, trans. John King, Grand Rapids: Eerdmans, 1948, 326–7, commentary on Genesis 41:35: "…prosperity intoxicates men… Joseph advises the king to take care that the country may have its produce laid up in store," and "Therefore the pride of Pharaoh was so wisely subdued, that he, setting aside ambition, preferred a foreigner just brought out of prison, because he excelled them in virtue."

94 Compare, among others, Schama 1987, 51–125. Volker Manuth presents several *caveats* against the link typically drawn between Calvinism and the phenomenon of identification with the nation of Israel, most importantly that Calvinism did not propagate the idea of the elect with regard to a group, tribe, or nation. See Volker Manuth, review of exhibition catalogue Amsterdam and Jerusalem 1991–92, in *Kunstchronik* 45, 1992, 482.

95 A similar observation about English interpretations of scriptural passages in the seventeenth century has been made by Philip Benedict: "English Protestant works of devotion encouraged

believers to apply the salvific or moral implications of biblical scenes to their own lives, to focus, in other words, not on the scene itself but upon its implications for belief and behaviour." In "Calvinism as a Culture? Preliminary Remarks on Calvinism and the Visual Arts," in *Seeing Beyond the Word. Visual Arts and the Calvinist Tradition*, ed. Paul Corby Finney, Grand Rapids and Cambridge: W.B. Eerdmans, 1999, 33.

96 Aristotle, *Poetics*, X and XI; see Aristotle, 39–43.

CHAPTER FIVE

1 See collection catalogue Hannover 1960, 25, no. 31.

2 Schatborn 1979, 120, 128n18.

3 See Appendix (2 May 1675).

4 See collection catalogue London 1915–30, 4:7–8.

5 See Mellaart 1926, 28 (illus. pl. 13, as Jan van Noordt); and collection catalogue London 1915–30, 4:7–8 (illus. pl. 15).

6 Black and white chalk on blue-grey paper, 39.0 x 24.0 cm, Amsterdam, Rijksprentenkabinet (inv. no. 1975:84); see Sumowski 1979–85, 4:1908–9, no. 873 (illus.). Flinck would also continue to develop the hatched style of pen-and-wash drawing that he had acquired under Rembrandt's tutelage.

7 See exhibition catalogue Amsterdam, Vienna, New York, and Cambridge 1981–82, 118.

8 See exhibition catalogue Amsterdam, Vienna, New York, and Cambridge 1981–82, 118n1. Held pointed to Goltzius as a possible influence on Rubens' use of chalk in portraits (1959, 1:52).

9 For a recent discussion of the problematic nature of the "Academy" in which Van Mander was reported to have participated, see Seymour Slive, *Dutch Painting 1600–1800*, New Haven and London: Yale University Press, 1995, 329n4. Roethlisberger 1993, 34 (Drawing Book), 571–2 (Academy), with reference to Marten Jan Bok, "'Nulla dies sine linea,' De opleiding van schilders in Utrecht in de 17de eeuw," *De zeventiende eeuw* 6, 1990, 58–68.

10 Jacob Adriaensz. Backer, *Seated Female Nude*, black and white chalk on blue-grey paper, 28.8 x 22.8 cm, Boston, collection of Maida and George Abrams; Govert Flinck, *Seated Female Nude*, black and white chalk on blue-grey paper, 36.3 x 24.9 cm, Berlin, Kupferstichkabinett (inv. no. 1327); see exhibition catalogue Amsterdam, Vienna, New York, and Cambridge 1981–82, 118, no. 50, note 7 (illus.).

11 See Dudok van Heel 1982, 74–5.

12 See Bredius 1915–22, 4:1255.

13 Houbraken 1976, 3:185: "...*J. Voorhout, die met hem (na dat hy van Rome weder tot Amsterdam was gekeert) op een Oeffenschool naar't leven geteekend heeft,...* (J. Voorhout, who [after he had returned from Rome to Amsterdam] joined him in drawing from life at a Practice School,...)"; see Hofstede de Groot 1893, 82, and Thieme-Becker, 11:474 (*s.v.* Ferreris [Freres], Dirck *oder* Theodorus).

14 On the period of Voorhout's tutelage see Hofstede de Groot 1892, 212–13, no. 14, and 350n28.

Works Cited

Alberti, Leon Battista. 1972. *On Painting and on Sculpture*. Trans. Cecil Grayson. London: Phaidon.

Andresen, Andreas. 1870. *Andreas Andresen, Handbuch für Kupferstichsammler oder Lexicon der Kupferstecher, Maler-Radirer und Formschneider aller Länder und Schulen nach Massgabe ihrer geschätztesten Blätter und Werke. Auf Grundlage der zweiten Auflage von Heller's pract. Handbuch für Kupferstichsammler*. 2 vols. 2nd. ed. Leipzig: T.O. Weigel.

Andrews, Keith. 1977. *Adam Elsheimer*. Oxford: Phaidon.

Arents, Prosper. 1962. *Cervantes in het Nederlands: Bibliografie*. Ghent: Koninklijke Vlaamse Academie voor Taal- en Letterkunde.

Aristotle. 1932. *The Poetics*. In *The Poetics; Longinus: On the Sublime; Demetrius: On Style*. Trans. W.H. Fyfe. Loeb Classical Library. London: W. Heineman, and New York: G.P. Putnam's Sons.

Bader, Alfred. 1974. *Selections from the Bader Collection*. Ed. Helen Bader. Milwaukee, published by the author.

Bartsch, Adam von. 1797. *Catalogue raisonné de toutes les estampes qui forment l'oeuvre de rembrandt et ceux de ses principaux imitateurs composé par Gersaint, Helle, Glomy & Yver*. 2 vols. 2nd ed. Vienna: A. Blumauer.

– 1803–21. *Le peintre-graveur*. 21 vols. Vienna: J. von Degen.

– 1978–. *The Illustrated Bartsch*. 96 vols to date. New York: Abaris Books.

Bauch, Kurt. 1926. *Jakob Adriaensz. Backer, ein Rembrandtschüler aus Friesland*. Berlin: G. Grote.

– 1957. "Ikonographische Forschungen zu Rembrandts Werk." *Münchner Jahrbuch der Bildenden Kunst* 8:195–210.

Bax, Dirk. 1952. *Hollandse en Vlaamse Schilderkunst in Zuid-Afrika. Hollandse en Vlaamse schilderijen uit de zeventiende eeuw in Zuid-Afrikaans openbaar bezit*. Capetown: Hollandsch-Afrikaansche Uitgevers Maatschappij.

Becker, Felix. 1904. *Gemäldegalerie Speck von Sternburg in Lutzschena. Separate Ausgabe der Kunsthistorische Gesellschaft für Fotografische Publikationen. 40 Aufnahmen Ausgewahlter Meisterwerke mit Text, Kunsthistorische Gesellschaft* XI. Leipzig: Kunsthistorische Gesellschaft für Photographische Publikationen.

Benesch, Otto. 1973. *The Drawings of Rembrandt*. 6 vols. London: Phaidon,

1954–57. 2nd ed., ed. Eva Benesch. London: Phaidon.

Bénézit, Emmanuel. 1976. *Dictionaire critique et documentaire des Peintres, Sculpteurs, Dessinateurs et Graveurs de tous les temps et de tous les pays par un groupe d'écrivains spécialistes français et étrangers*. Paris: Roger et Chernoviz, 1911–20. New edition, 10 vols. Paris: Librairie Grund.

Bernt, Walther. 1957. *Die niederländischen Zeichner des 17. Jahrhunderts*. 2 vols. Munich: F. Bruckmann.

– 1980. *Die Niederländischer Maler und Zeichner des 17. Jahrhunderts*. 4 vols. Munich: F. Bruckmann, 1948–50. 4th ed., 5 vols. Munich: Bruckmann.

Bijtelaar, B.M. 1947. *De zingende torens van Amsterdam*. Amsterdam: De Bussy.

– 1976. "Het Middenschip van de Oude Kerk (IV)." *Jaarboek Amstelodamum* 68:49–70.

Bikker, Jonathan. 1999. "The Deutz Brothers, Italian Paintings and Michiel Sweerts: New Information from Elisabeth Coymans's *Journael*." *Simiolus* 26:277–311.

Blankert, Albert. 1967. "Heraclitus en Democritus: in het bijzonder in de Nederlandse kunst van de 17de eeuw." *Nederlands Kunsthistorisch Jaarboek* 18:31–124.

– 1975. *Kunst als Regeringszaak in Amsterdam in de Seventiende Eeuw; rondom schilderijen van Ferdinand Bol*. Lochem: De Tijdstroom.

– 1976. *Ferdinand Bol (1616–1680) Een leerling van Rembrandt*. Dissertation, Utrecht University.

– 1982. *Ferdinand Bol (1616–1680); Rembrandt's Pupil*. Doornspijk: Davaco.

– 1983. "Rembrandt's Pupils and Followers in the Seventeenth Century." In exhibition catalogue. Amsterdam and Groningen, 13–34.

– 1989. *Ten Years of the Kunsthandel Drs. John H. Schlichte Bergen. 1979–1989*. Amsterdam: Kunsthandel Drs. John H. Schlichte Bergen.

Bloch, Vitale. 1927. "Vom Amsterdammer Kunsthandel." *Cicerone* 19:599–605.

Blunt, Anthony. 1940. *Artistic Theory in Italy, 1450–1600*. Oxford: Clarendon Press.

Boccaccio, Giovanni. 1972. *The Decameron*. Trans. H.G. McWilliam. Harmondsworth, Middlesex: Penguin Books.

Bok, Marten Jan. 1994. *Vraag en aanbod op de nederlandse kunstmarkt, 1580–1700*. Dissertation, Utrecht University.

Boonen, Jacqueline. 1994. "Die Geschichte von Israels Exil und Freiheitskampf." In exhibition catalogue, Amsterdam, Jerusalem, and Münster, 106–21.

Borluit, Guillaume. 1557. *Excellente figueren gesneden uuyten uppersten Poëet Ovidius uuyt vyfthien boucken der veranderinghen met huerlier bedietsele*. Lyon: Jan van Tournes.

Boucher, François. 1965. *Histoire du Costume en occident de l'antiquité à nos jours*. Paris: Flammarion.

Bouwsma, William J. 1975. "The Two Faces of Humanism. Stoicism and Augustinianism in Renaissance Thought." In *Itinerarium Italicum. The Profile of the Italian Renaissance in the Mirror of its European Transformations*, eds. Heiko A. Oberman and Thomas A. Brady, Jr., 3–60. Leiden: E.J. Brill.

Braun, J. 1980. *Alle tot nu toe bekende schilderijen van Jan Steen*. Rotterdam: Lekturama.

Bredius, Abraham. 1892. "De schilder Johannes van de Cappelle." *Oud Holland* 10:26–40, 133–6.

– 1915–22. *Künstler-Inventare*. Ed. Cornelius Hofstede de Groot. 7 vols. The Hague: Martinus Nijhoff.

Bredius, Abraham, and Horst Gerson. 1969. *Rembrandt. The Complete Edition of the Paintings*. 3rd ed., rev. Horst Gerson. London and New York: Phaidon.

Brenninkmeyer-de Rooij, B. 1982. "Notities betreffende de decoratie van de Oranjezaal in Huis Ten Bosch, uitgaande van H. Peter-Raupp." *Die Ikonographie des Oranjezaal*, Hildesheim/New York 1980." *Oud Holland* 96:133–90.

Broos, Benjamin J.P. 1975/76. "Rembrandt and Lastman's *Coriolanus*: The History Piece in 17th-century Theory and Practice." *Simiolus* 8:199–228.
– 1991. "Hippocrates bezoekt Democritus - door Pynas, Lastman, Moeyaert en Berchem." *Kroniek van het Rembrandthuis* 43:16–23.
Bruyn, Josua. 1983. Review of Blankert 1982. *Oud Holland* 97:208–16.
– 1984. Review of Sumowski 1983–94, vols. 1–4. *Oud Holland* 98:146–62.
Bruyn, Josua, et al. 1982–. *A Corpus of Rembrandt Paintings*. 4 vols to date. The Hague: Martinus Nijhoff.

Carman, Jillian. 1994. *Seventeenth-century Dutch and Flemish Paintings in South Africa: A Checklist of Paintings in Public Collections*. Johannesburg: Johannesburg Art Gallery.
Cats, Jacob. 1637. *Seldsaem trougeval tusschen een Spaens edelman en een Heydinne; soo als de selve Edelman en al de werelt doen geloofde*. In *'s Werelts begin, midden, eynde, besloten in den trov-ringh, met den proefsteen van den selven*, 471–516. Dordrecht: Matthias Havius.
– 1966. *Het Spaans Heydinnetje*. Ed. and commentary Hermina Jantina Vieu-Kuik. Zwolle: Tjeenk Willink.
Cervantes, Miguel de Saavedra. 1643. *Het schoone Heydinnetje. Vertaelt uyt de Schriften van Miguel de Cervantes Saavedra*. Trans. Felix van Sambix. Delft: Felix van Sambix.
– 1998. *The Little Spanish Gipsy*. In *Exemplary Stories*. Trans. Lesley Lipson. Oxford and New York: Oxford University Press.
Coornhert, Dirck Volkertsz. 1564. *50 lustige historien, ofte Nyeuwicheden Joannis Bocatij. Van nieus overgeset in Nederdutsche sprake duer Dirick Coornhert*. Haarlem: Jan van Zuren.
– 1982. *Zedekunst dat is Wellevenkunst*, n.p., 1586. Reprint, ed. B. Becker. Utrecht: HES Publishers.
Cornelis, Bart. 1995. "A Reassessment of Arnold Houbraken's *Groote Schouburgh*." *Simiolus* 23:163–80.
Czobor, Agnes. 1967. "An Oil Sketch by Cornelis de Vos." *Burlington Magazine* 109:351–5.

Dapper, Olfert. 1663. *Historische beschryving der stadt Amsterdam: waer in de voornaemste geschidenissen (na een kort verhael van gansch Hollant en d'omleggende dorpen, als ambachts-heerlijkheden, onder deze stadt gelegen) die ten tijde der herdoopers, Nederlandtsche beroerten, en onder Pris Willems, de tweede, stadt-houderlijke regeeering, hier ter stede voor-gevallen zijn, verhandelt, en al de stads gemeene, zoo geestelijke als wereltlijke, gebouwen, in meer als tzeventigh kopere platen, met haer nevenstaende beschrijving, vertoont worden*. Amsterdam: Jacob van Meurs.
Decoen, Jean. 1931. "Jean van Noordt." *Cahiers de Belgique* 4:9–19.
De Gelder, Jan Jacob. 1921. *Bartholomeus van der Helst: een studie van zijn werk, zijn levensgeschiedenis, een beschrijvende catalogus van zijn oeuvre, een register en 41 afbeelingen naar schilderijen*. Rotterdam: W.L. & J. Brusse.
De Jager, Ronald. 1990. "Meester, leerjongen, leertijd. Een analyse van zeventiende-eeuwse Noordt-Nederlandse leerlingcontracten van kunstschilders, goud- en zilversmeden." *Oud Holland* 104:69–111.
De Jongh, Eddy. 1967. *Zinne- en minnebeelden in de schilderkunst van de zeventiende eeuw*. The Hague: Stichting Openbaar Kunstbezit.
– 1968/69. "Erotica in vogelperspectief. De dubbelzinnigheid van een reeks 17de eeuwse genrevoorstellinge." *Simiolus* 3:22–72.
De Lairesse, Gerard. 1969. *Groot schilderboek*. 2 vols. Amsterdam: The heirs of Willem de Coup, 1707. Facsimile ed., Utrecht: Davaco.
Della Pergola, Paola. 1967. "P.P. Rubens e il tema della Susanna al bagno." *Bulletin des Musées Royaux des Beaux-Arts de Belgique* 16:7–22.

Der Kleine Pauly. Lexikon der Antike in fünf Bänden. 1979. Eds. Konrat Ziegler and Walther Sontheimer. 5 vols. Munich: Deutscher Taschenbuch Verlag.

Descamps, Jean Baptiste. 1972. *La vie des peintres flamands.* 4 vols. Paris: Charles-Antoine Jombert, 1735–64. Fascimile reprint, Geneva: Minkoff Reprints.

De Vries, Lyckle. 1998. *Gerard de Lairesse. An artist between stage and studio.* Amsterdam: Amsterdam University Press.

De Witt, David A. 1993. *The Texts and Contexts of Jan van Noordt's Two History Paintings in Kingston.* M.A. thesis, Queen's University, Kingston, Canada.

– 1999. "A Scene from Cervantes in the Stadholder's Collection: Lievens's *Gypsy Fortune-Teller.*" *Oud Holland* 113:181–6.

Dézallier, Antoine Joseph D'Argenville. 1745–52. *Abregé de la vie des plus fameux paintres.* 3 vols. Paris: Chez De Bure.

d'Hulst, Roger Adolph. 1982. *Jacob Jordaens.* Trans. S. Falla Ithaca: Cornell University Press.

Dirkse, Paul. 1980. "Christus en de Vrouw uit Kanaän, Jan van Noordt." *Jaarverslag Vereniging Rembrandt* 7:76–9.

– 1997. "Christus en de hoofdman van Kapernaüm. Een tekening door W. van Oordt van bijzonder documentair belang." *Catharijnebrief* 60:13–16.

Dongelmans, Bernardus Petrus Maria. 1982. *Nil Volentibus Arduum. Documenten en Bronnen: een uitgave van Balthasar Huydecoper's aantekeningen uit de originele notulen van het genootschap.* Utrecht: HES.

Dozy, Ch.M. 1887. "Aanteekeningen uit het Archief van Amsterdam." *Tijdschrift der Vereeniging voor Noordt-Nederlands Muziekgeschiedenis* 2:218–23.

Dudok van Heel, S.A.C. 1982. "Het `schilderhuis' van Govert Flinck en de kunsthandel van Uylenburgh te Amsterdam." *Jaarboek Amstelodamum* 74:70–90.

– 1984. "Noordt-Nederlandse Pre-Rembrandtisten en Zuid-Nederlandse muziek-instrumentenmakers, de schilders Pynas en de luit- en citermakers Burlon en Coop." *Jaarboek Amstelodamum* 76:13–37.

– 1996. "Een opmerkelijke dikzak. Jan Hinlopen door Bartholomeus van der Helst." *Maandblad Amstelodamum* 83:161–6.

Dusart, Catharina Verwers. 1644. *Spaensche heydin: blyspel.* Amsterdam.

Dutuit, Eugene. 1970–72. *Manuel de l'amateur d'estampes; introduction génèrale contenant un essai sur les plus anciennes gravures et estampes en manier criblée, sur les livres xylographiques et les livres à figures du XVe siècle.* 5 vols. Paris, 1881–88. Reprint, Amsterdam: G.W. Hissink.

Duyvené de Wit-Klinkhamer, Th.M. 1966. "Een vermaarde zilveren beker." *Nederlands Kunsthistorisch Jaarboek* 17:79–103.

Elias, Johan Engelbert. 1963. *De Vroedschap van Amsterdam, 1578–1795.* 2 vols. Haarlem, 1903–05. Reprint, Amsterdam: N. Israel.

Falk, Marguerite. 1969. "Anthoni van Noordt." *Musik und Gottesdienst* 1:6–14.

Fiorillo, Johann Domenik. 1815–20. *Geschichte der zeichnenden Künste in Deutschland und den Vereinigten Niederlanden.* 4 vols. Hannover: Brüder Hahn.

Fischer P. 1960. "De Sweelincks en de Van Noordts. De Gouden eeuw der Amsterdamse muziek." *Ons Amsterdam* 12:34–42.

Fokkens, Melchior, and J. Veenhuisen. 1662. *Beschrijvinge der wijdt-vermaarde koop-stadt Amstelredam, van hare eerste beginselen, oude voor-rechten, en verscheyde vergrootingen…. Amsterdam: Mark Willemsz. Doornick.

Foucart, Jacques, and J. Lacambre. 1968. "Acquisitions de peintures des écoles du Nord (XVIIe siècle)." *Revue du Louvre et des musées de France* 18:187–94.

Friese, Kurt. 1911. *Pieter Lastman, sein Leben und seine Kunst.* Leipzig: Klinkhardt und Biermann.

Gaskell, Ivan. 1982. "Transformations of Cervantes's 'La Gitanilla' in Dutch Art." *Journal of the Warburg and Courtauld Institutes* 45:263–70.

Geerebaert, Adhemar. 1924. *Lijst van de*

gedrukte Nederlandsche Vertalingen der oude Grieksche en Latijnsche Schrijvers. Ghent: Volksdrukkerij.

Giskes, Johan H. 1989. "Jacobus van Noordt (ca. 1616–1680), Organist van Amsterdam." *Jaarboek Amstelodamum* 81:83–123.

– 1994. "Amsterdam, centrum van musiek, musikanten en schilders." *Jaarboek Amstelodamum* 86:49–78.

Golan, Steven Robert. 1994. *Scenes from Roman Republican History in Seventeenth-century Dutch Art:* Exempla virtutis *for Public and Private Viewing*. Dissertation, University of Kansas.

Gonse, L. 1900. "Les Chefs -d'Œuvre des Musées de France." Paris: La Peinture.

Gooren, R. 1982. *…en dat zal noch Susann' een kuyssche vrouwe zijn*. MA thesis, Utrecht University.

Groenveld, Simon, and Jaap B. den Hertog. 1987. "Twee Musici, twee stromingen; Een boek-octrooi voor Anthoni van Noordt en een advies van Constantijn Huygens, 1659." In *Veelzijdigheid als levensvorm: facetten van Constantijn Huygens' leven en werk: een bundel studies ter gelegenheid van zijn drie hondertste sterfdag*, eds. A. Th. van Deursen, E.K. Grootjes, and D.E.L. Verkuyl, 109–27. Doornspijk: Deventer.

Gudlaugsson, Sturla J. 1948a. "Representations of Granida in Dutch Seventeenth-century Painting I." *The Burlington Magazine* 90:226–30.

– 1948b. "Representations of Granida in Dutch Seventeenth-century Painting II." *The Burlington Magazine* 90:348–51.

– 1949. "Representations of Granida in Dutch Seventeenth-century Painting III." *The Burlington Magazine* 91:39–43.

– 1959–60. *Geraert ter Borch*. 2 vols. The Hague: Martinus Nijhoff.

– 1975. *De komedianten bij Jan Steen en zijn tijdgenoten*. 1945. The Hague: A.A.M. Stols. Trans. James Brockway. Soest: Davaco.

Haak, Bob. 1969. *Rembrandt, His Life, His Work, His Time*. Trans. Elizabeth Willems-Treeman. New York: Harry N. Abrams.

Hall, James. 1974. *Hall's Dictionary of Subjects & Symbols in Art*. London: John Murray.

Hamann, Richard. 1936. "Hagars Abschied bei Rembrandt und im Rembrandt-Kreise." *Marburger Jahrbuch für Kunstwissenschaft* 8/9:471–578.

Hartt, Frederick. 1969. *Michelangelo. The Complete Sculpture*. New York: Abrams.

Heiland, Susanne. 1989. "Anmerkungen zur Richterschen Kunstsammlung." In *Das Bosehaus im Thomaskirchhof*, ed. Armin Schneiderheinze, 139–74. Leipzig: Ed. Peters.

Held, Julius S. 1959. *Rubens Selected Drawings*. 2 vols. London: Phaidon.

– 1961. "Flora, Goddess and Courtesan." In *De Artibus Opuscula XL: Essays in Honor of Erwin Panofsky*, ed. Millard Meiss, 201–8. New York: New York University Press, and Zürich: Buehler Buchdruk.

– 1980. *The Oil Sketches of Peter Paul Rubens: A Critical Catalogue*. 2 vols. Princeton: Princeton University Press.

Heller, Joseph. 1836. *Praktisches Handbuch für Kupferstichsammler oder Lexicon der vorzüglichsten und beliebtesten Kupferstecher, Formschneider und Lithographen*. 3 vols. Bamberg: J.G. Sickmüller.

– 1854. *Zusätze zu Adam Bartsch's Le peintre-graveur*. Nürnberg: J.L. Lotzbeck.

Heyblocq, Jacob. 1998. *The Album Amicorum of Jacob Heyblocq*. Ed. Kees Thomassen and J.A. Gruys. Facsimile ed., Zwolle: Waanders.

Hoet, Gerard. 1752. *Naamlyst van Schilderijen…* 2 vols. The Hague: Pieter Gerard van Baalen.

Hofstede de Groot, Cornelius. 1892. "Joan van Noordt." *Oud Holland* 10:210–18.

– 1893. *Arnold Houbraken und seine 'Groote Schouburgh' Kritisch Beleuchtet*. The Hague: Martinus Nijhoff.

– 1907–28. *Beschreibendes und kritisches Verzeichnis der Werke der hervorragendsten holländischen Maler des XVII. Jahrhunderts*. 10 vols. Paris: F. Kleinberger.

Hollstein, F.W.H. 1949–. *Dutch and Flemish Etchings,Engravings and Woodcuts, ca. 1450–1700.* 52 vols to date. Amsterdam: Menno Hertzberger.

Hooft, Pieter Cornelisz. 1636. *Gedichten van den heere Pieter C. Hooft.* Amsterdam: Johan Blaeu.

Houbraken, Arnold. 1976. *De Groote Schouburgh der Nederlantsche Konstschilders en Schilderessen.* 3 vols. The Hague: Arnold Houbraken, 1717–21. Reprint, The Hague: J. Swart, C. Boucquet, en M. Gaillard, 1753. Facsimile ed. of 1753 reprint, Amsterdam: B.M Israël.

Israel, Jonathan. 1995. *The Dutch Republic, Its Rise, Greatness and Fall: 1477–1806.* Oxford: Clarendon Press.

Jaacks, Gisela. 1978. "'Häusliche Musiksze-ne' von Johannes Voorhout. Zu einem neuen erworbenen Gemälde im Museum für Hamburgische Geschichte." *Beiträge zur Deutschen Volks- und Altertumskunde Hamburg* 17:56–9.

Janeck, Axel. 1968. *Untersuchung über den holländischen Maler Pieter van Laer, genannt Bamboccio.* Dissertation, Julius-Maximillians-Universität Würzburg.

Kettering, Alison McNeil. 1977. "Rem-brandt's *Flute Player*: A Unique Treatment of Pastoral." *Simiolus* 9:19–42.

– 1983. *The Dutch Arcadia. Pastoral Art and its Audience in the Golden Age.* Montclair, New Jersey: Allanheld & Schram.

Keyes, George S. 1984. *Esaias van den Velde.* Doornspijk: Davaco.

Kolleman, G. 1971. "Roelof Meulenaer. Postmeester tot Antwerpen." *Ons Amsterdam* 23:114–21.

Kramm, Christian. 1974. *De Levens en Wer-ken der Hollandsche en Vlaamsche Kunstchil-ders, Beeldhouwers, Graveurs en Bouw-meesters, van den vroegsten tot op onzen tijd.* 6 vols. Amsterdam: Gebroeders Diede-richs, 1857–64. Reprint, Amsterdam: B.M. Israel.

Krempel, Leon. 2000. *Studien zu den datier-ten Gemälden des Nicolaes Maes (1634–1695).* Petersburg: Michael Imhoff Verlag.

Kronig, J.O. 1911. "Een onbekende Joan van Noordt in het Museum van Brussel." *Onze Kunst* 20:156–8. [Also available in French: "Un Jean van Noordt Inconnu au Musée de Bruxelles." *L'art Flamand et Hollandais* 16:147–9; citations are from the Dutch version.]

Kuretsky, Susan Donahue. 1979. *The Paint-ings of Jacob Ochterveld.* Oxford: Phaidon, and Monclair, New Jersey: Allanheld & Schram.

Larsen, Erik. 1957. "The Original 'Judah and Tamar' by Pieter Lastman." *Oud Holland* 72:111–14.

Le Blanc, Charles. 1970. *Manuel de l'ama-teur d'estampe.* 4 vols. Paris: Bouillon, 1854–89. Reprint, Amsterdam: Hissink & Co.

Lepper-Mainzer, Gaby. 1982. *Die Darstel-lung des Feldherrn Scipio Africanus.* Disser-tation, Universität Bochum.

Lexikon der Christlichen Ikonographie. 1970. 4 vols. Ed. E. Kirschbaum. Rome, Frei-burg, Basel, and Vienna: Herder.

Linnik, Irina Vladirirovna. 1980. *Golland-skaja îivopis' XVII Veka i Problemy Atribuf ii Kartin* [Dutch paintings of the 17th century and problems of attribution]. St Petersburg: Iskusstvo.

Logan, Anne-Marie S. 1979. *The 'Cabinet' of the Brothers Gerard and Jan Reynst.* Amsterdam, Oxford, and New York: North-Holland Publishing Company.

Louvre. 1986. "Recentes Acquisitions des musées nationaux." *La Revue du Louvre* 36:139–44.

Lunsingh Scheurleer, T.H. 1987. "Drie Brieven van de architect Pieter Post over zijn werk voor Constantijn Huygens en stadhouder Frederik Hendrik in de Fon-dation Custodia te Parijs." In *Veelzijdig-heid als levensvorm. Facetten van Constantijn Huygens' leven en werk,* ed. A. Th. van Deursen et al. Deventer: Sub Rosa.

Manuth, Volker. 1987a. "The Levite and His Concubine at the House of the Field Labourer in Gibeah: The Iconography of an Old Testament Theme in Dutch Painting of Rembrandt's Circle." *Mercury* 6:11–24.

– 1987b. *Ikonographische Studien zu den Historien des Alten Testaments bei Rembrandt und seiner frühen Amsterdamer Schule.* Dissertation, Berlin: Freie Universität.

– 1993. "Denomination and Iconography: The Choice of Subject Matter in the Biblical Painting of the Rembrandt Circle." *Simiolus* 22:235–52.

– 1998a. "Zum Nachleben der Werke Hans Holbeins d.J. in der holländischen Malerei und Graphik des 17. Jahrhunderts." *Zeitschrift für Schweizerische Archäologie und Kunstgeschichte* 55:323–36.

– 1998b. "'Een kinskontrefeijtsel, antycqs gedaen' und 'Een…van Scipio africanus'- Zu zwei neu identifizierten Gemälden des Gerbrand van den Eeckhout." *Oud Holland* 112:139–50.

Marais, M.M. 1971. *Die Nederlandse sewentiende eeuse portrette in die Johannesburgse Kunsmuseum.* M.A. thesis, University of Pretoria.

Mariette, Pierre-Jean. 1851–60. *Abecedario de J. Mariette et autres notes inédites de cet amateur sur les arts et les artistes.* Eds. Philippe De Chennevières and A. De Montaiglon. 6 vols. Paris: J.-B. Dumoulin.

McGrath, Elizabeth. 1984. "Rubens's *Susanna and the Elders* and Moralizing Inscriptions on Prints." In *Wort und Bild in der niederländischen Kunst und Literatur des 16. und 17. Jahrhunderts*, eds. Herman Vekeman and Justus Müller Hofstede, 73–90. Erftstadt: Lukassen.

– 1997. *Rubens. Subjects from History.* 2 vols. Corpus Rubenianum Ludwig Burchard 13. London: Harvey Miller Publishers.

Meder, Joseph, and Joseph Schönbrunner 1893–1908. *Handzeichnungen alter Meister aus der Albertina und andern Sammlungen.* 12 vols. Vienna: Ferdinand Schenk.

Melion, Walter S. 1991. *Shaping the Netherlandish Canon: Karel van Mander's Schilder-Boeck.* Chicago and London: University of Chicago Press.

Mellaart, J.H.J. 1926. *Dutch Drawings of the Seventeenth Century.* London: E. Benn.

Miedema, Hessel. 1993. Review of *Shaping the Netherlandish Canon* by Walter S. Melion. *Oud Holland* 107:152–60.

Miller, Deborah. 1985. *Jan Victors, 1619–1676.* Dissertation, University of Delaware.

Moes, Ernst Willem. 1897–1907. *Iconografia Batava: beredeneerde lijst van geschilderde en gebeeldhouwde portretten van Noord-Nederlanders in vorige eeuwen.* 2 vols. Amsterdam: Frederik Muller.

Montias, John Michael. 1989. *Vermeer and his Milieu: A Web of Social History.* Princeton: Princeton University Press.

Morford, Mark. 1991. *Stoics and Neostoics: Rubens and the Circle of Justus Lipsius.* Princeton: Princeton University Press.

Moryson, Fynes. 1907–08. *An Itinerary written By Fynes Moryson Gent. First in the Latine Tongue and then translated By him into English.* 3 vols. London: John Beale, 1617. Reprint, Glasgow: MacLehose.

Muller, Frederik. 1853. *Beschrijvende Catalogus van 7000 Portretten, van Nederlanders, en van Buitenlanders, tot Nederland in betrekking staande, afkomstig uit de collectiën: de Berlett, Verstolk van Soelen, Lamberts, enz.* Amsterdam: Frederik Muller.

Murdzeńska, Maria. 1970. "A Mythological Picture by Jacob Adriaensz. Backer." *Bulletin du Musée National de Varsovie* 11:97–106.

Nagler, Georg Kaspar. 1832–52. *Neues allgemeines Künstler-Lexikon.* 22 vols. Munich: E.A. Fleischmann.

Nystad, Saskia. 1981. "Een Relatie Tussen Jan van de Capelle, Gerbrand van den Eeckhout en Jan van Noordt?" *Tableau* 3:710–12.

Oestreich, Gerhard. 1975. "Justus Lipsius als Universalgelehrter zwischen Renaissance und Barock." In *Leiden University in the Seventeenth Century: An Exchange*

of Learning, eds. Th.H. Lunsingh Scheur-
leer and G.H.M. Posthumus Meyjes,
177–201. Leiden: E.J. Brill.

Oldewelt, Willem Ferdinand Hendrick.
1942. "Een beroepstelling uit den Jare
1688." In *Amsterdamsche Archiefvondsten*,
172–6. Amsterdam: De Bussy.

Op de Beeck, E. 1973. "Suzanna en de twee
ouderlingen. Rubens gravures voor Anna
Roemer Visscher." *Jaarboek van het
Koninklijk Museum voor Schone Kunsten*,
207–21.

Parthey, Gustav. 1863–64. *Deutscher Bilder-
saal. Verzeichnis der in Deutschland vorhan-
denen Ölbilder verstorbener Maler aller
Schulen*. 2 vols. Berlin: Nicolaische Ver-
lagsbuchhandlung.

Peltzer, Rudolph Arthur. 1937–38. "Chri-
stopher Paudiss und seine Tätigkeit in
Freising." *Münchner Jahrbuch der bildenden
Kunst*, Neue Folge 12, 251–80.

Pigler, Andor. 1955. "Gruppenbildnisse mit
historisch verkleideten Figuren und ein
Hauptwerk des Joannes van Noordt."
Acta Historiae Artium II, Fasciculi 3–
4:169–86.

– 1968. *Barockthemen. Eine Auswahl von Ver-
zeichnissen zur Ikonographie des 17. und 18.
Jahrhunderts*. Budapest: Ungarische Aka-
demie der Wissenschaften, 1956. 2nd ed.
(with revisions), Budapest: Ungarische
Akademie der Wissenschaften.

Plietzsch, Eduard. 1915. "Holländische Bil-
der des 17. Jahrhunderts aus Leipziger
Privatbesitz." *Monatshefte für Kunstwissen-
schaft* 8, no. 2:46–57.

Poglayen-Neuwall, Stephan. 1930. "The
Wilhelm Ofenheim Collection." *Apollo*
12:126–32.

Pont, Daniel. 1958. *Barent Fabritius
1624–1673*. Orbis Artium. Utrechtse
Kunsthistorische Studien II. Utrecht:
Haentjens, Dekker & Gumbert.

Prêtre, Jean-Claude. 1990. "Suzanne par
Suzanne." In *Suzanne. Le procès du modèle*,
ed. Jean-Claude Prêtre, 29–128. Paris:
La Bibliothèque des Arts.

Renger, Konrad. 1970. *Lockere Gesellschaft:
zur Ikonographie des verlorenen Sohnes und
von Wirtshausszenen in der niederländischen
Malerei*. Berlin: Mann.

Richter. 1775. "Nachricht von Richters
Portrait, Leben und Kunstsammlung."
*Die Neue Bibliothek der schönen Wissenschaf-
ten und der freyen Künste* 18:303–22.

Rijksprentenkabinet 1983. Keuze uit de
aanwinsten van det Rijksprentenkabinet."
Bulletin van het Rijksmuseum 31:63–85.

Ripa, Cesare. 1644. *Iconologia, of Uytbeelding
des verstands*. Trans. and ed. Dirck Pieter-
sz Pers, woodcut illustrations by Giovan-
ni Zaratino Castellini. Leiden: Dirck
Pietersz Pers.

Roethlisberger, Marcel. 1980. *Bartholomeus
Breenbergh: The Paintings*. New York and
Berlin: De Gruyter.

– 1993. *Abraham Bloemaert and His Sons:
Paintings and Prints*. Doornspijk: Davaco.

Roscher, W.H. 1884–1937. *Ausführliches Le-
xikon der griechischen und römischen Mytho-
logie*. 7 vols. and supplement. Leipzig and
Berlin: B.G. Teubner.

Rovinsky, Dmitri A. 1894. *L'Oeuvre gravé
des élèves de Rembrandt et des maitres qui
ont gravé dans son gout*. St Petersburg.

Roy, Rainer. 1972. *Studien zu Gerbrand van
den Eeckhout*. Dissertation, Vienna.

Russell, Margarita. 1975. *Jan van de Cappelle
1624/6–1679*. Leigh-on-Sea: F. Lewis.

Schama, Simon. 1987. *The Embarrassment
of Riches: An Interpretation of Dutch Culture
in the Golden Age*. London: Collins.

Schatborn, Peter. 1979. "Tekeningen van
Jan van Noordt." *Bulletin van het Rijksmu-
seum* 27:118–28.

Scheller, Robert. 1961. "Rembrandt's repu-
tatie van Houbraken tot Scheltema."
Nederlands Kunsthistorisch Jaarboek
12:81–118.

Schlüter-Göttsche, Gertrud. 1971. "Das
Gemälde der Auferstehung Christi von
Jürgen Ovens aus dem Cassius-Altar.
Ehemals Michaelskirche Eutin." *Nordel-
bingen* 40:77–90.

– 1978. *Jürgen Ovens. Ein schleswig-holsteini-*

scher Barockmaler. Heide in Holstein: Boyens & Co.

Schneider, Han. 1931. "Jan van Noordt." Entry in Ulrich Thieme, Felix Becker, et al. Allgemeines Künstler-Lexikon. 25:511. Leipzig: W. Engelman.

Schwartz, Gary. 1984. Rembrandt, His Life, His Paintings. New York: Abrams.

Scullard, H.H. 1970. Scipio Africanus: Soldier and Politician. London: Thames & Hudson.

Secord, William. 1992. Dog Painting 1840–1940. A Social History of the Dog in Art, Including an Important Overview from Earliest Times to 1840. Woodbridge, Suffolk: Antique Collector's Club.

Seiffert, Max. 1897. "Anthoni van Noordt." Tijdschrift der Vereeniging voor Neerlandsche Muziekgeschiedenis 5:171–92.

Slive, Seymour. 1953. Rembrandt and His Critics. The Hague: Martinus Nijhoff.

Sluijter, Eric Jan. 1980–81. "Depictions of Mythological Themes." In exhibition catalogue Washington, Detroit, and Amsterdam, 55–64.

– 1986. De `Heydensche Fabulen' in de Noordnederlandse Schilderkunst, circa 1590–1670. Een proeve van beschrijving en interpretatie van schilderijen met verhalende onderwerpen uit de klassieke mythologie. Dissertation, Leiden University.

– 1993a. De Lof der Schilderkonst – Over schilderijen van Gerrit Dou (1613–1675) en een traktaat van Philips Angel uit 1642. Hilversum: Verloren.

– 1993–1994. "De entree van de amoureuze herdersidylle in de Noord-Nederlandse prent- en schilderkunst." In exhibition catalogue Utrecht and Luxembourg 1993–94, 33–57.

Sluijter, Eric Jan, and Nicôle Spaans. 2001. "Door liefde verstandig of door lust verteerd? Relaties tussen tekst en beeld in voorstellingen van Cimon en Efigenia." De zeventiende eeuw 17:75–106.

Smids, Ludolph. 1685. Gallerye, ofte proef van syne dichtoefeningen: met noodige verklaaringen verrykt. Groningen: C. Pieman.

– 1690. Gallerye der Uitmuntende Vrouwen: Of der zelver Deugden en Ondeugden, In Byschriften en Sneldichten vertoond, Met Verklaaringen en Konstplaaten verrijkt. Amsterdam: Jacob van Royen.

– 1694. Poësye. Amsterdam: Dirk Boeteman.

Smith, David. 1982. Masks of Wedlock: Seventeenth-century Dutch Marriage Portraiture. Ann Arbor: UMI Research Press.

Smith, John. 1842. A Catalogue of the Most Eminent Dutch, Flemish, and French Painters. 9 vols. and supplement. London: John Smith.

Smits-Veldt, Maria Barbara. 1986. Samuel Coster, ethicus-didacticus: een onderzoek naar dramatische opzet en morele intructie van Ithys, Polyxena en Iphigenia. Dissertation, University of Amsterdam. Groningen: Wolters-Noordhoff/Forster.

Snoep, Derk Persant. 1970. "Gerard de Lairesse als plafond- en kamerschilder." Bulletin van het Rijksmuseum 18:159–217.

Soeting, Adriaan G. 1980. "De Amsterdamse Muzikantenfamilie van Noordt." Mens en Melodie 35:273–9.

Staring, Adolph. 1946. "Weinig Bekende Portrettisten III: Joannes van Noordt." Oud Holland 64:73–81. [Republished in Kunsthistorische Verkenningen, The Hague: A.A.M. Stols, 1948.]

States Bible 1637. Biblia, dat is de gantsche Heilige Schrift… Leiden: Paulus Aertsz van Ravesteyn.

Stechow, Wolfgang. 1928–29. Review of Illa Budde, "Die Idylle im Holländischen Barock," Cologne, 1929. In Kritische Berichte zur Kunstgeschichtlichen Literatur 2:181–7.

Stewart, J. Douglas. 1990–91. "'And death moved not his generous mind': Allusions and Ideas, Mostly Classical, in Van Dyck's Work and Life." In exhibition catalogue Washington, 69–74.

Strauss, Walter L. 1977. Hendrick Goltzius 1558–1617: The Complete Engravings and Woodcuts. 2 vols. New York: Abaris Books.

Sumowski, Werner. 1956/57. Review of Benesch 1973. Wissenschaftliche Zeitschrift von der Humboldt-Universität zu Berlin 6:233–78.

– 1959. Review of Pont 1958. Kunstchronik 7:287–94.

– 1979–. *The Drawings of the Rembrandt School.* 10 vols to date. New York: Abaris.

– 1983–94. *Gemälde der Rembrandt-Schüler.* 4 vols. Pfalz/Landau: Edition PVA, 1983, with vols. 5 and 6 published as addenda in 1985 and 1994.

– 1986. "Paintings by Jan van Noordt." *The Hoogsteder-Naumann Mercury* 3:21–37.

– 1992. "In Praise of Rembrandt's Pupils." In *Rembrandt's Academy*, exhibition catalogue The Hague: Hoogsteder & Hoogsteder, 36–85.

– 1998. "Remarks on Jacob Adriaensz Backer and Jan van Noordt." *Master Drawings* 36:74–9.

Sutton, Peter. 1982. "The Continence of Scipio by Gerbrandt van den Eeckhout (1621–1674)." *Philadelphia Museum of Art Bulletin* 78:2–15.

– 1992. Review of exhibition catalogue Lyon and Lille 1991. *Burlington Magazine* 134:734–5.

Tengnagel, Mattheus Gansneb. 1643. *Het leven van Konstance: waer af volgt het toneelspel De Spaensche Heidin.* Amsterdam: Nicolaes van Ravesteyn.

Te Poel, Marleen A.H. 1986. *De Granida en Daifilo-voorstellingen in de Nederlandse Schilderkunst van de 17de eeuw.* M.A. thesis, Utrecht.

Ter Molen, Johannes Rein. 1984. *Van Vianen, een Utrechtse familie van zilversmeden met een internationale faam.* 2 vols. Dissertation, Leiden: Leiden University, and Rotterdam: Gemeentedrukwerk.

Terwesten, Pieter. 1770. *Naamlyst van Schilderijen, met derzelver prysen, zedert 1751 tot 1768 openbaar vercogt: dienende tot een vervog op de cataloguen door Gerard Hoet.* The Hague: Johannes Gaillard. Published as a third addendum volume to Hoet.

Thieme, Ulrich, Felix Becker, et al. 1907–50. *Allgemeines Künstler-Lexikon.* 37 vols. Leipzig: W. Engelman.

Trautscholdt, Eduard. 1958. Review of Bernt 1957. *Kunstchronik* 11:361–71.

Tümpel, Astrid. 1974. "Claes Cornelisz. Moeyaert." *Oud Holland* 38:1–163, 235–90.

Tümpel, Christian. 1968. "Ikonographische Beiträge zu Rembrandt: zur Deutung und Interpretation seiner Historien." *Jahrbuch der Hamburger Kunstsammlungen* 13:95–126.

– 1969. "Studien zur Ikonographie der Historien Rembrandts." *Nederlands Kunsthistorisch Jaarboek* 20:107–98.

– 1971. "Ikonographische Beiträge zu Rembrandt: zur Deutung und Interpretation einzelner Werke." *Jahrbuch der Hamburger Kunstsammlungen* 16:20–38.

– 1984. "Die Rezeption der Jüdischen Altertümer des Flavius Josephus in den holländischen Historiendarstellungen des sechzehnten und siebzehnten Jahrhunderts." In *Wort und Bild in der niederländischen Kunst und Literatur des 16. und 17. Jahrhunderts*, eds. Herman Vekeman and Justus Müller Hofstede. Erftstadt: Lukassen, 173–204.

– 1986. *Rembrandt.* Contributions by Astrid Tümpel. Amsterdam: H.J.W. Becht.

Valentiner, Wilhelm Reinhold. 1924. *Nicolaes Maes.* Stuttgart: Deutsche Verlags-Anstalt.

– 1941. "Jan van de Cappelle." *Art Quarterly* 4:274–95.

Van Arp, Jan. 1639. *Chimon: op de reeghel: Door Liefde verstandigh. Treur-bly-eyndent-spel. Ghespeelt in de Schouw-Burgh op Kerremis, 1639.* Amsterdam: Dirck Cornelisz Hout-haeck.

Van Biema, Eduard. 1906. "Nalezing van de Stadsrekeningen van Amsterdam vanaf het jaar 1531. V." *Oud Holland* 24:171–92.

Van Braam, F.A. 1951. *World Collector's Annuary* 3.

Van Breughel, Gerrit Hendriksz. 1605. *De tweede 50. lustige historien, oft Nieuwicheden Johannis Boccatii. Nu nieuwelijcks vertaelt in onse Nederduytsche sprake.* Amsterdam: Egbert Adriaensz.

Van de Kamp, Netty. 1991–92. "Die Genesis. Die Urgeschichte und die Geschichte

der Erzväter." In exhibition catalogue Amsterdam and Jerusalem, 24–53.

Van der Kellen, Johan Philippe. 1866. *Le Peintre-graveur Hollandais et Flamand.* Utrecht: Kemink et fils, Leipzig: T.O. Wiegel, and Paris: Jules Renouard.

Van de Waal, Henri. 1947. "'Hagar in de Woestijn' door Rembrandt en zijn school." *Nederlands Kunsthistorisch Jaarboek* 1:145–69.

Van de Wetering, Ernst. 1991–92. "Rembrandt's Manner: Technique in the Service of Illusion." In exhibition catalogue Berlin, Amsterdam, and London, 12–39.

– 1998. *Rembrandt. The Painter at Work.* Amsterdam: Amsterdam University Press.

Van Dyke, John Charles. 1914. *Brussels, Antwerp: Critical Notes on the Royal Museums at Brussels and Antwerp.* New Guides to Old Masters 4. New York: Charles Scribner's Sons.

– 1923. *Rembrandt and His School. A Critical Study of the Master and His Pupils with a New Assignment of Their Pictures.* New York: Charles Scribner's Sons.

Van Eeghen, Isabella Henrietta. 1969. "Het Amsterdamse Sint Lucasgilde in de 17de eeuw." *Jaarboek Amstelodamum* 60:65–102.

Van Fossen, David Raymond. 1969. *The Paintings of Aert de Gelder.* Dissertation, Harvard University.

Van Gelder, J.G. 1948–49. "De Schilders van de Oranjezaal." *Nederlandsch Kunsthistorisch Jaarboek* 2:118–64.

Van Gent, Judith. 1998. "Portretten van Jan Jacobsz. Hinlopen en zijn familie door Gabriel Metsu en Bartholomeus van der Helst." *Oud Holland* 112:127–38.

Van Gent, Judith, and Gabriël Pastoor. 1991–92. "Die Zeit der Richter." Exhibition catalogue, Amsterdam and Jerusalem, 66–87.

Van Gool, Johan. 1971. *De nieuwe schouburg der Nederlantsche Kunstschilders en Schilderessen: waer in de levens- en kunstbedryven der tans levende en reets overleedene schilders, die van Houbraken, noch eenig ander schryver, zyn aengetekend, verhalt worden.* 2 vols.

The Hague: Johan van Gool, 1750–51. Facsimile ed., Soest: Davaco.

Van Hall, Hendrick. 1963. *Portretten van nederlandse beeldende kunstenaars.* Amsterdam: Swets en Zeitlinger.

Van Hoogstraten, Samuel. 1969. *Inleyding tot de hooge schoole der Schilderkonst.* Rotterdam: Fransois van Hoogstraten, 1678. Facsimile ed., Utrecht: Davaco.

Van Lieburg, Frederik Agenietus. 1996. *Repertorium van Nederlandse Hervormde Predikanten tot 1816.* 2 vols. Dordrecht, published by the author.

Van Mander, Karel. 1969a. *Het schilder-boek, waerin voor eerst de leerlustighe ieucht den grondt des edle vry schilderconst in verscheyden deelen wort voorghedraghen.* Haarlem: Passchier van Westbusch, 1604. Facsimile ed., Utrecht: Davaco.

– 1969b. *Wtlegginge op de Metamorphosis Pub. Ovid. Nasonis.* Haarlem: Passchier van Westbusch, 1604. Facsimile ed., Utrecht: Davaco.

– 1969c. *Uytbeeldingen der Figueren: ware in te sien is hoe d'Heydenen hun Goden uytghebeeldt en onderscheyden hebben: hoe d'Egyptsche yet beteyckenden met Dieren oft anders en eenighe meeninghen te kennen gaven met noch meer omstandicheden.* Haarlem: Passchier van Westbusch, 1604. Facsimile ed., Utrecht: Davaco.

– 1973. *Den grondt der edel vry schilder-const.* 2 vols. Ed. and commentary Hessel Miedema. Utrecht: Davaco.

– 1994–99. *Lives of the illustrious Netherlandisch and German painters: from the first edition of the "Schilder-boeck."* Ed. and commentary Hessel Miedema, trans. Michaeal Hoyle, et al. 6 vols. Doornspijk: Davaco.

Van Noordt, Anthoni. 1976. *Tabulatuurboeck van psalmen en fantasyen.* Amsterdam: published by the author, 1659. Reprint editions: ed. Max Seiffert, Amsterdam: Den Algemeen Muziekhandel, and Leipzig: Breitkopf & Haertel, 1896; ed. Jan van Biezen, Amsterdam: Vereniging voor Nederlandse muziekgeschiedenis.

Van Regteren Altena, J.Q. 1963. "Gabriel Metsu as a Draughtsman." *Master Drawings* 1 (no. 2):13–19.

Van Stipriaan, Rene. 1996. *Leugens en vermaak. Boccaccio's novellen in de kluchtcultuur van de Nederlandse renaissance.* Dissertation, University of Amsterdam.

Vasari, Giorgio. 1963. *The Lives of the Artists.* 4 vols. Trans. William Gaunt. London: Dent, and New York: Dutton.

Verhagen, Rein. 1989. *Sybrandus van Noordt: organist van Amsterdam en Haarlem 1659–1705.* Amsterdam: Koninklijke Nederlandse Toonkunstenaars Vereniging.

Vignau Wilberg-Schuurman, Thea. 1983. *Hoofse minne en burgerlijke liefde in de prentkunst rond 1500.* Leiden: Martinus Nijhoff.

Vondel, Joost van den. 1617. *Vorstelijke Warande der Dieren Waerin de Zeden-rijcke Philosophie, Poëtisch, Morael, en Historiael, vermakelijck en treffelijck wort voorghestelt: Met exemplen uyt de oude Historien, in Prosende Vytleggingen, in Rijm verclaert: Oock met aerdige Afbeeldingen geciert, ende constich in coper gesneden, door Marcus Gerards, Schilder. Alles tot sonderlinghen dienst ende nutticheyt voor alle staten van menschen uytghegeven.* Amsterdam: Dirck Pietersz.

– 1927–40. *De werken van Vondel.* 11 vols. Eds. J.F.M. Sterck, et al. Amsterdam: Maatschappij voor goede en goedkope lectuur.

Von Moltke, Joachim Wolfgang. 1965a. *Govaert Flinck (1615–1660).* Amsterdam: Menno Hertzberger & Co.

– 1965b. "Einige Beobachtungen zu Zeichnungen des Govaert Flinck." In *Festschrift Eduard Trautscholdt zum 70. Geburtstag am 13. Januar 1963.* Hamburg: Dr. Ernst Hauswedell & Co.

– 1994. *Arent de Gelder: Dordrecht 1645–1727,* ed. Kristin Belkin. Doornspijk: Davaco.

Von Térey, Gabriel. 1919. "Boccaccio und die niederländische Malerei." *Zeitschrift für Bildende Kunst,* Neue Folge 30, 54:241–8.

Voorhelm Schneevoogt, C.G. 1873. *Catalogue des Estampes Gravées d'après P.P. Rubens, avec l'indication des collections où se trouvent les tableaux et les gravures.* Haarlem: Loosjes.

Vos, Jan. 1662. *Alle de Gedichten van den Poëet Jan Vos.* Amsterdam: Jacob Lescaille.

Vosmaer, Carel. 1877. *Rembrandt, sa vie et ses oeuvres.* 2nd ed. The Hague: Martinus Nijhoff.

Watson, Paul F. 1979. *The Garden of Love in Tuscan Art of the Early Renaissance.* Philadelphia: Art Alliance Press, and London: Associated University Press.

Weber, Gregor J.M. 1991. *Der Lobtopos des >lebenden< Bildes. Jan Vos und sein "Zeege der Schilderkunst" von 1654.* Hildesheim: Georg Olms.

Wessely, Joseph Eduard. 1866. *Jan de Visscher und Lambert Visscher: Verzeichniß ihrer Kupferstiche.* Leipzig: R. Wiegel.

Weyerman, Jacob Campo. 1729 and 1769. *De levens-beschryvingen der Nederlandsche konst-schilders en Konstschilderessen.* 4 vols. The Hague: The widow of E. Boucquet, H. Scheurleer, F. Boucquet, and J. de Jongh. 1729: vols. 1–3; 1769: vol. 4.

Wijnman, Hendrik Fredrik. 1959. "De schilder Abraham van den Tempel." In *Uit de kring van Rembrandt en Vondel. Verzamelde studies over hun leven en omgeving,* 39–93. Amsterdam: Noordt-Hollandsche Uitgevers Maatschappij.

Wishnevsky, Rosa. 1967. *Studien zum Porträt Historie in den Niederländen.* Dissertation, Munich, Ludwig-Maximilians-Universität.

Witcamp, Pieter Harmen. 1888. "Vroegere diergaarden en beoefenaars der dierkunde, inzonderheid met betrekking tot de verdiensten der Nederlanders op zoölogisch gebied." *Eigen Haard* 25:312–16.

Wolff, Christolph. 1983. "Das Hamburger Buxtehude-Bild." *Musik und Kirche* 53:8–19.

Würtenburger, Franszepp. 1937. *Das holländische Gesellschaftsbild.* Dissertation,

University of Freiburg. Schramberg: Gatzer & Hahn.

Wurzbach, Alfred von. 1906–10. *Niederländisches Künstler-Lexikon*. 3 vols. Vienna and Leipzig: Von Halm und Goldmann.

Wybrands, C.N. 1873. *Het Amsterdamsche Tooneel van 1617–1772*. Utrecht: Beijers.

EXHIBITION CATALOGUES

Amsterdam 1910. *Tentoonstelling van Kinderportretten*. Amsterdam: Maatschappij Arti et Amicitiae.

Amsterdam 1929. *Tentoonstelling van Oude Kunst*. Amsterdam: Rijksmuseum.

Amsterdam 1939. *Tentoonstelling Bijbelsche Kunst*. Amsterdam: Rijksmuseum.

Amsterdam 1950. *Amsterdams goud en zilver: tentoonstelling van werken der grote Amsterdamse edelsmeden van de 16e, 17e en 18e eeuw*. Amsterdam: Museum Willet-Holthuysen.

Amsterdam 1952. Josua Bruyn and J.L. Cleveringa, *Drie Eeuwen Portret in Nederland 1500–1800*. Amsterdam: Rijksmuseum.

Amsterdam 1987. Sjoerd Faber, et al., *Of Lords, who seat nor cushion do ashame. The Government of Amsterdam in the 17th and 18th centuries*. Amsterdam: Royal Palace on the Dam.

Amsterdam 1991. Astrid Tümpel, Peter Schatborn, et al., *Pieter Lastman; leermeester van Rembrandt/the man who taught Rembrandt*. Amsterdam: Museum het Rembrandthuis.

Amsterdam 1992. *De wereld binnen handbereik. Nederlands kunst- en rariteitenverzamelingen, 1585–1735*. Eds. Elinoor Bergvelt and Renée Kistemaker. Amsterdam: Amsterdams Historisch Museum.

Amsterdam 1993. *Dawn of the Golden Age*. Ed. Ger Luijten. Amsterdam: Rijksmuseum.

Amsterdam 1997. Eddy de Jongh and Ger Luijten, *Mirror of Everyday Life. Dutch Genre Prints 1550–1700*. Trans. Michael Hoyle. Amsterdam: Rijksmuseum.

Amsterdam 1999. Bob van den Boogert, et al., *Rembrandt's Treasures*. Amsterdam: Museum het Rembrandthuis.

Amsterdam and Groningen 1983. Albert Blankert, et al., *The Impact of a Genius*. Trans. Ina Rike. Amsterdam: Waterman Gallery, and Groningen: Groninger Museum.

Amsterdam and Jerusalem 1991–92. Christian Tümpel, et al., *Het Oude Testament in de Schilderkunst van de Gouden Eeuw*. Amsterdam: Joods Historisch Museum, and Jerusalem: Israel Museum. [Later revised and translated into German: *Im Lichte Rembrandts. Das Alte Testament im Goldenen Zeitalter der niederländischen Kunst*. Trans. Astrid Tümpel. Münster: Westfälisches Landesmuseum für Kunst- und Kulturgeschichte, 1994.]

Amsterdam, New York, and Toledo 2003–04. *Hendrick Goltzius, Dutch Master (1558–1517): Drawings, Prints and Paintings*. Amsterdam: Rijksmuseum, New York: Metropolitan Museum of Art, and Toledo: The Toledo Museum of Art.

Amsterdam, Vienna, New York, and Cambridge 1981–82. William W. Robinson, *Seventeenth-Century Dutch Drawings. A Selection from the Maida and George Abrams Collection*. Intro. Peter Schatborn. Amsterdam: Rijksprentenkabinet, Vienna: Graphische Sammlung Albertina, New York: The Pierpont Morgan Library, and Cambridge, Massachusetts: The Fogg Art Museum.

Basel 1987. Petra ten Doesschate-Chu, *Im Lichte Hollands. Holländische Malerei des 17. Jahrhunderts aus den Sammlungen des Fürsten von Liechtenstein und aus Schweizer Besitz*. Basel: Kunstmuseum.

Berlin 1890. Wilhelm von Bode, *Ausstellung von Werken der niederländischen Kunst*. Berlin: Kunstgeschichtliches Gesellschaft.

Berlin 1914. *Werke Alte Meister*. Berlin: Königliche Akademie der Künste.

Berlin 1989. *Europa und der Orient 800–1900*. Eds. Gereon Sievernich and Hendrik

Budde. Berlin: Martin-Gropius-Bau.

Bethnal Green 1872–75. C.C. Black, *Catalogue of the Collection of Paintings, Porcelain, Bronzes, Decorative Furniture, and other Works of Art, lent for exhibition in the Bethnal Green Branch of the South Kensington Museum, by Sir Richard Wallace, Bart. M.P.* Bethnal Green: Bethnal Green Branch of the South Kensington Museum.

Birmingham, et al. 1957–58. *Flemish, Dutch and German Paintings from the Collection of Walter Chrysler, Jr.* Birmingham, Alabama: Birmingham Museum of Art, Washington, D.C.: George Washington University, Columbus, Ohio: The Columbus Gallery of Fine Arts, Dallas, Texas: The Dallas Museum of Fine Arts, Columbus, Georgia: The Columbus Museum of Arts and Crafts, New Orleans, Louisiana: The Isaac Delgado Museum of Art, West Palm Beach, Florida: The Norton Gallery of Art, Columbia, South Carolina: The Columbia Museum of Art, Chattanooga, Tenessee: The George T. Hunter Gallery.

Bordeaux and Pau 1995. *Le Coeur et la Raison*. Bordeaux: Musée des Beaux-Arts, and Pau: Musée des Beaux-Arts de Pau.

Braunschweig 1983. Rüdiger Klessman, *Niederländische Malerei aus der Kunstsammlung der Universität Göttingen.* Braunschweig: Herzog Anton Ulrich-Museum.

Braunschweig 1989. *Europaische Malerei des Barock aus dem Nationalmuseum Warschau.* Braunschweig: Herzog Anton Ulrich-Museum.

Braunschweig 1994.

Brussels 1924. *Salon D'Été.* Brussels: Cercle Artistique et Literaire.

Brussels 1962–63. L. Ninane, *Hollandse Schilderijen en Tekeningen.* Brussels: Museum van Oude Kunst.

Brussels 1995–96. *Divertimento.* Brussels: Musée des Beaux-Arts.

Chicago 1969. Jay Richard Judson, *Rembrandt after Three Hundred Years.* Chicago: Art Institute of Chicago, Minneapolis:

Minneapolis Institute of Arts, and Detroit: Detroit Institute of Arts.

Cologne 1964. *Die Sammlung Henle. Aus dem großem Jahrhundert der niederländischen Malerei.* Intro. Gert van der Osten. Cologne: Wallraf-Richartz Museum.

Delft 1950. *Antiekbeurs.* Delft: Stedelijk Museum het Prinsenhof.

Delft 1965. *Antiekbeurs.* Delft: Stedelijk Museum het Prinsenhof.

Dieren 1939. Dieren, The Netherlands: D. Katz Gallery.

Dijon 2003–04. *Rembrandt et son École. Collections du musée de l'Ermitage de Saint-Pétersbourg.* Dijon: Musée des Beaux-Arts de Dijon.

Dortmund 1984. *Niederländische Gemälde und Zeichnungen des 17. Jahrhunderts aus der Kunstsammlung der Universität Göttingen.* Dortmund: Museum für Kunst und Kulturgeschichte der Stadt Dortmund.

Dublin 1985. Sylvain Laveissière, *Le Classicisme francais. Masterpieces of seventeenth-century painting.* Dublin: National Gallery of Ireland.

Dunkerque 1983. Jacques Kuhnmünch, *Acquisitions, Dons & Restaurations de 1967 à 1983.* Dunkerque: Musée des Beaux-Arts.

Florence 1977. *Rubens e la pittura fiamminga del Seicento nelle collezioni pubbliche fiorentine.* Ed. Didier Bodart. Florence: Palazzo Pitti.

Gdansk 1969. Zbiory Sztuki, *Muzeum Pomorski w Gdansku.* Gdansk: Muzeum Pomorskie.

Haarlem 1986. Eddy de Jongh, *Portretten van echt en trouw. Huwelijk en gezin in de Nederlandse kunst van de zeventiende eeuw.* Haarlem: Frans Halsmuseum.

Haarlem and Antwerp 2000. *Pride and Joy. Children's Portraits in the Netherlands 1500–1700.* Eds. Jan Baptist Bedaux and Rudi Ekkart. Haarlem: Frans Halsmuseum, and Antwerp: Koninklijk Museum voor Schone Kunsten.

The Hague 1930. *Verzameling Dr. C. Hofstede de Groot. III. Schilderijen, teekeningen en kunstnijverheid*. The Hague: Gemeente Museum.

The Hague 1936. *Nederlandsch Muziekleven 1600–1800*. The Hague: Gemeente Museum.

The Hague 1936–37. *Oude Kunst in Haagsch bezit*. The Hague: Gemeente Museum.

The Hague 1946. *Herwonnen Kunstbezit*. The Hague: Mauritshuis.

The Hague 1992. Paul Huys Janssen, *The Hoogsteder Exhibition of Rembrandt's Academy*. Intro. Werner Sumowski. The Hague: Hoogsteder & Hoogsteder Gallery.

Hamburg 1983–84. *Luther und die Folgen für die Kunst*. Ed. Werner Hoffman. Hamburg: Hamburger Kunsthalle.

Hartford 1949. *Pictures Within Pictures*. Hartford, Connecticut: Wadsworth Atheneum.

Helsinki 1936. *Old Foreign Art*. Helsinki: Konsthall.

Kalamazoo 1967. *The Alfred Bader Collection. 17th Century Dutch and Flemish Paintings*. Kalamazoo: Institute of Arts.

Kingston 1984. David McTavish, *Pictures from the Age of Rembrandt. Selections from the Personal Collection of Dr. Alfred and Mrs. Alfred Bader*. Kingston: Agnes Etherington Art Centre.

Kingston 1988. David McTavish, *Telling Images*. Kingston: Agnes Etherington Art Centre.

Kingston 1996. Volker Manuth, et al., *Wisdom, Knowledge and Magic. The Image of the Scholar in Seventeenth-Century Dutch Art*. Kingston: Agnes Etherington Art Centre.

Kobe and Tokyo 1993. *Exposition du bicentenaire du Musée du Louvre*. Kobe: Kobe City Museum, and Tokyo: Tiho Keizai Shimbun.

Laren 1966. *Oude Tekeningen. Een keuze uit de verzameling P. en N. de Boer*. Laren: Singer Museum.

Leiden 1975. *Boccaccio in Nederland*. Ed. F.J. Obbema, et al. Leiden: Academisch Historisch Museum.

Leipzig 1914. *Alte Meister aus Leipziger Privatbesitz*. Leipzig: Leipziger Kunstverein.

Leipzig 1937. *Alte Meister aus mitteldeutschen Besitz*. Leipzig: Museum der Bildende Künste.

Leipzig 1998. *Maximillian Speck von Sternburg. Ein Europäer der Goethezeit als Kunstsammler*. Ed. Herwig Guratzsch. Leipzig: Museum der Bildenden Künste.

Lille 1974. *La Collection d'Alexandre Leleux*. Lille: Musée des Beaux-Arts.

Lille, Arras, and Dunkerque 1972–73. Jacques Foucart and Herve Oursel, *Trésors des musées du Nord de France I. Peinture Hollandaise*. Lille: Musée des Beaux-Arts, Arras: Musée d'Arras, and Dunkerque: Musée des Beaux-Arts.

Liverpool 1956. *Children Painted by Dutch Artists. 1550–1820*. Liverpool: Walker Art Gallery.

London 1952–53. *Dutch Pictures 1450–1750*. London: Royal Academy of Arts.

London 1953. *Rembrandt's Influence in the 17th Century*. Intro. Horst Gerson. London: Matthiesen Gallery.

Lyon, Bourg-en-Bresse, and Roanne 1992. *Flandre et Hollande au Siècle d'Or; Chefs-d'oeuvre des Musées de Rhône-Alpes*. Lyon: Musée des Beaux-Arts, Bourg-en-Bresse: Musée de Brou, and Roanne: Musée Joseph Déchelette.

Lyon and Paris 1991. Hans Buijs, *Tableaux flamands et hollandais du Musée des Beaux-Art de Lyon*. Lyon: Musée des Beaux-Arts, and Paris: Institut Néerlandais.

Madrid 1992. Matías Días Padrón and Mercedes Royo-Villanova, *David Teniers, Jan Brueghel y Los Gabinetes de Pinturas*. Madrid: Museo del Prado.

Mänttä 1980. *Gösta Serlachiuksen Kokoelmat Ateneumissa. Serlachius' Samlingar I Ateneum*. Mänttä: Konstmuseet I Ateneum.

Mexico City 1964. *Pintura Neerlandesa en Mexico, Siglos XV, XVI y XVII*. Intro. Hugh Paget. Mexico: Museo Nacional de Arte Moderno.

Milan 1995. Ildikó Ember and Marco Chiarini, *Rembrandt, Rubens, Van Dyck e il Seicento dei Paesi Bassi*. Milan: Museo della Permanete Vai Turati.

Milwaukee 1976. Alfred Bader, *The Bible through Dutch Eyes*. Milwaukee: Milwaukee Art Museum.

Munich 1889. *Permanente Gemälde-Ausstellung alter und moderner Meister und Kunsthandlung von A. Rupprecht's Nachfolger*. Munich: A. Rupprecht.

Munich 1994. *Neuerwerbungen*. Munich: Galerie Arnoldi-Levie.

Munich 1995. *Sehnzucht zur Kindheit. Kinderdarstellung in der Romantik und ihre Vorläufer*. Munich: Galerie Arnoldi-Levie.

Ottawa 1968. Micheal Jaffé, *Jacob Jordaens 1593–1678*. Ottawa: National Gallery.

Paris 1987. *Nouvelles Acquisitions du Département des Peintures (1983–1986)*. Ed. Jacques Foucart, intro. M. Laclotte. Paris: Louvre.

Paris 1991–92. *Old Master Paintings, French, Northern and Italian Schools*. Paris: Habolt & Co.

Paris and Amsterdam 1970–71. *Le siècle de Rembrandt. Tableaux hollandais des collections publiques françaises*. Paris: Musée du Petit Palais, and Amsterdam: Rijksmuseum.

Paris and Lyon 1991. *Tableaux Flamands et Hollandais du Musée des Beaux-Arts de Lyon*. Ed. Hans Buijs. Paris: Institut Neérlandais, and Lyon: Musée des Beaux-Arts.

Perth, Adelaide, and Brisbane 1997–98. Norbert Middelkoop, *The Golden Age of Dutch Art*. Perth: Art Gallery of Western Australia, Adelaide: Art Gallery of Southern Australia, and Brisbane: Queensland Art Gallery.

Raleigh 1956. *Rembrandt and His Pupils*. Ed. Wilhelm Reinhold Valentiner. Raleigh, North Carolina: The North Carolina Museum of Art.

Rotterdam 1969. Hans R. Hoetink, *Tekeningen van Rembrandt en zijn school*, Rotterdam: Museum Boijmans Van Beuningen.

Rotterdam and Frankfurt 1999–2000. Albert Blankert, et al., *Dutch Classicism in Seventeenth-century Painting*. Rotterdam: Museum Boijmans Van Beuningen, and Frankfurt: Städelsches Kunstinstitut.

Utrecht 1946. *Herwonnen Kunstbezit*. Intro. C.H. de Jonge. Utrecht: Centraal Museum.

Utrecht 1984. *Zeldzaam Zilver uit de Gouden Eeuw. De Utrechtse edelsmeden Van Vianen*. Ed. M.I.E. Van Zijl. Utrecht: Centraal Museum.

Utrecht 1989. Robert Schillemans, *Bijbelschilderkunst Rond Rembrandt*. Utrecht: Museum Het Catharijneconvent.

Utrecht and Luxembourg 1993–94. Peter van den Brink, et al., *Het Gedroomde Land. Pastorale schilderkunst in de Gouden Eeuw*. Utrecht: Centraal Museum, and Musée National d'Histoire et d'Art de Luxembourg.

Warsaw 1950. Wladyslaw Tomkiewicz, *Catalogue of Paintings, Removed from Poland by the German Occupation Authorities during the Years 1939–45. I. Foreign Paintings*. Warsaw: Museum Narodowe.

Washington and The Hague 1995–96. Ben Broos and Arthur K. Wheelock, Jr., *Johannes Vermeer*. Washington: National Gallery of Art, and The Hague: Mauritshuis.

Washington, Detroit, and Amsterdam 1980–81. Albert Blankert, et al., *Gods, Saints and Heroes: Dutch Painting in the Age of Rembrandt*. Washington: National Gallery of Art, Detroit: Institute of Arts, and Amsterdam: Rijksmuseum.

Yokohama, Fukuoka, and Kyoto 1986–87. *Rembrandt and the Bible*. Ed. Christopher Brown. Yokohama: Sogo Museum of Art, Fukuoka: Fukuoka Art Museum, and Kyoto: Kyoto National Museum of Modern Art.

Amsterdam 1885. *Catalogus der Schilderijen in het Rijksmuseum Amsterdam*, Amsterdam: Rijksmuseum.

Amsterdam 1976. P.J.J. van Thiel, *All the Paintings in the Rijksmuseum*. Amsterdam: Rijksmuseum.

Amsterdam 1998. Marijn Schapelhouman and Peter Schatborn, *Dutch Drawing of the Seventeenth Century in the Rijksmuseum, Amsterdam. Artists Born between 1580 and 1600*. Trans. Michael Hoyle. 2 vols. Amsterdam: Rijksprentenkabinet.

Bordeaux 1990. Olivier Le Bihan, *L'or et l'ombre. Catalogue critique et raisonné des peintures hollandaises du dix-septième et du dix-huitième siècles, conservées au Musée des Beaux-Arts de Bordeaux*. Bordeaux: Musée des Beaux-Arts de Bordeaux.

Braunschweig 1983. Rüdiger Klessman, *Die holländischen Gemälde: kritisches Verzeichnis mit 485 Abbildungen*. Braunschweig: Herzog Anton Ulrich-Museum.

Braunschweig 1990. Thomas Döring, *Holländische Historienbilder*, Bilderhefte des Herzog Anton Ulrich-Museums Braunschweig 8. Braunschweig: Herzog Anton Ulrich-Museum.

Brussels 1906. Alphonse-Jules Wauters, *Catalogue Historique et Descriptif des Tableaux Anciens du Musée de Bruxelles*. 2nd. ed. Brussels: Musée Royale de Belgique.

Brussels 1913. Hippolyte Fierens-Gevaert. Brussels: Musée des Beaux-Arts.

Brussels 1927. Hippolyte Fierens-Gevaert, *Catalogue de la peinture ancienne. Musees royaux des beaus-arts de Belgique*. Brussels: Musées Royaux des Beaux-Arts.

Brussels 1957. *Catalogue de la peinture ancienne*. Brussels: Musée Royal des Beaux-Arts).

Brussels 1984. Henri Pauwels, *Musées Royaux des Beaux-Arts. Catalogue inventaire de la peinture ancienne*. Brussels: Musées Royaux des Beaux-Arts.

Budapest 1968. Regi Keptar, *Katalog der Galerie Alte Meister*. Budapest: Szépmüvészeti Múzeum.

Budapest 2000. Ildikó Ember and Zsuzsa Urbach, *Museum of Fine Arts Budapest: Old Masters' Gallery, Summary Catalogue Volume 2. Early Netherlandish, Dutch and Flemish Paintings*. Budapest: Szépmiveszeti Múzeum.

Budapest 2005. Teréz Gerszi, *17th-Century Dutch and Flemish Drawings in the Budapest Museum of Fine Arts. A Complete Catalogue*. Budapest: Szépmüvészeti Múzeum.

Butôt 1981. Laurens J. Bol, George S. Keyes, and F.C. Butôt, *Netherlandish Paintings and Drawings from the Collection of F.C. Butôt*. London: F.C. Butôt Collection, and Totowa, New Jersey: P. Wilson.

Celle 1789. Friedrich Wilhelm Basilius von Ramdohr, manuscript inventory. Celle: Zschorn Collection.

Dunkerque 1974. Guy Blazy, *La peinture des anciens Pays-Bas au Musée de Dunkerque*. Dunkerque: Musée des Beaux-Arts.

Dunkerque 1976. Guy Blazy, *La peinture des anciens Pays-Bas au Musée de Dunkerque*. 2nd ed. Dunkerque: Musée des Beaux-Arts.

Düsseldorf c.1716. Gerhard Joseph Karsch, manuscript inventory. Düsseldorf: Collection of the Elector Karl Philipp.

Düsseldorf 1719. Gerhard Joseph Karsch. Düsseldorf: Collection of the Elector Karl Philipp.

Düsseldorf 1778. Nicolas de Pigage, *La Galerie Electorale du Dusseldorf ou Catalogue raisonné et figuré de ses tableaux*. Düsseldorf: Gallery of the Elector.

Florence 1895. *Catalogo della Galleria Feroni*. Florence: Galleria Feroni.

Florence 1979. *Gli Uffizi. Catalogo generale*. Florence: Uffizi Gallery.

Florence 1989. Marco Chiarini, *I dipinti olandese del seicento e del settecento*. Florence: Gallerie e Musei Statali di Firenze.

Gavnø 1785. Gavnø: Collection of the Baron Reedz-Thott.

Gavnø 1876. Julius Lange, *Baroniet Gaunøgs Malerisamling. I, Malerier af bekendte mestere og kunstskoler*. Gavnø: Collection of the Baron Reedz-Thott.

Gavnø 1914. Karl Madsen, *Fortegnelse over to Hundrede af Baroniet Gaunøs Malerier af Ældre Malere Samt over dets Portrætsamling*. Gavnø: Collection of the Baron Reedz-Thott.

Getty 1997. David Jaffé, *Summary Catalogue of European Paintings in the J. Paul Getty Museum*. Los Angeles: J. Paul Getty Museum.

Göttingen 1806. Johann Domenik Fiorillo, *Verzeichnis der Gemälde*. Göttingen: Universität Göttingen.

Göttingen 1905. Emil Waldmann, *Provisorischer Führer durch die Gemälde-Sammlung der Universität Göttingen*. Göttingen: Universität Göttingen.

Göttingen 1926. Wolfgang Stechow, *Katalog der Gemäldesammlung der Universität Göttingen*. Göttingen: Universität Göttingen.

Göttingen 1987. Gerd Unverfehrt, *Kunstsammlung der Universität Göttingen. Die niederländischen Gemälde*. Göttingen: Universität Göttingen.

Grunewald 1933. Georg Poensgen, *Jagdschloß Grunewald*. Berlin: Jagdschloß Grunewald.

Grunewald 1964. Helmut Börsch-Supan, *Die Gemälde im Jagdschloß Grunewald*. Berlin: Jagdschloß Grunewald.

The Hague 1992. *Old Master Paintings: An Illustrated Summary Catalogue*. Trans. Shirley van der Pols-Harris. The Hague: Rijksdienst Beeldende Kunst (now Instituut Collectie Nederland).

Hannover 1960. Christian von Heusinger, *Handzeichnungen I: die Niederländer des 16. bis 18. Jahrhunderts*. Hannover: Kestner-Museum.

Hartford 1978. *Wadsworth Atheneum Paintings. Catalogue 1: The Netherlands and German-Speaking Countries*. Ed. Egbert Haverkamp-Begemann. Hartford, Connecticut: Wadsworth Atheneum.

Helsinki 1988. Marja Supinen, *Wuomen Taideakatemia Sinebrychoffin Taidemuseo, Ulkomainen taide, Kokoelmalnettelo I, Maalaukset*. Helsinki: Sinebrychoff Museum.

Hofstede de Groot 1923. Felix Becker, *Handzeichnungen holländischer Meister aus der Sammlung Hofstede de Groot im Haag: fünfzig ausgewählte Zeichnungen Rembrandts, seines Kreises und seiner Zeit*. Leipzig.

Johannesburg 1988. Jillian Carman, *Dutch Painting of the 17th Century*. Johannesburg: Johannesburg Art Gallery.

Krakow 1935. Krakow: Wawel Museum.

Krakow 1994. Jerzy Szablowski, *Zbiory Zamku Krvo'lewskiego na Wawelu*. Krakow: Wawel Museum.

Leipzig 1942. *Das Museum der Bildenden Künste im letzten Jahrhundert*. Leipzig: Museum der Bildenden Künste.

Leipzig 1995. Dietluf Sander, *Von Avercamp bis Wouwerman*. Leipzig: Museum der Bildenden Künste.

Lille 1875. Edouard Reynart, *Catalogue des Tableaux, Bas-reliefs et Statues Exposées das les Galeries du Musée des Tableaux de la Ville de Lille*. 5th ed. Lille: Musée des Tableaux.

Lille 1893. Lules Lengart, *Catalogue des Tableaux du Musée de Lille*. Lille: Musée des Beaux-Arts.

Lille 1984. Hervé Oursel, *La Musée des Beaux-Arts de Lille*. Lille: Musée des Beaux-Arts.

London 1915–32. Arthur M. Hind, *Catalogue of Drawings by Dutch and Flemish Artists Preserved in the Department of Prints and Drawings in the British Museum*. 5 vols. London: British Museum.

London 1973. Cecil Gould, *Illustrated General Catalogue*. London: National Gallery

London 1977. *Kate de Rothschild Exhibition of Old Master Drawings*. London: William Darby's Gallery.

Louvre 1929–33. Frits Lugt, *Musée du Louvre. Inventaire Général des Dessins des Écoles du Nord*. 3 vols. Paris: Louvre.

Lyon 1912. Paul Dissard, *Le Musée de Lyon. Les Peintures*. Lyon: Musée de Lyon.

Lyon 1993. Hans Buijs, *Lyon I, Écoles étrangères XIIIᵉ– XIXᵉ siècles*. Lyon: Musée des Beaux-Arts.

Mänttä 1965. *Gösta Serlachuis'en taidesäätiö*. Mänttä: Gösta Serlachius Fine Arts Foundation.

Mänttä 1978. Maritta Kirjavainen, *Gösta Serlachiuksen Taidesäätiön Kokoelmat. The Collection of the Gösta Serlachius Fine Arts Foundation*. Mänttä: Gösta Serlachius Fine Arts Foundation.

Milwaukee 1974. *Selections from the Bader Collection*. Ed. Alfred Bader, intro. Wolfgang Stechow. Milwaukee: Milwaukee Art Museum.

Moltke 1756. Gerhard Morell, *Katalog over den Moltke'ske malerisamling*. Copenhagen: Moltke Collection.

Moltke 1780. Copenhagen: Moltke Collection.

Moltke 1818. R.H. Weinwich. Copenhagen: Moltke Collection.

Moltke 1841. N. Høyen. Copenhagen: Moltke Collection.

Moltke 1885. F.C. Kiærskou. Copenhagen: Moltke Collection.

Moltke 1900. Karl Madsen. Copenhagen: Moltke Collection.

Moscow 1975. Tatiana Sedova, *Le Musée des Beaux-Arts Pouchkine de Moscou: peinture*. Moscow: Pushkin State Art Museum.

Munich 1845. Georg von Dillis, *Verzeichniss der Gemälde in der königlichen Pinakothek zu München*. 3rd. ed. Munich: Königlichen Pinakothek

Munich 1885. Franz von Reber and Ad. Bayersdorfer, *Katalog der Gemälde-Sammlung der Kgl. älteren Pinakothek in München*. Munich: Alte Pinakothek.

Munich 1973. Wolfgang Wegner, *Kataloge der Staatlichen Graphischen Sammlung München, I, Die niederländischen Handzeichnungen des 15.–18. Jahrhunderts*. Munich: Staatliche Graphische Sammlung München.

Munich 1998. Rüdiger an der Heiden, *Die Alte Pinakothek. Sammlungsgeschichte. Bau und Bilder*. Munich: Alte Pinakothek.

Oldenburg 1845. *Verzeichniß der Gemälde, Gipsabgüsse, geschnitte Steine etc. in der Großherzoglichen Sammlung zu Oldenburg*. Oldenburg: Großherzogliche Sammlung.

Oldenburg 1881. *Verzeichniß der Gemälde, Gypse und Bronzen in der Großherzoglichen Sammlung zu Oldenburg*. 5th ed. Oldenburg: Großherzogliche Sammlung.

Oldenburg 1966. Herbert Wolfgang Keiser, *Gemäldegalerie Oldenburg*. Oldenburg: Landesmuseum für Kunst und Kulturgeschichte.

Oxford 1999. Christopher White, *Ashmolean Museum Oxford. Catalogue of the Collection of Paintings. Dutch, Flemish, and German Paintings before 1900 (excluding the Daisy Linda Ward Collection)*. Oxford: Ashmolean Museum.

Paris 1922. Louis Demonts, *Catalogue des peintures exposées dans les galeries du Musée national du Louvre III, Écoles flamande, hollandaise, allemande et anglaise*. Paris: Louvre.

Paris 1950. Frits Lugt, *École Nationale Supérieure des Beaux-Arts Paris. Inventaire Général des Dessins des Écoles du Nord*, vol. 1, *École Hollandaise*. Paris: École Nationale Supérieure des Beaux-Arts Paris.

Paris 1979. Jacques Foucart and Arnauld Brejon de Lavergnée, et al., *Catalogue sommaire illustré des peintures du Musée du Louvre. I. Écoles flamande et hollandaise*. Paris: Musée du Louvre.

Paris 1983. Saskia Nihom-Nijstad, *Reflets du Siècle d'Or*. Paris: Fondation Custodia.

Rotterdam 1969. Hans R. Hoetink, *Tekeningen van Rembrandt en zijn school*. Rotterdam:

Museum Boijmans Van Beuningen.

Rotterdam 1972. *Old Paintings 1400–1900*. Rotterdam: Museum Boijmans Van Beuningen.

Rotterdam 1988. Jeroen Giltaij, *Drawings by Rembrandt and His School*. Rotterdam: Museum Boijmans Van Beuningen.

Schwerin 1882. Friedrich Schlie, *Beschreibendes Verzeichniß der Werke älterer Meister in der Großherzogliche Gemäldegalerie zu Schwerin*. Schwerin: Großherzogliche Gemäldegalerie.

Schwerin 1892. Wilhelm von Bode, *Die großherzogliche Gemälde-Galerie zu Schwerin*. Schwerin: Großherzogliche Gemäldegalerie.

Schwerin 1951. Heinz Mansfeld, *Holländische Maler des XVII. Jahrhunderts im Mecklenburgischen Landesmuseum Schwerin*. Schwerin: Mecklenburgischer Landesmuseum.

Semenov 1906. *Études sur les peintres des écoles hollandaise, flamande et néerlandaise qu'on trouve dans la Collection Semenov et les autres collections publiques et privées de St-Pétersbourg*. St Petersburg: Semenov Collection.

Speck von Sternburg 1827. Karl Tauchnitz, *Verzeichniß der von Speck'schen Gemälde-Sammlung mit darauf beziehung habenden Steindrucken*. Leipzig: Collection of the Baron Speck von Sternburg.

Speck von Sternburg 1889. *Verzeichniß von Ölgemälden welche sich inder freiherrlich Speck v. Sternburg'schen Sammlung auf dem Rittergute Lützschena bei Leipzig befinden*. Leipzig: Collection of the Baron Speck von Sternburg.

St Petersburg 1828. St Petersburg: Hermitage.

St Petersburg 1863. B. de Köhne, *Éremitage Impérial. Catalogue de la Galerie des tableaux*. St Petersburg: Hermitage.

St Petersburg 1895. *Ermitage Imperial. Catalogue de la Galerie des Tableaux*. 2nd. ed. Vol. 2, *Écoles neerlandaises et école allemande*. St Petersburg: Hermitage.

St Petersburg 1958. *Département de l'art occidental: Catalogue des Peintures I*. 2 vols. St Petersburg: Hermitage.

Stockholm 1990. Görel Cavalli-Björkman, *Illustrated Catalogue – European Paintings*. Stockholm: Nationalmuseum.

Utrecht 2002. J. Dijkstra, P.W.M. Dirkse, and A.E.M. Smits, *De schilderijen van Museum Catharijneconvent*. Utrecht: Museum Catharijneconvent.

Van Eeghen 1988. Boudewijn Bakker et al., *De verzameling van Eeghen. Amsterdamse tekeningen 1600–1950*. Amsterdam: Gemeentearchiefdienst Amsterdam.

Wallace Collection 1901. *A Provisional Catalogue of the Oil Paintings and Water Colours in the Wallace Collection with Short Notices of the Painters*. London: Wallace Collection.

Wallace Collection 1968. F.J.B. Watson, *Wallace Collection Catalogues, Pictures and Drawings*. 16th ed. London: Wallace Collection.

Wallace Collection 1979. John Ingamells, *Wallace Collection: Summary Illustrated Catalogue of Pictures*. London: Wallace Collection.

Wallace Collection 1992. John Ingamells, *The Wallace Collection: Catalogue of Pictures IV: Dutch and Flemish*. London: Wallace Collection.

Weimar 1994. Rolf Bothe, *Kunstsammlungen zu Weimar: Schlossmuseum, Gemäldegalerie*. Weimar: Schlossmuseum.

Worcester 1974. Seymour Slive, et al., *European Paintings in the Collection of the Worcester Art Museum*. Worcester, Massachusetts: Worcester Art Museum.

Index

(illus.); by Govert Flinck, Basel, 21, 116
(fig. 44); by Jan van Noordt, Avignon (cat.
15), 21, 109; (cat. L10) 278; 358n68
Cupid, by Jan van Noordt (cat. L17), 279

Dankerts, Cornelis, Dominee, portrait by Jan
van Noordt (cat. L45), 14, 283–4
David: by Jan van Noordt (cat. 5), 97–8
(illus.); by Salomon de Bray, Los Angeles,
97–8 (fig. 40). See also *Triumph of David*
dealers, 41, 49–50, 354n12
Decameron. See Boccaccio
Democritus. See *Hippocrates Visiting
Democritus in Abdera*
d'Hondecoeter, Melchoir, possession of a
painting by Jan van Noordt (cat. L7), 49
Diana, 128 (cat. 21); by Govert Flinck,
Kimberley, 30 (fig. 13). See also *Jupiter and
Callisto*
Diana and Actaeon, by Jan van Noordt (cat.
L14), 279
Disobedient Prophet, by the other Jan van
Noort (cat. R10), 21
Doeck, Cornelis, 41, 42, 50, 168, 353n11
Don Jan, or Don Juan. See *Pretioze and Don
Jan*
drawing academies, 80, 301, 302, 366n13
Dudok van Heel, S.A.C., 15
Dyck, Sir Anthony van, 62

Eeckhout, Gerbrand van den, 46, 116, 144;
connection to Van Noordt, 4; *Daniel
Proving the Innocence of Susanna*, Hartford,
364n72; *Merry Company on a Terrace*,
Worcester, 160 (fig. 55); *Satyr and the
Peasant Family*, various versions, 132;
Portrait of a Man, Amsterdam (cat. R54),
261 (illus.); *Portrait of Willem Woutersz.
Oorthoorn on a Goat Cart*, Germany, 310;
The Levite and His Concubine in Gibeah,
Moscow, 223; *Two Officers Playing Cards*,
unknown location, 211–12 (fig. 63)
Elisha, 204
Elsheimer, Adam, *Jupiter and Mercury in the
House of Philemon and Baucis*, Dresden,
238–9
eroticism in art, 50, 58, 208; in depictions of
Susanna and the Elders, 67–70

Esther at Her Toilette: by Rembrandt, Ottawa,
228; not by Jan van Noordt, Europe, 228–9
(illus.), 233
evangelist. See *St John the Evangelist*, *Four
Evangelists*
eventus, 74
Everdingen, Cesar van, 50

fables. See *Satyr and the Peasant Family*
Fabritius, Barent, 272; *Satyr and the Peasant
Family*, various versions, 132; *The Widow of
Elisha's Servant Implores his Aid*, unknown
location, 204
Fabritius, Carel, 263
Ferreris, Dirck or Theodorus, 80, 366n13
Five Senses, by Jan van Noordt, reference to,
collection of Cornelis Doeck (cat. L27), 281
Flinck, Govert, commission for the Amster-
dam City Hall, 11, 30, 44; drawing acade-
my, 80; drawing style, 366n6; former attri-
bution to, 102, 162, 230; influence on Van
Noordt, 21, 84, 102; *Crucifixion*, Basel, 21,
116 (fig. 440; *Diana*, Kimberley, 30 (fig.
13); *Manius Curius Dentatus Refusing the
Gifts of the Samnites*, Amsterdam, 64;
Pendant Portraits of a Couple, Raleigh, 30, 31
(figs 15a,b); *Solomon asks God for Wisdom*,
Amsterdam, 30, 31 (fig. 16); *Venus and
Cupid*, Jerusalem, 30 (fig. 14); *Young
Shepherdess*, The Netherlands (cat. R60),
265 (illus.)
Flora: by Jan van Noordt, unknown location,
119–20; by Rembrandt, St Petersburg, 120
floral symbolism, 174
Four Evangelists, by Jan van Noordt, Poole,
117–18 (illus.)

Gaskell, Ivan, 60–1
Geesteranus, Jan Evertsz., 68–9
Gelder, Aert de, 37, 274
Georgics. See Virgil
Giltaij, Jeroen, on *ricordi*, 306n1
Giskes, Johan, on Jan van Noordt, 5; on
Jacobus van Noordt, 5, 8
Goltzius, Hendrick: possible influence on
Rubens, 366n8; *Bacchus* (print), 128–9 (fig.
47); *Sine Cerere et Libero friget Venus* (print),
128

Index of Current or Last Known Locations of Works by Jan van Noordt